JAPANESE INK PAINTINGS

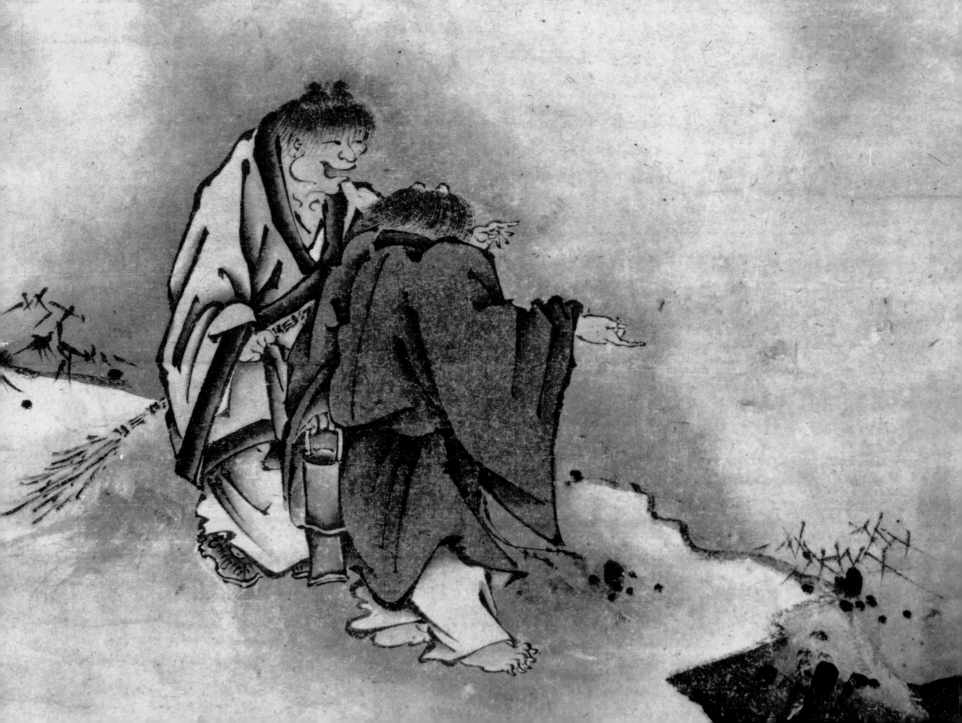

23.4 ('around

11.8

.7

JAPANESE INK PAINTINGS

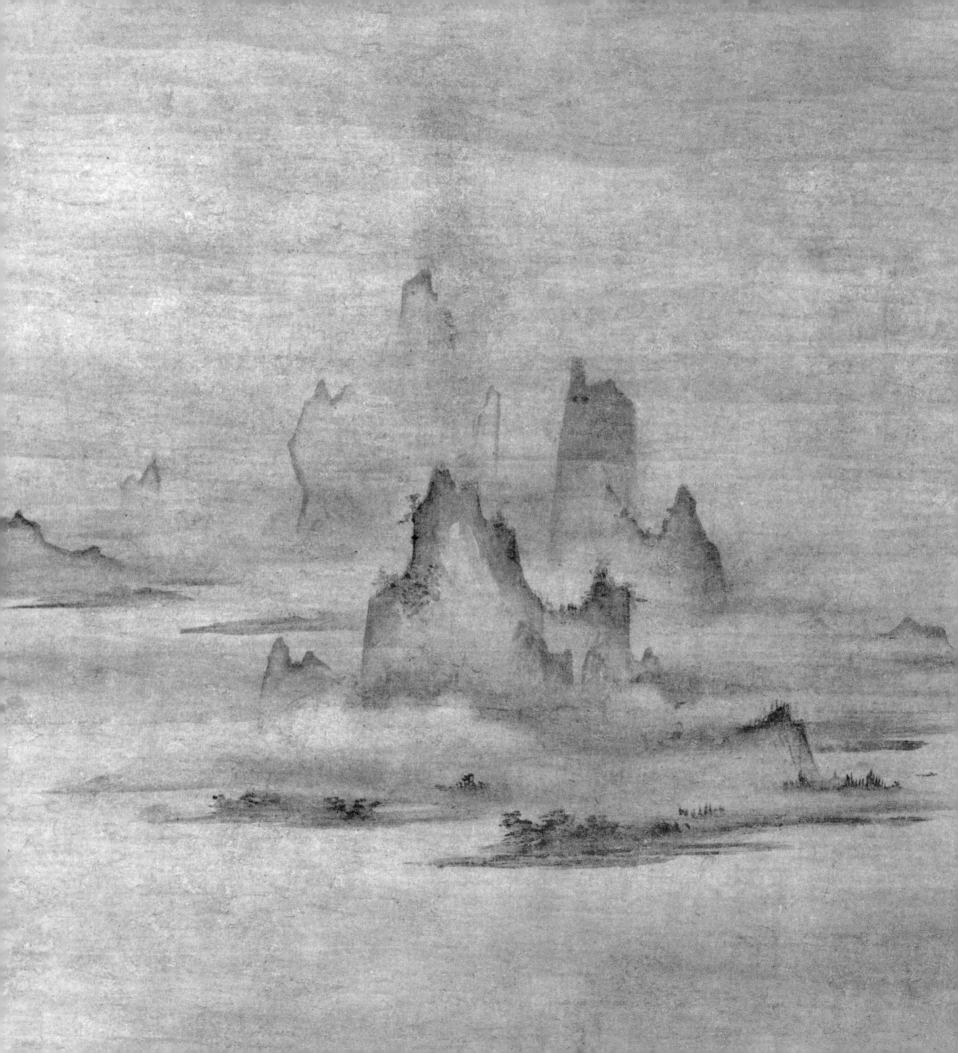

Edited by Yoshiaki Shimizu and Carolyn Wheelwright

JAPANESE INK PAINTINGS

FROM AMERICAN COLLECTIONS:

THE MUROMACHI PERIOD

AN EXHIBITION

IN HONOR OF SHŪJIRŌ SHIMADA

The Art Museum Princeton University

Distributed by Princeton University Press

*Publication of this volume is supported by grants from
Mr. and Mrs. Earl Morse and the JDR 3rd Fund.*

Dates of the exhibition: April 25–June 13, 1976

*Designed by James Wageman, Peterson Research Group
Type set by Dix Typesetting Company, Inc.
Printed by the Meriden Gravure Company*

*Library of Congress Catalogue Card Number 75-33450
International Standard Book Number 0-691-03913-5 (cloth)
International Standard Book Number 0-691-03918-6 (paper)*

*Distributed by Princeton University Press,
Princeton, New Jersey 08540*

Frontispiece: Detail of catalogue number 11,
Landscape with Distant Mountains

CONTENTS

FIGURES PAGE 8 PREFACE PAGE 13

FOREWORD by Wen C. Fong PAGE 11 INTRODUCTION PAGE 17

CATALOGUE OF THE EXHIBITION

Contents

PAINTING AND ARTIST	COLLECTION	ESSAY BY	PAGE
26 *Landscape in Wind* Sesson Shūkei	Private collection	Yoshiaki Shimizu	200
27 *Dragon* AND *Tiger* Sesson Shūkei	Cleveland Museum of Art	Yoshiaki Shimizu	206
28 *Figures in Landscape* Attributed to Kano Motonobu	Mary and Jackson Burke	Carolyn Wheelwright	212
29 *Reeds and Geese* Artist unknown	Mary and Jackson Burke	Yoshiaki Shimizu	218
30 *Orchids and Bamboo* Tesshū Tokusai	Mrs. T. Randag	Yoshiaki Shimizu	224
31 *Orchid and Rock* Tesshū Tokusai	Private collection	Carolyn Wheelwright	230
32 *Reeds and Geese* Tesshū Tokusai	Private collection	Yoshiaki Shimizu	234
33 *Orchid* Copy after Chō'un Reihō	Allen Memorial Art Museum, Oberlin College	Yoshiaki Shimizu	238
34 *Orchids, Bamboo, and Thorns* Gyoku'en Bompō	Brooklyn Museum	Yoshiaki Shimizu	244
35 *Lotus* Artist unknown	Private collection	Carolyn Wheelwright	252
36 *Radish* Jonan Etetsu	Private collection	Ann Yonemura	262
37 *Waterfowl* Shikibu	Private collection	Richard Stanley-Baker	266

FIGURES

FOREWORD

I FIRST MET Professor Shūjirō Shimada in Kyōto in 1956 when he was Curator at the Kyōto National Museum. The city of Kyōto was at that time brightly lit by such luminaries of Chinese art studies — besides Shimada — as Umehara Sueji, Mizuno Seiichi, Nagahiro Toshio, to mention only a few. The city, with its many ancient temples laden with great Chinese art treasures, provided a natural setting for Chinese art scholarship; one even encountered resident priests of these temples who turned out to be conversant in Chinese art and philosophy. After spending the previous eight years in America, I felt I was again "home" among far-eastern art scholars.

I was one of the many eager young men and women who had journeyed to Kyōto from Europe and America to study Chinese and Japanese art at first hand. For us Professor Shimada was the recognized teacher and mentor. A little card from the master miraculously opened doors to well-guarded temples and private collections. And for the lucky few who had occasions to accompany him on trips to view collections, we witnessed a way of life that has all but disappeared in the world. A native of Kansei, of which Kyōto was the traditional capital, Shimada inhabited a world that had, until that time, changed little in hundreds of years. He seemed to know intimately every art object in every nook and cranny of that wonderful city. As a historian of art, Shimada was able to combine his thorough and intimate knowledge of specific works of art with a rigorous intellectual discipline. Through the timeless world of Kyōto, he was able to view the larger vistas of art history with an exceptional lucidity and acuity.

In 1958–59, Shimada accepted a fellowship from Harvard, and during that year he visited and lectured at Yale, Princeton, and other places. Two years later, Professor Millard Meiss of the Institute for Advanced Study at Princeton had, upon my suggestion, met with Shimada in Japan. "Visiting the Byōdō-in sculptures with Shimada," Professor Meiss reported, "was one of the high moments of my life." So with Professor Meiss's encouragement and support, Princeton was able to invite, and persuade, Professor Shimada to join the faculty in 1965 as its first professor of the history of Japanese art.

The thirty-seven essays in this volume, which represent a milestone in the study of Japanese art in this country, are visible results of Shimada's nine years of teaching at Princeton. Each painting in the exhibition is precisely described and analyzed by Shimada's students and colleagues in essays that add important insight into Muromachi painting history. It is the story of cultural transformation from China to Japan during the fourteenth, fifteenth, and sixteenth centuries, which has been one of Shimada's principal scholarly concerns. One cannot fail to perceive a parallel between Shimada's own experience and the Muromachi history that he studies. As a modern I-shan I-ning, he has trained able scholars and fostered powerful interests in Japanese art in our universities, the modern equivalent of the Zen centers of learning in Muromachi Japan. And as Japanese art collections grow in this country, they will become an integral

Professor Shūjirō Shimada

part of our own expanding cultural legacy, as did the great Ashikaga collections of Chinese paintings in Japan.

Professor Shimada retired from active teaching at Princeton in June 1975. As we hold this important exhibition in his honor, we fervently hope that he will continue to play mentor and guide to us for many years to come.

WEN C. FONG
Edwards S. Sanford Professor of Art and Archaeology
Princeton University

PREFACE

A
WEALTH of Muromachi ink paintings surfaced after World War II, providing art buyers with notable additions to their collections and scholars with new data for art historical research. After more than a decade of exclusion from the Japanese art market, foreign purchasers in the 1950's were able once again to acquire Japanese works. Consequently, the number of ink paintings in America has increased significantly in the past twenty years, making this exhibition possible. We are presenting, in this exhibition, a group of important works, some only recently discovered, as evidence for certain artistic trends of the Muromachi period. Since major gaps hinder a faithful reflection of Japanese stylistic evolution from the fourteenth through the sixteenth centuries, these paintings should be viewed in relation to the larger development of Muromachi art history.

The history of Muromachi ink painting has been significantly revised by Japanese scholars working with newly disclosed materials in the past two decades. Guided by their researches, the writers of this catalogue have discussed in depth the thirty-seven Japanese ink paintings exhibited, placing them within the context of this new perspective on Japanese art history. It is hoped that their insights into persistent issues and their recognition of new problems will encourage others in additional investigation.

Contributors to the catalogue include: Helmut Brinker, Curator of East Asian Art at the Museum Rietberg and Universität Zürich; Sarah Handler, who pursues Ph.D. studies at the University of Kansas; John Rosenfield, Professor of Japanese Art History at Harvard University; David Sensabaugh, who is doing dissertation research in Kyōto; Yoshiaki Shimizu, who teaches Japanese art history at the University of California, Berkeley; Richard Stanley-Baker, who teaches Japanese art history at the University of Victoria in British Columbia; Carolyn Wheelwright, a Ph.D. candidate at Princeton; and Ann Yonemura, a Smithsonian Fellow at the Freer Gallery of Art.

In our capacity as editors of this catalogue, we should like to thank all contributors for their significant research into areas of Muromachi painting history. We hope this book will provide serious students with a chance to review Muromachi painting in the light of new sources of knowledge. We are indebted to Professor Shimada for his invaluable comments and corrections, and for his contribution of numerous informative footnotes. We should note that all translations not otherwise credited have been made by the contributors or the editors.

We wish to thank the lenders to the exhibition, without whose cooperation and enthusiasm neither this show nor its catalogue would have been possible. Institutional lenders include the Allen Memorial Art Museum of Oberlin College; the Avery Brundage Collection of the Asian Art Museum of San Francisco; the Baltimore Museum of Art; the Brooklyn Museum; the Cleveland Museum of Art; the Metropolitan Museum of Art; the Museum of Fine Arts, Boston; the Seattle Art Museum; and the University of Michigan Museum of Art. Lenders of works from private

collections include Mrs. Jackson Burke, the late Mrs. Milton Fox, Mr. R. V. Hammer (Collection Nesé), Kimiko and John Powers, Mrs. T. Randag, and four generous collectors who remain anonymous.

Research for this project was supported by generous grants from the Spears Fund of the Department of Art and Archaeology, Princeton University, the Glen Alden Foundation, and the McCrory Foundation, Inc.

YOSHIAKI SHIMIZU
CAROLYN WHEELWRIGHT

JAPANESE INK PAINTINGS

INTRODUCTION

Detail of
catalogue number 13,
Landscape

IN THE EARLY fourteenth century Takashina Takakane was chief painter of the Edokoro, the Bureau of Painting at the Imperial Court in Kyōto. Legend has it that he painted the first four scrolls which narrate the miraculous events connected with the founding of the temple of Ishiyama-dera near Kyōto (fig. 1). Takakane worked in the time-honored native Japanese style called Yamato-e, "the painting of Yamato" (home region of the Japanese people). He painted the rolling hills of his land in conventionalized undulations of vivid mineral green pigments, with stylized spits and swirls of opaque clouds. He created bold patterns of densely leafed trees and pines laden with clusters of needles. In his scrolls the Japanese people saw their landscape, their legends, their love of color and design.

About the same time, before 1317, a painter named Shikan — perhaps an amateur painter, a monk in one of Kamakura's Zen monasteries — painted a very different landscape in pure ink (fig. 2), very likely from a sequence of eight hanging scrolls. Shikan's subject had nothing to do with Japan: each scroll celebrated the beauty of one of the *Eight Views of Hsiao and Hsiang*, a pair of rivers in far-off China. The misty spires of distant mountains in Shikan's scroll find no parallel on the Japanese islands. Shikan himself had probably never seen such peaks, but learned of them through painted landscapes brought to Japan from China.

Ink painting (*suibokuga*) is executed on paper or silk, with a wide range of values produced by black ink diluted with water. Its tools are those traditionally used for writing in China and Japan and its expressive possibilities are enormous. In contrast to the rhythms of opaque pigments arranged by a Yamato-e artist, the ink painter orchestrates combinations of descriptive outlines, suggestive textures, and evocative washes not seen in native art until the Japanese began to experiment with techniques they saw in Chinese paintings. Increased contact with the mainland during the thirteenth century hastened the educative process. The most vigorous assimilation occurred during the fourteenth century; it underwent progressive transformation during the fifteenth, and continued fully "Japanized" throughout the sixteenth. These are the centuries in Japanese history called the Muromachi period.

Muromachi is the name of the quarter northwest of the old Imperial Palace in Kyōto. Here Ashikaga Taka'uji (1305–1358), maneuvering within the political conflicts of court disputes on the succession, established his government in 1338. Japan was divided between two courts, each emperor claiming to be the sole legitimate heir to the throne. The Northern court operated from Kyōto, supported by Taka'uji, while the Southern court established its center at Yoshino, south of Nara. This epoch, called by historians the Nambokuchō (Northern and Southern dynasties), lasted until 1392, when the country was unified under one emperor. With court disputes put to rest, the government functioned under the executive leadership of the Ashikaga family in Kyōto. The Shōgun, or military chief, exercised unlimited power to which even the emperor had to yield. Descendants of the first Shōgun, Ashikaga Taka'uji, managed to keep this position, though

Figure 1. *Ishiyama-dera Engi* (*The Legends of Ishiyama-dera Temple*), scroll one, scene one, attributed to Takashina Takakane (fl. early 14th century). Handscroll, colors on paper, 33.64 cm high. Ishiyama-dera, Ōtsu, Shiga prefecture

with decreasing effectiveness, until the fifteenth Shōgun, Ashikaga Yoshi'aki, was deposed in 1573 by provincial lords. This entire period of a little over two centuries takes its name from the Muromachi quarter.

Not all Ashikaga Shōguns were powerful or even especially relevant to cultural history. Their political and social influence was strongest during the time of the third Shōgun, Yoshimitsu (r. 1368–1394), and the fourth, Yoshimochi (r. 1394–1423). These two reigns are referred to as the Kitayama epoch, after the name of Yoshimitsu's residence on "North Hill" (Kitayama) in northwestern Kyōto. This was the site of the family's chapel, the Kinkaku or "Golden Pavilion," until it was burned by an arsonist-monk in 1953. A copy of the building stands today, picturesquely overlooking a lotus pond.

By the time of the eighth Shōgun, Yoshimasa (r. 1449–1473), factionalism within the Ashikaga family led to the Ōnin Civil War, eleven years of devastation from 1467 to 1477 that left Kyōto a shambles. Yoshimasa sequestered himself in the eastern hills of Kyōto, or Higashiyama. Hence the years until Yoshimasa's death in 1490 are known as the Higashiyama period.

The political and social impact of the Ōnin Civil War should not be understated. The Ashikaga Shōguns emerged in a precarious position; their economic base diminished as provincial families gained power. By the close of the fifteenth century, provincial military chiefs claimed local autonomy and Japan was bitterly divided. The long period of unrest from 1490 until 1573 is known by historians as the Sengoku Jidai, the Age of the Country at War.

During the first century of the Muromachi period, the development of Japanese ink painting was closely linked with the institutional, social, and cultural history of Zen Buddhism. Almost a hundred years old by the time of Ashikaga Taka'uji, the Japanese Zen community had matured during the second half of the thirteenth century under the enthusiastic patronage of the Hōjō family in the city of Kamakura. Chinese Ch'an priests determined the nature of its development: the Kenchō-ji was established in 1253 under a Chinese abbot, followed in 1282 by the Engaku-ji, built for a famous Chinese expatriate monk.

Impressive numbers of Japanese flocked to Kamakura to receive instruction from such famous Chinese. By 1325 the monastic population of Engaku-ji alone was about seven hundred. Young Japanese priests, encouraged by their Chinese masters, traveled to the continent on private trade ships to study at Chinese monasteries;

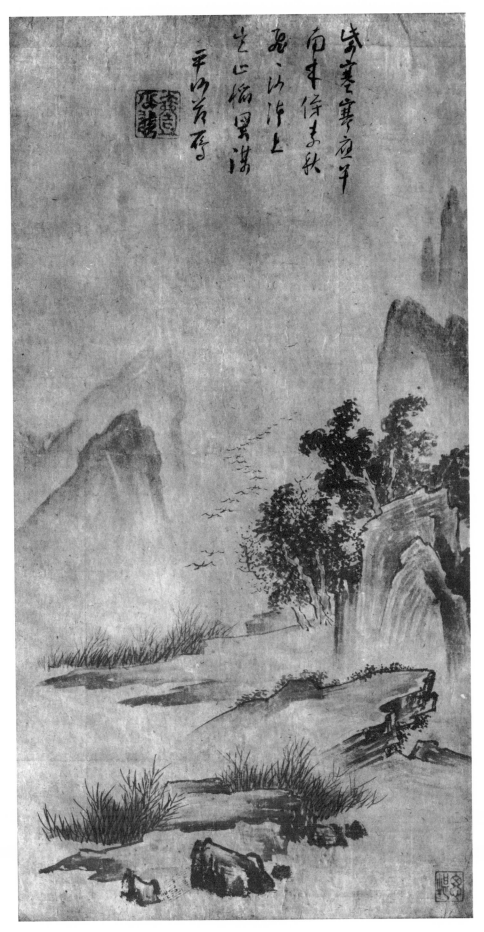

Figure 2. *Descending Geese on Sandbanks,*
Shikan, inscribed by I-shan I-ning
(1247–1317). Hanging scroll, one of the
Eight Views of Hsiao and Hsiang,
ink on paper, 57.6 x 30.3 cm.
Satomi Collection, Kyōto

contemporary literary sources record over two hundred Japanese pilgrim-monks during the first half of the fourteenth century. Many stayed ten years or longer; at least two remained over forty years. Welcomed by their Chinese contemporaries, these Japanese priests gained first-hand knowledge from noted Confucian scholars as well as from Ch'an masters.

At this time China was dominated by a foreign dynasty, the Mongols, who had established no official diplomatic contacts and no officially sanctioned trade with Japan. Indeed, Mongol naval forces had attempted to conquer Japan in 1274, and again in 1281. Partly as a result of "barbarian" control, many Chinese intellectuals entered Ch'an monasteries, making them centers of scholarship. And to evade political unrest in their homeland, not a few prominent monks emigrated to Japan. The first half of the fourteenth century is notable as a time of extremely close contact between individuals of the two countries, and consequently as one of the most creative epochs in Sino-Japanese cultural history.

In the fourteenth century the institutional make-up of Japanese Zen monasteries was thoroughly Chinese, and Japanese monks were deeply involved in Chinese scholarship and arts. Following Chinese precedent, the most important monasteries were designated as the Gozan, or "Five Mountains." By the end of the fourteenth century, there were five Gozan temples in Kamakura (the most important were Engaku-ji and Kenchō-ji), and five in Kyōto (highest ranking were the Tenryū-ji, Shōkoku-ji, and Tōfuku-ji; of lesser importance were the Kennin-ji and Manju-ji). Overseeing all Gozan monasteries was the most prestigious and powerful of all, Nanzen-ji in Kyōto. The most prominent priests were affiliated with these institutions, and are referred to as Gozan monks.

Impressive collections of Chinese books supplemented the intellectual influence of Chinese abbots to make Gozan monasteries centers of Chinese learning. A literary movement initiated in the early fourteenth century by the Chinese expatriate monk I-shan I-ning (1247–1317; called Ichisan Ichinei in Japanese) developed among Japanese Sinophile priests. During the fourteenth century *bunjin-sō,* or "humanist monks," avidly studied Chinese literature and wrote poetry in classical Chinese. Their literary movement was called Gozan Bungaku, or "Literature of the Five Mountains." The movement was strongest during the second half of the fourteenth century, when it was led by disciples of Musō Soseki (1275–1351). Besides being spiritual advi-

19

Figure 3. *Hōnen Shōnin Gyōjo Gazu* (*The Biography of Saint Hōnen*), scroll four, scene four, datable 1307–17, attributed to eight artists. Handscroll, colors on paper, 33.64 cm high. Chi'on-in, Kyōto

sor to the first Shōgun, Ashikaga Taka'uji, and an extremely successful proselytizer for the Zen sect, Musō was a noted scholar. During his time, Japanese Zen studies of Chinese classics and neo-Confucian philosophy became so intense that Musō warned his contemporaries of misplaced emphasis on secular learning. Just before his death he said: "I have three classes of disciples: those who steadfastly pursue enlightenment by severing all earthly connections are considered to be the Upper Class. Those who are being trained but meddle in impure and miscellaneous studies, they are called Middle Class. Those who are merely content with savoring their own spiritual elevation, tasting just the saliva of the patriarchs, they are the Lower Class. Those whose minds are intoxicated by books other than Buddhist, and those who make writing their calling, they are laymen with shaved heads." Ironically, Musō's disciples were the monks most closely involved with Chinese literature and the arts for a century after his death. In the second half of the fourteenth century, the Gozan Bungaku movement revolved around Musō's most prominent followers, Gidō Shūshin (1324–1388) and Zekkai Chūshin (1336–1405). The school continued in the fifteenth century, but shifted its focus from Chinese literature and poetry to Confucian scholarship and historical studies.

This rich artistic context nurtured Japanese ink painting. Initially, priests who painted in the Chinese manner were amateurs, humanist monks first and painters second. Professional Buddhist painters (*ebusshi*) continued to create conservative icons executed in full color, but their works reveal the influence of Chinese ink vocabularies in ancillary motifs such as rocks and trees (see fig. 30). Traditional Yamato-e painters were also aware of the new monochrome style: a handful of narrative handscrolls in the indigenous Japanese style show ink paintings on sliding doors or folding screens (fig. 3). But the fact remains that Japanese ink painting developed in the cultural milieu of the Zen monasteries.

Two monks in particular typify the early stages of the ink-painting tradition of the first half of the fourteenth century: Moku'an Rei'en and Ka'ō. A young and promising monk from Kamakura, Moku'an went to China as a pilgrim about 1326 or 1328, visited several important monasteries, and died in 1345 without returning to his homeland. One of his best-known works, *The Four Sleepers* (fig. 4), is inscribed by a Chinese monk, bears the seal of a Chinese collector, and reflects the style Moku'an learned from his Chinese contemporaries in the Ch'an monasteries. The narrative subject, popular in Zen circles, is Han-shan and Shih-te asleep with Feng-kan and his tiger (in Japanese they are called Kanzan, Jittoku, and Bukan; see cat. no. 5). The composition focuses on the figures in the middle ground, leading the viewer toward them across a foreground articulated by zigzag sweeps of pale ink wash and a few dark pebbles. The figures are placed against a neutral background and framed by a cliff on the left, where a few freely drawn tree branches and grasses direct attention to the sleepers. In contrast to the careful style of contemporary *ebusshi* and Yamato-e artists, Moku'an's method relies on spontaneity. Ka'ō's unstudied approach parallels that of Moku'an, as is evident from his *Kensu* (fig. 32). Although Ka'ō's biography remains obscure (see cat. no. 1), his painting reflects an attitude and a style derived from the same Chinese Ch'an artists that lie behind Moku'an's work, especially the thirteenth century Ch'an monk Mu-ch'i (figs. 23 and 26).

By the second half of the fourteenth century, amateurs were joined by more specialized monk-painters working in the pure ink medium. The technical mastery evident in the *White-Robed Kannon* by Ryōzen (fig. 5) speaks of a professional training also notable in the *Kannon* attributed to Isshi (cat. no. 2). Ryōzen's formal symmetry, his controlled delineation of face and drapery

Figure 4. *The Four Sleepers*, Moku'an Rei'en (fl. 1323, d. 1345). Hanging scroll, ink on paper, 73.0 x 32.2 cm. Maeda Ikutoku Foundation, Tōkyō

Figure 5. *White-Robed Kannon*, Ryōzen (fl. mid-14th century), inscribed by Kempō Shidon (d. 1361). Hanging scroll, ink on silk, 88.7 x 41.0 cm. Myōkō-ji, Ichinomiya, Aichi prefecture

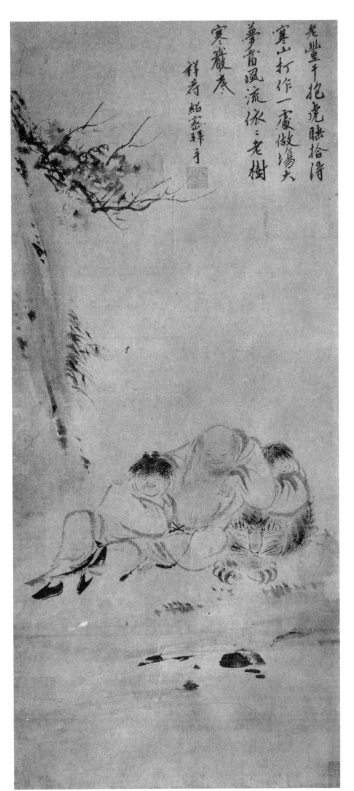

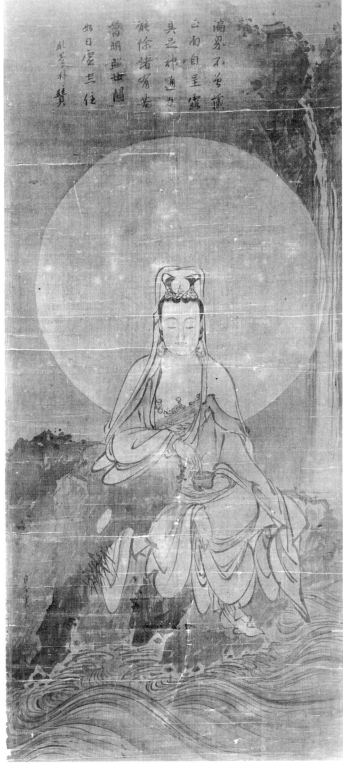

JAPAN IN THE MUROMACHI PERIOD

Sea of Japan

N

NOTO

Kanazawa

KAGA

Toyama

ETCHŪ

…N

HIDA

NO

SHINANO

…ya

WA

KA'I

TŌTŌMI

Fuji-san

SURUGA

Shizu'oka

Atami

IZU

Kamakura

Odawara

SAGAMI

Edo

MUSASHI

KŌZUKE

SADO ISLAND

Niigata

ECHIGO

Aizu

IWASHIRO

SHIMOTSUKE

Utsunomiya

Sendai

Fukushima

Miharu

IWAKI

DEWA

MUTSU

HONSHŪ

Ōta

Kantō Region

HITACHI

SHIMŌSA

KAZUSA

AWA

Pacific Ocean

23

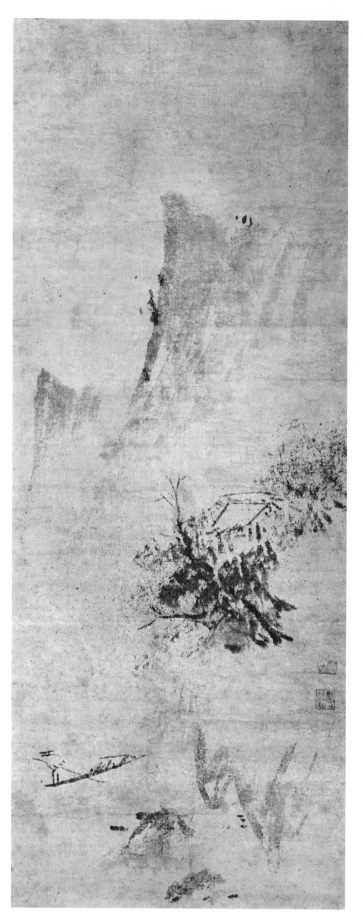

Figure 6. *Rainy Landscape,*
Gukei Yū'e (fl. 1361–75).
Hanging scroll, ink on paper,
82.3 x 32.2 cm. Tōkyō National
Museum

supplemented by carefully graded ink wash to describe forms, contrasts markedly with the abbreviated, casual approach of Moku'an and Ka'ō. The two categories of Zen monk painters continued to flourish for another century in Japanese monasteries, although not always with discernible stylistic differences. Professional painters were capable of spontaneity just as amateur painter-monks could acquire polished professional skills.

The figure paintings in this exhibition reveal a stylistic variety rather loosely linked with amateur or professional status. The *Daruma* by a true amateur, the fourth Ashikaga Shōgun Yoshimochi (cat. no. 3), is a variant of an abbreviated style widespread in Ch'an circles over a hundred years earlier in China. Another secular amateur of high social status, the sixteenth century warrior Yamada Dō'an (cat. no. 9), was inspired by his own Japanese ink-painting tradition of the fourteenth century monk-painter Moku'an. Paintings emerged from artists' workshops in major monasteries: both Sekkyakushi and Reisai (cat. nos. 4 and 5) worked in Kyōto's Tōfuku-ji monastery, where a thriving atelier had grown up around one of the pioneers of ink painting, Kichizan Minchō (1351–1431). In a Kamakura temple studio, Chū'an Shinkō (cat. no. 6) — and just possibly the earlier painter Isshi (cat. no. 2) — developed a fifteenth century style apparently influenced by professional *ebusshi* production of the early fourteenth century. But perhaps most indicative of the development of ink figure painting in Muromachi Japan is Yōgetsu's *Kensu* (cat. no. 8). Whimsically engrossed in his squirming shrimp, this figure by a late-fifteenth century monk represents a complete "Japanization" of the Chinese figure style learned two centuries earlier by the monk-painter Ka'ō.

While Buddhist figure subjects comprised the major category of early ink paintings, fourteenth century monk-painters, especially the amateur *bunjin-sō*, treated a wide range of themes. The influx of Chinese scholarship brought subjects not specifically Buddhist, but favored by Confucian men of letters in Sung and Yüan China. Symbolic plants, such as orchids and bamboo, were treated by two high-ranking Japanese monks of mid-century, Tesshū Tokusai and Chō'un Reihō (cat. nos. 30–33). Both traveled to China. Tesshū was a highly respected scholar of his day, abbot of a Gozan monastery and close friend of the eminent Gidō Shūshin, who inscribed one of his paintings (cat. no. 30). Orchids continued to be painted by *bunjin-sō* of the early fifteenth century, most notably by Gyoku'en

Bompō, a leader in Kyōto's Gozan literary circles, a friend of Shōgun Yoshimochi, and eventually the abbot of Nanzen-ji (cat. no. 34).

Tesshū's range of subjects was broad. Extant today besides his orchid paintings are several scrolls treating an allegorical Zen theme, reeds-and-geese (cat. no. 32). One of Tesshū's disciples, Gukei Yū'e (fl. 1361–1375), also painted a variety of subjects, from Buddhist figures to plants and landscapes, in various styles. The Chinese prototypes for almost all his surviving paintings can be identified. Especially important are his landscapes (fig. 6), for they reflect familiarity with the ink-breaking (haboku) method associated with the thirteenth century Chinese artist Yü-chien (see cat. nos. 14 and 19). In contrast to the linear style of Shikan's *Descending Geese* (fig. 2), Gukei's manner is painterly, achieved by broadly applied ink washes which suggest a moist atmosphere. Motifs are abbreviated, details eliminated. Pictorial structure is vertical, from the rocks at the bottom to the mountain cliff at the top; there is little penetration into depth and even less solid form. Gukei focuses on the ephemeral drama of mists and rain.

The fourteenth century transplantation of Chinese culture into Japanese monasteries was direct and swift, creating an artistic context in Japan close to that of China. The painting style developed by painter-monks such as Moku'an, Ka'ō, and Chō'un Reihō closely echoed that of their Chinese models. In some cases, such as the early fourteenth century *Reeds and Geese* in cat. no. 29, the nationality of an anonymous artist is difficult to determine.

It was Chinese paintings that the Zen monks valued, however, and they brought scores of them to Japan. By the mid-fourteenth century there was a sizable collection of Chinese painting, calligraphy, and utensils at the Engaku-ji in Kamakura; it was inventoried in the *Butsunichi-an Kumotsu Mokuroku* in 1365. This impressive collection included Buddhist iconic paintings, Zen narratives, and Taoist-inspired dragons and tigers, some of which were recorded in sets of two or four. The inventory provides evidence of the first Japanese attempts to collect Chinese paintings systematically: it records requests to purchase paintings from the collection, made by the Ashikaga Shōguns in Kyōto and by influential vassals in the provinces. The important Ashikaga Shōgunal collection of Chinese paintings recorded about the third quarter of the fifteenth century in the *Gyomotsu On'e Mokuroku* was thus begun a hundred years earlier.

During the third quarter of the fourteenth century the focal center of the Zen monastic system started to shift from Kamakura to Kyōto. In particular, bunjin-sō disciples of Musō Soseki (1275–1351) began to assume important positions in the capital: Tesshū Tokusai became abbot of Manju-ji in 1362, Shun'oku Myōha abbot of Nanzen-ji in 1379, and Shōgun Yoshimitsu himself called Gidō Shūshin to Kyōto in 1380 to become abbot of Kennin-ji. The Shōkoku-ji monastery was founded in 1382 and from its inception was dominated by succeeding generations of humanist monks in Musō's "line of transmission."

By the opening of the fifteenth century the center of activity rested solidly in the large metropolitan monasteries of Kyōto: Nanzen-ji, Tenryū-ji, Kennin-ji, Shōkoku-ji. There was little direct influence of Chinese monks in these communities. Times had changed. The Ming government had restricted private trade, fewer Japanese pilgrims traveled to China, and their visits were shorter. Japanese Zen communities became more Japanese.

In 1394 the third Shōgun, Yoshimitsu, stepped down from his executive position, took the tonsure, and his young son Yoshimochi became the fourth Shōgun. Throughout the first quarter of the fifteenth century, Yoshimochi played a significant role in support of Zen monasteries in Kyōto. Well versed in the history and traditions of the sect, he became closely allied with prominent monks of the time, such as Gyoku'en Bompō (cat. no. 34). And he also painted (cat. no. 3).

After the turn of the century ink landscape painting suddenly flourished. During this period emerged the first artistic personality of the great triumvirate of landscape painters affiliated with the Shōkoku-ji monastery: Josetsu. Apparently a professional monk-painter, Josetsu was commissioned by Shōgun Yoshimochi to paint a Zen literary riddle concerning capturing a slippery catfish with an equally slippery gourd (fig. 7). Some thirty Gozan monks were assembled to compose and inscribe short poems on a paper to be attached to the reverse side of a small screen used to display the painting. (Today the inscribed paper is mounted above the painting.) These monks were the most noted poets of their day. Many were disciples of Gidō Shūshin or Zekkai Chūshin, in the line of Musō Soseki, who formed a literary society (yūsha) centering around the major temples of Kyōto.

A significant feature of Josetsu's picture is the faint

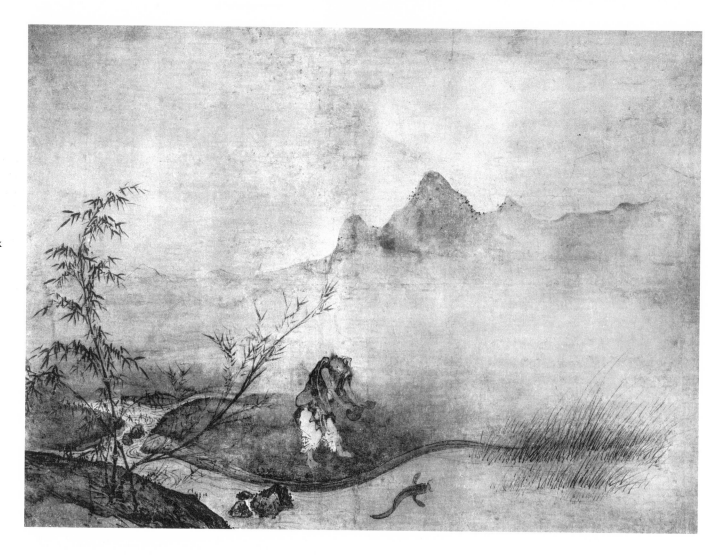

Figure 7. *Catching a Catfish with a Gourd (Hyōnen)*, ca. 1413, Josetsu (fl. early 15th century), inscribed by Gyoku'en Bompō and thirty other monks. Hanging scroll, ink and colors on paper, 111.5 x 75.8 cm. Taizō-in, Myōshin-ji, Kyōto

distant mountain which creates a depth of pictorial space not seen in fourteenth century painting. Clearly, as noted by one of the inscribers, a new style is emerging. Foreground terrain, bamboo trees, a running stream, the distant mountains rising beyond a vast stretch of space — these are the elements of one of the earliest well-articulated ink landscapes, forerunner of the evocatively idealistic paintings of Shūbun and the solidly constructed, vigorously executed scenes of Sesshū. It is also one of the earliest paintings known as *shigajiku*, scrolls which combined poetic inscriptions with landscape paintings and became the major pictorial expression of the first half of the fifteenth century. The format follows that of Chinese literati paintings of the thirteenth and fourteenth centuries, known today only through literary descriptions. These paintings are, consequently, further testimony to the influence of predominantly Confucian ideals on the culture of the Japanese Zen community. *Shigajiku,* like other Chinese-inspired art and literature, rapidly assumed its own Japanese character in the hands of Gozan monks.

Basically two types developed. The first served a commemorative purpose, as an expression of fellowship presented to a departing monk. Through the poetry inscribed on the painting the recipient would be reminded of the friends he left behind. While the landscape was imaginary and the poetry frequently Chinese, the *shigajiku* functioned as a token of communal relationship.

The second type of *shigajiku* served a supportive purpose, as an expression of friendship and encouragement to a monk within the monastery. These were called *shosaizu,* "paintings of the study." Fifteenth century Kyōto monasteries bustled with activity, developing a congested atmosphere from which reflective scholarly monks longed to escape, but could not. Unlike Chinese Confucian scholars who frequently chose a socially accepted way of life in retirement, Japanese Zen priests had to remain in their busy temple precincts. Gozan monks active in these large metropolitan monasteries gave names to their private studies which expressed their own ideals of peace. It became popular to have a painting made of this study, not as it existed within the temple walls, but as it was idealized by the priest. Other monks inscribed poetry on the painting, generally supporting the noble ideals suggested by the name of the scholar's study. The *bunjin-sō* could project his mind

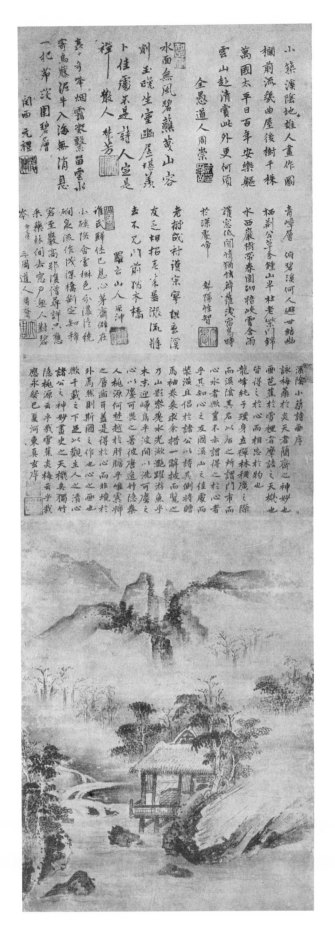

Figure 8. *Cottage by a Mountain Stream (Kei'in Shōchiku)*, 1413, artist unknown, attributed to Minchō (1351–1431), inscribed by Gyoku'en Bompō and six other monks. Hanging scroll, ink on paper, 101.5 x 34.5 cm. Konchi-in, Nanzen-ji, Kyōto

and heart into the painting and its accompanying poetry for spiritual solace.

One of the earliest existing *shosaizu* is *Cottage by a Mountain Stream (Kei'in Shōchiku,* fig. 8). The preface to the painting clearly describes its intention: "The temple has become a noisy and annoying place, but one must face the bustling market with a heart as silent as water." It is not a representation of a specific hermitage built in a certain region; rather it is an idealized retreat which dwells in the heart. It is, as the inscriber goes on to mention, a *shinga* or "picture of the heart." In the most profound Zen belief, the distinction between heart (or mind) and matter ceases to exist. Even living within a densely crowded Gozan monastery, the Zen adept finds mountains, pure waters, and quiet. Thus it is not necessary to depict actual scenery in a *shosaizu*. Any quiet landscape, even the landscape of China, serves as a spiritual refuge.

Cottage by a Mountain Stream is associated with the Tōfuku-ji workshop of Minchō (1351–1431), who, like his contemporary Josetsu at Shōkoku-ji, was a professional monk-painter active within a major Kyōto monastery. Minchō is known for a number of figure paintings which are significant as bridging the gap from careful colored productions of *ebusshi* to the new ink-painting style (see cat. nos. 4 and 5). Several early *shigajiku*, in which elements from Chinese landscapes appear, are also traditionally attributed to him.

Shigajiku landscapes generally picture tall mountains and expansive lakes, moored skiffs and distant sailboats. The towering peaks that form evocative skylines in these paintings mark no mountainous region of Japan; nor is a floating life on a river-boat part of Japanese experience. The motifs are derived from Chinese landscape paintings. Literal scenery is not the point at issue, for the significance of *shigajiku* goes beyond resemblance to an actual place.

Illuminating in this connection is a preface included in a literary anthology by a Gozan poet-monk. It was written in 1435 on a painting, now lost, entitled *Rozan* (or Lu-shan, a picturesque mountain in China's Kiangsi province known for its famous waterfall; see cat. no. 6). A priest who had never visited China took the Lu-shan landscape, painted by an artist who had likewise never been to China, to the Gozan poet-monk. He requested an inscription in which the poet praised the painting as a consoling substitute for a view of the actual scenery. The poet-priest demurred, protesting that he had never seen

Figure 9. *Chikusai Dokusho*
(*Reading in the Bamboo Study*),
detail, attributed to Shūbun (fl. 1423–60),
inscribed by six Zen priests,
preface by Jiku'un Tōren dated 1446.
Hanging scroll, ink on paper, 134.8 x 33.3 cm.
Tōkyō National Museum

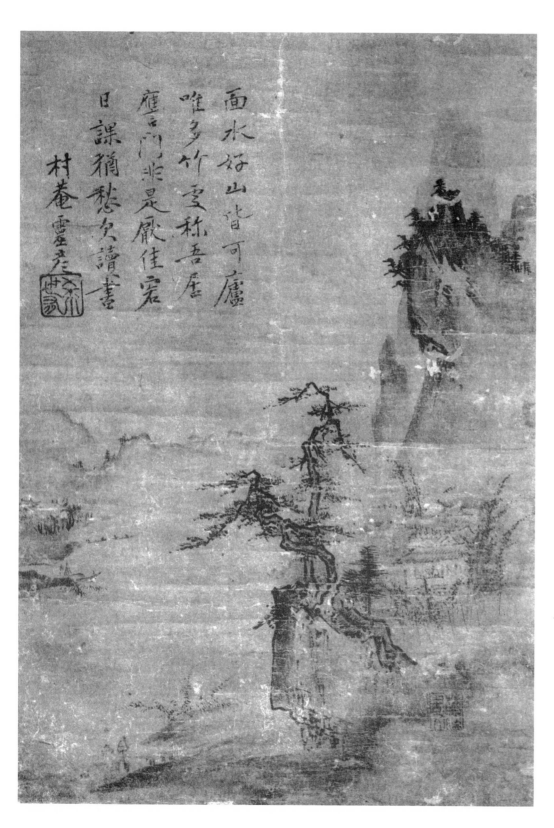

the famous mountain. The owner explained that it was precisely for that reason that the monk, as well as he himself and the painter, could understand the essence of the spot in his heart. The poet-monk then wrote the inscription.

It is not surprising that poems composed as inscriptions on paintings became an independent genre, indicated as such in the literary anthologies of fifteenth century humanist monks. The strong spiritual correspondence between poetry and painting, in scrolls such as *Cottage by a Mountain Stream,* loosened as poets sought literary effects and painters aimed at uniquely visual expressions. The format, however, had become standard: an extremely vertical scroll containing a landscape in its lower portion and inscriptions in the larger upper section. Within this format developed a landscape painting style based on Chinese paintings of the Southern Sung Academy. This is the style associated with the elusive painter-monk of Shōkoku-ji, Tenshō Shūbun (fl. 1423, d. ca. 1460).

There is an enormous gap between the magnitude of Shūbun's name and the dearth of biographical information, between the volume of paintings attributed to him and the works that possibly represent his style. The facts are few. Shūbun was a monk at Kyōto's Shōkoku-ji, a financial executive (*tokan*) in the administrative branch of the monastery. This suggests that he was not a learned classical scholar as were earlier *bunjin-sō* such as Tesshū Tokusai or Gyoku'en Bompō, who attained the abbacy of important Gozan monasteries. On the other hand, he accompanied a diplomatic mission to Korea in 1423–1424 to secure a printed edition of the Korean *Tripitaka,* so he had an opportunity for first-hand experience of foreign painting. Contemporary documents refer to his wide variety of artistic activities, including the carving and coloring of sculpture, the painting of *fusuma* (sliding doors) and *byōbu* (folding screens). They suggest that he was a skillful professional artist fulfilling the needs of his monastic community and taking outside commissions as well. He received a stipend from the Shōgunate. Artistic lineage charts designate him as the direct disciple of Josetsu and the teacher of Sesshū, but the details of his life are less important than the works associated with him. Shūbun's significance lies not in his biography but in the ink-painting tradition bearing his name as it developed during and after the second quarter of the fifteenth century.

Although there is no painting, among the scores attributed to him, that scholars agree is the authentic work

28

Figure 10. *Landscape,*
attributed to Hsia Kuei (fl. ca.
1190–1230). Hanging scroll, ink
on paper, 46.3 x 106.6 cm.
Hatakeyama Collection, Tōkyō,
formerly Asano Collection,
Tōkyō

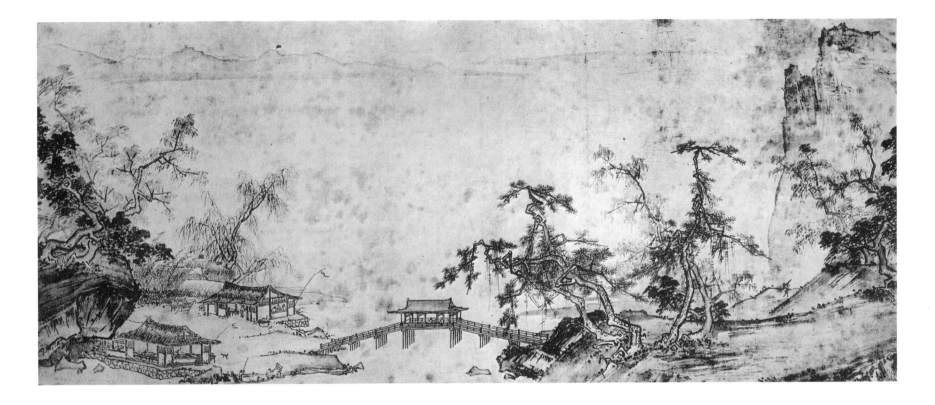

of Shūbun, many can be dated to the years of his activity on the basis of their inscriptions. These works present the landscape style that subsequent Japanese connoisseurs found reason to link with his name. Two landscapes in particular are important to convey what can be called the style of the Shūbun school: *Chikusai Dokusho (Reading in the Bamboo Study)* (fig. 9) and *Suishoku Rankō (Color of Stream and Hue of Mountain)* (fig. 39). Both are datable by their inscriptions to about 1445, and they illustrate two basic *shosaizu* compositions: one contrasts an enormous mountain cliff on one side with a deep and wide lake view on the other; the second places a towering central mountain across a misty lake from a foreground cottage. Both share an evocative sense of expansive space permeating every corner of the landscape. Diffused contours make background images seem to float above intervening mists, while crisp definition silhouettes foreground trees.

Individual motifs in such paintings of the Shūbun school as *Chikusai Dokusho* and *Suishoku Rankō* are Japanese reincarnations of features in Chinese paintings attributed to the Southern Sung Academy artists active in the first quarter of the thirteenth century, Ma Yüan and

Hsia Kuei (fig. 10). The pair of pine trees in *Chikusai Dokusho* (one growing straight up with the other twisting diagonally in front to point across the lake to distant shores) find their antecedents in the pines attributed to Hsia Kuei. The angular facets of rock faces in *Suishoku Rankō* are rendered with axe-cut textural strokes similar to the descriptive rock motifs in the Southern Sung painting. There are parallels in brushwork and use of ink: the heavy jagged contour lines of trees and rocks, the dark silhouetted edges of distant mountains which quickly fade into mist. What is different in the fifteenth century Japanese works is the emphasis on pervasive atmospheric space at the expense of logical clarity. In the Chinese painting the form of each landscape feature is clearly described: assertive texture strokes slice out facets of solid rock, a darker tree stands clearly in front of a muted background tree, mountains recede in logical stepped recession. Such attention to explicit definition is not a concern of the Japanese artist, and the viewer's attempt to find logically traversable paths through his landscape will end in frustration. The Japanese artist presents instead an imaginary landscape of the mind, an ambiguous space that does not bind the eye

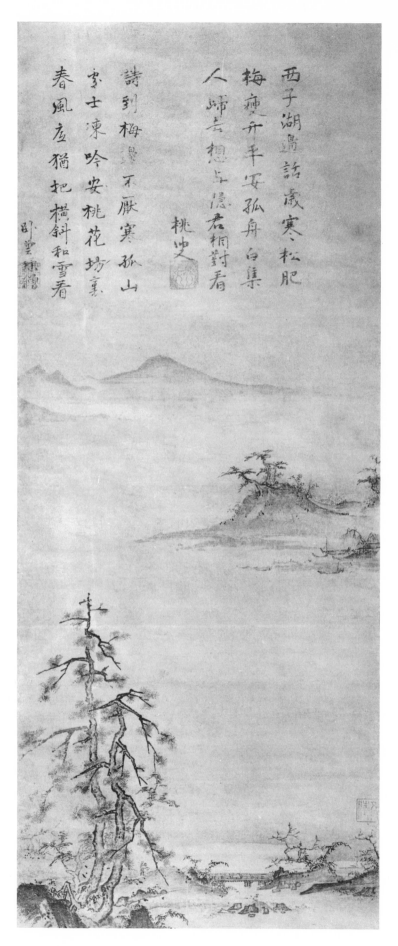

Figure 11. *West Lake*, Bunsei
(fl. 1460's), inscribed by Zuikei
Shūhō (d. 1476) and Ichijō
Kanera. Hanging scroll, ink on
paper, 80.8 x 33.4 cm.
Masaki Art Museum, Ōsaka

to forms but allows it to drift imperceptibly from solid to void. The essence of his landscape does not lie in forms depicted, but in the enigmatic fluidity of what is not clearly described. As the inscriber wrote in the preface to *Cottage by a Mountain Stream,* the significance of the landscape is felt in the heart or mind. It is a painting of a mental attitude, an expression of an ideal study in an ideal landscape that is not to be hindered by too literal description of non-ideal reality.

The aesthetic point of view embodied by these landscapes was also directed toward other artistic media of the period. It was articulated by the great master of Nō drama, Se'ami (1364–1443), in his treatise *The Book of the Way of the Highest Flower* (*Shikadō-sho*): "Among those who witness Nō plays, the connoisseurs see with their minds, while the untutored see with their eyes. What the mind sees is the essence; what the eyes see is the performance" (Tsunoda et al., *Sources of Japanese Tradition,* 1: 296). The experience of viewing the symbolic mime of Nō is eloquently explained to a western audience by Sir George Sansom: "The most powerful effects are those which are obtained by allusion, suggestion and restraint, and in this respect the Nō is a counterpart of the contemporary painting which was governed by Zen principles. Se'ami in his works lays it down that realism (*monomane,* imitating things) should be an actor's chief aim, yet it is clear that he did not contemplate the grosser forms of mimicry, but had in mind more subtle indications of truth" (Sansom, *Japan: A Short Cultural History,* p. 388).

During the first half of the fifteenth century it was not customary for artists to sign their works: the landscape was, in any case, secondary to the poetic sentiments proudly signed and sealed by their inscribers. In midcentury, however, the situation changed. As landscape painting became a more independent and praiseworthy activity, more artists added their names to their productions. A number of Shūbun's successors can be identified: Shōkei Ten'yū, Bunsei, Gaku'ō, and, above all, Sesshū. They demonstrate how quickly the suggestive landscapes of Shūbun's day began to be replaced by explicit articulation of landscape forms.

Space in Shōkei Ten'yū's *Landscape with Distant Mountains* (cat. no. 11) can be measured by the sharp visual contrast of compactly detailed fore- and middle ground against the filmy ink wash of distant mountains. The painting can be logically traversed from foreground into distance via space markers. In addition, Ten'yū creates a visual language of differentiated techniques to de-

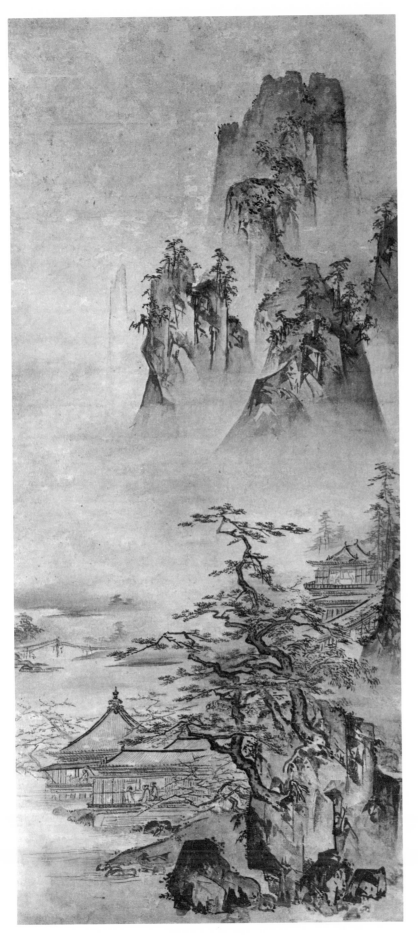

Figure 12. *Landscape*, Gaku'ō (fl. late 15th–early 16th century). Hanging scroll, ink and slight color on paper, 80.7 x 36.0 cm. Smithsonian Institution, Freer Gallery of Art, Washington, D.C. (05.268)

scribe the physical properties of natural motifs. An assemblage of short broken lines cut out the angular surfaces of foreground rocks; horizontal dots create the lateral spread of pine needles; delicate cascades of pale ink strokes suggest the graceful sway of willow branches. Background mountains are hazy and layered, clearly receding into distance.

Bunsei's *West Lake* (fig. 11), datable prior to 1467 on the basis of one of its inscriptions, further shifts the significance of landscape from an ethereal realm to the real world. Bunsei replaces the unmeasurable space of the earlier Shūbun style with a carefully controlled spatial sequence. Tall trees in the lower left corner provide the vertical axis; strips of horizontal embankments in foreground and middle ground and a low mountain range in the background move in measured recession into distance. A dramatic contrast between substance and emptiness provides a kind of atmospheric purity which stresses correct visibility. Distinctions between form and non-form are beginning to be made manifest.

By the time of Gaku'ō in the late fifteenth century, suggestive space has all but disappeared (fig. 12). While conservatively following the compositional framework of Shūbun style landscapes (see cat. no. 13), Gaku'ō lavishes attention on local clarity of individual motifs and neglects the ambient atmosphere. He concentrates on building rhythmic dynamic forms with impetuous brushwork. The gain in solid representational form is at the expense of encompassing space. The undifferentiated atmosphere which suffuses the visionary landscapes of the time of Shūbun never returns to Muromachi ink landscapes.

The direct inheritor of Shūbun's style, Sesshū, most dramatically displaces the elusive space of his master with solid tactile form. With his Japanese heritage supplemented by knowledge of contemporary Chinese painting and thorough study of Sung and Yüan painting styles, Sesshū evolved a forceful individual manner that surpassed even Shūbun in its influence on subsequent Japanese artists.

Sesshū Tōyō (1420–1506) was born in Bitchū province (modern Okayama prefecture) and learned painting as a youth. After serving as a novice in a local temple, he entered Shōkoku-ji monastery in Kyōto where he studied Zen under Shunrin Shūtō (fl. 1430, d. 1463) and painting under Shūbun. In his later years he acknowledged his debt to the great accomplishments of his teacher Shūbun and of Shūbun's teacher Josetsu. Sesshū attained the rank of Guest Prefect (*shika*); it was

Figure 13. *Haboku Landscape*,
detail, Sesshū (1420–1506),
artist's inscription dated 1495.
Hanging scroll, ink on paper,
147.9 x 32.7 cm. Tōkyō
National Museum

his duty to entertain official visitors and care for itinerant monks. His fellow priests called him Yōshika, or "Yō (from Tōyō) the Guest Prefect." His position was not high, but he was a part of the "Western Rank" of the monastery which encompassed most of the priests involved in literature and scholarship.

Sesshū apparently left Shōkoku-ji shortly after his two influential masters died, for by 1465 he had established a painting studio called the Unkoku-an in the province of Suwō (modern Yamaguchi prefecture). He was apparently awaiting an opportunity to travel to China, a goal he achieved in 1467, when he accompanied a two-year Ō'uchi family trade mission. A set of *Landscapes of the Four Seasons* (fig. 54) executed in China are his earliest known works. The monumental structure of these landscapes are nothing like the paintings of the Shūbun school, but directly reflect works in the Ming academic style which Sesshū saw on the mainland. Contemporary records by both Chinese and Japanese writers provide vivid evidence of his artistic activities in China. In Peking, Sesshū did a wall painting in the building of the Board of Rites; in villages and hamlets he made sketches of Chinese scenes; and he acquired a contemporary painting manual which he brought home with him in 1469.

After his return to Japan, Sesshū supplemented his exposure to contemporary Chinese painting with intensive study of Sung and Yüan scrolls. A number of sketches in fan format attest his examination of works by Li T'ang, Hsia Kuei, Mi Yu-jên (fig. 57), Mu-ch'i (fig. 49), and Yü-chien. Even these relatively faithful copies exhibit the unique brush manner and structural drawing which Sesshū developed into his personal artistic style.

Sesshū's *Haboku Landscape* (fig. 13), in the washy ink-breaking manner of Yü-chien (see cat. nos. 13 and 19), testifies to his personal transformation of the Chinese styles he studied. Yü-chien was one of the earliest Chinese landscape models used by Japanese ink painters. In the fourteenth century scroll by Gukei Yü'e (fig. 6), splashes of ink wash create a vertical essay in abbreviated atmosphere focusing on a cluster of moisture-laden trees. A *Haboku Landscape* from the second quarter of the fifteenth century (fig. 52) presents the Yü-chien subject matter infused by the nebulous space that permeates other idealized landscapes of the period. Sesshū's 1495 version of the theme reflects his solidly structural approach. He applies wash in cubist planes which build massive rocks, he sweeps rich black ink over

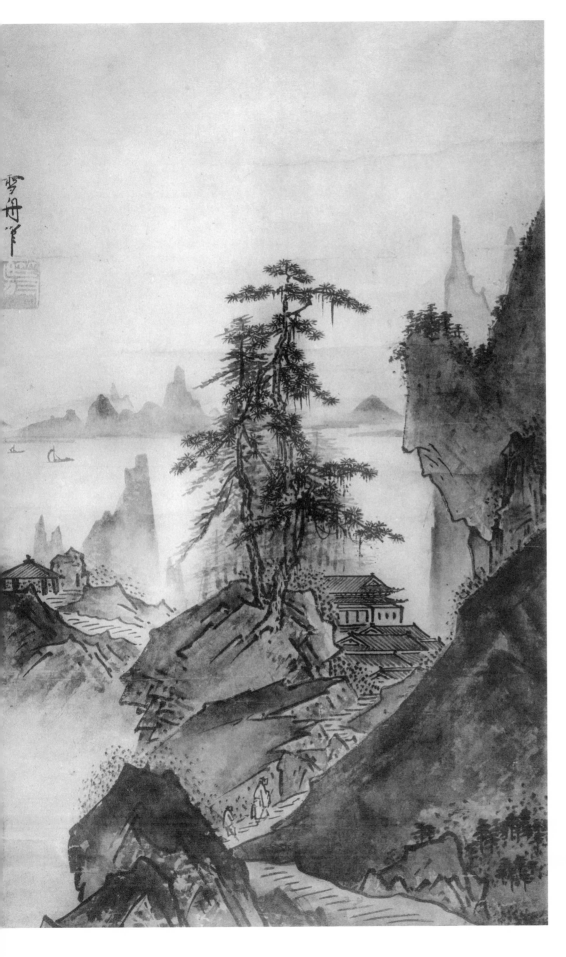

Figure 14. *Landscape,* detail,
Sesshū (1420–1506),
inscription by Ryō'an Keigo
dated 1507. Hanging scroll, ink
and light color on paper, 119.0 x
35.3 cm. Collection of Ōhara
Ken'ichirō, Ōsaka

still-wet gray to model tree foliage in relief. Pale ink
values merge into white paper to make a rock spire rise
in the distance behind the middle-ground tree motif.
Never have washes been so sculptural.

Shōkei Ten'yū and Gaku'ō altered the Shūbun tradi-
tion with localized development of motifs, and Bunsei
redefined the visibility of space. Sesshū challenged the
stillness of the void and the elusiveness of form, injecting
robust volume into natural motifs clearly defined in
space. He completely transformed the manner of his
painting master at Shōkoku-ji. The metamorphosis is
nowhere more dramatically illustrated than in the scroll
considered to be Sesshū's last painting before his death
in 1506 (fig. 14). Painted in the typical *shigajiku* format,
the *Landscape* in the Ōhara collection includes the
characteristic vertical peaks and the distant lake linked
with the tradition of *Suishoku Rankō* (fig. 39). But instead
of gently entering the picture at the foreground cottage
and drifting into space, the viewer jumps between
jutting foreground rocks and is quickly pulled along a
zigzag path to the middle ground. Rocks and trees force-
fully defined by galvanizing outlines and charged texture
strokes assert their solid forms in the clear atmosphere.
The landscape vibrates with the electric energy of
diagonal thrusts and counterthrusts, held in check by
the vertical axis of central pines and the crossing
horizontal of distant mountains.

Like the typical *shigajiku* in the Shūbun style, Sesshū's
Landscape carries poetic inscriptions written by friends,
Bokushō Shūsei (see cat. no. 19) and Ryō'an Keigo
(d. 1514). But while the poems on paintings such as
Chikusai Dokusho philosophically allude to nature imag-
ery from the Chinese classics, one of the inscriptions on
the Ōhara *Landscape* expresses personal emotions about
the relationship of inscriber and painter. The
significance of *shigajiku* has changed. Bokushō's poem
speaks appreciatively of the painting, but Ryō'an
Keigo's inscription expresses his feeling toward Bo-
kushō and Sesshū, who had died before Keigo arrived
at the Unkoku-an.

Sesshū's disciples remained in the provinces outside
Kyōto. Shūtoku (cat. no. 21) apparently took over
leadership of the Unkoku-an in Suwō, while Tōshun
(cat. no. 20) found commissions among former Sesshū
patrons in other areas of Japan. By this time Kyōto had
lost its force as the cultural center, for the Ōnin Civil
War (1467–1477) had devastated the capital. Many intel-
lectuals had fled, and provincial warlords began to as-
sume increasing power and prestige.

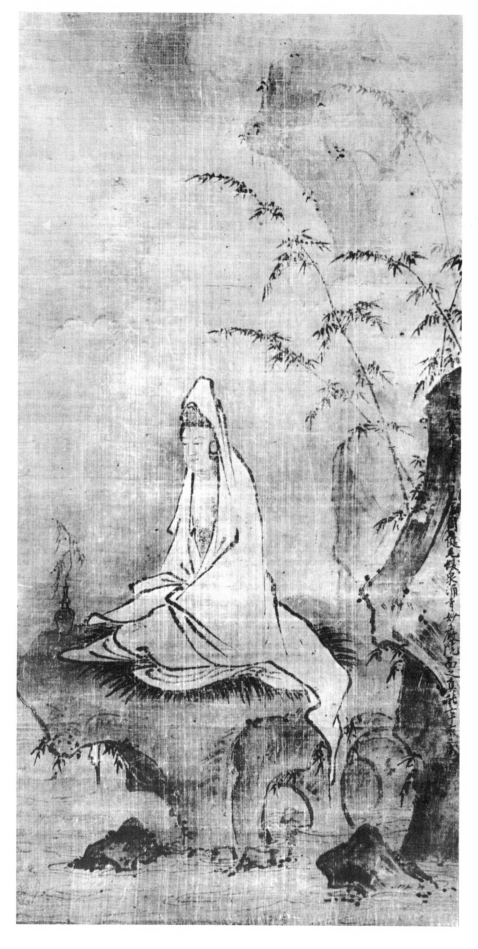

Figure 15. *White-Robed
Kannon*, dated 1466, Nō'ami
(1397–1471). Hanging scroll,
ink and color on paper, 77.6 x
39.3 cm. Mizoguchi Collection,
Kanagawa prefecture

A very different patronage situation had developed.
Active cultural centers in the provinces were nourished
by such powerful families as the Ō'uchi (who patronized
Sesshū), the Asakura, and the later Hōjō. No longer was
ink painting so intimately connected with the Zen sect;
painters more frequently were secular art specialists.
With Shūbun's death (ca. 1460) and Sesshū's departure
shortly thereafter, Shōkoku-ji lost its artistic leadership.
Shūbun's stipend from the Shōgun was received by
Oguri Sōtan beginning in 1463. None of his works sur-
vives, but it seems he was initially a secular artist with
links to the Daitoku-ji, the monastery most active in cul-
tural activities during this tumultous period of warfare.
Paintings by Sōtan's son, Oguri Sōkei, executed in 1490
at Daitoku-ji's Yōtoku-in (fig. 38), reveal a conservative
continuation of Shūbun's style with close dependence
on specific Chinese model paintings.

Two schools of artists managed to flourish in the dis-
rupted capital during the second half of the Muromachi
period: the Ami and the Kano. They were able to func-
tion because of their unique patronage situations. The
Ami were personal aesthetic advisors and painters-in-
residence to the Shōgun, while the Kano operated a
relatively independent workshop supported by commis-
sions from the Shōgun, powerful provincial lords who
had links with the capital, and certain thriving mon-
asteries such as the Shin sect Ishiyama Hongan-ji in
Ōsaka.

Cultural preferences of the Ashikaga Shōguns dur-
ing the first half of the Muromachi period had been
defined by close contact with *bunjin-sō* of Gozan monas-
teries, and Zen influence on the Shōgun was supple-
mented by the artistic direction of a special class of per-
sonal retainers called the *dōbōshū*. Many members of
this group were bearers of the Ami name, indicating
that they belonged to one of the Pure Land sects of
Buddhism and were specialists in a wide range of arts,
from Nō drama and *renga* (linked verse) poetry to con-
noisseurship and ink painting. During the second half
of the fifteenth century and the first quarter of the six-
teenth, three generations of Ami directed the cultural
activities of the Shōgunate, overshadowing the strongly
Sinophile influence of Zen monks with their own unique
blend of cognizance of Chinese art with indigenous Japa-
nese taste.

The first of the so-called three Ami was Nō'ami
(1397–1471), a noted *renga* poet as well as a respected
connoisseur of Chinese art objects and a proficient ink
painter. The second was Gei'ami (1431–1485), who

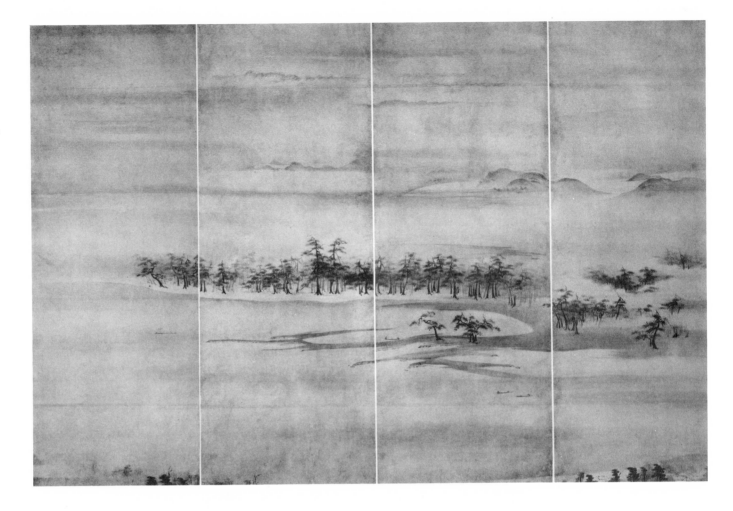

Figure 16. *Miho Pine Forest*, detail, artist unknown, mid-16th century. Four of six hanging scrolls originally mounted as a folding screen, ink and gold on paper, each 155.3 x 55.1 cm. Egawa Museum of Art, Nishinomiya, Hyōgo prefecture

maintained close contacts with Zen monks. The third, Sō'ami (d. 1525), evolved at least two distinct painting styles reflecting his personal synthesis of Chinese and Japanese cultural influences (see cat. nos. 22 and 23). As curators of the Shōgun's collection of Chinese art objects, the Ami were responsible for two documents which provide valuable information about the aesthetic preferences of Muromachi Japanese. The *Gyomotsu On'e Mokuroku* is an inventory of selected Chinese paintings in the collection, listing the artist's name, the subject matter, the painting format, and frequently an inscriber's name. The *Kundaikan Sayū Chōki* is a connoisseur's manual, qualitatively ranking Chinese painters and giving information about such details as the proper method of exhibiting certain kinds of painting.

Because of their close contact with the Shōgunal collection, the three Ami were well informed concerning Chinese painting styles. Nō'ami's *White-Robed Kannon* (fig. 15) reveals familiarity with the style of Hsia Kuei (fig. 10) in the heavy lines delineating the rocks and the axe-cut strokes which texture them. Dated 1466, it was painted when Nō'ami was a mature artist. It displays the developing Ami family style in the blunt brush contour lines and the thick mists that swirl around the Kannon. These features continue to be found in works such as Gei'ami's *Viewing a Waterfall* (fig. 61), together with even

closer observation of paintings in the style of Hsia Kuei. The same tendencies were pursued by Gei'ami's disciple, Kenkō Shōkei (cat. no. 24).

Sō'ami followed his family tradition in two directions, developing a "formal style" based on his knowledge of Hsia Kuei motifs (fig. 58) as well as a "soft style" evolved from his studies of Mu-ch'i and the manner of a group of Chinese artists collectively known as the Mi family (figs. 56 and 57). Sō'ami brought to his studies of Chinese painting an artistic vision shaped by his upbringing in the Shōgun's household. Features conditioned by an appreciation of Yamato-e works enter his painting, giving it a gently undulating, rhythmic quality. A work by a later sixteenth century Ami follower, *Miho Pine Forest* (fig. 16), carries Sō'ami's "soft style" further into the context of Yamato-e. This composition merges Sō'ami's sand spits and foliage-dotted mountains with stylized land forms and softly layered hills. It incorporates his heavy mists with streaks of gold Yamato-e clouds, his dense foliage made with the side of a heavily loaded brush with stylized patterns of Yamato-e pines. At the end of the Muromachi period, Chinese styles merged with Japanese as creative artists developed their own personal visions.

The Kano masters also created a distinctive style which synthesized Chinese and Japanese features. The

35

Figure 17. *Landscape,*
attributed to Kano Masanobu
(1434–1530). Hanging scroll,
ink and slight color on paper,
95.5 x 35.3 cm. Konishi
Collection, Itami, Hyōgo
prefecture

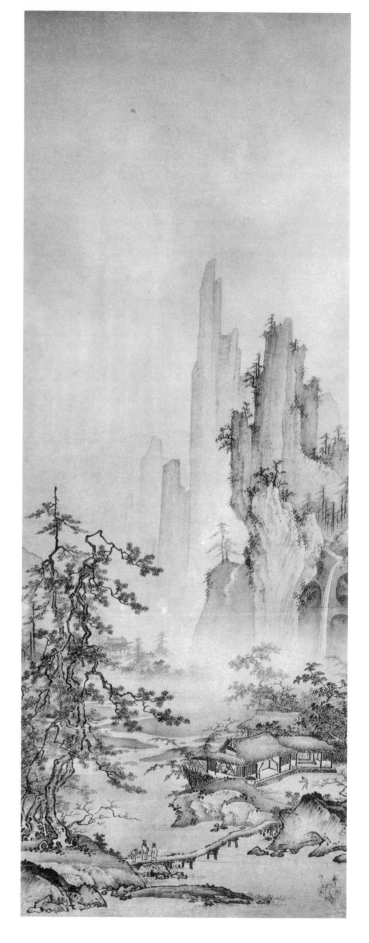

first important painter of the school, Kano Masanobu (1434–1530), began taking commissions in Kyōto in the 1460's, and eventually became *goyō eshi,* or official painter, to the Ashikaga Shōgun in the 1480's. He was not connected with a Zen monastery; rather, he apparently came from a minor warrior family in the Izu-Suruga region (modern Shizu'oka prefecture) and was a member of the popularly supported Hokke sect of Buddhism that relied solely on the *Lotus Sūtra.* But he was a thoroughly secular painter. His style, as seen in a *Landscape* in the Konishi Collection (fig. 17), conservatively looks back to the Shūbun tradition. The rocky mountain spires with a high waterfall echo the motif in the mid-century Yamamoto *Landscape* (fig. 35), while the humble cottages recall the rustic hermitages in early *shosaizu* such as *Suishoku Rankō* (fig. 39). The tall pines in the left foreground resemble those in the Yamamoto *Landscape,* but instead of standing in front of the mountain spires to emphasize their verticality, they have been moved to the left to balance the mountain. And this is the feature most characteristic of Masanobu's style: balanced clarity. Every motif in the painting is explicitly rendered, every relationship clearly defined in a space devoid of atmosphere. Sharply rendered contours and bold axe-cut textures derived from Southern Sung models move a step closer to stylization.

It was Kano Motonobu (1476–1559; cat. no. 28), a thorough and astute professional, who synthesized the range of styles current at the opening of the sixteenth century to establish a solid foundation for subsequent Kano school artists. He decorated gold screens for court nobles, painted narrative handscrolls in the Yamato-e style for Buddhist temples, produced colorful academic bird-and-flower screens for temple living-quarters, and, with amazing versatility, he worked with the whole range of Chinese Sung and Yüan styles. Like the Ami artists, he merged Chinese and Japanese elements according to his own vision, frequently combining the splendid coloration of Yamato-e with the expressive line and sturdy compositions of Chinese art. His brush method was fundamentally Chinese and his dramatic tendency fundamentally Japanese, but both were filtered through his unique artistic personality, and all his painting bears the stamp of straightforward rationality. This uncomplicated but versatile style was supremely suitable for decorating buildings formally commissioned by feudal patrons. These families frequently lived in the provinces but diplomatically supported se-

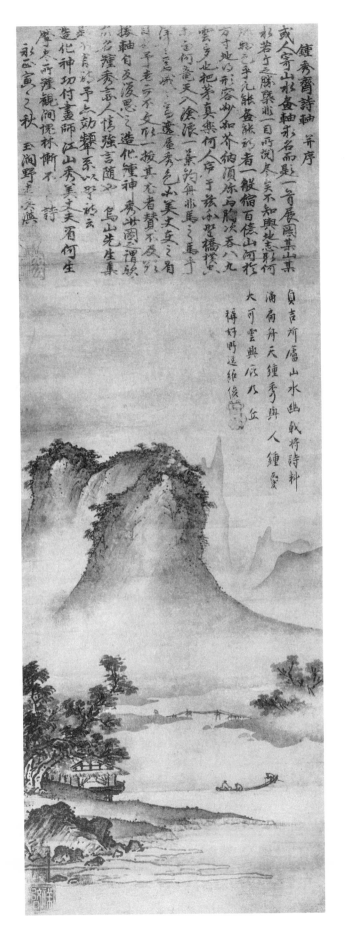

Figure 18. *Shōshūsai*, Kenkō Shōkei (fl. late 15th–early 16th century), preface by Gyoku'in Eiyo dated either 1506 or 1518. Hanging scroll, ink on paper, 78.9 x 27.6 cm. Ueno Collection, Ashiya, Hyōgo prefecture

lected Kyōto institutions as one means of reminding the titular government in the capital of their power.

Outside the capital, a number of cultural centers developed around some of these powerful families. The later Hōjō, for example, who established themselves in the city of Odawara in the Kantō region (modern Kanagawa prefecture), imported artists from Motonobu's Kyōto workshop in the second quarter of the sixteenth century. These painters were active throughout the remainder of the century and are known as the Odawara Kano.

Nearby in Kamakura a thriving painting workshop had expanded from a modest operation centering around Chū'an Shinkō in the mid-fifteenth century. Chū'an Shinkō's pupil, Kenkō Shōkei (cat. no. 24), went to Kyōto in 1478 for three years of study with Gei'ami. He returned to the Kenchō-ji in 1480 with a *shigajiku* presented to him as a remembrance by his master, and a command of Chinese painting styles as transformed by Gei'ami.

Kenkō Shōkei's position in the Zen monastery was that of scribe (*shoki*) so he was known as Kei Shoki, or "Kei, the Scribe," and he was responsible for the production of all official monastery documents. Besides holding this important position, Kei Shoki painted prolifically and gathered a band of disciples that kept Kenchō-ji's atelier active throughout most of the sixteenth century. Certain painters such as Senka (fig. 62) are known as Shōkei's disciples, others such as Shikibu (cat. nos. 25 and 37) are linked with his workshop on the basis of style. And their style elaborates on the sharply outlined and markedly textured mode which Shōkei learned from Hsia Kuei via Gei'ami.

Shōkei himself continued to develop his individual manner in response to personal assimilation of visual stimuli. He returned to Kyōto in the early 1490's and there apparently saw works by painters who were reinterpreting the manner of the Shūbun school of the second quarter of the fourteenth century — works such as the *shosaizu* of Gaku'ō (see cat. nos. 12 and 13) and the paintings of artists of the Soga school at the Daitoku-ji (see cat. no. 14). Kei Shoki's latest dated work is the *Shōshūsai* in the Ueno Collection (fig. 18). Painted in the first decades of the sixteenth century, this *shosaizu* in the retrospective Shūbun tradition shows a Chinese landscape style modified by the less extreme natural landscape which surrounded and affected the Japanese artist. Still present are the sturdy-trunked trees and the

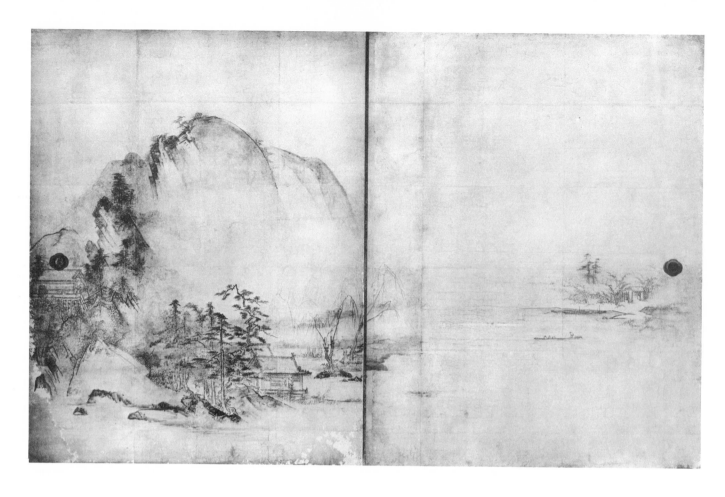

slashed texturing of rocks evolved from the Hsia Kuei tradition, but the motifs have been brought closer to the viewer for increased intimacy, the severity of the central mountain has been weathered and softened. Kei Shoki has assimilated the Chinese manner as if it were subject matter, just as Sō'ami and Motonobu were doing, transforming acquired motifs and brushwork according to his own artistic character.

Another group of artists, the Soga school, was involved in painting at the Daitoku-ji in Kyōto during the second half of the fifteenth century under the patronage of an upstart warlord, Asakura Toshikaga (1428–1481) of Echizen province (modern Fuku'i prefecture). In recent years several noted Japanese art historians have studied this school, focusing on a painter using the seal of *Sekiyō*. Besides several landscape scrolls (fig. 43), Sekiyō is thought to be the painter of the important *Landscapes of the Four Seasons* painted in 1491 on the *fusuma* at Daitoku-ji's Shinju-an subtemple (fig. 19). His style is characterized by angularity and economy of brushwork. In addition certain features, such as the softly rounded mountaintop with its crystalline rock outcroppings on one side in the *Summer* scene, hint at possible Korean influence. The traditional lineage charts of the Soga school indicate that the founder of the school was an immigrant from China or Korea, Ri Shūbun, who worked for the Asakura family in the second quar-

ter of the fifteenth century. Soga Dasoku, reputedly Ri Shūbun's son or his disciple, assumed prime importance in the second half of the century and it is to him that these monumental paintings at the Shinju-an are traditionally attributed. Unfortunately Dasoku's identity is shrouded in obscurity. A painter known as Bokkei Saiyo (see cat. no. 14), who was closely associated with the Zen reformer at Daitoku-ji, Ikkyū Sōjun (1394–1481), has also been linked with Dasoku, but the evidence is slight.

Despite the warning of Musō Soseki in the fourteenth century against excessive literary involvement, the Gozan Bungaku movement had thrived throughout the first half of the fifteenth century. As more monks became increasingly involved in Chinese studies, especially in classical literature, the spiritual significance of Zen institutions languished. Distressed Zen masters bitterly reprimanded priests who were famous not for their religious leadership but for their literary achievements. Incensed with the signs of degeneracy in increasing secularization, Ikkyū desperately campaigned to restore the vitality of Zen, particularly that of the Daitoku-ji line. He denounced the worldly priests, saying: "In bygone days those whose hearts were awakened to faith entered the monasteries, but now they all forsake the temples. A careful observer readily discovers that the bonzes are ignorant. . . . With much satisfaction they glory in their

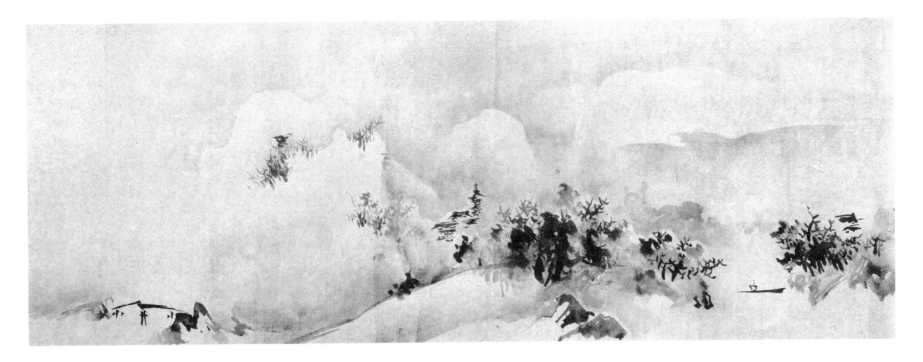

monastic robes, and though they wear the habits of a monk they are only laymen in disguise" (Dumoulin, *A History of Zen Buddhism,* p. 185).

Earlier, Shunrin Shūtō, Sesshū's spiritual teacher and abbot of Shōkoku-ji, had criticized the priesthood for similar misplaced emphasis on secular learning. In particular he cursed the eminent literary monks who inscribed typical Shūbun style paintings. He said, "It is horrifying when an unenlightened priest receives contributions. Whatever an enlightened priest says will naturally show his true virtue. One who does not know the Way should not be considered a priest, and it has been that way since the time of the First Patriarch. A man who has only words is a Confucian, yet even Confucians have practiced Zen since Su Tung-p'o and Huang Shan-ku of the Sung dynasty. Monks like Ishō Tokugan and Kōzei Ryūha have nothing but words. They, in particular, are Confucians. They are not Zen priests" (*Gōko Fūgetsushū-shō,* cited by Haga, *Chūsei Zenrin.*)

The inefficacy of Zen was accelerated by the Ōnin Civil War that broke out in Kyōto in 1467. During these disruptive times Zen monasteries lost their cultural and religious vitality, and many leading Zen priests, like other intellectuals, fled the capital to seek shelter under provincial lords. Some of them, such as Banri Shūkyū (d. 1502), became desperate about the future of Zen Buddhism and returned to the secular world, concentrating on Chinese literature. At the other extreme, some sincere Zen teachers sought reform in the *rinka,* or "in forest," movement: they took refuge in rural areas where they could cultivate a handful of devoted disciples in the essence of Buddhist belief. In the capital and its neighboring provinces, Zen had lost its vigor as a cultural force; Kyōto had lost its claim to cultural primacy. No single artistic tradition monopolized the sec-

ond half of the Muromachi period, and the provinces fostered the vital artistic activity that forecast a new age for Japan.

The last great Muromachi ink painter, Sesson (ca. 1502–ca. 1589; cat. nos. 26 and 27), lived into the new epoch in the provinces of north central Japan. He transmitted to his successors the Chinese styles that had been so repeatedly reworked during the two centuries of the Ashikaga Shōgunate, but he did not hand over these traditions in their original form.

Sesson's handscroll in the Masaki Art Museum (fig. 20) depicts one of the earliest Chinese themes to be painted in the new manner of ink painting, *Eight Views of Hsiao and Hsiang* (see Shikan, fig. 2). The painting method follows the tradition of Yü-chien, one of the first Chinese landscape styles to be learned by Japanese ink painters (Gukei Yū'e, fig. 6). The artist himself inscribed on the scroll that he was painting Yü-chien's *Eight Views,* but the transformation is so striking that Sesson's subject and his style can no longer be considered either purely Yü-chien's or Chinese. Sesson must have seen many Chinese paintings and many Muromachi artists' interpretations of these works. And he had wielded his brush to paint not a philosophical ideal, not an awed imitation of a foreign culture, not even a representation of his native land, but a visual creation in ink on paper. The power that Sesson infuses into landscape motifs with his rich sweeps of ink wash can be found neither in a Yü-chien prototype (fig. 51), nor in Mu-ch'i (fig. 56), nor in any other artist. Sesson himself remarked that he studied Sesshū, but that his painting was not like Sesshū's. The two artists' treatment of form in space differs radically. Sesshū mobilizes dense interlocking constructions to propel the viewer in and out of cohesive space. Sesson energizes elastic masses, giving

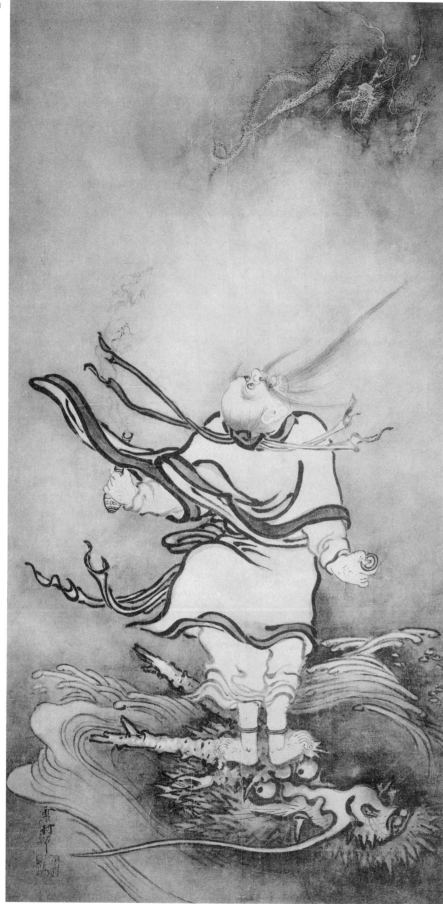

Figure 21. *Lu Tung-pin (A Chinese Taoist Immortal),* Sesson (ca. 1504–ca. 1589). Hanging scroll, ink on paper, 118.3 x 59.5 cm. Yamato Bunkakan, Nara

the forms themselves an inner dynamism. His viscous forms surge and swell independent of space.

Sesson's totally pictorial approach to painting is seen in his Chinese figure subjects. The Taoist immortal *Lu Tung-pin* (fig. 21) is humorous in his unnatural stance on a dragon's head. His contortionist posture and strangely bulging buttock are out of all human proportion. Yet, approached visually as a dramatic conception of ink forms, the painting assumes a different character. Sesson's rhythmic repetition of sinuous lines sweeps fanlike from the long whisker of the dragon at the bottom through the extravagant waves of the immortal's clothing. The movement pivots on the impossibly upturned head of Lu Tung-pin, following the line of his beard to the furiously active airborne dragon. Ultimately Sesson does not deal with objective reality. His pictures are newly created visual realms of energized ink on paper.

Sesson lived over eighty-six years, into a new era. Only twenty years after his death, Sōtatsu emerged from a different cultural background, the merchant class, to regenerate Japanese ink painting through traditional Japanese aesthetic ideas and techniques. The greatest of Sesson's followers is not one of the scores of minor late Muromachi ink painters working in the Chinese manner, but the great eighteenth century master of innovative design, Kōrin.

Yoshiaki Shimizu
Carolyn Wheelwright

CATALOGUE OF THE EXHIBITION

1

Priest Sewing under Morning Sun (Chōyō Hotetsu) AND
Priest Reading in the Moonlight (Taigetsu Ryōkyō)
Attributed to Ka'ō (fl. first half 14th century)

Pair of hanging scrolls, ink on paper, Priest Sewing *83.5 x 35.4 cm,* Priest Reading *89.0 x 34.2 cm.*
Square relief seals, Ka'ō *and* Ninga, *with traces of an erased signature, "Seikai-jin," on* Priest Sewing.
Priest Sewing: *Cleveland Museum of Art, Purchase, John L. Severance Fund (62.163).*
Priest Reading: *Museum of Fine Arts, Boston, Keith McLeod Fund (63.786)*

The two paintings are separated today, but they were probably painted to form a diptych. They illustrate a short poem by an obscure poet of the Sung dynasty, Wang Feng-ch'en,

> *In the early morning sun I mend my ragged clothes;*
> *In the moonlight I read my sūtra assignment.* [1]

These must have been familiar lines in Zen circles. At least from the thirteenth century on they incited a number of Chinese and Japanese artists alike to produce paintings with a charming touch of humanity and undertones of humor. The oldest extant version and certainly one of the finest examples is a pair of hanging scrolls in the Tokugawa Reimeikai by the otherwise unknown Yüan painter Wu Chu-tzǔ, inscribed by the artist and dated in accordance with 1295. [2] Of the various Japanese versions of the subject, perhaps the best known is the excellent pair by the Kenchō-ji monk-painter Chū'an Shinkō about the middle of the fifteenth century. [3]

The theme belongs to the category of *zenki-zu*, or "Zen activity pictures." Their purpose is to support the Zen practitioner's arduous efforts to attain enlightenment by visual reminders of exceptional conduct worthy of imitation. Extraordinary behavior may be expressed in ordinary occupations such as the humble, everyday task of mending clothes, or in the ascetic routine of uninterrupted reading of fundamental Buddhist scriptures. Both manual and intellectual pursuits are indispensable in bringing the Zen devotee to his ultimate spiritual goal, and they require concerted preparation and strong determination from early in the morning until late at night. These virtues of diligence and self-discipline are recognized by every serious practitioner.

In Japanese art-historical writings the subjects are usually referred to as *Chōyō* — "In the Morning Sun" and *Taigetsu* — "By the Moonlight," or more completely as *Chōyō Hotetsu* — "Priest Sewing under Morning Sun" and *Taigetsu Ryōkyō* — "Priest Reading in the Moonlight." The Cleveland painting, which is the right-hand scroll of the pair, shows an old monk in frontal view sitting in a relaxed posture on slightly sloping ground. He seems to have just finished mending his robe because he bends a little forward, apparently trying to cut the thread with his teeth. While holding the thread taut with his right hand, he brings the rough, dark robe close to his mouth with his left. The monk's face expresses intense concentration. His eyes move toward the left in a cunning flash; his lips are firmly pressed together. A sharp-edged rock located in the foreground indicates

the viewer's point of entry into the composition, and helps to define the spatial situation. A steep cliff rises along the right edge of the picture to the top, where overhanging rocks and sparse trees turn the upward movement back to the compositional center. A void background allows all attention to be focused upon the clearly silhouetted figure of the squat Zen priest. In the Boston painting on the left, a monk sits under pine trees on a projecting rock plateau. He holds a handscroll close to his face, straining his eyes to decipher a sūtra passage. Since the figure is shown in three-quarter rear view — a rare, yet not entirely alien compositional device of great efficacy — the viewer is given the chance to participate directly in the monk's reading. The loosely written grass script appears to be the painter's signature and the date. [4]

A compositional formula favored by fourteenth century Chinese and Japanese painters of Zen figure subjects characterizes both scrolls. A limited number of landscape elements form a foreground stage for the figures, with a cliff or a tree pushed to one side, ascending to the top and reversing directions in an audacious retroflex movement which usually points to the focus of interest. Side by side the Cleveland *Chōyō* and the Boston *Taigetsu* become a closed symmetrical composition, despite the one-sided emphasis of pictorial elements in each single scroll. Pale ink washes combine with broad, soft, and long brush strokes to render the surrounding natural forms. Some of the direct and unelaborated strokes are quickly executed with a dry split brush, allowing the grayish-white paper to show through. In one painting, layers of slightly curved horizontal strokes portray pine needles emerging from a veil of mist; in the other, irregular dots, scrawls, and vertical streaks suggest a weathered tree anchored to the overhanging cliff. With rhythmic distribution, a brush charged with heavier ink produces a few dark strokes which overlap and fuse with the uneven gray washes. Ragged energetic textures enhance the pictures with subtle variations in weight and ink tonality.

Marked thin-broad and light-dark contrasts characterize the simple, unassuming figures. Heads and hands of the two monks as well as their implements — the scripture handscroll, the needle and thread — are rendered with thin, precise lines of remarkable assurance. Intense sweeps of deep black ink with slivers of paper visible through them are deliberately confronted with simplified, fluent lines of light ink describing the casual fall of the drapery. The two paintings differ in their vari-

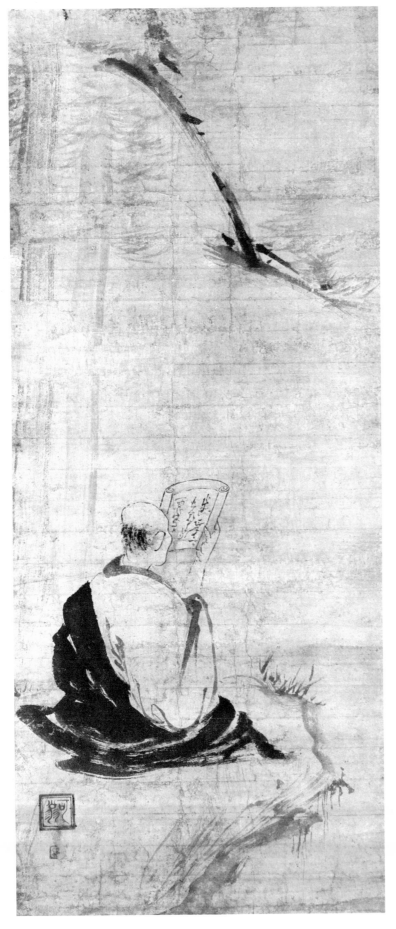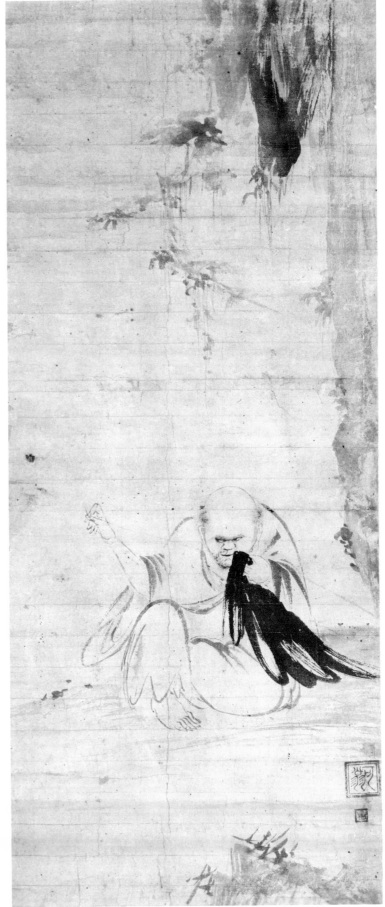

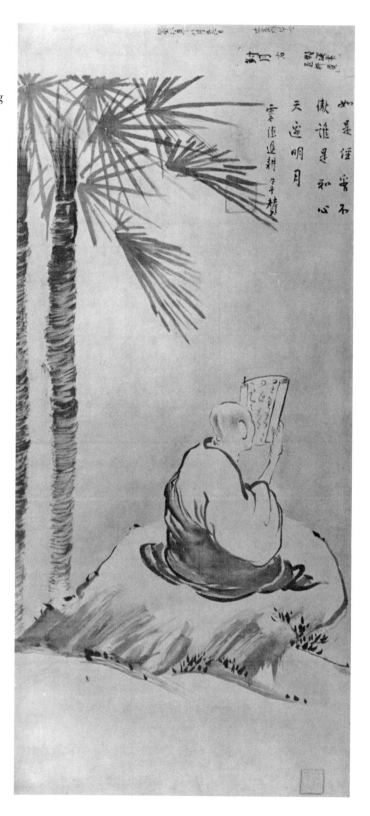

Figure 22. *Priest Reading in the Moonlight (Taigetsu Ryōkyō)*, Kano copy of a Chinese painting attributed to Mu-ch'i (d. 1269–74) and inscribed by T'ui-keng Te-ning (fl. 1262). Tōkyō National Museum, Kano copy no. 6744-30. Photographic Archives, Department of Art and Archaeology, Princeton University, courtesy Tōkyō National Museum

ations of width and contour, gradation and momentum. The Boston *Priest Reading* is done in a broader manner, with greater brush economy than is the Cleveland *Priest Sewing*. Neither painting, however, is completely devoid of uncontrolled superfluities and hence both display a somewhat amateurish playfulness. It is just this quality which distinguishes most early Japanese *suiboku* paintings produced within Zen circles and frequently dependent upon Chinese prototypes.

The model paintings for this pair of scrolls are related to the style of Mu-ch'i, a Chinese Ch'an monk active in the Hangchou area in the mid-thirteenth century.[5] Many of his works were brought to Japan by pilgrim-monks who traveled to China in the thirteenth and fourteenth centuries, and the Japanese developed a concept of a "Mu-ch'i style" in both figures and landscape. The *Gyomotsu On'e Mokuroku,* a fifteenth century inventory of the choice Chinese paintings in the Ashikaga Shōgunal collection, lists 103 paintings ascribed to Mu-ch'i.[6] One entry is of special relevance here: a triptych by Mu-ch'i with illustrations of *Chōyō* and *Taigetsu,* flanking a central painting of Daruma (Bodhidharma) inscribed by the Chinese monk Hsü-t'ang (Hsü-t'ang Chih-yü, 1185–1269).[7] Echoes of these paintings exist in both full-sized hanging scrolls and in the miniature copies made by seventeenth century connoisseurs of the Kano family of painters.

A copy identified by its Kano artist as the *Taigetsu* by Mu-ch'i and with the seal of the Ashikaga Shōgunal collection impressed in the lower right corner (fig. 22) is remarkably close to the *Priest Reading* from Boston. The inscription reproduced by the copyist was written not by Hsü-t'ang, but by a Chinese monk of the Ling-yin-ssu temple, T'ui-keng Te-ning.[8] In addition, there is another painting based on the same model formerly in the Akaboshi collection that bears a colophon signed by Hsü-t'ang,[9] the priest recorded as the inscriber of the Mu-ch'i triptych in the Shōgunal collection. Such paintings of a rear view of a priest reading, seated on a protruding rock beneath a few tree branches, must have been current in fourteenth and fifteenth century Japan. One of them provided the model for the Boston *Taigetsu.*

For the Cleveland scroll, a possible prototype exists in the Dōmoto collection in Kyōto (fig. 23). Its traditional attribution to Mu-ch'i links it with the painting recorded in the *Gyomotsu On'e Mokuroku.* The eulogy inscribed on the painting appears to be the authentic writing of Tung-sou Yüan-k'ai, a Ch'an master active during the

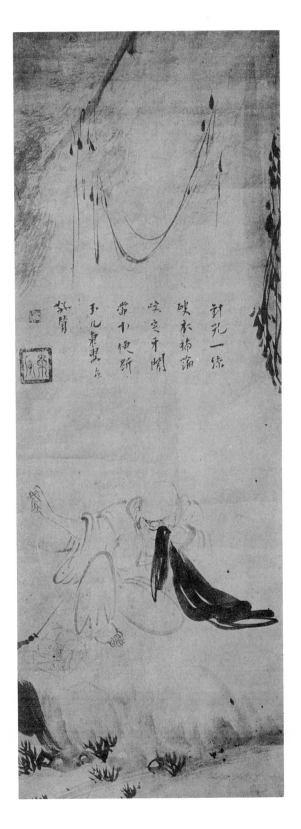

Figure 23. *Priest Sewing under Morning Sun (Chōyō Hotetsu)*, attributed to Mu-ch'i (d. 1269–74), inscribed by Tung-sou Yüan-k'ai, 1314–20. Hanging scroll, ink on paper, 83.9 x 30.3 cm. Dōmoto Collection, Kyōto

second half of the thirteenth century.[10] Therefore, although it cannot be considered a painting by Mu-ch'i, it does provide a Chinese version of the theme from the late Sung or early Yüan period which a Japanese painter might have seen. The striking similarities in the execution of the monk's figure suggest that the artist of the Cleveland *Chōyō* had first-hand knowledge of this work, or of another very close to it.[11]

Problems arise, however, when considering just who this artist was. Both the Boston *Taigetsu* and the Cleveland *Chōyō* carry two seals which are read *Ka'ō* and *Ninga*. Ka'ō Ninga was a priest-painter active during the first half of the fourteenth century, but beyond that his identity is unclear. Seventeenth century connoisseurs identified him with both the professional monk-painter Ryōzen and the high-ranking Zen priest Ka'ō Sōnen.[12] In recent years, Japanese scholars have distinguished Ryōzen and Ka'ō as quite different artistic personalities,[13] but the question of whether Ka'ō Ninga and Ka'ō Sōnen are the same person remains an issue.[14] The discussion is further complicated by the suggestion that Ka'ō was associated with the Takuma family of professional Buddhist monk-painters (*ebusshi*), since the second character *ga* in the small seal *Ninga* seems to fit into the lineage of Takuma artists Shōga, Shunga, Chōga, and Eiga.[15]

The paintings bearing the seals *Ka'ō* and *Ninga* provide more convincing insight into the nature of the artist. Clearly he was not an *ebusshi*. Rather, like his contemporary Moku'an Rei'en, Ka'ō created his own relaxed manner based on the pictures he saw by Chinese artists. Paintings such as his *Kensu* in the Tōkyō National Museum (fig. 32), the *Kanzan* in the Hattori collection, and the *Bamboo and Sparrow* in the Yamato Bunkakan display a convincing stylistic consistency despite their discrepancy in subject matter.[16] Their stunning economy and spontaneity of expression, their forceful, bold brushwork, and their subtle, exquisite handling of ink reveal close conceptual and technical points of correspondence. In these works Ka'ō concentrates on light ink tonalities, limiting the use of intensive dark ink to the outlines of his figures, the rendering of their hair, and to a few subordinate details in well-conceived coordination with other pictorial elements. Washes are always applied in varying gradations of gray, never in black ink. The heavy dark ink values do not gain as much prominence as in the Cleveland and Boston scrolls. The identification of *Priest Sewing* and *Priest Reading* as works by Ka'ō is questionable.

A closer look at the seals reinforces this suspicion. Both seals are identical on the Cleveland and the Boston scrolls, but they are markedly different from the well-known impressions on other paintings. The size relation between the *Ka'ō* seal and the *Ninga* seal has been altered: the latter is proportionately larger than in other accepted examples. The *Ninga* seal lacks any parallel in arrangement and number of strokes of the two characters, in its broad square frame, and in its strange sideways displacement. Closer investigation reveals that once a curiously inverted signature of Ryōzen was written on both paintings and the seals of Ka'ō were impressed over the signature.[17] Perhaps this was done by a collector of the seventeenth or eighteenth century, when the most respected connoisseurs confused the identity of Ka'ō and Ryōzen. Later, presumably when the independent artistic personalities of the two artists had been established, the signatures were erased, leaving only the seals to make these acceptable as Ka'ō paintings.

Although the two paintings cannot be ascribed to Ka'ō Ninga with any assurance, they can be considered representative works of the fourteenth century, comparable in structure and motifs to accepted works of the period. For example, like Moku'an's *Four Sleepers* (fig. 4) and Ka'ō's *Kensu* (fig. 32), the articulated foreground plane leads to the figure in the middle ground, and the background is undefined. The viewer can easily enter the painting and remain in intimate relation to the subject without drifting into unfathomable space. The motif of the cliff on the right in the Cleveland *Priest Sewing* finds close parallels in the *Monju (Mañjuśri) in the Form of a Monk* in Nanzen-ji, a painting datable no later than 1338 on the basis of its inscription,[18] and in the Roku'ō-in *Shaka Descending the Mountain*, which bears the seal *Ka'ō* but is probably a Ryōzen painting.[19] The stronger value contrasts in the Cleveland painting suggest slightly more evolved conventions. Since the Cleveland *Priest Sewing* and the Boston *Priest Reading* possess the somewhat naïve animation characteristic of paintings by Zen monks rather than the trim polish of those by *ebusshi*, they can probably be judged as works of a Zen priest-painter about the middle of the fourteenth century.

HELMUT BRINKER

NOTES

1. Zuikei Shūhō (1391–1473), a monk of the Roku'on-in of the Shōkoku-ji monastery in Kyōto, recorded the poem in his diary, *Ga'un Nikkenroku*, and identified its author as the Chinese poet Wang Feng-ch'en.

2. Published in *Sōgen no Kaiga*, pls. 32–33.

3. Discussed and published by Fontein and Hickman, *Zen Painting and Calligraphy*, no. 36.

4. The first three characters appear to be *saiji hei*-[?], or "the year dwells in the station *hei*-[?]," referring to a cyclical date. The last two characters can be deciphered as *sha shi*, "painted this." Presumably the illegible script of the middle characters contains the name of the painter.

5. Mu-ch'i Fa-ch'ang, a Ch'an monk from western Shu (modern Szechwan) studied Ch'an under the famous master Wu-chun Shih-fan (1177–1249) in the capital area of Hang-chou. He learned painting from Yin Chi-ch'uan. Later he became abbot of Liu-t'ung-ssu, a temple in Chekiang near West Lake. Unguarded political remarks necessitated some time in exile in the Hui-chi area, but he eventually returned to his temple. He died there sometime during the Chih-yüan era (1264–94), probably after 1269. His repertory covers a wide range of subject matter. Besides Buddhist figures (figs. 23, 26, and 50), he painted landscapes (see cat. nos. 18 and 22, and fig. 56), dragons-and-tigers (see cat. no. 27), flowers-and-fruits (see cat. no. 37 and fig. 81), reeds-and-geese (see cat. no. 29). One 14th century critic called Mu-ch'i's brushwork free and easy, and his expression immediate and forthright, but other writers criticize his work as coarse, lacking the orthodox brush methods. Some Chinese critics scathingly denounce his painting as distasteful. During his lifetime and immediately afterward, however, Mu-ch'i was highly appreciated by both the gentleman-scholar class and the monks in the Ch'an monasteries. About the mid-15th century he gradually began to be forgotten, and only a few Ming dynasty connoisseurs noted his high accomplishment. Today, very few Mu-ch'i paintings remain in China — only two copies of his paintings of fruit, vegetables, and birds are reported. In Japan, however, Mu-ch'i has been the most respected name among Chinese painters since the 14th century. Strong social demand for Mu-ch'i paintings naturally resulted in the emergence of a large number of alleged Mu-ch'i works, an indiscriminate mixture of copies of his works and paintings by his followers. Modern studies of Mu-ch'i have drastically reduced the number of acceptable Mu-ch'i paintings. The *White-Robed Kannon* (fig. 50) flanked by the *Crane* and *Monkey* are the only works by this monk-painter that most scholars today think are genuine. See Sirén, *Chinese Painting*, 2:138–42; Fontein and Hickman, *Zen Painting and Calligraphy*, pp. 28–29; Fuku'i, "Mokkei Itteki"; Tanaka Toyozō, "Mokkei Kanwa"; Wu T'ai-su, *Sung-chai Mei-p'u*, chap. 14; Hsia Wen-yen, *T'u-hui Pao-chien*, chap. 5.

6. See Tani, "Mokkei Hōjō" ("Mu-ch'i Fa-ch'ang") and

"Gyomotsu On'e Mokuroku," in *Muromachi Jidai Bijutsu-shi Ron,* pp. 81–115, 116–42.

7. *Ibid.,* p. 137.

8. T'ui-keng Te-ning was active ca. 1262. His biography is quoted in Ima'eda, *Shintei Zusetsu Bokuseki Soshiden,* p. 82.

9. *Reading a Sūtra,* hanging scroll, ink on paper, 83.3 x 31.1 cm, published in *Gei'en Shinshō,* 9: pl. 4.

10. The exact dates of Tung-sou Yüan-k'ai's life are unknown. He was a disciple of the famous Ta-ch'uan P'u-chi (1179–1253) and was appointed head of the high-ranking monastery on Mount Yü-wang in the 46th generation. In the same capacity he served in the Ching-tz'u-ssu near Hangchou, following the 47th abbot, Shih-fan Wei-yen, who had come into office there in 1265. His inscription on the Dōmoto painting was written during his residence on the A-yü-wang-shan, between 1314 and 1320.

11. Another remarkably similar version is known through a Kano copy in the Tōkyō National Museum (no. 6744-17), this one bearing an inscription by the mid-13th century Chinese Ch'an monk, Tung-sou Yüan-k'ai.

12. Kano Einō, *Honchō Gashi* (1678), p. 977. (For discussion of the *Honchō Gashi,* see cat. no. 2, n. 18.)

13. Ryōzen has been traditionally associated with the Tōfuku-ji monastery in Kyōto, and since he signed several of his paintings *kaisei-jin,* "the man from west of the sea," it is thought that he came from the island of Kyūshū. Two of his paintings, one of them the *White-Robed Kannon* in fig. 5, bear colophons by the Nanzen-ji monk Kempō Shidon (1285–1361) who, incidentally, came from Kyūshū, so Ryōzen's period of activity can be determined as ca. mid-14th century. All of his known paintings are of Buddhist subjects and exhibit an ink-painting style not far removed from traditional Buddhist painting of *ebusshi* (professional artists who specialized in painting Buddhist subjects using conventional techniques). See Tanaka Ichimatsu, *Ka'ō, Moku'an, Minchō,* pls. 18, 59–67.

14. A few biographical facts are known about Ka'ō Sōnen. He is said to have pursued his initial religious studies under Nampo Jōmyō (1235–1308). About 1317 or 1318, he went to China, perhaps as one of the group of eminent pilgrims headed by Jakushitsu Genkō (1290–1367). During his sojourn of almost ten years, he met the venerable Ch'an teachers Ku-lin Ch'ing-mou (1262–1329) and Chung-feng Ming-pen (1265–1323). After his return from the mainland he was appointed to the abbot's chair in three of Kyōto's foremost Zen institutions, the Manju-ji (16th abbot), the Nanzen-ji (18th abbot), and the Kennin-ji (28th abbot). Ka'ō Sōnen died in 1345 (*Koga Bikō,* pp. 283–84; for discussion of the *Koga Bikō,* see cat. no. 2, n. 8). If he was indeed the painter of some of the most outstanding examples of early Japanese *suibokuga,* this year becomes a date of crucial significance. Kanazawa Hiroshi, one of the most accomplished experts in this field, accepts it as *terminus ante quem* for all works bearing a Ka'ō seal that he seriously considers to be genuine. However, other factors argue against this identification. First, none of the biographical accounts of Ka'ō Sōnen mention that he painted; it is only in discussions of Ka'ō Ninga that the association is made. And second, none of Ka'ō's paintings bear poetic colophons by other Gozan monks. This lack of inscriptions is in marked contrast to the scrolls associated with the high-ranking *bunjin-sō* (humanist monks) Tesshū Tokusai (cat. nos. 31– 33) or Gyoku'en Bompō (cat. no. 35).

15. The traditional reading of the *Ninga* seal is far from safe and by no means commonly accepted, so caution is required. Most of the Takuma painters are little more than names written in records with only a few acceptable examples of their work. There are several pieces of circumstantial evidence linking Ka'ō Ninga with the Takuma family. The original seat of the Takuma family was located in Kyūshū, nearly all Takuma painters worked in Kyōto, and Takuma Eiga (active half a century later than Ka'ō; fig. 30) is said to have worked with Zen priests.

16. These and other paintings associated with Ka'ō can be found in Tanaka Ichimatsu, *Ka'ō, Moku'an, Minchō,* pls. 7–10 and 52–58.

17. On the Cleveland painting, the first three characters of the signature, *Seikai-jin,* are still visible. On the Boston painting the removal was more complete. About 1953 Professor Shimada took this scroll to the Scientific Division of the Kyōto Police, where he had infrared photographs made. These clearly reveal the characters *Seikai-jin Ryōzen hitsu,* "the man from west of the sea, Ryōzen painted this." *Seikai* is an inversion of Ryōzen's usual order, *kaisei.*

18. Inscribed by Ch'ing-cho Cheng-ch'eng, a Chinese monk who died in Japan in 1338. Published in *Nihon Kokuhō Zenshū,* no. 63, and in Tanaka Ichimatsu, *Ka'ō, Moku'an, Minchō,* pl. 50.

19. Published in Tanaka Ichimatsu, *Ka'ō, Moku'an, Minchō,* pl. 58.

White-Robed Kannon

Attributed to Isshi (fl. first quarter 15th century)

Hanging scroll, ink on silk, 95.62 x 49.53 cm. Square intaglio seal, 2.4 cm, in lower right, undecipherable.[1] Inscription on box containing the painting: "Takimi Kannon" (Waterfall-Gazing Kannon). Private collection, formerly Ueno Ri'ichi Collection

Seated under a cliff between two rocks jutting over frothy waves is Kannon draped in white, a translucent vase containing willow leaves placed on the rock to his right. The gray ink line contouring the folds of his drapery flows busily over the wave patterns below. His long hair, tied in a pretzel-shaped knot above an elaborate diadem, trickles in thin strands over his shoulders. Kannon's head is encircled by a halo, through which is visible part of the cliff and vegetation behind him. The overhanging cliff is rendered in wet ink with dry brushstrokes defining the rock texture. Lush vegetation tempers the craggy precipices; dangling vines resemble the jeweled strings festooning the canopies on Buddhist icons. A cooling waterfall cascades through the crevices of the rock beyond. The cliff overhang and the rocks below are the most representational motifs, the drapery patterns of the Kannon in the center less so, and the waves below are most patternized and abstract. The cliff formation above and the waves below create a space for the central image. Recession is conveyed through gradation of ink tones on the cliff and diminution of the size of the waves.

Kannon (Sanskrit: Avalokiteśvara; Chinese: Kuanyin) is the compassionate bodhisattva in the Mahāyāna pantheon who vows to save all mankind with his mercy and love. As one of the most popular Buddhist deities, he takes many forms. For example, in the *Lotus Sūtra*, perhaps the most influential text of Mahāyāna Buddhism, an entire chapter describes in vivid poetry thirty-three miraculous manifestations assumed by Kannon to help those in distress.[2] Another important text, the *Ganda-vyūha* (Chinese: *Ju-fa-chieh-p'in;* Japanese: *Nyūhokkai-bon*), which is the last chapter of the *Avatamsaka Sūtra* (Chinese: *Hua-yen-ching;* Japanese: *Kegonkyō*), describes the bodhisattva Avalokiteśvara residing at Mount Potalaka. The Chinese developed a concept of the location of Mount Potalaka (or the Chinese transliteration, Mount P'u-t'o-lo-chia) in China, on an island off the shore of Ningpo.[3] Thus they associated the bodhisattva's residence with ocean waters. Avalokiteśvara is described in the sūtra as surrounded by "flowers and fruit trees amidst rivulets and ponds."[4] This picturesque image gave the impulse, in T'ang China, to representation of Kannon in a landscape setting which included water, rocks, and bamboo. An early example of the type is the Water-Moon Kannon. Chou-fang (fl. 780–810) is recorded to have painted one such Kannon in a landscape setting.[5] The Potalaka Kannon as it developed during the T'ang period in China became the

prototype for various later images of Kannon on a Rock, Willow Kannon, Waterfall-Gazing Kannon, and the White-Robed Kannon seen here.

The earliest extant representations of this type date from China's Five Dynasties-early Northern Sung period. Tenth century paintings of Potalaka Kannon discovered in the cave sites of Tun-huang,[6] the terminus of the northern silk-road on China's northwest border, are often colored, and one shows strong Greco-Indian influence.[7] Contemporary with the Tun-huang paintings is a drawing of Kannon incised on a bronze mirror dated 985, brought to Japan from T'ai-chou in China by the Japanese Buddhist pilgrim, Chōnen.[8] Since pictorial representation of the Potalaka Kannon developed from a narrative, there were no specific iconographic rules, and extant versions vary in type as well as in style. But distinct Chinese features, especially the emphasis on landscape setting, indicate rapid Sinification of the concept. By the mid-eleventh century, Kannon in a Potalaka setting of rocks and water was widely painted.

Ink paintings of Kannon based on this iconographic tradition first appear in China in the eleventh century. Li Kung-lin (1040–1106) painted a Kannon image reclining on a rock.[9] There is visual evidence that by the second half of the twelfth century there were ink paintings of White-Robed Kannon seated on a rock gazing at a waterfall,[10] but no surviving full-fledged ink painting of the White-Robed Kannon predates the thirteenth century. One important example by Mo-an in the Fuji'i collection can be dated between 1256 and 1263 on the basis of its inscription.[11] Another, by far the most evocative ink painting of Kannon known, is that in Daitoku-ji by the mid-thirteenth century painter-monk, Mu-ch'i (fig. 50).

With the close contacts Japanese Buddhist pilgrims established with China from the twelfth through the fourteenth centuries, numerous Kannon paintings in both ink and color entered Japan. Some Japanese monasteries came to possess Chinese paintings and iconographical drawings based on Chinese models. The well-known sketch from Kōzan-ji of Potalaka Kannon now in the Cleveland Museum dates from the early thirteenth century.[12] In the fourteenth century some of the Japanese Zen Buddhist pilgrims are themselves known as painters of White-Robed Kannon, such as Moku'an Rei'en and Ose Shū'on. So popular was this subject among Japanese monks in China that the mid-fourteenth century Chinese scholar and critic of painting, Hsia Wen-yen made a special note of it.[13]

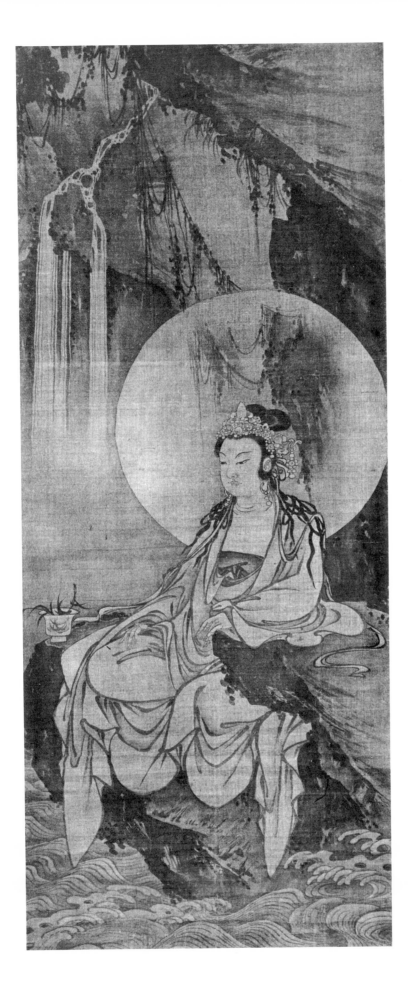

The Japanese developed stylistic variants on the ink Kannon tradition. During the third quarter of the fourteenth century, two basic styles were current in Japan: one is represented by Tesshū's disciple, the painter-monk Gukei Yū'e, the other by the professional Buddhist painter Ryōzen (fig. 5).[14] Gukei's *White-Robed Kannon* evolved from the style Moku'an practiced in China. Characterized by its freedom in execution, it is a mode suited to the amateur painter-monk. Ryōzen's style, as seen in the *White-Robed Kannon* of the Myōkō-ji collection, is professional in execution, characterized by deliberate description of details — particularly in the facial features and drapery patterns.

By the end of the fourteenth century painters of traditional Buddhist images practiced diverse styles. The demand for Kannon paintings, whether executed in ink alone or in a combination of color, ink, and gold, must have been great. Important Zen monasteries began to develop their own painting workshops. The best known was that at Tōfuku-ji in Kyōto, led by the painter-monk Minchō (1351–1431)[15] and sustained by his followers, Sekkyakushi (cat. no. 4) and Reisai (cat. no. 5), during the first half of the fifteenth century. By that time new types and styles of Kannon painting, developed in Yüan and early Ming China, were flowing into Japan.

Since there were numerous models of Kannon paintings from which to choose, no single prototype served as the only source for any given painter. Japanese artists and connoisseurs have identified several stylistic traditions and associated certain Kannon paintings, perhaps none too critically, with individual Chinese artists. In this way they have created type groupings for different modes, such as the "Mu-ch'i Kannon" or the "Chang Yüeh-hu Kannon."[16] Therefore, in considering the stylistic development of Kannon paintings from the fourteenth into the fifteenth century, traditional types as well as formal morphology must be considered. With this in mind, certain generalizations can be made concerning stylistic change.

In fourteenth century paintings by Moku'an, Gukei, and Ryōzen, foreground space leading up to the Kannon image is consciously articulated, while the space between the middle ground and far distance is left undefined. The bodhisattva's form relates clearly to the space in front of it, and a representational intent is evident in the relative simplicity of drapery folds. Elaboration in setting and image increases near the end of the century, and, as the fifteenth century opens, there is a greater degree of abstraction in the figure itself and in the overall concept of the painting. There is more freedom of movement, more zest in linear play of drapery patterns. The main image becomes psychologically isolated from the setting and assumes the weighty monumental character seen in the Kannons of Minchō, Reisai, and Sekkyakushi. The Kannon shown in this exhibition belongs to this period, the first quarter of the fifteenth century.

The most peculiar feature of this Kannon painting is the patternization of the waves. Diminution in size gives an effect of recession despite the high degree of stylization. Precedents for this convention can be found in Chinese paintings of the Yüan period: a painting of *Taoist Immortals* in the Museum of Fine Arts, Boston, dating from the fourteenth century, shows similar water patterns; another example is found in the *Eight Taoist Immortals* painted on the wall of the Chinese Taoist temple Yung-lo Kung, datable no later than 1325.[17]

This *White-Robed Kannon* has been traditionally attributed to an obscure painter known as Isshi. Standard biographies of Muromachi painters have little to say about him. One source briefly mentions that Isshi was Kō, the Sūtra Keeper, a monk who followed the style of Minchō. His painting of Monju (Mañjuśri) was said to resemble the style of an obscure Chinese painter named Hsüeh-chien. Another source mentions that Isshi was a foreigner who resided at Nanzen-ji and learned from Minchō, yet another connects him with the Kenchō-ji monastery in Kamakura.[18] These biographical accounts conflict, but a group of Kannon paintings which carry attributions to Isshi reveal him as a distinctly individual artistic personality.

The unusually severe face of the Kannon exhibited here appears on another Kannon painting attributed to Isshi in the former Akimoto collection.[19] The undulating eyebrows, the bow-shaped upper eyelid, the tightly sealed mouth and broad cheeks resemble a theatrical mask. There is none of the benign quality seen in the faces of Kannon by Mu-ch'i (fig. 50) or Moku'an. Drapery patterns and landscape setting recall two other White-Robed Kannon paintings in Japan: one attributed to Isshi formerly in the Ōshima collection (fig. 24), and one from a set of thirty-two (originally thirty-three) Kannon paintings in the Kenchō-ji in Kamakura (fig. 25).[20] This set is erroneously attributed to Kenkō Shōkei, but the paintings are by more than one hand.

The drapery patterns of these three Kannons — the one exhibited here, and those from the Ōshima collection and from Kenchō-ji — are markedly different

Figure 24. *White-Robed Kannon,* attributed to Isshi (fl. first quarter 15th century). Hanging scroll, ink on silk. Collection unknown, formerly Ōshima Collection, Matsu'e, Shimane prefecture

Figure 25. *White-Robed Kannon,* attributed to Isshi (fl. first quarter 15th century), from a set of *Thirty-Three Kannon* erroneously attributed to Kenkō Shōkei. Hanging scroll, ink on silk, 128.0 x 51.0 cm. Kenchō-ji, Kamakura

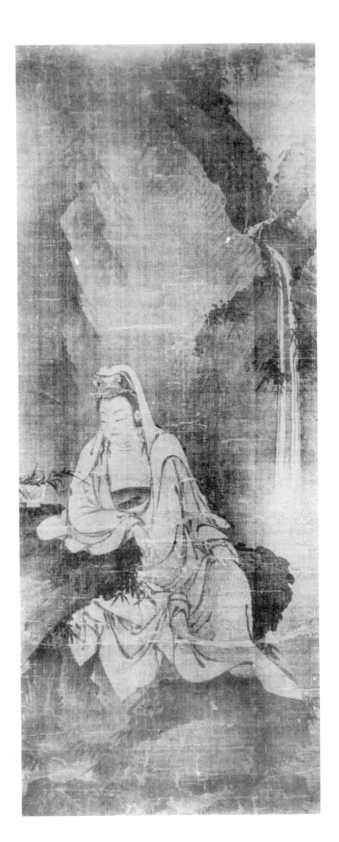

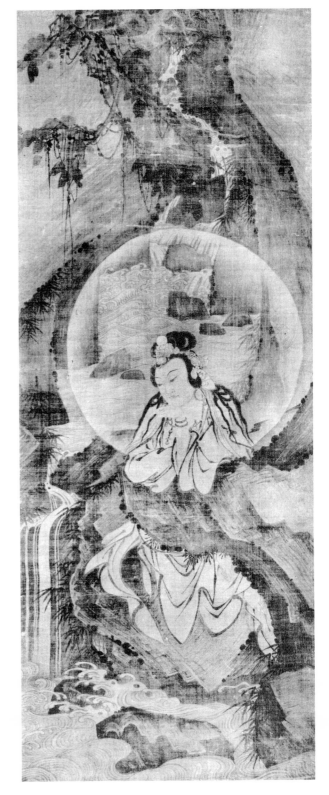

from the style of robes painted by Kyōto's Tōfuku-ji artists of the early fifteenth century. On his *White-Robed Kannon* in the Nezu Museum, for example, Minchō combines discontinuous long and short lines, for creases and folds, with contour lines which completely enclose the mass of the drapery. The same formula is used by his followers Sekkyakushi and Reisai.[21] The Kannon exhibited here, like the Ōshima and Kenchō-ji figures, has drapery patterns defined by both continuous lines and jointed lines, resulting in more descriptive in-and-out flections — a continuous flux of planes. Clearly Isshi followed prototypes different from those of Minchō and his school. His drapery patterns are closer to the mode represented by Ryōzen's *White-Robed Kannon* in the Myōkō-ji collection (fig. 5). Perhaps Isshi followed the same earlier models.

The stylistic link between the Ōshima Kannon and the one in this exhibition is very close, especially in the drapery type which shows the inner garment over the chest. Many features of the Kenchō-ji painting are also strikingly similar: the wet ink wash applied to cliff and vegetation, the easily penetrable spatial recession, the brushwork of Kannon's drapery. A certain exotic flavor can be noted in both, which recalls the story that Isshi was a foreigner. The highly stylized wave-patterns of these paintings reappear in the Kannon by another Kenchō-ji monk, Chū'an Shinkō (cat. no. 6), active in the midfifteenth century.

Therefore it seems likely that the artist of this *White-Robed Kannon* was connected with the artistic milieu of Kamakura rather than with that of Kyōto. Kamakura had been the pulsating center of Zen culture during the Hōjō Regency of the thirteenth century, and its temples had fostered the Japanese monks who created the early ink-painting style of the fourteenth. But as the religious and governmental focus shifted to Kyōto during the second half of the fourteenth century, so did artistic patronage. Little is known of painting activity in Kamakura until the emergence of Chū'an Shinkō (cat. no. 6) and his more famous pupil, Kenkō Shōkei (cat. no. 24), in the fourth quarter of the fifteenth century. If this Kannon is indeed by Isshi, who is reported as a monk at Kamakura's Kenchō-ji monastery, then the painting provides a valuable start for the understanding of artistic developments outside the capital of Kyōto during the first half of the fifteenth century.

YOSHIAKI SHIMIZU

NOTES

1. No seals of Isshi are known. In the section of the *Koga Bikō* (see below, n. 18) on joint works and unidentifiable seals (p. 2082), there is a sketch of an incomplete seal on a painting of Kanzan that might be related to Isshi. The note remarks that the seal is tilted 90° and that the painting resembles that of Kenkō Shōkei.

2. This is the *Fumon* chapter of the *Lotus Sūtra* (Sanskrit: *Saddharma-pundarīka-sūtra*), popularly known as *Kannon-gyō* (*Kannon Sūtra*). A useful Japanese edition is Sakamoto and Iwamoto, translators and collators, *Hokke-kyō*, 3:262. See also Mochizuki, *Bukkyō Daijiten*, 4:3462–63, and 2:1545 under "Sanjūsan Kannon." The Sanskrit version was translated into English in 1884 by Kern, and is available in a paperback edition, *Saddharma-Pundarika*.

3. Chih-p'an, *Fo-tsu T'ung-chi* (preface 1269), *chüan* 2, in *Dainihon Kōtei Daizōkyō, chi* 9, p. 90.

4. *Ta-fang-kuang-fo Hua-yen-ching Ju-fa-chieh-p'in* (*Daihokobutsu Kegon-kyō Nyūhokkai-bon*), *chüan* 68, in *Dainihon Kōtei Daizōkyō, ten* 4, p. 33. The relationship between the *Gandavyūha* and the *Avatamsaka Sūtra* is the first question dealt with by Dr. Jan Fontein in his book, *The Pilgrimage of Sudhana*, pp. 1–5. Also see Kameda, "Tōdai-ji Kegon Gojūgokasho'e Shōkō."

5. Chang Yen-yüan, *Li-tai Ming-hua Chi* (847), *chüan* 3, p. 127. *Chüan* 1–3 are translated by Acker, *Some T'ang and Pre-T'ang Texts*. Chou-fang's *Kannon* is mentioned on p. 293.

6. Matsumoto, *Tonkoga no Kenkyū*, pl. vol., pls. 97a-b, 98a-b; text vol., pp. 344–55.

7. Matsumoto, "Suigetsu Kannon-zu Kō," and Auboyer, *Rarities of the Musée Guimet*, frontispiece.

8. The mirror is kept at Seiryō-ji in Saga, Kyōto, and is published in *Nihon Chōkokushi Kiso Shiryō Shūsei*, 1:pl. 55.

9. Li Ch'ih, (*Te Yü Chai*) *Hua P'in*, in *Sung Jen Hua Hsüeh Lun chu*. Yang Chia-lo, ed., *Chung-kuo Hsüeh-shu Ming-chu Mulu*, no. 10, pp. 195–96.

10. Chou Chi-ch'ang's *Rakan Viewing a Kannon Painting*, from the set of *Five Hundred Rakan* at Daitoku-ji, dated 1178, and published in *Hihō*, 11 (Daitoku-ji): pl. 10.

11. It is inscribed by Yen-ch'i Kuang-wen, abbot at Ching-shan between 1256 and 1263. Although the inscription on the painting is not recorded in Yen-ch'i Kuang-wen's *Collected Sayings*, it can be verified by stylistic comparison of his calligraphy. The painter Mo-an cannot be identified. The painting is published in *Kokka*, no. 813.

12. Other examples of iconographic drawings from Kōzan-ji can be seen in Yamato Bunkakan, *Kannon no Kaiga*, p. 20. The Cleveland drawing is published in Mayuyama, *Japanese Art in the West*, pl. 95. A late 12th-century copy kept at Ninna-ji of a Potalaka Kannon dated 1058 is printed in *Besson Zakki, kan* 22, in *Taishō Shinshū Daizōkyō: Zuzō*, 3: no. 86. The *Besson*

Zakki is a voluminous collection of iconographic drawings compiled by the monk Shingaku (1117–80).

13. Hsia Wen-yen, *T'u-hui Pao-chien* (1365), *chüan* 6, p. 92.

14. Ryōzen is discussed in cat. no. 1, n. 13. Gukei's *White-Robed Kannon* is published by Etō, "Yū'e Gukei hitsu Byaku'e Kannon-zu," and in Fontein and Hickman, *Zen Painting and Calligraphy*, no. 35. For Gukei's biography, see Shimada, "Yū'e Gukei no Sakuhin Nishu."

15. Minchō is discussed by Tanaka Ichimatsu in *Nihon Kaigashi Ronshū*, pp. 279–88. See also Tanaka Ichimatsu, *Ka'ō, Moku'an, Minchō*, where Minchō is the subject of an article by Kanazawa Hiroshi, pp. 61–66.

16. Chang Yüeh-hu is an obscure Chinese painter who has never been recorded in Chinese painting texts. In Japan, however, he was one of the most famous artists of Buddhist figure paintings, particularly well known for his Kannon pictures. His name is listed in several works of Muromachi literature among such well-known Chinese masters as Mu-ch'i and Chang Su-kung. An example of the Chang Yüeh-hu Kannon type can be seen in *Kokka*, no. 533.

17. The Boston Taoist painting is published in Tomita, *Portfolio of Chinese Paintings*, pl. 105; the wall painting from the Taoist temple of Yung-lo Kung is published in *Yung-lo Kung*, pl. 179.

18. The two standard painters' biographies which mentioned Isshi are the *Honchō Gashi* (p. 980) and the *Koga Bikō* (p. 541). The *Honchō Gashi*, one of the earliest Japanese art histories, was written by Kano Einō (1634–1700), based on the records of his father, Kano Sanraku. It was first published in 1678, organized into five chapters under the title *Honchō Gaden*. Chapter 1 gives a general discussion of the development of painting in early Japan, chapter 2 gives brief biographies of 147 artists of the Nara and Heian periods. Chapter 3 is most relevant to this exhibition, for it provides information about 160 artists of the Kamakura and Muromachi periods. The professional families of artists, primarily the Kano school and the Hasegawa school, are outlined in chapter 4, which also includes a section on the painting themes and techniques used by these artists. Chapter 5 contains miscellaneous biographies, with a concluding section on artists' tools (ink, brush, kinds of paper) which gives special emphasis to pigments. Kano Einō supplemented these five chapters with a separate book on artists' seals called the *Honchō Ga'in;* he published it in 1693 with its present title, *Honchō Gashi*. The five chapters of the *Honchō Gashi* are published in Sakazaki, ed., *Nihon Gadan Taikan.* Both the *Honchō Gashi* and the *Honchō Ga'in* are included in Sakazaki, ed., *Nihon Garon Taikan*, 2:951–1017 and 1018–54, respectively. All references are to this latter edition.

The *Koga Bikō* was initially written by a 19th century member of the Kano school, Asa'oka Okisada (1800–56). It contains biographical information about almost 4,000 Japanese painters from the Asuka period to the end of the Edo period with special reference to their representative works. It is arranged according to the social standing and dates of the painters, and includes appendices cataloguing sliding door paintings, screens, and picture scrolls, as well as a list of technical painting terms. Ōta Kin revised and enlarged Asa'oka's work and published it in 1905 as *Zōtei Koga Bikō.* This revised edition, to which information was added by a number of Meiji period scholars, including members of Teishitsu Hakubutsukan, is what is commonly understood by the title *Koga Bikō.* It was reprinted by Shibunkaku in 1970 in three consecutively paginated volumes, a fourth index volume, and a paperback mimeographed *katakana* index.

19. Hanging scroll, ink on paper, 117.5 x 45.8 cm, published in *Kokka*, no. 35.

20. Not all the thirty-two paintings have been published. Two of them are in the Yamato Bunkakan catalogue, *Kannon no Kaiga*, p. 30.

21. For Kannon paintings of the Minchō school, see Tanaka Ichimatsu, *Ka'ō, Moku'an, Minchō*, pls. 21, 95, 96, 104, 105, 110.

3

Daruma (Bodhidharma)

Ashikaga Yoshimochi (1386–1428)
Inscription by Shunsaku Zenkō (fl. 1425–26)

*Hanging scroll, ink on paper,
74.4 x 25.7 cm.
Oblong vertical intaglio seal
Haku'an to upper left of
inscription; oblong horizontal
intaglio seal reading Shunsaku
and oblong horizontal relief seal
reading Zenkō to lower right of
inscription.
Accompanied by certificate of
authenticity by Kanda Teijō (or
Sadatsune).*[1]
Collection Nesé

This imaginary profile portrait of Bodhidharma (Japanese: Bodaidaruma, or Daruma for short), Indian prince and founder of the Zen school of Buddhism, is rendered in extremely abbreviated form. A broad brush dipped in pale ink contours the hood of the patriarch and continues into the sleeves of the cape. Fewer than ten brush strokes in dark ink define the profile of the face: bumpy forehead, bulbous nose and bulging nostril (characterizing the "Indianness" of the patriarch), sharp cheekline and tightly sealed mouth. The eye is drawn using a simple scheme: a small circle for the pupil with an inverted "C" for the lower eyelid. The stubby beard is indicated by a lighter tone of mottled ink, while a dot and a short vertical line in dark ink below the chin suggest the neckline of the patriarch. Over the eye a dry brush marks a long eyebrow. The dramatic tonal contrast of the white cape and the sharp outline of the profile as well as the immediacy of the brushwork heightens the intensity of this image of the First Patriarch of the Ch'an school of Chinese Buddhism.

Ch'an Buddhists emphasized the importance of seeking enlightenment directly through meditation, without reliance on written words. This teaching, Ch'an adherents maintained, was passed from Śākyamuni to his disciple Mahākāśyapa and then without interruption through succeeding patriarchs to Bodhidharma. According to traditional hagiography, Bodhidharma went to China in the early sixth century to transmit the doctrine of meditation.[2] He had an audience with the Emperor Wu-ti (502–550) of the southern state of Liang, and told the monarch that traditional acts of piety, such as copying Buddhist sūtras, building temples, or giving alms to monks, were altogether futile. But his attempts to gain adherents in the south were unsuccessful, so Bodhidharma crossed the Yang-tze River (on a reed, the later story goes) and went north to Shao-lin temple at Mount Sung. There he meditated for nine years in front of a rock wall, an episode which later accounts describe as "nine-year wall-gazing." It is his intense mental concentration while staring resolutely at the rock wall that this painting captures.

In the upper section of the scroll is a poem and a short inscription written by the monk Shunsaku Zenkō (fl. 1425–1426) of the Daitoku-ji monastery in Kyōto.[3] From left to right it reads:

> *He came all the way from India,
> With ease he beguiled the people of China.*

> *Five petals unfurled from this fragrant flower,
> In a breath he overturned the universe.*

> *This hallowed portrait of Daruma was
> painted by Shōjō-in's distinguished
> brush. Shunsaku, the old Zenkō,
> respectfully burns incense in praise of it.*

The verse makes direct reference to a poem which Bodhidharma composed, after nine years of intense sitting, as he transmitted his teaching to his first Chinese disciple, Hui-k'o.

> *I originally came to China,
> To transmit the teaching and save deluded beings.
> One flower opens five petals,
> And the fruit ripens of itself.*[4]

The "fragrant flower" of Zenkō's verse refers to Bodhidharma and his teaching, and the "five petals" to the five branch schools that he said would emerge from his teaching, as indeed they did.[5] Shōjō-in, whom Shunsaku Zenkō identifies as the artist of the Daruma, is the posthumous Buddhist title of Ashikaga Yoshimochi (1386–1428), the fourth Shōgun.[6]

Yoshimochi, in both public and private life, showed particular enthusiasm for the Zen sect. As the Bakufu's chief executive, he frequently issued economic policy directives favorable to the Gozan monasteries. His cultural activities in Kyōto, especially after his father Yoshimitsu died in 1408, were closely linked to notable Gozan monks such as Daigu Shōchi (1439), Genchū Shūgaku (1350–1428), and Gyoku'en Bompō (see cat. no. 34). Yoshimochi often sponsored poetry gatherings for scholarly monks talented in poetry in the Chinese style. He commissioned the painter Josetsu of Shōkoku-ji to paint *Catching a Catfish with a Gourd* (fig. 7), for which some thirty Gozan monks, including the three cited above, composed verses in Chinese. In the closely knit cultural sphere of Gozan Zen temples Yoshimochi had opportunities to see Chinese paintings, and, as a talented amateur, like Winston Churchill at his easel, Yoshimochi created his own ink paintings.

The seventeenth century biography of painters, *Honchō Gashi*, mentions that Yoshimochi learned painting from the artist-monk Minchō (1351–1431). It says he was skilled at painting Kannon, and quotes a verse that the Shōgun composed and inscribed on one such painting.[7] A Kannon painting on silk with the identical inscription that is recorded in *Honchō Gashi* exists today

in the Atami Museum in Japan.[8] *Honchō Gashi* also cites Yoshimochi's painting of *Tu Fu Riding a Donkey,* with his own inscription which gives a date corresponding to 1413. Although this painting does not survive, at least three paintings of this subject attributed to Yoshimochi exist, one of which is in the Seattle Museum.[9] Most of the paintings associated with Yoshimochi depict themes like these, popular also in the artistic environment of the Gozan communities, but in addition he painted subjects associated with other Buddhist sects. In 1410, for example, Yoshimochi painted a Jizō (Ksitigarbha) for Nyaku'oji Shrine in Kyōto and inscribed it himself.[10] Jizō, a popular deity as a savior of people destined for hell, was seldom painted for Zen monasteries. It is the subject for which Yoshimochi's great-grandfather, the first Ashikaga Shōgun Taka'uji (1305–1358) and a strong adherent of Jōdo doctrines, is well known.[11]

A Bodhidharma tradition 500 years old preceded this *Daruma* by Yoshimochi, although the earliest extant paintings date from the twelfth century. The subject originated in China in about the eighth century, when the Ch'an sect began to develop as a major religious force. Because the Ch'an sect in China was formed much later than the other traditional Buddhist sects, it needed to justify its historicity: a hagiography was created to establish a doctrinal pedigree in terms of continuous transmission of unwritten teaching from Śākyamuni himself. The most systematic extant hagiographical work dealing with this transmission is *Ch'uan-fa Cheng-tsung-chi* (Japanese: *Dempō Shōsōki,* "The Record of the Transmission of the Law and the Correct Teaching").[12] Dating from 1053, it links Bodhidharma to Śākyamuni through twenty-seven Indian patriarchs. Bodhidharma, the twenty-eighth, became the First Patriarch of China, and the most important in the establishment of the historical rationale of the Ch'an lineage.

As the sect consolidated its foothold in China and began to extend its sphere of cultural influence, there arose an increasing need for pictorial representations. No depictions of the founder of the Ch'an sect earlier than the twelfth century now exist, but two types of Bodhidharma painting developed during the T'ang dynasty and must have been current from late T'ang into Northern Sung. One, a narrative type, pictured the First Patriarch in the act of transmitting the teaching to the Second Patriarch, who in turn passed it to the Third, and so on through the Sixth Patriarch. One such painting may have existed as early as the eighth century, at the time of the Sixth Patriarch, Hui-neng (638–713).[13] Existing twelfth century representations of Bodhidharma of the narrative type reveal no major stylistic difference from the iconographic drawings executed for the traditional Buddhist sects.[14]

The other type of Bodhidharma representation was an individual portrait which formed a set with those of succeeding patriarchs, very much like the set of *Five Patriarchs of the Shingon Sect* which the Japanese priest Kūkai (774–835) brought from China in 806.[15] This second type varied in format. Some portrayed full figures of the patriarch either standing or sitting, giving rise to a special genre of Ch'an portraiture known as *chinzō,* "portraits of the masters." The earliest extant *chinzō* date from the Southern Sung period. A set of these portraits could be either individual hanging scrolls assembled in a group, or one scroll picturing the masters in sequence. Sometimes a single *chinzō* of a living master was given to his disciple as a certificate that he had attained enlightenment, like a college diploma. Or sometimes a portrait of a past master or patriarch was given to a priest, as a commemorative pseudo-icon and a reminder of the continuous transmission of the doctrine passed to the recipient. The portrait of Bodhidharma was often given to the Ch'an practitioner in this way. One of the earliest existing examples of Bodhidharma painting in the descriptive *chinzō* tradition is presumed to be a Japanese copy and is dated to 1189 by its inscription.[16] Concurrent with such descriptive paintings in color on silk, examples exist of a freer style of depicting the First Patriarch. A *Daruma* inscribed by Mieh-weng Wen-li (fl. 1212) in the Myōshin-ji collection is painted in ink on paper, using abbreviated brushwork for drapery while retaining descriptive methods for facial features.[17] So at least these two modes of imaginary portraits of Bodhidharma were known in the twelfth century; other kinds also developed and were current by the thirteenth century.

Bodhidharma paintings began to appear in Japan in the late thirteenth century, and reflect a variety of Chinese models. The earliest, the *"Red-Robed" Daruma* inscribed by Lan-ch'i Tao-lung (d. 1278), is in the realistic *chinzō* tradition.[18] Two other early Japanese examples reveal different emphasis on the "Indianness" and "Chineseness" of Bodhidharma's features. The first, in ink on silk and datable by its inscription to 1296, is the quasi-narrative *Daruma with a Sandal* in the Masaki Museum,

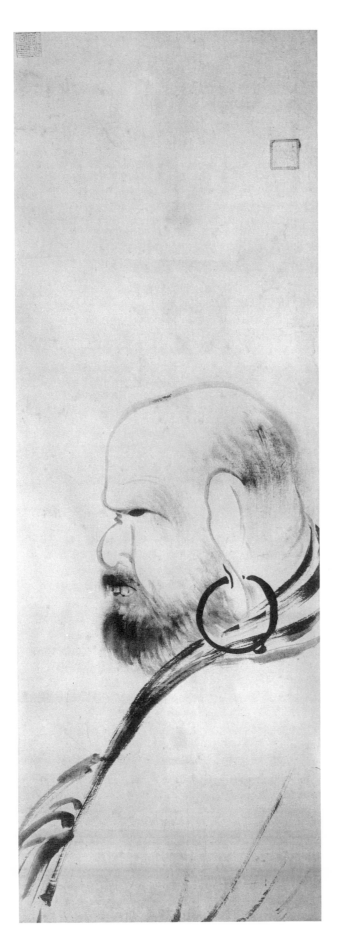

Figure 26. *Meguro Daruma* (*Black-Eyed Bodhidharma*), attributed to Mu-ch'i (d. 1269–74). Hanging scroll, ink on paper. Collection unknown, formerly Kawasaki Collection, Kōbe

Ōsaka.[19] Particular emphasis on the bulging eyes and tumorous nose make the face appear almost demonic. There is no obvious "Indianness" in the second example, *Daruma Crossing the Yang-tze on a Reed,* which carries an inscription by Tōgoku Myōkō, an early-fourteenth century monk of Manju-ji. This painting, in color on silk, is in the Freer Gallery.[20]

The exact model behind Yoshimochi's *Daruma* cannot be traced, but given the wide stylistic scope available by the beginning of the fourteenth century, a profile portrait in abbreviated ink style emphasizing Indian physiognomy must have existed in China. Relevant here is a half-bust profile portrait traditionally attributed to Mu-ch'i, known as *Meguro Daruma* (*Black-Eyed Bodhidharma*) and formerly in the Ashikaga Shōgunal collection (fig. 26). This painting is quite different from Yoshimochi's *Daruma* in brushwork and ink handling, and the patriarch wears no hood. In addition, the particular emphasis on "Indianness" is conspicuously absent. The similarity in format, however, suggests the tradition underlying Yoshimochi's *Daruma.*

Yoshimochi may have set a precedent for *Daruma* as a painting subject appropriate for secular leaders. In 1443 the young seventh Shōgun (nine years old by western count), Ashikaga Yoshikatsu, painted a *Daruma* which was inscribed by the scholar-monk Kōzei Ryūha.[21] In the following Momoyama period, the Emperor Go-Yōzei (1571–1617) produced a *Daruma* in the "flying-white" brush technique.[22]

Yoshimochi's *Daruma* is not recorded in any art-historical texts, but its authenticity can be attested by another of his paintings, the *Kanzan* in the Sonoyama Collection.[23] Not only is the abbreviated brush style comparable to the *Daruma,* but this scroll is also inscribed by Shunsaku Zenkō and the calligraphy can be judged reliable. In recent years Matsushita Taka'aki has cited seven paintings by Yoshimochi which, like the works of most amateurs, vary in quality.[24] But the *Daruma* and the *Kanzan,* as well as the *Tu Fu Riding a Donkey* in the Seattle Museum, reflect the best work of this enlightened Shōgun.

Although the *Honchō Gashi* refers to Yoshimochi as having learned painting from Minchō, and Minchō's biography in the same source mentions the painter's close contact with Yoshimochi, there is scarcely any visual evidence that Minchō directly influenced Yoshimochi's paintings. The *Koga Bikō* remarks that the *Kanzan* painting reflects the style of Yin-t'o-lo, a painter-

Detail of catalogue number 3, *Daruma*

monk from India who worked in China about the 1350's. Matsushita recently put Yoshimochi's surviving works into two groups: those following the Mu-ch'i mode and those in the Yin-t'o-lo manner.[25] Strictly speaking, however, Yoshimochi's style cannot be readily linked to any authentic works of either painter. The *Daruma*, in particular, is unique.

YOSHIAKI SHIMIZU

NOTES

1. Kanda Teijō was a professional connoisseur of the 18th century.

2. The best study of the historicity and the legendary accounts of Bodhidharma is Sekiguchi, *Daruma no Kenkyū*. The book is written in Japanese, but contains an abstract in English.

3. For the inscriber Shunsaku Zenkō, see Shiban, *Empō Dentōroku, kan* 29, 1972 edition, p. 26. See also Tamamura Takeji's chart of the transmission line of Zenkō in *Hihō*, 11 (Daitoku-ji):22–23. The *Empō Dentōroku* gives no date for Zenkō, but briefly mentions his connection with Ashikaga Yoshimochi. Shunsaku Zenkō compiled biographies of Tettō Gikō (1314–69) and Shūhō Myōchō (1281–1337), both of Daitoku-ji, in 1425 and 1426 respectively. These two biographies are published in *Zoku Gunsho Ruijū*, vol. 9B. The first, *Ten'ō Daigen Kokushi Gyōjō*, is on pp. 592–94; the second, *Daitō Kokushi Gyōjō*, on pp. 410–16.

4. Translation by Yampolsky, *The Platform Sutra*, p. 176. The earliest work to record Bodhidharma's poetry is the *Pao-lin Chuan* (full title: *Shuang-feng-shan Ts'ao-hou-ch'i Pao-lin Chuan*) of 801. See Yampolsky, pp. 47–49 and n. 165.

5. The five branch schools are Lin-chi, Ts'ao-tung, Yün-mên, Fa-yen, and Wei-yang (Japanese: Rinzai, Sōtō, Unmon, Hōgen, and Igyō).

6. Yoshimochi's Buddhist name (*hōmyō*) is Dōsen. His Buddhist title (*dōgo*) is Kenzan. His family tree and major dates are succinctly accounted in *Sompi Bunmyaku*, 60A: 253. *Sompi Bunmyaku* is a compendium of genealogies of noble families from the early Muromachi period.

7. Kano Einō, *Honchō Gashi*, p. 980.

8. Hakone Museum and Atami Museum, *Meihin Zuroku*, 1(Atami, 1968): pl. 4.

9. Published in Seattle Art Museum, *Japanese Art*, pl. 89, and Matsushita and Tamamura, *Josetsu, Shūbun, San-Ami*, pl. 27. The painting carries an inscription dated 1575 by the 15th Shōgun, Ashikaga Yoshi'aki (1537–97). A second version of *Tu Fu Riding a Donkey* is in the Nishi Hongan-ji collection (published in *Kokka*, no. 153), and a third is in a private collection (published in Matsushita, *Muromachi Suibokuga*, pl. 15).

10. Kyōto National Museum, *Muromachi Jidai Bijutsu Ten Zuroku*, pl. 4. The painting is in ink on silk and is recorded in the *Koga Bikō*, p. 110.

11. Taka'uji's *Jizō* is published in Matsushita, *Muromachi Suibokuga*, pl. 4.

12. The *Ch'uan-fa Cheng-tsung-chi* is in *Dainihon Kōtei Daizōkyō, un* 9.

13. The *Platform Sutra*, the book that purports to give the history and teaching of Hui-neng, mentions a wall painting of "Five Patriarchs transmitting the Robe and Dharma." For this passage, Yampolsky's translation, "the Fifth Patriarch transmitting...," seems to be in error. See Yampolsky, *The Platform Sutra*, Chinese text p. 2, and English translation p. 129.

14. Five 12th century drawings of Bodhidharma can be cited, four in Japan and one in Taiwan. The first is *Sangoku Soshi Ei* (Portraits of Eminent Patriarchs of Three Countries), dated 1129, in the Kanda Collection, published in Takahashi, *Sangoku Soshi Ei no Kenkyū*. The second is *Dempō Shōsō Teisozu* (Drawings of Established Patriarchs Transmitting the Law and Correct Teaching), dated 1154, in the Kanchi-in of Tō-ji monastery, Kyōto, published in *Taishō Shinshū Daizōkyō: Zuzō*, vol. 10. The third work is *Kōsōzō* (Lofty Priests), copied in 1163 by the monk Kan'yū, now in the Ninna-ji, *ibid.*, vol. 11. The fourth, *Rokusozu* (Six Patriarchs), a 13th century Japanese copy based on a Chinese woodblock print of 1054, now in Kōzan-ji, is published in Fontein and Hickman, *Zen Painting and Calligraphy*, no. 1. The fifth is the 1180 scroll of Buddhist images by Chang Sheng-wen in the Palace Museum, Taiwan, known as the *Ta-li-kuo* scroll, published in Chapin, "Three Early Portraits," pl. 11, fig. 1.

15. Published in *Hihō*, 6 (Tō-ji): pls. 6–12.

16. *Daruma*, published in Tokunaga, "Nansō Shoki no Zenshū Soshizō ni tsuite." The painting carries an inscription by Cho-an Te-kuang (d. 1203) dated 1189. Tokunaga accepts this as a Southern Sung work. A later copy traditionally attributed to the Chinese painter Yên Hui (see cat. no. 15, n. 2, for discussion of this Yüan painter) is in the Nezu Museum and is published in Nezu, *Seizansō Seishō*, 1: pl. 8.

17. Fontein and Hickman, *Zen Painting and Calligraphy*, no. 7.

18. In color on silk in the Kōgaku-ji, Yamanashi prefecture. Published as the cover of Fontein and Hickman, *Zen Painting and Calligraphy*, and discussed in cat. no. 20.

19. Kanazawa, *Shoki Suibokuga*, pl. 31.

20. Published in Toda, *Mokkei, Gyokkan*, pl. 56.

21. Cited by Yashiro Hirokata (1748–1841), *Rin'ō Gatan*, in Sakazaki, ed., *Nihon Gadan Taikan*, p. 902.

22. This painting, owned by the Jishō-in, Kyōto, was shown in the 1975 Momoyama exhibition at the Metropolitan Museum of Art and is published in the catalogue of that exhibition, *Momoyama*, no. 31.

23. Published in Matsushita and Tamamura, *Josetsu, Shūbun, San-Ami*, pl. 28. This painting is recorded in *Koga Bikō*.

24. Lecture by Matsushita, "Shōgun Yoshimochi no Gaji," ("Painting Activities of the Shōgun Yoshimochi"), and reprinted in his *Muromachi Suibokuga*. Four of the seven paintings have been published: the Sonoyama *Kanzan* (see above, n. 23), two versions of *Tu Fu Riding a Donkey* (see above, n. 9), and a *Hotei* in the Museum Matsunaga Kinenkan, published in Matsushita and Tamamura, *Josetsu, Shūbun, San-Ami*, pl. 1.

25. Matsushita, "Shōgun Yoshimochi," *Muromachi Suibokuga*. Yin-t'o-lo is discussed in cat. no. 4, n. 8.

Ox and Herdsman
Sekkyakushi (fl. first half 15th century)

*Hanging scroll, ink on paper,
29.35 x 53.7 cm.* [1]
*One oblong
intaglio seal reading*
Sekkyakushi *identical to the
one reproduced in* Koga Bikō,
*p. 546, under the name "Kan
Densu."*
*Mary and Jackson Burke
Collection (formerly
Nakamura Tani'o Collection)*

This *Ox and Herdsman* is probably the most familiar of the known works bearing the seal reading *Sekkyakushi*. Its composition is extraordinarily simple, comprising only the most essential motifs. In the foreground is a small earthen bank executed in pale ink wash. Dark, rounded dots representing moss accentuate its contour. Behind it, the ox and herdsman walk at leisure down a larger slope that echoes the diagonal of the foreground bank. A single pine branch projects into the scene from the corner overhead. Both the sparseness of the landscape and the disposition of elements within it enhance the focus on the figures. Moreover, the technical restraint of the landscape setting contrasts effectively with the more elaborate brushwork employed in depicting the figures. The artist's concentration on portraying the figures is particularly evident in the masterly combination of ink wash and sweeping textural strokes that make palpable the long, soft fur of the ox. Against the austere landscape, the intimate harmony between the two companions is sympathetically portrayed. In the stillness of the scene, the quiet rhythm of their footfalls can almost be heard.

Illustrations of oxherding became very popular among Ch'an monks of the Southern Sung period, in part because of their development of a philosophical system which represented the process of enlightenment by means of an analogy to oxherding. Although this analogy originated in a sūtra, the *Zōichiagon-kyō* (Sanskrit: *Ekottarāgama*)[2] used in other Buddhist sects, monks of the Ch'an sect extended the system to comprise ten stages or aspects rather than the usual eight.[3] So appealing was this analogy that it inspired the composition during the Sung period of numerous sets of ten verses known as the "Ten Oxherding Songs." Some of these sets of verses were illustrated, the most popular among them in woodblock printed editions.[4]

Despite the importance of these illustrations in popularizing the theme of oxherding as a metaphor for enlightenment, not all of the surviving paintings of this theme by Ch'an or Zen monk painters were illustrations of specific verses of the "Ten Oxherding Songs." Such paintings may be considered to constitute a separate genre, distinct in purpose and expressive quality from illustrations of the "Songs." Like paintings of Ch'an sages (see cat. nos. 5, 8, and 9), they were intended to express directly the spiritual vitality of the enlightened being, rather than to present a logical, theoretical analysis of the process of enlightenment. They were to be apprehended directly through the senses rather than by

intellectual analysis. This more generalized conception of the oxherding theme naturally appealed to artists, for it allowed greater freedom of expression than did the literal illustration of a didactic text.

Sekkyakushi's *Ox and Herdsman* bears no inscription, nor is there any conclusive evidence that the painting refers specifically to one of the "Ten Oxherding Songs."[5] It is therefore likely to belong to the tradition of oxherding paintings that were intended to be independent of text. Sekkyakushi must have had a special fondness for this subject, since two other paintings of the same theme, one in the Asian Art Museum of San Francisco[6] and one in the Freer Gallery of Art (fig. 27), are among his few attributed works. All three paintings have a diagonal branch delineated by a thick zigzag line projecting from an upper corner, and the ox and herdsman occupy a central position on a sloping bank below. In two of the three versions, a foreground element further defines the space in which the figures move. The compositional similarity among the three paintings suggests their derivation from a common model.

The three *Ox and Herdsman* paintings by Sekkyakushi bear a remarkable compositional and, to some extent, technical resemblance to a pair of paintings of the same subject by Chang Fang-ju (fig. 28), a Chinese artist of the Yüan period whose work is known only in Japan.[7] Chang Fang-ju's compositional formulation is simple, and the two paintings form nearly a symmetrical pair. In each one the trunk of a large tree begins in the foreground and extends toward the edge of the painting on a diagonal. The tree trunk is cut by the edge of the format, but the branches of the same tree reenter the painting from above. This device creates a prominent, bracket-like foreground "frame" along one side. This is also a distinctive compositional feature of the work of the Ch'an monk-painter, Yin-t'o-lo (fl. mid-fourteenth century).[8] Behind the tree is a land bank, delineated mainly by ink wash in graded tonalities. The figures of the ox and herdsman occupy central positions on the bank, and are seen in the distance through the framing tree.

Of the three paintings of *Ox and Herdsman* attributed to Sekkyakushi, the version in the Freer Gallery of Art (fig. 27) most closely resembles the pair by Chang Fang-ju, which is likely to have been its prototype. Nevertheless the Freer painting shows significant modifications which reveal the individuality of Sekkyakushi's interpretation of the model. The scale of figures in Sekkyakushi's version is much larger, and they domi-

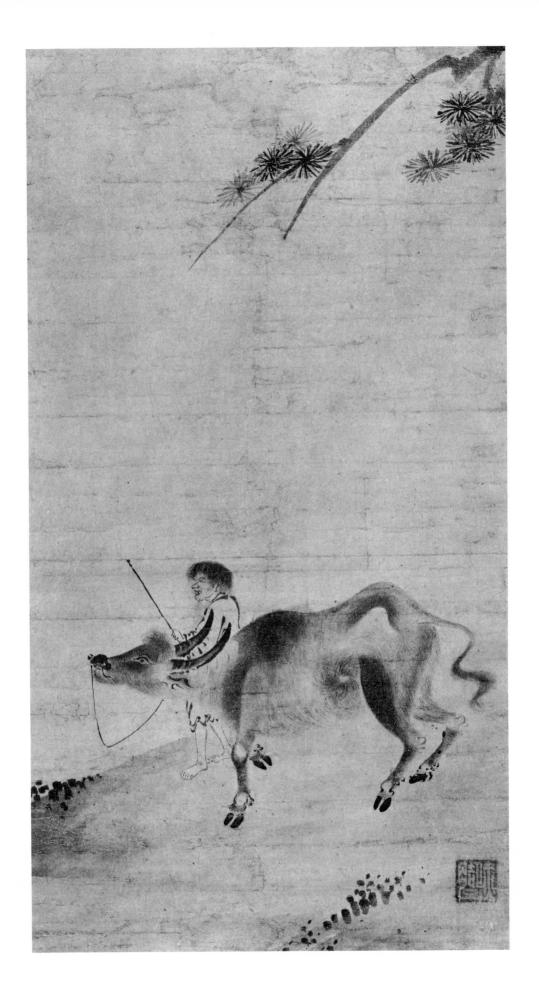

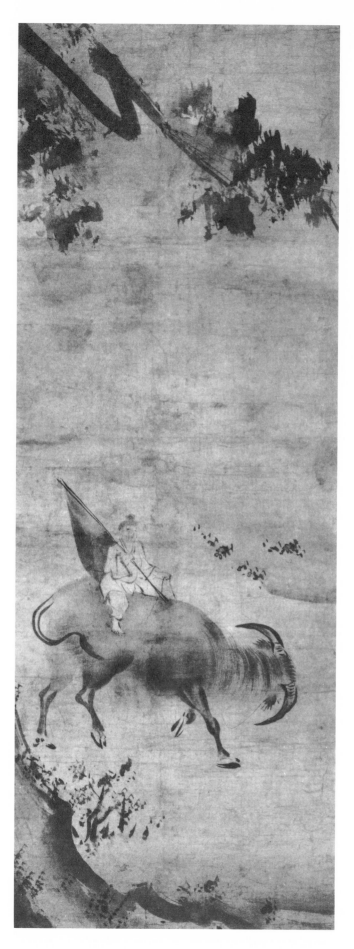

Figure 27. *Ox and Herdsman*
(*Boy on a Water Buffalo*),
Sekkyakushi (fl. first half 15th
century). Hanging scroll, ink on
paper, 97.2 x 35.6 cm.
Smithsonian Institution, Freer
Gallery of Art, Washington,
D.C. (66.16)

nate the composition. Moreover, the artist has much simplified the spatial setting and has set the figures against an ambiguous void space instead of on stable ground constructed of interacting horizontals and diagonals as in the Chinese model. In setting his figures against an indefinite void space, Sekkyakushi has followed a precedent established during the fourteenth century by Japanese Zen monk-painters such as Ka'ō (see cat. no. 1).

Thus, even in his close adherence to a specific Chinese prototype, Sekkyakushi has modified it in accordance with his own artistic predilections. His individual stylistic preferences, evident in the Freer painting in his use of long, sweeping textural strokes to depict the fur of the neck and hindquarters of the ox, are more fully expressed in his two other paintings of the same subject. In these he abandons the conspicuous compositional device of depicting the tree trunk in the immediate foreground. As the tree becomes less prominent, it yields emphasis to the figures, which are large in scale and nearly fill the painting horizontally. Sekkyakushi has thus diminished the intrinsic formal tension seen in Chang Fang-ju between the figures and the foreground tree, which like a stage-prop conspicuously fixes the position of the figures beyond. His modification of the composition allows a more intimate and integrated treatment of the subject. In the *Ox and Herdsman* of the Burke Collection, the visual tension between tree and figures is fully diminished by the placement of the branch directly above them, adding emphasis to their position as the thematic and formal focal point of the composition.

Another important modification in the Burke and Asian Art Museum versions is in the form and technique of rendering the figures. For the depiction of oxen, it appears that a prototype other than Chang Fang-ju has been followed. A possible source is suggested by a Kano painter's copy of an oxherding painting by the obscure Chinese painter, Chih Jung,[9] which shows a similar use of contrasting ink wash for the definition of the bony structure of the flanks of the animal, and the expressive but disproportionately large head seen in the two paintings by Sekkyakushi.

Still more intriguing are the human figures in the Burke and Asian Art Museum paintings. In contrast to the herdsman in the Freer version, which follows Chang Fang-ju, the herdsmen in these two versions wear ragged garments and loose, shaggy coiffures. Their smiling features, exaggerated to the point of caricature, recall images of the legendary Ch'an sages, Han-shan and

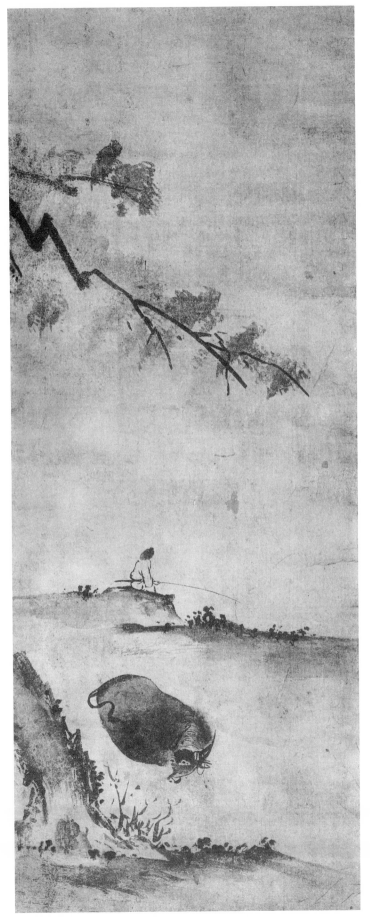
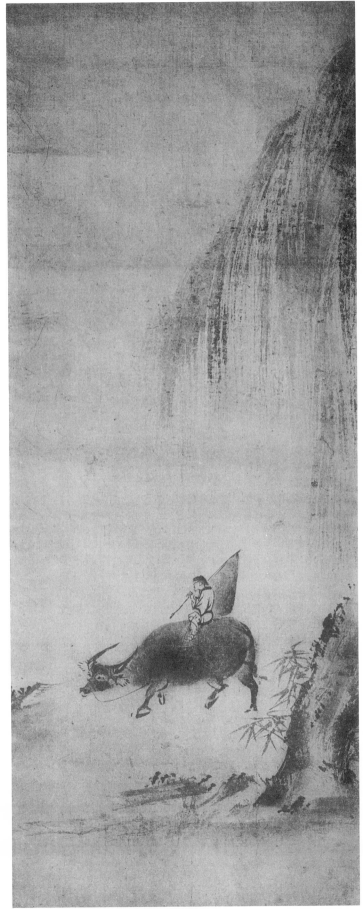

Figure 28. *Ox and Herdsman*, Chang Fang-ju (fl. 14th century). Pair of hanging scrolls, ink on paper, each 87.2 x 34.8 cm. Atami Art Museum, Atami, Shizu'oka prefecture

Shih-te (see cat. no. 5). If the allusion to these two famous sages is intentional, then the actual subject of these paintings might not be simply "Ox and Herdsman," but rather Han-shan or Shih-te in the guise of the herdsman, a unique combination of themes.

The individuality of Sekkyakushi's conception of the "Ox and Herdsman" theme in the Burke and Asian Art Museum examples comes in part from his selective combination of elements from more than one source. However, the differences between the two paintings, which appear superficially similar, express contrasting aspects of Sekkyakushi's artistic personality. The Asian Art Museum version technically resembles such works attributed to Sekkyakushi as the *White-Robed Kannon*.[10] The brushwork in both paintings is accented and broken, especially in the robes of the figures. The overall effect is exuberant and lively, but the active mannered brushwork tends to countervail the contemplative mood of the subjects.

In contrast, the Burke version stands out as one of Sekkyakushi's finest paintings. The freedom and control of the mature artist is most clearly expressed in the formal, decorative interplay of contrasting ink washes and fine, sweeping textural strokes which render the fur of the bull. Here the degree of technical mastery is such that the artist's delight in decorative pattern and texture is expressed without seeming unnatural or studied. Touches of contour judiciously used as accents add a flicker of visual excitement to the otherwise tranquil scene. The artist's careful and deliberate attention to formal detail creates an interplay of linear rhythms and tonalities that is profoundly quiet but replete with latent energy.[11]

The artist known as Sekkyakushi from the characters appearing on his seal is an elusive figure about whom little is surely known, except through the small corpus of paintings bearing that seal. A document accompanying the Burke painting and written by the great connoisseur of painting Kano Einō (1634–1700), author of the *Honchō Gashi*, the first systematic account of the history of Japanese painting, identifies the painter of this *Ox and Herdsman* as "Kan Densu . . . whose sobriquet was Sekkyakushi. . . ."[12] Sekkyakushi has also been confused with Minchō and Reisai (see cat. no. 5)[13] because of the similarity of their seals and sobriquets, all of which refer ironically to "feet." Traditional biographical accounts of Sekkyakushi simply identify him as a disciple of Minchō and a monk of the Tōfuku-ji. The range of subjects painted by Sekkyakushi, on the evidence of his surviving works, supports this tradition. His paintings include both the Buddhist iconographic subjects to be expected of a professional painter-monk and more informally rendered figure and animal subjects that reflect the changing taste in Zen circles following the inspiration of models imported from China.

The only indication of Sekkyakushi's period of activity comes from inscriptions on two of his paintings by Gukyoku Reisai (1363–1452) of the Tōfuku-ji, and Koshin Jihaku (d. 1414) of the Kennin-ji. On the basis of this evidence, Sekkyakushi may be assumed to have been active within the first half of the fifteenth century. This period is consistent with the tradition that he was a disciple of Minchō (1351–1431), and the style of his Buddhist figure paintings confirms his association with the Tōfuku-ji atelier.

Since Sekkyakushi is the only member of the Minchō atelier to have painted the theme of the *Ox and Herdsman,* his paintings of this subject are not directly comparable with other works of the school. Nevertheless the high artistic quality of the Burke painting distinguishes it as a masterpiece of the artist's maturity, and its intimate and sympathetic portrayal of the subject well expresses the individuality of this artist among his talented contemporaries.

Ann Yonemura

NOTES

1. Condition: considerable damage to paper near the top of the painting, to left of overhanging branch. Otherwise in good condition.

2. Mochizuki, *Bukkyō Daijiten,* 3: 2229; 4: 3031.

3. See Fontein and Hickman, *Zen Painting and Calligraphy,* pp. 113–18.

4. According to Fontein and Hickman, the two most prevalent editions of the "Ten Oxherding Songs" were the version by the 11th century Ch'an master, P'u-ming, which was most popular in China, and that by Kuo-an (ca. 1150), most popular in Japan. One of the earliest Japanese printed editions of Kuo-an's version "may date from about 1325" (*ibid.,* p. 116).

5. Fontein and Hickman have suggested that if this painting and the more recently discovered one now in the collection of the Asian Art Museum of San Francisco form a pair, they may represent specific stages of the "Ten Oxherding Songs": the fifth, the "Herding of the Ox," and the fourth, the "Catching of the Ox," respectively (*ibid.,* p. 104). However, Yonezawa Yoshio, in his brief article in *Kokka,* no. 802, has noted numerous discrepancies between the two paintings, including their seals, which tend to refute the idea that they form a pair. It seems reasonable, therefore, to consider these paintings apart from any specific connection with illustrations of the "Ten Oxherding Songs."

6. Ex-collection Kumita, ink on paper, hanging scroll, 47.8 x 23.2 cm, published in *Kokka,* no. 802.

7. The name Chang Fang-ju is not found in Chinese literary sources. The earliest record of Chang Fang-ju's work in Japan is in the *Satsujōshū* (1446). He is also recorded in the late 15th century *Kundaikan Sayū Chōki* as a painter of the highest class who did ink paintings of landscapes, human figures, and oxen; in *Gunsho Ruijū,* 19:649. For an explanation of the *Kundaikan,* see cat. no. 29, n. 13.

8. Yin-t'o-lo is presumed to have been a native of India who was active as a painter in China during the second half of the 14th century. A Ch'an monk who had some connection with the Chinese Ch'an teacher Ch'u-shih Fan-chi, he seems to have first settled in the Chiang-nan area; later he was appointed abbot of Hsiang-fang Yu-kuo-ssu in Pien-liang in the north. Most of his works are figure paintings. A group of narrative paintings depicting famous Ch'an teachers and their encounters with other clerics or lay disciples, probably cut from handscrolls, have compositional features in common with Chang Fang-ju's oxherding pictures in terms of the framing function of a tree motif. In Yin-t'o-lo's work, the tree functions to separate one scene of the continuous handscroll from the next. Another example of this compositional device in Yin-t'o-lo's work is seen in his Pu-tai in the Nezu Museum, published in *Tōsō Genmin Meiga Taikan* (1929), p. 205.

9. Kano copy. Tōkyō National Museum catalogue no. 5384.

10. Published in Tanaka Ichimatsu, ed., *Ka'ō, Moku'an, Minchō,* pl. 104.

11. Yonezawa discusses in detail the contrast between the Burke and Kumita (now Asian Art Museum) versions, "Sekkyakushi hitsu Bokudō-zu."

12. Document accompanying *Ox and Herdsman,* written and signed by Kano Einō (1634–1700), "Painting of boy and bull I have examined. It is the authentic work of the painter, Kan Densu. He was a disciple of Minchō, and his sobriquet was Sekkyakushi. This seal is on the painting. The brush strength is pure and wonderful. A valuable work. The above by Ichiyōsai Kano Einō [flower signature], the twenty-fifth day of the eighth month [incomplete cyclical date]." Kano Einō's opinion is also cited in *Koga Bikō,* pp. 545–46.

13. *Ibid.* See also *Koga Bikō,* p. 2088, under Reisai, where Sekkyakushi is given as a sobriquet for Reisai. Watanabe Hajime's article on Reisai in *Bijutsu Kenkyū* includes quotations of traditional biographical accounts of Sekkyakushi and Minchō as well as Reisai, since the identities of the painters were often confused.

Bukan AND *Kanzan and Jittoku*
Reisai (fl. mid-15th century)

Pair of hanging scrolls, ink and color on paper, Bukan *96.4 x 34.55 cm,* Kanzan and Jittoku *96.35 x 34.55 cm.*
Mary and Jackson Burke Collection

This striking pair of hanging scrolls portrays three legendary Zen sages: Kanzan (Han-shan) and Jittoku (Shih-te) on the left, and Bukan (Feng-kan) with his companion, a sleeping tiger, on the right. The paintings are in excellent condition, except for horizontal cracking in the lower third of the scrolls and some evidence of repairs along the edges. They are mounted with borders of silk decorated with a repeated tiger motif. The two paintings are similarly composed. In each, a large triangular rock in the foreground is delineated in broad blunt contour lines and extremely dark ink wash. A stark, flat plateau with sparse bamboo and dotted moss extends behind, ending just beyond the figures. In the left painting, Kanzan and Jittoku stand at the edge of the precipice, gesturing toward the void beyond. In the other, Bukan sits upon a wide, flat rock, facing the abyss, while his tiger sleeps placidly by his side. The color scheme is simple, restricted mainly to the deep brown of Bukan's robe and the flesh tones of the figures. The effect of other coloration is achieved through the tonal variation of ink. The most remarkable feature of these paintings is the vast open space above and beyond the figures, which occupies a far greater proportion of the composition than the figures themselves and makes the paintings unique among the many extant versions of this popular subject. Thick clouds arise from the unfathomable depths of the chasm before the figures, spreading their vapors through the boundless void. The painter has succeeded in one of the most difficult problems in painting: to render visible the intangible quality of deep and infinite space.

Kanzan, Jittoku, and Bukan are legendary figures frequently depicted by Ch'an and Zen painters. Kanzan (Han-shan) is believed to have been a recluse in the Mount T'ien-t'ai region of China, and to have written an anthology of poems entitled *Han-shan Shih* (*Poems of Cold Mountain*).[1] The preface to this anthology provides the only biographical account of Kanzan, but it is not sufficiently detailed to allow an exact identification of the poet or his dates of activity. Jittoku (Shih-te) was said to have been found by Bukan (Feng-kan) as a child, and to have been brought up in the Kuo-ch'ing-ssu monastery. Kanzan is said to have visited this same monastery periodically to obtain food from Jittoku, who worked in the kitchen and is therefore usually depicted holding a broom. The three eccentric sages are listed in the eleventh century *Record of the Transmission of the Lamp* (*Keitoku Dentōroku* in Japanese, *Ching-tê Ch'uan-têng Lu* in Chinese) as among those "who reached the gate of Ch'an but were not prominently known then."[2] In Ch'an and Zen pictorial tradition, these sages appear frequently in paintings dating from the Sung period on — Kanzan and Jittoku often appear together, either in the same painting or in pairs of hanging scrolls. Bukan and his tiger are often treated as a separate subject. Occasionally the three sages and the tiger appear together in one painting as *The Four Sleepers*. The best-known example of this subject is the version by Moku'an Rei'en (fl. 1323; d. 1345), a Japanese Zen monk-painter who died in China (fig. 4).

The figures in the pair of hanging scrolls exhibited here derive from the style of the Chinese painter Liang K'ai[3] (fl. early thirteenth century), a member of the Imperial Painting Academy whose repertoire included Ch'an figure subjects. Only a few of Liang K'ai's original works survive, but numerous close copies by Japanese painters of the Kano school provide additional evidence of the probable range of his styles. One such copy of a work no longer extant depicts Han-shan and Shih-te standing together on a sloping bank (fig. 29). One, probably Shih-te, has his back to the viewer, while the other points into the distance, beyond the edge of the painting. The setting is extremely simple, consisting of a sloping bank in light ink wash with sparse foliage indicated in a sharp and abbreviated manner, and a tree which leans outward at the edge of the painting format, with its branches reappearing overhead. This conventional use of the large tree at the edge of the format has been noted in the discussion of the works of Chang Fang-ju, whose paintings served as the model for Sekkyakushi's *Ox and Herdsman* (see cat. no. 4). The close correspondence between the Kano copy of a work attributed to Liang K'ai and the left hanging scroll of this pair, especially in the attitude, costume, and facial features of the figures, strongly suggests that the model for this painting must have been Liang K'ai.

However, when *Kanzan and Jittoku* is closely compared to the prototype by Liang K'ai, it is possible to recognize the distinctive characteristics that identify its artist. In the figures, for example, contour lines are far more extensively used than in the Chinese painting, which depends more heavily on ink wash. The contour lines in *Kanzan and Jittoku* are sharp and clear, with acute turns and emphatic changes of pressure. The swift and assured, but highly stylized line succeeeds at once in rendering the fullness and volume of the figures and in producing a lively, visually exciting abstract pattern. This quality of abstraction is still more evident in the

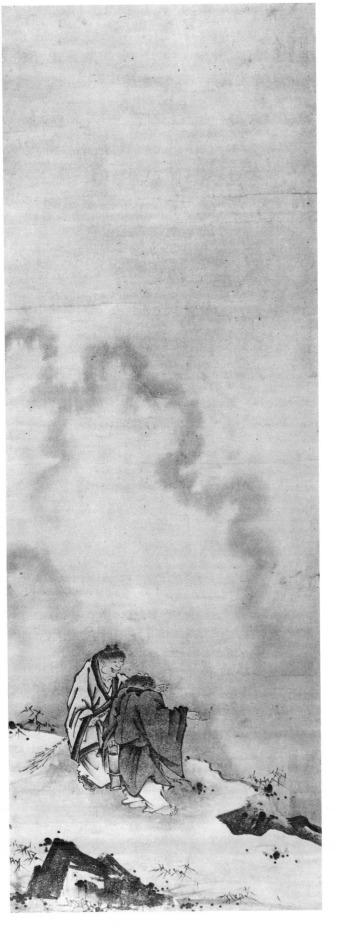
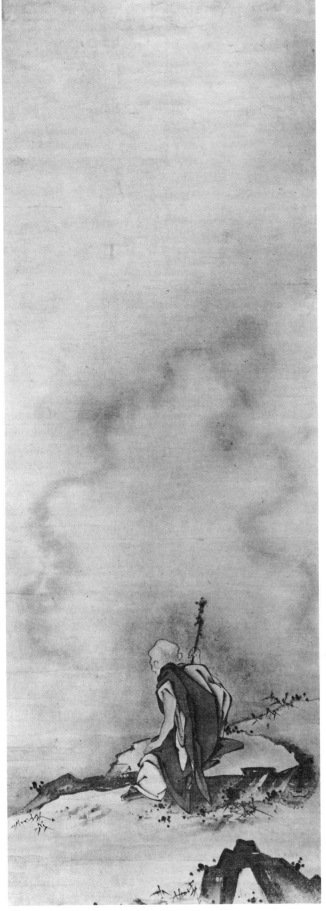

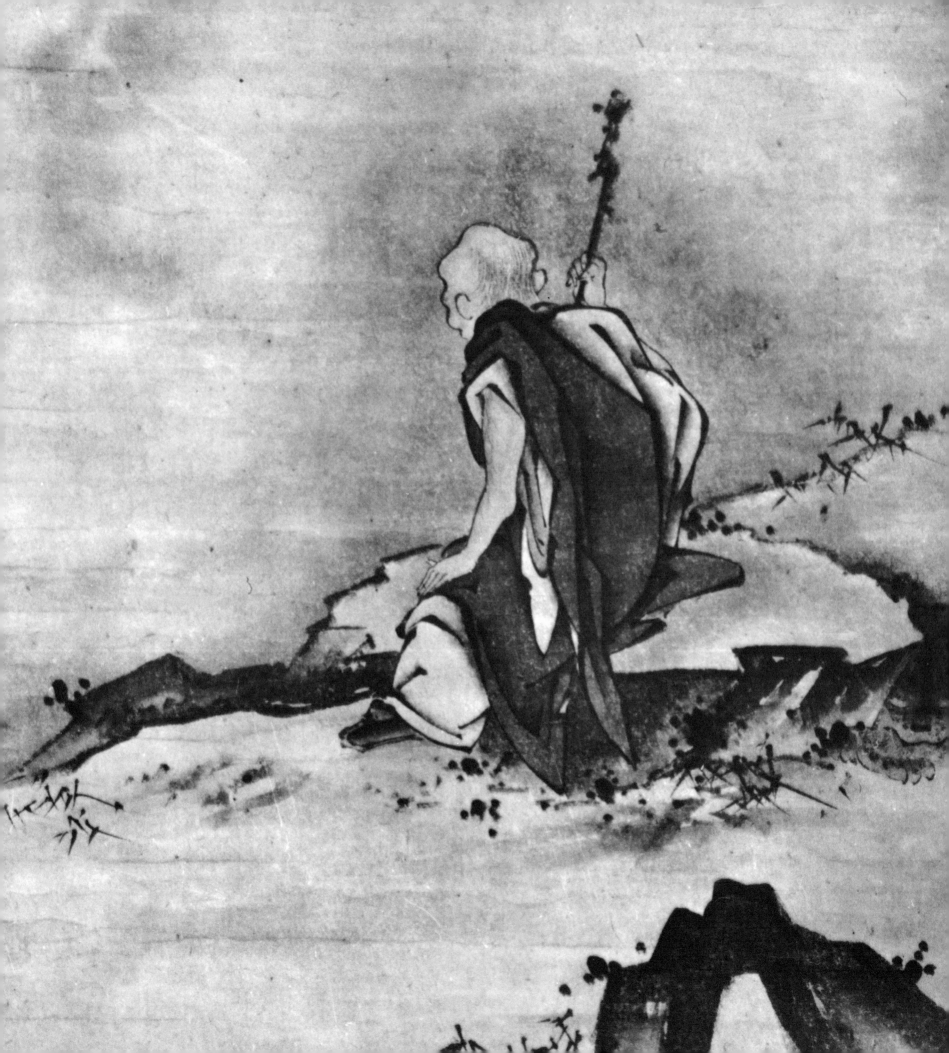

Figure 29. *Han-shan and Shih-te*,
Kano copy of a painting by
Liang K'ai (fl. early 13th
century). Tōkyō National
Museum

Detail of
catalogue number 5,
Bukan

boldly rendered rocks — drawn in heavy, blunt contour lines and broad, flat washes.

The particular attention to the graphic qualities of line and pattern observed in *Kanzan and Jittoku* and *Bukan* is the definitive characteristic of the style of Reisai, to whom these paintings, though lacking their original seal and signature, are now attributed.[4] The peculiarly stylized draftsmanship typical of Reisai's work can best be seen in the *Three Vinegar Tasters* of the Umezawa Collection,[5] both in the decorative, wavy patterns of the robes and in the contorted faces which are the focal point of the composition. Another fine example of Reisai's painting is the *Monju (Mañjuśri)* in the Tōkyō National Museum;[6] here the lines of the costume form zigzag curves and radiating patterns that sweep boldly over the lion, whose fur has been conceived as a fantastic surface design scarcely suggesting the form of the animal it represents.

In all of Reisai's work, a bold conception of overall composition and a careful choice and control of technical means create figure paintings in which the aesthetic qualities of linear pattern and rhythm and of abstract shapes and tonal contrasts take precedence over the definition of physical form. Rocks, as seen in *Kanzan and Jittoku* and *Bukan,* as well as in the *Kanzan* of the Daitōkyū Kinen Bunko Collection,[7] are virtually flat, geometric forms, suggesting depth only by the juxtaposition of light and dark areas. The facial features of Reisai's figures are also peculiarly formalized, as seen in the contours of Bukan's head and of his left ear, which is rendered by a single stroke in the shape of a reversed letter "C," or in Kanzan's face — composed of a few brush strokes that would not indicate their function if taken out of context. The abstraction that is typical of Reisai's work is clearly a deliberate artistic choice, motivated by his concern for the graphic presentation of the subject, rather than by an insufficiency of understanding of physical form. The figure of Bukan shows particularly well the artist's clear conception of the body beneath the billowing robes, and the foreshortening of the arm is accomplished with a grace and skill rarely seen in Japanese painting.

The identity of Reisai, like that of Sekkyakushi (see cat. no. 4), seems to have been obscured soon after his death. Watanabe Hajime, in his study of Reisai, suggests that one reason must have been the preeminence of Minchō among the painters associated with the Tōfuku-ji.[8] Because of the lack of reliable biographical data, Reisai's seal was once considered to belong to

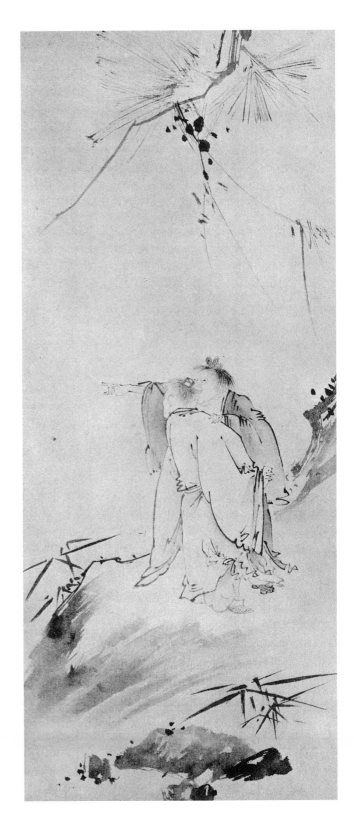

Minchō, as that of Sekkyakushi was thought to belong to Reisai.[9] A single historical record of Reisai surviving from his own lifetime provides one secure date for his period of activity. In the *Richō Jitsuroku* (*True Record of the Yi Dynasty*),[10] which is a chronicle of the Yi dynasty in Korea, the entry dated 1463 names Reisai as a member of a mission from Japan sponsored by Shibukawa Noritada, Governor General of Kyūshū. Reisai is said to have presented a painting of a *White-Robed Kannon* on this occasion.[11] He may thus be assumed to have been active as a painter in 1463. Another possible indication of Reisai's period of activity as a painter comes from the inscription on the back of the *Shaka Nehan* (*Nirvana of Śākyamuni* in the collection of the Daizōkyō-ji, which states that the painting was executed by Reisai in 1435.[12] Although this inscription is dated 1821 and must therefore be viewed with caution, neither its attribution of the work to Reisai nor the alleged date of execution can be conclusively rejected on the basis of the evidence of the painting itself, which is stylistically close to Reisai's works and datable by comparison with other works of the same subject to the third or fourth decades of the fifteenth century.[13] Even apart from its late inscription, the Daizōkyō-ji *Nirvana* seems provisionally acceptable on the basis of internal evidence as an early work of Reisai, and suggests that he was painting at least by the fourth decade of the fifteenth century. Taken together with the more explicit and reliable reference in the *Richō Jitsuroku*, the *Nirvana* painting suggests that Reisai's period of activity spanned the middle of the fifteenth century, at least from the 1430's to 1463. His participation in the mission to Korea leaves open the possibility of some Korean elements in his work, as has been suggested by Etō Shun in his brief article on the pair of paintings in this exhibition.[14]

The range of subject matter, and to some extent the style, of Reisai's paintings, confirm his traditional association with the Tōfuku-ji atelier as a follower of Minchō and near-contemporary of Sekkyakushi. Figure paintings of Buddhist and other subjects by Minchō and his followers, Reisai and Sekkyakushi, reflect on the one hand their study and interpretation of available Chinese models, and on the other, their conservative maintenance of compositional formulae established by fourteenth century Japanese Zen monk-painters such as Ka'ō and Moku'an. A conspicuous characteristic of fourteenth century Japanese figure painting is the extreme simplification of the landscape setting, which is often confined to one side of the composition as in Ka'ō's *Kensu* (fig. 32). Landscape elements are not logically related in space, but are placed vertically, and are seen in one plane parallel to the painting surface. This compositional formula is seen most clearly in Reisai's *Kanzan* (Daitōkyū Kinen Bunko collection), and in Sekkyakushi's *Ox and Herdsman* paintings (cat. no. 4). Another element of fourteenth century figure painting maintained by Reisai is the large, simply delineated rock used to articulate space in the foreground. This device, which appears in *Kanzan and Jittoku* and *Bukan* as well as in the other *Kanzan*, derives from such works as Moku'an's *Four Sleepers* (fig. 4).

Japanese figure painting during the fifteenth century, in contrast to landscape painting which was concurrently developing and diversifying in response to fresh stimuli, remained relatively conservative and faithful to established traditions. Nevertheless, in *Kanzan and Jittoku* and *Bukan*, Reisai has made certain innovations which parallel the progressive trends in landscape painting of his time. In particular, his conceptual emphasis of space above, below, and beyond the figures, achieved through the placement of the figures facing into the painting and his highly effective use of soft, spreading ink wash to render the clouds that seem to spread into the void, creates a sense of dynamic space that seems to expand both laterally and into depth. This sense of infinitely expansive space reaching far beyond the limits of the painting format is the most remarkable feature of the landscapes by Bunsei (fig. 11) and Shōkei Ten'yū (cat. no. 11), two followers of Shūbun whose dates of activity are roughly contemporary with those of Reisai.

Thus, although in some respects he maintains the legacy, held in common with Minchō and Sekkyakushi, of his conservative training as a professional Buddhist painter, Reisai has in this pair of paintings creatively responded to contemporary trends in Japanese landscape painting. In combining his characteristically virtuosic draftsmanship and sense of design with a newly bold and imaginative conception of space, Reisai has given form to a unique vision.

ANN YONEMURA

NOTES

1. Translated into English by Watson, *Cold Mountain*. See also Iriya, *Kanzan.*

2. Shimizu, *Problems of Moku'an Rei'en,* p. 178. The *Record of the Transmission of the Lamp* was written by a Chinese monk, Tao-hsüan, in 1004. It gives the lineage of the Ch'an school of Buddhism, beginning with the seven Buddhas of the past. It contains biographies of 1,701 Indian and Chinese Ch'an masters.

3. Liang K'ai is one of the best-known court painters of the Southern Sung Imperial Painting Academy. He served Emperor Ning-tsung (r. 1195–1224) as a Painter-in-Attendance, and was granted a gold belt which, tradition has it, he hung on the Academy gate and left the Painting Academy. Although he painted a variety of subjects, including landscapes, he won highest fame for his figure paintings of Buddhist and Taoist subjects. Although many of Liang K'ai's paintings show an extreme abbreviation of forms in both linear and washy styles, some excellent examples executed in a relatively realistic detailed manner survive to show the other aspect of his style. His works have been well preserved in Japan. See Sirén, *Chinese Painting,* 1:133–38; Bijutsu Kenkyūjo, Tōkyō, *Ryōkai;* Hsia Wen-yen, *T'u-hui Pao-chien,* chap. 4.

4. In addition to stylistic evidence for the attribution to Reisai discussed briefly by Etō Shun in Shimada, ed., *Zaigai Hihō,* 2: pt. 2:104, Professor Shimada has noted the trace of an effaced seal in the upper right-hand corner of *Kanzan and Jittoku.* This observation has been confirmed by ultraviolet examination. The dimensions of the seal correspond to Reisai's seal, *Kyaku To Jitsu Chi,* which appears on the *Three Vinegar Tasters* and is recorded in the *Koga Bikō,* p. 575. In a parallel position on the painting of *Bukan,* there is a trace of an effaced signature which may possibly have been that of Reisai.

5. Published in *Bijutsu Kenkyū,* no. 87, pl. 2.

6. Published in Tanaka and Yonezawa, *Suibokuga,* pl. 43.

7. Published in Fontein and Hickman, *Zen Painting and Calligraphy,* no. 44.

8. Watanabe, "Reisai," p. 105.

9. See cat. no. 4, n. 13. Watanabe cites all accounts of Reisai known at the time (1939) he wrote his article on this artist, "Reisai," pp. 112–15.

10. Akazawa, "Richō Jitsuroku," *Kokka,* no. 884, p. 30.

11. *Ibid.* Paragraph dated the seventh month (intercalary) of 1463.

12. The inscription on the back of the *Nirvana* painting is quoted by Watanabe, "Reisai," p. 112.

13. Ms. Yanagisawa of the Bijutsu Kenkyūjo, Tōkyō, who is currently researching *Nehan* paintings, has privately expressed the opinion that the Daizōkyō-ji *Nehan* seems likely to have been executed within a decade or so of the date claimed by the inscription, based on its comparison with works of known date. Further corroboration is given by the reference in the same inscription to repairs to the painting done in 1557. According to Ms. Yanagisawa, such repairs are usually required between 100 and 150 years after the execution of the painting.

14. Etō, in Shimada ed., *Zaigai Hihō,* 2: pt. 2: 104.

6 *Kannon* (CENTER), *T'ao Yüan-ming* (RIGHT), AND *Li Po Viewing a Waterfall* (LEFT)

Chū'an Shinkō (fl. mid 15th century)

Triptych of hanging scrolls, ink on silk, each 125.0 x 48.0 cm. Private collection

Kamakura was the thriving focus of Zen culture during the first half of the fourteenth century. Eminent Chinese monks resided in temples such as Kenchō-ji and Engaku-ji, disseminating the most recent Ch'an traditions brought from Southern Sung China. The temple of Engaku-ji formed and recorded one of the early collections of Chinese art, and Kamakura temples provided training grounds for young Japanese monks who aspired to make pilgrimages to the continent. This vigor waned during the second half of the century as the center of the Zen sect shifted to Kyōto. Leading monks were obliged to transfer to the capital: Shun'oku Myōha (1311–1388) and his disciple Gyoku'en Bompō (see cat. no. 34) moved to Kyōto in the late 1370's, followed by Gidō Shūshin (1325–1388) in 1380. With superior economic, social, and cultural resources, Kyōto Zen temples superseded their Kamakura counterparts.

But it was in Kamakura that the harbingers of Japanese ink painting — Moku'an Rei'an, Tesshū Tokusai, Gukei Yū'e — received their formal Zen training, and the city never lost its historical significance. Although Kamakura did not regain its original cultural energy, its monasteries accommodated a small group of painter-monks in the fifteenth century who created an engaging pictorial style differing from the major current in Kyōto. Their school produced paintings which might be called "archaistic" or "revivalistic" in orientation. Chū'an Shinkō, the painter of this Kannon triptych and a monk at Kenchō-ji, provides evidence for the mid-fifteenth century artistic milieu of Kamakura.

The three scrolls composing this set are in remarkably good condition considering their age. Executed in ink on roughly woven silk, they were in several major private collections in Japan before coming to this country.[1] Tradition has it that they originally came from the Seirai-an subtemple of the Kenchō-ji monastery, where the painter Chū'an Shinkō resided.

Kannon, the most benign of all Buddhist deities, occupies the center of the triptych, while a non-Buddhist figure in a landscape setting is depicted in each of the outer scrolls. The combination of a central Buddhist image flanked by paintings of secular figures, animals, birds, or plants was not uncommon during the Muromachi period. The Ashikaga family collection of Chinese paintings, for example, contained sets of three and five scrolls which had landscapes and figures centering around a Kannon or a Shaka. One triptych of particular interest had a waterfall by Ma Lin and figures by Ma Yüan flanking an image of Hotei (Pu-tai).[2]

Kannon is shown here in a special manifestation called the Fudaraka Kannon (Chinese: P'u-t'o-lo-chia; Sanskrit: Potalaka; see cat. no. 2). Encircled by a double halo, the solitary white-robed figure sits on a rock in the midst of a vast ocean, looking down contemplatively at the breaking waves. This is one of the most popular Buddhist themes painted in the Muromachi period, but this example has a quite unusual theatrical quality. The luminosity of the double halo suggests a glowing glass sphere; the diminishing size of the repeated wave pattern moving up the scroll gives a remarkable sense of deep space. In contrast to the surreal spatial recession behind the central image is the tight compression of space in the flanking scrolls. This difference between closed outer compositions and an open central composition heightens the unearthly quality of the religious image.

To the left, a very human Chinese gentleman sits solidly on an embankment under a pine tree growing from an overhanging cliff. He gazes at a waterfall cascading from a mountain behind him. Water laps around his promontory, eroding the earthen bank and billowing into the distance. As in the central Kannon painting, the stylized wave patterns diminish gradually in size from the foreground to the whitecaps near the foot of the waterfall. A growth of young bamboo, lightly silhouetted against vaporous clouds in front of the waterfall, sways over the head of the gentleman's boy attendant. Vines dangling from the downward-thrusting branches of the gnarled pine create a spatial compartment like a canopy to enclose the figure.

The great T'ang poet Li Po (701–762) is identified with poetry he wrote on seeing the magnificent waterfall at Lu-shan (Mount Lu) in Kiangsi province. One short poem well known to any educated Chinese or Japanese describes the grandiose scale of the waterfall — dropping like the Milky Way falling from the vast sky.[3] The subject was painted frequently by Chinese artists, especially by painters of the Southern Sung Painting Academy, and in particular by Ma Yüan.[4] Throughout the Muromachi period Li Po Viewing a Waterfall was a favored theme of both poets and painters in Japanese Gozan communities. One reason for its popularity was the high regard of the Japanese for Li Po's poetry; in addition, many Japanese were familiar with the site of Lu-shan itself through visits made by pilgrim monks. The waterfall was so celebrated that even those who had never been to China knew of its magnificence. In 1374 Gidō Shūshin went to the hot springs in Atami for a

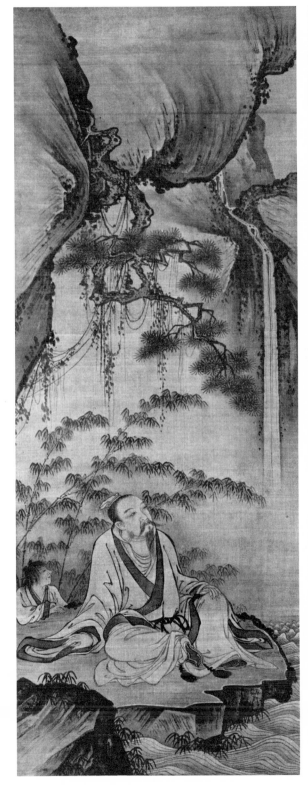
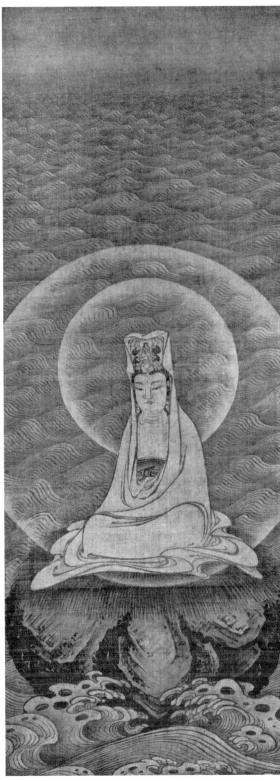
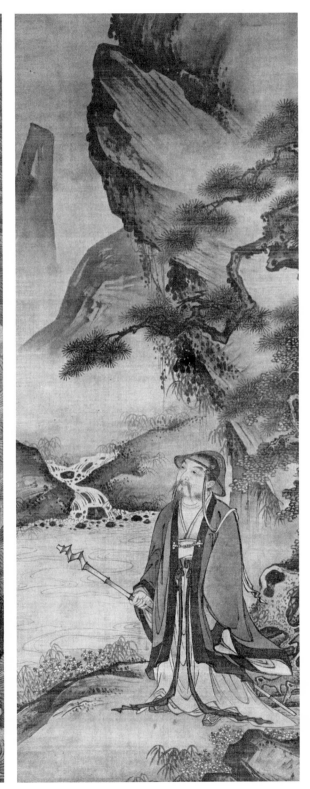

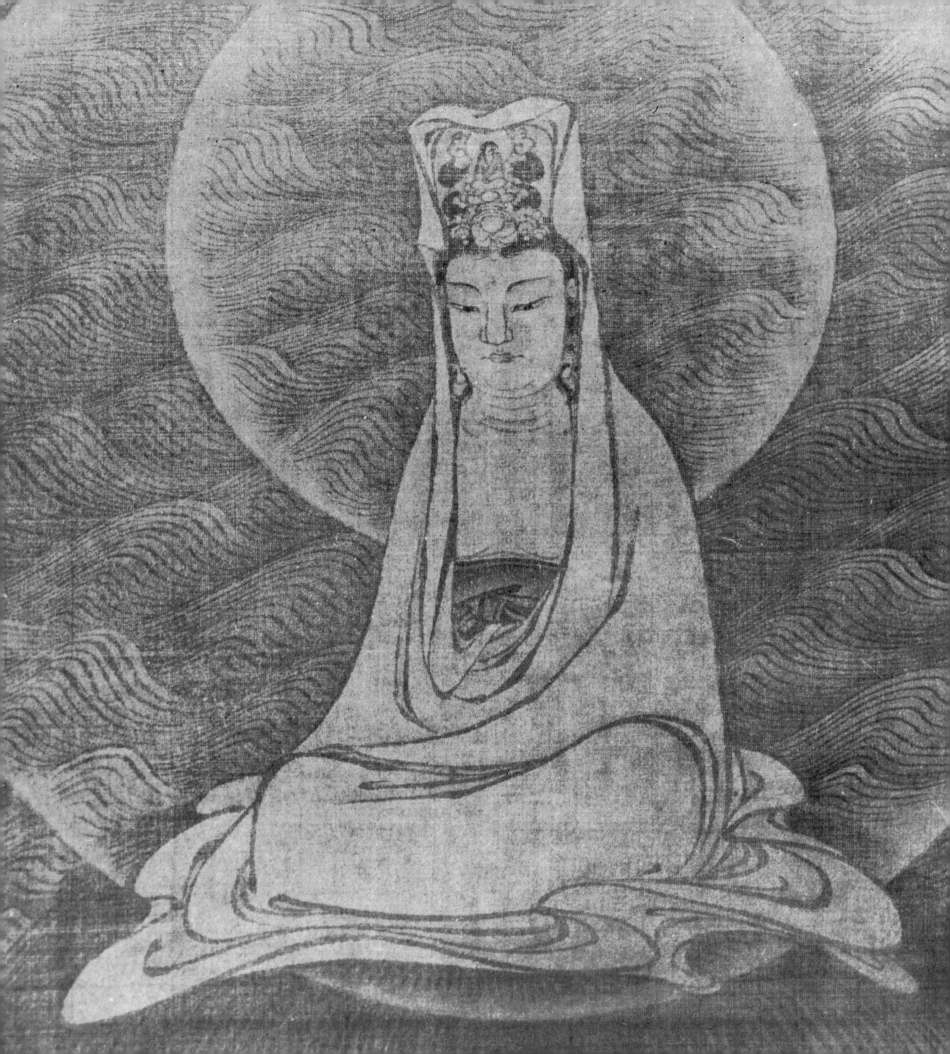

rest, and saw a waterfall; although he had never visited China, he composed a long poem associating the Atami cascades with the Lu-shan waterfall of Li Po's poetry.[5]

The painting on the right depicts a Chinese man who holds a bamboo cane and stands reflectively by flowing water, framed by the outward thrust of a rocky cliff and a few gnarled pine branches. On either side of him, partly screened by the contour of the earthen bank in the middle ground and by a rock peeking into the right foreground, grow clusters of chrysanthemums mingled with ground-hugging bamboo. The round-faced figure wearing the translucent silk cap is T'ao Yüan-ming (365–427), poet and recluse of the Ch'in dynasty. Again the subject relates to poetry written by him. T'ao Yüan-ming is famous for a retired life spent peacefully growing chrysanthemums around his cottage. In a sequence of poems called "Drinking Wine," he describes his mental detachment from the bustling noises of the world of men, picking chrysanthemums and viewing the southern mountains. In another poem, called "Returning Home," T'ao Yüan-ming returns to find his garden bare and desolate save for the thriving pine and the chrysanthemums.[6] This theme, too, was familiar to the Japanese. In his anthology of literary works, Gidō mentions he had seen a handscroll of poetry dealing with paintings of T'ao Yüan-ming and his chrysanthemums.

The flanking scrolls of Li Po and T'ao Yüan-ming must have been conceived as a pair from the beginning, for they create symmetrical brackets around the central Kannon. The somewhat crowded appearance of the composition suggests that the sides have been cut off: there may have been seals of the artist which were removed in remounting.[7] The stylistic consistency of the three scrolls allows them to be seen as a visual unit, and their attribution to Chū'an Shinkō can be justified by their stylistic similarity to a group of paintings carrying the seals of this Kamakura artist. Three paintings in particular are relevant to this triptych: *Three Laughers of Tiger Valley* in the Hosomi Collection, and a pair of paintings in the Kumita Collection entitled *Li Po Viewing a Waterfall* and *Immortals.*[8] Chū'an Shinkō's figures are rather short and strangely proportioned, with large heads and stunted legs. Their baggy robes never seem to fit. His landscape settings tend to be crowded, the closed effect further exaggerated by heavy use of ink washes in dark tones.

Kano Einō's *Honchō Gashi,* the standard seventeenth century biography of Muromachi ink painters, is curiously silent about this artist. A later source, the *Kōchō*

Meiga Shū'i written in the late eighteenth century, gives two separate accounts, but the information is succinct and sufficient.[9] Chū'an Shinkō lived at the subtemple Seirai-an of the Kenchō-ji monastery, and was known as Kō Seidō, or Kō (taken from Shinkō) of the "western hall" (Seidō). This meant he had previously attained the abbacy of a Zen temple accredited and sponsored by the Shōgunal government.[10] The biography is confused about his seals.[11] Perhaps the most important information given in the *Kōchō Meiga Shū'i* is that Kenkō Shōkei (see cat. no. 24) learned painting from Chū'an Shinkō. Since the earliest known date of Kenkō Shōkei's artistic activity is 1478, Chū'an Shinkō's productive period can be placed about the mid-fifteenth century. The *Koga Bikō,* by far the most comprehensive source for biographies of Japanese painters, cites a letter written to a Shintō shrine and signed by Shinkō with a date corresponding to 1452.[12] This is the extent of information about this artist that can be gleaned from written records.

But the existing corpus of paintings connected with Chū'an Shinkō reveals much more: a distinct artistic personality with unique characteristics different from the main style practiced by contemporary artists in Kyōto. Chū'an Shinkō's pictorial vision is not that of Shūbun or Shōkei Ten'yū or Bunsei. Most exceptional are his landscape motifs. Rocks, cliff overhangs, trees, embankments, all are sharply delineated with heavy contour lines. Cliff tops pile one above the other, their edges are rendered in rich dark ink wash and their flat rock faces, like those above the figure of T'ao Yüanming, jut out in relief. A series of parallel texture lines and washes curve from the heavy boundary lines, to contour bulging cliff overhangs such as the one forming a weighty canopy above Li Po. Clearly silhouetted pine needles appear quite flat against light mist. None of these features appears in landscape paintings by Shōkei Ten'yū or in works in the Shūbun style (cat. nos. 10–13).

But they do appear in the landscape motifs of latefourteenth century conservative Buddhist painting. The cliff configuration of the T'ao Yüan-ming scroll and the similar rocks in Chū'an Shinkō's *Three Laughers of Tiger Valley* find an antecedent in one of the Fujita Museum's *Sixteen Rakan* signed by Takuma Eiga[13] (fig. 30). The heavily textured cliff overhang of the Li Po scroll echoes the rock technique used by Eiga in his *Monju* (Mañjuśri) in the Freer Gallery.[14] The pine needles silhouetted above the heads of both Li Po and T'ao Yüan-ming are

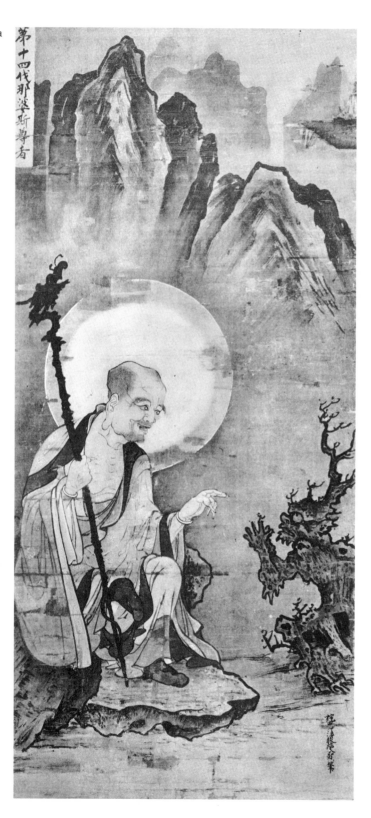

Figure 30. *Rakan*, Takuma Eiga (fl. end 14th century). One of a set of *Sixteen Rakan*, hanging scroll, color on silk, 90.7 x 40.5 cm. Fujita Museum of Art, Ōsaka

seen in another *Rakan* by Takuma Eiga.[15] Without doubt, Chū'an Shinkō was influenced by a pictorial model similar to the one Takuma Eiga followed a half-century earlier. Measured against contemporary stylistic developments in Kyōto, this model must have been considered already obsolete.

Parallels can be found with other paintings of the second half of the fourteenth century. Li Po sits on an eroded embankment with a curious white edge created by an interval between the thin film of ink wash on the horizontal plane and the dark line contouring the vertical edge. This convention of rendering a highlighted edge appears in two paintings by the semi-professional painter-monk Ryōzen, active in the 1360's: the *Nyoirin Kannon* in the Yamamoto Collection and the *Shaka* from the triptych in the Kiyoshi-kojin, Seicho-ji.[16]

Chū'an Shinkō's scrolls provide a glimpse at the stylistic complexity of mid-fifteenth century Japanese ink painting. They reveal a style practiced in Kamakura, by then provincial in relation to the cultural center of Kyōto, and they give an example of what Nakamura Tani'o calls "revivalism" of a conservative style.[17] To the extent that Chū'an Shinkō revived a conservative mode of ink painting in Kamakura, he may be linked stylistically with Isshi (cat. no. 2), who was quite likely a priest-painter of the first quarter of the fifteenth century said to be connected with Kenchō-ji. Parallels can be found in their work. The rather stern face of Chū'an Shinkō's *Kannon* is strongly reminiscent of the facial expression on Isshi's *White-Robed Kannon*. The thoroughly patterned waves which markedly diminish in size to create spatial recession in Chū'an Shinkō's triptych also appear in Isshi's *Kannon,* as well as in one of the *Sixteen Rakan* by Eiga.[18] In the early twentieth century a copy made from the *Li Po* in Chū'an Shinkō's Kannon triptych, forming a pair with a very similar painting of T'ao Yüan-ming, was attributed to Isshi.[19] The series of interweaving stylistic influences outside the capital of Kyōto is only beginning to be analyzed by Japanese art historians.

YOSHIAKI SHIMIZU

NOTES

1. They were in the Kuki, Mori, and Fuku'oka collections.

2. The Ashikaga collection was begun by the third Shōgun, Ashikaga Yoshimitsu (1358–1408), and a catalogue of the collection written by Nō'ami (1397–1471) at the time of the eighth Shōgun, Yoshimasa (1435–70). For a discussion of the catalogue, the *Gyomotsu On'e Mokuroku,* see Tani, *Muromachi Jidai Bijutsu-shi Ron,* pp. 116–42. The *Hotei* triptych is listed on p. 135.

3. Translated into English by Obata, *The Works of Li Po,* p. 133.

4. See Li Ê, *Nan-Sung Yüan-hua Lu* (1721; 1884 edition), *chüan* 7 and 8 on Ma Yüan.

5. Gidō Shūshin, *Kūge Shū,* pp. 727–28. As discussed in the introduction, Gidō was a central figure in Zen Buddhist circles in Kamakura and Kyōto, a disciple of Musō Soseki (1275–1351) and a leader of the Gozan Bungaku movement, which focused on Chinese classics. In addition to the anthology of his literary work (the *Kūge Shū*), his journal, the *Kūge Nikkō Shū,* provides valuable information about both the Zen monasteries and the Ashikaga Shōgunate in the 14th century.

6. English translations of the twenty poems on "Drinking Wine" and the poem on "Returning Home" are found in Chang and Sinclair, *The Poems of T'ao Ch'ien,* pp. 62–69 and 103–5; and in Hightower, *T'ao Ch'ien,* pp. 124–27 and 268–70.

7. Mizu'o Hiroshi, discussing this triptych in *Kokka,* no. 797, mentions that the set had a certificate attributing it to Kenkō Shōkei (fl. after 1478). Mizu'o notes that the truncation of the paintings suggests that the seals of Chū'an Shinkō may have been stamped on it originally, but were later removed so that the set could be called the work of Kenkō Shōkei.

8. The following is a current list of other works attributed to Chū'an Shinkō: *Shaka Descending the Mountain* in the Berlin Museum, published in Nakamura, *Shōkei,* pl. 29; *Hotei* in the Nezu Museum, *ibid.,* pl. 30; *Daruma* in the Masaki Museum; Portrait of *Kao-feng Yüan-miao* in the Freer Gallery, published in Matsushita and Tamamura, *Josetsu, Shūbun, San-Ami,* pl. 132; *Three Laughers of Tiger Valley* in the Hosomi Collection, *ibid.,* pl. 131; *Priest Sewing under Morning Sun* and *Priest Reading in the Moonlight* in the Tōkyō National Museum, *ibid.,* pls. 133–34, and in Fontein and Hickman, *Zen Painting and Calligraphy,* no. 56; *Li Po* and *Immortals* in the Kumita Collection, published in *Kokka,* no. 797; *Mount Fuji* in the Kobayashi Collection, published in Matsushita and Tamamura, *Josetsu, Shūbun, San-Ami,* pl. 129; *Bird* in the Masaki Art Museum, *ibid.,* pl. 130; *Plum* in the Masaki Art Museum, *ibid.,* pl. 25.

9. *Kōchō Meiga Shū'i* by Hiyama Tansai (Gishin; 1774–1842) was first published in 1819 in five chapters. A follow-up to Kano Einō's *Honchō Gashi* (see cat. no. 2, n. 18), it is known also as *Zoku Honchō Gashi,* and includes biographies of 483 painters ranging from Buddhist artists of the 7th century through Kano Einō of the 17th. Tansai was a noted connoisseur of painting and calligraphy, and author of several books on the arts. His comments on Muromachi painters and their works are frequently cited in *Koga Bikō* (see cat. no. 2, n. 18). It is published in Sakazaki, ed., *Nihon Gadan Taikan,* pp. 1235–79, and in Sakazaki, ed., *Nihon Garon Taikan,* 2: 1383–1443. All page references will be to the latter source. Chū'an Shinkō is discussed on pp. 1421, 1423–24.

10. The career pattern of Zen monks within the institutional structure of a Gozan monastery is discussed by Collcutt, "The Zen Monastic Institution in Medieval Japan," chap. 6.

11. Chū'an Shinkō's identity apparently was confused during the Edo period. His personal artistic name was Isoku Dōjin, seen in an oblong relief seal. Existing works such as the *Li Po* and *Immortals* in the Kumita Collection show this seal in combination with a square relief seal, *Chū'an,* and a tripod relief seal, *Shinkō.* The *Isoku Dōjin* seal was connected with an artist of a later date, Ryūkyō (or Shikibu Terutada, see cat. no. 25). Ryūkyō, in turn, was confused with Kenkō Shōkei. To make this confusion worse, Chū'an Shinkō was mixed up with another painter-monk, Chū'an Bonshi, an earlier artist mentioned in the *Honchō Gashi.* The earliest discussion which confronts the problems regarding seals and the painters involved is to be found in the *Bunchō Gadan* (p. 757), a book compiled by Tani Bunchō (1763–1840) ca. 1811. It discussed miscellaneous topics related to Chinese and Japanese painters, books on painting, artists' techniques and tools, sources of subject matter, and so forth. Not all of the discussions are Bunchō's own. The comments on the distinction between Chū'an Bonshi, Chū'an Shinkō, Ryūkyō (Shikibu), and Kenkō Shōkei actually originated from the arguments of Sugawara Dōsai, a close friend of Bunchō.

12. *Koga Bikō,* pp. 795–96.

13. The period of Takuma Eiga's activity is discussed by Tanaka Ichimatsu, "Ebusshi Chōga to Sono Sakuhin" ("The Buddhist Artist Chōga and His Work") in *Nihon Kaigashi Ronshū,* pp. 143–44.

14. Tanaka Ichimatsu, *Ka'ō, Moku'an, Minchō,* pl. 14.

15. *Ibid.,* ref. fig. no. 13 on p. 190.

16. *Ibid.,* pls. 60, 64.

17. Nakamura, *Shōkei,* pp. 11–14.

18. Kanazawa, *Shoki Suibokuga,* pl. 17.

19. Pair of hanging scrolls, ink on paper, 103.1 x 40.2 cm, published in *Bijutsu Shū'ei,* 19 (1912).

The Three Laughers of Tiger Valley
Bunsei (fl. mid-15th century)

Hanging scroll, ink on paper,
56.8 x 31.75 cm.
Square relief seal reading Bunsei.
Collection of Kimiko and John
Powers

By virtue of its authorship, subject matter, and artistic properties, this is one of the most important works of Japanese ink painting in a foreign collection. It has been thoroughly studied by scholars in Japan and widely published in that country and abroad.

The identity of the artist is established by the seal, read as *Bunsei,* in the lower right corner. The same seal appears on five and possibly eight other paintings which, in the absence of other dependable biographical data, provide the evidence on which to base a hypothetical account of the man. Bunsei seems to have been a serious monk-painter active in the 1450's and early 1460's; he belongs to a class of artists who were strongly influenced by Tenshō Shūbun, men such as Shōkei Ten'yū (cat. no. 11), Gaku'ō (figs. 12 and 37), and Oguri Sōtan. Indeed, two of the Bunsei paintings are lyrical essays in the idealized landscape genre perfected by the Shūbun school: the uninscribed landscape in the Museum of Fine Arts, Boston,[1] and an inscribed work in the Masaki Art Museum, Ōsaka (fig. 11).

Monks were often peripatetic and lived in many places, but Bunsei seems to have had strong connections with Daitoku-ji. Two portrait paintings with the Bunsei seal have been preserved there. The first, dated to 1452, depicts the controversial monk Yōsō Sō'i, who was an adversary of Ikkyū Sōjun and became the 27th abbot of the monastery. The other, which portrays a monk of the T'ang period, Yang Ch'i, was inscribed by Yōsō.[2]

The evidence that can be deduced from his paintings further indicates that Bunsei was a relatively prominent artist. The landscape in the Masaki Art Museum (fig. 11), for example, was inscribed by Kanera, a courtier of the prestigious Ichijō family who was serving as Kampaku (Civil Dictator) at the outbreak of the Ōnin rebellion. And in 1457 a samurai from Suruga in eastern Japan commissioned Bunsei to paint a memorial portrait of his late father in the guise of the holy Indian sage Vimalakirti, who had become a popular ideal among the Zen Buddhist laity. This painting is now in the Yamato Bunkakan, Nara.[3]

Finally, there is a mysterious Korean element in the Bunsei material. A small landscape in the National Museum in Seoul bears a *Munch'ong,* or *Bunsei,* seal, and closely resembles two landscapes in the Takano Collection; they too have Bunsei seals and are done in the Korean style.[4] Whether these three works may be attributed to the same artist who painted the six listed above is still an issue. Certainly the relationships between Japanese and Korean Zen establishments were strong until the anti-Buddhist policies of the Yi dynasty took effect.

Shūbun, for example, is recorded as having gone to Korea in 1423 in search of printed Buddhist texts.

The theme depicted here is of great interest for its meaning, which is at once humorous and philosophic. The three men facing one another are known as "The Three Laughers of Tiger Valley" and are familiar to persons with a classical Chinese education: the famous poet T'ao Yüan-ming (ca. 365–417; see cat. no. 6) shown in the center; the important Buddhist theologian Hui-yüan (334–416) standing to the left in a patchwork robe; and to the right Lu Hsiu-ching (ca. 406–477), a leader in the movement to establish Taoism as a formal ecclesiastical system. They are illustrating an allegorical tale in which the monk Hui-yüan is violating one of his most solemn monastic vows. He had long lived as a recluse in a monastery atop Mount Lu on the southern bank of the Yangtze River. Noted for fanatically strict austerities, he had vowed never to reenter the impure secular world, never to cross the Tiger Ravine that marked the outer boundary of the sanctuary. However, according to the allegory, the poet and the Taoist came to visit him, and, after a long convivial evening spent in conversation, the monk accompanied the other two as they began their walk back to their homes. Inadvertently Hui-yüan crossed the Tiger Ravine and went on; when he realized what he had done they all broke out in laughter, for they realized that the spiritual purity of a man is in no way limited by such artificial boundaries.

Another version of this painting, and very similar to it in style and detail, is preserved in the Asano Collection, Tōkyō (fig. 31); that painting, however, has retained what this one has lost, namely the long section of paper above the figures in which inscriptions had been written. The Asano picture was inscribed by a Japanese monk prominent in Gozan literary circles, Moku'un Ryūtaku, and with poems by four foreigners, Koreans or Chinese. The poems stress the fact that the Three Laughers were representatives of Confucianism, Buddhism, and Taoism, the dominant creeds of traditional China. The poems also claim that when Hui-yüan crossed the ravine, they all attained a higher state of insight, for they saw that narrow, orthodox, and legalistic adherence to social rules was an obstacle to wisdom.

Historically, the allegory of the Three Laughers can be traced back to the late T'ang period, to the writings of the eccentric Ch'an Buddhist poet and painter Kuan-hsiu (832–912). The oldest recorded painting of the theme was from the brush of another Ch'an eccentric, Shih-k'o (d. after 975), who painted it on the walls of a mansion that later belonged to the statesman Ou-

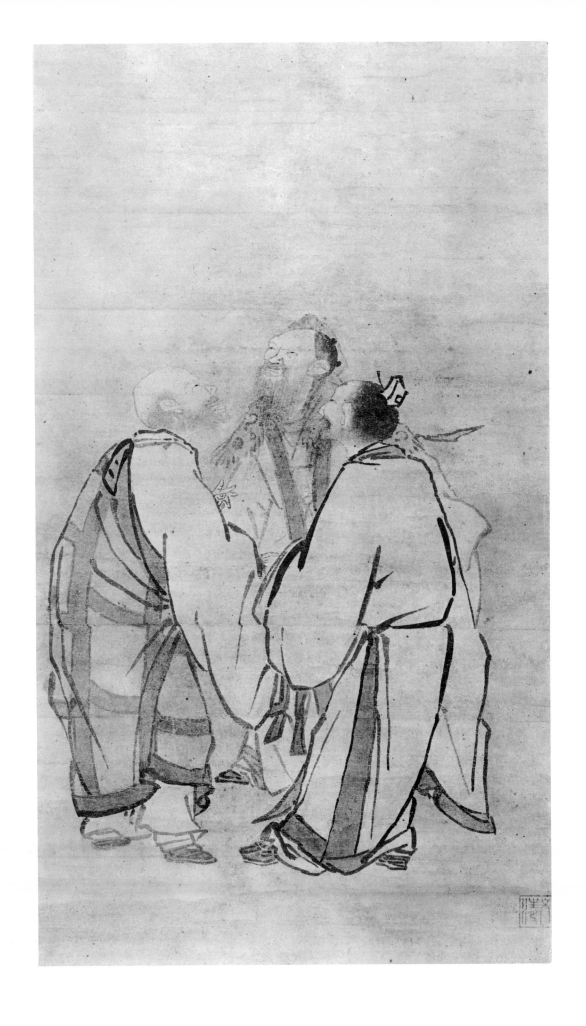

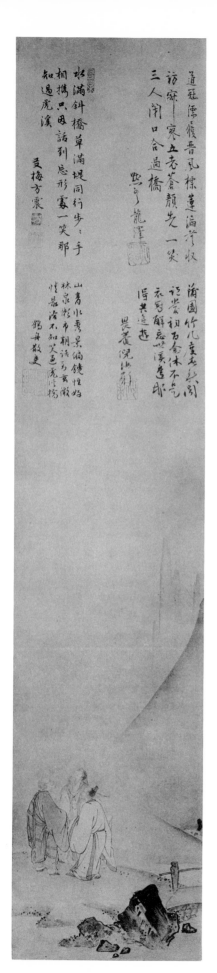

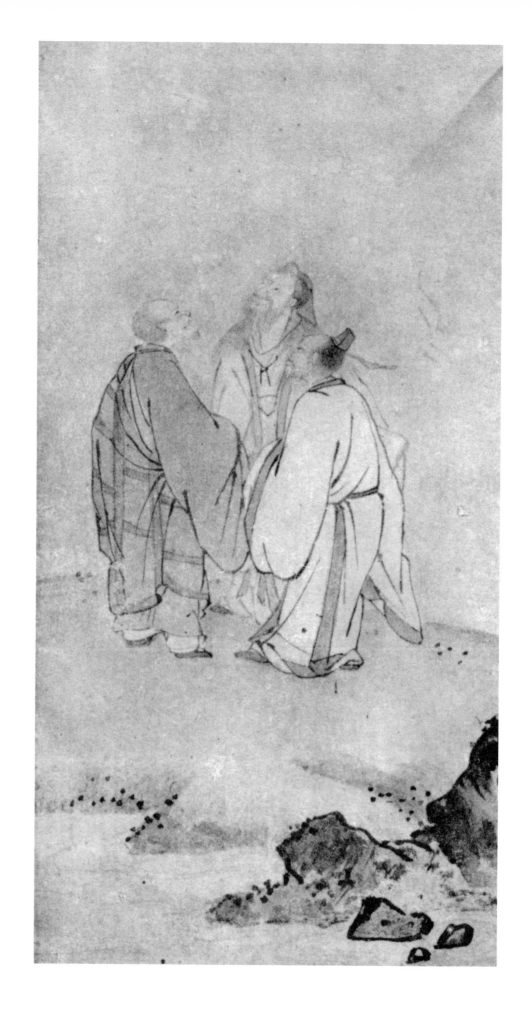

Far left: Figure 31.
The Three Laughers of Tiger Valley,
artist unknown, inscribed by
Moku'un Ryūtaku (d. 1508).
Hanging scroll, ink and light
color on paper, 94.62 x 20.32 cm.
Collection unknown, formerly
Asano Collection, Tōkyō

Left: Detail of figure 31,
The Three Laughers of Tiger Valley

yang Hsiu. This painting was then inscribed in verse by Su Shih (Tung-p'o), and one can find evidence that this was a familiar theme among Northern Sung literati such as Su and his friend Huang T'ing-chien (Shan-ku). There are records of paintings of Southern Sung date, by Ma Yüan for example, now lost, but it is entirely possible that the work by Bunsei exhibited here is the oldest surviving version of the theme; its debt to Southern Sung prototypes, however, is clearly evident. The Bunsei painting originally must have had an inscription, and Mr. Nakamura Tani'o of the Tōkyō National Museum discovered a connoisseur's sketch of the same composition drawn in the 1670's by Kano Tan'yū, on which Tan'yū recorded the inscription.[5] Written by a Tōfuku-ji monk active in the 1460's, Kōshi Ehō,[6] the text explored the question of whether the allegory had any basis in fact, and concluded that it did not.

Paintings of the Three Laughers belong to the symbolic genre which depicts the same men as Tasters of Vinegar, or shows Śākyamuni, Confucius, and Lao Tze as personifications of the Three Creeds. These themes, often painted in Japan in the fifteenth and sixteenth centuries, could express in a straightforward manner the ancient ecumenical ideal of the fundamental unity of China's higher creeds; or, as in the work shown here, they would lightly satirize the subject and demean the persons who symbolized the three creeds. In doing so, they exalt the idea of freedom from orthodoxy, freedom from external constraints on man's spirit; and they anticipate the ideology of the literati movement.

Unlike the other five major Bunsei paintings, the *Three Laughers* has been washed and is somewhat faded; the dark inks have lost some of their intensity. Nonetheless the painting captures the spirit of the subject. The old men are shown slightly off-balance, as though shocked by the impact of their new discovery. The drawing of their bodies is not incisively descriptive or structural but is dissolved into a softly independent play of lines and patterns. Only the carefully painted faces convey the psychological intensity of the moment. The wavering quality of the outlines and the uncertain drawing of the sleeves suggest that this work may have been copied from another. This possibility is reinforced by the Asano painting, which is so close in composition and details of the figures that the two must be linked, most likely by another picture from which both were derived, even though the Asano picture is perhaps two decades later in date.

JOHN M. ROSENFIELD

NOTES

1. *Landscape,* by Bunsei, hanging scroll, ink and light colors on paper, 73.7 x 36.1 cm, Museum of Fine Arts, Boston; published in Matsushita and Tamamura, *Josetsu, Shūbun, San-Ami,* pl. 96.
2. The two portraits are published in *Hihō,* 11 (Daitoku-ji): pls. 15, 60.
3. *Yuima (Vimalakirti),* by Bunsei, dated 1457, hanging scroll, ink on paper, 92.5 x 34.4 cm, Yamato Bunkakan, Nara; published in Tanaka and Yonezawa, *Suibokuga,* pls. 55–56.
4. *Landscape,* by Munch'ong (or Bunsei), hanging scroll, ink and color on paper, 31.27 x 42.55 cm, National Museum of Korea, Seoul; published in McCune, *The Arts of Korea,* pl. 182. The pair of paintings in the Takano Collection is illustrated in Matsushita, *Ink Painting,* trans. by Collcutt, pl. 94.
5. Nakamura, "Bunsei hitsu Kokei Sanshō-zu."
6. See cat. no. 11, n. 6.

Kensu (Hsien-tzŭ)

Yōgetsu (fl. late 15th century)
Inscribed by Yü Ch'eng-hsien

*Hanging scroll, ink on paper,
59.9 x 24.7 cm.
Square intaglio seal of the
painter near left edge of
painting, below inscription; the
two characters are read
Yōgetsu.
Three seals of the inscriber:
upper right of inscription, one
oblong relief seal reading I-lung
I-shê ("a dragon at one time, a
snake at another");[1] two seals
beneath inscriber's signature, one
small four-character intaglio seal
reading Ch'eng-hsien Chi
Ying ("seal of Ch'eng-hsien"),
and one small relief seal reading
Yüan-chang (probably Ch'eng-
hsien's gō, or art name).
Private collection*

The slightly stooped figure of Kensu stands in profile holding a live shrimp in his raised left hand; his gaze is fixed on his catch. The converging lines of the composition reinforce his focus on the shrimp. The smooth curve of the back of the robe is continued by the raised arm, while the vertical axis defined by the front edge of the garment and the edge of the sleeve held back by the right hand parallels the vertical suspension of the shrimp and gives it emphasis. The dignified figure seems totally absorbed in the imminent act of eating his shrimp. His self-contained composure and his isolation from any indication of physical setting intensify intangible qualities of psychological concentration and spiritual vitality.

Above the figure an undated Chinese-style poem, written in Chinese-style calligraphy is signed and sealed by Yü Ch'eng-hsien, who was probably a fifteenth century Chinese or Korean scholar.[2]

> *Zen believers say the origin [of all things] is emptiness.*
> *An enlightened one like you — is there another?*
> *Cold or hot, just one plain robe is enough.*
> *Every day, carrying nets, you accompany fishermen.*

Kensu (Hsien-tzŭ), like Kanzan and Jittoku (see cat. no. 5), is a chiefly legendary character who became a popular subject for Ch'an and Zen painters. The earliest account of this Chinese monk occurs in the *Record of the Transmission of the Lamp* (*Ching-tê Ch'uan-têng-lu* in Chinese, or *Keitoku Dentōroku* in Japanese, A.D. 1004).[3] In this brief biography, Hsien-tzŭ is described as a disciple of Tung-shan Liang-chieh (807–869), one of the founders of the Ts'ao-tung (Sōtō in Japanese) sect of Ch'an. Hsien-tzŭ is said to have had no fixed place of residence or possessions. He spent his days along riverbanks gathering shrimp and clams to eat, and slept among the paper offerings at the White Horse Shrine of Eastern Mountain. Because of his habit of eating shellfish, he came to be known as Hsien-tzŭ (Kensu), or "Clam." This early account of Kensu is simple and brief, and speaks mainly of his catching shrimp for food, a practice usually forbidden for devout Buddhists.

The apparently paradoxical theme of a monk catching shrimp became popular in Ch'an painting from the Sung period on, because it illustrated the concept that the enlightened mind realizes that all phenomena and distinctions are illusory, including the distinction between observing or defying the Buddhist discipline of not killing any living thing. No doubt part of the appeal of this subject for painters was the challenge of depicting the delight of Kensu at the very moment of catching the shrimp. A well-known Southern Sung illustration of the theme is the *Hsien-tzŭ* attributed to Mu-ch'i in the Hinohara Collection.[4]

This painting of Kensu bears a seal of the late fifteenth century Zen monk-painter, Yōgetsu. It belongs to the same tradition as the early fourteenth century *Kensu* by Ka'ō (fig. 32), and derives from a style which the Japanese identified with the thirteenth century Chinese painter, Liang K'ai. Extant paintings by Liang K'ai show several aspects of his painting style, one of which delineates the figure with broad, soft contour lines of medium tonality, with dark ink accents emphasizing the expression of the eyes and mouth. In contrast to Reisai (see cat. no. 5), who follows the more angular, linear style seen in Liang K'ai's *Patriarch Cutting Bamboo*, Yōgetsu follows the manner which is exemplified by the *Han-shan and Shih-te* attributed to Liang K'ai in the Atami Art Museum. A comparable example, closely related in style to this *Han-shan and Shih-te*, is the Pu-tai by Li Ch'üeh,[5] a thirteenth century Ch'an painter who is said to have studied Liang K'ai's works. Yōgetsu follows the Chinese prototypes closely, depicting an isolated figure in a self-contained profile stance by means of soft, broad contour lines and ink washes against a neutral background. Accents of darker ink, while slightly more extensive than in the Chinese models, are still sparingly used.

Nevertheless, despite its essential fidelity to Chinese models, Yōgetsu's *Kensu* shows many indications of the artist's Japanese heritage. Like other fifteenth century painters such as Sekkyakushi and Reisai (cat. nos. 4 and 5), Yōgetsu follows certain conventions established by his Japanese predecessors of the fourteenth century. For example, he renders Kensu's hand holding back the edge of his robe in the peculiar manner used by Ka'ō for the hand holding the fishing net in the latter's version of the same subject.

However, Yōgetsu's Japanese sources are not limited to the direct line of Chinese-inspired Zen figure paintings to which they belong. The extremely simplified but highly expressive facial features of his *Kensu* derive instead from the uniquely Japanese Yamato-e style of painting that had been developed by professional artists under the patronage of the hereditary aristocracy. The rendering of the eye is a crucial point in Zen figure painting. Ka'ō follows closely the conventional manner seen in many Chinese Ch'an paintings of the thirteenth century. Beneath the deeply curved arch of the brow,

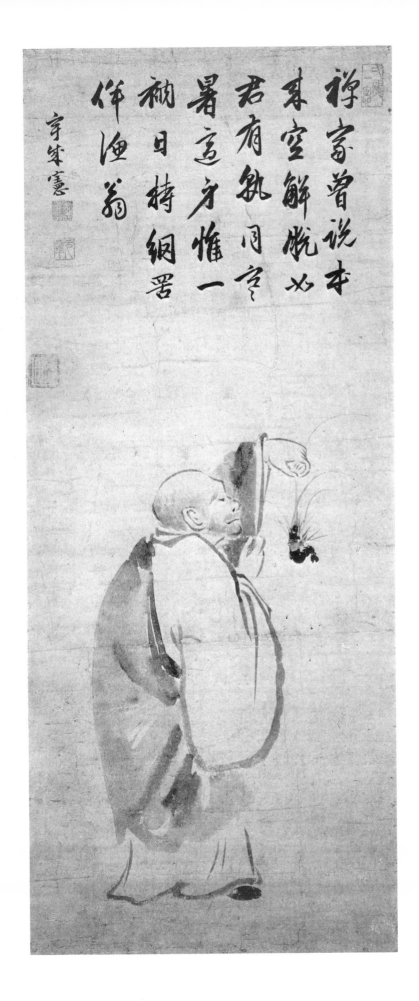

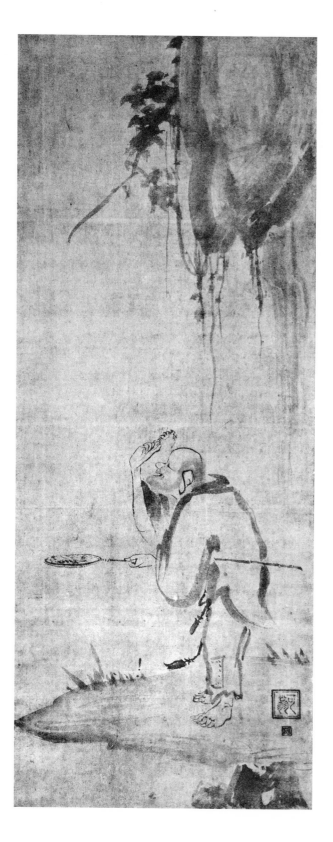

Figure 32. *Kensu* (*Hsien-tzŭ*), Ka'ō (fl. first half 14th century). Hanging scroll, ink on paper, 98.6 x 33.5 cm. Tōkyō National Museum

the iris is rendered in strikingly black ink, with a very fine line representing the eyelid in close contact with it. This technique produces a bright, deep-set eye suggesting acute vision. It is seen full front in the Dōmoto *Chōyō* (fig. 23) and in profile in the *Meguro Daruma* (fig. 26), both attributed to Mu-ch'i. In contrast, Yōgetsu follows the simpler formula of Yamato-e painting, rendering the eye by means of a single brush stroke accented at one end, thereby transforming the incisive spiritual vision of his Zen and Ch'an prototypes to the gentle sensibility characteristic of Yamato-e. Other techniques typical of Yamato-e figure painting are seen in the rendering of the mouth as a single line and in the particular method of delineating the head by means of a modulated ink line of medium tonality. Comparable profiles occur in Yamato-e narrative handscrolls of the fourteenth century.[6]

Another peculiarity of Yōgetsu's *Kensu* is the formal *kesa* worn by the monk over his ordinary robe. According to the inscription on the painting itself, as well as the pictorial tradition of representing Kensu, he should be wearing one plain garment. Ka'ō's *Kensu* is, for example, appropriately attired in simple, rough clothing; there is even a patch on the trousers. The *kesa* seen in Yōgetsu's painting is a garment worn strictly on formal occasions. With the exception of formal *chinsō* portraits and paintings of "Zen meetings" in which the *kesa* is appropriate attire, such a costume is never found on Ch'an monks in Chinese painting, nor does it occur in Zen painting until the end of the fifteenth century. On the screens painted by Motonobu for the Daisen-in in the early sixteenth century, the Zen patriarch Hsiang-yen just as illogically wears a *kesa* as he sweeps bamboo outside his hut (fig. 67). The origin of this strange notion of a monk wearing a formal robe while doing manual labor or digging for smelly shellfish is unknown, but the costume appears with increasing frequency as the sixteenth century progresses.

In purely aesthetic terms, however, Kensu's *kesa* creates a strong visual impact. The gray wash coloring the formal robe continues in an almost unbroken sweep up the monk's back through his upraised arm, setting off the two white areas of his ordinary robe and silhouetting Kensu's expressive profile. Yōgetsu has also transformed the function of the Southern Sung Ch'an artist's use of black ink accents. Whereas thirteenth century Ch'an painters often reserved the blackest touches for the eyes and corners of the mouth, thus effectively emphasizing psychological expression, Yōgetsu uses

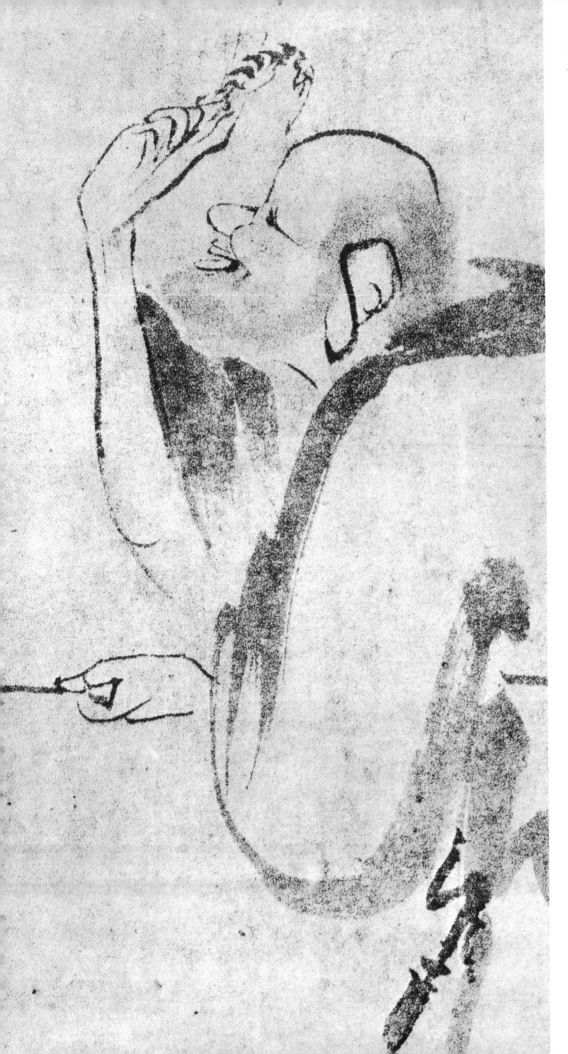

thick ink to highlight the shrimp and even the monk's shoe. The result of these alterations is an image less spiritually penetrating than its Chinese or Japanese prototypes, but which portrays instead the sensitivity of its subject, and manifests a concern for aesthetic qualities in its striking overall design.

Yōgetsu is recorded in the *Honchō Gashi* to have been a native of Satsuma province who lived at the Kasagidera near the southeast corner of Yamashiro province (modern Kyōto prefecture), and who was hence known as "Kasagi Yōgetsu." He is said to have been a follower of Shūbun and Sesshū, the foremost Japanese painters of the fifteenth century. According to this account, Yōgetsu studied Mu-ch'i and was good at painting landscapes, human figures, and birds-and-flowers.[7] One Yōgetsu landscape in the Hirase Collection has an inscription by Son'an Reigen with a date of Bunmei 17 (1485).[8] Yōgetsu's date inferred from this inscription is chronologically in accord with the tradition that he followed Sesshū, but his paintings show little direct influence of Sesshū. However, this landscape as well as a pair of landscape screens in the Umezawa Collection[9] remarkably exhibit features of the style of other late fifteenth century followers of Shūbun.

The works attributed to Yōgetsu include the entire range of subjects mentioned in the *Honchō Gashi.* Moreover, he seems to have been familiar with prototypes by more than one Chinese artist. Some of his figure paintings, particularly his *Hotei,*[10] are executed in a manner characterized by coarser brushwork and a greater use of ink wash, which is very different from that of *Kensu.* It is possible that this aspect of Yōgetsu's style does indeed derive from the expanded notion of Mu-ch'i's style as it was understood in Japan at the time the *Honchō Gashi* was written (1678). The painting of *Hsien-tzŭ* in the Hinohara Collection traditionally attributed to Mu-ch'i, like Yōgetsu's *Hotei,* is a figure in three-quarter view executed in coarse brushwork with some use of wash in the lower garment. Regardless of prototype, however, Yōgetsu's paintings generally have the quality of "soft and moist" brushwork described in his biography.

There is some problem in defining Yōgetsu's corpus because of the existence of more than one style of seal on paintings attributed to him. Best accepted is the four-character seal recorded in the *Honchō Ga'in,*[11] which appears on his *Tenjin Crossing Over to China* and on the pair of paintings, *Melons* and *Bamboo Shoots,* of the Hojuin Collection.[12] The latter pair provides, incidentally, further evidence of Yōgetsu's familiarity with Mu-ch'i

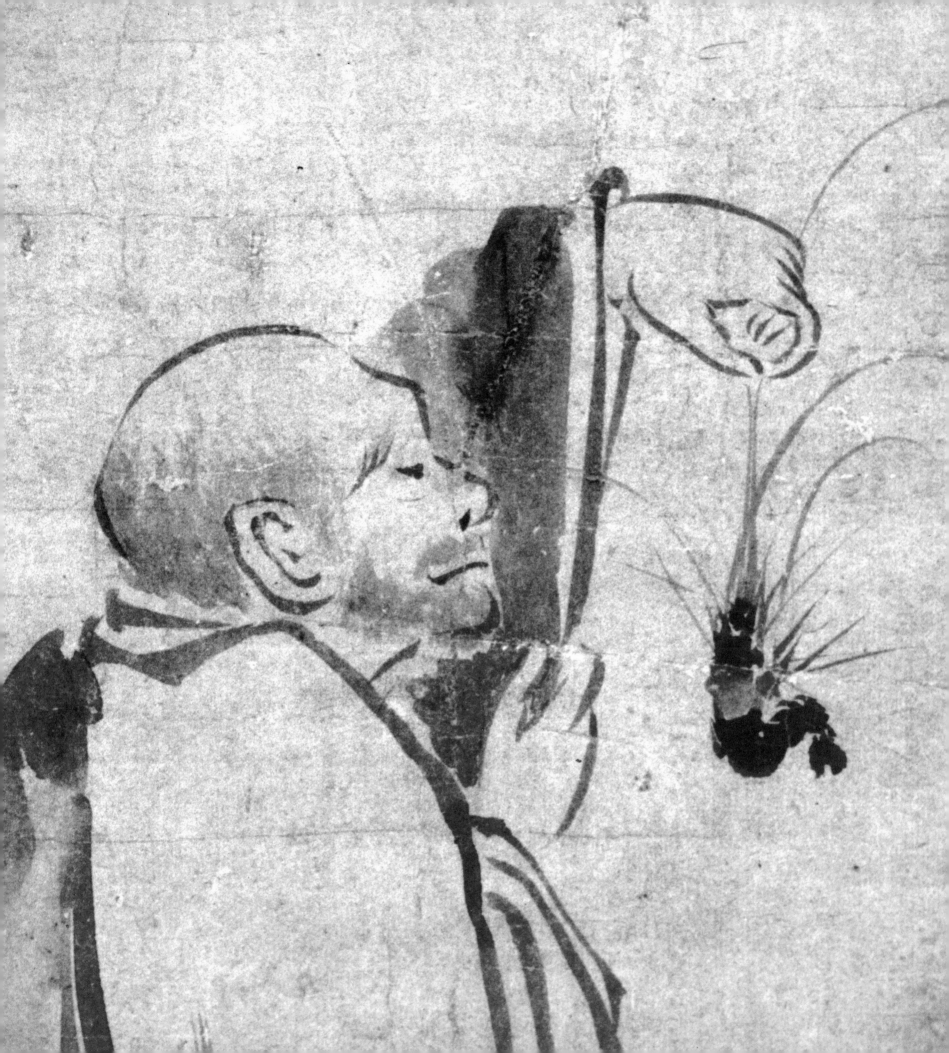

Detail of
catalogue number 8,
Kensu

(see cat. no. 36). *Kensu* displays a different seal, reading *Yōgetsu*, with a white border. The quality of the painting seems, however, sufficiently consistent with the best-accepted attributions to Yōgetsu to permit assigning it to his hand.

Yōgetsu's paintings, including *Kensu*, show several interesting characteristics of the period of activity approximately established by the date of 1485 inscribed on his *Landscape.* One is his retrospective following of the conventions of fourteenth century Japanese figure painting, a conspicuous trait of many late-fifteenth century painters. Another is his knowledge of specific Chinese models, especially those associated with Mu-ch'i, which had not previously exerted notable influence on Japanese artists. It must be assumed, from the evidence reflected in late-fifteenth century Japanese painting, that paintings by Mu-ch'i had recently become available as models, and that they became highly influential to painters at that time. In landscape painting as well as in figure painting, the increased availability of newly imported or previously unknown Chinese models was a crucial factor in the development of Japanese painting of the period.

Knowledge of both their own artistic heritage and of Chinese models by master painters of the Sung and Yüan periods enabled Japanese Zen monk-painters of the late fifteenth century to create works of extraordinary freshness and vitality. Yōgetsu's *Kensu* embodies these qualities and captures the essence of a fleeting moment.

ANN YONEMURA

NOTES

1. A proverb from Chuang-tzu meaning a person sometimes very active like a dragon, at other times quietly secluded like a snake.

2. "Yü" is a common Chinese family name. The calligraphy is that of a 15th century Chinese or Korean following the manner of the famous Chinese calligrapher Chao Méng-fu (1254–1322).

3. Tao-yüan, *Ching-tê Ch'uan-têng-lu, chüan* 17, pp. 140–41.

4. Published in Yonezawa and Nakata, *Shōrai Bijutsu*, pl. 39.

5. Published in Bijutsu Kenkyūjo, *Ryōkai*, pls. 13, 23.

6. See, for example, the fleeing fishermen in the 14th century part of *Ishiyama-dera Engi*, scroll 2, section 7, published in *Nihon Emakimono Zenshū*, 22: pl. 5. In this section of the *Ishiyama-dera Engi*, a Buddhist narrative painting executed in the traditional Japanese Yamato-e style (fig. 1), the profile figures of the fishermen are depicted in the extremely abbreviated but expressive manner favored by painters trained in the Yamato-e tradition.

7. Kano Einō, *Honchō Gashi*, p. 985. Also quoted in *Koga Bikō*, p. 706. A conflicting and less reliable biographical account is given in the late-17th century *Gakō Benran* (see cat. no. 21, n. 15). Here Yōgetsu is mentioned as a monk at Kamakura's Kenchō-ji, who studied the painting of Kenkō Shōkei (cat. no. 24) and whose style resembled that of Kano Motonobu (cat. no. 28). In Sakazaki, ed., *Nihon Garon Taikan*, p. 1097.

8. Published in *Kokka*, no. 164. This landscape was recorded earlier in *Koga Bikō*, p. 707.

9. In the Umezawa Kinenkan Collection, and published in Kyōto National Museum, *Chūsei Shōbyōga*, pl. 17.

10. *Hotei* is published in *Kokka*, no. 213.

11. Kano Einō, *Honchō Ga'in*, p. 1026; and *Koga Bikō*, p. 708.

12. Published in *Higashiyama Suibokugashū. Bamboo Shoots* is in Tanaka and Yonezawa, *Suibokuga*, pl. 117.

Hotei (Pu-tai)

Yamada Dō'an (d. ca. 1573)
Inscription in four lines signed "Tokei Dōjin"

*Hanging scroll, ink on paper,
85.7 x 35.3 cm.
One seal of artist in lower right
corner on bag, oblong relief type
with double border, reading*
Yamada-shi Dō'an.
*Two square seals of inscriber
below signature; upper seal reads*
Jo-tai no In, *lower seal reads*
Jaku-rin.
Collection of Mrs. Milton S. Fox

The subject of this painting is Hotei (Pu-tai), a Ch'an monk of the Later Liang period (d. ca. A.D. 905) who soon after his death became the center of many popular legends. The inscription signed "Tokei Dōjin" at the top of the painting is undated, and the identity of the inscriber and of the owner of the two seals below the signature is not known. The inscription reads:

> Big stomach, gaping garment,
> Treasures gathered deep in the bag's bottom,
> Passing through the sky is another road,
> Do not seek what his fingertip points out. [1]

Below the inscription, which admonishes against seeking enlightenment by conscious effort, Hotei strides forward, stepping unhindered over his staff, while grasping his large bag in one hand. He smiles brightly and points directly upward with his finger. Apart from the placement of the bag and stick, which enhances the sense of depth in the composition, there is no indication of physical setting. This spatial convention, often seen in Ch'an and Zen paintings (see cat. no. 8), is intended to emphasize the intangible spiritual ideal of enlightenment, which is represented in this case somewhat paradoxically by the corpulent monk with his huge bag.

Legends of Hotei (Pu-tai) evolved from the biography of the monk, Ch'i-tz'u, as recorded in the important Chinese hagiology, the *Sung Kao-sêng Chuan* (ca. A.D. 988).[2] According to this source, Ch'i-tz'u simply wandered about speaking incomprehensibly. Like Kensu (Hsien-tzŭ; see cat. no. 8), he is said to have had no fixed abode. Ch'i-tz'u was later nicknamed Pu-tai, which means "Cloth Bag" or "Big Belly," depending upon the interpretation of his punning name. He was believed to have been an incarnation of Maitreya, the bodhisattva who would become the next Buddha in the future.

There was an early belief, based upon a poem thought to have been left by Pu-tai himself, that his image could not be painted because of the non-corporeal nature of his Buddha-body.[3] Nevertheless, the *Sung Kao-sêng Chuan* mentions portraits of Pu-tai made in the Chêkiang region,[4] thus indicating that the making of such portraits had already begun soon after his death. The earliest extant examples date from the Southern Sung period, by which time Pu-tai had become a popular subject among Ch'an painters. By the fourteenth century, legends of Pu-tai had developed to the point of inspiring an extensive biography.[5] Later accretions to the legendary accounts of Pu-tai extended far beyond Ch'an and Zen circles, and the popular cult in both China and Japan gradually affected his portrayal in

painting. Later images increasingly emphasize, often grotesquely, his physical aspect and his symbolic representation of material abundance.

This painting, despite its probable date in the late sixteenth century, belongs to the earlier phase of the evolution of the image of Hotei, in which the spiritual aspect of the subject is strongly expressed. Despite contemporary trends toward a coarser, more materialistic conception of the subject, this artist has evidently chosen his models from the earliest phase of Japanese Zen painting, by monk-painters of the fourteenth century who had followed Chinese models of the Southern Sung and early Yüan periods.

The attitude of Dō'an's *Hotei* is almost identical to that of Hotei in a painting by Moku'an Rei'en (d. 1345; fig. 33), a Japanese Zen monk-painter who spent the latter years of his life in China. Both in stance and in the configuration of the drapery the figures are almost identical, indicating that Dō'an must have been familiar either with Moku'an's paintings or with other paintings or copies based on the same prototypes. There are two major differences between Moku'an's *Hotei* and Dō'an's version. One is the more dynamic quality of Dō'an's painting, in which Hotei strides forward on a diagonal, stepping over the staff lying across his path. The forward movement of Dō'an's figure recalls the active conception of Hotei in a painting by the Sung painter Liang K'ai.[6] The depiction of Hotei walking is relatively unusual, and is a special feature of Dō'an's work.

The other major contrast between Dō'an's *Hotei* and the general model or prototype represented by Moku'an's version is in manner of execution. Moku'an's brushwork is bold, particularly in the draperies, and he uses relatively dark ink tones in delineating the figure. In contrast, Dō'an's touch is light and swift, and the ink tones relatively pale, except for a few dark accents restricted to the eyes, corners of the mouth, sash, stick, and sandals. In this respect, Dō'an's *Hotei* seems to reflect a specific style of painting dating from the Southern Sung period, rather than the Yüan period models followed by Moku'an.

A characteristic feature of certain Southern Sung Ch'an figure paintings, known as *mōryō-ga* (apparition paintings, or in Chinese, *wang liang hua*),[7] is the intense focus on the facial expression and especially on the brightness of the eyes. This is technically accomplished through the contrast between the extremely subdued, pale ink tones used for rendering the figure, and the touches of black ink accents which are strictly limited to the eyes and the corners of the mouth. The viewer's

大肚分偈裸

褒髮靈鏖凉

遶雷别肯路

勾同指尖尋

桃溪道人題

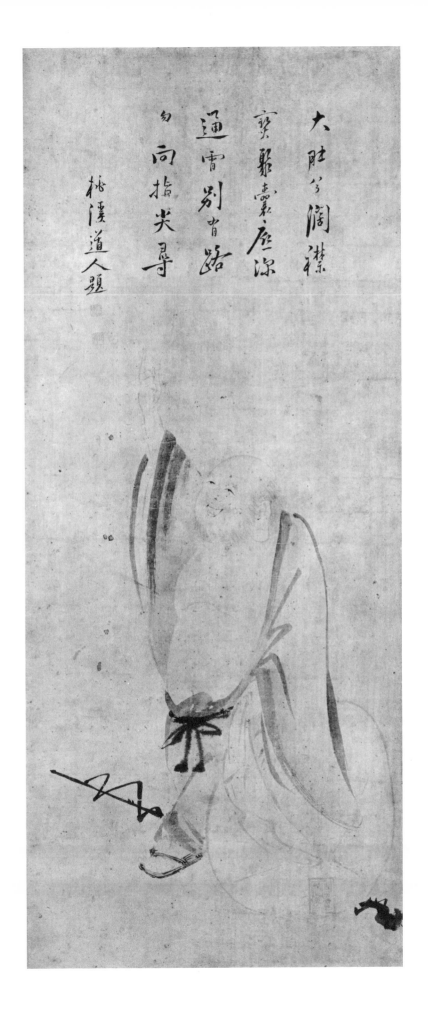

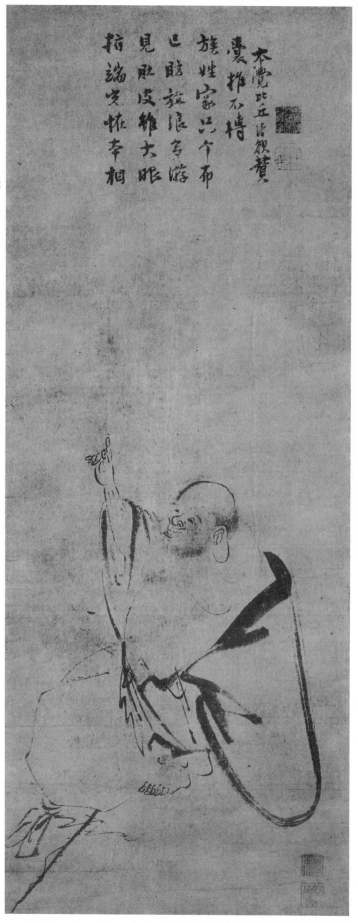

Figure 33. *Hotei (Pu-tai)*, Moku'an Rei'en (fl. 1323, d. 1345). Hanging scroll, ink on paper, 80.3 x 31.3 cm. Atami Art Museum, Atami, Shizu'oka prefecture

attention is thus effectively drawn to the face, and especially to the eyes, which communicate directly, through their intensity, the special awareness of the enlightened mind.

Dō'an's use of these specific techniques reflects a knowledge of Southern Sung apparition paintings which may have been attained through direct study of such paintings or through study of copies. In either case, he has captured in *Hotei* the essential spiritual intensity of paintings of that period, a quality seldom seen in late Muromachi period figure paintings.

In this respect *Hotei* resembles *Rinzai (Lin-chi) Planting a Pine*,[8] the best of the extant figure paintings attributed to Dō'an. Although the method of execution in *Rinzai* is different, reflecting a different model, it has in common with *Hotei* the confident placement of the figure in space and the energetic conception of the subject, as well as the unmistakably similar intensity of focus that appears to be characteristic of Dō'an's style of figure painting.

Identification of the painter known as Dō'an and of a corpus of works attributable to him is complicated by the fact that Japanese painting histories record three painters by that name. Moreover, the extant works bearing one or more of the rectangular or gourd-shaped seals reading *Dō'an* are not consistent in style, and cannot all be attributed to the same hand. The wide range of subject matter and prototypes among paintings bearing Dō'an seals and the differences among the seals themselves further complicate the problem of distinguishing the range of styles attributable to a single hand.

Kano Einō described Dō'an in his *Honchō Gashi* (1678) as follows:

Yamada Dō'an. He was initially known as Minbu; his given name is unknown. Dō'an was his Buddhist name, [which he assumed] after taking the tonsure. For generations his family have been warriors who lived in Fukuzumi Township, located south of Mount Kasuga, in Yamato province. Some say it is a branch of the Tsutsu'i family. Dō'an was naturally good at painting. He followed Shūbun and Sesshū, and also studied Sung painting and used its ideas. His brushwork, however, is rough and abbreviated. Since then three generations of the family have been skilled in painting and used the same seal [of Dō'an]. However, in brush-strength, there are differences of superiority and inferiority among them. Dō'an was also skillful in wood sculpture. There was once a small statue of a monk devised to strike a bell in the Western Buddha Hall of Kōfuku-ji. When the statue was stolen, Dō'an

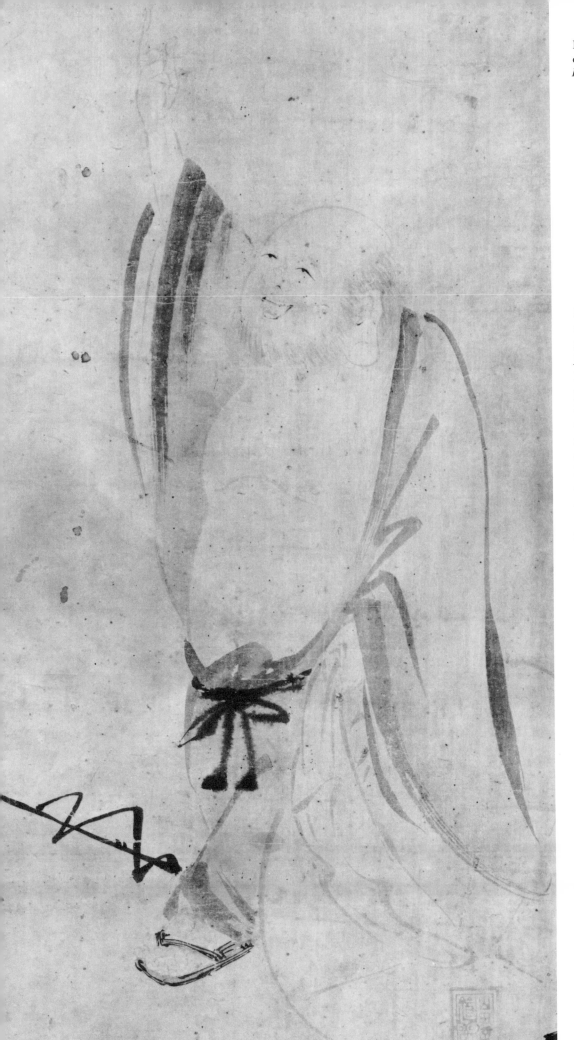

carved a similar one to replace the lost one. It is said that after the head of the Shaka [The Great Buddha] of Tōdai-ji was burnt down by Matsunaga Hisahide [1567], Dō'an contributed funds for recasting it. His wealth and prosperity can be easily imagined from this story. From this we know him as a man of wealth and prosperity, and above all as one who had great merit with respect to Buddhist temples.[9]

Einō's wording leaves some ambiguity about the exact number of Dō'ans who shared the same name, but all subsequent sources mention only three Dō'ans. In the *Fusō Meikō Gafu* [10] (early eighteenth century), Asai Fukyū presents a slightly different biography of the painter, in which he interprets Einō's words, "since then three generations," to include the first Dō'an. To Einō's description, he adds the information that the first Dō'an may be identified as Yamada Junchi, lord of Yuwakake castle in Yamada city, Yamato province. Yamada Junchi held a second-grade position (Taiho) in the Department of Finance (Minbu-shō), and was thus an official of the Lower Junior Fifth Rank. His death date is given as 1573, and Asai comments that Dō'an was good at painting fruits. The second and third Dō'ans are not specifically identified.[11]

A biographical account that clearly distinguishes the generations of Dō'ans is provided in the *Gakō Ryakuden,* quoted in both the *Koga Bikō* [12] and the *Fusō Meiga Den* by Hori Naonori (1806–1880): [13]

During the Bunsei era [1818–1830] there was a Buddhist priest Kakuhō, the abbot of Kōfuku-ji temple, Ushijima, who was a descendant of Dō'an's family. He owned a painting of Shōki [Chung-k'uei] by Junchi, Dō'an III. He said there were three Dō'ans: Junsei, Dō'an I, who painted fruit; Juntei, Dō'an II, who painted human figures — the seal of *Dō'an* and the seal of *Yamada-shi Dō'an* are both of Juntei, Dō'an II; and the third generation is called Junchi, Dō'an III.

Although this account endeavors to clarify the distinction among the generations of Dō'ans by naming three individuals and specifying the subjects at which each excelled, it actually complicates the problem of identifying and distinguishing the painters. For example, Yamada Junchi, whom Kakuhō identified as Dō'an III, is the same name as Yamada Junchi, whom the author of the *Fusō Meikō Gafu* identifies as Yamada Dō'an I of the *Honchō Gashi.* Since the biographies of Yamada Junchi and Dō'an I in the latter two accounts are closely in agreement with respect to dates of activity

and social status of the artist (for example, the nickname "Minbu," mentioned in the *Honchō Gashi*, agrees with the fact that Yamada Junchi held an office in the *Minbushō;* it was a common practice to call officials by an abbreviation for the title of their posts), it seems reasonable to identify Dō'an I as Yamada Junchi and to suppose that Kakuhō's account has confused the order of the generations.

The best of the paintings attributed to Yamada Dō'an, including *Rinzai Planting a Pine*, are usually ascribed to the first Dō'an (Dō'an I), who may further be identified as Yamada Junchi. The probable date of his death (ca. 1513) given by Asai Fukyū places his lifetime in the Sengoku period, the prolonged period of warfare that brought an end to the Muromachi period. Dō'an I was an active patron of Buddhism. Besides the record of his contributions to the restoration of the Great Buddha, there is another which cites his donation of a lantern to the Kasuga Shrine.[14] The exceptional quality of paintings of Zen subjects attributed to Dō'an I, such as *Rinzai* and *Hotei*, seems to reflect his strong interest in Buddhism and his close relationship to local temples, which was unusual for a warrior of that era.

The style of *Hotei* seems to confirm his knowledge of Sung figure painting, and some landscapes[15] bearing Dō'an seals are remarkably close in style to Sesshū's landscapes in the *haboku* (ink-breaking) style, which are in turn based upon the style of the Southern Sung painter Yü-chien. The best of the Dō'an landscapes that appear to refer to Sesshū's *haboku* manner are of outstanding quality among the many later works following Sesshū and Yü-chien. Thus the style of the surviving works attributable to Dō'an I seem to accord well with Kano Einō's description. Moreover, a purely qualitative judgment suggests that *Rinzai Planting a Pine* and the *Hotei* exhibited here are by the same hand, and are likely to be by Dō'an I; their exceptional spiritual expression agrees with the facts of his biography as known from contemporary historical sources. Some of the landscapes bearing Dō'an seals, such as the two cited above, may also be by Dō'an I.

Identifying with certainty the work of the other two Dō'ans mentioned by Kakuhō is difficult. His attribution of the gourd-shaped and rectangular seals with Dō'an II is not convincing. Moreover, it is impossible to accept his classification of works bearing Dō'an seals according to subject, since the styles within each category vary too greatly to be attributable to one hand.

There are, for example, three other published paintings of *Hotei* bearing various seals with the name *Dō'an*. One, in the Powers Collection, has some points in common with a landscape bearing a Dō'an seal.[16] However, in comparison to *Rinzai*, the most securely accepted work of Dō'an I, and to the *Hotei* exhibited here, which is of comparable quality, the expressive and technical quality of the *Hotei* in the Powers Collection is less high. It seems reasonable to accept the judgment of Professors Rosenfield and Shimada[17] that it is probably a seventeenth century painting. Another *Hotei* bearing both oblong and gourd-shaped seals of Dō'an[18] is very loosely rendered, with poor description of form, and is clearly by a third hand.

Still another *Hotei*, recently published as a new accession of the Denver Art Museum,[19] is almost exactly like the *Hotei* exhibited here, both in composition and in manner of execution, but is of lower quality. Certain details, such as the robes around the left hand, are illogically rendered, and strongly suggest that the painting may actually be a copy of the *Hotei* exhibited here. It is significant, too, that the artist of the Denver *Hotei* has altered the composition by dropping the pointing arm, which in the *Hotei* here is essential to the meaning of the painting. In the overall looseness of execution and poor rendering of form the Denver *Hotei* seems to resemble the other *Hotei* bearing both gourd-shaped and rectangular seals. Since the Denver painting seems likely to be a copy of the *Hotei* in this exhibition, which indicates a direct knowledge of this painting, it seems highly probable that the paintings bearing the gourd-shaped seal of Dō'an are by one of the artists described in Japanese painting histories as Dō'an II or III. *Gakō Ryakuden* attributes the gourd-shaped seal to Dō'an II, while Kano Einō's *Honchō Ga'in* lists that seal and the other oblong seal under "Dō'an" without making a distinction.[20] In any case, the gourd-shaped seal does not appear on any painting attributable to Dō'an I.

The *Hotei* exhibited here is of outstanding quality among the figure paintings attributed to Yamada Dō'an, and must be by the hand of the master painter known as Dō'an I. It shows clearly Dō'an's knowledge not only of the techniques but also of the spirit of Southern Sung Ch'an painting, and, no doubt, his familiarity with earlier Japanese masters. The strong religious conviction expressed by Dō'an in this painting is the mark of a contemplative character that stands in contrast to the warfare prevalent in the late Muromachi period.

ANN YONEMURA

NOTES

1. My thanks to Hin-cheung Lovell, Assistant Curator at the Freer Gallery of Art, for her suggestions regarding translation of the last line of this poem.

2. Tsan-ning *et al.*, compilers, *Sung Kao-sêng Chuan, chüan* 21, published in *Dainihon Kōtei Daizōkyō, chi* 5, p. 66. Cited in Shimizu, "Problems of Moku'an Rei'en."

3. The poem is quoted in *ibid.*, p. 172. It is from the 13th century *Wu-teng Hui-yuan.*

4. *Ibid.*, p. 172. Tsan-ning, *Sung Kao-sêng Chuan, chüan* 21.

5. Meng-t'ang T'an-e (fl. 1339–57), *Ming-chou Ting-ying Ta-shih Pu-tai Ho Shang Chuan*, cited in Shimizu, "Problems of Moku'an Rei'en," p. 171.

6. Published in Bijutsu Kenkūjo, *Ryōkai*, pl. 10.

7. For a discussion of apparition painting see Shimada, "Mōryō-ga." For an English summary of Professor Shimada's article and further discussion of the development of apparition painting in the 14th century, see Shimizu, "Problems of Moku'an Rei'en," pp. 250–68.

8. *Rinzai Planting a Pine*, by Yamada Dō'an, hanging scroll, ink and color on paper, 81.3 x 34.2 cm, collection of Tōkyō Geijutsu Daigaku; published in Tanaka and Yonezawa, *Suibo-kuga*, pl. 115.

9. Kano Einō, *Honchō Gashi*, pp. 985–86.

10. *Fusō Meikō Gafu* by Asai Fukyū: among major Japanese painting histories, this collection of biographies of Japanese painters appeared in the early 18th century and is preceded only by Kano Ikkei's (1599–1662) *Tansei Jakubokushū* and Kano Einō's *Honchō Gashi* (1678; see cat. no. 2, n. 18). It includes many more artists than the two preceding works. Not much is known about the author, a man of Kyōto active in the late 17th and early 18th centuries. He is particularly well known to Japanese connoisseurs for his elaborate *Honchō Gaka Inpu*, a large collection of seals of Japanese painters that is unfortunately lost. Fragmental portions of it are cited by a few scholars in the *Koga Bikō*. An abbreviated version of *Fusō Meikō Gafu* is published in Sakazaki, ed., *Nihon Garon Taikan*. A complete edition of it is published by Aimi Kō'u in his *Gei'en Sōsho*, a book which is rather rare today.

11. The Museum of Fine Arts, Boston, owns a fine pair of eggplants and melons which fits into the fruit-and-vegetable category. These paintings bear the oblong relief seal reading *Yamada-shi Dō'an.*

12. *Koga Bikō*, p. 129.

13. *Fusō Meiga Den*, consisting of fifty-three chapters, is the most comprehensive collection of biographies of Japanese painters. Its author, Hori Naonori, was a member of a feudal lord's family in central Japan and lived in Edo (modern Tōkyō), indulging in the study of Japanese literature and history and collecting paintings. His work, with a great contribution made by Kurokawa Harumura, seems to have been finished ca. 1859, but was not published until 1899, when Te-tsugaku Shoin included it as part of *Shiryō Taikan*, edited by Takatō Chūzō. This edition is incomplete, with part of one chapter and all of the last four chapters missing. Yamada Juntei is discussed in chap. 28. The *Gakō Ryakuden* cited by Hori is no longer available.

14. Reported in Wakimoto, "Sengoku no Bujin Gaka, Yamada Dō'an," *Gasetsu*, no. 11, p. 459.

15. See *Kokka*, no. 247, and Tanaka and Nakamura, *Sesshū, Sesson*, pl. 143.

16. Published in *Kokka*, no. 663.

17. *Traditions of Japanese Art*, p. 187.

18. Published in *Kokka*, no. 41.

19. *Archives of Asian Art*, 25 (1971–72): 95, fig. 13.

20. Kano Einō, *Honchō Ga'in*, p. 1029.

Landscape in Shūbun Style
Artist unknown, late 15th century

Hanging scroll, ink and slight colors on paper, 90.1 x 33.6 cm. Square relief seal reading Shūbun, *a later addition. Seattle Art Museum, Eugene Fuller Memorial Collection (49.90)*

A giant boulder and a tall twisting pine dominate the foreground of this painting. Following the angular trunk of the pine, the eye moves to the lofty pinnacles behind it and notes a waterfall plunging from high on the peak to hidden depths below. Seen through the latticework of pine branches and the long branches of the plum tree behind it, a figure crosses a broad bridge to a group of elegant waterside pavilions flanked by bamboo and plum trees. Inside the pavilions other figures read and observe at leisure the lakeland scenery around them. Boats are moored in the distance on the far side of an expanse of water and houses and trees are shrouded in mist below remote towering peaks.

At the top of the painting two large vertical rectangles of patched-in paper are barely visible at left and right, indicating that once there were two or more inscriptions, probably eulogies by Gozan monks. Since the quality of the paper used in the patches is very similar to the adjacent paper, it seems probable that paper from above the original inscriptions was used to fill in the patches. The original condition of the scroll, therefore, was very much different from its present appearance: like many other paintings attributed to Shūbun, it had a markedly vertical format and bore at least two inscriptions. Most likely the inscriptions were removed and the height cut down in order to meet the tastes of collectors in the Edo period (1615–1868), who favored smaller paintings as centerpieces for the *tokonoma* (alcove for displaying prized art objects).

The type of composition seen here is quite commonly found among landscape paintings of the Shūbun school. The main features may be outlined as follows: a tall pine or group of pine trees is featured in the foreground; behind this is placed a vertiginous, pinnacled peak from which a waterfall emerges at a high point, thundering down to undefined depths below; elegant, double-roofed pavilions are often placed in the foreground or middle ground; and the far distance comprises a broad expanse of lakes and mountains. Japanese landscape paintings of this type began to appear soon after the resumption of official relations with China in 1433.[1] The motifs are based on paintings brought from China which the Japanese associated with the Chinese Imperial Painting Academy of the thirteenth and fourteenth centuries. The Japanese eventually developed a concept of the manner of three Chinese artists in particular: Ma Yüan (fl. ca. 1190–1224) and Hsia Kuei (fl. ca. 1180–1230)[2] of the Southern Sung Academy, and their Yüan dynasty follower, Sun Chün-tse (fl. ca. 1300).[3] The Japanese image of these painters was strongly influenced by contemporary fifteenth century Chinese painting executed for the court of the newly established Ming emperor. Nonetheless, Japanese painters and connoisseurs evolved a picture of what they called the Ma-Hsia style.

Influence from the Ma-Hsia style is not as well documented in early literary sources as are other prototypes, such as the Mu-ch'i figure style (see cat. no. 1) or the Yü-chien landscape manner (see cat. no. 14). The *Gyomotsu On'e Mokuroku*, which catalogues selected works from the fifteenth century Ashikaga Shōgunal collection, contains only twelve sets of landscapes among its ninety-odd entries.[4] Of these, two hanging scrolls of landscapes and a handscroll of *Eight Views of Hsiao and Hsiang* are listed by Hsia Kuei (see cat. no. 16), there is a set of four landscapes by Ma Yüan, and a pair of landscapes flanking a painting of the *Three Teachers* by Sun Chün-tse. The earliest reliable literary evidence for the use of a Hsia Kuei painting as a model for a Japanese painter is found in the late fifteenth century writings of the priest Seishū Ryūtō (1434–1498). In meticulous detail, Ryūtō describes a set of screens painted for him in the Hsia Kuei manner by his friend Gei'ami (1431–1485), who was advisor to the Shōgun on artistic matters and thus in close contact with the Ashikaga collection.[5]

Physical evidence of Ma-Hsia models used in painting, however, is unmistakable, and appears quite early in the fifteenth century. Influence from the Chinese Southern Sung academic style can be detected seeping into Japanese painting as the focus shifted from the figure subjects prevalent in the fourteenth century to a new concern with landscape. The earliest Japanese landscape reflecting Southern Sung Academy prototypes is *Kōten En'i* (*Remote Thoughts on an Inlet under Clear Skies*) in the Nezu Museum (fig. 34). The death date of one of the twelve priests who wrote inscriptions on the scroll allows it to be dated before 1419. A rustic hermitage tucked into a rocky cliff and sheltered by an enormous angular pine tree occupies only a small triangular space in the lower left of the painting, with a few distant mountains across the inlet sketched in the upper right. This composition echoes the diagonal emphasis of the so-called one-corner style associated with Ma Yüan and Hsia Kuei. The strongly outlined bending pine with its exposed roots is also a well-known Ma-Hsia motif, but the rather scumbled texturing of the bank and the softly dotted distant hills are not connected with the academic style. The Ma-Hsia type of brushwork is notable for sharply faceted rocks with the "big axe-cut" modeling strokes (called *ta fu p'i ts'un* in Chinese). A Japanese translation

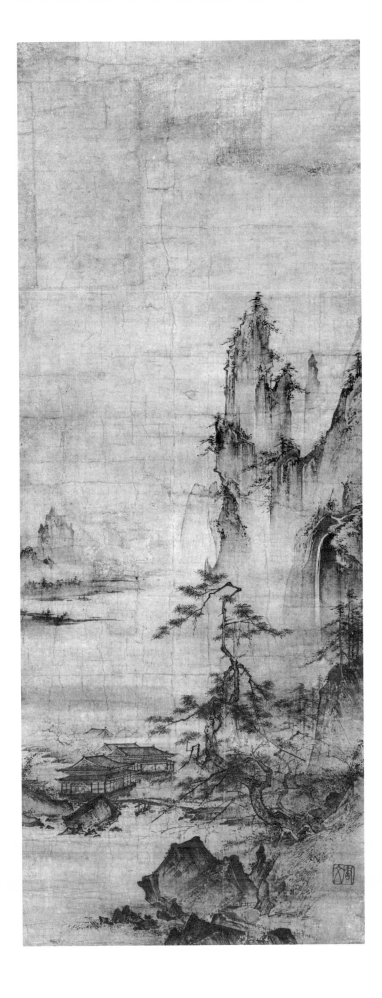

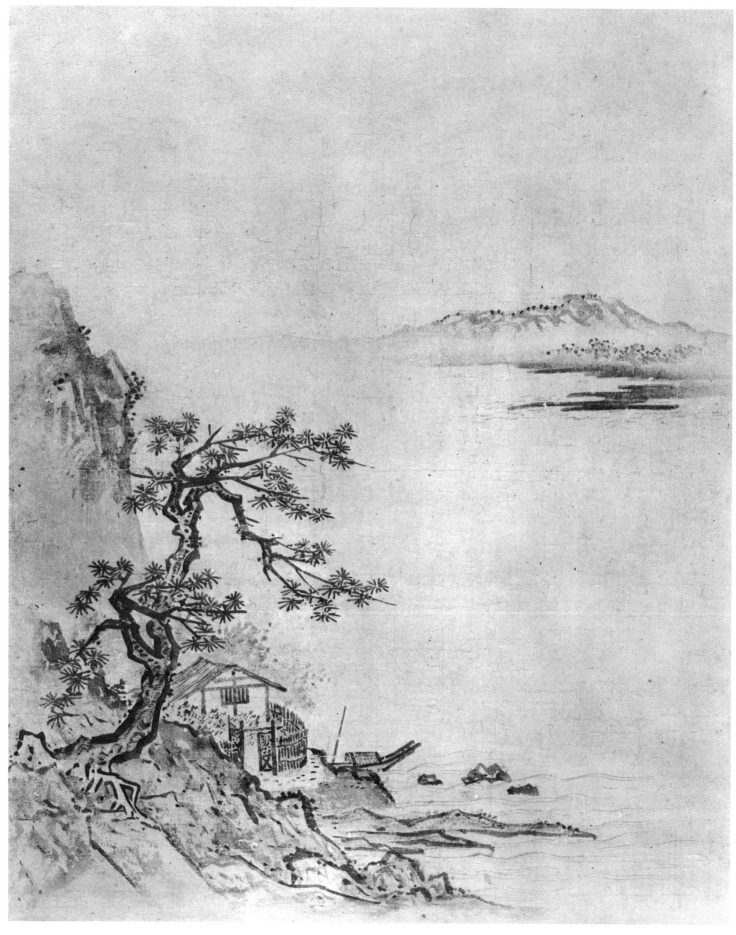

Figure 34. *Kōten En'i* (*Remote Thoughts on an Inlet under Clear Skies*), detail, artist unknown, inscribed by Taigaku Shūsū (d. 1419) and eleven other priests. Hanging scroll, ink and light color on paper, 103.6 x 33.9 cm. Nezu Art Museum, Tōkyō

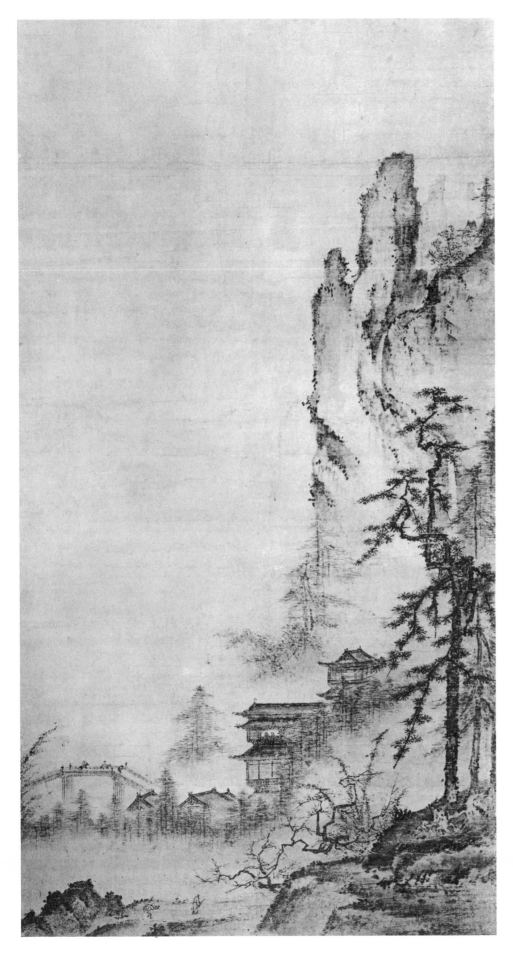

Figure 35. *Landscape*, detail, artist unknown, attributed to Shūbun (fl. 1423–60), inscription by Jiku'un Tōren dated 1455. Hanging scroll, ink on paper, 93.98 x 36.83 cm. Yamamoto Collection, Tōkyō

of this technique is well illustrated by the foreground rocks of the Seattle landscape exhibited here. The earliest extant painting which shows this typical rendering of rocks with axe-cut strokes is *Kōzan Sekiyō* (*Setting Sun over Lake and Mountains*) in the Kosaka Collection, a painting which can be dated ca. 1437.[6]

As the fifteenth century advanced, the use of Ma-Hsia models increased steadily. Direct evidence of the study of Hsia Kuei is found in the work of Sesshū (1420–1506), the artist who dominated painting circles of the last third of the fifteenth century. Among his fan paintings done in the manner of identified Chinese artists, at least four were studies of Hsia Kuei.[7] Many Sesshū paintings attest to very close adherence to such prototypes (see cat. no. 18).

Frequently a sequence of fifteenth century landscapes derives from the same model painting. The *Landscape* in the Seattle Art Museum can be identified with a group of paintings based, more or less directly, on a painting of the Ma-Hsia type which apparently entered Japan in the 1530's.[8] Several known Japanese landscapes reflect this prototype, including the *Landscape* attributed to Shūbun in the Yamamoto Collection, inscribed by Jiku'un Tōren in 1455 (fig. 35), and three paintings by Gaku'ō Zōkyū,[9] one of the few recorded students of Shūbun (see cat. nos. 12 and 13). Certain features of the Seattle *Landscape* compare closely to paintings of this type: the pine trees in the right foreground, the rock spires aligned with the right edge of the scroll, the plummeting waterfall, the motif of solidly constructed pavilions at the base of the mountain. Yet, while the Yamamoto *Landscape* was painted within the probable period of Shūbun's activity (he apparently died ca. 1460), the Seattle *Landscape* was without doubt executed after his time.

The interlocking of foreground rocks and fenced path parallels the kind of closely integrated structure seen in paintings of the latter decades of the fifteenth century — for example, in Sesshū's *Landscape* in the Ōhara Collection (fig. 14) or in the works of Kantei (see cat. nos. 15–17), or even in the paintings of Shūbun's disciple, Gaku'ō (figs. 12 and 37). Foreground rocks jut up from the bottom of the picture frame as in Sesshū, Kantei, or Gaku'ō, and the eye is led zigzag fashion into depth. Extensive overlapping of motifs creates an effect of considerable density: the foreground pine, plum, and bamboo cross one another in a variety of layers over a background of pines, rocks, a bridge, and river banks. Such overlapping is not found in landscapes of the Shūbun school before the late fifteenth century. By con-

97

Detail of catalogue number 10,
Landscape in Shūbun Style

trast, a landscape in typical mid-fifteenth century Shūbun style, such as the one inscribed by Jiku'un Tōren in the Tōkyō National Museum,[10] presents an additive lateral arrangement of motifs. The rocks stand side by side forming a screen; the fenced path winds its way above one set of rocks and beneath another. Seldom is one motif superimposed on another, and there is no tight interlocking of rocks and path.

The brushwork of the Seattle *Landscape* is delicate and sensitive, yet in the main extremely hesitant. The clearest indications of the manner in which the artist was working appear in the handling of the pine branches, where angular turns are weakly executed, accents occur in illogical places, and some of the longer strokes waver. Here we are provided with strong suggestions that the artist was following a particular model very carefully, most probably making a close copy. Other features in the painting appear to be the errors of a copyist. For example, the waterfall emerges from the cliff in a manner which is at some points physically impossible and inconsistent with the logic reflected in the waterfall of the Yamamoto *Landscape* (fig. 35). The faintly visible peak at the lower left of the major pinnacle conflicts violently with the otherwise fairly smooth recession into space seen in the upper left of the painting. The foremost pine of the small pine group beneath the waterfall has a branch which is far too long for the size of the pine. Such errors are commonly found in copies.

In Japan, as in China, the practice of copying paintings was not confined to forgers. Copying works of the great Chinese and Japanese masters was considered part of a fifteenth century painter's training. Some extant works by Kenkō Shōkei (cat. no. 24) demonstrate that painters fortunate enough to have access to the Chinese paintings in the Ashikaga Shōgunal collection would often make close copies as study pieces.[11] Evidence that *bona fide* copies of early fifteenth century paintings were made also exists in Gaku'ō's fairly close copy of a landscape of that period known as *Seizan Haku'un* (*Blue Mountains and White Clouds*).[12] Therefore the Seattle painting, in view of the nature of its brushwork, is very likely a close copy of a given model made as a study piece by a disciple of the Shūbun school.

Other features of the painting suggest that the original on which it was based was a landscape painting of the Shūbun school dating from the mid-fifteenth century. The high horizon line incorporates an extensive view of the waterside landscape in the distance, and indicates that the model was related to the great lake landscapes of the Shūbun tradition. Bunsei (fig. 11) and

Shōkei Ten'yū (cat. no. 11) typify this development, in which extensive scenery is seen in a bird's-eye view. The arrangement and depiction of the rocks, bridge, pavilions, and plum trees emerging from the mist in the middle ground of the Seattle painting provide a virtual reverse image of the passage in the right-hand corner of Shōkei's *Kozan Shōkei* (*Small Scene of Lake and Mountains*) in the Fuji'i Collection (fig. 36). The architecture of the pavilions in the Seattle painting is almost identical to that seen in Shōkei Ten'yū's work and is found in some of Gaku'ō's paintings as well: note the pavilions in his *Landscape* in the Freer (fig. 12). The sprawling plum branches characteristic of Shōkei's work are so closely paralleled in the Seattle *Landscape* that it is tempting to believe that the latter might be a copy of an original Shōkei Ten'yū. There are problems with this notion, however, since the brush style of the rocks in the Seattle work finds no close parallel in the four remaining known landscapes by Shōkei. Perhaps Shōkei and the painter of the original from which the Seattle *Landscape* was copied both drew on the same model painting. The depiction of the scenery in the far distance at the top left of the Seattle painting also parallels developments seen in the work of Shōkei. The division and staggering of the sandbanks and mountains creates an effect of continuous recession into space similar to Shōkei's background scenery. This represents an advance from the more close-knit, less expansive recession seen in the top left corner of *Chikusai Dokusho* (fig. 9).[13] There is thus ample reason to suppose that the Seattle *Landscape* was based on a landscape of the Shūbun school dating from about the middle of the fifteenth century.

What the artist has contributed to his model consists primarily in the tightly interlocked structure of the foreground rocks, the density of the pine, plum, and bamboo section (in contrast to the additive manner seen in the Powers Shōkei Ten'yū, cat. no. 11), and the relative solidity of the rocks, which are seen more in the round than in Shōkei's time. There is, in effect, more interest in and more understanding of the articulation of space and forms than is evident in paintings of the mid-fifteenth century. Together with this comes reduced interest in widening space: there is much less expansiveness in the distant vistas than in the lake landscapes of Shōkei Ten'yū's time. This painting, albeit a copy, is a rare example of an early study piece, and is furthermore the best representative of the style of the Shūbun school presently available in American collections.

RICHARD STANLEY-BAKER

NOTES

1. One of the earliest is an unpublished landscape in the Nezu Museum called *Pavilions Overlooking the Sea* (*Bōkairō*), bearing an inscription by the monk Isho Tokugan dated 1435. The inscription is published in Fujita, *Muromachi Jidai Gasanshū*, no. 19.

2. Hsia Kuei (his *tzu,* or pseudonym, was Yü-yü) served as Painter-in-Attendance at the Imperial Painting Academy of the Southern Sung emperor Kuang-tsung (r. 1190–95). Chinese critics generally link him with his contemporary Ma Yüan, referring to both as the leading representatives of the later academic style of landscape painting. Ma Yüan was nicknamed "One-Corner Ma" because of his many narrow paintings that show a foreground scene in one corner and totally omit middle ground and background. Hsia Kuei, while sharing many stylistic features with Ma Yüan, was distinguished from him by his simplified depiction of mountains and rocks, his excellence in blunt brushwork, and his rich ink tonalities. Most of the paintings attributed to Hsia Kuei — and there are many, since he had numerous followers among professional painters of the Yüan and Ming dynasties — are small compositions in which a diagonal tension is created by balancing a foreground mass against a minimized background. In addition to these small works, two long handscrolls and several handscroll segments present wide views of landscape with the three distances clearly distinguished.

Muromachi Japanese knew Hsia Kuei's style by the middle of the 15th century. They admired his work and classified him in the highest grade of Chinese painters in the *Kundaikan Sayū Chōki.* Both visual and literary evidence attest that Hsia Kuei's influence on Japanese painters increased remarkably from the 1470's into the 16th century. Sesshū copied at least four of Hsia Kuei's small landscapes (see cat. no. 18, n. 8), and Oguri Sōkei adopted Hsia Kuei models for his paintings four times within four years at the end of the century. The enormous influence of the *Eight Views of Hsiao and Hsiang* handscroll, one of the three Hsia Kuei works recorded in the painting catalogue of the Ashikaga Shōgun's collection, can be documented by paintings of late 15th century Japanese artists. Oguri Sōkei apparently took this painting as the model for his sliding-door decorations executed in 1491 at the Shōsenken of Kyōto's Shōkoku-ji (see cat. no. 12, n. 3, and cat. no. 15, n. 11). Other painters, including Gaku'ō, Kantei, Shūsei, and Unkei, adopted the same handscroll as their model for paintings of the *Eight Views* (see cat. no. 16). There is also evidence that at least two other landscape handscrolls by Hsia Kuei existed in the Muromachi period. One is available in a copy. The composition of the other is reflected in the *Ch'i-shan Ching-yüan* (*Clear and Remote Views of Rivers and Mountains*) in the Palace Museum, Taiwan, and it is thought that the picture of a wine shop by a bridge in the Asano Collection (fig. 10) may be a fragment from the Hsai Kuei painting known to the Muromachi Japanese. For more information about Hsia Kuei, see Sirén, *Chinese*

Painting, 2:119–24, and Li O, *Nan-sung Yüan-hua-lu,* chap. 6. For illustrations of Hsia Kuei and Ma Yüan paintings, see Sirén, *Chinese Painting,* vol. 3, *Sōgen no Kaiga,* pls. 102–6, and Suzuki, *Ri Tō, Ba'en, Kakei.*

3. Sun Chün-tse, a Yüan dynasty painter from Hangchou, followed the academic style of Ma Yüan and Hsia Kuei. Hsia Wen-yen mentions him in *chüan* 5 of his *T'u-hui Pao-chien* (1365). In Muromachi Japan he was well known as a landscapist; his depictions of architecture were particularly appreciated. At least six works by Sun Chün-tse are recorded in diaries by Muromachi writers, and one triptych is listed in the *Gyomotsu On'e Mokuroku,* the catalogue of the Ashikaga Shōgunal collection. The *Kundaikan Sayū Chōki,* a 15th century connoisseur's manual, classifies him in the upper class. A pair of excellent landscapes by Sun Chün-tse exists today, and is published in *Sōgen no Kaiga,* pl. 113.

4. See *Gyomotsu On'e Mokuroku,* in Tani, *Muromachi Jidai,* pp. 134–42.

5. Seishū Ryūtō (1434–98) was a leading literary priest representing the Kennin-ji group of Chinese scholars. According to his "Record of a Screen Painting" in the *Tokubi Chōheisō,* chap. 7, Gei'ami worked on the pair of screens for over a year, shortly before his death in 1485, elaborating on a specific Chinese model by Hsia Kuei. When the work was complete, the painter was very proud of it, claiming that all his capacity had been exhausted in it and that he could not expect anyone to surpass his work. Ryūtō gives an extensive description of many details of the screen in a lengthy passage. (In Tamamura, *Gozan Bungaku Zenshū,* 4:100–5.)

6. *Kōzan Sekiyō,* in the Kosaka Collection, is done in ink and light color on paper, 130.3 x 30.3 cm, and has inscriptions by twelve Zen priests, including the seventy-nine-year-old Taigu who died in 1439 at a little over eighty. The painting has been frequently published, for example in *Kokka,* no. 252, in *Higashiyama Suibokugashū,* and in Tanaka and Yonezawa, *Suibokuga,* pls. 48–49.

7. Two of Sesshū's copies of Hsia Kuei paintings are in the Asano Collection and are published in Tōkyō National Museum, *Sesshū,* pl. 16. Two more, now lost, are known through a handscroll in the Tōkyō National Museum in which Kano Tsunenobu (1636–1713) carefully copied all twelve of Sesshū's fan-shaped copies of Sung paintings. See cat. no. 18, n. 8.

8. The Nezu *Pavilions Overlooking the Sea* cited in note 1 is the earliest-known painting based on this model.

9. Paintings by Gaku'ō which reflect the influence of this model include the *Landscape* formerly in the Kōmoto Collection (*Kokka,* no. 523), the *Landscape* in the Hara Collection (*Bijutsu Kenkyū,* no. 55), and the *Landscape under an Evening Moon,* ex-Yama'oka Collection (*Higashiyama Suibokugashū*).

10. *Landscape,* traditionally attributed to Shūbun, inscribed by Jiku'un Tōren, in ink and slight color on paper. Published in *Higashiyama Suibokugashū.*

11. Shōkei's *Horse and Groom* paintings are close copies of works by the Chinese painter Jèn Jèn-fa which were in the Ashikaga Shōgunal collection. Frequently illustrated, good color reproductions of Shōkei's paintings can be found in *Higashiyama Suibokugashū.*

12. *Seizan Haku'un,* traditionally attributed to Minchō, is painted in ink on silk, 102.1 x 27.1 cm, and is in the Hara Collection. It bears inscriptions by Japanese monks which are terminally datable to 1420, and a *Hasō'ai-in* seal of Minchō. Although some accept this as a genuine Minchō, others find certain elements which suggest that it might be a Korean painting. It is frequently published, and may be seen in *Kokka,* no. 540. Gaku'ō's version in the Tōkyō National Museum bears an inscription by Ten'in Ryūtaku and is published in *Kokka,* no. 223, and in *Bijutsu Kenkyū,* no. 125. Gaku'ō's adaptation of the original is discussed by Richard Stanley-Baker in "Gaku'ō's Eight Views of Hsiao and Hsiang."

13. *Chikusai Dokusho* was one of the first Shūbun landscapes known. Typical of the *shigajiku* (picture-poem scrolls) of the first half of the 15th century, it is inscribed by six Zen priests, including a preface by Jiku'un Tōren dated 1446. It illustrates an idealized study of a Nanzen-ji monk named Kō. Professor Fuku'i Rikichirō asserts that *Chikusai Dokusho* is one of five paintings acceptable as authentic works of Shūbun. The others are the *Suishoku Rankō* (fig. 39) in the Fujiwara Collection, *Kōzan Sekiyō* (see above, n. 6), a pair of screens in the Yamato Bunkakan (fig. 40), and a pair of screens in the Matsudaira Collection (*Kokka,* no. 6). *Chikusai Dokusho* is generally acknowledged by specialists today as one of the very best among the numerous landscapes in the Shūbun style, although not necessarily a real Shūbun painting. See Fuku'i, "Nihon Suibokuga no Genryū."

Landscape with Distant Mountains
Shōkei Ten'yū (fl. 1440–60)

*Hanging scroll, ink and slight
color on paper, 78.9 x 36.1 cm.
Square relief seal reading* Shōkei.
*Collection of Kimiko and John
Powers*

When *Landscape with Distant Mountains* was first published in *Kokka* in 1895, it was attributed to a painter, "Shōkei," on the basis of the square relief seal in the lower right corner reading *Shōkei*. At that time only a painting of *Kanzan and Jittoku* in the Tokugawa Collection which bore the same seal could be linked with it.[1] In 1950 Tanaka Ichimatsu published a third painting with the same seal: a landscape which had recently entered the Umezawa Collection in Tōkyō.[2] These three paintings composed the oeuvre of a Shōkei whose exact identity remained unclear. Stylistically his work was clearly in the Shūbun tradition, but no Shōkei could be documented as a pupil of Shūbun. Confusing the issue was the fact that several fifteenth century monks used "Shōkei" as an alternative name. Some information existed about a painter Shōkei, however. Kano Einō in *Honchō Gashi* said he was adept at painting ink Kannon, he studied Mu-ch'i, and he was a descendant of the Takuma family of professional Buddhist painters. In *Honchō Ga'in*, by the same author, the square relief Shōkei seal is recorded.[3] Kano Hisanobu, in *Honchō Gaka Jinmei Jisho*, an early-twentieth century dictionary of artists, gives an entry for "Takuma Shōkei" which merely says that he was active in the Eikyō era (1429–1440). No more was known about the painter Shōkei.

Two other landscapes, however, can be cited as bearing close stylistic affinities to the landscapes with Shōkei's seal: the well-known *Kozan Shōkei (Small Scene of Lake and Mountain)* (fig. 36) now in the Fuji'i Collection, and a painting in the Takada Collection, Tōkyō, which was destroyed in the great Kantō earthquake of 1923.[4] Both carried a square relief seal reading *Ten'yū*. Watanabe Hajime had considered this to be a collector's seal on the basis of *Kozan Shōkei* alone, since several monks in the fifteenth century had used the name Ten'yū,[5] but the existence of the Takada painting with the same seal and the closeness of the two paintings argued that Ten'yū was a painter. Some evidence for the period of his activity is provided by an inscription written by the Tōfuku-ji monk Kōshi Ehō on *Kozan Shōkei*: Ehō said that the painting reminded him of scenery he had seen in China in 1436. Since the Ehō inscription is not included in his collected works, *Chiku-kyo Seiji*, an exact date cannot be determined, but it was certainly written after his return to Japan in 1436 and before his death in 1464 or 1465.[6] Thus a painter Ten'yū, active during the middle of the fifteenth century, was recognized. There remained no direct connection between Ten'yū and Shōkei until 1955, when Shimada un-

covered a *Hotei* painting which had both the Shōkei and the Ten'yū seals.[7] It was then possible to link the two names and confirm the stylistic relationship observed among the landscapes. A corpus of five extant works can now be attributed to the painter Shōkei Ten'yū.

The composition of the Powers landscape is striking for its horizontal division into two parts, with rocks and pavilions in the bottom half and misty mountains in the top half. The painting is entered at the lower right corner through a repoussoir of rocks in dark ink. A central rock mass with two down-turning pine trees dominates the foreground. To the right of this mass a figure follows a path around the base of a rock, into an opening which discloses a view of pines and buildings seen in mist. To the left several buildings project over water, and, continuing the rhythmically stepped movement of their base lines, a series of banks stretch to the left edge of the painting. A boat is being poled through a gap in these banks. The foreground grouping of rocks, pines, and architecture gives a decided weight to the center of the painting, which is emphasized by the dark ink tonalities of the rocks. Recession is achieved through a zigzag movement on either side of the central rock: on the right following the rocks and banks into the mist, and on the left following the base lines of the buildings and the banks. The trees pick up the same angular movement, leading the eye upward along their branches to the two boats. The principle of pairing operates throughout the painting to help create the effect of recession: the pavilions in echelon, the two rocks, the twin pines, the two boats, and finally the distant hills. Strong horizontal rhythms result from both the zigzag movements and the pairing of elements: the eye is allowed to move laterally beyond the confines of the picture plane. Contrasting with this horizontality is the vertical axis, already observed in the central foreground grouping and further accentuated by the placement of the distant mountains directly above the foreground section.

The brushwork throughout gives an unusual amount of detail. The foreground rocks are built up of angular contour lines and diagonal texture strokes which stress the verticality of the composition. Shading along the contour lines highlights the center of the rock and brings it to the fore; the diagonal texture strokes appear against this highlighted area. The rock thus appears to be eroded and faceted. The far distant mountains are done in wash with some texturing and appear as silhouettes one behind the other.

Characteristics of all four of Shōkei Ten'yū's land-

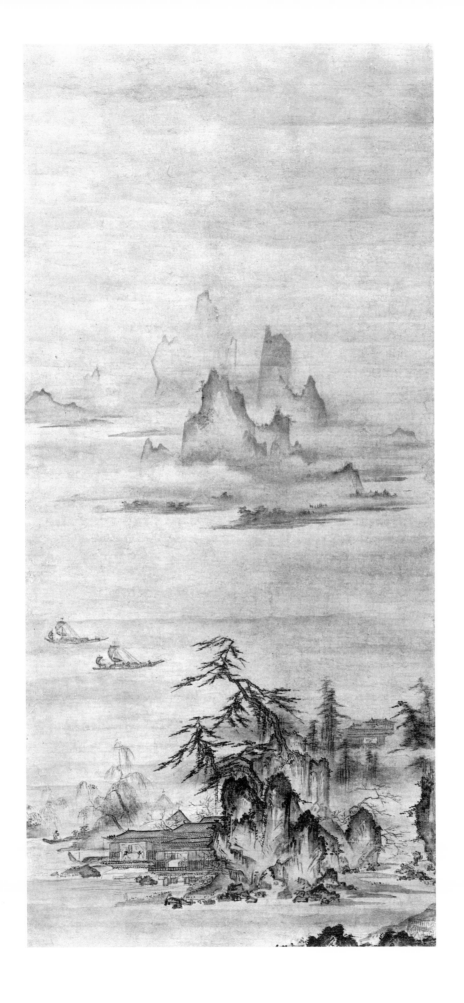

Figure 36. *Kozan Shōkei*
(*Small Scene of Lake and
Mountains*), detail, Shōkei
Ten'yū (fl. 1440–60), inscribed
by Kōshi Ehō. Hanging scroll,
ink and light color on paper,
121.5 x 34.8 cm. Fuji'i
Collection, Nishinomiya,
Hyōgo prefecture

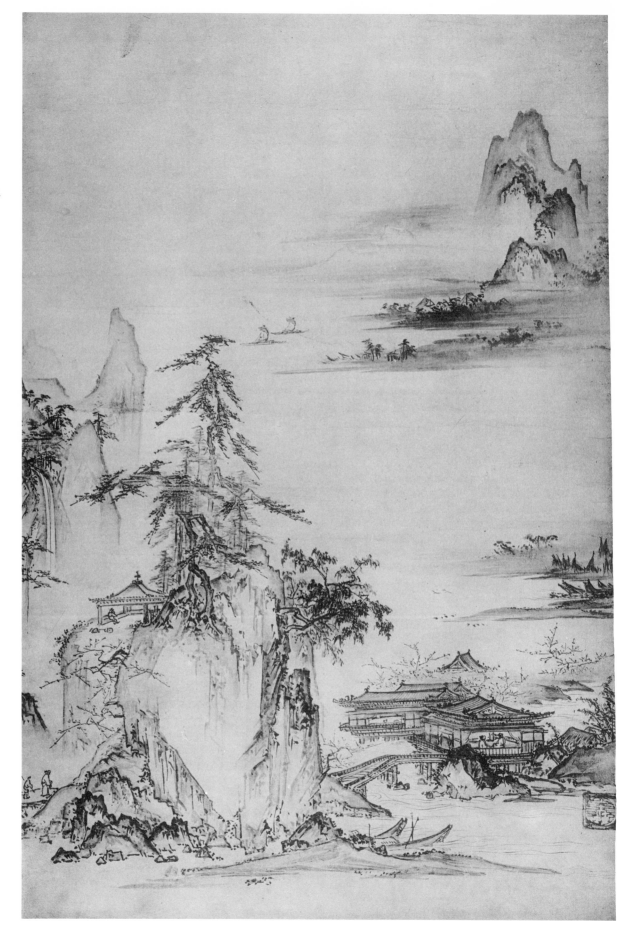

scapes can be defined in terms of this composition and brushwork. In the Powers landscape, in *Kozan Shōkei*, and in the landscape formerly in the Takada Collection, the viewer is presented with a complete view of foreground, middle ground, and far distance. Despite the direct entry into the Powers painting, all elements of the landscape are set at a distance from the viewer. Movement from one distance to the next is clear; in *Kozan Shōkei* and in the Takada landscape, a diagonal tension different from the level distance view of the Powers painting aids in the recession. Yet in all these landscapes Shōkei employed the zigzag movement into space noted in the Powers painting. The eye follows the diagonal lines of undercut rocks and the turning rooflines of buildings.

Rocks are built up in the same way in the four landscapes. Angular contour lines shape the boulders and strong diagonal lines pull in at their bases to create the effect of faceting and undercutting. Hatching strokes combined with softer dotting seem to be characteristic of Shōkei. Different types of texturing exist together in one painting, particularly in the destroyed Takada landscape and the landscape in the Fuji'i Collection (fig. 36). In the latter the distant mountains are done in almost hemp-fiber strokes (*p'i-ma ts'un*) [8] in contrast to the angularity of the foreground rocks.

A chronological sequence of Shōkei's four landscapes based on both internal and external evidence places the Powers landscape earliest, the Fuji'i landscape latest, and the Umezawa and Takada paintings in between. The Fuji'i painting reveals the most sophisticated and developed use of Shōkei's characteristic compositional devices and brushwork, arguing that it is the latest painting. The use of gold wash over the surface is particularly refined. As noted above, the death of Kōshi Ehō in 1464 or 1465 provides a *terminus ad quem* for the execution of the painting. In the early 1460's, Ehō was employed by the Ashikaga Shōgunate as an emissary to the Ō'uchi family in Yamaguchi. One of his seals used on *Kozan Shōkei* indicates this period of his employment, so the date of the inscription may be fixed to those years just before Ehō's death. Thus the painting, considered the latest of Shōkei's landscapes, probably dates from the early 1460's. The Powers landscape in its brushwork and its almost too strict pairing of elements shows a certain naïveté that can be considered as an earlier attempt, perhaps the earliest among the four. The Umezawa painting, both in motifs and composition, suggests a closeness to a Chinese prototype that makes it more

difficult to determine its time relationship with the other three. While both the Umezawa and the Takada painting seem to come before the Fuji'i landscape, their relation to the Powers painting is not so clear.

Another painting which might be attributed to Shōkei Ten'yū is the Seikadō Foundation's *The Ten Thousand Mile Bridge*, exhibited in Boston in the Zen painting and calligraphy exhibition of 1970.[9] Dated by an inscription of Kyū'en Ryūchin to 1467 and traditionally attributed to Shūbun, it bears many similarities to Shōkei Ten'yū: the same detailed brushwork, the undercut rocks, the architecture. It is a complete view of landscape set at some remove from the viewer. Whether the painting can be accepted as by Shōkei Ten'yū remains open. It has no seal, and detailed comparison with the other four landscapes is not conclusive.

Further characteristics of Shōkei Ten'yū's landscapes can be clarified by comparison with others of the Shūbun lineage. Shōkei Ten'yū's landscapes are seen in a clear atmosphere in contrast to the misty suggestiveness of paintings commonly accepted as representing the Shūbun tradition, such as *Chikusai Dokusho* in the Tōkyō National Museum (fig. 9) or *Suishoku Rankō* in the Fujiwara Collection (fig. 39). The expansion of space in a clear atmosphere is a mid-century development from the atmospheric space of the earlier Shūbun tradition. Shōkei's paintings have a brightness and, in the use of gold wash, a decorativeness not seen in the more somber paintings in the Shūbun style. The Umezawa painting is the closest of Shōkei's landscapes to the earlier Shūbun compositions, since the view to the right is cut off by a shoreline and the space beyond is enveloped in mist, but the motifs also suggest close adherence to a Chinese prototype that makes it difficult to relate to the other three. Another aspect of Shōkei's landscapes that separates them from other paintings in the Shūbun style is the architecture. Shōkei does not paint the idealized studios of scholar-monks seen in the typical *shigajiku* of the Shūbun tradition, but real pavilions in a Chinese architectural style.

The vertical orientation of *Landscape with Distant Mountains* invites comparison with a sequence of vertical compositions in the Shūbun tradition, beginning with the Fujiwara Collection's *Suishoku Rankō*, dated by Kōzei Ryūha's inscription to 1446 (fig. 39). The pines are centered and the mountain mass is directly above them. There is a sense of enveloping space, with mist on the left and a view into far distance on the right. The central trees, although not growing on large rocks, are accom-

panied by a large protrusion of rock and houses on the left. The next painting with a strong vertical thrust is *Landscape in Moonlight* (*Getsuya Sansui*) in the Mizoguchi Collection, with a terminal date of 1457 given by Son'an Reigen's inscription.[10] The trees spread out at the base of the mountain stress the verticality and monumentality of the towering mass. A view into deep distance opens on the right, while the left side is screened. A third vertical painting is in the Yamada Collection and attributed to Sesshū, with a terminal date of 1464 given by Ryūko Shinkei's inscription.[11] Again the composition has a strongly vertical axis; the foreground is separated from the viewer by an expanse of water. The elements of the landscape appear as if piled on the surface of the picture plane. Banks on the left cut the progression into the distance, but on the right, as in the Mizoguchi painting, there is a deep view into space. An anonymous painting formerly in the Koizumi Collection [12] goes one step beyond this, pulling together the centralized mass more closely with an emphasis on the solidity of the landscape rather than on the void areas. All of these landscapes show vertically oriented compositions with suggestive use of space. Compared with this sequence, the Powers Shōkei shows the development of a different type of composition that, although centralized, concentrates on the expansion of space and the development of void areas. Shōkei's horizon line is higher and his scenery further removed from the viewer.

Two paintings offer close comparison with the Powers Shōkei. One is *Descending Geese on Sandbanks* in the Fujita Museum, Ōsaka, dated by an inscription of Gyo'an Sōkan to 1454.[13] Like *Landscape with Distant Mountains*, the foreground and the far distance are the major areas of the composition and are separated by an expanse of water. The middle ground is more developed, showing banks, rather than merely being suggested by boats as in the Shōkei. Both paintings show a complete view of a landscape and in both there are strong horizontal rhythms. This horizontality in the composition may ultimately relate the two paintings to Korean sources. Like the Powers Shōkei, the Fujita painting is entered directly, but the recession appears more logical than in Shōkei: the distances are more closely linked through the motifs of the streambed and the descending geese. The second painting is the Bunsei *Landscape* in the Museum of Fine Arts, Boston.[14] Bunsei's period of activity is contemporaneous with or slightly later than Shōkei's (see cat. no. 7). The Boston painting also shows two centralized masses one above the other and emphasizes void

areas. The Fujita landscape, the Boston Bunsei, and the Powers Shōkei all illustrate one aspect of the Shūbun tradition: the development of expanding space through the use of voids. The dates of all the paintings involved point to the middle decades of the fifteenth century for this development.

From the above comparisons and from Kōshi Ehō's inscription, it is clear that Shōkei Ten'yū's period of activity falls into the 1450's and 1460's. The influence of his motifs and compositional devices can be seen in paintings of Gaku'ō Zōkyū (fl. ca. 1482–1515) and Sesshū (1420–1506). Gaku'ō's paintings employ the same middle ground motif of moored boats seen both in the destroyed Takada landscape and in the Fuji'i landscape. Comparison of the rock and architecture unit in the Gaku'ō *Landscape* in the Freer Gallery of Art (fig. 12), as well as motifs of the Gaku'ō painting in the Masaki Museum,[15] shows a development of motifs from Shōkei. The mountains of the early Gaku'ō *Priest Dōzan*, owned by the Seikadō Foundation,[16] are particularly close to Shōkei's distant mountains in the Fuji'i landscape. Gaku'ō's space is not the lateral expansion of Shōkei, however, and in his concentration on solids rather than voids he reflects the age of Sesshū. Sesshū himself picked up something of Shōkei's angularity of rock structure as well as the motif of down-turning pines. Shōkei's characteristic zigzag movement into space becomes much more solidly constructed in Sesshū, with an emphasis on penetration of depth. Comparison of the rocks and the pines in the Fuji'i landscape and the Sesshū in the Ohara Collection (fig. 14) points to this relationship.

The format of the Powers Shōkei Ten'yū may originally have been much taller, and at one time may have included an inscription. It was the practice of Edo period connoisseurs to cut down Muromachi landscapes in order to fit them into the Edo period *tokonoma*, and thus many inscriptions have been lost. The painting is presently accompanied by an authentication by Kohitsu Ryōchu (d. 1736), a member of the Kohitsu family of connoisseur-critics in the Edo period and a public certifier of calligraphies and paintings.[17] Ryōchu's document says: "A landscape by Takuma Shōkei in the 'Shin (Chen)' style with his seal. An inscription by Yamamoto Tai'an on the cover of the painting box. I certify that both are doubtlessly authentic. The year of the tiger, sixth month."

DAVID SENSABAUGH

NOTES

1. The Tokugawa Collection is now the Tokugawa Rei-meikai, Nagoya. *Kanzan and Jittoku* is frequently published; a convenient source is Tanaka and Yonezawa, *Suibokuga*, pl. 59; or Matsushita and Tamamura, *Josetsu, Shūbun, San-Ami*, color pl. 9.

2. *Landscape with Pavilion (Rōkaku Sansui)*, hanging scroll, ink and color on paper, 55.4 x 32.7 cm, Umezawa Kinenkan Collection, Tōkyō. Published in Matsushita and Tamamura, *Josetsu, Shūbun, San-Ami*, pl. 69, and in *Kokka*, no. 695

3. Kano Einō, *Honchō Gashi*, p. 990, and *Honchō Ga'in*, p. 1041.

4. Published in *Bijutsu Shū'ei*, vol. 19.

5. Watanabe, "Shūbun," *Bijutsu Kenkyū*, no. 80, p. 353.

6. There is contradictory evidence for Kōshi Ehō's death date. The 1465 date cited here is based upon a reminiscence by his friend Kikō Daishuku in his journal, *Shaken Nichiroku*. The other account suggests Ehō's continued activity up to 1469. The seal pressed at the lower right corner of Ehō's inscription on this landscape reads *Funsho Kōka* ("Leisure at the White Office"), an inappropriate seal for a Zen monk, particularly for one like Ehō who did not seek a high rank at his monastery. Thus the seal may suggest that the inscription was written while Ehō was working as a Shōgunal envoy, on a political task of negotiation with a powerful feudal lord, the O'uchi, in 1463–64.

7. *Hotei*, by Shōkei Ten'yū, hanging scroll, ink and light color on paper, 74.9 x 34.5 cm, two relief seals reading *Ten'yū* and *Shōkei*, Kōsetsu Museum. Published in Matsushita and Tamamura, *Josetsu, Shūbun, San-Ami*, pl. 70. Referred to by Tanaka Ichimatsu in *Nihon Kaigashi Ronshū*, pp. 328–29 and 344, n. 37.

8. *P'i-ma ts'un*, or hemp-fiber texture strokes, are long, slightly wavy brush strokes which resemble spread-out hemp fibers. They are associated with the early Northern Sung painters Tung Yüan and Chü-jan, and are thus part of the brush vocabulary of the Chinese amateur painting tradition rather than the academic tradition of artists such as Hsia Kuei, or the Ch'an tradition of artists such as Mu-ch'i.

9. Fontein and Hickman, *Zen Painting and Calligraphy*, no. 47.

10. Published in Tanaka and Yonezawa, *Suibokuga*, pl. 62.

11. *Landscape*, attributed to Sesshū, hanging scroll, ink on paper, 80.9 x 33.0 cm, signature of "Sesshū hitsu" ("by the brush of Sesshū") and seal of *Tōyō*, Yamada Collection, Ashiya. Published in Kyōto National Museum, *Sesshū*, fig. 45.

12. This anonymous *Landscape in Moonlight* is published in *Kokka*, no. 461, as a work of the Gaku'ō school.

13. Published in *Bijutsu Kenkyū*, no. 80, pl. 8.

14. Published in Tanaka and Yonezawa, *Suibokuga*, pl. 54; and in Matsushita and Tamamura, *Josetsu, Shūbun, San-Ami*, pl. 96.

15. Published in Matsushita and Tamamura, *Josetsu, Shūbun, San-Ami*, pl. 14.

16. Published in *Kokka*, no. 312.

17. The Kohitsu is a family of professional connoisseurs of calligraphy and painting. It began with Ryōsa in the early 17th century. Ryōsa's lay name was Hirasawa Norisuke. He was given the family name Kohitsu (meaning "old calligraphy") by Kampaku (Civil Dictator) Toyotomi Hidetsugu, in admiration of his connoisseurship in that art. His descendants in two branch lines of the family continued the profession of connoisseurship until the late 19th century. Certificates of authentication issued by the family are frequently written in the form of a label, such as the one attached to the Cleveland screen in cat. no. 12.

Winter and Spring Landscape
Attributed to Shūbun (fl. 1423–60)

Six-fold screen, ink and slight color on paper, 117.48 x 365.76 cm.
Label signed and sealed by Kohitsu Ryō'etsu which reads "Shūbun, Landscape, twelve pieces" is pasted in upper right corner of far right panel.
Cleveland Museum of Art, Norweb Collection (58.476)

The first four panels of this screen, counted from the right, represent winter scenery; the last two, in its present format, represent spring. The winter scenery opens with an old, gnarled evergreen of unspecified nature set among bamboo on a snow-covered rocky shore; behind it is a pine on a taller bank. The eye is soon drawn across a short expanse of void to the curiously shaped overhanging rock whose base is found in panel two. On its craggy slopes, various evergreen trees overshadow the little thatched houses of a rustic riverside village. A wine shop is distinguished by its flag, and two figures sit outside casually chatting, while another, dressed in a wide-brimmed hat and straw mantle, approaches the village from the foreground. In the distance beyond the houses nothing is seen save snowy haze. The third panel is dominated by a giant pine with two trunks joined at the bottom, its base surrounded by bamboo. The long pine branches extend into the preceding panel. Shadowy images of houses and trees are set in a ravine above the pine, and a huge snow-laden mountain rises toward the left. Its top is not visible. In the fourth winter panel, a rustic bridge straddles a rushing torrent. On a large snowy rock a cluster of pines spread their branches. Behind them a path is implied, while above, crevices of the giant peak glimpsed in panel three are indicated.

In the first of the spring panels, tall pines grow on a crystalline rock projection which dominates the foreground. Behind the rocks protrude a few straggling branches of flowering prunus, a symbol of spring. The wall and gates of a pair of elegant pavilions are set at the foot of a sharply faceted mountainside, extending to the adjacent panel. Behind the enormous foreground rock and cliff overhang, two scholars accompanied by attendants bid one another farewell. The figure on the right is doubtless the host, master of this elegant residence. Beyond them, an attendant sweeps the ground beneath groups of pine trees. Branches of another budding plum extend from the roofed wall surrounding the pavilion. A large building, possibly a temple, commands attention at the foot of a tree-topped cliff.

The reconstruction of this screen was the work of western collectors and connoisseurs. As Sherman Lee, Director of the Cleveland Museum of Art, explains, "Two hanging scrolls which are now the central panels of the Cleveland screen . . . were acquired in Japan by Osborne and Victor Hauge, under the advice of T. Matsushita, a well-known scholar of Chinese and Japanese painting. Somewhat later a pair of two-fold screens, obviously similar in style and content, were acquired by the same dis-

cerning collectors from the Shimazu collection."[1] Then these were reconstructed in Cleveland to produce the present format.

Questions have since been raised about the wisdom of this arrangement. As Martinson points out, while there seems no difficulty about the connection of the winter scenes, there are formal problems in connecting the last winter panel to the spring scene.[2] One such problem involves the motif of the rustic bridge across a rushing stream. Framed by large rocks, one of which is topped by overhanging pines, this motif is found elsewhere in late-fifteenth and early-sixteenth century Japanese painting. It appears in one of the panels painted by Sōkei for the Yōtoku-in,[3] and it is seen in a landscape attributed to Shūbun in the former Mutō Collection.[4] The Mutō painting contains giant snowy peaks in the background which suggest that the model was a winter landscape, but Sōkei transformed the season to spring to suit his own purposes.[5] Both paintings have as a major motif a waterfall emerging from a high point behind the bridge. The turbulence of the water beneath the bridge in the Cleveland panel is a motif generally associated with waterfalls in Muromachi landscapes. This fact, combined with the incomplete nature of the composition, suggests that the succeeding panel might have contained a description of a waterfall, then possibly houses or pavilions as seen in the Yōtoku-in and Mutō paintings. It is certainly illogical to suppose that the succeeding panel would open with the large-scale rocks and spring mountains seen in the present reconstruction.

Aside from the formal problems, this arrangement runs counter to established traditions in screen painting in which spring is always the first of the four seasons and winter the last. It is far more likely that the spring and winter sections are fragments of either a pair of folding screens representing spring and winter (a rather unlikely combination) or a set of two screens each representing two of the four seasons, or a set of four screens each depicting one season. Attached to the screen a certificate of judgment written by a professional connoisseur, Kohitsu Ryō'etsu, reads, "Shūbun, Landscape, twelve pieces." This suggests that the connoisseur saw other pieces or that he knew the Cleveland panels were part of a group of twelve pieces of landscape (mounted or unmounted) which once had formed a pair of six-fold screens. However, considering the large scale of the winter scene extending over four panels, it is more likely that the panels were originally part of a set of four screens each representing one season.[6] Judging from

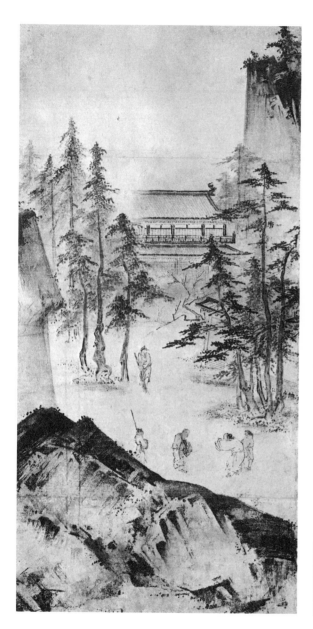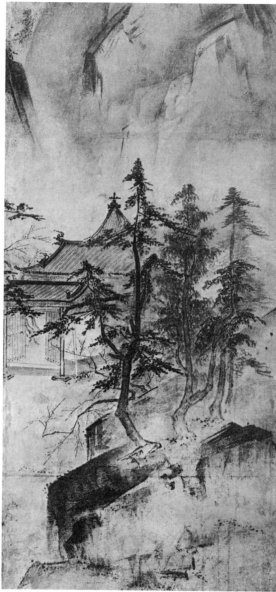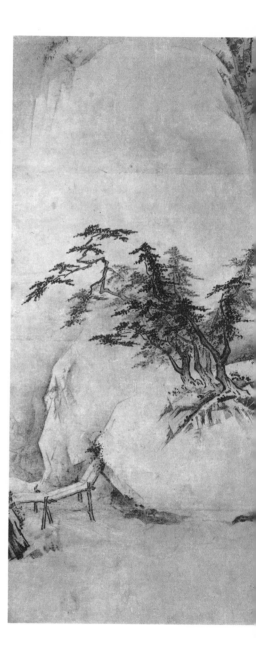

Catalogue number 12,
Winter and Spring Landscape

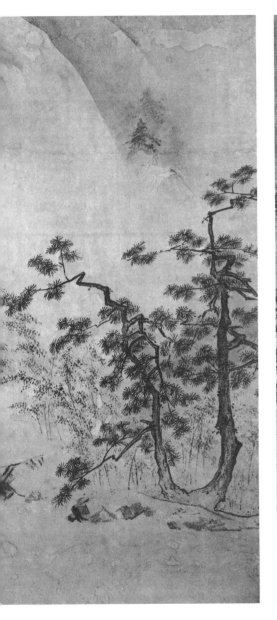
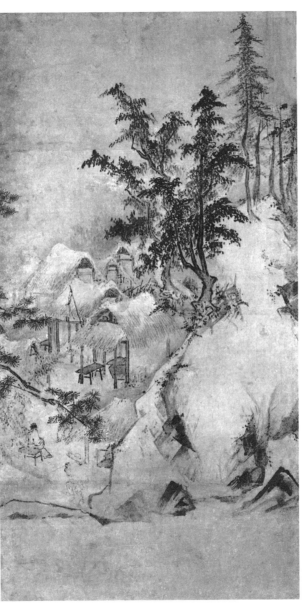

the composition, the two spring panels probably formed the first and second (or maybe the second and third) panels of the spring screen.[7] The winter scene probably represents panels two, three, four, and five of the winter screen: the panel with the bridge is unsatisfactory as the end of the composition, so it must have been followed by another segment, and, in the first panel, the way the pine tree is cut vertically suggests that it was preceded by more foreground scenery, perhaps including a cliff-face with which to consolidate the opening of the composition.

Besides representing only a fourth of an original compositional group, it appears that the tops of these six panels have been severely cut down. The proportions of the Cleveland screen are not consistent with the size relationships of fifteenth century screen paintings. Two pairs of folding screens in particular are generally regarded as representing the post-Shūbun school style and are currently owned by the Matsudaira family and the Maeda Foundation. The individual panels of these paintings, which surely must have been pared down somewhat over the years, measure ca. 155 cm high by ca. 60 cm wide. The average original height of fifteenth century screens was ca. 160 cm.[8] The measurements of the Cleveland panels are only 117.48 cm high by 60.96 cm wide. Clearly, their height has been reduced by about 40 cm, which is about the height of one and one-quarter of the five standard sheets of paper which fifteenth century painters used for folding screens. This reduction in height is more than enough to explain the curiously truncated look of the background mountains, which some scholars have related to the truncated mountain faces of the Li T'ang paintings in the Kōtō-in.[9] It is more likely that originally the mountains were complete at the top, and set against a background of void space. Visualizing this considerably reduces the overcrowded quality of the panels in their present form. In addition, the spring panels may have been cut somewhat at the bottom. The width of the panels has been very slightly curtailed by the mounting silk, but, judging from the contiguous composition, little has been lost. The width, which agrees with the average width of fifteenth century folding screen panels, indicates that these panels must have formed parts of folding screens and not sliding doors, which were considerably wider.[10]

Contemporary historical records provide literary evidence that Shūbun, the master-artist of the Shōkoku-ji monastery in Kyōto, painted large-scale folding screens and sliding doors,[11] but none of these works is known to exist today. A good example of a screen contemporary with Shūbun's active years is found painted as part of the architectural setting in the *Konda Sōbyō Engi* (*Illustrated History of the Konda Hachiman Shrine in Ōsaka*), a narrative handscroll which is dated 1433.[12] The combination of tall crossing pines with a vertical cliff which opens the composition on the right, set against an expansive vista with distant mountains in the center, is quite typical of compositions and motifs found in landscape screens of the later Shūbun school.

These screens, of which the Maeda and Matsudaira versions are thought to be most typical, are all four-seasons landscape compositions arranged over a pair of six-fold screens. The major land masses are placed at either end of the total composition, with vistas of expansive void space occupying the center. The four seasons from spring to winter are identified by distinctive seasonal motifs, and scattered through the composition are references to the *Eight Views of Hsiao and Hsiang*. This curious melange of motifs combined within a composition that reflects the influence of Southern Sung academic painting nicely represents the heterogeneous nature of the Shūbun school style. The Matsudaira screens in particular provide a cultivated integration of these various features.

The Cleveland panels, which are probably truncated fragments of a set of four screens, should not be compared too closely to four-seasons compositions which are confined to a pair of screens. It can be safely noted, however, that they present a very different appearance. What is strikingly absent is the classic balance seen in the Matsudaira screens between solid and void, the interest in expansive space, and the prevalence of a poetic, eremitic mood.[13] In the Cleveland screen there is little or no sense of expansion in void space: the emphasis is on solid forms. The poetic mood has vanished with the lake mists, replaced by a literal approach to the subject.

The fragmental condition of the Cleveland panels makes it difficult, or even dangerous, to try to analyze too closely the artist's concept of space, compositional structure, or other features crucial to determining his stylistic context. Still, it is clear that the stylistic integration of elements is extremely limited, especially in the four winter panels. A sense of recession into depth occurs only in isolated areas such as the winter village scene. Even here, however, the rocks enclosing the space pocket tightly squeeze the disproportionately small houses and figures. The village has no connection with either the foreground or the snowy mountains behind.

The scene appears "plugged in," spatially unrelated to its surroundings. This is a result of the artist's heavy dependence on models he has not thoroughly digested. A close look at some of the motifs in the panels further reveals his manner of adapting models.

Certain motifs of the Cleveland panels are comparable to those found in works of the so-called Soga school,[14] a branch of the later Shūbun school. The large number of upright pines, in contrast to the leaning pines representative of the Shūbun-style in *Chikusai Dokusho* (fig. 9), are comparable to those seen in the Shinju-an landscape sliding-door panels traditionally attributed to Dasoku [15] (fig. 19). The preponderance of horizontal lines in the representation of the pine branches and needles is also close to that of the Shinju-an paintings. The broad, somewhat coarse brushwork in the pine trees and rocks, showing traces of a predilection for straight lines and square angles, is comparable to works now attributed to Sekiyō [16] (fig. 43). Yet, although the Cleveland screen's artist used similar texture strokes, his rocks are not clearly contoured with firm brushlines in thick ink, as are the rocks in the Shinju-an panel paintings and the landscapes bearing the *Sekiyō* seal. These contours give the rock forms of the Soga school paintings a structural solidity lacking in the rocks of the Cleveland panels, with the exception of the firmer rocks in the spring scene rendered in broken contours with moderate to pale ink. Similar distinctions can be made in the depiction of architecture. But the most important difference is that the rich sense of expansive space felt in the Shinju-an compositions is absent in the Cleveland pictures.

The stylistic reference points for this artist were paintings of the Shūbun school based on what were considered to be works by Hsia Kuei. Examples of oddly shaped overhanging rocks appear in both the Maeda and Yamato Bunkakan screens (fig. 40) which Nakajima Junji has shown to be based on Hsia Kuei style models.[17] The broad, dark texturing strokes applied to the underside of many of the rock forms are also comparable to the brush handling seen in the Maeda screens. The largest number of motifs, however, seems to parallel those found in the works of Gaku'ō, a painter of the late fifteenth century who closely adhered to many of the stylistic formulas established by Shūbun school works of the middle of the century.[18]

But Gaku'ō also carefully studied paintings in the style of Hsia Kuei, especially for several versions he did of *Eight Views of Hsiao and Hsiang*.[19] A comparison of the two spring panels of the Cleveland screen with the *Moun-*

tain Village scene from Gaku'ō's *Hsiao and Hsiang* screens in the Murayama Collection (fig. 37) reveals that the artist of the Cleveland painting was familiar with a similar prototype. Unlike the easy entry into the composition characteristic of works of the Shūbun school, which is echoed in the neutral foreground of the Cleveland winter panels, Gaku'ō constructs a narrow access between two formidable rocks. The same blocked foreground with a bottleneck entry appears in the Cleveland screens, strangely juxtaposed with the open area of the mountain stream in the winter scene as presently reconstructed. The peak in the center of the Cleveland spring scene echoes the shape of the central large rock in the Murayama painting. The broad dark texture strokes used to describe the angular shoulder of the Cleveland mountain are very like those Gaku'ō used in another large-scale painting now in the Matsudaira Collection, based on the same model.[20]

The scene surrounded by these rocks differs: the artist of the Cleveland screen replaces the humble mountain dwellings characteristic of Gaku'ō's model with elegant pavilions. He found this motif, also, in another painting rather than in his own surroundings, and he is unable to define clearly the spatial relationships between the buildings. The smaller gate partly obscured by trees in the center of the scene does not logically connect with the wall beside it, which in turn does not rationally lead to the more elaborate gate in the right panel. In terms of the intent of fifteenth century painters, such spatial misunderstanding should be considered as an unsatisfactory adaptation of motifs from a model painting.

Although the painter of the Cleveland screen replaced Gaku'ō's thatched cottages with rich architecture in this spring scene, he did not discard the mountain village motif. This is the scene he "plugged in," in the pocket between the large twisting rock and the enormous paired pine trees of the winter scene. He retained the central position of the wine shop with its flag and its convivial customers. The transformation of what is generally depicted as a spring or summer scene into a winter landscape posed certain problems which the painter did not solve. The figures who chat outside the wine shop, while entirely appropriate in a spring or summer scene, are somewhat out of place in the chilly atmosphere suggested by the winter panels.

Other motifs in the Cleveland *Winter and Spring Landscape* also echo those characteristic of Gaku'ō which can be seen on other panels of the Murayama screens. Groups of spreading pines, such as those in the fourth

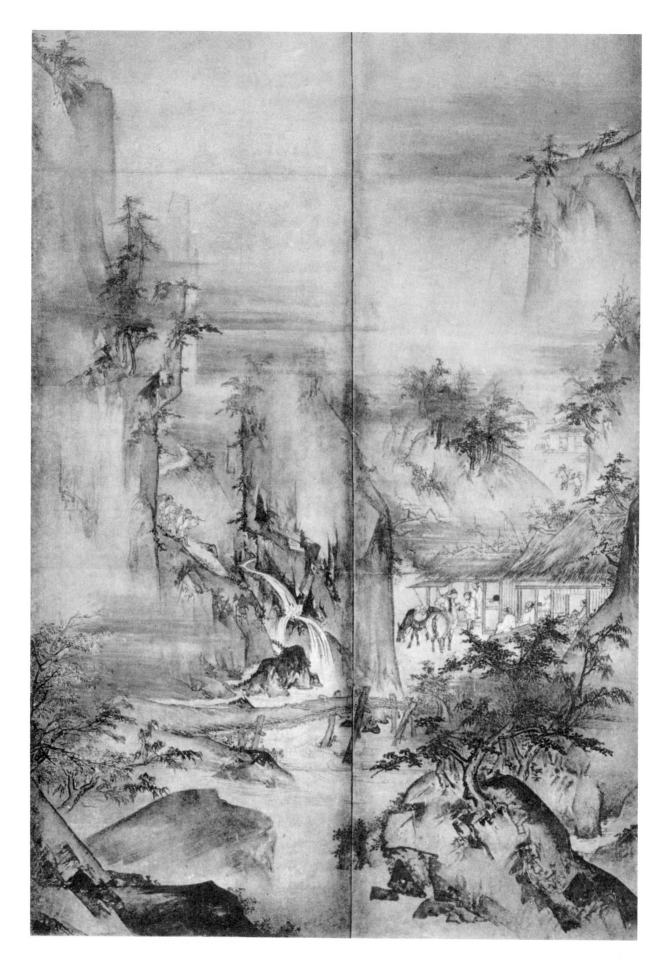

Figure 37. *Mountain Village* from *Eight Views of Hsiao and Hsiang,* attributed to Gaku'ō (fl. late 15th–early 16th century). Two panels from a pair of six-fold screens, ink and slight color on paper, each panel 162.0 x 56.8 cm. Murayama Collection, Kōbe

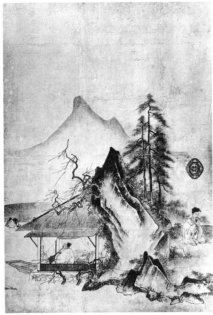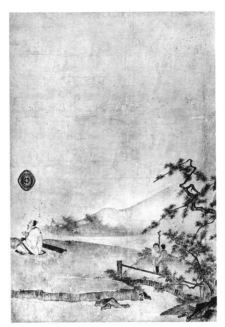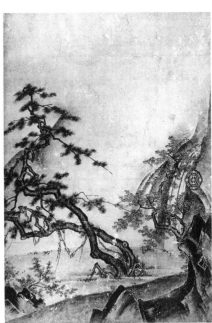

Figure 38. *The Four Accomplishments* (*Kinki Shoga*), datable to 1490, Oguri Sōkei (fl. late 15th century). Four door-panel paintings, ink and slight color on paper, each 170.0 x 91.3 cm. Kyōto National Museum, formerly in the Yōtoku-in, Daitoku-ji, Kyōto

winter panel, are often found in Gaku'ō's works in Hsia Kuei style. The peculiar contortion of the snowy mountain in the first two panels recalls similarly twisted peaks which Gaku'ō was fond of painting.[21] The Murayama *Eight Views of Hsiao and Hsiang* is considered a relatively early work by Gaku'ō. In this pair of screens he enlarged motifs derived from small compositions (hanging scrolls or handscrolls) to almost grotesque proportions. Like Cleveland's *Winter and Spring,* the Murayama screens exhibit the awkwardness which results from inability to arrange such enlarged borrowed motifs in a well-balanced composition.[22]

A comparison of the Cleveland screen with the sequence of *The Four Accomplishments* (*Kinki Shoga*) from the Yōtoku-in (fig. 38) reveals that the painter's underlying concept of pictorial space accords with that of Sōkei, who painted these panels in 1490. Both of these large-scale works have lost the spaciousness characteristic of mid-fifteenth century screens of the Shūbun school. There is little or no sense of expansion in void space. Nothing is depicted behind the oddly shaped overhanging rock in Cleveland's winter scene except blank void; the emphasis is on solid forms. In the Yōtoku-in panels distant mountains serve only as a backdrop, bearing no relation to intervening space, but merely paralleling the lateral movement of sequential motifs arranged in the front of the middle ground. Likewise, even if the Cleveland winter mountains had not been cut at the top, they would serve the same function that they do now — a neutral background for the major motifs which are placed at a fairly even distance from the viewer. In both works, development of depth is severely limited. There is scarcely any diagonal movement. Instead, the progression is lateral. The viewer begins at the right and is led in rather monotonous fashion from one form across a rather uniform interval to the next form. Consequently, the picture surface is static.

Clearly, the Cleveland work belongs to the period at the end of the fifteenth century when commissions for large-scale works often outweighed the artist's experience. The artist, not quite able to cope with the problems of transforming relatively unfamiliar small-scale models into a large-scale composition, created an illogical sequence of oversimplified motifs strung laterally across his painting format. Like Sōkei in his Yōtoku-in panels of 1490 and the young Gaku'ō in his *Eight Views of Hsiao and Hsiang* scenes, this artist was unable to integrate all the elements of his work. The three also share a tendency to magnify the foreground and emphasize features of human interest, to give attention to solid form with a consequent lack of interest in the development of depth in expansive space. In their somewhat literal approach, the overall poetic atmosphere characteristic of mid-century work disappears.

The Cleveland fragments, in spite of their drastic truncation and curious misarrangement, represent a valuable trace of a grandiose tradition in late-fifteenth century painting of the Shūbun school which has been all but lost. We are fortunate that this at least has been preserved.

RICHARD STANLEY-BAKER

NOTES

1. Lee, "Winter and Spring by Shūbun," p. 179. The spring panels from the Shimazu Collection have been published by Nakamura, "Den Shūbun hitsu Sansui Byōbu."

2. Martinson, "Early Muromachi Screen Paintings," chap. 5. See also Etō's commentary in Shimada, ed., *Zaigai Hihō,* 1: nos. 82–83, p. 110.

3. Oguri Sōkei, whose style name was "Gessen," was the son of Kan'ō Sōtan (ca. 1413–81), who was appointed to succeed Shūbun as the painter serving Shōgun Ashikaga Yoshimasa. His activity as a painter is recorded in great detail in *Onryōken Nichiroku* (see cat. no. 15, n. 11), although for a limited span of time, 1489–93. According to the Onryōken diary, Sōkei completed his paintings on the Yōtoku-in door panels in 1490. The number of panels in the original set is not known, but they spanned at least five intercolumniations. The panels were preserved at the Yōtoku-in until the Meiji era, when they moved to the Ino'ue Collection. Extant Yōtoku-in panels, now in the Kyōto National Museum, consist of twenty-eight pieces and can be divided into seven compositions, each executed in a more or less different manner following famous Chinese masters such as Hsia Kuei or Mu-ch'i, as indicated in the Onryōken diary. The paintings have been frequently published in recent years: in Kyōto National Museum, *Chūsei Shōbyōga,* pls. 31–33; Matsushita and Tamamura, *Josetsu, Shūbun, San-Ami,* pls. 17, 83–84; and *Tōyō Bijutsu Taikan,* vol. 3. For a discussion of the Yōtoku-in paintings, see Kanazawa, "Kyū-Yōtoku-in Fusuma-e"; for details of Sōkei's biography, see Haga, *Higashiyama Bunka no Kenkyū,* pp. 719–36. The panel referred to here can be conveniently found in Tanaka and Yonezawa, *Suibokuga,* pl. 64.

4. Published in Mutō, *Chōshō Seikan,* 2: pl. 35. The painting is obviously post-15th century but reflects some of the interests of works of the Shūbun school.

5. Sōkei has plum blossoms, but his combination of bridge, rocks, waterfall, and the pavilions to the left strongly suggests that he is making reference to the same model that is reflected in the Mutō painting.

6. Martinson also assumes that these are fragments of a pair or a set of four screens.

7. In typical pairs of four-seasons screens, such as the Maeda or Matsudaira screens (published in *Kokka,* nos. 538 and 6, respectively), a large mountain is placed at the beginning of the screen.

8. The total measurement of each Maeda screen is 152.7 x 311.5 cm, and each Matsudaira screen is 151.5 x 355.2 cm. These measurements are consistent with those of other 15th century screens of the post-Shūben school: in the Tōkyō National Museum, 162.3 x 359.2 cm; in the Yamato Bunkakan, 153.4 x 360.0 cm; in the Seikadō, 154.5 x 329.7 cm; and in the Murayama Collection, 162.0 x 341.2 cm. All these screens are published in Kyōto National Museum, *Chūsei Shōbyōga,* pls. 3–8.

9. The Li T'ang argument, originated by Sherman Lee ("Winter and Spring by Shūbun"), has been further expanded by Richard Barnhart ("Li T'ang and the Kōtō-in Landscapes"), who argues that the two central panels of the Cleveland work were based on the Kōtō-in landscapes and arranged in reverse order. Aside from the question of truncation, this somewhat hasty assumption quite ignores the clear connection of the Cleveland panels with the Shūbun-school versions of the Hsia Kuei style, which is its central reference point.

10. The average width of the narrowest 15th century sliding doors is ca. 90 cm. Examples are found in the Shinju-an (fig. 19), the Daisen-in (fig. 67), and the ex-Yōtoku-in (fig. 38) sliding doors.

11. Son'an Reigen (1403–88) said that Tokan Shūbun painted "flowers and birds and landscapes in the residences of nobles, which sparkled on folding screens and sliding doors." Son'an inscribed this eulogy on a posthumous portrait of Shūbun painted by Hyōbu Bokkei. It is recorded in his collected works, *Son'an-kō,* and reported by Watanabe in his study of Shūbun first published in *Bijutsu Kenkyū,* no. 80 (1938), and later reprinted in his book, *Higashiyama Suibokuga no Kenkyū.* The only account of large-scale works which is contemporary with Shūbun's period of activity, ca. 1423–60, is that of Go-Sukō'in (Fushimi Sadashige), who mentions in his *Kanmon Gyoki* that Shūbun returned to inspect some sliding doors he had painted, for he was somewhat uneasy about them. The *Kanmon Gyoki* is the personal diary of Go-Sukō'in (d. 1456), who was the father of Emperor Go-Hanazono, and provides well-informed observations about his daily life, the Imperial government, and activities in Kyōto covering the years 1416–49. It is published in two volumes of *Zoku Gunsho Ruijū.* The comment about Shūbun's sliding-door paintings is quoted in Watanabe, "Shūbun."

12. *Konda Sōbyō Engi,* scroll 3, scene 1, is published in Kyōto National Museum, *Chūsei Shōbyōga,* fig. 97, in the section on sliding-door and folding-screen paintings in pictures.

13. Nakajima Junji discusses the eremitic flavor of the Matsudaira and Maeda screens which comes from the mood and artistic interest of *Shigajiku* painting, versus the more elegant, luxurious nature of the screens of the Shūbun school in the Tōkyō National Museum and Seikadō collections. See Nakajima, "Keishiki Yōkyū to Gikotensei."

14. See cat. no. 14, n. 21.

15. The Shinju-an is a subtemple of Daitoku-ji monastery in Kyōto, founded in 1491 to commemorate Ikkyū Sōjun (1393–1481), the Zen master who campaigned to revitalize Zen Buddhism. Its Hōjō (Abbot's Quarters) was expanded on the east side in 1601, and door panels of the new rooms were painted by Hasegawa Tōhaku, one of the leading painters of the time. The present Hōjō was rebuilt in 1638, with the orig-

inal 15th century paintings and Tōhaku's panels reinstalled as they are today. The original door panels are all ink paintings, attributed by temple tradition to Soga Dasoku, a mysterious painter who is said to be the ancestor of the Soga family or Soga school (see cat. no. 14, n. 21). They consist of three units installed in three rooms. The largest composition is sixteen panels of *Birds and Flowers in Landscape Setting* in the *shitchū* (center room). The second group is *Landscapes of the Four Seasons* (fig. 19) painted in formal style on eight panels in the first *gekan* (lower room). The third, *Landscape* in the manner of Yü-chien, is painted on four panels in the second *gekan*. The traditional attribution of these panels to Dasoku was supported by authors of pre-modern painting histories, although they disagreed in their identification of Dasoku. In modern studies, most scholars endorse the date of 1491 for the works, as well as the Dasoku attribution, but with reservations about the painters' identity. See *Shōhekiga Zenshū*, vol. 8 (Daitoku-ji).

16. Sekiyō, or "Red Fly," is a strange name for a painter. It was not recorded in pre-modern Japanese painting histories, but two paintings with the seal *Sekiyō* are recorded in *Koga Bikō* under the entry for Soga Dasoku. In recent years, Sekiyō has been recognized by Japanese specialists as a painter of the late fifteenth century, and has become the focal point for study of the Soga school. Three landscapes by Sekiyō are known to exist today, one in the Fuji'i Collection and two in the Inoue Collection, published in *Nihon Bijutsu Kyōkai Hōkoku*, no. 30, and in Kyōto National Museum, *Muromachi Jidai Bijutsuten Zuroku*, pl. 70, respectively. Two other Sekiyō landscapes destroyed in the 1923 Tōkyō earthquake are reproduced in *Gei'en Shinshō*, vol. 3. The close stylistic kinship between Sekiyō's paintings and the Shinju-an sliding-door paintings is undebatable. Increasing numbers of Japanese scholars agree that Sekiyō can be identified as the painter of the most important section of the Shinju-an sliding-door paintings, one of the monumental works of Muromachi ink painting. Sekiyō's relation to the Shinju-an door-panel paintings has been discussed by Nakajima, "Shinju-an Fusuma-e." See also Aimi, "Den Soga Dasoku Sansui-zu"; Tanaka Ichimatsu, "Soga Dasoku to Sōjō o Meguru Sho-mondai"; and Tanaka Ichimatsu, "Gaku'ō Zōkyū no Shiteki Ichi," *Nihon Kaigashi Ronshū*.

17. Nakajima, "Shinju-an Fusuma-e."

18. See cat. no. 13, esp. n. 6.

19. See Stanley-Baker, "Gaku'ō's Eight Views."

20. *Mountain Village*, by Gaku'ō, now in the Matsudaira Collection, is one of two extant scrolls from a set of *Eight Views of Hsiao and Hsiang*, executed in ink and slight color on paper and measuring ca. 89 x 45 cm. The other is *Night Rain over Hsiao and Hsiang* in the Kobayashi Collection. A third scroll, *Returning Sails from a Distant Shore* formerly in the Ogihara Collection, was destroyed in the last war and is known only from reproductions. These paintings reportedly were mounted on sliding-door panels. All three closely resemble scenes on the Murayama screen and are probably based on the same model. *Mountain Landscape* is published in Tanaka Ichimatsu's article on Gaku'ō in *Nihon Kaigashi Ronshū*, fig. 170, p. 316.

21. Both are present in the Murayama screens: a similar pine group appears in the left two panels of the right-hand screen, and the twisted mountain is in panels four and five of the left-hand screen.

22. The above points of comparison with Gaku'ōs work represent, in the main, suggestions inspired by Professor Shimada. It is perhaps worth noting that the question of the relationship of these screen paintings to lost Chinese and Japanese models, no less than their relationship to one another, is extremely delicate. It is possible that further study of 15th century Ming painting, and of presently unavailable Kano copies of lost Chinese and Japanese paintings, may throw further light on this still murky area.

Landscape

Artist unknown, late 15th or early 16th century

Hanging scroll, ink and slight color on paper, 71.8 x 25.4 cm. Two seals in upper left-hand corner: upper seal, 3.6 x 3.0 cm, relief-type with embellished border along both sides, with eight characters reading Kigan Chinpō Shingan Kagi *("These curious treasures, why doubt whether real or forged?"); lower seal, 2.35 cm high, intaglio-type, with four characters reading* Kisai Seishō *("Pure appreciation of the studio Kisai"). Connoisseur's inscription on inside lid of box.[1]* Baltimore Museum of Art, Levy Fund (62.39)

Two trees with sharply bending trunks grow from a large rock in the foreground. Just behind it a path enters the painting from the lower left-hand corner, opening onto a level plateau where the buildings of a solitary dwelling, sheltered by the rocky embankment that rises to one side, nestle among willows and bamboo. A scholar reclines beside the open window, facing away from the viewer and directing his attention into the tranquil scene. Water flows gently around the plateau, disappearing in the thick mists that rise among lofty mountains in the distance. A central peak predominates; a lesser pinnacle in front and to the right echoes its form. A remote range of mountains, silhouetted by ink wash along the outer edge of its contour, stands behind the main peak, screening the view into the distance. The enclosure of the scene by this mountain range enhances the mood of seclusion and stillness. The *Landscape* is executed predominantly in ink wash of medium to dark tonalities, with a few loosely organized, dry textural strokes in the rocks to indicate volume. Foliage dots and the contour lines delineating the rocks and mountains are relatively dark in tone. Warm, light touches of ocher and russet color the grasses, the hut, rocks, and mountains. Cooler shades of blue, often deepened by the addition of ink, shade the pinnacles and foliage, and lightly tint the water. It is a quiet scene, in harmony with the contemplative mood of the scholar who inhabits the mountain retreat.

The Baltimore *Landscape* carries a traditional attribution to Shūbun, on the basis of the label on its box. It has since been reattributed to Gaku'ō Zōkyū (fl. late fifteenth and early sixteenth centuries), a follower of Shūbun, on the basis of its style, which is indeed closer to that of Gaku'ō than to any other identifiable painter of that period. However, the *Landscape* has no artist's seal or signature. The seals in the upper left-hand corner have not been clearly identified, but they probably designate a previous owner or owners of the painting rather than its artist.[2] Moreover, the style of the landscape is not sufficiently consistent with that of Gaku'ō (fig. 12) to support an attribution to his hand.

Nevertheless, the Baltimore *Landscape* can be placed with certainty in the direct line of development of the Shūbun school. The artist has utilized the type of composition and visual vocabulary of motifs that are seen in their classic form in the famous painting attributed to Shūbun, *Suishoku Rankō* (fig. 39), which is datable to 1445 or slightly earlier.[3] Taking his inspiration from such a composition, this artist has created his own landscape using the same major motifs: a dominant central peak emerging from mist that obscures its base, a reed-roofed study in a bamboo thicket sheltered by a rocky embankment to one side and overlooking an expanse of water, and tall trees growing from a prominent boulder in the immediate foreground.

However, despite its faithful retention of the main elements of the mid-fifteenth century *Suishoku Rankō*, the Baltimore *Landscape* manifests many deviations, both in composition and in manner of execution, that establish its later date on the verge of the sixteenth century. The addition of subordinate mountain peaks to left and right of the central pinnacle screens the view into the distance and encloses the composition from the rear. The foreground scene, too, shows a proliferation of minor motifs, such as the earthen bank and additional rocks. which extend laterally across the entire foreground and interrupt the view of open water to the right.

Although a composition with the view into distance blocked by mountains occurs in one early-fifteenth century painting traditionally attributed to Shūbun, a landscape in the collection of the Jishō-in in Kyōto,[4] it is not at all typical of most paintings attributed to Shūbun and dating from the early to middle fifteenth century; these are characteristically spacious compositions, open on one or both sides. The closing-off of the distant view seen in the Baltimore *Landscape* is, however, typical of landscapes of the late fifteenth century, including those of the Shūbun school. This general trend reflects indirectly the new spatial conceptions inspired by the Southern Sung painter Hsia Kuei (fig. 10), whose work had just become widely known to Japanese painters at this time. It is especially characteristic of landscapes by Sesshū (1420–1506; see cat. no. 18), a disciple of Shūbun, and by Kenkō Shōkei (fl. late fifteenth–early sixteenth century; see cat. no. 24), both of whom developed styles of landscape painting strongly reflecting their knowledge of model paintings by Hsia Kuei. Thus this compositional trait of the Baltimore *Landscape* reflects a major trend of late fifteenth century landscape painting and contrasts with earlier works of the Shūbun school, such as *Suishoku Rankō,* which are simpler and less clearly defined, but incomparably evocative.

In addition to changing the spatial structure of the composition, the juxtaposition of subordinate pinnacles in the Baltimore *Landscape* diminishes the role of the central peak, which in *Suishoku Rankō* stands almost as an emblem of solitude. The diminution of the central peak is compounded by the displacement of the foreground rock and trees toward the left side, which ne-

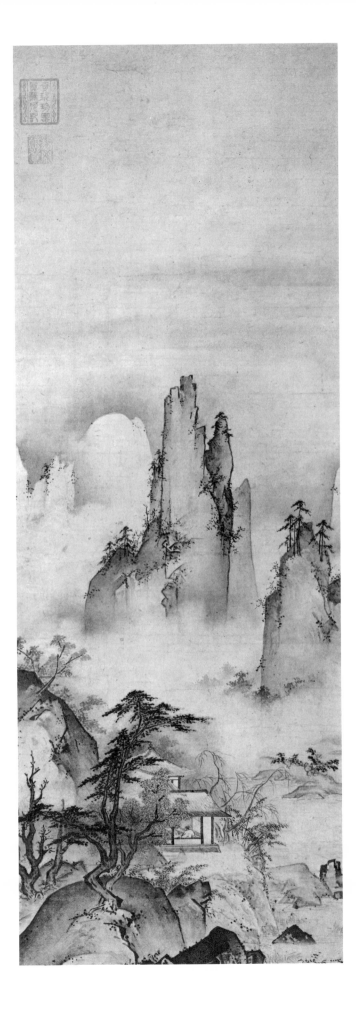

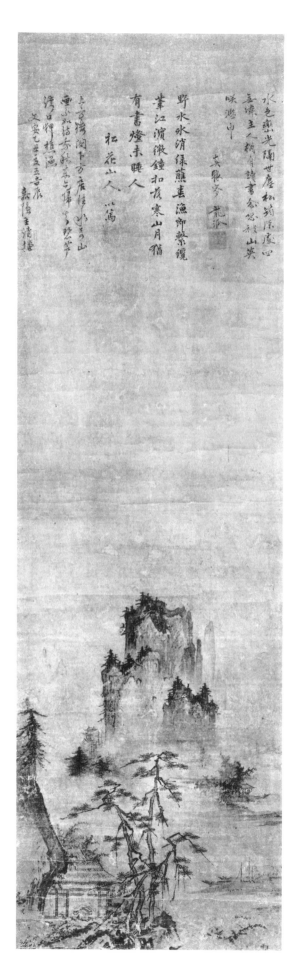

Figure 39. *Suishoku Rankō*
(*Color of Stream and Hue of
Mountain*), artist unknown,
attributed to Shūbun (fl.
1423–60), inscription by
Shinden Seihan dated 1445.
Hanging scroll, ink and light
color on paper, 107.5 x 32.6 cm.
Fujiwara Collection, Tōkyō

gates their former function of accentuating the vertical aspect of the central mountain. A compression of space accompanies the obstruction of far distance, the reduction of the central mountain, and the proliferation of subsidiary peaks. In *Suishoku Rankō* the mist spreads freely from the lakeside study far into the distance, drifting into the hollow crevices of the lofty central mountain. In contrast to the boundless space of this mid-century painting, the dense clouds of the Baltimore *Landscape* seem narrowly confined among the slender pinnacles. These substantial vapors fail to convey the sense of light, poetic atmosphere that was the supreme achievement of landscapes of the Shūbun school just prior to the mid-fifteenth century, and mark this as a painting done toward the end of the development of post-Shūbun landscapes. The tendency toward reduction of the role of the central mountain and the simultaneous contraction of space, in later works following the general prototype represented by *Suishoku Rankō,* is already observable in the *Landscape in Moonlight* (*Getsuya Sansui*) in the Mizoguchi Collection [5] which is approximately dated only a decade later. It remains a consistent trend among landscapes following this prototype well into the sixteenth century.

The Baltimore *Landscape* also shows many technical characteristics of late-fifteenth century landscape painting. Its extensive use of relatively heavy ink contour lines is not seen in *Suishoku Rankō,* in which light, dry textural strokes have the major role in defining form. The slightly later Mizoguchi *Landscape in Moonlight,* however, shows more extensive reliance upon heavy contour lines, and this stylistic trend is given impetus by the decidedly linear painting style of such late-fifteenth century painters as Sesshū. Another outstanding characteristic of the Baltimore *Landscape* is the extensive use of ink wash of fairly dark tonality with the juxtaposition of contrasting light and dark areas to define volume, particularly in the rocks and mountains. A similar use of strong contrast is seen in the Mizoguchi *Landscape in Moonlight.* With the increase in popularity of model paintings in the manner of Hsia Kuei during the late fifteenth century, this convention in depicting rocks became prevalent. However, as can be seen in the foreground rocks and main peak of the Baltimore *Landscape,* the intended form-building function of this device is sometimes lost in Japanese "translations" of the method of strong contrast, and the result is a relatively flat, abstract pattern.

Japanese landscape painting of the late fifteenth century shows a rapid differentiation of styles which results

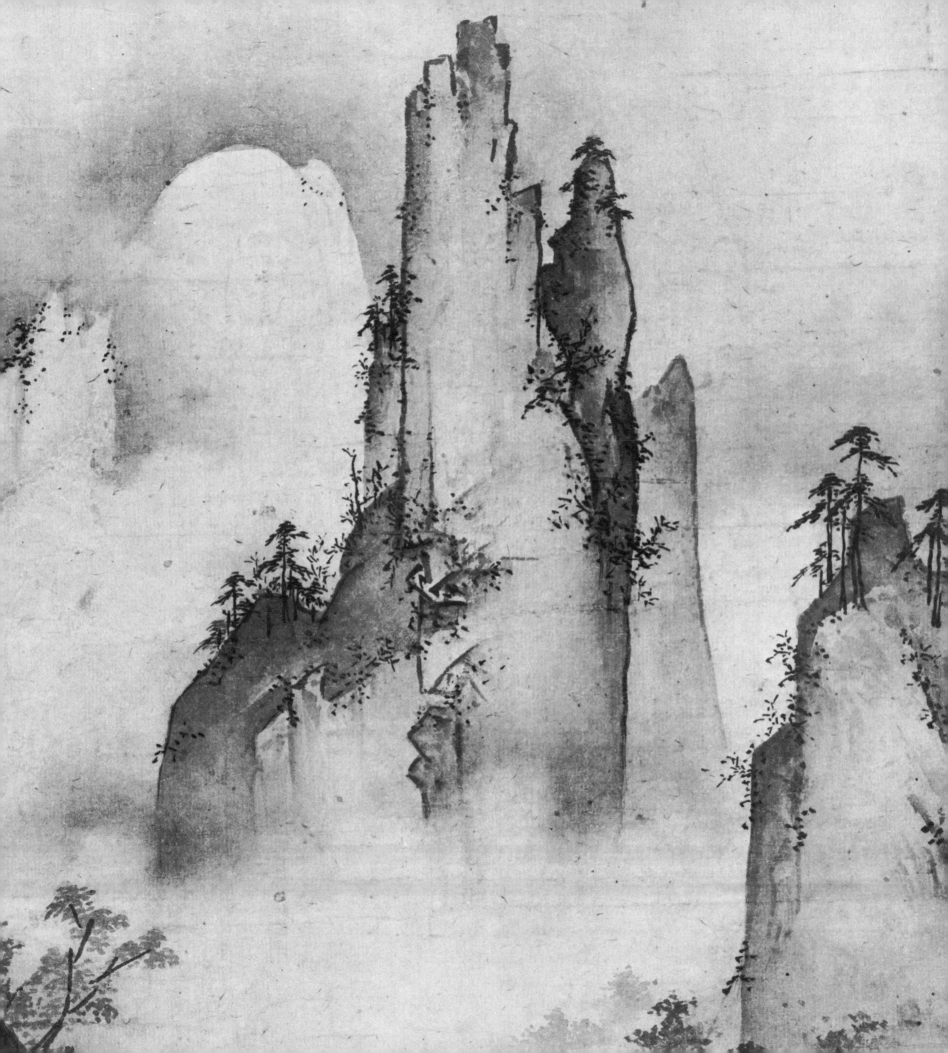

Figure 40. *Landscape*, detail, artist unknown, attributed to Shūbun (fl. 1423–60). Four panels from a pair of six-fold screens, ink on paper, each screen 153.4 x 360.0 cm. Yamato Bunkakan, Nara

in part from the development by Japanese painters of means of expressing individual taste, but also in part from the dramatic increase in the number and variety of Chinese paintings available for study. Among the followers of Shūbun, several major trends can be identified, ranging from the development of the expressive qualities of open space derived from earlier works of the Shūbun school by Shōkei Ten'yū (cat. no. 11) and Bunsei (fig. 11) to the strikingly innovative line of Sesshū and his followers, who incorporated many ideas derived from newly available Chinese models (cat. no. 18). A relatively conservative tendency which utilized compositional elements from works of the Shūbun school of the beginning or middle of the fifteenth century is typified by the painting of Gaku'ō Zōkyū [6] (figs. 12 and 37). The Baltimore *Landscape*, in overall composition and manner of execution, relates more closely to works by Gaku'ō than to works by any other identifiable late-fifteenth century follower of Shūbun.

The density of motifs in the foreground scene, which is given a compositional weight almost exceeding that of the distant mountains, and especially the predominance of the scholar's study in the foreground, are distinctive traits of Gaku'ō's work that are echoed in the Baltimore *Landscape*. This type of composition reflects Gaku'ō's conservative retrospective interest in a theme known as *shosaizu* (study paintings) in which the scholar's study is an essential motif. *Suishoku Rankō* is a fine example of

this genre, which declined in importance and nearly disappeared after the mid-fifteenth century but was temporarily revived by Gaku'ō and a few other painters near the end of the century. It is significant that while their contemporaries were concentrating their efforts on the study and interpretation of Chinese model paintings, Gaku'ō and the artist of the Baltimore *Landscape* were seeking inspiration in earlier works by Japanese master painters. By the beginning of the sixteenth century Gaku'ō's retrospective attitude is echoed even by such innovative painters as Sesshū, who clearly expresses his esteem for the earlier Japanese masters, Josetsu and Shūbun, in an inscription on one of his last paintings. [7]

Despite its close relationship to works by Gaku'ō, the Baltimore *Landscape* has many features which clearly identify it as the work of a separate artist. Although certain details such as the manner of rendering the foliage of the trees resemble early works of Gaku'ō, the brushwork in this painting is much finer and more delicate than that of Gaku'ō. Particularly conspicuous is the absence of the sharp, triangular textural strokes typical of Gaku'ō. The use of textural strokes in the Baltimore *Landscape* is unusually limited, and appears only in localized areas. The rock and mountain forms are largely depicted by means of contrasting ink washes, which produce overall a smooth, rather abstract effect. A somewhat mannered, decorative treatment of the rock forms is also seen in the sawtooth contours of the upper edges

of rocks in the foreground and in the contrasting form of the main boulder, which has a smooth, rounded shape with just one bump. This decorative effect appears as well in some of the foliage patterns, which seem to float on the surface rather than to describe natural form.

A similarly abstract and decorative treatment of landscape motifs is seen to an even greater degree in the pair of landscape screens traditionally attributed to Shūbun in the collection of the Yamato Bunkakan (fig. 40). For example, the somewhat awkward and highly stylized form of the foreground tree trunks, with a sharp bend near the base, occurs both in the Baltimore *Landscape* and in the Yamato Bunkakan screens. There is also some similarity in the rounded form of the foreground rocks and in the peculiar, localized facets and protrusions of the central peak. In contrast to the simpler foreground rocks, the strikingly greater elaboration of the protrusions on the distant mountains tends to attract attention to disparate points but does not effectively integrate with the form of the mountain itself.

The Baltimore *Landscape* also incorporates certain elements which are rarely found in landscapes of the Shūbun school and clearly indicate the distinct identity of its artist. The dead trees which appear to the left of the foreground rock have no precedent in works of the Shūbun school, and their incorporation here must be a specific idea of its artist derived from some other source. The heavy mists and delicate coloring are also distinctive features of this work.

Although the artist cannot be precisely identified, the Baltimore *Landscape* provides a rare and important example of a work of high quality, in very good condition,[8] by a follower of Shūbun in the circle of Gaku'ō. Looking back to models from the early fifteenth century, the artist portrays the scholar's study secluded among cloud-wrapped mountains with a grace and delicacy uncommon in his time.

ANN YONEMURA

NOTES

1. Document on the inside of the lid of the box: Brush and ink of this painting are full and firm,/It has the flavor of great vigor in spite of its small format./No one but an old painter could have made this./Out of admiration, here I write a few words on it./Spring of the year of Kigai [1803?]/Shō'in Uso Hiroshi/[Two seals] Seal of *Hiroshi* and of *Shō'in*.

2. Professor Shimada suggests that these may be Korean seals, judging from the style and type of inscription. It was not unusual during the Muromachi period for Japanese paintings to be taken to Korea for the appreciation of Korean scholars.

3. *Suishoku Rankō,* like many other landscapes of the early 15th century, was painted in a particularly tall format intended to receive the inscriptions of numerous Zen monks, friends of the monk who was to receive it as a farewell gift. From these inscriptions, when the biography of one or more of the inscribers is known, it is possible to establish a *terminus ante quem* for the date of execution of the painting. One of the three inscriptions on *Suishoku Rankō* is dated to 1445.

4. *Landscape,* attributed to Shūbun, hanging scroll, ink on paper, 88.4 x 26.1 cm, Jishō-in, Kyōto. Published in Fontein and Hickman, *Zen Painting and Calligraphy,* no. 46.

5. *Getsuya Sansui (Landscape in Moonlight)*, artist unknown, hanging scroll, ink and slight color on paper, 89.0 x 32.2 cm, datable to 1457 on the basis of its inscription by Son'an Reigen, Mizoguchi Collection. Published in Tanaka and Yonezawa, *Suibokuga,* pl. 62.

6. Gaku'ō Zōkyū, probably a Zen monk-painter with a special connection with Ryō'an Keigo, the abbot of Tōfuku-ji monastery, was active between 1482 and ca. 1514. In the diary of a contemporary monk he is described as a direct disciple of Shūbun. Kano Einō reports with some reservation in *Honchō Gashi* that Gaku'ō studied the Hsia Kuei style and skillfully painted lightly colored landscapes that resemble Shūbun's work. He cites another view that Gaku'ō is a style-name of Shūbun. Since the 17th century, therefore, Gaku'ō has been confused with the master Shūbun. His identity was established in the 1930's when a group of his paintings was brought to light by Mr. Okazaki, whose Tōkyō collection included most of the Gaku'ō works known today. His paintings have been better preserved than those of his contemporaries, and are published in many books. The latest and most extensive study of this painter is Tanaka Ichimatsu's article, "Gaku'ō Zōkyū no Shiteki Ichi," in *Nihon Kaigashi Ronshū,* pp. 308–47. Gaku'ō's *Eight Views of Hsiao and Hsiang* are extensively discussed against the general background of paintings of this theme by late-fifteenth century artists in Richard Stanley-Baker's article, "Gaku'ō's Eight Views of Hsiao and Hsiang."

7. This inscription, dated 1495, appears on Sesshū's *Haboku Landscape* (fig. 13), which was a gift to his disciple Sō'en.

8. The condition of this painting is very good except for some wear along the lower edge, some damage in an area near the left edge of the distant mountain range, and some horizontal cracking which is now repaired.

14 *Mountain Landscape*

Saiyo (fl. late 15th century)

Hanging scroll, ink and slight color on paper, 56.4 x 21.6 cm. Square intaglio seal reading Saiyo.
Seattle Art Museum, Eugene Fuller Memorial Collection (55.55)

In the foreground, a tiny figure carrying firewood makes his way behind an outcrop of rocks toward the moisture-laden forest which occupies the center of the picture. The destination of the figure, the houses at the right of the forest, can be dimly glimpsed behind the blanket of misty trees. Directly above the trees towers a ridge of gigantic peaks, their bases entirely shrouded in clouds. Behind these soar ranges of wispy mountains, a fairyland of enchanted forms scarcely visible in the heavy atmosphere of mists and cloud. Above them, in the stormy evening sky, the moon is barely perceptible. Fully half of the picture surface is devoted to vaporous space and the stormy heavens. The tiny figure is dwarfed against the majesty and breathtaking beauty of the scene.

On the whole the condition of the painting is good, although there is extensive retouching in the foreground rocks and in the dark area in the trees above the figure. A blank band cuts off the rocks at the bottom; clearly, at some point the bottom of the painting was damaged and replaced by blank paper. The upper half of the painting is entirely untouched.

Professor Shimada was the first to observe that the seal on this painting is identical with a square intaglio seal recorded in *Koga Bikō* which may be read as *Saiyo*. The latter seal, introduced under the entry on Soga Dasoku, is reported to have appeared on a scroll depicting *Daruma Crossing the River Yangtze on a Reed* in Liang K'ai style.[1]

The name *Saiyo* appears in a round relief seal on several paintings, together with the square relief seal *Bokkei*. This painter, who may be called Bokkei Saiyo, was active in the 1450's and 1460's and was closely associated with the famous Zen revivalist Ikkyū Sōjun (1394–1481) of the Daitoku-ji. His paintings include two portraits of Ikkyū and a remarkable Daruma, all of which bear dated inscriptions by Ikkyū.[2]

On the ground of the period of his activity, it is generally assumed that this Bokkei Saiyo corresponds to the "Hyōbu Bokkei" who is recorded as having been a direct student of Shūbun.[3] It is further assumed, on the ground of his close connection with Ikkyū, that he is the same painter Bokkei whose paintings of the Zen masters Rei'un and Kōgen were seen by Ikkyū in 1469 at the Shū'on-an, a temple about halfway between Kyōto and Nara.[4] If this Bokkei followed Ikkyū to the Shū'on-an to escape the wars that were ravaging the capital (Ōnin Civil War, 1467–1477), it is likely that he is the "painter Hyōbu" who died in Ise in 1473:[5] this date would also

be fitting for a direct student of Shūbun. The literary evidence concerning Bokkei is fragmentary and deserving of extreme caution, since there appears to have been at least one other painter called Bokkei who was also active in the circle of Ikkyū: this figure was named Tōrin An'ei; he received the studio name Suiboku from Ikkyū, and he was active in the 1480's.[6]

Although no incontrovertible evidence linking the Saiyo of the Seattle painting to Bokkei Saiyo is yet publicly known,[7] there is a certain amount of circumstantial evidence. First, there is a painting of *Hotei (Pu-tai)* bearing the same square intaglio seal of *Saiyo* that appears on this Seattle landscape which apparently is consistent in style with Bokkei Saiyo's figure paintings.[8] Second, identical *Dasoku* seals have been found accompanying both the square intaglio seal of *Saiyo* (on the painting of *Daruma Crossing the Yangtze River* mentioned in the *Koga Bikō*) and the round relief seal of *Saiyo* (on the *Hotei* mentioned in the same book).[9] Although these are probably later additions, they demonstrate at least that later connoisseurs considered the two Saiyos to be the same individual. Third, the Seattle painting, which is in Yü-chien style, has certain features in common with some of the paintings in Yü-chien style executed by painters associated with Ikkyū and the Daitoku-ji. Apparently fond of the *haboku* (ink-breaking) manner[10] of Yü-chien, this group produced paintings which are quite distinct from the Yü-chien style of the Sesshū, Kano, or Ami schools.

The works of the late Southern Sung artist generally known as Yü-chien[11] enjoyed a high degree of popularity in Muromachi Japan. Contrary to the opinion of early critics such as Tōhaku[12] and Kano Einō (*Honchō Gashi*), the Yü-chien style was known well before the time of Josetsu and Shūbun: the late-fourteenth century landscapes by Gukei Yü'e demonstrate clear influence from the Yü-chien manner (fig. 6).[13] During the Shūbun era, the Yü-chien style appears to have been largely overshadowed by the mainstream Ma-Hsia style, although it appears sporadically, sometimes combined with Ma-Hsia elements and generally somewhat transformed by the indigenous tendencies of the Shūbun school.[14] In the latter half of the fifteenth century, when the styles of individual Sung masters such as Hsia Kuei and Mu-ch'i were studied more assiduously, the Yü-chien style came into its own. At this time, according to Tōhaku,[15] the Shōgun Ashikaga Yoshimasa had Yü-chien's handscroll of the *Eight Views of Hsiao and Hsiang* cut up and remounted as eight hanging scrolls.

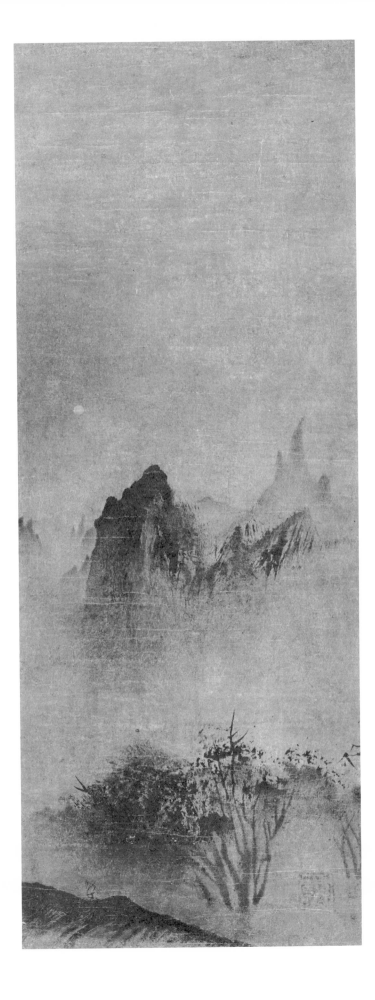

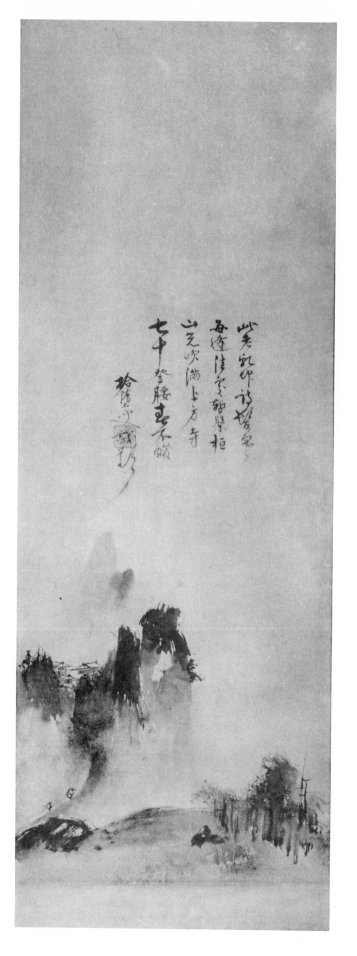

Figure 41. *Haboku Landscape*,
Bokusai (d. 1492), inscribed by
the artist. Hanging scroll, ink
on paper, 106.3 x 38.3 cm.
Shinju-an, Daitoku-ji,
Kyōto

Sesshū made a point of studying the Yü-chien style, as seen in his fan paintings after various Chinese masters.[16] Some of his followers, notably Sō'en, specialized in this manner. Sesshū recognized Sō'en's proficiency in the wash style of Yü-chien when he presented his disciple with his own *Haboku Landscape* in Yü-chien style (fig. 13). Moreover, with the development of screen and sliding-door painting, the sparse wash style of Yü-chien came to be favored as a deliberate contrast to the more descriptive, linear styles of Ma Yüan, Hsia Kuei, and Sun Chün-tze. The stylistic program of the sliding-door paintings in the Rei'un-in and the Shinju-an provide evidence of this conscious juxtaposition of paintings based on different stylistic models.[17]

As the Yü-chien manner became more popular, various post-Shūbun schools produced their own distinctive versions of it. Sesshū (fig. 13) and his followers, such as Sō'en,[18] emphasized broad, square brush strokes and showed, even in this sparse style, a constant concern for rendering mass as a solid, integrated unit. Representing the Ami school, Sō'ami's hanging scrolls of the *Eight Views of Hsiao and Hsiang* in the Daisen-in[19] (fig. 55) are unique in their ample exploitation of broad, coarse brushwork in the earthen banks and mountains. Kano Motonobu's Yü-chien style, seen on the eight sliding-door paintings in the Rei'un-in, still maintains the artist's rather flat depiction of rock surfaces and his concern for the consistent articulation of the composition as a whole.[20]

Against this background of distinctive school styles, the Saiyo landscape can be easily related to works of painters of the so-called Soga school.[21] In the landscape painted and inscribed by Bokusai (fig. 41) the technique used to depict trees in mist is very similar to that used in the Saiyo painting.[22] Here, unlike the techniques of Sesshū, Sō'ami, or Motonobu, the tree trunks themselves have been blotted with a water-laden brush to blur the outlines and cause them to merge with the massed dots which represent the foliage. A similar effect, although more simplified, is achieved in the tree foliage of the *Landscape* by Sōjō inscribed by Bai'un Shū'i (d. 1505) in the Kobayashi Collection. The development of this wash technique by the Daitoku-ji school of painters may owe a little to Mu-ch'i,[23] but it is clear from the conformation of the silhouetted tree branches and the curiously abbreviated figures that reference in the Seattle painting is to Yü-chien rather than Mu-ch'i. The major peaks of the Saiyo *Mountain Landscape* were painted with an extremely large, coarse brush, possibly

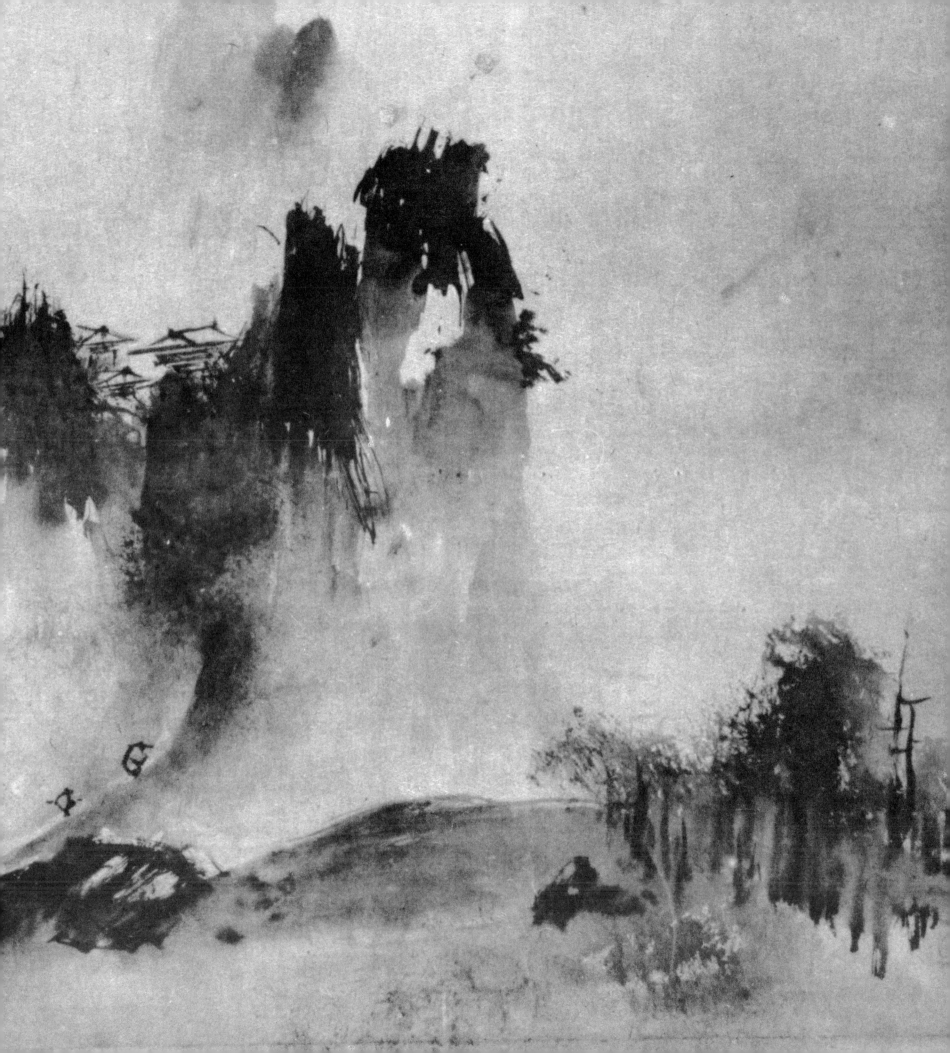

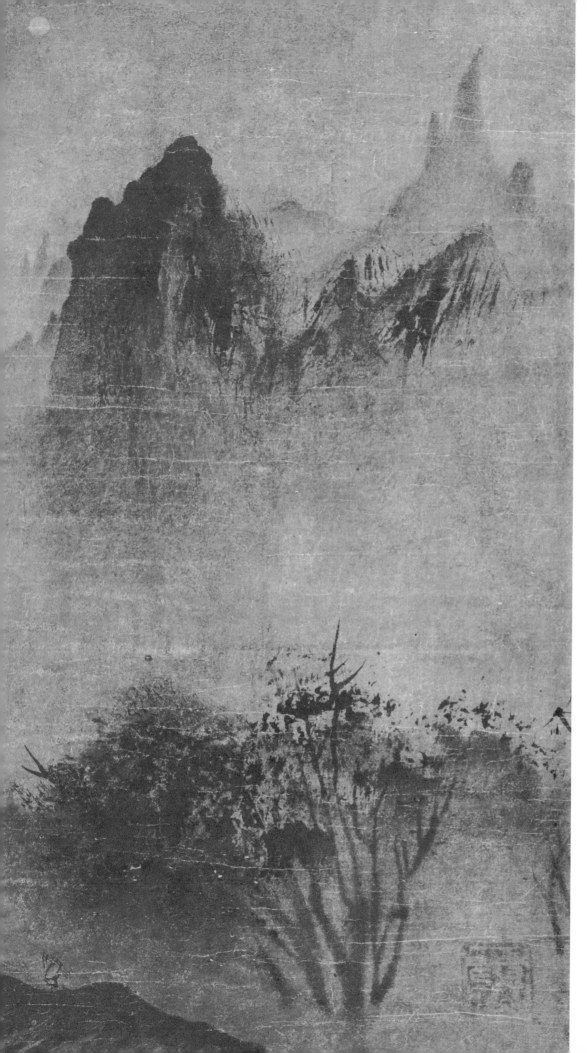

made of an unusual material such as bamboo or straw, and may be compared to the coarse brush used in Yü-chien's *Lu-shan* painting. The rough brush was taken up with a vengeance by painters at Daitoku-ji such as Bokusai (fig. 41) and Sōjō. The most extreme examples are the landscapes in Yü-chien style in the second *gekan* room of the Hōjō building of the Shinju-an, which are thought by some to have been painted by Sōjō.[24] The Saiyo landscape, less exaggerated in this respect, may be seen as a predecessor of this development.

The Saiyo *Mountain Landscape* retains certain traditional elements which are lost in Sesshū and painters of other post-Shūbun schools. The swaying W-shaped strokes which appear in the coarse brushwork of the tall peaks may be compared to similar motions seen in the foreground of Gukei's *Rainy Landscape* in the Tōkyō National Museum (fig. 6) and of Sessō's Yü-chien style landscape in the Masaki Art Museum (fig. 42).[25] Saiyo also displays some interest in expansive space between the foreground and background, which is appropriate for a probable direct student of Shūbun. Despite this, the tendencies of the late fifteenth century are evident in the increased size and proximity of foreground elements. What is entirely new, however, is the vertical structure of the composition. A comparable, though more developed version of this tendency is seen in the anonymous *Landscape in Moonlight* in the Moriya Collection.[26] Here the question of new models arises. It is possible that both Saiyo and the artist of the Moriya landscape were influenced by the same model in their treatment of moonlit tall peaks in the background.

In view of the connections with the Yü-chien style developed by the Daitoku-ji school of painters, a style favored by Ikkyū who painted some amateur landscapes in this manner,[27] there is ample reason to suppose that this Saiyo is indeed the same Bokkei Saiyo who was closely connected with Ikkyū. His brilliance in landscape painting is clearly not inferior to his genius as a figure painter. His brushwork is firm and round. His use of dots and wash to create the effect of trees in mist is marvelously evocative, yet realistic too. The central peak, in which the form has been built up with dark and light wash and then brushed over with a coarse brush in powerful strokes, is both solid and dramatic. His handling of the wispy peaks behind and the misty atmosphere from which they emerge reveals a remarkable poetic sensitivity. It is an excellent work by one of the best of Muromachi painters.

RICHARD STANLEY-BAKER

Figure 42. *Haboku Landscape*, detail, Sessō Tōyō (fl. ca. 1460–88), inscribed by Isan Shūsei. Hanging scroll, ink on paper. Masaki Art Museum, Ōsaka

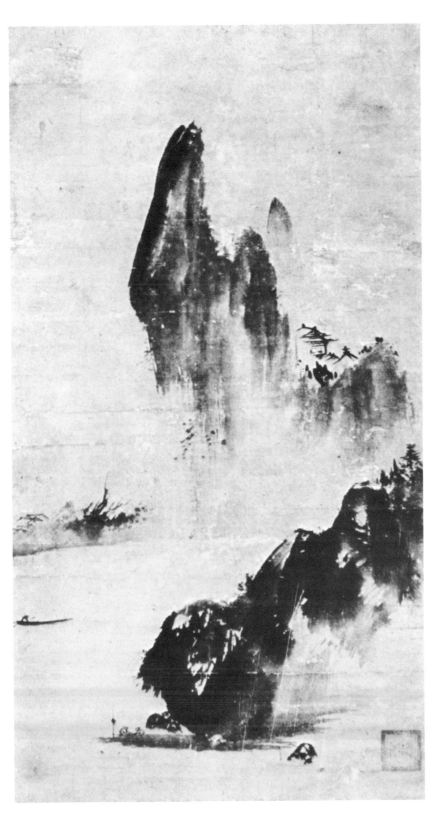

NOTES

1. *Koga Bikō*, p. 605. For Liang K'ai, see cat. no. 5, n. 4.

2. The portrait of Ikkyū in the Shōrin-ji temple, Shiga prefecture, is dated 1452, the portrait in the Umezawa Kinenkan 1453, and the *Daruma* in the Shinju-an 1465. All three paintings are published in Minamoto, "Soga-ha to Asakura Bunka." There is also a pair of paintings without inscriptions depicting Kanzan and Jittoku (ex-Gōchi Collection) published in Matsushita and Tamamura, *Josetsu, Shūbun, San-Ami*, pls. 107–8. All bear the round relief seal *Saiyo* and the square relief seal *Bokkei*.

3. Recorded in *Son'an-kō*, the anthology of the literary works of the eminent Gozan monk Kisei Reigen (or Son'an Reigen, 1403–88).

4. *Ikkyū Oshō Nempu* (Chronological Record of Ikkyū's Life), the entry of the first year of Bunmei (1469) quoted in *Koga Bikō* under the entry on Kantei, p. 612. The author of *Koga Bikō* follows Kano Einō's identification of Bokkei as Kantei in his *Honchō Gashi*. For Kantei, see cat. no. 15.

5. Recorded in *Daijō-in Jisha Zōjiki*, a day-to-day record of miscellaneous matters of the Kōfuku-ji temple and Kasuga shrine kept by priests of Daijō-in, a subtemple of Kōfuku-ji, Nara. See Tanaka Ichimatsu, "Soga Dasoku to Sōjō," n. 6.

6. Recent arguments concerning the identity of Bokkei are presented in Tanaka Ichimatsu, "Soga Dasoku to Sōjō," and in Minamoto, "Soga-ha to Asakura Bunka." Both Tanaka and Minamoto, however, have failed to observe the possibility that there might have been more than one painter named Bokkei. They have assumed that Hyōbu Bokkei is Bokkei Saiyo and is the Hyōbu who died in 1473 in Ise. They further assume that this is the same man as Tōrin An'ei who is recorded in Ōsen Keisan's *Ho'an Keikashū* as active in 1481. In addition to the chronological problem, it is unlikely that the name Bokkei Saiyo, which contains a reference to "ink" and "colors," belongs to Tōrin An'ei, whose name contains equally paired characters referring to the peach paradise of Chinese legend. The problem is further complicated by Kano Einō's identification of Kantei as Bokkei in his *Honchō Gashi* (see cat. no. 15).

7. Tanaka Ichimatsu, "Soga Dasoku to Sōjō," n. 5, reports a number of Bokkei paintings he has seen, including a snow landscape. Details of the seals and style of these paintings have not yet been published.

8. This painting, as yet unpublished, was seen in the Ōsaka area by Professor Shimada some years ago.

9. *Koga Bikō*, p. 611.

10. *Haboku* (*p'o-mo* in Chinese) is a technical term signifying a specific way of using ink in painting. *Ha* (or *p'o*) means "to tear, to break," and hence the term is usually translated "broken ink," which some think is meaningless and misleading. It first appeared in a T'ang dynasty painting text, but without explanation. An eighteenth century Chinese painter-critic explained that *p'o-mo* meant to contour forms (mainly rock

129

forms) in thick ink over a preliminary drawing or wash in thinner ink. But this definition, based on the landscape painting styles of later literati schools, does not satisfy references in early texts. Since the term has been in use, although infrequently, in different contexts over many centuries, it can and should be interpreted more generally to allow room for the different artists, schools, and periods associated with it. Various interpretations have been proposed. Among them, those by Alexander Soper and Tanaka Toyozō seem probable. Soper says *p'o-mo* is a graded ink wash technique, while Tanaka identifies it as a method for creating tonal harmony in building forms by applying layers of pale ink. The key point is in the term "to break." It should be remembered that in Chinese painting terminology there are several terms which include *p'o* as a component meaning to break up the even tonality of ink, color, or just the blank area of paper or silk. The term, then, can be interpreted as a technique of using ink so that the even tonality of lighter ink in lines, washes, or on blank areas of paper or silk is broken by remarkable, sudden changes of tone created by any technique of adding darker ink — in fine or broad lines, in sweeping brush strokes, in washes or dots. If this interpretation is acceptable, then the *Eight Views of Hsiao and Hsiang* by Yü-chien (fig. 51), which features marked use of dark ink accents on hill tops, on trees, and on rocks which produce contrasts against light ink background, and the *Haboku Landscape* by Sesshū in the manner of Yü-chien (fig. 13) can be called *haboku* landscapes. In Japan, the *haboku* method has traditionally been associated almost exclusively with Yü-chien. There is no sure evidence, however, that Yü-chien was especially proficient or prolific in the *haboku* manner. Nor does Sesshū say clearly in his inscription on his *Haboku Landscape* that his landscape or the Yü-chien model for it is in the *haboku* manner, although he does mention that he learned the method in China during his visit in the 1460's.

11. Yü-chien was one of the Chinese Southern Sung painters who most influenced Muromachi ink painting, even though he was little known in China after the 15th century. His works are not as well documented as those of Mu-ch'i. Fifteen scrolls, including the eight scrolls of the *Eight Views of Hsiao and Hsiang,* had been recorded in Japan by the end of the 16th century. All that remains today are three of the *Eight Views* and two segments from the *Lu-shan* (Mount Lu) handscroll that was cut into three pieces. The two works differ in manner of execution. The *Eight Views* is marked by economical use of brush and ink, facile brushwork, and attractively contrasting ink tonalities, while the *Lu-shan* displays bold, strong brush strokes and rich values of very wet washes. Japanese followers of Yü-chien in one way or another combine the two aspects of his style for their own purposes. These paintings are published in Toda, *Mokkei, Gyokkan.*

The identity of Yü-chien has not yet been firmly established. Ten'in Ryūtaku (1423–1500), in his inscription on Sesshū's landscape in the Yü-chien manner, identifies Yü-chien as Ying Yü-chien of West Lake. (His inscription is included in Fujita, *Muromachi Jidai Gasanshū,* item 65). Hasegawa Tōhaku (1539–1620) was inclined to think he was Yü-chien Jo-fên. Ying Yü-chien was a Ch'an monk of Ching-tzu-ssu on the south side of Hangchou's West Lake, who painted landscapes following Hui-ch'ung of the early Northern Sung. (See Hsia Wen-yen, *T'u-hui Pao-chien* [1365], chap. 4.) Jo-fên Yü-chien, or Jo-fên Chung-shi, was also a monk. He served for some time at a temple of the T'ien-t'ai sect near West Lake, Hsiang-T'ien-chu-ssu. Later he returned to his native province of Mouchou, where he built a hermitage on a mountain stream that he named Yü-chien. Hence he gave himself the same style-name. Some Yüan connoisseurs say he liked to paint mountains in clouds. (See Wu T'ai-su, *Sung-chai Mei-p'u,* chap. 14; and Hsia Wen-yen, *T'u-hui Pao-chien,* chap. 4.) Modern scholars are inclined to agree with Tōhaku and identify Yü-chien as Jo-fên Chung-shi. See Sirén, *Chinese Painting,* 2:142–44; and Suzuki, "Gyokkan Jakufun Shiron."

12. *Tōhaku Gasetsu,* p. 7.

13. Gukei's *Rainy Landscape* (fig. 6) and his two landscapes in the Masuda Collection reveal knowledge of the Yü-chien manner. See Shimada, "Yū'e Gukei no Sakuhin Nishu."

14. For example, see the *Landscape* attributed to Shūbun in the Ueno Collection, which bears an inscription by Kōzei Ryūha (d. 1446), in *Kokka,* no. 214. The *Haboku Landscape* in the Ishi'i Collection inscribed by Kōzei Ryūha (fig. 52) nicely exemplifies the "Shūbunization" of the Yü-chien style. The composition is dominated by a central mountain in a manner reflecting tendencies seen in *Suishoku Rankō* (fig. 39), and the space in the middle ground is more typical of the expansive space seen in paintings of the Shūbun school than in anything associated with Yü-chien.

15. *Tōhaku Gasetsu,* p. 7.

16. Tōkyō National Museum, *Sesshū,* pl. 14.

17. The sliding-door paintings from the Rei'un-in and the Shinju-an are illustrated in *Shōhekiga Zenshū,* vol. 8 (Daitoku-ji), and *Hihō,* vol. 11 (Daitoku-ji).

18. For Sō'en's *Haboku Landscape* in the Fuku'oka Collection, see Matsushita, *Muromachi Suibokuga,* pl. 45.

19. The Daisen-in, famous for its stone garden, is a subtemple of Daitoku-ji monastery, Kyōto, built to commemorate the Zen priest Kogaku Sōkō (d. 1548). The present Hōjō (Abbot's Quarters), completed in 1513, is one of the best examples of Zen architecture of the Muromachi period. Its interior was decorated with sets of sliding-door paintings of different subjects and varying styles by three painters — Sō'ami, Kano Motonobu, and Kano Yukinobu. All extant panels have been remounted in the form of hanging scrolls for purposes of preservation. The Sō'ami set (fig. 55), a landscape of the four seasons incorporating the *Eight Views,* was originally done on more than sixteen panels installed in the *shitchū* (center room). As usual for Muromachi sliding-door paintings, it was not signed or sealed by the artist. There is no historical record to

validate the temple's traditional attribution to Sō'ami except a document that suggests some connection between the temple founder and the artist, but the traditional attribution is generally accepted by both pre-modern and modern scholars. The greater part of the work is in good condition with the exception of some sections of damage on the smaller panels. See the sections on the Daisen-in paintings in *Shōhekiga Zenshū*, vol. 8, and *Hihō*, vol. 11.

20. Tajima, *Motonobu Gashū*, 1: pls. 34–41.

21. Soga school refers to a group of painters of the 15th and 16th centuries who worked in the orbit around the 15th century Zen master Ikkyū Sōjun (1394–1481) and his disciples. Traditional lineage systems show them as descendants of the Soga family that begins with Dasoku, or descendants of his in terms of teacher-and-disciple relationship. These painters share the prefix of either *Sō* or *Shō* in their Buddhist names, which indicates their kinship to the Daitoku-ji line in the genealogy of Japanese Zen Buddhism. The school includes the names Dasoku, Sōjō, Sōyo, Shōsen, Shōshō, and Shōkyū. A few more painters in the 17th and 18th centuries also claimed descent from Dasoku. Because of total lack of first-hand historical evidence about the activities of Soga painters in the Muromachi period, their identities and interrelationships are very cloudy. Since the 17th century a series of scholars have proposed versions of the Soga lineage that rarely accord with each other. A good number of paintings attributed to Soga artists exists today, the most important among them being the sliding-door panel paintings in the Hōjō (Abbot's Quarters) of the Shinju-an subtemple of Daitoku-ji (fig. 19), the headquarters of the Ikkyū line. They do not show, however, common stylistic features that are readily recognizable. Recent studies of the Soga school center on the Shinju-an panel paintings, and on a few works of Sekiyō and Sōjō in an attempt to identify these artists. The earliest pedigree of the Soga family is that written in 1656 by Soga Nichoku-an, now kept in the Hōryū-ji temple, Nara. See the entries in *Koga Bikō* for Shūbun (different from the famous Shūbun of Shōkoku-ji), Dasoku Sōyo, Shōsen, Soga Sōyō, and Shōshō, on pp. 604–16; Tanaka Ichimatsu, "Soga Dasoku to Sōjō;" and Minamoto, "Soga-ha to Asakura Bunka."

22. Bokusai is the style-name of Zen monk Botsurin Jōtō (d. 1492). A disciple of Ikkyū, he once lived at Shū'on-an and later became the abbot of Shōrin-ji of Ōmi province, which now owns Bokkei's portrait of Ikkyū. Unlike his master, he was active in the literary associations of Gozan monks, and often exchanged poems with them. The Shinju-an *Landscape* and the *Grapes* of the ex-Murakami Collection (published in *Nihon Kokuho Zenshū*, no. 1) display his high achievement in painting. For a biographical study of this monk-painter, see Washio, *Nihon Zenshū-shi no Kenkyū*, pp. 338–42; and Nakamura, "Bokusai hitsu Sansui-zu ni tsuite."

23. Compare with his *Evening Bell from a Distant Temple* in *Sōgen no Kaiga*, pls. 117–18.

24. Sōjō is thought to be a member of the Soga school, but because of the very complex problems surrounding study of the Soga family, his identity is cloudy. Some scholars identify him as Soga Dasoku, son of the legendary ancestor of the Soga family said to be a Chinese immigrant; others identify him as the son of Dasoku. Two landscapes by Sōjō in the manner of Yü-chien have recently become known: one, inscribed by Bai'un Shū'i, is in the Kobayashi Collection; the other, inscribed by Keijo Shūrin, is in the ex-Kuhara Collection. These paintings shed some light on the date of Sōjō's activity, placing him in the late 15th century. Tanaka Ichimatsu, comparing these two works with the landscapes done in the same manner in the rear *gekan* room of Shinju-an's Hōjō, asserts that Sōjō is the painter responsible for those door-panel paintings which can be dated ca. 1491. See Tanaka Ichimatsu, "Soga Dasoku to Sōjō."

25. Sessō Tōyō is presumed to have been roughly contemporary with Sesshū Tōyō, for two of his landscapes bear inscriptions by Zen priests indicating that he was active from the 1460's to the 1480's. Otherwise his life is obscure. More than ten paintings by the artist, including the triptych of *Three Teachers* flanked by *Lotus* in the Museum of Fine Arts, Boston, are known to exist. Kano Einō in the *Honchō Gashi* gives a puzzling comment on this painter, saying that Sessō learned from Shūbun, and then reporting a Sessō painting inscribed by the artist, "by the brush of Tōyō, Zen monk from Japan." Kano Einō says this painting is very close in style to Sesshū, and supposes that Sessō might have been a disciple of Sesshū Tōyō. Hiyama Tansai comments in the *Koga Bikō* that a figure painting he saw by Sessō done in the Liang K'ai manner showed little Sesshū influence. Extant Sessō works support his opinion and display in a remarkable way features of the post-Shūbun style.

26. Unpublished photograph is in the Photographic Archives, Department of Art and Archaeology, Princeton University. A landscape which shares the same tall, vertically structured format and is very probably by the same hand is in the Fuji'i Collection and published in *Kokka*, no. 341. See Tanaka Ichimatsu, *Nihon Kaigashi Ronshū*, fig. 188.

27. Tanaka Ichimatsu, "Soga Dasoku to Sōjō," fig. 4.

Autumn Moon over Tung-t'ing Lake / Evening Bell from a Distant Temple AND Descending Geese on Sandbanks / Evening Snow on the Hills

Kantei (fl. late 15th century)

Two hanging scrolls, ink on paper, each 46.0 x 30.1 cm, from a set of four illustrating the Eight Views of Hsiao and Hsiang (Shōshō Hakkei). Square intaglio seal reading Kantei, 2.1 x 2.1 cm. Mary and Jackson Burke Collection

The sole source of biographical information about Kantei appears in the seventeenth century *Honchō Gashi*, where Kano Einō says: "The painter Kantei was styled Bokkei; he was generally known as Nara Hōgen [a monk of Nara with the clerical rank of Hōgen]; in his painting style he followed Shūbun, but in figure painting he followed to some extent Liang K'ai of the Southern Sung; his brushwork was fine but not detailed and it was accomplished in an abbreviated manner; in his screen painting he used light colors; he applied ink but not thick colors." [1] Kano Einō's identification of Kantei as Bokkei is not supported by any other evidence. Moreover, since the identity of the painter or painters named Bokkei is still a complex problem, it is not possible to determine to which Bokkei Einō is referring (see cat. no. 14).

Consequently, literary sources are of limited aid in developing a concept of this painter. Kantei's artistic personality must be constructed on the basis of his surviving paintings. These are largely landscapes, but two figure paintings are also known: a *Portrait of Tōgan-koji* in Yên Hui style formerly in the Moriya Collection, [2] and a *Daruma* in Liang K'ai style mentioned in the *Koga Bikō*. [3] There is also a pair of flower-and-bird paintings in the Ino'ue Collection, [4] but the poor quality and positioning of the Kantei seals suggest that these seals are later forgeries.

Kantei's landscape paintings are close in some respects to works of the so-called Soga school, the painters associated with the Daitoku-ji temple in Kyōto in the late fifteenth century. [5] Kantei's brushwork, in particular, is similar to those paintings bearing the seal *Sekiyō* [6] (fig. 43), and to the sliding-door landscape paintings in the Shinju-an datable to 1491 (fig. 19) which are thought to be by the same artist. Kantei's use of a blunt brush to produce numerous planes with straight lines of even thickness, his fondness for right angles, his broad square axe-strokes, and his economy and forthright simplicity find many parallels in the work of Sekiyō. Because of this stylistic similarity, as well as Kano Einō's suggestion that Kantei was the Daitoku-ji painter Bokkei, it has been considered that Kantei might have been related to the Soga school.

The influence of the Shūbun school also appears in Kantei's landscape motifs. The straight pines which accentuate the vertical aspect of the ascending peak in his *Spring Landscape* (cat. no. 17) relate to the Shūbun type of composition seen in the Seattle *Landscape* and the Yamamoto *Landscape* (see cat. no. 10). Another tree motif appearing in Kantei's *Sunset Glow* (cat. no. 16), as well as in his *Returning Sails* in the Tōkyō College of Arts (fig. 45), also relates to the Shūbun tradition: the manner in which the spreading pines at the corner of the composition are used to emphasize the expansive vista across the lake can be compared to *Chikusai Dokusho* (fig. 9).

Other features, however, relate to a quite different type of model painting — that associated with the Chinese Southern Sung Academy artist Hsia Kuei. In *Sunset Glow* (cat. no. 16) and again in the Tōkyō College of Arts *Returning Sails* (fig. 45), the foreground is set very close to the viewer and the means of entering the scene is carefully defined with a path leading behind the large rocks. This is quite different from the more gentle, less defined type of entry seen in the *Spring Landscape* exhibited here (cat. no. 17), which is closer to the type of the Shūbun school. Another new feature in Kantei's *Sunset Glow* and in the left-hand work from the Burke Collection is the use of large rocks rising abruptly in the immediate foreground. These features show an interest in increased articulation of space and a desire to render mass in a relatively realistic manner. They are based on paintings in Hsia Kuei's style which provided models for a number of painters working in the late fifteenth century. Sesshū, in particular, carefully studied these paintings.

Therefore, although there is no reliable documentary evidence about the period of Kantei's activity as a painter, the style of his works places him in the context of late-fifteenth century post-Shūbun developments. Kantei's work postdates the expansive lake landscapes of painters such as Shōkei Ten'yū (cat. no. 11) and Bunsei (fig. 11) in the 1450's, although he retains some measure of influence from landscapes of this type. Like the late-fifteenth century painters of the Sesshū school in particular, Kantei reveals much interest in models in the Hsia Kuei style and in definition of space within the picture. As a result, the expansive void space characteristic of landscapes of the Shūbun school (*Chikusai Dokusho*, fig. 9; *Suishoku Rankō*, fig. 39) and post-Shūbun lake landscapes is severely reduced. However, he clearly predates the degeneration into excessive preoccupation with detail and the breakdown of the spatial distinction between near and far seen in early-sixteenth century paintings, such as the work of Soga Shōsen. [7] In contrast to his contemporary in Kamakura, Kenkō Shōkei (cat. no. 24), Kantei appears unaffected by trends toward decorativeness, banality of motifs, and by the reduction

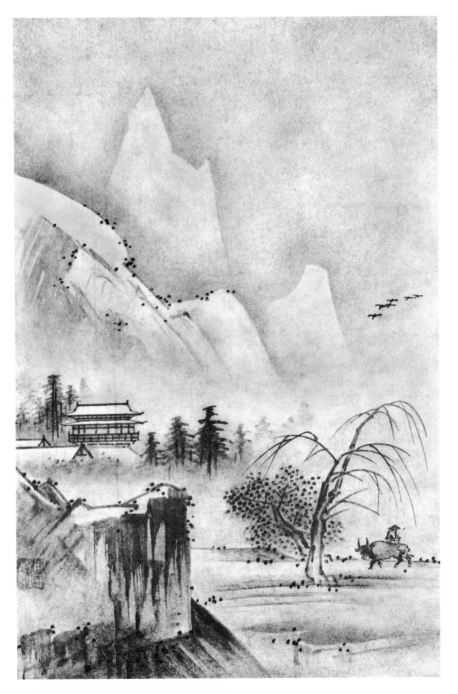

Figure 43. *Landscape*, Sekiyō
(fl. late 15th century). Hanging
scroll, ink on paper, 61.0 x 30.0
cm. Fuji'i Collection,
Nishinomiya, Hyōgo
prefecture

of spacious vistas. Shōkei anticipates directions which
were to be followed in the sixteenth century. He tends to
divide scenes into foreground and background areas,
with a heavy emphasis on the foreground, and seems
more interested in decorative effects than in the repre-
sentation of depth. Kantei, on the other hand, continues
to make a clear distinction between foreground, middle
ground, and background motifs. He can be placed as an
approximate contemporary of Sesshū, sharing some of
his interests in pictorial structure while remaining closer
to the brush style and mood of painters of the Soga
school such as Sekiyō.

This pair of paintings in the Burke Collection makes
clear reference to scenes from the *Eight Views of Hsiao
and Hsiang,* known in Japanese as *Shōshō Hakkei.* The
Hsiao and Hsiang are rivers of southern China which
flow north into Tung-t'ing Lake in Hunan province, and
hence designate the region along the two rivers. Eight
views in particular, famous for their poetic beauty, pro-
vided themes for landscape painting: mountain village
in light mist, returning sailboat from a distant shore,
autumn moon over Tung-t'ing Lake, rainy night on the
Hsiao and Hsiang, evening bell from a distant temple,
sunset over a fishing village, wild geese alighting on flat
sandbanks, and snow at evening over the river.

In China, the concept of the *Eight Views of Hsiao and
Hsiang* as a subject for painting is said to have originated
with the eleventh century painter Sung Ti, and it be-
came a popular topic for painters from the Southern
Sung on.[8] In Japan the *Eight Views* appears to have been
one of the first subjects of ink painting, for it is the
theme of the earliest extant Japanese ink painting, a
view of *Descending Geese on Sandbanks* by Shikan (fig. 2)
which bears an inscription by I-shan I-ning who died in
Japan in 1317.[9] By the mid-fifteenth century, Hsiao-
Hsiang motifs had become standard elements in screen-
and sliding-door painting of the Shūbun school, where
they formed part of four-seasons compositions, a combi-
nation apparently unique to Japanese painting.[10] In the
late fifteenth century, concomitant with the increasing
importance of screen- and sliding-door painting, the
Eight Views often became the central theme of such paint-
ings.[11]

In Japanese hanging scrolls the *Eight Views* were gener-
ally depicted in eight separate compositions. As early as
the mid-fourteenth century, however, there also existed
a convention of combining two of the themes in each
scroll to make a set of four paintings.[12] The works of
Kantei demonstrate that both these conventions were

followed in the late fifteenth century. The two Burke paintings refer to four of the Hsiao-Hsiang themes and represent half of a four-painting set. The moon and temple gate in the right-hand scroll indicate the views of *Autumn Moon over Tung-t'ing Lake* and the *Evening Bell from a Distant Temple,* while the descending geese and snow-covered peaks in the left-hand work suggest *Descending Geese on Sandbanks* and *Evening Snow on the Hills.* Other works by Kantei containing Hsiao-Hsiang themes depict each topic singly, and thus represent fragments of one or more eight-painting sets: the third Kantei landscape exhibited here (cat. no. 16) is *Sunset Glow over a Fishing Village;* the painting in the Tōkyō College of Arts (fig. 45) presents *Returning Sails from a Distant Shore;* and a painting in the Tōkyō National Museum (fig. 46) depicts *Evening Bell from a Distant Temple.*

On the back of the two Burke scrolls, behind the seals, the numbers "four" and "six" are written on the right and left paintings, respectively. This indicates that at one time these two paintings were mounted on a screen composed of at least six or possibly eight panels. Kantei's *Evening Bell* and *Returning Sails* are also numbered, showing that at some stage these paintings too must have been mounted in a similar fashion.

Since the numbers may have been added at a later date, they do not provide solid evidence concerning the original arrangement. However, if these small-scale individual paintings of the *Eight Views* were mounted on screens, there is a strong likelihood that each painting was surmounted by a eulogy written on a separate sheet of paper. Evidence from contemporary literature reveals that Gozan monks were often commissioned to write poems on separate sheets of paper to accompany paintings of the *Eight Views.*[13] This custom, moreover, was not confined to paintings of the *Eight Views:* the paintings of *Birds and Flowers and Figures* by Tōshun, now mounted with inscriptions on separate sheets of paper above them, were probably originally mounted on a small-scale screen.[14] The dimensions of the paintings on Tōshun's screen are very close to those of the four numbered Kantei paintings, reinforcing the likelihood that Kantei's four-painting set and his eight-painting set were originally mounted on small-scale screens together with eulogies on separate papers.

The two Burke paintings present sharply contrasting spatial concepts. In the right-hand scroll, the viewer edges by a ponderous foreground cliff to be swept into an infinitely expansive background. A low-hanging moon positioned close to the sheer rock wall dramati-

cally pulls the eye into far distance, where space suggested by temple walls and atmosphere implied by misty forests seems to spread right and left, extending behind the powerful cliff in the foreground and drifting out of the picture on the left. In the left-hand scroll the viewer joins a slow-moving ox and a line of flying geese, in focused progression into an enclosed pocket of space between the foreground rock and the receding row of snowy mountains. While in the right-hand scroll the eye squeezes past a powerful obstruction to penetrate distance and drift into free space, in the left-hand scroll it is drawn from the open depths and wide plains into a limited cul-de-sac.

The two scrolls also contrast in relationship of motifs and articulation of space. In the right-hand painting, foreground and background motifs are distinctly separated from one another, the only link being a faint suggestion of a path across the misty ground in front of the temple gate. Yet the course of recession is quite clear, rhythmically punctuated by distribution of thick ink from the flat rocks in right foreground — to the bridge — to the gate. While the level recession and lateral expansion are well within the Shūbun tradition, the logical and metric means by which it is attained is quite un-Shūbunesque. In addition, Kantei achieves stability by contrasting the strong vertical of the cliff with the rhythmic horizontals of the foreground boulder, the bridge, and the temple wall. The firm weight of each individual motif reinforces this stability.

Instead of the dramatic juxtaposition of vertical screen and horizontal spaciousness, ponderous gravity and boundless lightness, Kantei's left-hand painting securely follows the Shūbun tradition. His compositional scheme condenses the space and compacts the motifs of winter scenes painted on large screen- and sliding-door compositions by Shūbun school artists. The spread of water found in paintings in the Shūbun style is replaced with flat ground. Kantei juxtaposes the rocks and plateau with a clearly defined but remarkably reduced spatial relation between them. From rocks to oxherd to pavilions, from geese to mountains to misty trees, Kantei directs the eye into the closed compartment on the left. Although compact, the clarity of arrangement prevents an impression of crowding. The delicate brushwork with which Kantei skillfully renders the weight of the ox evokes a feeling of repose which harmonizes with the quiet evening mood suggested by the Hsiao-Hsiang motifs of evening snow and descending geese.

The extreme economy and incisive clarity of Kantei's brushwork are striking in this painting. He renders his crystalline foreground rock almost entirely with broad filling strokes; outlines play a minor role. He describes the rocky plateau with a minimum of lines, wash, and dots. In the willow tree, the unaccented firm lines of the branches are drawn with a simplicity and directness in which the individual personality of the painter Kantei is most clearly apparent.

The composition of the right-hand Burke scroll is apparently based on paintings in the Hsia Kuei style. Similar motifs appear in Sesshū's fan-shaped winter landscape in the Asano Collection which the painter identifies as "after Hsia Kuei,"[15] as well as in Sesshū's famous *Winter* landscape in the Tōkyō National Museum (fig. 44). These paintings contain the same dramatic combination of a massive cliff face, the top of which is not visible, and a distant temple building which is the focal center of the painting. Yet, although Sesshū and Kantei may have derived inspiration from similar models, a comparison of Kantei's Burke landscape and Sesshū's *Winter* landscape reveals basic differences in each painter's approach. While Kantei adroitly juxtaposes foreground weight against background space, Sesshū tightly links foreground and middle-ground motifs as an architectonic unit, leading the viewer step by step to the focal area in the middle distance. Kantei serenely sets off his central gate by isolating it on a tranquil horizontal expanse made even quieter by its balance with the markedly vertical cliff. Sesshū dramatizes his focal area by framing it with diagonals and verticals in the rocks and cliff faces. Sesshū gives his rocks weight and solid dimensions by means of dark outlines, energetic filling strokes, and ample highlighting with blank paper. Kantei uses a few pale outlines, but forms his solid rocks with a stable equilibrium of broad washy streaks.

In the left-hand scroll, Kantei depicts the oxherd on the plateau in a manner similar to Sesshū's round fan-shaped painting of an oxherd after Li T'ang.[16] It seems likely that here again Kantei was familiar with either the same model painting or one similar to that used by Sesshū.

RICHARD STANLEY-BAKER

NOTES

1. Kano Einō, *Honchō Gashi*, p. 985.

2. Published in *Kokka*, no. 561. Yen Hui was a Yüan dynasty Chinese painter with some connection with the Imperial Court. He was active about the opening of the 14th century, and was known for his Buddhist and Taoist figures. His work was highly appreciated by the Japanese of the Muromachi period, who classified him in the top rank of Chinese painters in the *Kundaikan Sayū Chōki* of the late 15th century. Consequently he became one of the basic models to be followed in figure painting. Generally speaking, paintings attributed to Yen Hui are rendered with broad brush strokes in thick ink tones for clothing, while facial features and details of the body are relatively realistically executed in colors. The most famous of his extant works is the pair of Taoist figures of *Tieh-hai* and *Ha-mo* (*Tekkai* and *Gamma* in Japanese) in the Chi'on-ji, Kyōto, and published in *Sōgen no Kaiga*, pl. 46. See also Sirén, *Chinese Painting*, 2:12–14; and Hsia Wen-yen, *T'u-hui Pao-chien*, chap. 5.

3. *Koga Bikō*, p. 612. This painting was seen in Osaka by Professor Shimada in 1948. He says it is a three-quarter profile view of Daruma in ink monochrome, bearing a square intaglio seal of Kantei, but that the seal seems a little different from seals impressed on other Kantei works generally accepted as genuine. As recorded in the *Koga Bikō*, above the figure on a separate sheet of paper is an inscription dated 1503 saying that the painting is the property of Entsū-ji temple and that it is by the brush of Minchō. Professor Shimada comments that the broad and angular brush strokes in the drawing of Daruma's robe could be associated with Yen Hui rather than Liang K'ai.

4. Published in Hasumi, "Nara Hōgen Kantei."

5. See cat. no. 14, n. 21.

6. Two landscapes are published in Matsushita and Tamamura, *Josetsu, Shūbun, San-Ami*, pls. 97–98. See also cat. no. 12, n. 16, for Sekiyō.

7. Shōsen was a Soga school painter identified in the *Honchō Gashi* as the son of Sōjō (see cat. no. 14, nn. 21, 24). He has been reidentified by a modern scholar, Aimi Kō'u, as Hyōbu Keishu, who was described by Gesshū Jukei (d. 1533) as a descendant of a family noted as painters for generations. In the 1520's Keishu was working in Echizen province. There are two well-known landscapes by Shōsen. One, in the Tōkyō College of Arts collection, is inscribed by Gesshū and is published in *Tōkyō Geijutsu Daigaku Zōhin Zuroku*. The other, with an inscription by the same Zen priest Gesshū and dated 1523, is in the Nezu Museum and is published in *Kokka*, no. 630, and in Tanaka and Yonezawa, *Suibokuga*, pl. 70. See Aimi, "Soga Hyōbu Keishu," and Tanaka Ichimatsu, "Soga Dasoku to Sōjō."

8. Shimada, "Sō Teki to Shōshō Hakkei." Shimada discusses the early development of the theme, its literatus-oriented associations, and its later degeneration into depiction of actual scenery. In Japanese ink painting, because the locale of Hsiao and Hsiang was known almost exclusively through Chinese literature, the concept retained a large measure of literary flavor and became popular during the heyday of poem-paintings (*shigajiku*).

9. See Tanaka Ichimatsu, "Shikan hitsu no Heisha Rakugan-zu," in *Nihon Kaigashi Ronshū*.

10. Discussed by Nakajima, "Shinju-an Fusuma-e Yori no Yoshiteki Kenkyū."

11. *Onryōken Nichiroku*, the daily record kept by priests of the Shōkoku-ji monastery in Kyōto, provides the most detailed documentation for late 15th century screen- and sliding-door painting. It gives, for example, a day-by-day account of the work of Sōkei (son of Oguri Sōtan who was Shūbun's successor as official painter to the Shōgun) on his painting of *fusuma* at the Shōsenken in the seventh month of 1490, in which the *Eight Views of Hsiao and Hsiang* were combined with other types of landscape and flower-and-bird painting in the manner of Hsia Kuei. In Tamamura and Katsuno, ed., *Onryōken Nichiroku*, entry for Entoku 3.

12. Sesson Yūbai's poetry collection, *Hōkaku Shinkū Zenshi Roku*, composed in the second quarter of the 14th century, records poems for the eight-painting format and the four-painting format consecutively. Tamamura, ed., *Gozan Bungaku Shinshū*, vol. 3.

13. See Ōsen Keisan's *Ho'an Keikashū*, p. 535, and Tamamura and Katsuno, ed., *Onryōken Nichiroku*, Chōroku 2(1485), 1:164.

14. *Birds and Flowers and Figures* by Tōshun. A set of twelve pictures. Each painting is in ink and color on paper, 47.1 x 35.6 cm, and is accompanied by a sheet of paper on which is inscribed a quatrain of seven-character lines written by the Zen priest Keijo Shūrin (1440–1518). An anthology of Shūrin's poems reveals that these poems were composed ca. 1512. See Tanaka Ichimatsu, "Tōshun-ga Setsu."

15. Published in Tōkyō National Museum, *Sesshū*, pl. 16.

16. *Ibid.*, pl. 17.

Sunset Glow over a Fishing Village
Kantei (fl. late 15th century)

Hanging scroll, ink on paper,
60.1 x 31.4 cm.
Square intaglio seal reading
Kantei.
Private collection (formerly
Nakamura Gashin
Collection, Nara)

A path leads behind a great boulder which rises in the immediate foreground, then turns abruptly behind the rocky plateau on which grow a tall pine and two smaller ones. Beyond, a figure makes his way along the riverside path toward a pair of houses half-hidden by tall banks. In one of the houses, beside which fishing boats are moored, a man sits enjoying the waterside view. In the distance, fishermen aboard two small boats draw in their haul, and behind them a ponderous mountain looms above the trees and river banks. The evening air is calm and clear.

The subject matter — fishermen drawing in their nets, the moored boats and a homegoing figure, twilight over the distant mountains — indicates that the painting represents *Sunset Glow over a Fishing Village,* one of the *Eight Views of Hsiao and Hsiang* (see cat. no. 15). Two other Kantei paintings probably belong to the same set of eight scrolls: *Returning Sails from a Distant Shore* in the Tōkyō College of Arts (fig. 45) and *Evening Bell from a Distant Temple* in the Tōkyō National Museum (fig. 46). A reasonable amount of stylistic evidence exists to suggest that Kantei's set of Hsiao-Hsiang scrolls was based on a handscroll, now lost, by the Chinese Southern Sung Academy painter Hsia Kuei.[1] This scroll, which was recorded in the fifteenth century inventory of the Ashikaga Shōgunal collection,[2] provided the model, either directly or through copies, for at least four late-fifteenth century Japanese painters. Therefore, Kantei's *Sunset Glow over a Fishing Village* is a stylistic document which, in connection with a group of other existing paintings, provides information about how Muromachi painters used their Chinese models.

Two complete sets of the *Eight Views of Hsiao and Hsiang* survive which seem to be based on Hsia Kuei's lost scroll: a set of eight small hanging scrolls by Shūsei (fig. 47), a late-fifteenth century artist whose identity has only recently been established,[3] and the album of eight paintings by Kenkō Shōkei in the Hakutsuru Art Museum (fig. 48).[4] Since Kenkō Shōkei had access to the Shōgun's collection during the three years (1478–1481) he was in Kyōto studying with the Ashikaga family's resident connoisseur, Gei'ami (1431–1485), his set of Hsiao-Hsiang paintings assumes great significance.[5] It is possible that Shōkei's *Eight Views* is a free version, based either on a copy or on the actual Hsia Kuei handscroll in the Shōgun's collection. On the other hand, stylistic evidence seems to indicate that Shūsei's group of paintings are closest to the original model.[6] In addition to these complete versions of the *Eight Views of Hsiao and Hsiang,*

fragments of sets by Gaku'ō (late fifteenth century) as well as by Kantei provide subsidiary evidence. The remaining paintings by Gaku'ō which are most relevant to the Hsia Kuei model, like the two Kantei paintings in the Burke Collection (cat. no. 15), combine two scenes in each scroll.[7]

When Kantei's *Sunset Glow* is viewed in the context of these paintings, it is possible to draw tentative conclusions about what elements he derived from the Chinese prototype and what features came either from another stylistic tradition or from his own creativity. For example, Kantei's painting shares with both Shūsei's version (fig. 47) and Shōkei's version (fig. 48) the idea of placing the trees in the lower right foreground directly beneath a distant mountain and contrasted against a level expanse of water to the left. In the middle ground of both Shūsei's painting and Kantei's *Sunset Glow,* there are moored boats, houses, and homegoing figures. Shōkei substitutes drying fishing nets for the boats and houses. Gaku'ō's comparable painting, a combination of *Sunset Glow* and *Night Rain* formerly in the Gō Collection,[8] contains the same ideas but reversed from right to left. Such features recurring in four interpretations may be judged to have come from the model.

Other elements in Kantei's *Sunset Glow* do not appear in the parallel versions by Shūsei, Kenkō Shōkei, or Gaku'ō, and reveal Kantei's creative approach to his model. His adaptation of foreground elements is unique. He substitutes a flat plateau for the round foreground rocks of the other paintings. His trees are pines, a reference to the Shūbun tradition, in contrast to the leafy trees which apparently reflect the model painting. Kantei rejects the abruptly upjutting rocks found in the paintings of Shūsei, Gaku'ō, and to some extent in Shōkei, and provides a structured entry into the painting by way of a path which leads behind the rocks. As noted under cat. no. 15, this convention is often found in Sesshū's work and derives from paintings in the Hsia Kuei style. However, in view of the evidence provided by the other Hsiao-Hsiang versions, it does not seem to have appeared in the model. Here Kantei probably is adapting the composition of his *Eight Views* prototype in terms of conventions he learned from other paintings in the Hsia Kuei style. This is not an unusual practice for fifteenth century painters.[9] Kantei also omits the fishing nets hung out to dry, preferring to suggest the theme of fishing by boats set in the far distance of the river. Placed in this way, the boats contribute to the clear articulation of the three distances.

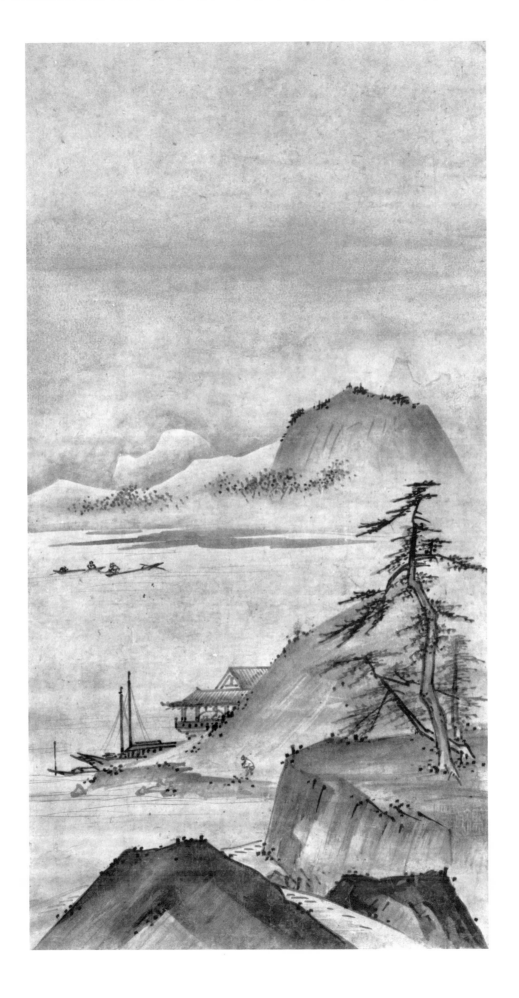

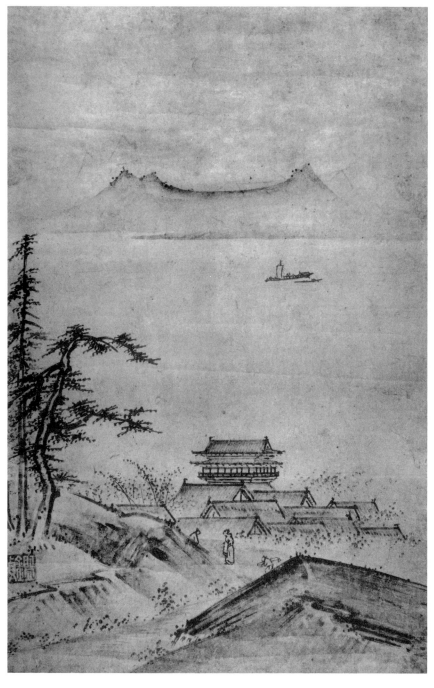 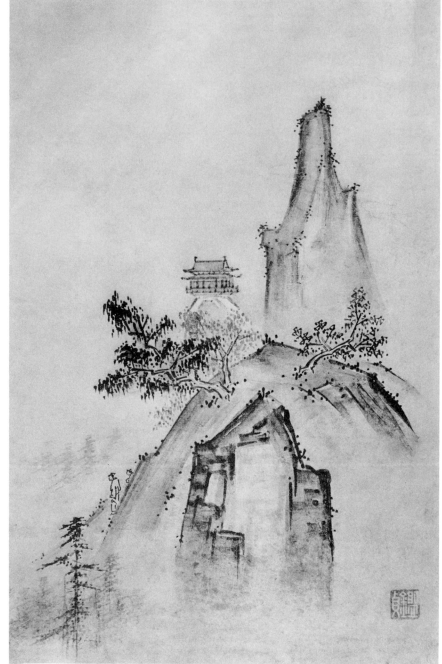

Far left: Figure 45. *Returning Sails from a Distant Shore,* Kantei (fl. late 15th century). Hanging scroll, ink on paper, 48.0 x 31.6 cm. Tōkyō College of Arts

Left: Figure 46. *Evening Bell from a Distant Temple,* Kantei (fl. late 15th century). Hanging scroll, ink on paper, 47.5 x 31.6 cm. Tōkyō National Museum

Right: Figure 47. *Sunset Glow over a Fishing Village,* Shūsei (fl. late 15th century). Hanging scroll from a set of *Eight Views of Hsiao and Hsiang,* ink on paper. Hosomi Collection, Ōsaka

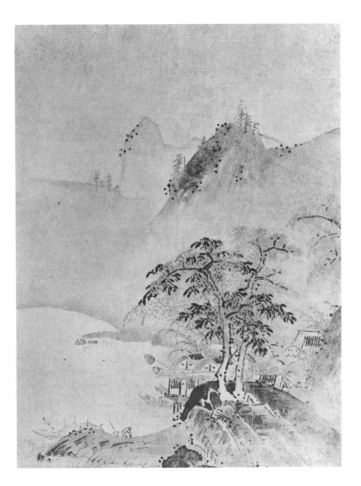

By similarly comparing motifs and composition of Kantei's *Returning Sails* (fig. 45) and *Evening Bell* (fig. 46) with the equivalent works by Shūsei, Shōkei, and Gaku'ō, further conclusions can be drawn about Kantei's approach to painting. The most striking feature of Kantei's *Evening Bell* is its unusual composition, with a large foreground rock emerging from the bottom of the painting, the pinnacle towering above the temple, and the centralization of major motifs. The suggestion of "deep distance" (*shen yüan*) is quite different from the more or less "level distance" (*p'ing yüan*) compositions of his *Sunset Glow* and *Returning Sails* and can be explained largely in terms of what he derived from his model; in this case Kantei's composition is closest to that of Shūsei, whose version is probably closest to the Hsia Kuei handscroll. Other features seen in Kantei's *Evening Bell* are also found in the paintings of Shūsei, Shōkei, and Gaku'ō, and can be pinpointed as coming from the Chi-

nese prototype: a temple gate partially hidden by rocks and trees, two figures near the temple.

On the other hand, Kantei's *Returning Sails* (fig. 45) differs sufficiently from the versions of Shōkei and Shūsei to suggest that it is based on a different model. The general format of the composition is similar to Shōkei's, with trees in the left foreground leading the eye diagonally across the river to distant boats against a background of mountains. However, Kantei's *Returning Sails* does not contain the essential features of Shōkei's and Shūsei's versions: a large cliff, full-blown sails, wind-swept leafy trees in the foreground. Instead, Kantei has sedate pines depicted in the Shūbun manner similar to those in *Sunset Glow,* and an almost stationary boat in the far distance. He carefully describes his foreground, with a zigzag path leading the eye into the painting through a firm structure of rocky mounds. Once again Kantei uses the foreground convention of the Hsia Kuei style seen in *Sunset Glow,* which probably was not derived from the *Eight Views* model.

The relationship of these three Kantei paintings to other interpretations of Hsia Kuei's *Eight Views of Hsiao and Hsiang* identifies several characteristics common to Kantei's adaptation of his model. First, he shows lack of interest in atmospheric effects: the almost windless scene of *Returning Sails* has the same uniform light haze which permeates *Evening Bell* and *Sunset Glow.* Second, his brush style in the three paintings is very close, and rather different from his other works. The use of many L-shaped hooks depicting pine needles in both *Sunset Glow* and *Returning Sails* is an exaggerated mannerism appearing rarely in other pine trees by Kantei. The broad, sweeping wash strokes used to fill the earthen banks and rocks, and the prominence and clarity of dots which are often executed in vertical strokes are similar in the three works. Third, in two of these paintings — *Sunset Glow* and *Returning Sails* — Kantei included the foreground structure of the Hsia Kuei style that comes from a model other than his scroll of *Eight Views of Hsiao and Hsiang.* In addition, Kantei adapted the *Eight Views* model in terms relating to the Shūbun tradition, showing a preference in both *Sunset Glow* and *Returning Sails* for pine-tree groups in the Shūbun style.

A few problems exist in considering these three paintings as part of one group of *Eight Views of Hsiao and Hsiang. Sunset Glow,* for example, is about twelve cm taller than the other two, but this can be explained. There is a break near the top of the painting which has been repaired. Although the quality of the paper above

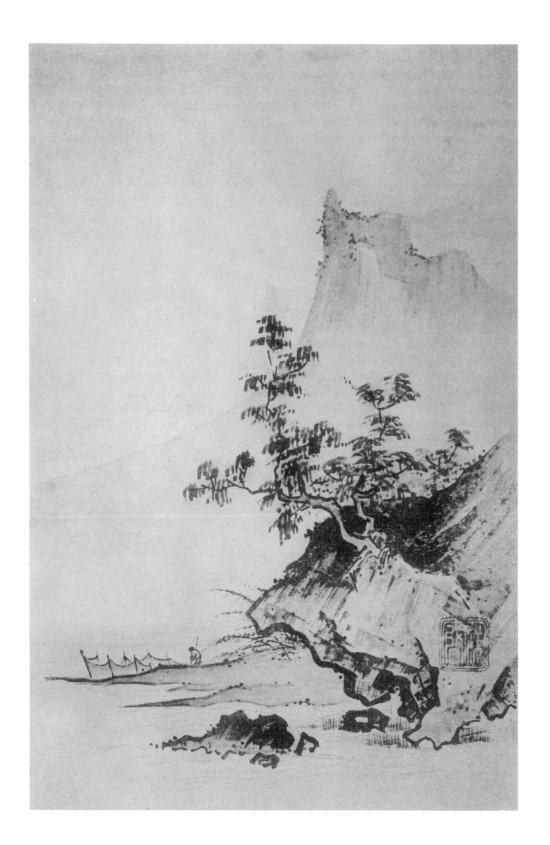

the break is similar to that below, it is possible that extra
paper was added to the painting at a later date. Like-
wise, the numbers on the reverse sides of *Evening Bell*
and *Returning Sails,* indicating that they were once
mounted in a screen format, may have been added at a
later date. Therefore, the fact that no number appears
on the reverse side of *Sunset Glow* does not obviate the
possibility that it was originally part of the same set. The
common stylistic features noted above seem stronger evi-
dence for a positive conclusion. In sum, the manner in
which Kantei adapted his models and the stylistic fea-
tures common to all three paintings, although far from
being conclusive evidence in view of the paucity of
extant works by Kantei, suggest strongly that *Sunset
Glow* probably belongs to the same set of *Eight Views of
Hsiao and Hsiang* as that represented by *Evening Bell* and
Returning Sails.

The economy and clarity of Kantei's brushwork in
Sunset Glow contributes to the nice articulation of space
within the painting as a whole. Nowhere else in Kantei's
extant work is depth handled so intelligibly. Depicted
with a bare minimum of broad axe-strokes, pale out-
lines, accent strokes and dots, Kantei's rocks and
earthen banks convey an impression of solidity and
clearly suggest the space they occupy. His brushwork,
although sparse and often consisting of broad strokes, is
slow and deliberate. It evokes a quiet serenity in contrast
to the bursting vigor of his contemporary Sesshū (fig.
14) or the somewhat impetuous emotional quality seen
in Gaku'ō (fig. 12). The quiet brushwork lends sub-
stance to individual motifs — it gives weight to the fish-
ermen's net as their boats lie low in the water.

Unique to Kantei is the naïve awkwardness of the
group of pines. Although the tallest one reflects the
graceful form of pines in the Shūbun style (*Chikusai
Dokusho*, fig. 9), the slightly awkward manner in which
the second tree leans behind the first has a certain inno-
cent charm. A similar quality can be found in crossing
trees in other Kantei landscapes.[10] It is a far cry from
the refined elegance of the Shūbun style, a rather en-
dearing personal quirk which is quite the property of
Kantei.

RICHARD STANLEY-BAKER

NOTES

1. The stylistic evidence is given in detail in Stanley-Baker, "Gaku'ō's Eight Views of Hsiao and Hsiang." For Hsia Kuei see cat. no. 10, n. 2.

2. *Eight Views of Hsiao and Hsiang*, a handscroll by Hsia Kuei, is listed in the *Gyomotsu On'e Mokuroku* with three other scrolls of the same theme by Mu-ch'i, Yü-chien, and Chang Fang-ju (in Tani, *Muromachi Jidai Bijutsu-shi Ron*, p. 139). Four sections of the scroll associated with Mu-ch'i still exist, published in *Sōgen no Kaiga*, pls. 114–19. Three fragments of the Yü-chien version remain, *ibid.*, pls. 120–23. The history of the Mu-ch'i and Yü-chien paintings is discussed by Takagi, *Gyokkan Mokkei Shōshō Hakkei-e to Sono Denrai no Kenkyū*. Chang Fang-ju, who is not listed in the Chinese painting histories, is recorded in the *Kundaikan Sayū Chōki* in the "middle rank of the upper class" as a Yüan painter who painted "landscapes, human figures, and oxen" (see cat. no. 4).

3. See Matsushita, "Shūsei no Suten no Sakuhin." Six of the Hsiao-Hsiang paintings by Shūsei are published as comparative figures by Matsushita and Tamamura, *Josetsu, Shūbun, San-Ami*, p. 194.

4. All eight paintings are published in Matsushita and Tamamura, *Josetsu, Shūbun, San-Ami*, pls. 139–46.

5. It is known that part of Shōkei's training with Gei'ami included copying Chinese works in the Shōgunal collection. An inscription by Ōsen Keisan on a lost painting by Kenkō Shōkei entitled *Hinrakusai* is recorded by Asa'oka in the *Koga Bikō* (pp. 800–1): "Kei Shoki came to the capital [in 1478]. Gei'ami looked over his work and praised it as having high quality. Finally Gei'ami invited him to his house and allowed him to make copies of a great many paintings in the Shōgun's collection. By this means his art was greatly improved." Two of these study pieces, *Horse and Groom* paintings carefully copied from scrolls by the Yüan dynasty horse painter Jên Jên-fa, exist today and are frequently published. Good reproductions can be found in *Higashiyama Suibokugashū*. See also cat. no. 24.

6. Although there are paintings showing that Shūsei derived influence from the traditions of the Shūbun school, there is little in his *Eight Views* that can be related to it. His Hsiao-Hsiang paintings exhibit features which are rarely found in 15th century Japanese ink painting and can only be judged to come from the Hsia Kuei model: attention to atmospheric differences, compositional structuring which leads to a rather dense area in the center of the painting, propensity for compositions of the "deep distance" type, use of long parallel brush strokes in light wash. See Stanley-Baker, "Gaku'ō's Eight Views," pp. 10–11.

7. *Evening Bell / Returning Sails* in the Tōkyō National Museum; *Autumn Moon / Descending Geese* in the Freer Gallery of Art; *Sunset Glow / Night Rain*, ex-Gō Collection. In addition, there are a single view of *Evening Snow* in a private collection, U.S.A., two large hanging scrolls with Hsiao-Hsiang motifs once in the Okazaki Collection (a third was destroyed in the last war), and a pair of six-fold screens containing Hsiao-Hsiang views in the Murayama Collection (a detail of two panels is shown in fig. 37). See Stanley-Baker, "Gaku'ō's Eight Views," for discussion and illustration of these works.

8. *Ibid.*, fig. 16.

9. A typical example is *Suishoku Rankō* (fig. 39) attributed to Shūbun, in which the foreground derives from a landscape in the "one-corner" style while the distant central mountain theme comes from the type of composition called "total view" (*zenki*).

10. Kantei's *Landscape with Waterfall* in the Hara Collection, published in *Kokka*, no. 544; and his *Landscape* in the Kono'e Collection published in Hasumi, "Nara Hōgen Kantei."

Spring Landscape
Kantei (fl. late 15th century)

*Hanging scroll, ink on paper,
47.1 x 31.2 cm.
Square intaglio seal reading*
Kantei.
*Private collection (formerly in
Tsuchiya Hotel, Atami)*

A scholar and his attendant walk quietly along a broad path which emerges from behind a group of pines half-hidden in mist. Behind the pines towers a vertiginous peak. The attendant carries a plum branch which indicates that it is early spring, the season for viewing plum-blossoms. The dense foliage of the pines, described with a multitude of dots and short brush strokes, suggests the fresh verdure of spring. The view across the lake reveals a small rustic bridge, and in the far distance a group of buildings encircled with mist are set against a background of distant peaks.

On the reverse side of this painting, directly beneath the seal, are written the characters for "Spring 1." The characters are visible in mirror image from the front of the painting, since the ink has gradually penetrated the paper. It is clear that the landscape must have been part of a group of four-seasons landscape paintings. Since the addition of the number 1 would be superfluous in a set of four paintings which always places spring as the first of a group, the set must have consisted of eight (two for each season) or twelve paintings (three for each season).[1] An alternative possibility is that the group may have incorporated a variety of subjects, including the four-seasons and perhaps flower-and-bird and figure paintings,[2] such as is found on Tōshun's pair of six-fold screens of *Birds and Flowers and Figures*.[3] As one of a group of paintings, it would normally have been mounted on a folding screen. The measurements of the painting support this possibility; it is very close to the size of Kantei's paintings of single scenes from a set of *Eight Views of the Hsiao and Hsiang,* which were probably mounted on small-scale screens. Furthermore, as in the case of the Hsiao-Hsiang paintings, it is likely that four-seasons paintings were surmounted with eulogies written on separate papers, for there are many examples in contemporary literature of poems written to accompany four-seasons screen-painting.[4] Like the sets of Hsiao-Hsiang scenes, and the groups with variegated subject matter such as the Tōshun screens, paintings surmounted with eulogies were individual paintings and were not designed to be seen in a continuous landscape composition. Kantei's *Spring Landscape* is one such self-contained composition.

In this landscape Kantei clearly displays his inheritance from the tradition of the Shūbun school: his composition is based on a type commonly used by mid-fifteenth century painters of this school. Entry into the painting is gradual, with the foreground elements set a little back from the viewer. The path along which the

poet and his attendant walk leads into a misty area behind the trees: the position of the cliff in relation to the foreground elements is not defined very clearly. This is typical of compositions of the Shūbun school, represented by the *Landscape* in the Yamamoto Collection which bears the dated (1455) inscription of Jiku'un Tōren (fig. 35) and the *Landscape in Shūbun Style* in the Seattle Art Museum (cat. no. 10).

Kantei transforms the abundant complexity of details in prototypes of the Shūbun school, restructuring them in terms of his new conception of spacing and solidity of form inspired by Hsia Kuei models. From a composition similar to the Yamamoto *Landscape,* Kantei has taken the ideas of tall pines augmenting the verticality of a towering pinnacle at the right, rocks at the left foreground, a broad path leading behind the trees, a scholar and attendant on the path, and a bridge in the middle ground. But by assigning a more significant role to verticals in the middle ground, Kantei significantly reduces the essential height of his mid-century prototypes. The dominant mountain in most landscapes of the Shūbun school is composed of numerous vertical pinnacles, generally depicted with rather fussy brushwork which details the many-faceted rock face. Although Kantei retains the twisted form of the peak, the topmost protrusion stands alone with complicated crevices and outcroppings eliminated. The waterfall which appears from a high point in most paintings based on this model is gone, replaced by flat rock surface and mist.

The mountain form is rendered with remarkable economy of brush strokes, comparable to those found in Kantei's *Evening Bell* in the Tōkyō National Museum (fig. 46). He uses long parallel strokes, dry brush outlines, and a similar kind of highlighting. As in the single-view Hsiao-Hsiang paintings (cat. no. 16), Kantei's rather ample use of dots functions descriptively in *Spring Landscape.* This is different from the more staccato, somewhat more abstract energy of the dots in the Burke paintings (cat. no. 15).

Kantei simplifies the prodigious detail of tree types and branches and foliage, between the major mountain and the foreground pines in paintings of the Shūbun school, replacing them with a row of pines disappearing into mist. He removes the motif of the flowering plum, which is a main feature of the Yamamoto *Landscape,* retaining the theme by subtle suggestion: the boy attendant holds a plum branch while the scholar gazes into space where perhaps plum-blossoms are visible. Kantei's tall pines do not stand as high nor are they as dominat-

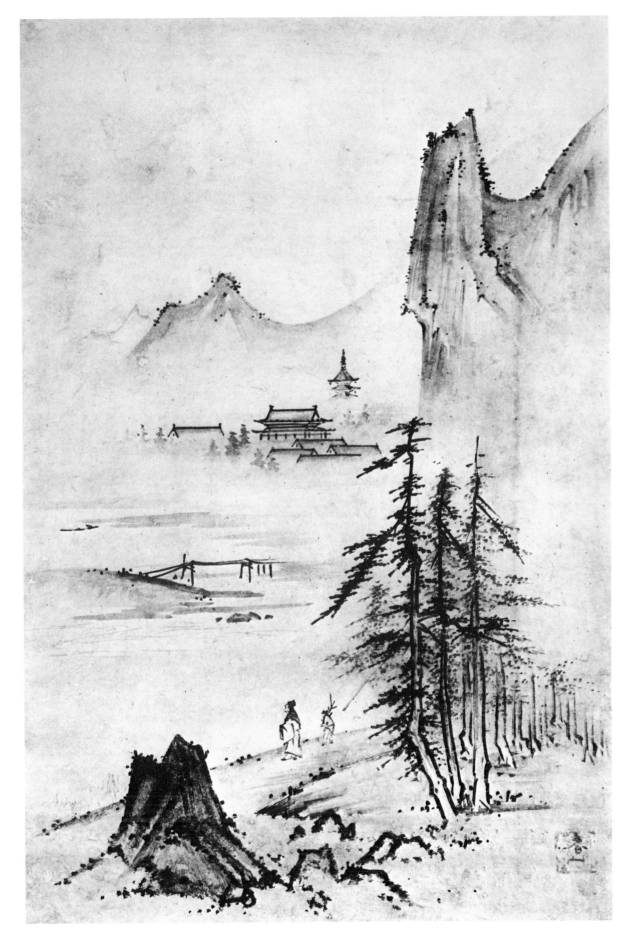

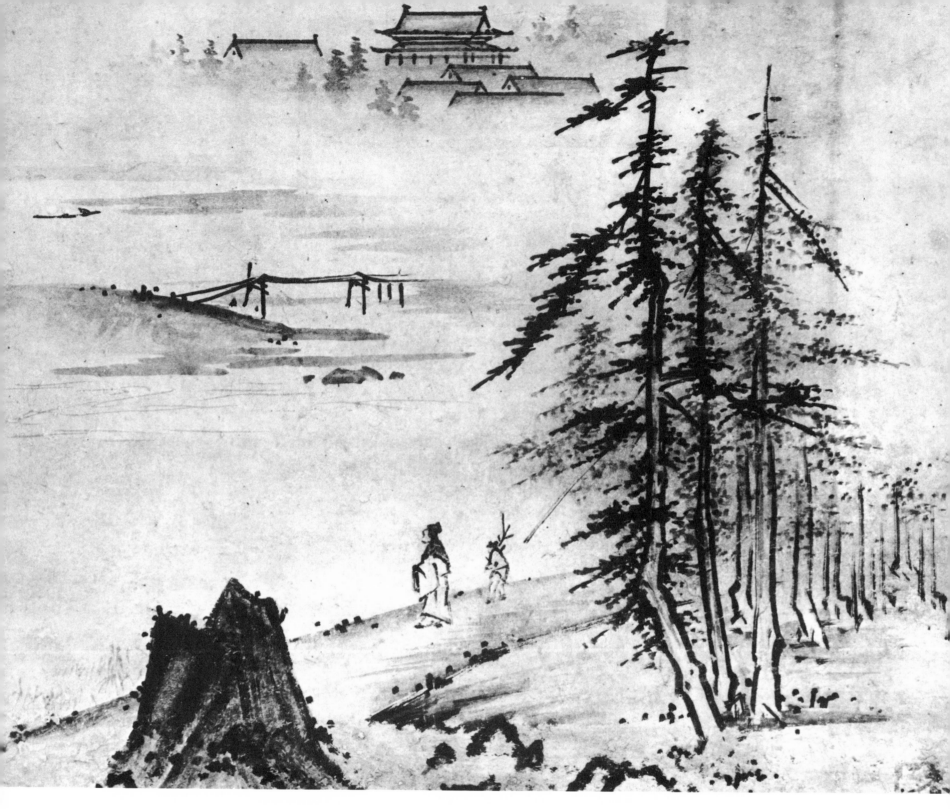

ing as the pines in the Yamamoto *Landscape*. While the pines of the Shūbun type reinforce the vertical vitality of the mountain structure behind, Kantei's pines recede into space, remaining more related to the middle ground of the painting than to the height of the cliff. Kantei's handling is more successful in describing spatial recession than are most versions by the Shūbun school, a feature shared by Gaku'ō's painting of a *Pine Retreat* in the Tōkyō National Museum.[5]

A triangular rock projecting from the bottom left of the composition dramatizes the introduction to this *Spring Landscape*. Paintings of the Shūbun school provide unobstructed entry without giving such importance to a foreground motif. The path on which Kantei's scholar stands runs diagonally behind the rock, quickly leading the viewer to the misty mountain base. Recession into distance is accelerated by the bridge, the sequential sand bars, and the architectural complex. Thick

ink tones applied to horizontals of the bridge and buildings clearly articulate the middle-ground space. While paintings of the Shūbun school generally have an area of void space in the center or to one side of the background, in Kantei's *Spring Landscape* the possibility of further spatial recession is cut off by his grouping of buildings at the foot of a horizontal range of distant mountains.

Therefore, although *Spring Landscape* is based on a mid-century prototype of the Shūbun school, similar to one used for the Yamamoto and Seattle landscapes, Kantei has transformed his model by eliminating detail and clearly articulating space. There is evidence of careful attention to description of form, such as in the construction of the foreground rocks, in contrast to the kind of shorthand seen in the small triangular rocks in the right-hand Burke painting. The attention to description of form seen in the brushwork and the careful articulation of space in this *Spring Landscape* suggest that it is probably fairly close in date to Kantei's single-view Hsiao-Hsiang paintings (cat. no. 16). The Burke paintings (cat. no. 15), by contrast, may be somewhat later: the hand is more confident, there are tendencies toward abstraction and the reduction to formulas, and there is less interest in the articulation of space.

Many of Kantei's transformations of his model — such as his removal of the opulent double-roofed pavilions, his reduction in type and complexity of trees and foliage, his simplification of the mountain form and elimination of the waterfall — can be viewed as a rejection of the luxury and complexity of mid-century landscapes of the Shūbun school in favor of greater simplicity. He places greater emphasis on the figure of the poet wandering in the spring scenery, which lends a quiet ingenious flavor to the whole. Kantei refers to a tradition which appeared as early as the first quarter of the fifteenth century in paintings such as *Kōshi Tambai* (*A Gentleman Viewing Plum-Blossoms*).[6] The dress of the scholar in *Kōshi Tambai* is very similar to that of Kantei's scholar. Both paintings undoubtedly represent the Chinese poet Lin Ho-ching,[7] who was as well known in Japan as in China for his love of plum-blossoms.

Richard Stanley-Baker

NOTES

1. Banri Shūkyū (d. 1502) records in his *Baika Mujinzō*, under the year 1495, a pair of six-fold screens depicting the four seasons for which he wrote twelve poems, three for each season. He further records under the year 1496 a series of poems for four-seasons wall paintings, where each season is allotted two poems, with the exception of autumn which for some reason has only one. Tamamura, ed., *Gozan Bungaku Shinshū*, 6: 801–2.

2. Examples of folding-screen paintings depicting variegated topics, for each of which poems were written, are recorded in contemporary literature. Again, in *Baika Mujinzō*, Banri Shūkyū records poems written for a series of ten paintings, which included a variety of subjects: figures, landscapes, birds, etc. Tamamura, ed., *Gozan Bungaku Shinshū*, 6:809.

3. See cat. no. 20, and cat. no. 15, n. 14.

4. For example, see the poems recorded by Ōsen Keisan in his *Ho'an Keikashū*, p. 295, or by Keijo Shūrin in his *Kanrin Koroshū*, in U'emura, ed., *Gozan Bungaku Zenshū*, 4:276–77.

5. *Shō'in Inkyo* (*Retreat in the Shadow of Pines*), by Gaku'ō Zōkyū, hanging scroll, ink and color on paper, formerly in the Ōmura Seigai Collection, now in the Tōkyō National Museum. Published in *Kokka*, no. 417.

6. *Kōshi Tambai*, artist unknown, attributed to Josetsu, hanging scroll, ink and light colors on paper, 87.8 x 28.0 cm, inscribed by Chūhō En'i (d. 1413), Sekizumi Collection, Tōkyō. Published in Matsushita and Tamamura, *Josetsu, Shūbun, San-Ami*, pl. 32.

7. Lin Ho-ching (Lin Pu, posthumous title Ho-ching Hsiensheng) was a Chinese recluse poet of the early 11th century who lived on the shore of West Lake near Hangchou, Chêkiang province. He was much respected by the Imperial Court and gentlemanly society for the loftiness of his character and for his poetry, particularly that about his beloved plum flowers. Since Sung times he has been a symbol for the expression of an enduring love of plum-blossoms. Through the centuries both Chinese and Japanese painters have represented him in different attitudes and surroundings. Many show him as a recluse with a cane, strolling under a plum tree accompanied by a crane and an attendant carrying a Chinese lute, while others represent him as a poet at his desk contemplating a poem. On the desk is a vase with a plum branch. See *Sungshih*, chap. 475.

Summer AND *Winter*

Late 15th century follower of Sesshū

The landscape scrolls *Summer* and *Winter* have traditionally been attributed to Sesshū (1420–1506) on the basis of the signature "Sesshū hitsu" and seal *Tōyō*, which appear on each painting in the upper left- and upper right-hand corners respectively. Both scrolls were formerly in the Kuroda Collection in Japan. In *Summer*, a rocky promontory leads diagonally into the composition from the lower right-hand corner. A solitary figure walks toward the right. Behind the bank, to the left, a moored boat continues the lateral structure of foreground motifs, to form a unit that interrupts the expanse of water extending from the immediate foreground to the distant shore. To the right of the promontory, roofs of houses nestling among bamboo visually balance the boat moored to the left and enhance the stability of the foreground composition. From the center of the foreground land mass, a prominent cluster of trees rendered in ink contour and dark ink wash rises to intersect a small bay at the base of the distant peaks. From the shoreline in the distance, which extends horizontally across the whole width of the painting, hills emerge from a thick mist. The *Summer* landscape is remarkable for its compositional balance and cohesion. Throughout the composition there is a balance between left and right, foreground and distant motifs, and they are linked by an intersecting structure of horizontals and verticals which produces an effect of stability.

In contrast to the virtual symmetry of *Summer*, the *Winter* landscape is a "one-sided" composition with the land mass concentrated on the left and open space to the right. Moreover, in *Winter* there is a continuous zigzag movement into distance, first suggested by the small figure walking along a path that turns sharply behind the rocks, and continued by the gradual recession of the dominant mountain peak. Nevertheless, it has in common with *Summer* a stable, intersecting structure of horizontal and vertical elements. The paintings are technically similar. One of the most striking technical features is the rendering of the rocks and mountains by means of a combination of ink contour lines, ink wash, and hemp-fiber textural strokes parallel to the contours. Both near and distant mountains are similarly rendered. The clouds and mists, depicted in an unusual manner using both ink wash and contour lines, are palpable forms with the same life-force as the rocks.

This pair of landscapes may have once formed a triptych with a *God of Longevity*, now in a private collection, as the central painting.[1] It was not an unusual practice in Japan during the Muromachi period to form triptychs

with a central religious figure flanked by landscapes, flowers, or animal subjects instead of the conventional attendant figures.[2] An early example is the *White-Robed Kannon* flanked by two landscapes, by the fourteenth century Zen monk-painter, Gukei Yū'e (fl. ca. 1461).[3] However, judging from the clearly identifiable seasonal motifs in this pair of landscapes, it seems possible that they may originally have been two members of a set of four *Landscapes of the Four Seasons,* a theme that became prevalent in Japanese painting of the late fifteenth century. Whatever their original context, the pairing of these seasonal landscapes as a set is paralleled by numerous examples from the late fifteenth century, such as the famous *Winter* (fig. 44) and *Autumn* landscapes by Sesshū.[4]

The signatures and seals of Sesshū on the Michigan *Summer* and *Winter* landscapes are not genuine and must be later additions. A photograph of the signature and seal from *Winter* shows clearly that the paper on which they appear has been patched in. Undecipherable traces of the original seal, now effaced, can be seen in the lower left corner of the painting.

Although the signature and seals of Sesshū are not genuine, the paintings themselves have some stylistic features in common with his work and must have been done by a follower with direct knowledge of his painting. Among the important characteristics distinguishing Sesshū's work from that of his contemporaries in the late fifteenth century, particularly those who followed more faithfully the models established by Shūbun (see cat. nos. 10–13), is his skillful building up of massive rock and land formations which displace space. In most paintings by close followers of Shūbun, void space is given emphasis at least equal to that of the rocks and mountains, which have relatively less gravity and solidity than is seen in Sesshū's work. The *Summer* and *Winter* landscapes have in common with Sesshū's paintings the ordered and logical articulation of solid forms and the clear indication of recession into depth, which contrasts with the "leap" into depth through ambiguous space often seen in later works of the Shūbun school. The massiveness of the land forms, the cohesion of motifs, and the emphasis on "deep distance," accentuated by the relatively level point of view and low horizon line are elements which relate this pair of landscapes closely to the innovations of Sesshū, who introduced many fresh ideas into late fifteenth century Japanese painting.

Sesshū's importance in the history of Japanese painting of the late Muromachi period can best be under-

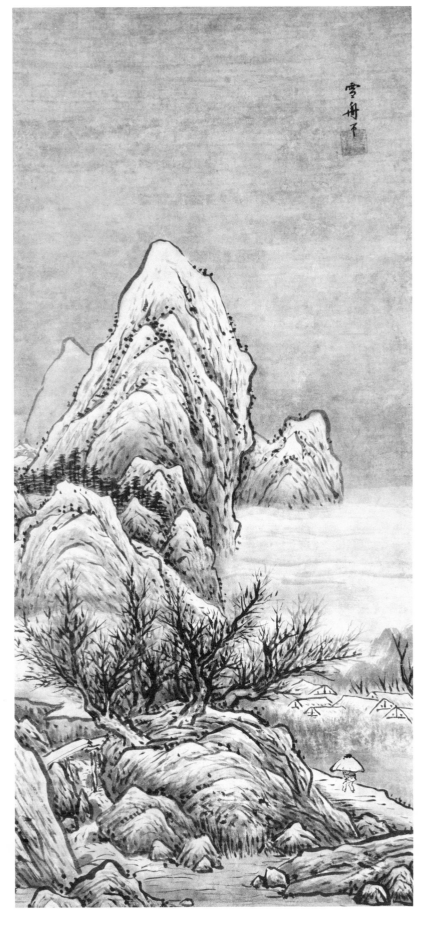
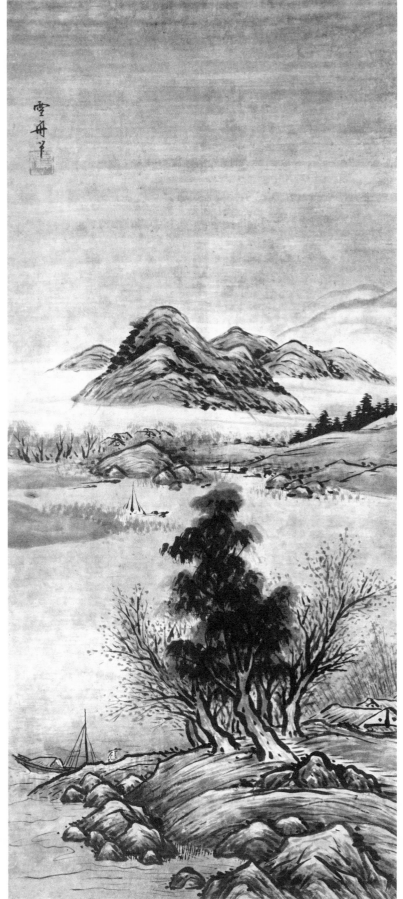

stood in light of certain details of his biography, which is relatively well documented for a painter of that time. He spent his early years in residence at the Shōkoku-ji, where he had an opportunity to study painting under Shūbun, the master painter of the mid-fifteenth century.[5] About 1464 Sesshū moved to the Unkoku-an in Yamaguchi city, in the heart of a region controlled by the Ō'uchi warlords. Although official missions to China had ceased by this time, the Ō'uchi and other powerful daimyō as well as a few Zen monasteries continued to sponsor private trade missions. Thus, in 1467, Sesshū was able to travel to China on a trade vessel dispatched by the Ō'uchi family. His sojourn in China, during which he traveled overland from the port of Ningpo to Peking, gave him the opportunity to visit some of the famous sights of China and see many Chinese paintings, including those by contemporary Ming artists whose works were not yet familiar to Japanese painters. Sesshū remained in Yamaguchi after returing to Japan, so throughout the rest of his career he worked in an area that continued to be an important center of trade with China, and offered exceptional opportunities to see newly imported paintings. Sesshū's innovative painting style reflects his unusually direct contact with Chinese painting, which provided him with fresh ideas and inspiration for his own work.

Although the Michigan *Summer* and *Winter* landscapes are clearly related to Sesshū's works in their logical spatial structure and massive land forms, they differ technically from typical works of Sesshū's mature period, as exemplified by the so-called *Long Landscape Handscroll* [6] and the *Winter* (fig. 44) and *Autumn* hanging scrolls in the Tōkyō National Museum. These paintings, which represent the style of Sesshū most often imitated by his followers, are based on his study and free interpretation of landscape paintings by the Southern Sung painter, Hsia Kuei. The rock and mountain forms in these works are typically defined by angular contour lines, sweeping washes, and sharp, axe-cut textural strokes. In contrast, the dominant technique employed in the Michigan *Summer* and *Winter* landscapes is a modified hemp-fiber stroke running parallel to the softer contours of the rocks and mountains; and the atmosphere, in contrast to the light, clear atmosphere of Sesshū's typical paintings in the Hsia Kuei manner, is rich and moist, so dense that the clouds seem to function in the composition more as an extension of solid forms than as a contrasting image of void space.

The technical contrast between the Michigan paint-

ings and the typical style of Sesshū suggests that they reflect a prototype other than Hsia Kuei. There is relatively little evidence of paintings by Sesshū himself in the manner of the Michigan paintings. However, like other Japanese painters of the Muromachi period, he was capable of mastering and working in more than one style, while still expressing his personal touch. His landscapes in the manner of Yü-chien, done entirely in ink wash, are one example (fig. 13).[7] As further evidence of his broad knowledge of Chinese painting styles there survive six of his original set of twelve paintings in the format of round fans, each following the style of a Chinese painter whose name is noted beside each fan. Fortunately the appearance of the lost fans is known through accurate copies of the entire set by Kano Tsunenobu (1636–1713).[8]

Two of these copies of Sesshū's fan-shaped paintings were originally labeled "Mu-ch'i" by the artist himself (fig. 49), and bear a remarkable technical and, to some extent, compositional resemblance to the Michigan *Summer* and *Winter* landscapes. The *Summer* landscape is particularly close in composition, motifs, and technique to one of the two fans in the manner of Mu-ch'i, [9] and there is little doubt that the *Summer* and *Winter* landscapes are based upon Sesshū's free interpretation of the style of this Southern Sung painter, now known only through the Kano copies. However, a close comparison between the *Summer* and *Winter* landscapes and the fan paintings after Mu-ch'i shows the brushwork of the Michigan paintings to be more angular and less supple, with less subtle tonal variations. In general, the *Summer* and *Winter* landscapes are slightly stiffer and more mannered than the fan paintings, and must be considered to be the work of a painter who was closely following Sesshū's Mu-ch'i manner.

Sesshū's two fan paintings in the manner of Mu-ch'i are exceptional, not only because of their contrast to Sesshū's usual style of painting, which derives mainly from Hsia Kuei, but also because they differ from the prevalent image of Mu-ch'i's manner of landscape painting as exemplified by the four surviving landscapes of a set of *Eight Views of Hsiao and Hsiang* (fig. 56).[10] Although these paintings, executed entirely in ink wash, are no longer considered to be authentic works of Mu-ch'i, they have long been held to represent Mu-ch'i's landscape style. This style relies heavily on washes to create panoramic landscapes fading gradually into the distance from an open foreground, and appears in paintings by members of the Ami school, whose activity was

Figure 49. *Fan Paintings in the Manner of Mu-ch'i,* copies of paintings by Sesshū (1420–1506) made by Kano Tsunenobu (1636–1713). Tōkyō National Museum

roughly contemporary with that of Sesshū (see cat. nos. 22 and 23).

In contrast, Sesshū's understanding of Mu-ch'i's landscape style, as indicated by the Mu-ch'i fan paintings, is based upon a linear technique, relying upon a combination of contour lines, textural strokes, washes, and dots. This Mu-ch'i manner, as understood by Sesshū, although it does not resemble the *Eight Views,* is closely comparable to landscape elements seen in some of the best-known paintings by Mu-ch'i, such as the *White-Robed Kannon* in the collection of the Daitoku-ji (fig. 50). Hemp-fiber textural strokes like those running vertically from the base of the rocks in Mu-ch'i's *White-Robed Kannon* are also seen in the middle ground of the Michigan *Winter.* Still closer in manner of execution to Sesshū's Mu-ch'i manner, as seen in the fan paintings and the closely related Michigan landscapes, is the

Rakan attributed to Mu-ch'i in the Seikadō Foundation Collection.[11] Although more ink wash is employed in this painting than in the *White-Robed Kannon,* the composition as a whole has the balance, cohesion, and serenity that is characteristic of Sesshū's landscapes in the Mu-ch'i manner. Moreover, thick clouds swirl around the Rakan, merging into the rocks, like the clouds in Sesshū's fans after Mu-ch'i and in the Michigan landscapes. The rock forms of the Seikadō *Rakan* are particularly comparable to those of the Michigan landscapes, in both their overall configuration and technique. Thus, Sesshū's unique conception of Mu-ch'i's landscape style is consistent with the style of landscape elements in paintings attributed to Mu-ch'i. The uniqueness of Sesshū's understanding of the Mu-ch'i manner suggests that, either through his journey to China or through his long residence in a center of commerce with China, he

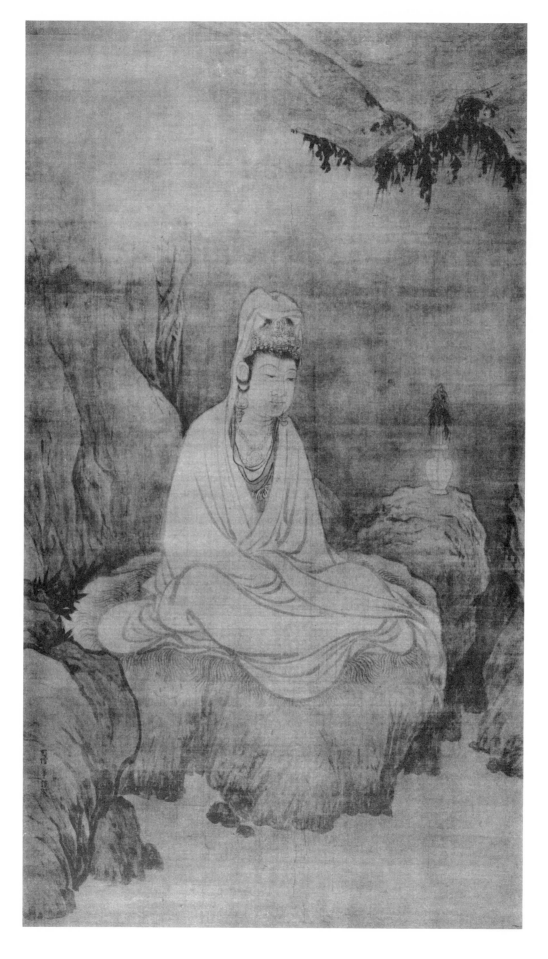

Figure 50. *White-Robed Kannon*, Mu-ch'i (d. 1269–74). Hanging scroll, ink on silk, 172.4 x 98.8 cm. Daitoku-ji, Kyōto

must have had access to a type of Mu-ch'i landscape that is otherwise unknown today.

Other than his Mu-ch'i fan paintings which survive only in Kano copies, there are no works by Sesshū's own hand in this Mu-ch'i manner. However, of the few surviving paintings in this manner by Sesshū's followers, the Michigan *Summer* and *Winter* scrolls are among the closest in overall manner of execution to the prototypes represented by Sesshū's fan paintings after Mu-ch'i. A closely related work of extremely high quality is the pair of landscape screens attributed to Sesshū in the Freer Gallery of Art.[12] The Freer screens are freely and skillfully rendered in Sesshū's Mu-ch'i manner, and have other points, such as the sudden contrasts between near and far distance, in common with his work. The thick, clinging mists that obscure the ground plane in the Freer screens are particularly similar in effect to the clouds in the Michigan landscapes and in the prototype represented by Sesshū's Mu-ch'i fans. Another related work by a known follower of Sesshū is *West Lake* attributed to Shūgetsu on the basis of its inscription, dated 1496.[13] The technique of rendering the mountains using primarily linear textural strokes and the thick misty atmosphere in the distance reflect Sesshū's Mu-ch'i manner, but the artist does not employ as much ink wash. Thus, the overall effect of his extremely linear interpretation of Sesshū's Mu-ch'i manner is stiffer, less descriptive, and far less cohesive than in the Michigan and Freer examples, which remain quite faithful not only to Sesshū's interpretation of Mu-chi's landscape style as seen in the copies of his Mu-ch'i fan paintings, but also to landscape elements in surviving examples of Mu-ch'i's actual work.

The Michigan paintings by a close follower of Sesshū thus provide extremely important evidence of a style of Sesshū's painting, based upon his unique idea of Mu-ch'i's landscape style, that is not directly known through works by his own hand. The *Summer* and *Winter* landscapes are among the few extant examples of this style, which was apparently introduced into Japanese painting by Sesshū. They exemplify the stylistic diversity of Japanese landscape painting of the late fifteenth century, which reflects both the innovative character of painters such as Sesshū and the fresh stimulus of newly imported or newly available Chinese model paintings.

SARAH HANDLER
ANN YONEMURA

NOTES

1. This painting was last seen in a private collection in Japan by Professor Shimada, and to the best of our knowledge probably remains in Japan.

2. It is also possible that this practice existed in China; but it is a subject of much debate whether examples such as Mu-ch'i's *White-Robed Kannon* flanked by *Monkeys* and *Crane*, or Liang K'ai's *Shussan Shaka* flanked by a pair of landscapes, were originally painted as triptychs or later brought together by Japanese collectors. See, for example, Tanaka Toyozō, "Mokkei Kanwa," and Fuku'i Rikichirō's rebuttal, "Mokkei Itteki."

3. Gukei Yū'e, *White-Robed Kannon* and two landscapes, hanging scrolls, ink on silk, 98.6 x 40.3 cm. The *Kannon* is in the collection of the Yamato Bunkakan, Nara, and the landscapes are in the Masuda Collection, Kyōto. They are published in Fontein and Hickman, *Zen Painting and Calligraphy*, nos. 35–36.

4. Tōkyō National Museum, *Sesshū*, pls. 3–4.

5. See Kumagai, "Sesshu-ga Nendai Kō." Sesshū entered the Shōkoku-ji about 1435, during the height of Shūbun's period of activity as a painter.

6. Tōkyō National Museum, *Sesshū*, pl. 10.

7. *Ibid.*, pls. 1, 14, 18–19.

8. The six surviving fan-format paintings are illustrated in *ibid.*, pls. 14–17. Sesshū's copies of two paintings by Li T'ang and two by Hsia Kuei are now in the Asano Collection; his copy of Yü-chien's work is in the Katakura Collection, and his copy of Liang K'ai's painting is in the Kawabata Collection. Six other copies known through Tsunenobu's handscroll in the Tōkyō National Museum include two more works by Hsia Kuei, another by Liang K'ai, two paintings after Mu-ch'i, and one by Mi Yu-jên.

9. See cat. no. 1, n. 5.

10. The four surviving paintings from this set are in separate Japanese collections. They are published in *Sōgen no Kaiga*, pls. 114–19.

11. *Ibid.*, pl. 23.

12. Published in Stern and Lawton, *The Freer Gallery*, 2: pls. 26–27. Pair of six-fold screens, ink and light color on paper, Freer Gallery of Art (58.4, 58.5), formerly in the Kuroda Collection. Although they differ from Sesshū's typical style and are viewed with some caution by scholars of Japanese painting, this pair of screens has not been conclusively attributed to another hand. Thus, of the surviving works in Sesshū's Mu-ch'i manner, the Freer screens are most likely to represent the work of the master himself.

13. Ink on paper, 46.6 x 84.8 cm, Ishikawa Prefectorial Art Museum, Kanagawa. Published in Matsushita, *Ink Painting*, pl. 83. Also part of this tradition is an unpublished painting belonging to a Tōkyō dealer with the seal of the obscure painter "Shuken." It is a "one-sided" composition with looser relationships and brushwork than in the Sesshū fans.

Haboku Landscape

Bokushō (fl. late 15th century)

Hanging scroll, ink on paper,
97.9 x 33.9 cm.
Square double-contoured
intaglio seal reading Bokushō.
Document of Meiji date by
Maeda Kosetsu in box.
Mary and Jackson Burke
Collection (formerly Moriya
Collection)

A broad brush sweep of pale, wet ink defines the foreground embankment and merges with faint silhouettes of plants in the middle ground. Two dark drops of ink dot rocks on the fringe of the embankment. A precarious wooden bridge supports a stooping figure who wears a straw hat and carries a cane tucked under his arm. From the lower right of the composition another sweep of ink wash curves upward, representing the flank of a hill to the right and an overhanging cliff toward the center with a growth of trees on top. Tree trunks, branches, and foliage are rendered in graded tones of ink wash which blur into each other. A second figure climbs the mountain path to the buildings rendered in simple ink lines beyond the trees. Elusively pale ink designates the dizzy height of a peak beyond, its face accented with darker ink dots. The mountain hovers like gossamer in the distant sky.

A seam runs vertically through the center of this composition, joining two sheets of paper. At the top of the scroll a section of damage indicates that there must have been more paper, perhaps as much as ten cm, which was cropped at the time of remounting. On the lower right, a square, double-contoured intaglio seal reading *Bokushō* identifies the painter.

Japanese of the Muromachi period would immediately associate this landscape in a wash style, showing a tiny figure climbing a mountain path toward a group of distant houses, with a specific painting by a much-admired Chinese artist; the scene of *Mountain Village and Clearing Mist* from the handscroll of the *Eight Views of Hsiao and Hsiang* by Yü-chien (fig. 51).[1] The stylistic tradition of Yü-chien's splashy wet ink and spontaneous brushwork was familiar to Muromachi painters as a contrast with the hard-edge academic style of Ma Yüan and Hsia Kuei. And while Japanese painters frequently painted the *Eight Views* in the Ma-Hsia academic style,[2] they found Yü-chien's unique painterly approach especially appealing. Painter-monks of the fourteenth century used his technique without referring specifically to Hsiao-Hsiang scenes: three landscapes in Yü-chien's style by Gukei Yü'e (fl. 1360's) survive today (fig. 6). At least one painting in this spontaneous ink-breaking (*haboku*) manner[3] survives from the first half of the fifteenth century when Shūbun was active (fig. 52). During the second half of the century, interest in this tradition increased, especially among painters of the Soga school such as Saiyo (cat. no. 14). From the 1490's through the first quarter of the sixteenth century, the *haboku* manner was adopted with gusto by major paint-

ers such as Sesshū (fig. 13), his disciple Sō'en,[4] Sessō Tōyō (fig. 42), and the painter-connoisseur Sō'ami (see cat. nos. 22 and 23).

Little is known of the painter Bokushō. In the seventeenth century biography of painters, *Honchō Gashi*, Kano Einō simply says, "Bokushō was good at painting patriarchs of the Zen sect," and illustrates a seal which corresponds closely to the one stamped on the Burke *Haboku Landscape*.[5] The nineteenth century *Koga Bikō*, on the other hand, cites four different types of seals; one is like that on this painting, but the three other types are considered spurious.[6]

A square double-contoured intaglio seal reading *Bokushō*, similar but not identical to the one on the Burke painting, is stamped on three other landscapes: a horizontal work in the Korean style in the Ōhashi Collection, a vertical *Landscape* in Yü-chien manner in the Yama'oka Collection, and a *Landscape* executed in a syncretic mode, combining Yü-chien elements with Ma-Hsia and Mu-ch'i features, from the former Nakamura Collection and now in a private collection in this country.[7] An unpublished painting of a cat carries a seal of similar type. All these paintings cannot be by the Bokushō who painted the *Haboku Landscape* in the Burke Collection.

A seal identical to the one stamped on this landscape appears on another work of excellent artistic quality, a half-bust imaginary portrait of *Daruma*, done in ink on paper in the collection of the Jishō-in subtemple of Shōkoku-ji.[8] The *Daruma* carries a signed inscription by the literary monk of Shōkoku-ji, Gichiku (or Keijo) Shūrin (1440–1518), indicating that the painter Bokushō was active at the end of the fifteenth century. It was customary for a Zen monk to write an inscription on a friend's painting or calligraphy, and there is evidence that Bokushō and Keijo Shūrin were close friends: private letters and poetry exchanged between the two men are recorded in *Kanrin Koroshū*, the collected literary works of Keijo Shūrin.[9]

Isan Shūsei, a prominent monk of the second half of the fifteenth century, was Keijo Shūrin's close friend, and his title in Zen (*dōgō*) was Bokushō. Contemporary diaries and literary anthologies refer to him frequently.[10] Bokushō (or Isan) Shūsei's name appears as early as 1465, when he was known as "Sei (from Shūsei), the Sūtra Keeper." Like Keijo Shūrin, Bokushō Shūsei was a fifteenth century descendant of Musō Soseki in the Zen lineage, which was closely connected with the continuous succession of the abbacy at Shōkoku-ji in

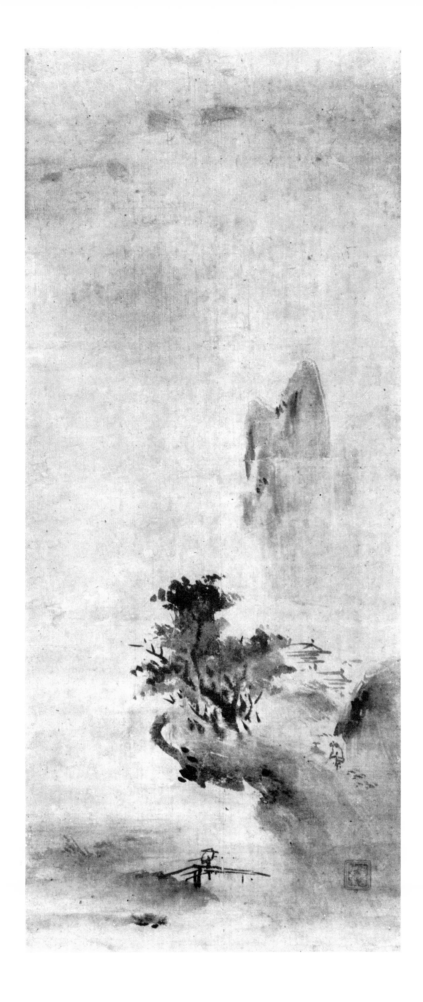

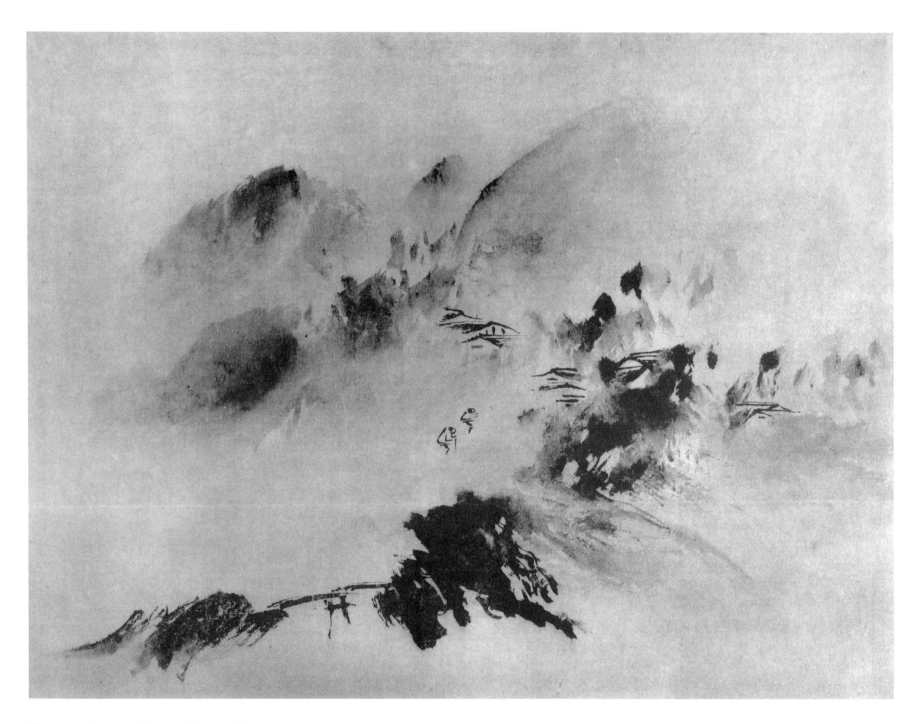

Figure 51. *Mountain Village and Clearing Mist,*
detail, attributed to Yü-chien
(fl. 13th century). Fragment from a handscroll of
Eight Views of Hsiao and Hsiang,
ink on paper, 33.0 x 84.0 cm.
Collection of Yoshikawa Ayako, Tōkyō

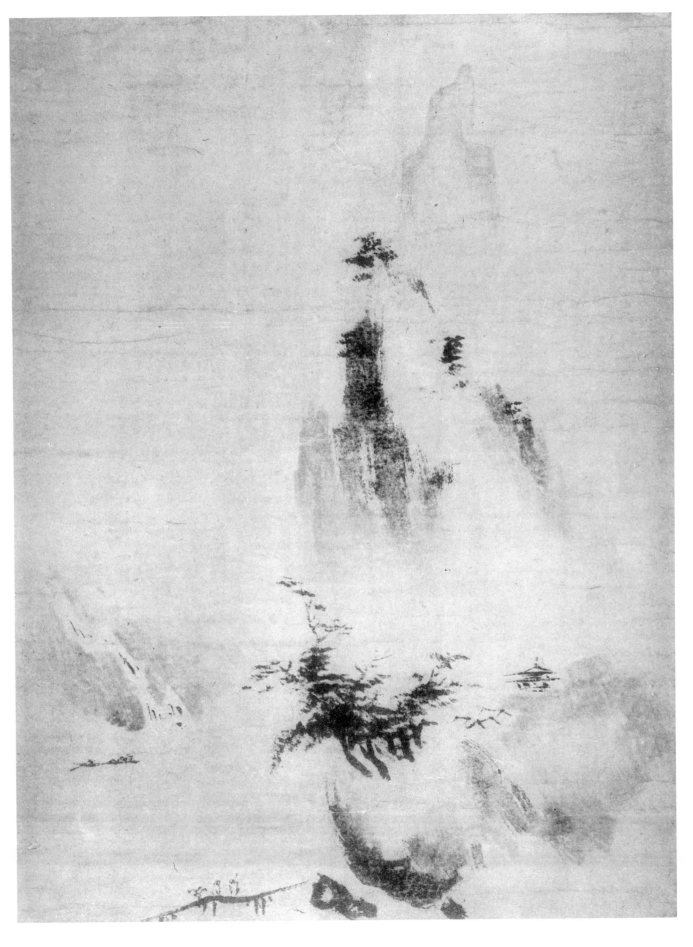

Figure 52. *Haboku Landscape,* detail, artist unknown, attributed to Shūbun (fl. 1423–60), inscribed by Kōzei Ryūha (d. 1446). Hanging scroll, ink and light color on paper, 75.2 x 27.1 cm. Collection unknown, formerly Ishi'i Collection, Tōkyō

Kyōto and with Chinese studies in the Gozan Bungaku movement. Bokushō, however, was active in Suwō (modern Yamaguchi prefecture), the province ruled by the powerful Ō'uchi family. There he resided at a temple called Hoju-ji. Although he lived away from the capital, he was not a provincial monk. Even when he was sūtra keeper, his literary ability had come to the attention of the eminent Kōshi Ehō (d. 1466),[11] the luminous literary monk of Tōfuku-ji and friend of Sesshū, the great painter of Unkoku-an in Suwō. While in Suwō, Bokushō the priest drafted some diplomatic documents for the Ō'uchi family, which was at that time deeply involved in trade with Korea.[12] In 1484 Isan Shūsei became abbot of Shōkoku-ji in Kyōto. Besides Keijo Shūrin, Bokushō's circle of friends included Kikō Daishuku (d. 1487) of Tōfuku-ji in Kyōto, and Tōkei (or Ryō'an) Keigo (d. 1514), another eminent Gozan monk of the late Muromachi period.

Both Kikō Daishuku and Ryō'an Keigo were close friends of Sesshū in Suwō, particularly during Sesshū's late years, after his journey to eastern and northeastern Japan and his eventual return to the Unkoku-an. Bokushō Shūsei's friendship with Sesshū is known through his inscription on a painting in the Ōhara collection which is considered to be Sesshū's latest known landscape (fig. 14).[13] The accompanying inscription was written by Ryō'an Keigo, who inscribed it in 1507 at Unkoku-an where he had learned of Sesshū's death. He wrote, "Bokushō left behind his poem, gone is Sesshū. . . ."

It is still uncertain whether this prominent monk of Suwō province was the painter Bokushō, although it was not unusual for a monk of his caliber to engage in ink painting and calligraphy and to inscribe the paintings of his close friends. Another inscription by Bokushō Shūsei appears on a landscape painting by Sessō Tōyō (d. 1488) in the Masaki Art Museum (fig. 42), which is executed in Yü-chien style tempered by Sesshū's interpretation. It seems reasonable, at least, to link the artist Bokushō, who painted the Burke *Haboku Landscape* in the Yü-chien manner, with the well-known priest Bokushō, who knew the painters Sesshū and Sessō, both of whom left works done in Yü-chien style.

The style of this *Haboku Landscape* by Bokushō differs considerably, however, from works inspired by Yü-chien executed by his contemporaries. During the late fifteenth century paintings in the Yü-chien style served as models for a range of artists. Two major groups can be identified: painters of the Soga school on the one hand (Sōjō, Bokusai, Saiyo; see cat. no. 14), and a group under the dominating influence of Sesshū on the other (Sō'en, Sessō). The ink-breaking (*haboku*) method of the Soga school appears for the first time in the Seattle painting by Saiyo, and reaches its extreme in the coarse brushwork and sharply contrasting ink tones of Bokusai. In contrast, Sesshū and his followers transformed the Yü-chien idiom to emphasize solidity and mass by piling up ink tones in almost geometric brushwork (fig. 13). In the works of the Soga school motifs contrast in flatly vertical and horizontal thrusts; in paintings influenced by Sesshū natural motifs acquire architectonic structure.

Bokushō's *Haboku Landscape* differs from both contemporary expressions of Yü-chien style. His painting is more tempered, more conservative. The pale sweep of ink wash in the foreground embankment, the graded ink-wash tones that blend with each other in the tree group, the movement of the brush which changes the diagonal thrust of the cliff into a linear sweep — all recall the fourteenth century Yü-chien style of Gukei Yü'e (fig. 6). In addition, Bokushō's *Haboku Landscape* continues to reflect traditional components of the Shūbun school. Like the Ishi'i *Haboku Landscape* inscribed by Kōzei Ryūha (fig. 52) — and also like *Chikusai Dokusho* (fig. 9) — Bokushō focuses on the central tree group. The evocative vertical cliff delicately emerging in the distant sky echoes the Shūbun tradition.

There is none of the fierce overlapping or superimposition of horizontal and vertical elements found in works of the Soga school. But there may be some influence from Sesshū, for the tactile volume of Bokushō's tree-laden cliff is not seen in paintings of his predecessors of the Shūbun school. This stylistic feature is one more thread of evidence suggesting that this painter might well have been the priest closely associated with Sesshū in Suwō, Bokushō Shūsei.

YOSHIAKI SHIMIZU

NOTES

1. A handscroll of *Eight Views of Hsiao and Hsiang* by Yü-chien is one of the four catalogued in the 15th century *Gyomotsu On'e Mokuroku.* For a discussion of the theme as a subject for Chinese and Japanese painters, see cat. no. 15. For more information about the Chinese Southern Sung painter Yü-chien and his influence on Muromachi painting, see cat. no. 14, esp. n. 11.

2. The earliest-known Japanese ink painting is one of the *Eight Views* done in the descriptive academic style: *Descending Geese on Sandbanks* by Shikan (fig. 2), inscribed by the Chinese priest who died in 1317 in Japan, I-shan I-ning. It is considered part of a lost set of eight hanging scrolls. This painting is published in color in Kanazawa, *Shoki Suibokuga,* pl. 20. Another part of this set, *Autumn Moon over Tung-t'ing Lake,* also inscribed by I-shan I-ning, is known through a copy made by Kano Tan'yū (1602–74) and published in *ibid.,* pl. 84. The illustration also appears in *Koga Bikō,* p. 282 (under "Ichisan Ichinei"). See also cat. no. 15.

3. See cat. no. 14, n. 10, for a discussion of the technical term *haboku.*

4. *Haboku Landscape* in the Yü-chien manner by Sō'en is published in Matsushita, *Muromachi Suibokuga,* pl. 45.

5. Kano Einō, *Honchō Gashi,* p. 990; and *Honchō Ga'in,* p. 1044.

6. *Koga Bikō,* p. 827. Six seals are illustrated, but two are duplicate seals taken from different paintings. One of them, in combination with an oblong seal, is reported to have come from a landscape which, according to the *Koga Bikō's* commentary, "looks like a Sesson." The second type corresponds to the seal on this Burke painting. The third is a seal of the "Cauldron" type, and the fourth is taken from one of the set of *Thirty-Three Kannon* of Kenchō-ji attributed to Kenkō Shōkei (see cat. no. 2, fig. 25). A handful of paintings which bear seals similar to the types published in *Koga Bikō* is extant, all under Bokushō's name. Two Kannon paintings, in the Okazaki and the Nishiwaki collections, carry a seal similar to the one from the Kenchō-ji *Kannon* cited in *Koga Bikō.* Further detailed study of *Bokushō* seals is required.

7. The Ōhashi *Landscape* is unpublished; the Yama'oka painting is illustrated in Yamaguchi Prefectorial Museum, *Sesshū,* pl. 65; the third landscape is published in Kyōto National Museum, *Sesshū,* pl. 55.

8. Published in *Kokka,* no. 385.

9. The inscription on the *Daruma* is a short poem eulogizing the First Patriarch and is signed by Keijo as "Gichiku Keijo," referring to his studio, the Gichiku-ken, an annex of the Jishō-in subtemple of Shōkoku-ji, where he died in 1518. Keijo's literary works are collected in a fairly chronological compilation, the *Kanrin Koroshū.* The Daruma eulogy is included in chap. 10, p. 476.

10. For example, Kikō Daishuku refers to Isan Shūsei in his diary, *Shaken Nichiroku,* in three entries for the year 1484: the fifth day of the ninth month, the twenty-fifth day of the eleventh month, and the seventeenth day of the twelfth month. Keijo Shūrin mentions him several times in his *Kanrin Koroshū,* pp. 343, 394–95, 406. In these references, Isan Shūsei is referred to as "Hoju" after Hoju-ji, the temple in Yamaguchi where he resided. The question of Bokushō Shūsei is considered in detail by Nakamura Tani'o, "Bokushō Shūsei ni Kansuru Shiryō."

11. Kōshi Ehō, *Chiku-kyo Seiji* (preface 1465), in U'emura, *Gozan Bungaku Zenshū,* 3:841. For discussion of Kōshi Ehō's death date, see cat. no. 11, n. 6.

12. Kumagai, "Sesshu-ga Nendai Kō," pp. 32–33.

13. See Shimada, "Sesshū Nempu," in Kyōto National Museum, *Sesshū.*

Viewing a Waterfall
Tōshun (fl. first half 16th century)

Hanging scroll, ink on paper, 60.81 x 33.54 cm. Square intaglio seal reading Tōshun in lower right. Collection of Kimiko and John Powers (formerly Nakamura Collection)

With the death of the great master Sesshū in 1506, the creative energy engendered by his Unkoku-an studio in Suwō province (modern Yamaguchi prefecture) appeared to stagnate. But Sesshū's versatile Japanese metamorphosis of traditional Chinese styles influenced several outstanding pupils, who diffused his manner throughout Japan during the first half of the sixteenth century. Shūgetsu, for example, returned to his home province of Satsuma on the island of Kyūshū after study with Sesshū, and followed his master's footsteps by making his own journey to Ming China in 1496. His painting of the picturesque West Lake in Hangchou [1] is executed in one of Sesshū's late styles, the linear manner of Mu-ch'i (see cat. no. 18). Sō'en, after receiving Sesshū's *Haboku Landscape* (fig. 13) as a certificate of his artistic achievement, traveled east and settled in Kamakura. He is best known for interpretations of Yü-chien (see cat. nos. 14 and 19).[2] Tōshun, who painted the Powers *Viewing a Waterfall*, found commissions among his master's patrons; his works tend to follow the Chinese models that Sesshū studied during his developing years as much as the individual manner of the mature Sesshū himself.

In *Viewing a Waterfall*, the sharp edge of a cliff cuts the composition diagonally in half. A gnarled tree grows downward from the cliff's shoulder with a characteristic twist of two crossing branches. A waterfall cascades through a pitted rock wall in the back, breaks into bubbles at the foot of the cliff, and surges into a mountain brook in the lower left. A massive rock thrusts upward from the bottom of the scroll. Rendered in crisp contour lines, graded ink washes, and small axe-cut texture strokes, the boulder stands like a screen in front of the flowing brook. Behind the right shoulder of this rock and beside the low elbow of a rocky mountain slope, a narrow mountain path leads to a terrace in the middle ground. There, securely protected by a guardrail, a goateed gentleman sits on a bench quietly contemplating the pool of water below. He is attended by a servant carrying a mountain staff. The painting is remotely related to the theme of *Li Po Viewing a Waterfall* (see cat. no. 6). However, in Japan as in China, this subject became so generalized that scrolls such as this one by Tōshun should be considered simply as *Viewing a Waterfall*.

The painting is executed predominantly in ink wash. Clear linear treatment is given only to the twisting tree above and protruding rock below, the gushing brook and the figure with their ambient motifs. The expressive quality of the work is conveyed primarily through well-distributed ink tones, ranging from the dark foreground rock to the medium gray cliff in the middle ground and the lighter-toned rock wall behind the waterfall.

The paper shows traces of abrasion, with creases resulting from years of rolling and unrolling. Retouching is noticeable on the small rock in lower left. Stamped in the lower right-hand corner, a square intaglio seal reads *Tōshun*. It is the standard seal recorded for this artist since the seventeenth century.[3]

Tōshun's biography, however, is far from clear. The *Honchō Gashi* reports that he was from Bizen (modern Okayama prefecture), a province adjacent to Suwō, that when he was young he was a stableboy good at painting horses, and that Shūbun discovered the artistic talent of the young Tōshun.[4] Such a relationship to the great fifteenth century master of the Shōkoku-ji is chronologically impossible, however, when placed in the context of other evidence.

A more reliable picture of Tōshun emerges from various comments made by his follower Hasegawa Tōhaku (1539–1609), in his informal remarks on painting and painters recorded in *Tōhaku Gasetsu* (ca. 1591).[5] According to Tōhaku, Tōshun was a native of Yamato province (modern Nara prefecture). In marked contrast to such humanist painter-monks as Bompō (cat. no. 34), Tōshun was a man of humble birth and education, apprenticed to a carpenter in Nara. His talent was discovered by Sesshū during an artistic pilgrimage through Nara.[6] Tōhaku's mention of Tōshun's link with Sesshū is supported elsewhere in *Tōhaku Gasetsu* by a chart of Tōshun's artistic lineage, citing him as one of Sesshū's three disciples. Another seventeenth century lineage chart, the *Gashi Tekiden Shūhazu*, corroborates Tōhaku's genealogy, listing a "monk Tōshun" of Yamato province as one of nine followers of Sesshū.[7] A "monk Shūtoku" of Suwō is also included among the nine (see cat. no. 21).

From the fragmentary comments made by Tōhaku, Tōshun appears as a close disciple of Sesshū and was patronized by powerful feudal lords. He accompanied Sesshū on his trip to Kaga (the southern part of modern Ishikawa prefecture), where he remained for three years and probably came to know Lord Togashi. About 1501 he went with Sesshū to Noto (the northern peninsular region of Ishikawa prefecture), where he may have met Lord Hatakeyama Yoshinori.[8] One of Tōshun's patrons during these early years was Lord Hosokawa Shigeyuki (1434–1511), governor of Sanuki and Awa pro-

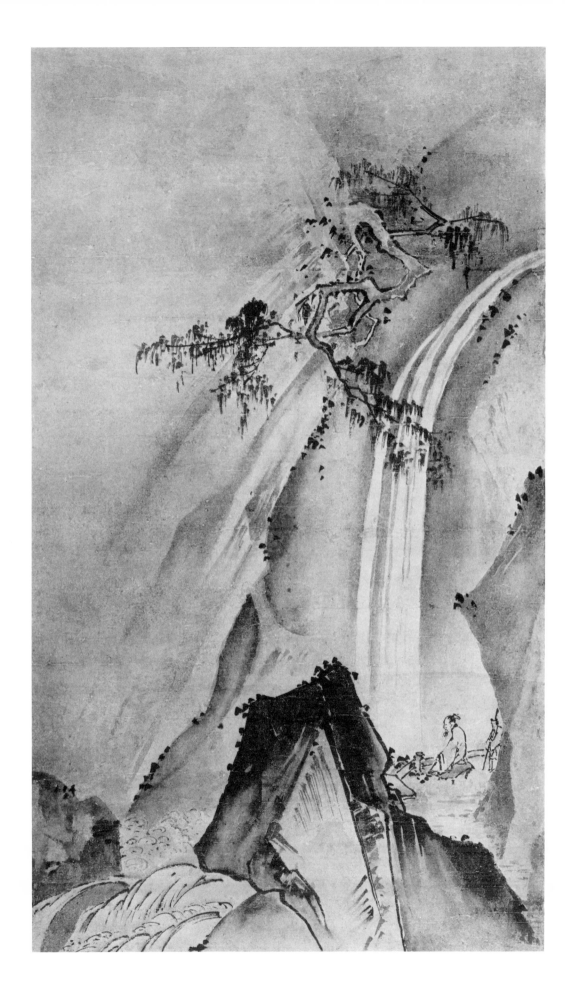

vinces (modern Tokushima prefecture on the island of Shikoku), who paid Tōshun a regular stipend and even advised the young artist not to imitate slavishly the grand "magnitude" of Sesshū.[9] Finally, sometime after 1528 at Kutsuki in Ōmi province (modern Shiga prefecture), the former carpenter's apprentice met the twelfth Shōgun, Ashikaga Yoshiharu, who asked him to execute three fan paintings.[10]

Besides these early accounts of Tōshun's high-ranking clientele, gleaned from the pages of *Tōhaku Gasetsu*, Professor Tanaka Ichimatsu has recently identified the lord of Suwō province, Ō'uchi Yoshioki (1477–1528) as the patron of Tōshun's well-known set of twelve paintings of *Birds and Flowers and Figures*. For each of these small paintings, the literary priest of Shōkoku-ji, Keijo Shūrin (1440–1518), composed and inscribed a seven-syllable quatrain. Today Shūrin's poems are mounted above Tōshun's paintings in a set of hanging scrolls.[11] All the poems are recorded in Shūrin's *magnum opus*, the *Kanrin Koroshū*,[12] and are datable according to other dated poems appearing in chronological sequence. Since Professor Tanaka concludes that these poems were written in 1513 or 1514, the painting must have been done just prior to this date, or ca. 1512. The paintings on this pair of screens are the earliest extant datable works by Tōshun.

Two other scrolls by Tōshun can be dated according to their inscriptions. A portrait of *Daruma* in slight color on paper bears an inscription by Ryūkō Sōshō (1449–1522), the eighty-third abbot of Daitoku-ji, so it must have been done before 1522.[13] A half-bust portrait of *Yuima* (*Vimalakirti*) in three-quarter view, in the Umezawa Kinenkan, is inscribed by Tōki Eikō (fl. 1530, d. 1542), the 273rd abbot of Kennin-ji.[14] This painting, however, must be approached with caution, since neither the painting style nor the seals are comparable to any of the above works.[15] There is a possibility of more than one Tōshun.

Based upon datable accounts of Tōshun noted in *Tōhaku Gasetsu*, existing datable paintings, and other documentary evidence related to Tōshun's activity, Professor Tanaka has proposed a tentative chronology for this artist. During his late twenties and early thirties, from about 1492 until Sesshū's death in 1506, Tōshun's activity was centered in western Honshū in close contact with his painting master, Sesshū. He was already a recognized artist in the service of Lord Hosokawa. Soon after Sesshū's death, Tōshun was called to Kyōto to engage in a campaign of decoration at Ryūgen-in, Dai-

toku-ji. The construction of this subtemple, patronized by Lord Hatakeyama of Noto, had just been completed in 1506.[16] On the sliding-door panels in one room Tōshun painted figure subjects in the manner of Liang K'ai, and on those of an adjacent room monkeys based on the Mu-ch'i style.[17]

Tōshun's earliest extant paintings, the set of *Birds and Flowers and Figures*, probably painted in 1512, were done by a mature artist in his late thirties. Within the next ten years, before 1522, he painted the *Daruma*. Then, if the *Yuima* portrait is by the hand of this Tōshun, its latest date, 1542, marks this artist's late years.

Tōshun's existing paintings reveal that, like his contemporaries, he worked in different modes and with varied subject matter. The colorful style and overall composition of his *Birds and Flowers and Figures* follow Ming rather than Sung models. His bird-and-flower paintings especially are comparable to Ming academic painters such as Lü Chi (fl. 1488–1505),[18] but pictorial elements seen in contemporary Chinese works characterize his figure paintings as well. Tōshun staggers his motifs compactly from foreground to distance, consistently suppressing atmospheric space.

There are three landscapes besides *Viewing a Waterfall* by Tōshun. One, known only from a seventeenth century Kano copy, follows Sesshū's style,[19] but the others reflect little influence from his master. A set of *Eight Views of Hsiao and Hsiang* in the Yü-chien ink-wash mode, formerly an album but now mounted as a continuous handscroll, is in the Masaki Museum,[20] and a quasi-narrative painting in ink on paper, *Yen-ch'i Visiting Tai An-tao*, is in the Tazawa Collection.[21]

Viewing a Waterfall has little in common with any of these paintings. It is based on a specific Chinese round fan painting, attributed to the Southern Sung painter Hsia Kuei and also called *Viewing a Waterfall* (fig. 53), which originally formed a pair with another fan depicting a scholar seated under a tree. Tōshun was serious about using models. In the instance cited above when the Shōgun Ashikaga Yoshiharu asked him to do three fan paintings, Tōshun replied that he could not paint them without models. Fifty model paintings were immediately procured from Sō'ami, the Shōgun's connoisseur-painter, and a work by Hsia Kuei was chosen. The way Tōshun used such a model can be demonstrated by his interpretation of *Viewing a Waterfall*.

Although the key motifs and overall design were taken from the round fan, Tōshun's handling of space differs from that in his Chinese model. He shifts the

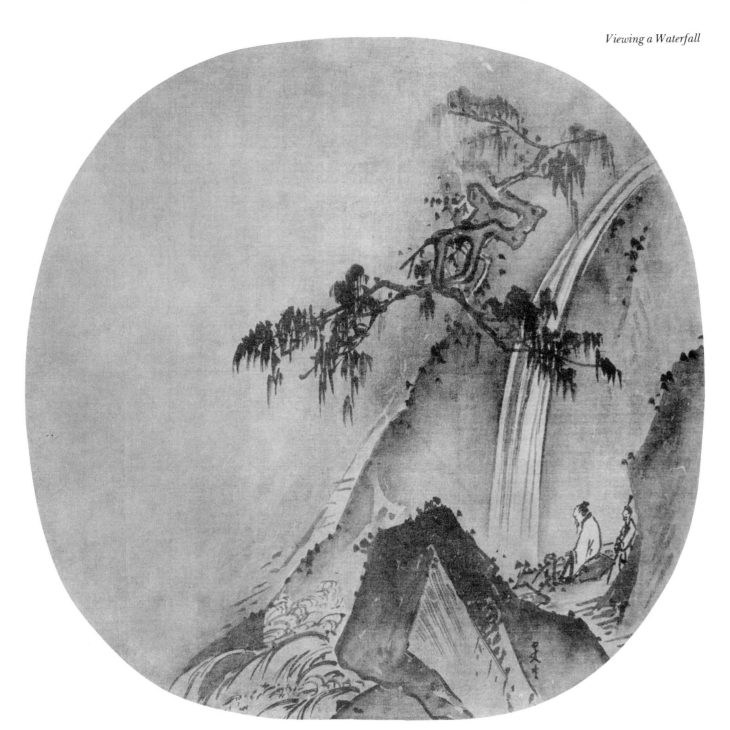

Figure 53. *Viewing a Waterfall,* attributed to Hsia Kuei (fl. ca. 1190–1230). Fan painting, ink on paper. Collection unknown, formerly Akaboshi Collection, Tōkyō

focal center from the figures in the right-hand corner to the space created by the downward thrust of the tree branches above and the upward surge of the dark rock form below. Tōshun makes the cliff, which stretches diagonally across the composition, more dynamic. In the Chinese model it is defined by soft ink wash, but Tōshun suggests textural variety with quick sweeps of his brush. In addition he gives the diagonal cliff a rhythmic contour, three scallops from the lower left to the contorted tree. Thus Tōshun transforms the atmospheric space of his model into flat planes. A tight com-

position results, its compression emphasized by contrasts in ink tonalities.

In terms of translating the Chinese academic style of Hsia Kuei into a personalized expression, Tōshun's painting can be compared with Gei'ami's *Viewing a Waterfall,* painted in 1480 (fig. 61). Both Japanese works place motifs of the Hsia Kuei type within a vertical format, focusing on a waterfall plummeting from upper right down to a bubbling pool in the middle ground. Similar motifs include the severe dark rocks and the gnarled tree above the cliff, although Gei'ami's tree grows up-

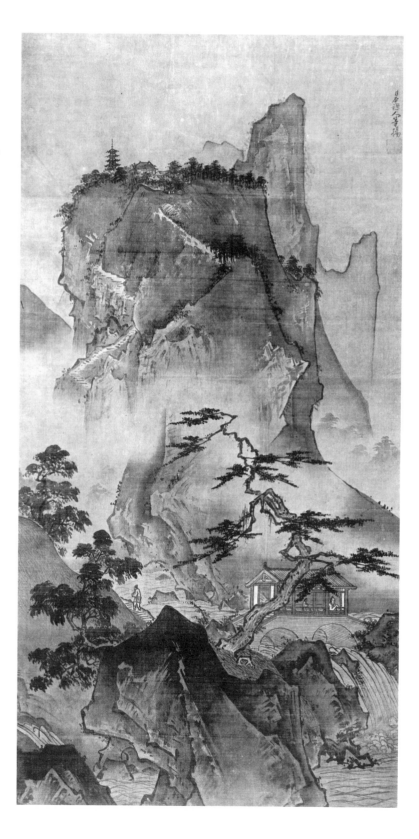

Figure 54.
Summer Landscape,
Sesshū (1420–1506).
Hanging scroll
from a set of
*Landscapes of the
Four Seasons,*
ca. 1467–69,
ink and colors on silk,
149.3 x 75.7 cm.
Tōkyō National
Museum

ward. Gei'ami focuses on the narrowly enclosed middle-ground space in a manner equivalent to Tōshun's compact concentration on the scholar's middle-ground terrace.

Viewing a Waterfall, painted in the hard-edge academic ink style, exemplifies Tōshun's finest works. There are few signs of Sesshū's mature style in this painting. Instead, it compares most closely with *Summer Landscape* (fig. 54), one of the set of four-seasons landscapes which Sesshū presumably painted during his sojourn in China between 1467 and 1469. These paintings reflect Sesshū's investigation of the Ming style of Li Tsai (fl. 1426–1435) and other academic painters following the Southern Sung tradition of Ma Yüan and Hsia Kuei.[22] The sharp delineation of Tōshun's foreground rock significantly resembles the one in Sesshū's *Summer Landscape.* Other comparable features include the twisting tree branches and the prevalent compositional use of diagonal planes.

Tōshun's interpretation of the Hsia Kuei style of *Viewing a Waterfall* is intermingled with translations of the Southern Sung academic style rendered by Japanese artists who had studied earlier Chinese paintings (Gei'ami), Ming Chinese artists who followed the earlier style (Li Tsai), and Japanese artists who had studied both Southern Sung prototypes and Ming interpretations of them (Sesshū). Tōshun was heir to the entire complex tradition. The date of his painting in relation to other works cannot be hastily decided. His translation of the Chinese fan painting expresses a mature style reaching far beyond the model itself, reviving the earlier style of Sesshū and reflecting the late fifteenth century Chinese academic painting style.

YOSHIAKI SHIMIZU

NOTES

1. *West Lake,* by Shūgetsu, hanging scroll, ink on paper, 46.6 x 84.8 cm, Ishikawa Prefectoral Art Museum, Kanazawa; published in Matsushita, *Ink Painting,* pl. 83; and Kyōto National Museum, *Sesshū,* pl. 52.

2. *Haboku Landscape,* by Sō'en, is published in Matsushita, *Muromachi Suibokuga,* pl. 45. For an explanation of the *haboku* technique, see cat. no. 14, n. 10.

3. Kano Einō, *Honchō Ga'in,* p. 1026.

4. Kano Einō, *Honchō Gashi,* p. 986.

5. *Tōhaku Gasetsu* (Tōhaku's Discussion of Painting) is a record of the impromptu remarks on painting made by the Momoyama period artist Hasegawa Tōhaku, written by his friend Nittsū, the priest of Hompō-ji. Internal evidence dates the original manuscript to 1591. It was first published by Tanaka Kisaku in *Bijutsu Kenkyū,* no. 1, in 1932. In 1963 Minamoto Hōshin published an independent volume, in which there were photographs of the original manuscript as well as a transcription of the text with brief annotations. All references are to this edition.

6. *Tōhaku Gasetsu,* p. 18.

7. The most thorough study of Tōshun is by Tanaka Ichimatsu, "Tōshun-ga Setsu" ("Discussion of the Art of Tōshun"), first published in two installments in *Kokka,* nos. 888, 890 (1966), and then included in Tanaka's *Nihon Kaigashi Ronshū* published in the same year, pp. 383–449. All succeeding references will be to the latter publication. *Gashi Tekiden Shūhasu* is cited on p. 401. The original source of this artistic lineage table is unknown, but there is a 17th century copy by Kōgetsu Sōgan (1574–1643), a priest-aesthete of Daitoku-ji. Sōgan's handwritten chart is kept at Sūfuku-ji in Hakata, pasted on a screen. It is probably a fragment from Kōgetsu's *Bokuseki no Utsushi* (Records of Calligraphies) kept in the temple collection.

8. *Tōhaku Gasetsu,* p. 21. First-hand evidence for Sesshū's trip to the Hokuriku region (which includes Kaga and Noto provinces) is Sesshū's painting of *Ama no Hashidate,* now in the Kyōto National Museum and frequently published; a color reproduction is in Tanaka and Yonezawa, *Suibokuga,* pls. 84–85. Ama no Hashidate, a scenic spot of the northernmost area of Kyōto prefecture, is within a short distance of Noto. The painting, believed to be an accurate sketch of the actual spot with only slight changes in composition, was done after 1501, for it includes the stupa of Chi'on-ji, which was erected in that year. See Kumagai, "Sesshū-ga Nendai Kō," pp. 31–35.

9. *Tōhaku Gasetsu,* pp. 5, 17–18, on Awa no Sanshu, identified as Hosokawa Shigeyuki in n. 7 on p. 43. See also Tanaka Ichimatsu, "Yōshun-ga Setsu," pp. 407–8, 440, n. 32.

10. *Tōhaku Gasetsu,* pp. 17 and 58, n. 17. See also Tanaka Ichimatsu, "Tōshun-ga Setsu," pp. 407–8, 440, n. 2.

11. Tanaka Ichimatsu, "Tōshun-ga Setsu," pp. 383–400, esp. 395–400. The scrolls, painted in ink and color, are illustrated on pp. 384–87. Today only eleven of the original twelve paintings remain.

12. Keijo Shūrin, *Kanrin Koroshū,* pp. 291–92. See also Tanaka Ichimatsu, "Tōshun-ga Setsu," pp. 394–95.

13. *Ibid.,* pp. 420–21. Tanaka's sketch of the *Daruma* is fig. 250.

14. Exhibited in Boston in 1970, the *Yuima* is published in Fontein and Hickman, *Zen Painting and Calligraphy,* no. 64. See also Tanaka, "Tōshun-ga Setsu," figs. 252, 421, and pp. 422–23, 446–47, n. 57.

15. Two unusual seals are stamped on this painting. One is a round intaglio seal, *San Eki* or *Ichi Eki,* and the other a square relief seal, *Tōshun.* Neither is found on any other Tōshun paintings. Stylistically, the painting strikes a note of discord.

16. Tanaka, "Tōshun-ga Setsu," p. 415, chronological table on p. 434, 443–44, n. 43.

17. *Tōhaku Gasetsu,* pp. 17–18. Figure paintings associated with Liang K'ai can be seen in Bijutsu Kenkyūjo, *Ryōkai.* See also cat. no. 5, n. 4. Mu-ch'i's painting of monkeys, which is the right flanking scroll of his famous triptych centering around the *White-Robed Kannon* (fig. 50), initiated a long tradition of monkey painting in Japan. It is published in Yonezawa and Nakata, *Shōrai Bijutsu,* pl. 40.

18. For paintings by Lü Chi, see *Minshin no Kaiga,* pls. 16–17.

19. *Kinzan-zu,* known through a Kano copy in the Tōkyō National Museum, is published in Tanaka, "Tōshun-ga Setsu," fig. 262 on p. 429.

20. *Ibid.,* fig. 256, pp. 426–27, 447, n. 61.

21. *Ibid.,* fig. 259, p. 428. This painting must be approached with caution. Professor Shimada observes that the strange space depicted here suggests that the painting may have been cropped considerably.

22. For Li Tsai and other academic artists of the early Ming period, see Suzuki, *Ri Tō, Ba'en, Kakei,* pl. 72, p. 167n., and passim.

Landscape

Shūtoku (fl. 1539–40)
Inscribed by Chōkoku Kentō and Teihō Shōchū (fl. ca. 1538)

Hanging scroll, ink and slight color on paper, 70.49 x 40.64 cm.
Two seals of inscribers: double-contoured square intaglio seal reading Chōkoku, *and square relief seal reading* Shōchū.
Square intaglio seal, 2.4 x 2.4 cm, in lower right, reading Shūtoku.
Mary and Jackson Burke Collection (formerly Sorimachi Collection)

During the first half of the sixteenth century, while many of Sesshū's important disciples were dispersed throughout Japan, Shūtoku kept alive his master's individualistic style in Suwō province. Tradition holds that Shūtoku succeeded Sesshū as master of the Unkoku-an. The Burke *Landscape* testifies that he adopted his teacher's unique brush manner and sturdy landscape forms.

Above the horizontal edge of the foreground terrain, a solid cluster of tilted rocks supports three twisting pines and a smaller deciduous tree. One pine twists toward the cliff and waterfall on the right. Another angles over the sloping embankment, a double-roofed pavilion on stilts in water, and a moored unmanned boat. From the pavilion a man peeks toward the boat. The third and tallest pine tree ascends vertically, following the axis of the jagged precipices that escalate in the middle ground. Behind the rocky pinnacles are silhouettes of even taller mountain spires. From foreground up, nature motifs densely pack the right side of the composition. The low-bending pine tree on the left points toward a stretch of lake which opens up the left side of the painting. Willow trees grow on the opposite shore, a sign of spring or early summer, and a bridge spans a tributary stream. Dense mist hovers over a forest which gradually fades into distance, stopping at the base of an undulating mountain range. A nocturnal atmosphere is conveyed by traces of ink wash on the sky, water, and most of the foreground terrain, and by effective contrasts of white projections and deep ink-wash shadows which define the pinnacles in the middle ground. Several creases are on the paper, most severely on the upper section. A seal reading *Shūtoku* identifies the artist.

In the upper left, two poems in Chinese style by Chōkoku Kentō and Teihō Shōchū, the 169th and 170th abbots of the Kenchō-ji monastery in Kamakura,[1] speak appreciatively of the landscape:

> *Although spring waters are fertile on this*
> *western shore,*
> *The boat is closed tightly outside Pi-hsiang*
> *gate [of Changsha].*
> *If the east wind is favorable to this youth*
> *in the boat,*
> *He will return home by moonlight, bearing a*
> *bit of Wu district frost.*
> *[Signed] Priest Kankyō-kansha* [2]
> *[Seal]* Chōkoku

> *Spring waters seem to float high up to the sky.*
> *The boat is moored; when its sleep ends, what*
> *will it seek?*

> *For the rest of my life I will follow the*
> *simple dignity of the oar.*
> *These mountains are like beautiful maidens,*
> *the river like a white gull.*
> *[Signed] Zen-Fukusan Shōchū*
> *[Shōchū, former abbot of Fukusan]*
> *[Seal]* Shōchū

Fukusan refers to Kenchō-ji, and the inscription of its former abbot, Teihō Shōchū, can be approximately dated. Shōchū inscribed a landscape painting by Senka, dated 1538 by an accompanying colophon which also refers to Shōchū as residing at Kenchō-ji.[3] The style of Shōchū's calligraphy in the two inscriptions is comparable. Since he had left Kenchō-ji when he inscribed Shūtoku's painting, it seems reasonable to date this *Landscape* shortly after 1538.

The painter Shūtoku is believed to have been a monk, a native of Suwō province, and a follower of Sesshū. One of the earliest lineage tables of the Sesshū school, the early-seventeenth century *Gashi Tekiden Shūhazu*, lists the monk Shūtoku along with Tōshun among ten pupils of Sesshū, and indicates that his disciple was Unkoku Tōgan (1547–1618), the founder of the Unkoku school.[4] However, Japanese art histories from the late-seventeenth century *Honchō Gashi* to the late-nineteenth century *Koga Bikō* present a confused picture of this painter. Their conflicting reports suggest the existence of more than one Shūtoku ca. 1500.[5]

In the *Honchō Gashi*, Kano Einō describes a monk Shūtoku who succeeded Sesshū as master of the Unkoku-an and whose Buddhist title (*dōgo*) was Ikei. Einō quotes an inscription written by the high-ranking priest Sakugen Shūryō (1500–1578) on a painting in Yū-chien style by Shūtoku which says, "The master of the Unkoku-an, Shūtoku the sūtra keeper [*zōkyōku, i.e., zōsu*] has become famous in western Suwō province for his painting." [6] But Einō is confusing two different persons. The painter Shūtoku could not have been the prominent Ikei Shūtoku, abbot of the Shōkoku-ji, for when Ikei died in 1490 at the age of eighty-six (by western count), Sakugen Shūryō had not been born and Sesshū was still quite active at the Unkoku-an.

Seals reading *Shūtoku* which are recorded in the early art histories vary in type. Kano Einō prints a square double-contoured relief seal in the *Honchō Ga'in*.[7] Two similar seals are illustrated in the *Koga Bikō*, one of which is accompanied by the signature "Shūtoku hitsu" (by the brush of Shūtoku), with the comment that it was copied from a painting of *Fukurokuju* (the god of longev-

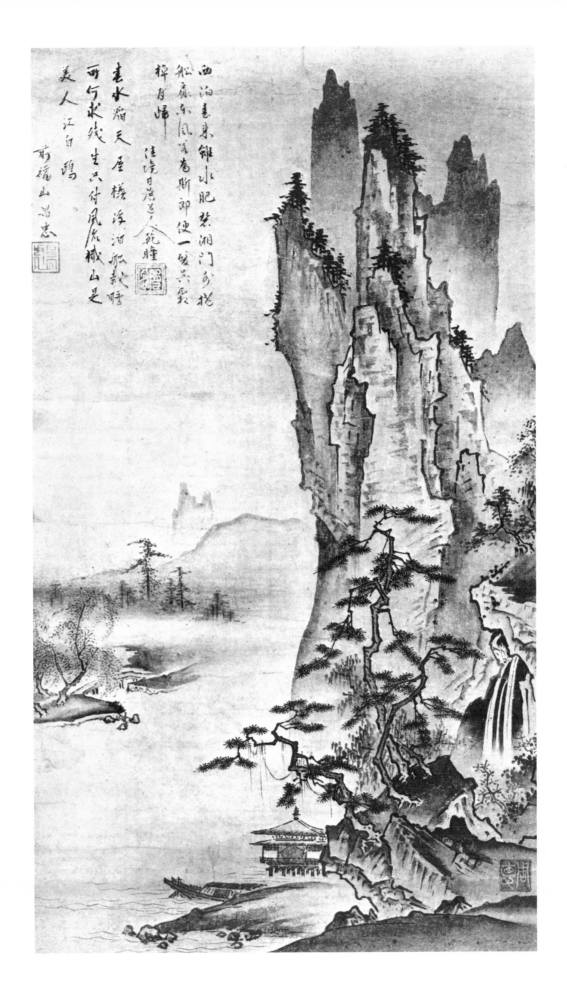

ity).[8] Six paintings surviving today, three of them landscapes, bear a similar seal.[9] One landscape, done in Yü-chien manner on a horizontal sheet of paper, has a signature, "Ikei," in running-style calligraphy superimposed on the seal.[10] The signature is a later addition based on the erroneous reference to Ikei Shūtoku first made in the *Honchō Gashi*. A second landscape, in a private collection, is a small work in ink, slight color, and gold, reminiscent of Sesshū's Hsia Kuei style.[11] The third is a *Winter Landscape* in the Tokiwayama Library collection.[12]

The *Koga Bikō* records two additional seals of square intaglio type.[13] The commentator notes that one came from a painting of a *Loquat*, a work in color on paper that was known to exist in the early twentieth century.[14] The other seal was stamped on a landscape which is sketched in the *Koga Bikō* with the comment, "it is taken from a vertical landscape painting inscribed by Chōkoku and Shōchū, both of Kenchō-ji." Both the comment and the sketch make it unmistakable that this is the *Landscape* now in the Burke Collection. The *Koga Bikō* author transcribes the inscriber's signatures, and makes a note on the landscape drawing to show that the inscriptions are in the upper left corner. His critical appraisal of the landscape's quality and style is interesting. He writes, "it is a good painting for Shūtoku," it is very much like Shūbun with very little [influence of] Sesshū," and finally, it is "less refined than Shūbun."

From the evidence of these seals and the style of the paintings on which they appear, there may be at least two different painters bearing the name Shūtoku, aside from the totally unrelated abbot of Shōkoku-ji, Ikei Shūtoku. One painter used a relief seal, the other (who did the Burke painting) an intaglio seal. The *Gakō Benran*, an art history compiled ca. 1680 and attributed to the scholar-politician Arai Hakuseki of the early Edo period, adds further complication by citing what can only be a third painter. This Shūtoku came from Utsunomiya and was called Tsubara after a place-name in Shimotsuke province (modern Tochigi prefecture north of Tōkyō). He studied the art of Kano Motonobu (1513–1559; cat. no. 28).[15]

The most plausible clue to the identity of the Shūtoku who was Sesshū's successor at the Unkoku-an and who painted the Burke *Landscape* is gleaned from the inscription on his landscape in Yü-chien style recorded in the *Honchō Gashi*. Sakugen Shūryō, the inscriber, was a prominent priest of Tenryū-ji who was twice (1539–1541 and 1547–1550) dispatched to Ming China by the Ashikaga Shōgun as the vice-envoy of official diplomatic missions. In 1956 Professor Shimada noted that Sakugen, in the journal of his first mission, mentions a Senior Officer (*jōsu*) Shūtoku, who painted. Sakugen wrote the second character of Shūtoku's name, *toku* meaning "virtue," with a homophonic character, *toku* meaning "to acquire."[16] But there was only one Shūtoku in Sakugen's circle who painted, and the date of his journey to China in 1539–1541 agrees with the date of shortly after 1538 established for the Burke *Landscape*. This must be the Shūtoku who painted a landscape in Yü-chien style which was inscribed by Sakugen and recorded in the *Honchō Gashi*.

Shūtoku's *Landscape* displays many stylistic features that characterize ink landscapes of the first half of the sixteenth century. It is archaistic work and a pastiche. The heavy piling-up of foreground and middle-ground motifs in a staggered fashion, as if seen through a telephoto lens, is a feature which appears in the Baltimore *Landscape* (cat. no. 13) of the late fifteenth century. The contrasting open space on the left of the composition, defined by the expanse of water and the distant pinnacles, recalls one aspect of the style of Kenkō Shōkei in his landscapes of Hsia Kuei type in the Museum of Fine Arts, Boston (cat. no. 24), and in the Nezu Museum (fig. 60). The crisp delineation of the cluster of peaks in the middle ground, sharply contoured with broken and pointed heavy lines, comes directly from the influence of Sesshū (see his Ōhara *Landscape*, fig. 14, or his *Winter* landscape, fig. 44). The explicit texturing of rock surfaces by repeated short horizontal strokes also recalls Sesshū and Kantei (cat. nos. 15–17). The nocturnal mood conveyed through the mysterious contrast of dark and light, on the other hand, reflects the direction taken by the followers of Kenkō Shōkei working in Kamakura, such as Senka (fig. 62), Kōboku, and Kō'etsu.[17]

Nevertheless, the basic compositional scheme employed here faintly echoes the century-old tradition of Shūbun. For example, the pine-tree group placed on the rocks between the foreground terrain and the dense column of peaks is a feature directly influenced by the typical Shūbun type of motif seen in *Chikusai Dokusho* (fig. 9) and, especially in the pine-tree motifs, in *Suishoku Rankō* (fig. 39). But the artistic context of Shūtoku's motifs is altogether different from the mid-fifteenth century paintings, and his models (namely Hsia Kuei via Sesshū and Kenkō Shōkei) are readily detectable. The sharply rendered contour lines and texture strokes, as well as the shading given by ink washes, solidify the rock motifs. The crisply defined pinnacles in the middle

ground virtually suppress the space, which was the most conspicuous feature of typical Shūbun paintings. This same tendency has been noted in the Baltimore *Landscape* (cat. no. 13). The lack of all-inclusive spatial clarity and the assertion of local structural clarity of individual motifs are stylistic features which also appear in the landscape of Shūbun type attributed to Kano Masanobu (1434–1530) in the Konishi Collection (fig. 17).

Shūtoku's *Landscape* is an example of the very last stage of the century-old tradition of landscape painting in Shūbun style in a vertical format. From the evocative, space-conscious landscape through the dynamic momentum of Sesshū, Japanese painters shift from intuitive visual exploration to studied reconstruction of fragmentary motifs from different sources. The result is a constrained and mannered pictorial essay. Shūtoku's composition is cerebral in the best sense of the word, intellectually summarizing the achievement of past masters.

Yoshiaki Shimizu

NOTES

1. For the succession of Chōkoku Kentō and Teihō Shōchō as Kenchō-ji abbots, see *Rinzaishū Kenchō-ji Juji Rekidai* in *Dokushi Biyō*, pp. 1010–12.

2. *Kakyō-kansha* means "the sweetest part of the sugar cane," carrying the association of arriving at the best part of something gradually. In modern Japanese the word *kakyō* has come to mean the most interesting part, or the climax of a story. The phrase comes from the well-known anecdote recorded in *Shih-shuo Hsin-yü* about the 4th century Chinese painter Ku K'ai-chih, who ate sugar cane from both ends in order to arrive gradually at the sweetest part in the center.

3. *Setsureisai* (*Snow Peak Studio*) in the Gotō Art Museum by Senka, a 16th century follower of Kenkō Shōkei in Kamakura (cat. no. 24), published in Matsushita and Tamamura, *Josetsu, Shūbun, San-Ami*, pl. 150. The colophon by Rinchū Soshō, the 172nd abbot of Kenchō-ji, gives the date Temmon 7 (1538). See Kumagai, "Senka hitsu Setsureisai-zu," p. 25. Kumagai refers to *Kamakura Gozan Juji Iji* (Record of Abbot's Succession in the Five Monasteries of Kamakura), known through a later copy in the Tōkyō University Source Library. Rinchū Soshō refers to Shōchū as "Old Master of Hosen." This is the Hosen-an subtemple of Kenchō-ji. Kumagai mistakenly identified it as Hosen-ji, another Kamakura temple. See the list of Kenchō-ji subtemples in *Kamakura-shi Shi*, p. 288.

4. Tanaka Ichimatsu, "Tōshun-ga Setsu," pp. 401, 439n.

5. See Tanaka Kisaku, "Gashi Shūtoku."

6. Kano Einō, *Honchō Gashi*, p. 988.

7. Kano Einō, *Honchō Ga'in*, p. 1030.

8. *Koga Bikō*, p. 710.

9. The three others are *Sparrow and Bamboo*, in ink on paper, in the Taizo-in, Kyōto; *Daruma*, in ink on paper, also in the Taizo-in, and *Hotei under a Pine Tree*, in ink on paper, inscribed by the Daitoku-ji priest Senrin Sōkei (1476–1543), in the former Hara Collection and now in the Kubo Collection. The three paintings are published in Tanaka Kisaku, "Gashi Shūtoku," pl. 3, fig. 2 on p. 19, and fig. 3 on p. 20. Whether all these works can be considered Muromachi paintings is a question yet to be settled.

10. *Ibid.*, fig. 1 on p. 17; also in *Gumpō Seigan*, no. 9 (1920).

11. Matsushita, *Muromachi Suibokuga*, pl. 56.

12. *Sumi no Bi*, pl. 8. The painting is inscribed by the monk Daigu So'en (d. 1611) of Nanzen-ji.

13. *Koga Bikō*, pp. 710–12.

14. The *Loquat* is published in *Gumpō Seigan*, no. 6 (1918).

15. The *Gakō Benran* gives information about Japanese painters beginning with Shōtoku Taishi (572–622) and ending with an early Edo artist, Shōzen. Some say, without evidence, that the author was the famous historian Arai Hakuseki (1656–1725). Its date is uncertain, but since it refers to Kano Tan'yū, who died in 1674, as a deceased master, the book is considered to have been compiled about 1680. It was transmitted by handwritten manuscripts until quite recently, when it was published by Sakazaki Tan in his *Nihon Gadan Taikan* of 1917, and later in his enlarged *Nihon Garon Taikan*, 2:1055–1116. All page references are to the latter. Information in the *Gakō Benran* must be approached with caution, as its reliability is often questionable. The reference to Shūtoku, which confuses the identity of Sesshū's disciple Shūtoku, is on p. 1099.

16. Shimada, "Sesshū Nempu," in Kyōto National Museum, *Sesshū*. For more information about Shūtoku, the officer accompanying Sakugen Shūryō during his first mission to Ming China, see Makita, *Sakugen Nyūmin-ki no Kenkyū*, 1:179, 186–87, 204–5. Three entries in Sakugen's account of the year corresponding to 1541 (the 27th day of the first month, the 5th and 6th days of the third month) mention him as in China, and one entry (26th day of the seventh month) refers to him after their return to Japan. The phonic interchangeability of the characters *toku* ("virtue") and *toku* ("to acquire") is demonstrated in the above entries. The first mention cites Shūtoku with *toku*, "to acquire," while the second and third entries simplify the name to *Toku-jōsu* (Senior Officer Toku), more consistent with Zen monastic custom. The last entry records *Toku-jōsu* with the character *toku* ("virtue").

17. For Senka, see Kumagai, "Senka hitsu Setsureisai-zu," and Matsushita and Tamamura, *Josetsu, Shūbun, San-Ami*, pl. 150. Kōboku's six-fold screen in the Kimiko and John Powers Collection is published in *ibid.*, pl. 158; and in Rosenfield and Shimada, *Traditions of Japanese Art*, no. 72. Kō'etsu's painting can be seen in Matsushita, *Muromachi Suibokuga*, pl. 89. See also Nakamura, *Shōkei*, pp. 46–52, on disciples of Kenkō Shōkei.

Hanging scroll, ink on paper, 128.6 x 111.7 cm. Cleveland Museum of Art, Purchase, John L. Severance Fund (63.262)

This hanging scroll of very large format depicts a charming scene of a lake and river, marshlands and fog-wrapped hills. A path leads into the scene from the right, passing over a bridge of piles and earth, and disappears behind the opposite bank of the channel. A group of donkeys and two travelers cross the bridge. Beyond, a level marshland leads gradually into the distance, met by a small waterfall that emerges from between two hillocks. Two ranges of hills, meeting at an angle, diverge into the distance as a thick ground fog moving in from either side gradually fills the valleys.

The dimensions of the painting indicate that it was once part of a much larger composition which was originally mounted in a different manner, as a sliding-door panel or folding screen. Thus, the scene must be imagined to have continued laterally in both directions. In its present state it also shows evidence of having been trimmed at the sides and top,[1] probably to adjust its proportions when the painting was removed from its original mounting and remounted as a hanging scroll.

This *Eight Views* was formerly believed to have belonged to a group of large paintings originally executed for the sliding-door panels of the *shitchū* (the central room in front of the room containing the altar) in the Abbot's Quarters of the Daisen-in (fig. 55). Since the Daisen-in was established in 1513, it is likely that the paintings for its door panels were executed at about that time. The surviving parts of the set of eighteen panels, which would originally have formed a continuous sequence along the three inner faces of the room, were subsequently remounted in the form of hanging scrolls.[2] Although the paintings of the *shitchū* are unsigned, they have long been attributed to Sō'ami (d. 1525), and are now considered to be among the finest extant works by this painter.

The Cleveland *Eight Views* is very similar to the Daisen-in *shitchū* panels in format, subject, and style. However, a close comparison between this hanging scroll and those from the Daisen-in reveals numerous slight discrepancies which establish that although the Cleveland painting undoubtedly came from a similar context, it does not belong to that particular group. Nevertheless, the Cleveland *Eight Views* is so close to these works in style that, although it lacks a signature or seal to support its attribution, it must still be regarded as an important example of the distinctive style of Sō'ami seen in the Daisen-in panels.

Sō'ami's invitation to paint the door panels of the *shitchū* indicates that he had achieved recognition as an outstanding painter during his lifetime, since the honor of painting the panels for that room was customarily reserved for the greatest master engaged to produce interior paintings for the residence.[3] Very little information on Sō'ami is verifiable from contemporary records. Later Japanese histories of painting identify Sō'ami as the Buddhist name of the painter Shinsō, whose style-name was Kangaku and whose family name was Naka'o. He is known to have died in 1525. His age can be estimated to have been about seventy, on the basis of a signed and dated inscription by the artist himself which gives his age as sixty-eight. Although the painting with the inscription is not extant, the inscription as recorded in the *Koga Bikō* seems reasonably in agreement with the few other known dates of Sō'ami's activity.

Traditionally, Sō'ami has been considered to be the son of Gei'ami (1431–1485) and the grandson of Nō'ami (1397–1471). In the *Honchō Gashi* (1678), Kano Einō records a colophon by a priest, Keitetsu, which was written on a painting of the *Eight Views of Hsiao and Hsiang* by Sō'ami. This colophon states that Nō[ami], his son Gei[ami], and Gei'ami's son Sō[ami] were all excellent painters, and that there are few parallels to such an uninterrupted family tradition through three generations.[4] The painting and colophon seen by Kano Einō are not extant, and the validity of this lineage has been questioned. However, the family relationship of the three painters can in fact be partially corroborated by contemporary records, so there seems to be no compelling reason to dismiss this account.[5]

The syllables "Ami" (an abbreviation for Amidabutsu, or Amida Buddha) in the names of these painters indicate their affiliation with one of the Japanese Pure Land sects, probably the Ji sect which had a long tradition of involvement in the arts.[6] The Amis were active in a wide range of aesthetic pursuits. Nō'ami, for example, was an accomplished poet of Japanese *renga* (linked-verse), as well as an able painter. Both Gei'ami and Sō'ami earned the title *Kokko* (National Artisan). All three served as *dōbōshū* (literally, comrades), a special group of advisors to the Shōgun in aesthetic matters. Although Gei'ami's function in this capacity is not clearly known, both Nō'ami and Sō'ami served as keepers of the large collection of Chinese objects, including paintings, that were in the Shōgunal collection. Their duties included painting (often at the Shōgun's request), restoration, and appraisal of the collection, which had assumed even greater importance with the rise of the tea ceremony, for which Chinese paintings

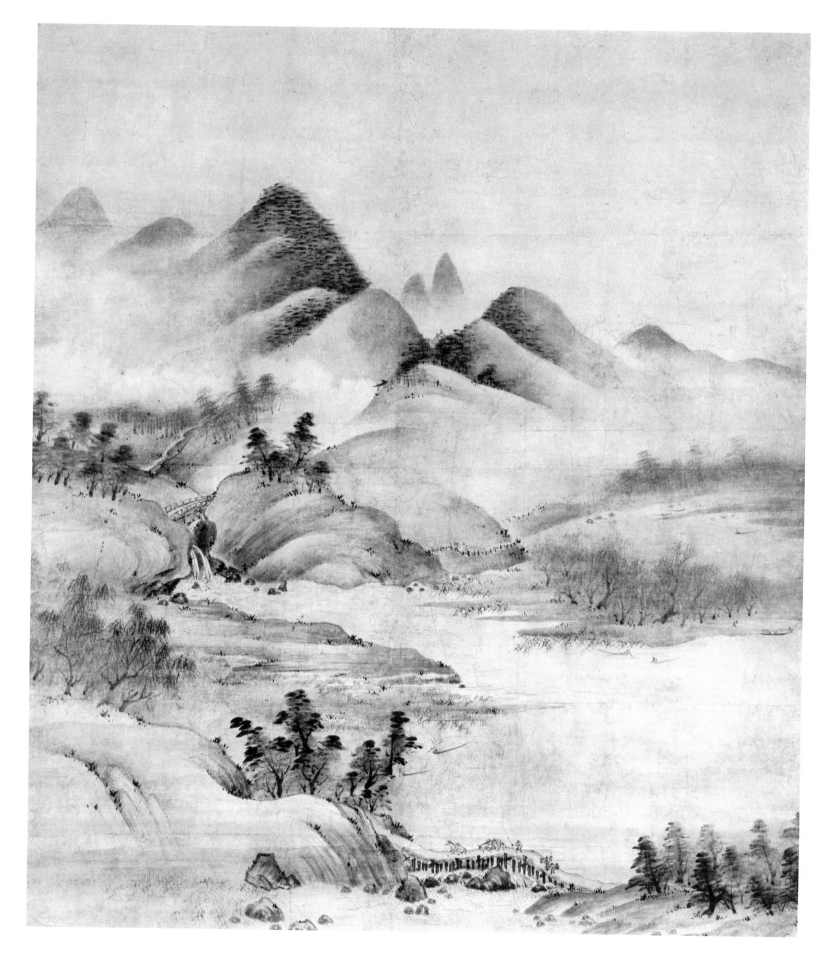

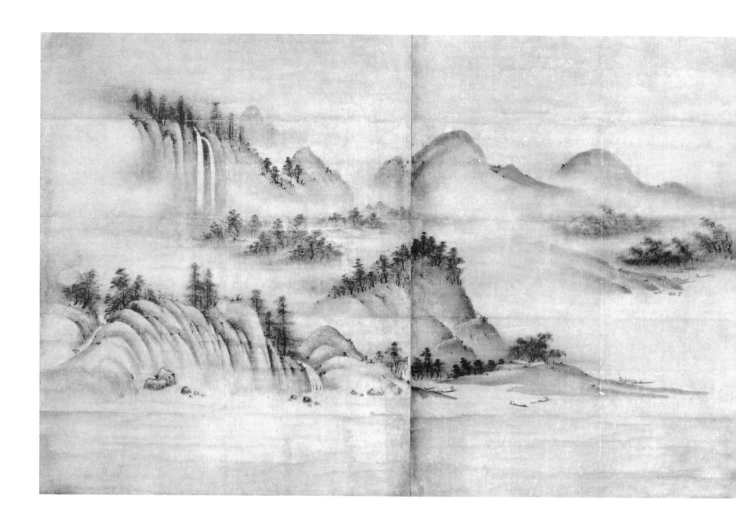

and art objects were greatly favored for display in the *tokonoma* (alcove for displaying prized art objects). The *Kundaikan Sayū Chōki,* a handbook on Chinese works of art that includes a list of more than 150 Chinese painters classified into three grades, was the work of either Nō'ami or Sō'ami. It is further evidence of the extensive and thorough knowledge of Chinese painting gained by the three Amis through their professional duties, which must have greatly contributed to their artistic achievement.

Of all late fifteenth century painters, only Sesshū had a comparably direct opportunity to study original works of Chinese painting. There is, however, a notable difference in the types and styles of Chinese painting known to the Amis and to Sesshū. The Shōgunal collection, in formation from the fourteenth century onward, reflected the tastes of its owners for Chinese paintings of the Sung and Yüan periods, many of them by painters not well known or appreciated in China. Sesshū, on the other hand, because of his journey to Ming China and his long residence in a major port of trade with China, had a far greater opportunity to see paintings reflecting current Chinese taste, including some by Ming Academic painters.

Moreover, Ami painters, reared in the intellectual milieu of the Shōgun's household, were directed toward more traditional Japanese aesthetic ideas than were their contemporaries in the Zen monasteries. While Gozan monks aimed at writing regulated classical Chinese verses, Sō'ami, like Nō'ami, composed Japanese *renga* as well. Sō'ami's landscape painting has a Japanese character related to the native Yamato-e tradition, even when it is demonstrably based on Chinese prototypes. Elements such as softly rounded hills fringed by heavily leaved trees that are typical of landscapes in Yamato-e paintings of the thirteenth and fourteenth centuries (see fig. 1) are readily apparent in such works as the Cleveland landscape and the Daisen-in panels; but the resemblance goes beyond mere similarity of motifs and extends to the whole concept of and approach to nature, which seems distinctively Japanese.

The unique style of the Daisen-in landscapes (fig. 55), which were probably executed when Sō'ami was nearly sixty, suggests that he developed this concept of landscape style from models other than those in current use. Notably absent from the Daisen-in landscapes or the closely related Cleveland scroll are the angular rock formations delineated by heavy contours and textured by

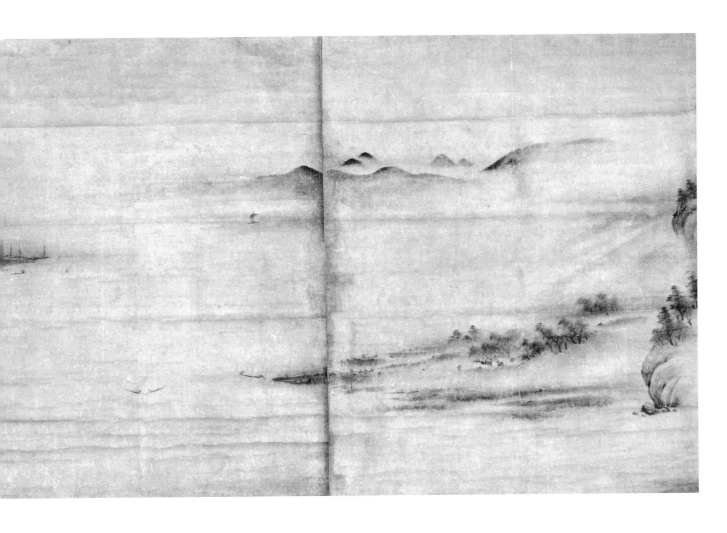

Figure 55. *Eight Views of Hsiao and Hsiang* (*Shōshō Hakkei*), Sō'ami (d. 1525). Four sliding-door panels, now mounted as hanging scrolls, ink on paper, each 174.8 x 140.2 cm. Kyōto National Museum, formerly in the Daisen-in, Daitoku-ji, Kyōto

relatively straight, sharp lines that are characteristic of paintings based on models by Hsia Kuei (see cat. nos. 15–17 on Kantei, 24 on Kenkō Shōkei, and 25 on Shikibu). Sō'ami was by no means isolated from the contemporary trend of landscape painting following the Hsia Kuei style. Nō'ami's *White-Robed Kannon* of 1466 (fig. 15) and Gei'ami's *Viewing a Waterfall* of 1480 (fig. 61), which exhibit a certain degree of influence from Hsia Kuei models, suggest that Sō'ami was familiar with the style through his family tradition. In recent years, Matsushita Taka'aki has directed attention to a group of previously overlooked works revealing this aspect of Sō'ami's style, which contrasts to the traditional image of his style exemplified by the panels from the Daisen-in *shitchū*. These paintings demonstrate a knowledge of Hsia Kuei's style which he is likely to have acquired through his family heritage. Nevertheless, what distinguishes Sō'ami as one of the most important painters of the Muromachi period is his accomplishment in the ink-wash style exemplified by the Daisen-in panels and the Cleveland landscape.

Few Japanese painters before Sō'ami had painted landscapes in ink-wash styles. A few earlier examples, such as those by Gukei (fig. 6) or the fifteenth century

works by Sesshū (fig. 13), Sessō Tōyō (fig. 42), and Saiyo (cat. no. 14), are remarkably different from the soft wash style of Sō'ami. Basically inspired by Yü-chien, these artists rendered the abbreviated forms of mountains and rocks in a range of wet ink tones, energetically applied in broad, abrupt sweeps of the brush. Sō'ami's intimate scenes of gently rounded hills executed in carefully graded ink wash have no precedent in earlier Muromachi landscapes. The several paintings attributed to Nō'ami which are executed in a similar manner must actually be recognized as later works of the sixteenth century. Sō'ami's unique ink-wash style, best exemplified by the panels from the Daisen-in *shitchū*, results from his creative synthesis of techniques learned from several Chinese sources, especially paintings by Mu-ch'i,[7] Mi Yu-jên,[8] and Kao Jan-hui,[9] transformed by his Japanese concept of nature.

Sō'ami's landscape panels for the Daisen-in *shitchū* combine the subjects of the Eight Views of Hsiao and Hsiang and Landscapes of the Four Seasons. The combination of the two themes is not uncommon in large-scale compositions of the late Muromachi period. Members of the Ami school are particularly associated with paintings of the Eight Views, although the only surviving exam-

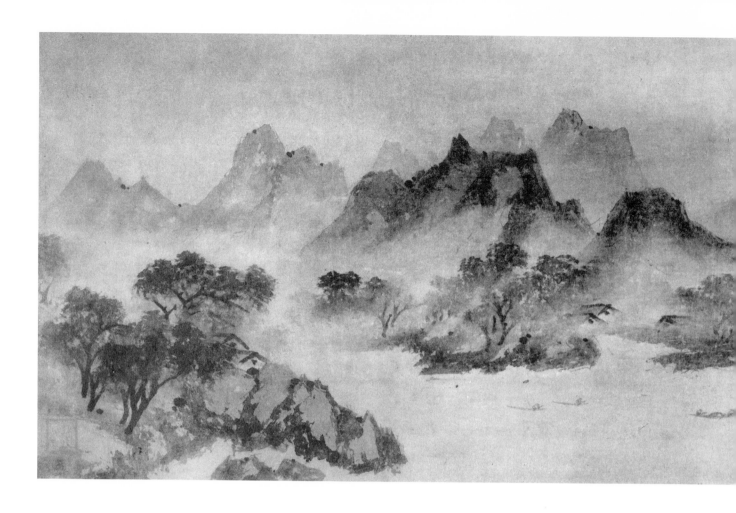

ples are by Sō'ami. The distinctive style of the Daisen-in landscapes and the related Cleveland landscape, both of which contain motifs of the Eight Views, confirms the traditional notion that Sō'ami painted this theme in a soft wash style quite different from that of his contemporaries.

Of the four Chinese handscrolls of *Eight Views of Hsiao and Hsiang* recorded in the *Gyomotsu On'e Mokuroku*,[10] a fifteenth century catalogue of paintings in the Shōgunal collection, the one which is likely to have served as a source for the Daisen-in landscapes is the handscroll attributed to Mu-ch'i (fig. 56), of which four sections survive today.[11] Although these are no longer considered to be authentic works by Mu-ch'i, they have long represented the prevalent Japanese image of his landscape style. From this model, Sō'ami adopted the general idea of a broad landscape of open water and low mountain ranges extending into distance, with low-lying mists hovering between them. Moreover, Sō'ami's method of handling specific motifs — the rays of the setting sun represented by the painting surface itself, edged by bands of mist in pale ink wash, which appear in both the Daisen-in panels (fig. 55) and the Cleveland landscape; or the delicate ink tonalities used for the distant, mist-covered forest in the Daisen-in panels — derive unmistakably from two of the *Eight Views* ascribed to

Mu-ch'i: *Sunset Glow over a Fishing Village* (fig. 56) and *Evening Bell from a Distant Temple*, respectively.

Despite such evidence of Sō'ami's knowledge of the handscroll of *Eight Views of Hsiao and Hsiang,* the Daisen-in and Cleveland landscapes contain a linear element, seen mainly in the textural strokes of mountains, hills, and river banks in the foreground and middle ground sections, that does not appear in the *Eight Views* which are done entirely in ink wash. This particular method builds relatively smooth or gently undulating forms of rocks and mountains by means of ink-wash strokes running upward from their bases parallel to their contours. It occurs only rarely in late Muromachi paintings, particularly in a group of works associated with Sesshū and his followers (see cat. no. 18). Copies of Sesshū's handscroll of fan-shaped paintings after various Chinese masters identify this style as that of Mu-ch'i. Although no landscapes in this style remain by Mu-ch'i himself, Sesshū's two fan-shaped copies in this style are sufficiently consistent with landscape elements in figure paintings by Mu-ch'i to be considered as representative of an aspect of Mu-ch'i's landscape style. Although Sō'ami's interpretation of this particular method is much finer than the image of this style transmitted by Sesshū and his followers, there is no doubt that both derive from the same source. In certain areas, such as

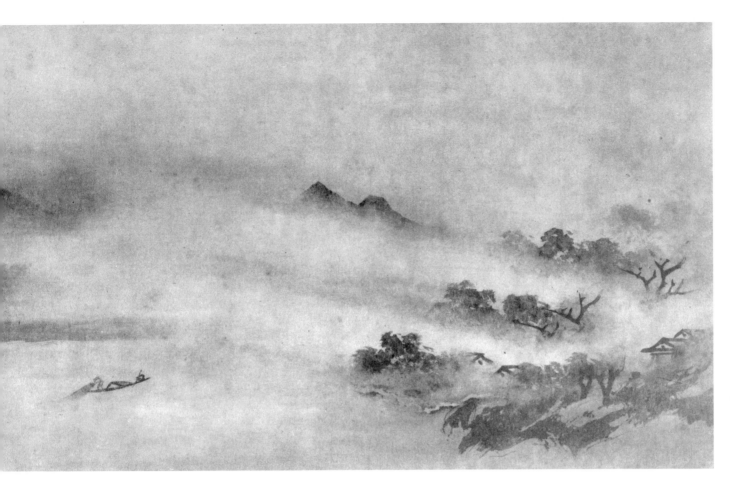

Figure 56. *Sunset Glow over a Fishing Village*, attributed to Mu-ch'i (d. 1269–74). Fragment from a handscroll of *Eight Views of Hsiao and Hsiang*, ink on paper. Nezu Art Museum, Tōkyō

the rock to the left of the middle ground waterfall in the Cleveland painting, a waving textural stroke, probably aimed at producing a rougher configuration, is employed. This corresponds to the hemp-fiber textural strokes seen in the rocks of Mu-ch'i's *White-Robed Kannon* in the Daitoku-ji Collection (fig. 50), and is somewhat suggested by Sesshū's fan paintings after Mu-ch'i. A comparable example of this Mu-ch'i influence on Muromachi painters is Sōkei's *Reeds and Geese* from the Yōtoku-in, described by a contemporary Zen chronicler as a work in the style of Mu-ch'i.[12] River banks in the immediate foreground of this painting are executed in the softly linear manner which, though much more detailed, reflects the same prototypes as Sō'ami's Daisen-in and Cleveland landscapes. Mu-ch'i prototypes were far more influential for Muromachi paintings of flowers-and-birds and figures than for landscapes. Sō'ami and his followers were among the few who adopted Mu-ch'i as a model for landscapes.

A unique characteristic of the Daisen-in and Cleveland landscapes, also probably derived from Mu-ch'i, is the effective rendering of gradual ascent and recession into distance of banks, terraces, hills, and mountains. This feature contrasts sharply with the abrupt transitions between solid and void, giving sudden views into depth that are characteristic of painting by Sesshū and

his followers, and also with the emphasis on verticality of tall peaks or laterally expansive space seen in works of the Shūbun school. The heavy mists of Sō'ami's landscapes, derived from Mu-ch'i and seen both in the *Eight Views* and in Sesshū's fans in the Mu-ch'i manner, function as positive, linking motifs which contribute to the articulation of gradual and continuous recession of solid forms rather than as a contrasting image of void space. The copy by Kano Tsunenobu (1636–1713) of one of Sesshū's two fan-shaped paintings after Mu-ch'i shows a range of hills beginning just behind a slope in the foreground and receding gradually on a diagonal toward a distant peak at the center of the composition. A similar arrangement of mountains receding continuously into distance on a diagonal appears both in the Daisen-in and Cleveland landscapes. The Cleveland *Eight Views* differs from the fan painting in the style of Mu-ch'i in that much of the foreground and middle ground is composed of open water, but the same method of linking motifs without interruption is employed: a continuous chain formed by earthen banks, a bridge, and low hills is picked up across the water by a terrace in the middle ground, which in turn is connected with the hills traversing the middle ground to meet the mountains in the distance. The continuous recession into distance thus attained is a feature of Sō'ami's works that rarely ap-

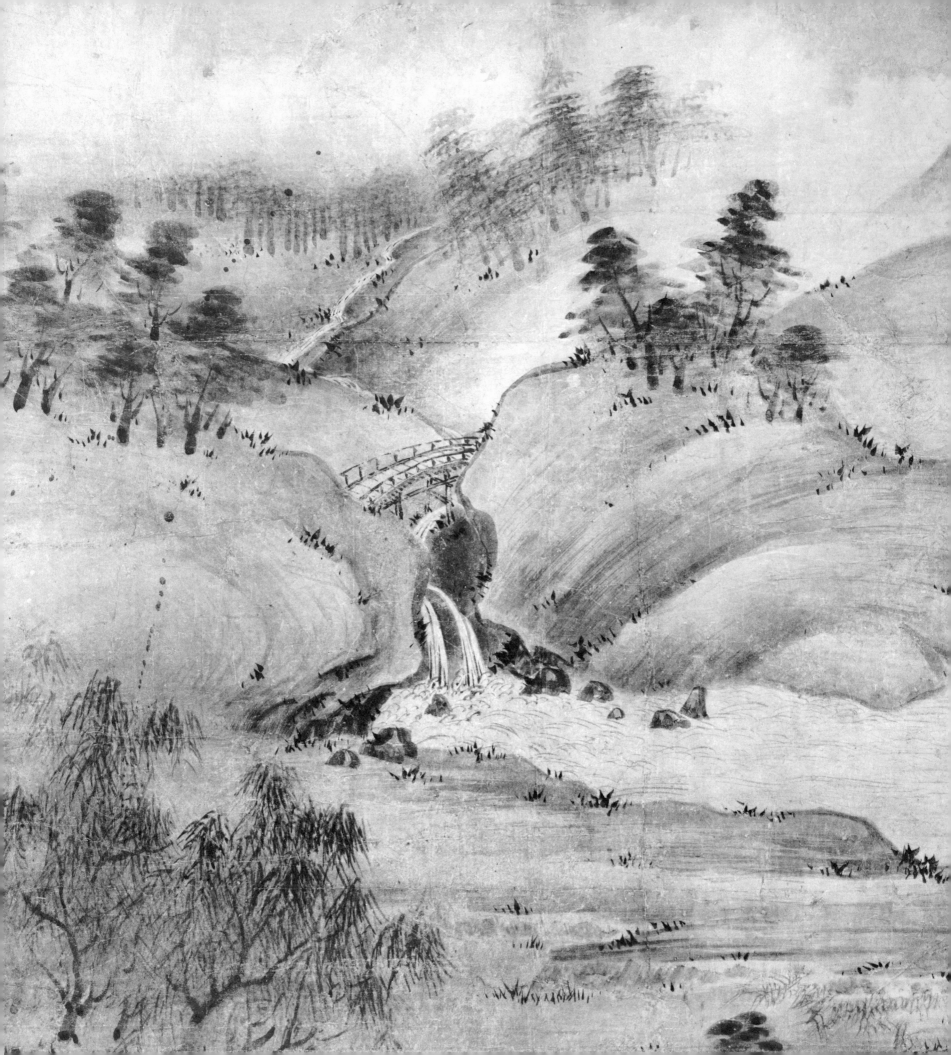

Figure 57. *Fan Painting in the Manner of Mi Yu-jên*, copy of a painting by Sesshū (1420–1506) made by Kano Tsunenobu (1636–1713). Tōkyō National Museum

pears in Muromachi landscapes, and is one distinctive result of his study of Mu-ch'i.

There are also elements in Sō'ami's landscapes which may be associated with paintings of the Mi school (fig. 57). Few of their paintings survive, and many are in poor condition. The main common features of these works seem to be mountain forms of a symmetrical, almost parabolic shape, rendered in wash and a particular type of large dot, executed in wet ink with the side of the brush, which serves the double function of defining the form of the mountain and its foliage. Mi school landscapes, like those of Mu-ch'i, are also characterized by a very heavy, moist atmosphere. The Cleveland landscape demonstrates particularly well Sō'ami's assimilation of motifs from the Mi school: the form of mountains, the use of laterally oriented dots along their sides, as well as the manner of execution of groups of trees in the foreground and middle distance, all appear to relate to such a prototype. Additional insight into the Mi school style as known to late Muromachi painters is provided indirectly by Sesshū's fan painting after Mi Yu-jên (fig. 57), which is closely comparable in these respects to Sō'ami's works. Another element that is seen in many paintings by Sō'ami, including the Cleveland landscape, is the rendering of clouds by means of a thin contour line, rather than by wash alone. Although such a technique appears in Sesshū's fan paintings after both Mu-ch'i and Mi Yu-jên, the mist with decorative scalloped edges which curl upward in Sō'ami's work is far closer to the formal, decorative style of the latter model. Other evidence of the influence of the Mi style is seen in Sō'ami's handling of foreground tree motifs. The silhouetted forms of leafy trees are rendered by large lateral dots and washes, and spread gently to left and right without a central core. There are counterparts in the Sesshū fan painting after Mi Yu-jên and in some landscapes attributed to Kao Jan-hui, another follower of the Mi style, such as the one in the Akimoto Collection.[13]

Another possible source of elements of the Mi style in Sō'ami's work is Kao K'o-kung, a representative follower of the Mi style in the Yüan period. His style was not widely practiced by Muromachi painters, but was known to Sesshū and his followers, as is indicated by an early seventeenth century copy of a handscroll by Sesshū in the style of Kao K'o-kung.[14] Although the mountains of Sō'ami's landscapes come very close to those of Kao K'o-kung in their forms of rounded triangles emerging from thick clouds, Sō'ami interprets

the Mi style in his own way, which contrasts to the Sesshū version. He renders the mountains with very fine contour lines and dense lateral dots in darker ink tones, producing more delicate forms with a remarkable effect of shading. It is likely that he intentionally created this impression of light and shadow in the context of the adjacent scene of evening glow. Such a close observation of natural phenomena is a special quality of Sō'ami's approach to landscape painting, through which he transforms his synthesis of various Chinese styles into a manner uniquely his own.

Although the Cleveland *Eight Views* does not achieve the effects of spaciousness and hovering mists quite as subtly as do the Daisen-in landscapes, it is nevertheless close in style and quality, and communicates a similarly serene and harmonious mood. Little is known about followers of Sō'ami. His only recorded disciple, Tan'an Chiden,[15] died in his youth and left very few paintings, none of which is comparable in scale or complexity to the Cleveland landscape. It therefore seems reasonable to believe that the Cleveland scroll may have been executed by Sō'ami, but somewhat earlier than the Daisen-in paintings, which show the freedom and assurance of the artist's late years.

177

The Cleveland *Eight Views* is thus an important example of a painting very close in style to the landscapes of the Daisen-in *shitchū*. Although this distinctive manner of landscape painting, developed from numerous sources, has sometimes been referred to as idealistic, the Cleveland scroll shows the artist's sympathetic and perceptive observation of the natural world: the natural flow of water down from the hills over rocks and through channels, the appearance of trees and mountains in a misty atmosphere, and the humidity of shallow marshlands. Even the human inhabitants of the scene carry out their activities in perfect harmony with nature. *Eight Views* well exemplifies the lyricism and sentiment characteristic of the Japanese approach to nature that finds expression through Sō'ami's unique stylistic synthesis.

ANN YONEMURA

NOTES

1. The painting ground is made up of eight sheets of paper. There is evidence of cropping at top and sides. The damage to the painted surface, including abrasion and losses, is described as "evenly severe," and there is much evidence of retouching, usually recognizable by exceptionally heavy ink tonality, for example, on the supports of the bridge, the foliage of trees, and the rocks in the foreground.

2. See Ōta, "Daisen-in Fusuma-e no Shōshō Hakkei ni tsuite."

3. At least two other painters worked on this project, Kano Motonobu (1476–1559, see cat. no. 28) and Kano Yukinobu.

4. Kano Einō, *Honchō Ga'in*, pp. 1026–27.

5. Matsushita Taka'aki, in his essay on the Ami school in *Muromachi Suibokuga* (unpaged), asserts that no contemporary records positively support the direct family line of the three Amis. He discredits the colophon to Sō'ami's *Eight Views of Hsiao and Hsiang* reported by Kano Einō, saying that its writer, the monk Keitetsu of Manju-ji, cannot be identified as the painter's contemporary. Professor Shimada comments that while it is true there is no direct evidence from first-hand historical records for Gei'ami being Nō'ami's son, Gei'ami can be verified as the father of Sō'ami on the basis of records in the *Onryōken Nichiroku* (the 15th century diaries of abbots of Onryōken of the Shōkoku-ji in Kyōto). See the entries of the 2nd and 3rd days of the 11th month in Bunmei 17 (1485). Keitetsu may in fact be identified as Boshin Keitetsu, an abbot of Manju-ji, Kyōto.

6. Buddhist painters bearing the Ami name began to appear in the 13th century, and in the 14th century there were many prolific *renga* poets with this name, particularly among members of the Ji sect. Ami artists and poets held quite low social status, but because of their involvement in aesthetic pursuits they were frequently sought by high-ranking people as companions and tutors in the arts. The Ashikaga Shōgun selected many Ami artists to serve as *dōbōshū*, his personal faculty for the arts. The specialities of *dōbōshū* members covered a wide range, including the Nō drama, *renga* poetry, painting, gardening, flower arrangement, and the tea ceremony.

7. See cat. no. 1, n. 5.

8. Mi Yu-jên (1086–1165), whose *tzu* (pseudonym) is Yüan-hui, was the son of Mi Fei (1051–1107). A critic, calligrapher, and painter, Mi Fei is one of the most important literati artists in Chinese histories of painting and calligraphy. Sung critics report that he painted mountains in clouds in a rough wash style totally free from convention. His son, Mi Yu-jên, slightly less famous than his father, is said to have transformed his father's style, painting "rootless trees and nebulous clouds." The Chinese traditional view holds that the two Mis painted cloudy mountains with washes and large lateral dots that later became known as the "Mi dot" or the "fallen eggplant dot." Sources for this view are not clear. A large number of land-

scapes executed in the Mi manner have been attributed to the two Mis without clear distinction between father and son. Almost all of them show conventionalized aspects of an established style — they lack the freshness of an original conception. A landscape in Mi style, thought to date from the late 12th century, is *Hsiao-Hsiang Chien Yu* in the Tōkyō National Museum, once unaccountably attributed to Li Kung-lin (1040–1106), a painter contemporary with Mi Fei. Whether the two Mis are really responsible for initiating this style is a question yet to be resolved. The style, however, was a significant artistic invention in Chinese ink landscape. The Mi dot can serve a double function, both defining the form of a mountain and depicting the plants on it. It became one of the fundamental Chinese methods of painting landscape. In Muromachi Japan, although both Mi Fei and Mi Yu-jên are recorded as painters of the middle grade in the *Kundaikan Sayū Chōki*, their influence was limited to Sō'ami and his followers.

9. Kao Jan-hui (pronounced Kō Nenki in Japanese) was a Chinese painter never recorded or identified by Chinese art historians and connoisseurs. In Japan he is known as a landscapist of the Yüan dynasty who worked in a style similar to that of Mi Yu-jên. He was classified in the middle grade in the *Kundaikan Sayū Chōki*. Not all the paintings attributed to him can be considered to be by the same hand, but all share a wash style marked by the Mi dot method, and seem to be works of the 14th or early 15th centuries. Some scholars suspect Kao Jan-hui might be a corruption of Kao Yen-ching, the *tzu* (pseudonym) of Kao K'o-kung (1248–1310), the famous literati painter of the Yüan dynasty generally recognized as a close follower of the Mi family style. Landscapes in the Mi style which are attributed to the two Kaos are quite different in many respects, but they share certain stylistic elements. In both, for example, round-headed central mountains rise from clouds and mists in the middle distance immediately above the low-lying foreground construction. Generally speaking, Kao Jan-hui attributions use "wetter" ink than those of Kao K'o-kung. Kao K'o-kung as a landscapist was not well known in Muromachi Japan, and the only known Muromachi reference to his landscape is Sesshū's inscription on his *Small Landscape Handscroll* in the Asano Collection, Tōkyō. Sesshū says that while staying in China he saw many Chinese painters working in Kao's style, and that he too painted a number of landscapes in this manner (see below, n. 13). For Kao K'o-kung, see Sirén, *Chinese Painting*, 4:54–57; for Kao Jan-hui, see *ibid.*, p. 57, and Wakimoto, "Kō Nenki ni tsuite."

10. *Gyomotsu On'e Mokuroku*, in Tani, *Muromachi Jidai Bijutsu-shi Ron*, p. 139. See also cat. no. 16.

11. All four of the surviving segments of this handscroll are published in *Sōgen no Kaiga*, pls. 114–19.

12. The *Reeds and Geese* by Sōkei is a part of the Yōtoku-in door-panel paintings now in the Kyōto National Museum. The *Onryōken Nichiroku*, which records in detail the making of the panel paintings, reports that in 1490 Sōkei painted the

Reeds and Geese on four panels to complete an unfinished work of the same theme by his father, Sōtan, on two panels, and that the whole painting was in the style of Mu-ch'i. The surviving six panels conform to the description in the *Nichiroku*. River banks appear in two of the four panels presumably by Sōkei. See cat. no. 12, n. 3.

13. Published in *Bijutsu Kenkyū*, no. 13; and in *Kokka*, no. 211.

14. Sesshū's landscape in the style of Kao K'o-kung, known as the *Small Landscape Handscroll*, is in the Asano Collection, Tōkyō. The first half of the scroll is presumably the first half of the original handscroll by Sesshū, and the second half is an early-17th century copy of the rest. According to a colophon on the Asano handscroll written by a minor warlord, Kinoshita Toshinaga, his grandfather Nobutoshi and his friend Hosokawa Tadaoki had purchased the Sesshū handscroll from a painter, a certain Hasegawa, early in the 17th century. The collectors cut the scroll into two pieces. Kinoshita kept the first half, while the second half, supposedly with Sesshū's inscription, went to Hosokawa. Kinoshita asked the painter Hasegawa to copy the Hosokawa piece and join the copy to his original to restore the appearance of the original composition. The original Hosokawa painting was destroyed by a fire in Edo in 1657. Sesshū's inscription of 1474, copied on the Asano scroll, comments on his experience with Kao's style and says that he painted the scroll to be used as a model at the request of his disciple Umpō Tō'etsu. The original section of the Asano scroll represents a misty river scene with groups of trees and houses near river banks, and the copy that follows it depicts a group of mountains in the distance emerging from waving blankets of clouds. There are some problems about the relation among the painting, Sesshū's inscription, and Kinoshita's colophon to the scroll, but no serious study of it has yet been made. See *Kokka*, no. 700; and Tōkyō National Museum, *Sesshū*.

15. The only reference stating that Tan'an Chiden was Sō'ami's disciple occurs in the *Tōhaku Gasetsu*, entry 76, p. 22.

Pair of six-fold screens, ink on paper, each 173.4 x 370.8 cm. Signed "Kangaku Shinsō hitsu" in lower right-hand corner of right screen and lower left-hand corner of left screen.
Square intaglio seal with double border reading Shinsō, *impressed beneath last character of each signature.*
Metropolitan Museum of Art, New York, Gift of John D. Rockefeller, Jr., 1941 (41.59.1–2)

This pair of screens depicts a landscape of the four seasons in a continuous panorama beginning from the lower right. A solitary figure crosses a bridge, entering the scene from the right. A range of soft mountain peaks, diverging into the distance, rises through heavy mists. Here and there are seen the roofs of mountain villages, nearly concealed by trees and mists, and the roof of a temple appears from behind the shoulder of the mountain in the second panel from the right. The scene of summer begins in the distance, across an expanse of lake and mist. From a range of soft and misty hills, barely suggested by ink wash, a shallow waterfall drops by steps into the lake. To the left, another waterfall cascades from between two higher peaks. Below, hills descend to a marshland and willows. The dense foliage of the trees indicates the season. Autumn occupies the right three panels of the left screen. Two fishermen with folded nets make their way up the bank, from the moored boats barely visible behind it. The foliage of the autumn trees is rendered in thinner ink tone and sparser texture, with a few bare branches already visible. Through the thinning treetops on the hillock in the middle distance, the roofs of a group of buildings can be seen. A rocky ledge overhangs the scene, suggesting in its inaccessibility the greater severity of the autumn season. In the distance stands a mountain gate in a pass, while to the left, a flight of geese descends to the marsh. To the left is the winter scene. The whiteness of the snow-covered mountains is intensified by the ink-wash along their outside edges that silhouettes their forms. Sheltered villages nestle among trees in the mountain valleys, and only a few fishing boats venture out. Bare trees stand prominently on a hillock as a symbol of the season, and a solitary figure wearing a straw hat and raincoat crosses a bridge into the scene from the left.

This pair of folding screens has long been attributed to Sō'ami (d. 1525, see cat. no. 22) on the basis of the signature and seal which appear on each screen, and because their style is related to that of the Daisen-in door panels and the *Eight Views* in the Cleveland Museum of Art (cat. no. 22). Both scrolls are signed "Kangaku Shinsō hitsu" (by the brush of Kangaku Shinsō), and have a double-bordered square intaglio seal reading *Shinsō*. This seal and signature, although accepted by some scholars as similar to those on other works attributed to Sō'ami, remain somewhat problematic.[1] There are no paintings attributed to Sō'ami of comparable scale and style that bear a seal or signature. The only works attributed to Sō'ami with seals and signatures are

a group of smaller-scale hanging scrolls executed in a contrasting manner, with many more elements of the angular, linear style associated with Gei'ami, late works of the Shūbun school, and Hsia Kuei.[2] None of the seals on this group of paintings resembles the seals of the Metropolitan screens, which are the only square seals of the group to have a double border. Moreover, no signature includes the sobriquet "Kangaku," although most of the seals are composed of these characters. The signatures on the Metropolitan screens also seem slightly different in style from the other signatures, so the authenticity of the signatures and seals themselves does seem to be open to question.

The image of Sō'ami's style has changed considerably in recent years, owing to the discovery and publication of a number of works with the "Shinsō" signature and/or seals reading *Kangaku* or *Shinsō*.[3] These paintings, all hanging scrolls of usual size and format, contain many motifs and techniques which do not appear in the large-scale compositions attributed to Sō'ami, the best representatives of which are from the Daisen-in *shitchū* (fig. 55). One of the best examples of this contrasting style of Sō'ami is a tall hanging scroll of *Viewing a Waterfall* (fig. 58). The composition is entered over open water, which is characteristic of Sō'ami's large-scale works. Angular rocks, rendered in heavy contour and strongly contrasting ink wash, lead back to a rocky ledge that juts out from the left side of the painting. This rock is also rendered by contour lines with the addition of a few bold, straight textural strokes. Tall evergreens grow almost vertically from this promontory overhanging the water, and the motif is repeated to the left. Two figures stand on the plateau below and look out over water toward the waterfall beyond. The waterfall, coming from behind a rocky pinnacle above, suddenly cascades forward through a concealing mist. The cave-like rock formation behind the waterfall is unmistakably derived from the prototype of Gei'ami (fig. 61). Beyond the mist, depicted with soft wash and slight scalloped contours, vertical peaks rise in the distance.

This example indicates that Sō'ami, like other outstanding painters of his time, was capable of working successfully in more than one style. In this painting, for instance, in addition to the direct quotation of the Gei'ami waterfall, we see a composition that is strikingly reminiscent of prototypes of the Shūbun school. It is essentially arranged in two sections separated by an expanse of water. However, the artist has reversed the orientation of the foreground scene, which in work of the Shūbun school would begin from the side of the tall

Catalogue number 23,
Landscape of the Four Seasons

distant peaks, so that the vertical evergreens would directly emphasize the height of the mountains beyond. By altering the orientation, Sō'ami allows an unobstructed view toward the waterfall, and also produces a composition more consistent with his usual preference for relative balance, rather than the contrast of solid and void typical of works of the Shūbun school. The strongly contrasting ink tones and use of dark contour and straight textural strokes refer, possibly indirectly, to the style of Hsia Kuei, and are elements prevalent in late fifteenth century Japanese landscape paintings.

Despite its incorporation of motifs from sources entirely different from those of the large-scale landscapes associated with Sō'ami (see cat. no. 22), this painting has many points in common with those works. One notable similarity is the building up of the foreground rock form in a parallel, stepped fashion, a distinctive configuration that is also seen executed in an entirely different technique in the foreground mounds and hillocks of the Daisen-in landscapes. Another point in common is the unified and logical overall conception of space, where the interrelationship of elements is not lost, even when transitions are concealed by other motifs such as obscuring mists. This is particularly evident in the depiction of the waterfall, which flows logically over the crest of a mountain ridge and emerges naturally from the mist below, having somewhat changed its course in the meantime.

The group of paintings represented by *Viewing a Waterfall* is, for several reasons, exceedingly important

to the study of Sō'ami's artistic accomplishment. It provides an important body of works attributable to this artist on the basis of seals and/or signatures. It also indicates his versatility and familiarity with elements of painting styles very different from the unique style he perfected for his large-scale landscapes. In addition to indicating his utilization of certain motifs of the Shūbun school, these paintings also provide important evidence of his knowledge of Gei'ami's style, of which his large-scale landscapes give no evidence. Certain motifs, such as the foreground scene of sharply angular rocks and nearly vertical pines, invite comparison with works by Gei'ami's disciple, Kenkō Shōkei, such as the one exhibited here (cat. no. 24). Sō'ami's handling of similar motifs is different, particularly in brushwork. Whereas Shōkei faithfully maintains the relatively blunt contour typical of Gei'ami's style, achieved by holding the brush at right angles to the surface so that its tip remains centered, Sō'ami holds the brush more obliquely, which results in a less "solid" structure. *Viewing a Waterfall* thus establishes not only that Sō'ami was familiar with the style of his predecessor in the Ami school, but also that he was far more independent of Gei'ami's style than was Kenkō Shōkei, whose contact with Gei'ami was limited to the three years he spent in Kyōto under Gei'ami's tutelage.[4]

The pair of screens exhibited here is related in composition, subject, and general manner of execution to other large-scale compositions attributed to Sō'ami, but they include a few motifs also seen in the group of small-

scale hanging scrolls that represent the other aspect of Sō'ami's style. These include the peculiar form of the overhanging peak in the autumn scene, with its convex undercutting. This motif does not appear in the Daisen-in door panels but it recalls the form of the pinnacle in *Viewing a Waterfall*, which must have come from another prototype. The shapes of the distant pinnacles of the winter scene, silhouetted by wash along the outside edges of their contours, recalls forms seen in landscapes of the Shūbun school. Thus the Metropolitan screens, although they appear to be relatively close in style to the Daisen-in landscapes, also incorporate a few elements not seen in those examples.

The Metropolitan screens also show a more even emphasis of all four land masses than is seen in the more spacious Daisen-in landscapes. This may in part arise from the difference in format, since Japanese screen paintings generally follow certain compositional conventions which require that the screens as a pair show a certain symmetry and balance in the disposition of land masses. The relative weight or emphasis given each pair of land masses differs, of course, according to the preferences of individual artists and also with the taste of the period. It should be noted, however, that the Metropolitan screens are unusual for their time in the relatively equal emphasis given to each scene. A comparison with screen compositions of the Shūbun school or with the slightly later screen-paintings by Ryūkyō exhibited here (cat. no. 25) shows that the more typical tendency among Japanese artists of this period was to emphasize

strongly the scenes at the left and right ends of the composition, while greatly reducing the central scenes for the sake of visual contrast.

The problem of relating the style of the Metropolitan screens to comparable works by Sō'ami is complicated by the poor condition of their surfaces, and the widespread retouching that necessitates caution in studying the brushwork in individual motifs. There is extensive loss and damage along the lower one-third of both screens and along both sides of each fold.[5] Insofar as it is possible to determine, in view of the present condition of the screens, they seem technically very closely related to the Daisen-in door panels. However, there are slight dissimilarities which cause some doubt as to whether they can be by the same hand. There is, for example, in the Metropolitan screens, a looser and more haphazard orientation of textural strokes in the foreground rocks. In groups of trees, there is also less variation of rhythm in their grouping or manner of execution.

In composition, too, apart from differences perhaps attributable to format, there are a number of marked dissimilarities. In particular, the Metropolitan screens seem to lack the underlying concept of the whole that integrates the elements of the Daisen-in compositions. In these, as well as in the Cleveland *Eight Views* (cat. no. 22) and in stylistically contrasting works by Sō'ami such as *Viewing a Waterfall*, there is a remarkable sense of integrity and spatial consistency in the composition, despite the concealment of certain structural relationships by the hovering mist. In the Metropolitan screens the

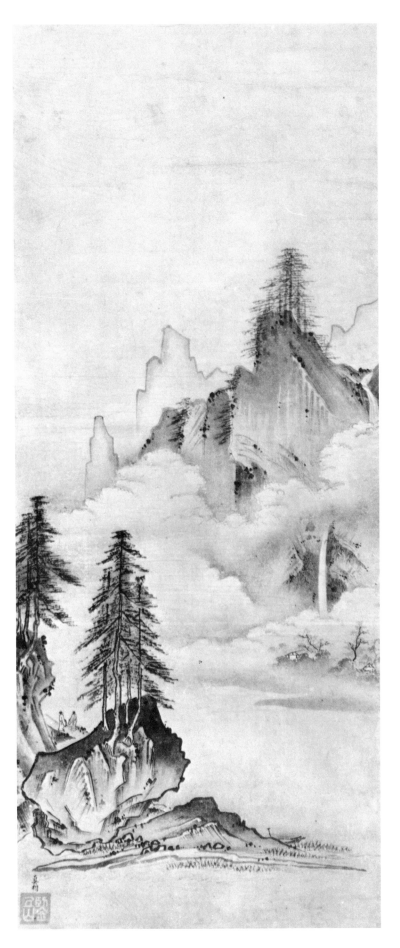

Figure 58.
Viewing a Waterfall,
detail, Sō'ami (d. 1525),
inscribed by
Genryū Shūkō (d. 1508).
Hanging scroll,
ink and light color on
paper, 113.8 x 29.7 cm.
Fuji'i Collection,
Nishinomiya,
Hyōgo prefecture

interrelationship of elements is often unclear. For example, the waterfall in the summer scene comes from between two mountains, but it almost seems to come from nowhere, since there is no visual indication of the river from which it should flow, nor hint of a plateau from which it could logically fall. Instead there are only the shadows of mountains in the far distance, considerably separated from the head of the waterfall. In contrast, the waterfall in the *Eight Views* of the Daisen-in (fig. 55) can easily be imagined to be falling from a hidden stream flowing from the ridge to the left.

The Metropolitan screens thus seem to lack the integration brought about by the close observation of nature that is seen in works by Sō'ami. It is this point above all, despite the apparent similarities of technique and motifs, which seem to set it apart from his oeuvre. The only widely accepted work attributed to Sō'ami that shares a similar format, the screens in the collection of the Myōshin-ji (fig. 59),[6] shares with the Daisen-in landscapes a greater sense of natural interrelationships. The waterfall motif in the Myōshin-ji summer scene is logically placed, and there is a sense of consistent spatial recession. The point from which the far distance is seen is higher than that of the Daisen-in painting, however, giving a slightly tilted aspect to the receding river, especially in contrast to the lower horizon indicated by the village motifs in the foreground. This difference in perspective, combined with the somewhat more mechanical application of textural strokes and the regular spacing of grassy clusters on the foreground rocks, makes the division between the opening spring scene and the following summer motifs more pronounced. Yet within the two large scenes there is less segmentation than in the Metropolitan screens, and evidence of more careful observation of the natural world.

In addition to the weakness in integration of motifs observed above, the Metropolitan screens show a slight tendency toward repetition of forms, producing a more decorative effect. The grouping of the trees, for example, does not have the variety seen in works by Sō'ami. The Metropolitan screens are, however, very closely related to the style of Sō'ami's large-scale compositions, such as the Daisen-in panels and the Cleveland landscape in this exhibition. Although these screens seem unlikely to be by his hand, they must be based directly upon his works, and are probably close to them in date.

ANN YONEMURA

Figure 59. *Eight Views of Hsiao and Hsiang*, Sō'ami (d. 1525). Right-hand screen of a pair of six-fold screens, ink on paper, 157.6 x 355.5 cm. Myōshin-ji, Kyōto

NOTES

1. Matsushita, *Muromachi Suibokuga,* section 4 of unpaginated essay.

2. These paintings and their seals are published in *ibid.,* pls. 79–83. Most of the seals read *Kangaku.* One, on the three paintings published as pls. 81–82, has a *Shinsō* seal entirely different from the seal on the Metropolitan screens.

3. Matsushita, in *Muromachi Suibokuga,* was the first to publish and discuss many of these works in relation to Sō'ami's style.

4. See cat. no. 24 for a discussion of Gei'ami (d. 1485) and his relationship to Kenkō Shōkei (d. early 16th century). Although his dates are not clearly known, it is evident from the recognition of his talent as a painter by Gei'ami that he was already an accomplished artist when he arrived in Kyōto from Kamakura in 1478. Sō'ami, who is believed to have been about seventy when he died in 1525 (an unverifiable written source gives his age at that time as sixty-seven), would have been twenty or younger at the time of Kenkō Shōkei's three-year period of study under Gei'ami. Thus, Shōkei's contact with Gei'ami as a teacher may well have been much closer than Sō'ami's, although the latter has always been assumed to have been Gei'ami's direct descendant.

5. No single panel is in perfect condition, and the overall condition shows severe damage with uneven tears. It was remounted prior to export from Japan, and treated for buckling during display at the Metropolitan.

6. Both screens are published in Kyōto National Museum, *Chūsei Shōbyōga,* pl. 29; and in *Kokka,* no. 169.

Landscape with Figures Going Up a Hill
Kenkō Shōkei (ca. mid-15th–early 16th century)

Hanging scroll, ink on paper,
39.2 x 91.3 cm.[1]
Two seals of the artist in lower
left-hand corner, imprinted over
foreground rocks. Upper oblong
relief seal with double border,
3.0 x 1.5 cm, reading Kenkō;
lower intaglio square seal with
double border, 2.25 x 2.2 cm,
reading Shōkei.
Museum of Fine Arts, Boston,
Fenollosa-Weld Collection
(11.4127)

This painting, of unusual format for a hanging scroll, offers a panoramic view of mountains and water that is more usually seen in handscrolls or large-scale screens. Moreover, the formal elements of the composition are so arranged as to interrelate the two land masses confronting each other across the open lake in the very center of the composition. As is customary in landscape paintings of wide format, the composition begins from the right-hand margin. A gently sloping earthen bank, somewhat obscured by the partially submerged rocks and the large boulder in the foreground, extends into the lake from the right-hand edge of the composition. On the far side of the bank, secluded by a grove of luxuriant trees, are a rustic hut and an open pavilion that looks out across the lake. In the distance a mountain inclines toward the lake; double-roofed buildings are visible beyond its shoulder. A range of mountains barely suggested by ink wash is seen in the distance; it continues across the scene beyond the far shore of the lake. Finger-like projections of sandy shoals extend into the lake, directing attention toward the left, across the water. The boats moving across the lake, the figure walking along the foreground shoal, and even the gaze of the figure seated in the pavilion, all repeat this suggestion of movement leftward — toward the opposite shore where a rocky precipice topped by tall evergreens rises abruptly from the water, dramatically terminating the level passage across the lake. Between this rock and the massive rocky mountain that dominates the left section of the composition, a waterfall cascades into the lake, intensifying the impression of sudden elevation in this area. Behind a great boulder in the immediate foreground, a path begins from the left and winds in a zigzag up the steep incline toward a complex of large buildings.

This *Landscape,* unlike many others of the same period which have occasional touches of pale color wash, is executed entirely in ink. The artist's virtuosic control of ink tonality and brush work can best be seen by comparing motifs in different parts of the composition. The foliage of the low-lying trees in the right foreground, for example, is executed in parallel groups of wide curving strokes that indicate the use of a splayed-brush technique and have a rather casual, playful quality. In contrast, the foliage of the evergreens on the left is rendered by means of extremely fine, short, vertical lines that create a more restrained, formal effect. A contrast can also be seen between the soft texture of the distant mountain on the right, produced by a careful blending

of the tonalities of ink wash and textural strokes that define its form, and the sharp angular forms of the rocks to the left, which employ greater tonal contrast. By means of his careful control of technique the artist expresses contrasting moods within the same composition: the hospitable and leisurely scene of lowlands and lake, full of human activity, and the solitude of the steep, austere mountains on the opposite shore.

Near the lower left-hand corner of the painting are two seals of Kenkō Shōkei, a Zen monk-painter of the late fifteenth century who spent most of his career at the Kenchō-ji in Kamakura. Because he held the temple position of *shoki* (secretary, or keeper of temple records),[2] he has been commonly known as Kei Shoki. Information about Shōkei's early career at the Kenchō-ji is not verifiable from contemporary sources, but he is supposed to have first studied painting under Chū'an Shinkō (cat. no. 6), a monk-painter of the Kenchō-ji who was probably active in the mid-fifteenth century.

The first clear reference to Shōkei occurs in an inscription dated in correspondence to 1480 on Gei'ami's painting *Viewing a Waterfall* in the Nezu Museum (fig. 61).[3] This inscription by Ōsen Keisan (1429–1493), one of the great Zen literati of the Gozan school of the late fifteenth century, clearly states that Shōkei had come to Kyōto in 1478 to study under Gei'ami, then one of the leading painters in the capital. When Shōkei was about to return to Kamakura in 1480, Gei'ami painted *Viewing a Waterfall* as a farewell gift and as a certificate of his pupil's achievement in painting, and three Gozan monks were asked to write dedicatory eulogies on it.

A colophon by Ōsen recorded from a scroll of poems related to the studio *Hinrakusai,* which was probably separated from a painting of the same study, now lost, says that Shōkei was once again in Kyōto in 1493.[4] In this colophon, Ōsen reminisces about Shōkei's experiences under his departed master, saying that Gei'ami had been greatly impressed by his painting, and that the master granted him the privilege of studying and making copies of Chinese paintings in the extensive and exclusively guarded Shōgunal collection. Members of the Ami school were the official keepers of these valued works (see cat. no. 22). The two inscriptions by Ōsen Keisan thus establish Shōkei's lineage as a disciple of Gei'ami, and provide clear dates for his activity in the late fifteenth century. The duration of Shōkei's second stay in Kyōto is not known, but an inscription by a Kamakura Zen priest, Gyoku'in Eiyo, on his painting *Sōsetsusai*[5] indicates that he was back in Kamakura by 1499.

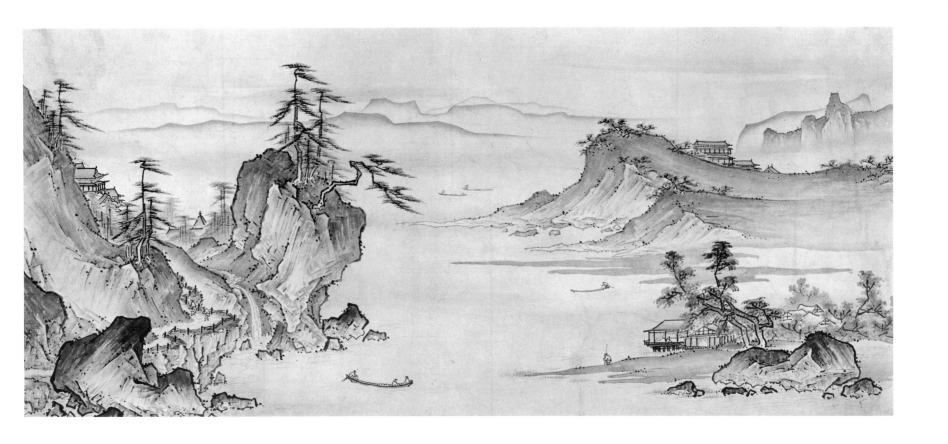

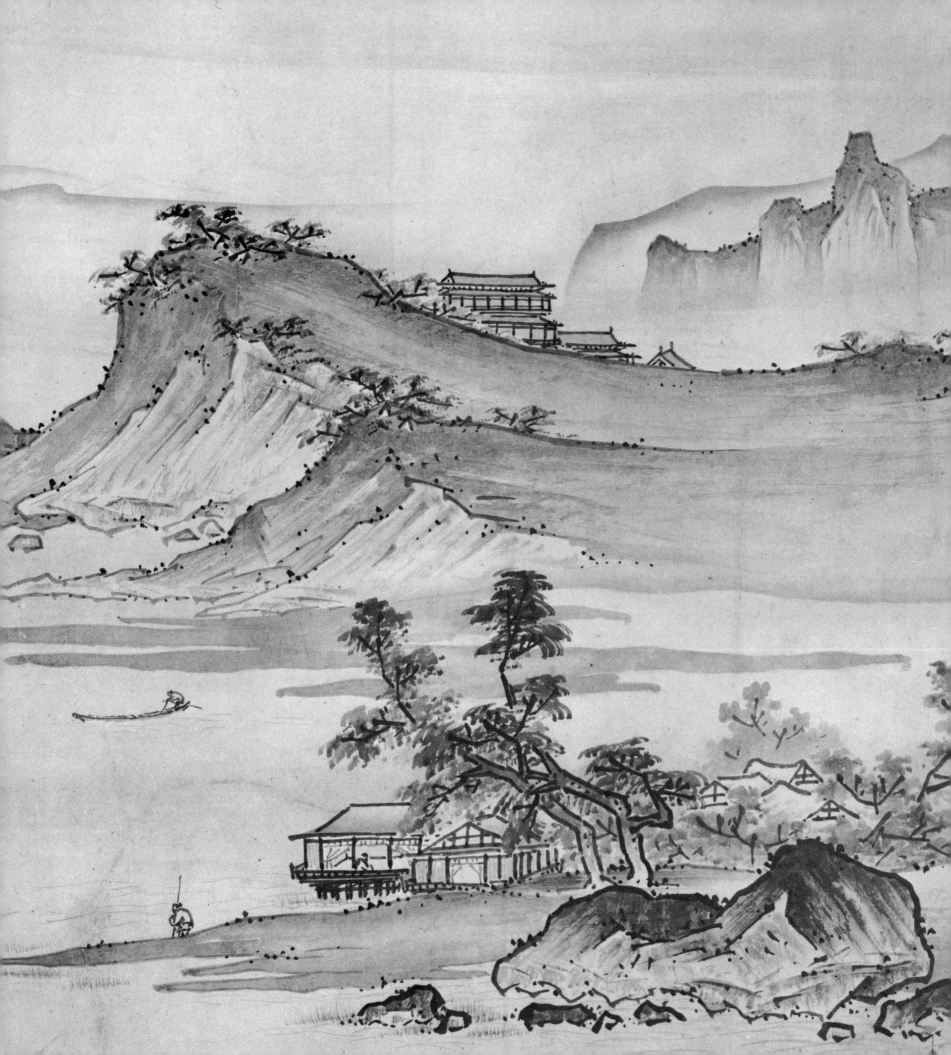

Left: Detail of
catalogue number 24,
*Landscape with Figures
Going Up a Hill*

Below: Figure 60. *Landscape,*
Kenkō Shōkei (fl. late 15th–early
16th century). Hanging scroll,
ink and light color on paper,
51.2 x 30.6 cm.
Nezu Art Museum, Tōkyō

Landscape with Figures Going Up a Hill

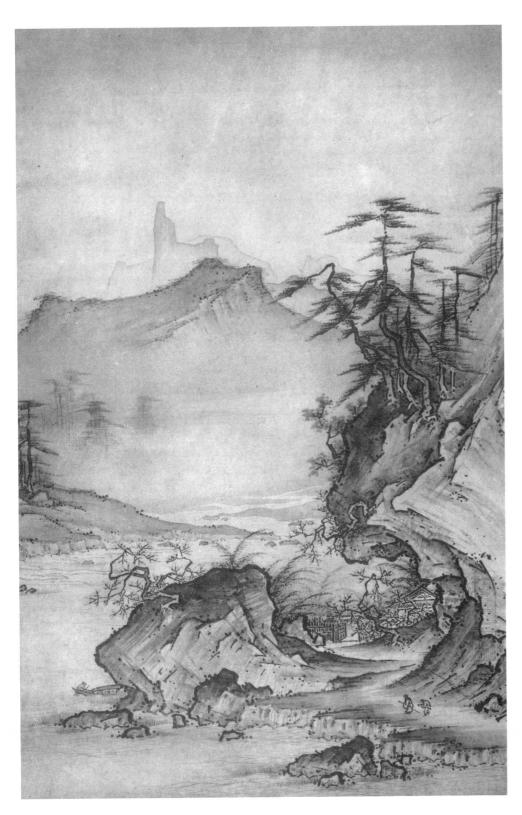

Shōkei's latest datable work, entitled *Shōshūsai* (fig. 18), carries only one character (Tiger) of a cyclical date that may be interpreted to read either 1506 or 1518, although the earlier of the two is usually accepted. Since there is no documentary evidence of the date of Shōkei's death, it must simply be inferred that he ceased to paint in the early sixteenth century.

Shōkei's paintings during and after his first period of study in Kyōto show his mastery of a remarkable range of subjects and styles. Among them are superb copies of Chinese academic painting, such as a round fan-shaped painting of a bird on a branch with the sublime delicacy of line and color characteristic of the Sung Academy,[6] and the fine, delicately colored paintings of horses and grooms following works by the Yüan specialist in this genre, Jên Jên-fa.[7]

The largest group of Shōkei's extant works, however, are landscapes, all relatively consistent in style, which reveal Shōkei's development of a unique and influential personal style of landscape painting. Most if not all of the landscapes convincingly attributed to Shōkei must date from the period after his first visit to Kyōto, since they show many elements of Gei'ami's distinctive style, which he could have learned from no other source. They also reflect his study of Chinese model paintings, especially those by Hsia Kuei, whose influence was pervasive in late-fifteenth century Japanese painting.

A *Landscape* by Shōkei in the Nezu Museum (fig. 60) provides the best example of Shōkei's adaptation of motifs and techniques of Gei'ami's style, as represented by the only extant painting reliably attributed to Gei'ami's hand, *Viewing a Waterfall* (fig. 61). Since this painting was given to Shōkei when he left Kyōto in 1480, it may well have served as a direct source of inspiration for the Nezu *Landscape,* which may thus be assumed to date from the period immediately after Shōkei's return to Kamakura. From Gei'ami's *Waterfall* Shōkei adopts the idea of a hut viewed through a concave opening in the rocks. However, he increases the inherent dynamism of this unusual construction by composing the foreground rocks in an arc-like configuration, suspending a mass of rocks topped by tall pines without balancing support from below. A similar effect can be seen in the vertical pinnacle of the Boston *Landscape,* which precariously overhangs the water. Other similarities between Gei'ami's *Waterfall* and Shōkei's Nezu *Landscape* are apparent in the angular faceted texture of the rock forms; these are defined by means of heavy, blunt contours, strongly contrasting

Figure 61. *Viewing a Waterfall* (*Kambaku Sō*), Gei'ami (1431–85), inscription by the artist dated 1480. Hanging scroll, ink and light color on paper, 105.8 x 30.3 cm. Nezu Art Museum, Tōkyō

areas of dark ink wash, and sweeping textural strokes drawn with the brush held obliquely. Shōkei also utilizes the dark, rounded dots that characterize Gei'ami's representation of moss, and a manner of rendering evergreen foliage by means of minute vertical strokes that also appear to derive from Gei'ami.

Despite the many apparent formal and technical similarities between the Nezu *Landscape* and the *Waterfall* by Gei'ami, the Nezu *Landscape* clearly shows Shōkei's compositional preference for a foreground scene opening onto a lake and overlapping a range of distant mountains. The Boston *Landscape*, despite its different format, also shows this characteristic type of composition. The Boston painting also has a relatively low horizon line overlapped by the foreground motifs, which gives a view of the distant shore and mountains beyond the deeply arched boundaries of the overhanging rock. This compositional device is seen most clearly in the center section, where the top of the vertical pinnacle, extended by the pine that bends over the water, is countered by the concave form of the mountain in the middle distance on the right and by the trees bending inward in the foreground.

Although the left side of the Boston *Landscape* is noticeably similar to the Nezu *Landscape* in terms of the density and manner of execution of the foreground composition, the scene on the right has some elements which seem to derive from Shōkei's study of paintings by the Chinese master Hsia Kuei. Among Shōkei's surviving paintings are a complete set of *Eight Views of Hsiao and Hsiang* in the Hakutsuru Museum (fig. 48).[8] Shōkei's *Eight Views* constitutes one of the few complete sets of several late-fifteenth century versions that follow a single prototype. The prototype is considered to have been a handscroll painting by Hsia Kuei, recorded in a contemporary catalogue of the Shōgunal collection but no longer extant (see cat. no. 16). In particular, the low, spreading forms of the leafy trees, the gradual entry into the scene over open water, the sand banks executed in ink wash that extend into the lake, the rounded form of the mountain in the distance, the human figures on the shore, and the fishing boats, all resemble motifs in Shōkei's *Eight Views*. The rather consistent gradual recession into distance, usually over water, is another element of Shōkei's landscape style that may well derive from his study of Hsia Kuei.

The unusually wide format of the Boston *Landscape*, with its strong suggestion of lateral movement, gives rise to the possibility that this painting was once part of a

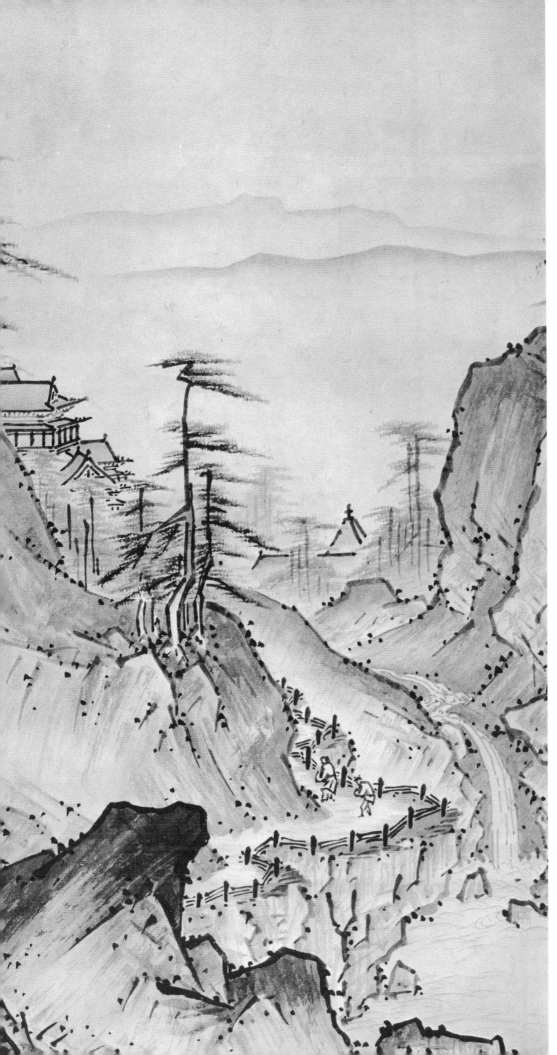

longer handscroll. The composition, with land elements more or less symmetrically placed to each side and an open space in the center, is unusual among Shōkei's landscapes, which characteristically have the greatest open space along one side. On the other hand, contemporary painters such as Sesshū made use of a similar wide format on exceptional occasions, for example in his famous late work *Ama no Hashidate,*[9] which depicts a panoramic view of a famous scene in Japan. Whatever the original format of the Boston *Landscape,* it is exceptional among Shōkei's works in its incorporation of some compositional principles of landscapes in the handscroll format, of which no other example survives among his works.

Two of Shōkei's few dated works, *Sōsetsu-sai* (1499) and *Shōshūsai* (1506 or 1518; fig. 18), give an accurate impression of Shōkei's late style, after his second visit to Kyōto (ca. 1493). Both paintings are of tall format with numerous poetic inscriptions at the top, and are late examples of a special type of landscape painting known as *shigajiku* (poetry-picture scrolls), a sort of literary landscape in which elements of painting and poetry were of equal aesthetic and philosophic importance. *Shigajiku* were especially popular in Zen circles during the early fifteenth century, and are often seen among works of that period attributed to Shūbun. They are less common in the late fifteenth century, when the landscape itself gradually takes precedence. Another theme of these two works by Shōkei that recalls traditions of the Shūbun school is the motif of the scholar's studio in the foreground, a reference to the theme of *shosaizu* (studio paintings) seen in many landscapes of the early fifteenth century.

Thus Shōkei's late paintings, although executed in an entirely different style, draw upon traditions of the Shūbun school, an element that is scarcely evident in his earlier works. In this respect he is participating in the retrospective trend, looking back for inspiration to the mid-fifteenth century Japanese master, Shūbun, that is strongly evident in Japanese landscape paintings of the late fifteenth and early sixteenth centuries. Sesshū, Gaku'ō, and the unknown painter of the Baltimore *Landscape* (cat. no. 13) also participate in this trend. The return to model paintings of Shūbun by artists of such diverse training signifies a widespread revival of enthusiasm among Japanese painters for the achievements of their own predecessors. The appearance of elements of the Shūbun tradition in the work of Shōkei, who had no direct links with the Shūbun school, demonstrates

191

the continuing appeal of the forms and themes associated with this tradition.

Stylistically, the late paintings of Shōkei show a great reduction in the number of elements and complexity of composition, as well as an overall abbreviation of technical effects. Although Shōkei maintains to some extent the distinctive curving dynamism of rock and mountain forms, particularly in *Sōsetsu-sai,* the emphasis in these works is on the creation of harmonious, stable compositions and a mood of uncomplicated serenity. This quality of harmony and tranquility is still more evident in *Shōshūsai* (fig. 18), in which the gently rounded peak fringed with trees along its crest is rendered by softly blending ink washes and textural strokes, and has a distinctively Japanese appearance reminiscent of Yamato-e paintings.

When compared with these late paintings by Shōkei, the Boston *Landscape* can be seen to occupy an earlier position in Shōkei's oeuvre. Although it is less exuberantly dynamic than the Nezu *Landscape,* it shares an emphasis of dramatic compositional contrast that is not seen in Shōkei's late works, and, also a legacy from Gei'ami, a sharp, faceted manner of rendering rock formations. Shōkei's late works show a striking divergence from such elements of Gei'ami's style. The Boston *Landscape,* although it has much in common with that in the Nezu Museum, already shows a tendency toward the greater technical control and restraint seen in Shōkei's later works. It therefore seems to exemplify a more mature style, far less dependent on Gei'ami. The Boston *Landscape* also includes some motifs derived from the style of Hsia Kuei, and is thus an important point of reference in tracing the evolution of Shōkei's distinctive landscape painting style from more than one source. This painting, with its unusual and somewhat complex composition, seems most likely to have been executed during the decade after Shōkei's return to Kamakura in 1480, and it provides an important example of the style of landscape that influenced his followers to a far greater extent than the masterworks of his late years (see cat. no. 25).

Shōkei's career, centered in Kamakura, represents an important new trend in the history of Japanese ink painting of the late fifteenth century — the rise of significant provincial schools of painting. Like Sesshū, who was active at the same time in distant Suwō province, Shōkei was highly recognized for his talent and had many friends among eminent Gozan monks in Kyōto. Both painters developed unique personal styles of paint-

ing and inspired many followers who continued the independent trends fostered by their masters.[10]

The artistic activity in Kamakura of Shōkei and of Chū'an Shinkō, who may have been his first teacher, marks an important revival of that city as a cultural center. During the fourteenth century, under the patronage of the Hōjō regents and the Ashikaga Shōguns, Kamakura had been the first center of ink monochrome painting and the study of Chinese literature and art. The accomplished Zen monk-painter Gukei Yū'e (fl. ca. 1461+)[11] spent part of his career in Kamakura after studying painting under Tesshū Tokusai (see cat. nos. 30–32) in Kyōto. But Gukei, unlike Shōkei, apparently left no disciples in Kamakura; with his return to Kyōto, the center of Japanese painting shifted decisively to Kyōto and its two major ateliers — that of Minchō and his followers at the Tōfuku-ji (see cat. nos. 4–5), and that of Josetsu and the Shūbun school at the Shōkoku-ji.

Although Chū'an Shinkō is the first painter after Gukei who is known to have worked in Kamakura, it is really Shōkei, with his thorough knowledge of diverse Chinese subjects and painting styles and his special excellence in landscape painting, who inspired the renascence of the Kamakura *suiboku* school. The landscape paintings of his followers[12] are readily recognizable by their reliance upon the style exemplified by the Nezu and Boston landscapes, which dates from the middle period of Shōkei's career between his two visits to Kyōto. Shōkei's followers often imitate the forms and techniques of complex compositions such as the Boston *Landscape* in a repetitious, mannered way which results in peculiar, sometimes bizarre rock formations, such as those in the screens of Shikibu (cat. no. 25) in this exhibition. The odd variations seen in many of these derivative works by Shōkei's followers result in part from their isolation from other contemporary influences. Nevertheless, the Boston *Landscape,* which shows a mature synthesis of elements from the models of Gei'ami and Hsia Kuei, is a major example of the classic image of Shōkei's style as it was known among his successors.

ANN YONEMURA

NOTES

1. Condition: overall condition excellent; slight horizontal cracking in center section, well repaired; slight, irregular damage in upper left-hand corner and irregular fissures in lower right corner now repaired; condition of painting surface itself remarkably good, showing very little abrasion.

2. Nakamura Tanio describes the duties associated with this position in *Shōkei,* p. 25. See also Collcutt, "The Zen Monastic Institution," chap. 6.

3. See Wakimoto, "Gei'ami no Kampaku So-zu."

4. The texts of the inscriptions of the *Hinrakusai* scroll are recorded in the *Koga Bikō.* They include Getsu'ō Shūkyō's preface, Ōsen Keisan's colophon, six poems by Zen literati, and one additional poem taken from a 17th century anthology of poems in Chinese style by Zen monks of the Muromachi period, *Kanrin Gohōshū.* The 1493 date is given by Getsu'ō in his preface. Ōsen restates that Shōkei of Kenchō-ji, Kamakura, came to Kyōto to study painting under Gei'ami, and that when he was returning to his home temple he was presented with a painting of a *Monk Viewing Waterfall* by his master as a farewell gift. Ōsen also makes it clear, by referring to a poem by Huang T'ing-chien, the distinguished Chinese poet of the 11th century, that the naming of Shōkei's study "Hinrakusai," meaning "Study of Joy in Poverty," derives from Confucius' words about his disciple Yen Huai in the *Analects.* The author of *Koga Bikō* reserves a doubt on Ōsen's colophon, mainly because the text appears not in Ōsen's collected works, but in those of Keijo Shūrin, *Kanrin Koroshū.* However, this poses no problem because Shūrin wrote a number of works for Ōsen, his teacher, and Ōsen died only eight months after Getsu'ō wrote his preface in the spring of 1493, predicting that Ōsen would write a colophon to the poems. *Koga Bikō* suggests that the source of the inscriptions is a memorandum by a member of the Kohitsu family, the family of hereditary connoisseurs of calligraphy and painting (see cat. no. 11, n. 17), but does not mention the existence of a painting of the Hinrakusai study accompanying the inscriptions. One of the Hinrakusai poems in *Kanrin Gohōshū,* however, indicates that a picture of the study had been made. It may be that the original scroll of the Hinrakusai painting and inscriptions had been cut into two sections, and that the Kohitsu connoisseur saw only the section of calligraphy.

5. Published in *Kokka,* no. 302. Seikadō Collection. Inscription dated 1499.

6. Fan-shaped painting in the style of the Sung emperor Hui-tsung, published in *Kokka,* no. 699.

7. *Horses and Grooms* in the Kobayashi Collection, published in *Higashiyama Suibokugashū.*

8. Published in *Kokka,* no. 118, and in Matsushita and Tamamura, *Josetsu, Shūbun, San-Ami,* pls. 139–46.

9. Published in Tanaka and Yonezawa, *Suibokuga,* pls. 84–85.

10. The general parallelism of the careers of Sesshū and Shōkei is noted by Fontein and Hickman, *Zen Painting and Calligraphy,* p. 141.

11. The article by Shimada, "Yū'e Gukei no Sakuhin Nishu," presents the only biographical information on Gukei's life, other than an inscription on his painting of *Sparrows and Bamboo,* published in an article by Nakamura Tani'o in *Kokka,* no. 762.

12. A convenient list of Shōkei's followers is given in Nakamura, *Shōkei,* pp. 47, 51.

Landscape of the Four Seasons
Shikibu (Ryūkyō; fl. mid-16th century)

Pair of six-fold screens, ink, color, and gold dust on paper, each 171.45 x 322.58 cm. Rectangular relief seal reading Terutada, *square intaglio seal reading* Shikibu *on each screen. Asian Art Museum of San Francisco, Avery Brundage Collection (B60 D48+, D49+)*

Following long established conventions of screen painting, the composition opens with spring scenery at the extreme right of the right screen. The bare branches of plum trees indicate that the season is early spring. A scholar and his attendant view the spring scenery from a mountain path; behind them is a walled compound, probably the scholar's home, veiled in vernal mists. The enormous oddly shaped outcrops of rock in the foreground of panels two and three (counted from the right) mark the transition from spring to summer. Luxuriant foliage surrounding the rustic hovels of a mountain village suggest the humid heat of summer and the accompanying clamour of cicadas. From a high gorge, in the cliff above the village, spring the cool waters of a mountain waterfall, a theme often associated with summer in Japanese literature. A scholar and his attendant visit the village, while below, in the foreground, villagers unload provisions from a boat. In the middle distance, by the lake, a fisherman leaves his nets out to dry. Boats lie at anchor by the thatched houses. It is the quiet cool of a summer evening.

The left screen depicts autumnal scenery in the first three panels from the right. The leaves are gradually turning brown; a sense of solitude and a certain desolation, so often expressed in Japanese poems about autumn, is nicely suggested in the solitary figure of the fisherman in panel one, and in the empty lakeside house in panel three. In the middle distance in panel one, a scholar and two attendants return to a rustic retreat by the lake, while in the background, low-lying hills and moored boats are interspersed with expanses of water. Winter is depicted in the last three panels. A scholar returns home with his lute-bearing attendant, across a snow-covered bridge. A solitary boat is poled through icy waters. A group of pavilions is encircled by enormous snow-laden peaks, a waterfall courses between the pavilions, under an elegant bridge. Rustic figures in the foreground, clad in straw mantles, make their slow way along a broad, cold path.

The extensive areas of gold dust, which in most cases take the form of a kind of mist covering mountains, water, and sky, are almost all later additions, added in recent years to cover large areas of damage and to enhance the decorative value of the painting.[1] The gold, while undoubtedly dramatizing the decorative qualities of the screen, has greatly altered its original appearance and in some respects disfigured the rather meticulous descriptive quality of the work. For example, the gold applied over large areas of the mountains in the winter

scene tends to flatten the rock face and detract from the otherwise relatively realistic depiction of the mountain crags. Originally the only yellow coloring was the yellow seen at the outer edges of the rocks, where it serves a primarily descriptive function.

The name of this painter has been the subject of some controversy. The square intaglio seal which appears on many of his works may be read either as *Ryūkyō* or *Shikibu*.[2] The rectangular relief seal has been read as *Tōkō Tadashi*, and more recently as *Terutada*. Although this issue has not yet been satisfactorily resolved, most scholars at present follow Fuku'oka Kōtei, who observed in his notes in *Koga Bikō* that the painter's name should be read as Terutada Shikibu.[3] Over the square intaglio seal on the right screen a round relief seal has been impressed. This is the seal of a temple, probably the Jinshō-ji, the former owner of the screens.

The identity of the painter was not clear to early critics. The late-eighteenth century art historian Hiyama Tansai states in *Kōchō Meiga Shū'i* that "Ryūkyō" was the *gō* (style-name) of Chū'an Shinkō (fl. mid-fifteenth century; see cat. no. 6), and that certain collectanea of seals mistakenly list the *Ryūkyō* seal under Kenkō Shōkei.[4] Asa'oka Okisada repeated this error in *Koga Bikō*, listing the *Ryūkyō* seals under Chū'an Shinkō. Asa'oka mentions *Bengyokushū* (1672) as one of the seal collectanea which listed the *Ryūkyō* seal under Shōkei, and notes that certain people, thinking that "Ryūkyō" was Shōkei, added *Ryūkyō* seals to fake Shōkei paintings.[5] At least one such painting exists today.[6]

The confusion was cleared up with the appearance of more Shikibu paintings. Shikibu's eight hanging scrolls depicting *Eight Views of Mount Fuji*,[7] mentioned in *Koga Bikō* and extant today, bear inscriptions by the monk Jō'an Ryūsū, the 222nd abbot of the Kenchō-ji who died in 1536. Another painting mentioned in *Koga Bikō*, the *Li Po Viewing a Waterfall* in the Kobayashi Collection,[8] has an inscription by the monk Genkō Kei'in, once abbot of the Myōshin-ji, who lived in the second half of the sixteenth century. It is clear from these inscriptions, as well as from the style of his other paintings (at least thirty are known today), that Shikibu was active about the middle of the sixteenth century, a century after Chū'an Shinkō and considerably later than Kenkō Shōkei.

The numerous extant works by Shikibu reveal that he painted a great variety of subjects and was a master of several styles. His flower-and-bird paintings, like those of Kenkō Shōkei, reveal familiarity with Chinese aca-

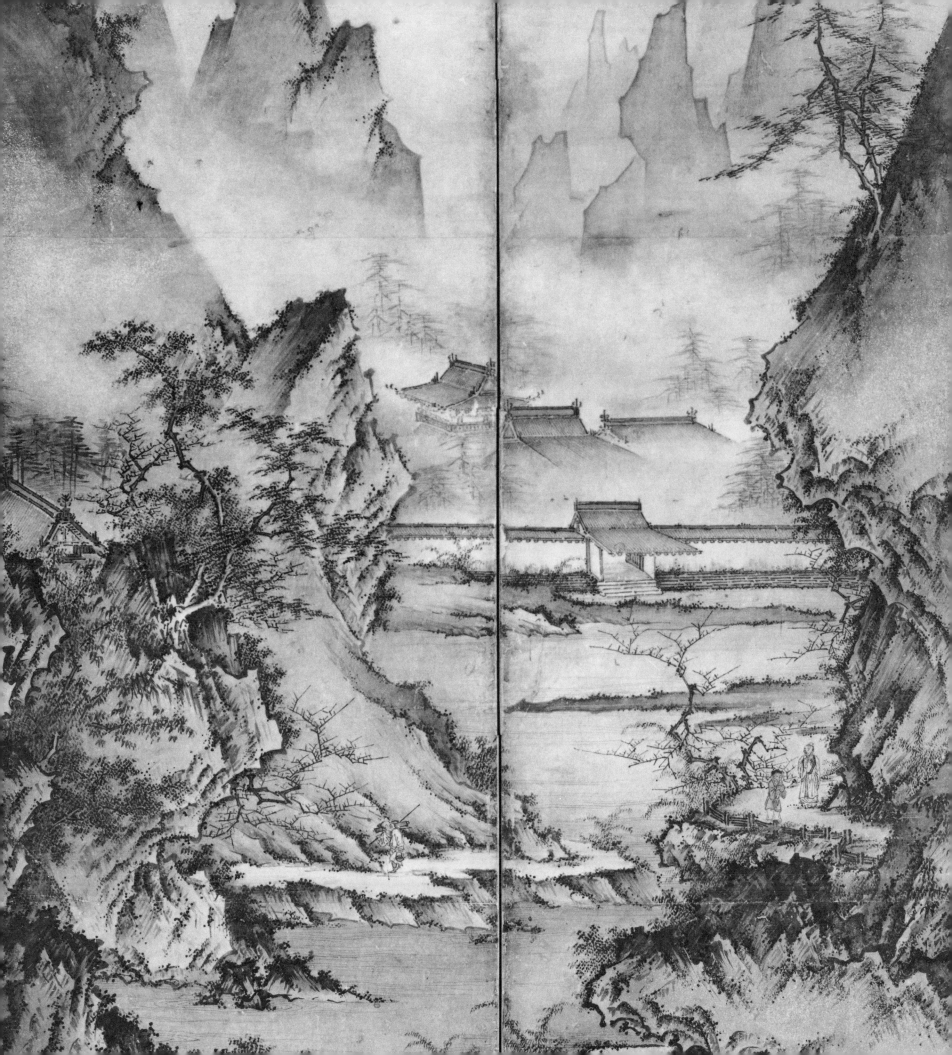

demic painting,[9] but are far from being stilted and formalized. As seen in the *Waterfowl* in this exhibition (cat. no. 37), his birds are often extremely lively and endearing in expression. He produced figure paintings, known from his *Li Po Viewing a Waterfall* mentioned above, and a *Kanzan and Jittoku*.[10] His landscapes, however, compose the most numerous category, and for the most part they are painted in the Ma-Hsia style, as typified by the Asian Art Museum screens and the pair of six-fold screens depicting *Landscape of the Four Seasons* in the Seikadō Collection.[11] There are also fan paintings in the "Mu-ch'i abbreviated style" (fig. 56),[12] and a pair of six-fold screens of monkeys in the "linear Mu-ch'i style" (see cat. no. 18).[13]

There is no reliable documentary evidence concerning the location of Shikibu's activities or his painting lineage, but the character of his formal paintings in Ma-Hsia style suggests a connection with the followers of Kenkō Shōkei, who were active in Kamakura in the sixteenth century. The curiously serrated rocks which appear so frequently in Shikibu's work may be compared to the rocks of Kenkō Shōkei's landscapes in the Museum of Fine Arts, Boston (cat. no. 24) and in the Nezu Museum (fig. 60). The broad, heavily indented outline so characteristic of Shōkei's work appears in Shikibu in a degenerate form; the slight accents which appear at the V-shaped edges of certain rocks in Shōkei

are greatly exaggerated in Shikibu. The same tendency is visible in Senka (fig. 62), a follower of Shōkei active in Kamakura in the first half of the sixteenth century.[14] While Shōkei tended to retain the centered slow brush of his teacher Gei'ami, Shikibu, like Senka, frequently held his brush at a slant and painted rapidly, virtually flicking his wrist around the corners. The brushline is weaker, more limpid than that of Shōkei. It is therefore not surprising that Edo period critics and the author of *Koga Bikō* associated "Ryūkyō" with the Kamakura school.

The Asian Art Museum screens reveal dependence on the tradition of screen paintings of the Shūbun school. Like those in the Matsudaira, Maeda, and Tōkyō National Museum collections,[15] which are the best representatives of screen paintings of this school, the principal land masses are concentrated at the right and left ends of the total composition on each screen, while void space expands in the center. Many motifs favored by artists of the Shūbun school also appear in Shikibu's screens. For example, the two pines leaning out over a background of lakeland scenery in panels four and five from the right are reminiscent of those in *Chikusai Dokusho* (fig. 9). The pines set on a high, sloping rock face in the opening panel of the right screen is a motif commonly found in screens of the Shūbun school, as are the pines set atop oddly shaped, vertical rocks.[16] The prominence of the

mountain village in panels three and four of the right screen refers to one of the *Eight Views of Hsiao and Hsiang,* while there is a passing reference to another of the scenes, *Sunset Glow over a Fishing Village,* in the fishing nets of panels five and six. Such incidental references to the *Eight Views* within the framework of a four-seasons composition appear frequently in early screen paintings of the Shūbun school.[17] The lakeside house, half-hidden by a low bank and trees, in the foreground of the left screen provides evidence of the painter's familiarity with Hsia Kuei model paintings; it is closely comparable to a similar passage in the *Landscape of the Four Seasons* attributed to Motonobu in the Rei'un-in, which is entirely based on models in Hsia Kuei style.[18] The high plateau in panel five of the right screen is also a familiar feature derived from the Hsia Kuei style.[19]

In rendering of space and articulation of form, the lessons of the late fifteenth century have been well learned. There is a relatively consistent ground plane throughout; rocks are articulated in great detail, and recession is accomplished comfortably in a rather realistic manner. Most significant, however, is the unity of the composition as a whole. Screen paintings of the Shūbun school, even in the late fifteenth century, tended to juxtapose fragments of a large view.[20] But in this pair of screens, as in the pair in the Seikadō, Shikibu presents the entire composition as a contin-

uous panoramic view. This is a development not seen before the time of Kano Motonobu (1476–1559; cat. no. 28), and in screen painting strictly of the Shūbun school; the earliest example is the pair of *Landscape of the Four Seasons* screens in the Taisan-ji, datable about the mid-sixteenth century.[21] The mannered pine trees as well as the compositional mode of this screen have much in common with Shikibu's screens in the Seikadō. Another feature of the Asian Art Museum screens which differs from the traditional mode of the Shūbun school is the addition of a land mass in the center of the composition, rather close to the foreground. This element appears in Shikibu's screen painting in the Seikadō and in some of the screen paintings attributed to Kano Motonobu, notably the pair of landscape screens formerly in the Sakai Collection.[22]

The unique characteristics of Shikibu's style are well represented by the San Francisco screens. The artist, extremely preoccupied with detail, describes trees, bushes, and rocks with an extraordinary proliferation of dots and small strokes. Although some members of the Shōkei school such as Keison are notable for density of brushwork, there is nothing quite comparable to Shikibu's busy profusion. Despite this, however, there is scant description of the rock faces: only some shading of the upper edges and the addition of dots. In distinct

Figure 62. *Landscape*, Senka (fl. 1438). Hanging scroll, ink and slight color on paper, 29.3 x 49.6 cm. Tōkyō National Museum

contrast to the many large axe-strokes used by Kenkō Shōkei and such followers as Senka, Shikibu's mannered groups of small parallel axe-strokes scarcely succeed in conveying an impression of solidity despite the considerable energy given to delineating rock forms. On the other hand, the outlines of Shikibu's rocks, which describe an almost incredible series of indentations in a rather flamboyant manner, can be related to the Shōkei school. His rapid mannered line is quite distinctive, forecasting the close of the age of ink painting proper and pointing to the following era of the decorative screen. Shikibu makes ample use of color washes, especially yellow ocher at the edge of rocks and a bluish wash on

rocks and banks. The fresh tone of his colors is again comparable to that in paintings of the Shōkei school, which excel in this respect. The phantasmagoric shapes of Shikibu's rocks and mountains, characterized by extreme overhangs and a multitude of repeated sharp angles, show the screen-painting tradition derived from Shūbun entering a truly baroque phase.

RICHARD STANLEY-BAKER

NOTES

1. Professor Shimada saw this painting before the gold had been added, while it was still in the Jinshō-ji. The practice of adding gold to cover damage is not unusual in Japan.

2. If the square seal is divided into three vertical sections, the center and right sections taken together may be read *Ryū* and the left section *kyō*. If the right section is taken alone, it may be read *Shiki* and the center and left sections are then read *bu*.

3. Fuku'oka Kōtei was a member of the team, led by Ōta Kin, which enlarged the original text of Asa'oka's *Koga Bikō*. The enlarged edition was first published in 1905. His notes on the *Ryūkyō* seal appear in vol. 2, pp. 796–98. He later published a collection of notes on seals, including that of *Ryūkyō*, in a series of articles in *Kokka* entitled "Inpu Benmō."

4. Hiyama Tansai, *Kōchō Meiga Shū'i*, pp. 1423–24. For discussion of this book, see cat. no. 6, n. 9.

5. *Bengyokushū*, compiled and published in 1672 by an unidentified author known by the pen name of Rakusuikyo Shūjin, is primarily a handbook on pottery for the tea ceremony, but two of its five volumes deal with painters' biographies and seals. This section, entitled *Gakō Inshō Bengyokushū* (Discrimination of Jade from Stone in Painters' Seals), comments on painters and their seals from the 9th century Kōbō Daishi to the early 17th century Kano artists. Notes on painters are very brief, and seals are inaccurate or distorted, often unrelated or confused with seals of other artists. The *Gakō Inshō Bengyokushū* is published in vol. 2 of Sakazaki's *Nihon Garon Taikan*. Asa'oka's mention of the *Bengyokushū* and the *Ryūkyō* seals is in *Koga Bikō*, pp. 795–96.

6. A fake Shōkei landscape with a fake *Ryūkyō* seal is published in *Kokka*, no. 33.

7. This set is now in a private collection in Japan. Two of the paintings are illustrated in Shimada, ed., *Zaigai Hihō*, 2:129.

8. Tanaka and Yonezawa, *Suibokuga*, pl. 116.

9. See, for example, the pair of hanging scrolls of flowers and birds in the Murayama Collection published in *Kokka*, no. 461. These may be compared with similar works by Shōkei illustrated in *Kokka*, no. 699.

10. The *Kanzan and Jittoku* was mentioned in *Kokka*, no. 701, as extant in 1932.

11. Illustrated in Kyōto National Museum, *Chūsei Shōbyōga*, no. 20.

12. Two fan paintings, one in the Tōkyō National Museum (Matsushita, *Muromachi Suibokuga*, pl. 96), and one in the Burke Collection, illustrate Shikibu's handling of the "Mu-ch'i abbreviated style," which follows the wash style of the famous *Eight Views of Hsiao and Hsiang* (fig. 56).

13. Published in *Kokka*, no. 801.

14. See also *Setsureisai* by Senka in the Gotō Art Museum, dated by inscription to 1538, published in Matsushita and Tamamura, *Josetsu, Shūbun, San-Ami*, pl. 150.

15. The Matsudaira screens are published in *Kokka*, no. 6; the Maeda screens in *Kokka*, no. 538; and those in the Tōkyō National Museum in *Kokka*, no. 751. All three sets are also published in Kyōto National Museum, *Chūsei Shōbyōga*, nos. 5, 3, and 4, respectively.

16. Such motifs are found in the Tōkyō National Museum and Maeda screens.

17. In early screens of the Shūbun school, such as those in the Maeda and Matsudaira collections, these references are treated as incidental motifs. In the late 15th century screens centered specifically on the theme of the *Eight Views*, such as Gaku'ō's screens in the Murayama Collection (fig. 37), were painted quite frequently. For discussion of the theme of the *Eight Views of Hsiao and Hsiang*, see cat. no. 15.

18. See *Bijutsu Kenkyū*, no. 270, fig. 12, panels *d* and *e*, and Tsuji's discussion of these paintings in *ibid.*, no. 271, pp. 86–89. This is part of Tsuji's excellent series of articles on Kano Motonobu.

19. Such plateaus appear frequently in paintings in Hsia Kuei style, notably in the famous handscroll entitled *Ch'i shan ch'ing yüan* in the National Palace Museum, Taiwan. See Suzuki, "Hsia Kuei and the Pictorial Style of the Southern Sung Academy." A version of this scroll was known to Muromachi painters and is reflected in a handscroll by Gei'ai published in Matsushita, *Suibokuga*, fig. 105, and in a set of paintings attributed to Motonobu formerly in the Mori Collection, published in *Bijutsu Kenkyū*, no. 271, fig. 44. The Asano landscape (fig. 10) is probably a fragment of the original scroll on which such paintings were based.

20. An example from the late 15th century is the screen in the Seikadō Collection attributed to Shūbun, published in *Kokka*, no. 304.

21. Published in Kyōto National Museum, *Chūsei Shōbyōga*, no. 9. Discussed in Nakajima, "Shiki Sansui no Henyō."

22. See Tsuji, "Kano Motonobu," *Bijutsu Kenkyū*, no. 271, p. 102, fig. 76.

Landscape in Wind

Sesson Shūkei (ca. 1504–ca. 1589)

Hanging scroll, ink and slight color on paper, 27.31 x 78.63 cm.
Tripod relief seal reading Sesson, *intaglio gourd-shaped seal reading* Shūkei.
On inside of outer box containing the painting is a note written by a painter-connoisseur of the Kano school, Yosen-in Korenobu (1753–1808). A slip of paper attached to the box mentions that the painting has been handed down in the Matsuzawa family.
Private collection

A moon rising on the left illuminates a tableau of irregular rocks set above a stretch of soundless water. Formidable boulders on the right thrust their massive weight toward the lake. Sheltered between them, a small fishing boat is moored amidst clusters of reeds and a man wearing a straw raincoat stands fishing on the bow. Mist settles around the inlet, obscuring the base of the rock in the middle ground. Two central trees are firmly rooted on the foreground rock, but their trunks oscillate and branches bend in the night wind. Two hazy trees only partially visible in the middle ground are more sharply swayed by the gale. The wind rustles through bamboo leaves blowing above the middle ground rock; it breaks and spills into the inlet, gently sweeping over the reeds. The fisherman's line ripples.

Remarkably well-orchestrated contrasts in forms, brushwork, ink tonality, and colors produce the painting's extraordinary expressive quality. The deep quiet of the lake waters swirling around a sharp outcrop of rock lit by a low-hanging moon becomes even more mysteriously still when contrasted with the robust embankment which seems to hurtle toward it. Technical elements such as the crisp contour line and the ink texturing strokes can be traced to Chinese masters such as Li T'ang, Ma Yüan, Hsia Kuei, and Sun Chün-tse.[1] But Sesson has so changed the academic painting style that it is almost irrelevant to speak of prototypes. Most striking is the way ink washes transform the nature of rock surfaces into elastic forms like dough before baking. Applied with broad sweeps of the brush, ink tones blend fluidly from dark to light, light to dark, so that basically static rocks become moving flexible forms. Kenkō Shōkei and Sesshū employed similar techniques, but Sesson's unique use of ink dematerializes the solidity of stone, making it malleable. A very different handling of ink, in subtle negative wash, defines the pale moon which accentuates the placid air of the left side of the composition.

The climactic action of the trees bending away from the quiet lake counters the sweep of rocks toward the water. The large motion of the trees decelerates in the bamboo leaves and settles on the fragile reeds around the solitary fisherman. All are rendered in gray ink tones. The brown on the boat, on its straw cabin roof, and in the fisherman's coat adds a touch of human warmth, contrasting with the pale blue wash which sharpens the rock faces and heightens the movement of tree leaves.

The truncation of the small rock farthest left suggests that the original composition was much wider. Clearly this painting is a section of a handscroll. Two seals are impressed on the right: the upper tripod seal reads *Sesson*, and the lower intaglio gourd-shaped seal, *Shūkei*.[2]

The painter Sesson Shūkei is generally believed to have been born in the first decade of the sixteenth century, a few years prior to Sesshū's death.[3] His home is thought to have been the small provincial village of Hetare in Ōta, castle town of Hitachi province (modern Ibaragi prefecture).[4] Only legends tell of his early years, and nothing is known of his early training as a painter. By 1542, however, he had written a theoretical treatise on painting for his disciples, called the *Setsu-monteishi*.[5] Presumably by that time he was already an accomplished painter.

Also by the 1540's, Sesson had acquired a powerful patron, Ashina Mori'uji (1521–1580), lord of Aizu castle and controller of the region southeast of modern Fukushima prefecture. Through marriage, Mori'uji was allied with the powerful Date family in the north, and was considered one of the more important lords of the northern part of the Kantō region before the outbreak of the Sengoku ("provinces at war") period of the sixteenth century. An Edo period source records that Sesson gave Mori'uji instructions in painting in 1546.[6]

In the same year Sesson painted his earliest dated work which is still extant, *One Hundred Horses (Hyakuba)* for a Shintō shrine in Aizu.[7] These twelve paintings are signed "Shūkei" and "Shūkyosai," an art name meaning "[master of the] studio on a boat." Sesson's next dated work is a conservative *chinzō* portrait [8] of the Zen monk Iten Sōsei (1452–1554). Now in the collection of the Hōshun-in subtemple of Daitoku-ji, the portrait has an inscription by Iten himself, dated 1550.[9] This painting establishes a connection between Sesson and another important patron, for Iten was abbot of Sō'un-ji, a Zen temple erected by the Hōjō family in Odawara, Sagami province (modern Kanagawa prefecture). The portrait suggests that Sesson was commissioned by Hōjō Uji'yasu (1515–1571), who was active in this region southwest of Tōkyō at that time. This was the period when the "Odawara Kano" were painting — a group apparently led by Kano Gyokuraku, who had been a disciple of Kano Motonobu in Kyōto before coming to Odawara to serve the Hōjō family. Their pictorial manner followed the Chinese academic tradition as transformed and synthesized by Kano Motonobu.[10] Another bit of evidence linking Sesson with patrons of the Hōjō

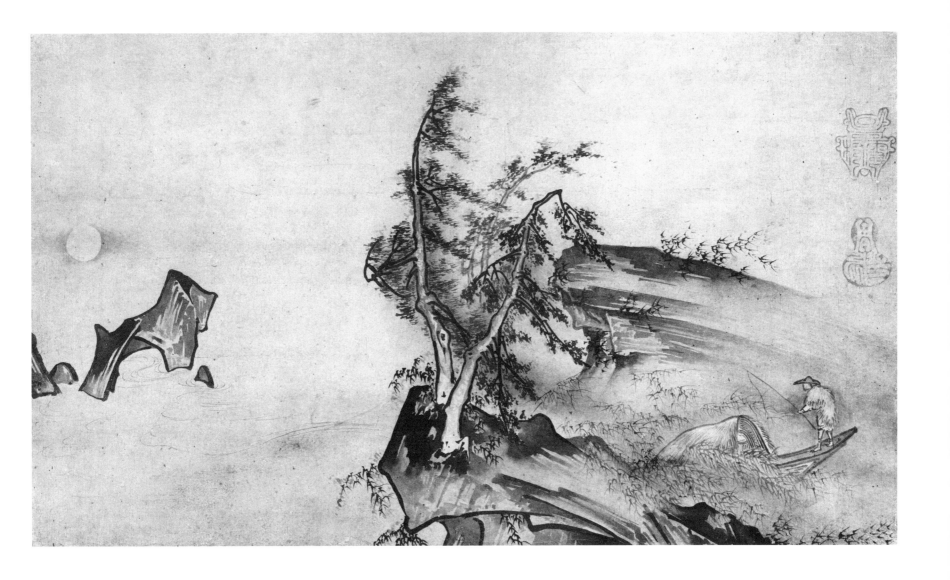

family at mid-century is his handscroll in Yü-chien style inscribed by a disciple of Iten Sōsei, a monk of Daitoku-ji named Daishitsu Sōseki (d. 1560).[11]

Odawara was not far from Kamakura, and Nakamura Tani'o reasonably concludes that Sesson must have visited there.[12] A painting by Sesson dated 1555 was inscribed by Keisho Shūzui, the 152nd abbot of the Engaku-ji in Kamakura.[13] Nearby, at the Kenchō-ji, a group of Kenkō Shōkei's followers had a flourishing workshop. Their style, like that of the Odawara Kano, had its basis in the academic tradition of Hsia Kuei — but the Kamakura style was traced from Gei'ami's Nezu Museum *Viewing a Waterfall* (fig. 61) through Gei'ami's student, Kenkō Shōkei, to his own disciples such as Senka (fig. 62).[14]

About 1573 Sesson apparently ceased his peripatetic existence, and settled down to paint at Tamura in Mihara, in the province of Iwaki (modern Fukushima prefecture). The place of his retirement, near the Fukuju-ji temple, was known eighty years after his death as Sesson-an (Sesson's Hermitage).[15] He spent ten to fifteen years as a productive artist in Tamura. A group of large screens as well as hanging scrolls, some inscribed by Sesson with his age, survive from this period.[16]

Since Sesson was already a competent painter by 1542 and continued to paint into the late 1580's, his activity spans half a century. Stylistic change is inevitable during such a period, yet the sparsity of dated works makes it difficult to formulate a chronology of his painting. The initial effort was made by Professor Fuku'i of Tōhoku University in 1933, when paintings attributed to Sesson numbered thirty-three.[17] His scheme divides Sesson's life into three major periods. The early period corresponds to Sesson's life in Hetare, Ōta, prior to 1542 and the appearance of the theoretical treatise which establishes him as a flourishing painter. His middle period, covering his life at Aizu under the patronage of Ashina Mori'uji, is divided into two parts, 1542–1562 and 1563–1572. His late period, which Fuku'i calls the Tamura Period, includes his work in retirement from 1573 until his death, which is assumed to have been about 1589. Fuku'i cites as Sesson's earliest work a pair of *Summer* and *Winter* landscapes in the Kyōto National Museum,[18] and as his latest work the six-fold screen illustrating scenes from the *Eight Views of Hsiao and Hsiang* now in the Kuroda Collection.[19] This screen is signed by the artist, giving his age as eighty-six (eighty-five by western count). Subsequent scholars tend to agree with Fuku'i's judgment on these two extremes. Concerning the long interval between, however, there are varied opinions about the chronological sequence of Sesson's paintings.

During the past fifteen years, largely through the efforts of the Japanese art historians Nakamura Tani'o and Etō Shun, Sesson's corpus has doubled. The most recent list of his works, which includes a handful of close copies by later artists, contains over sixty items depicting all categories of subject matter. Ten of these are in American collections, and five of the highest quality should be mentioned: a pair of six-fold screens of *Birds and Flowers* in the Minneapolis Institute of Arts, a pair of *Landscape of the Four Seasons* screens in the Art Institute of Chicago, a *Landscape* handscroll in the style of Yü-chien in the Rockefeller Collection, a pair of *Dragon* and *Tiger* screens in the Cleveland Museum of Art (cat. no. 27), and the *Landscape in Wind* exhibited here.[20]

Fuku'i places the *Landscape in Wind* in the first part of Sesson's middle period, 1542–1562, and his well-known *Wind and Waves* (fig. 64), now in the Nomura Collection, in the second, 1563–1572. Nakamura Tani'o's recent analysis, while shifting the relative position of other Sesson paintings,[21] concurs that *Landscape in Wind* belongs to the very early part of Sesson's middle period, apparently ca. 1542–1546 and contemporary with his album of *Eight Views of Hsiao and Hsiang*, which bears the same tripod seal.[22]

The subject matter, size, and format of this *Landscape in Wind* is close to that of the eight paintings of Hsiao and Hsiang scenes (fig. 63). Moreover, the *Hsiao and Hsiang* album paintings seem to be the next stage in Sesson's stylistic development, after the early *Summer* and *Winter* landscapes in the Kyōto National Museum. But there are important differences between them and the painting exhibited here. The space spanned between foreground and far distance in the *Hsiao and Hsiang* paintings, as well as the distant mountain motifs themselves, are virtually taken from landscapes of the Hsia Kuei type. This kind of space is significantly absent from *Landscape in Wind*. In addition, the ink tonality of the *Hsiao and Hsiang* album leaves is characterized by abrupt contrasts of dark and light on the rocks, applied part-to-part as if to accentuate the rock surface. In *Landscape in Wind* the ink tones on the rocks fuse over the entire area, and give a sense of the cohesion of the rocks. It seems that Sesson's stylistic development proceeded from a part-to-part definition of form toward a fusion of mass, and therefore that *Landscape in Wind* was painted later than the album of *Eight Views of Hsiao and Hsiang*. While his early landscapes are restrained in personal

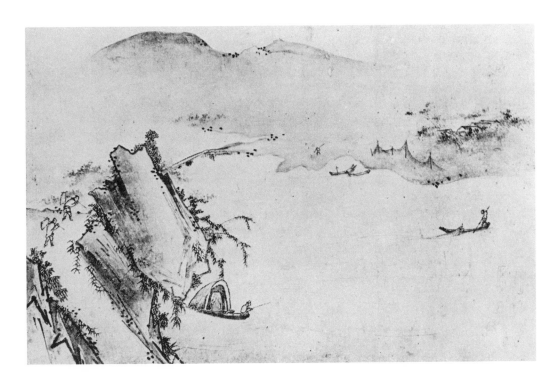

Figure 63. *Sunset Glow over a Fishing Village,* Sesson (ca. 1504–ca. 1589). One of eight album leaves of *Eight Views of Hsiao and Hsiang,* ink on paper. Private collection, Japan

Such sensitivity to ink tonality was enhanced by Sesson's study of the two most "painterly" Chinese landscapists, Yü-chien (fig. 51) and Mu-ch'i (fig. 56). In the late 1550's and early 1660's, Sesson painted a series of landscapes in handscroll format based on Yü-chien and Mu-ch'i (fig. 20).[24] These scrolls, as well as several small hanging scrolls, have become increasingly important in relation to the style of some of Sesson's works that have surfaced in recent years. For example, two works recently published show significant influence from flower-and-bird-and-vegetable paintings connected with Mu-ch'i. Sesson's *Mynah Bird (Ha-ha Chō)* in the Tokiwayama Bunko, dated 1555,[25] recalls the *Mynah Bird on a Pine Tree* [26] attributed to Mu-ch'i, in its broad use of graded tones of wet ink over the black bird's plumage. And Sesson's *Radish* (fig. 82) is related to the *Radish* by Jonan Etetsu exhibited here (cat. no. 36) in terms of its common prototype by Mu-ch'i (fig. 81).

Unlike Yü-chien and Mu-ch'i, however, Sesson's landscapes convey no illusion of space. In fact, this highly individual provincial artist shows less concern for space than his near-contemporaries working in Kyōto, such as Kano Motonobu (cat. no. 28). Sesson had no interest in leading the viewer gradually into distance, as the painters active a century earlier wanted to do. Rather, he contrived to capture the viewer in compulsive surface or middle-ground rhythms. In this sense, his works approach the pictorial concerns dealt with by Motonobu's son, Kano Shō'ei (d. 1594) and Shō'ei's son, Kano Eitoku (d. 1590), who ushered in a whole new stylistic age with their paintings on the sliding-door panels of the Jukō-in subtemple of the Daitoku-ji in 1566.[27]

Landscape in Wind must also be considered a later work than the *Wind and Waves* in the Nomura Collection (fig. 64). This famous painting reveals more of Sesson's personal style than do the *Eight Views of Hsiao and Hsiang* (fig. 63) in brushwork and ink tonality, in the dramatic expression of blowing wind and surging waves. But in compositional scheme, as well as in the basic linearity of brushwork, it still follows the academic Hsia Kuei tradition. The transmission comes through the work of a lesser-known painter of the Chinese Academy, a follower of Li T'ang known for his wet ink wash, Lu-ch'ing (fl. 1191–1195). *Wind and Rain* by Lu-ch'ing is known through a careful copy made by the seventeenth century master-painter and connoisseur Kano Tan'yū.[28] The graded ink wash of rock surfaces, as well as the specific motifs of sailboat, trees, and

expression and show great dependence on models, the *Landscape in Wind* is more expressive and seems to reflect more of Sesson's uniquely personal approach. Therefore more attention must be given to the development of his style.

In his *Setsu-monteishi* (Instructions to his Disciples), written before 1542, Sesson emphasizes the importance of learning art from nature and not from painting alone. Copying other masters' works, he maintains, is for acquiring the ability to simplify nature in brushwork. While he openly admits that he learned much from Sesshū, he insists that his own art is very different. He places great importance on freedom of brush and distribution of ink, topics on which he elaborates in concrete terms.

One of the unique qualities of *Landscape in Wind* not present in his earlier work is the predominantly dark ink tonality subtly balanced by the light-toned area which gives a rather mysterious atmosphere to overall space. The lighter tone conveys the chilling rays the moon casts over the lake, which are absorbed by the dark motifs of tree and rock. In his painting theory, Sesson emphasizes, "use dark ink tones first, followed by light ones," and "[if there are ten values of ink tones] use seven dark ones and three light ones." [23]

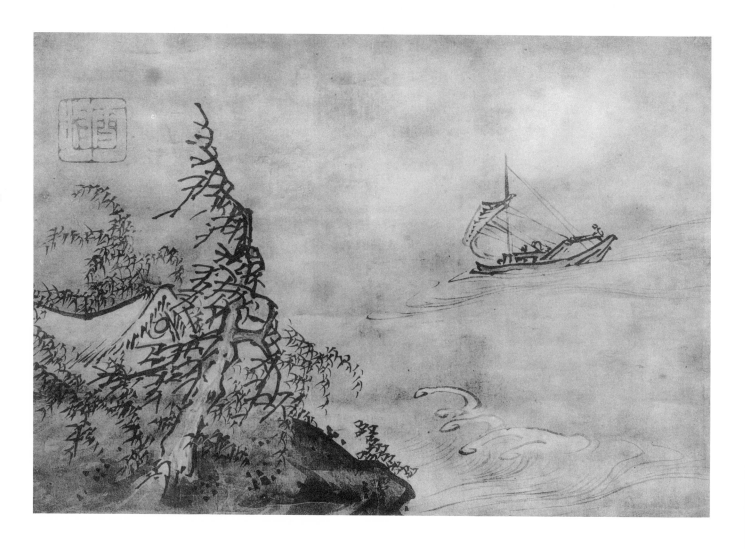

Figure 64. *Wind and Waves,*
Sesson (ca. 1504–ca. 1589).
Hanging scroll, ink and colors
on paper, 22.4 x 31.4 cm.
Nomura Collection, Kyōto

farmhouse, relate Sesson's well-known painting to the model behind Tan'yū's copy.

The flexible handling of rocks in *Landscape in Wind* far exceeds that of *Wind and Waves,* and could not have entered Sesson's work had he not been familiar with the painterly scrolls of Yü-chien which he studied in the late 1550's and early 1560's. *Landscape in Wind* is the work of a painter who learned from both the processes of nature and the brush interpretations of other artists, then transformed both kinds of knowledge according to his own unique vision: a marvelously theatrical production of a natural drama conceived in highly individual rhythms of brooding darks and luminous lights.

YOSHIAKI SHIMIZU

NOTES

1. For paintings attributed to these Chinese artists see Yonezawa and Nakata, *Shōrai Bijutsu,* pls. 7, 20, 22, and Suzuki, *Ri Tō, Ba'en, Kakei,* pls. 12–14, 33–34, 53–54.

2. The tripod relief seal appears on the album of *Eight Views of Hsiao and Hsiang,* six leaves published in Nakamura, *Sesson to Kantō Suibokuga,* pls. 28–33(one of them is fig. 63 here). The intaglio gourd-shaped seal appears on a painting of Liu Sungyüan, *ibid.,* pl. 52. The combination of the two seals occurs on no other known painting.

3. Biographical information comes from the earliest study of Sesson by Fuku'i, "Sesson Shinron," and in the most recent study by Nakamura, *Sesson to Kantō Suibokuga.*

4. Kano Einō, *Honchō Gashi,* p. 987. Conflicting information is given in the earlier *Tansei Jakubokushū* and the *Bengyokushū* (p. 1158; see cat. no. 25, n. 5), which name Tamura as Sesson's birthplace and refer to Ōta as his later residence. Both Fuku'i and Nakamura accept the *Honchō Gashi* account.

Tansei Jakubokushū, one of a few early Japanese painting histories, was compiled by Kano Ikkei (1599–1662) ca. 1650. Approximately 140 painters beginning with Minchō (1351–1431) are included. They are loosely classified in four groups: (1) Muromachi painters who worked in Chinese styles; (2) the Tosa school of Yamato-e painting, including a few artists of the 13th century or earlier; (3) the Kano school, including a

chart of Kano lineage which may have been added or expanded by a later editor; and (4) early 17th century painters other than those included in the two professional schools of Tosa and Kano. Biographical accounts of some leading Muromachi painters such as Josetsu, Shūbun, and Sesshū differ markedly from those given in other painting histories. The date of its first publication is unknown. It is published in Saka-zaki, *Nihon Garon Taikan*, 2:923–50. The account of Sesson is on p. 930.

5. The *Setsu-monteishi* is quoted in Tani Bunchō (1763–1840), *Bunchō Gadan*, pp. 809–10. It is quoted in Fuku'i, "Sesson Shinron," p. 52, and in Nakamura, *Sesson to Kantō Suibokuga*, pp. 22–23. For discussion of the *Bunchō Gadan*, see cat. no. 6, n. 13.

6. Ashina Mori'uji's patronage of Sesson is recorded in Kano Ikkei, *Tansei Jakubokushū*, p. 930, and in Arai Hakuseki (attrib.), *Gakō Benran*, p. 1098. (For discussion of *Gakō Benran*, see cat. no. 21, n. 15.) Both Fuku'i in "Sesson Shinron" and Nakamura in *Sesson to Kantō Suibokuga* discuss the support of this powerful family. See especially the family lineage charts for the Ashina and Date families in Nakamura, p. 31.

7. Nakamura, *Sesson to Kantō Suibokuga*, pls. 42, 106.

8. A *chinzō* portrait is a formal likeness of a Zen monk. The genre is discussed in cat. no. 3.

9. Published and discussed by Tanaka Ichimatsu, "Sesson Jiga Jisanzō."

10. Little is known of the activities of the Odawara Kano beyond their stylistic dependence on Kano Motonobu. Dispute centers on such basic problems as the identity of the leader of the group: was Kano Gyokuraku the same person as Maejima Sōyū? See Nakamura, "Kano Gyokuraku ni tsuite," and Naka-mura, "Sōyū to Gyokuraku."

11. Nakamura, *Sesson to Kantō Suibokuga*, pl. 46 and p. 36.

12. *Ibid*, pp. 37–39, 41.

13. *Mynah Bird* (*Ha-ha Chō*), a small ink painting in the Tokiwayama Bunko Collection. See Etō, "Sesson no Kachō-ga," p. 12.

14. The style of Senka's *Setsureisai* in the Gotō Art Museum, dated by inscription to 1538, is close to Kenkō Shōkei's *Sōsetsusai* in the Seikadō, dated by its inscription to 1499. *Sōsetsusai* is published in *Kokka*, no. 302; Senka's Gotō painting is published in Kumagai, "Senka hitsu Setsureisai-zu." The important link among Kenkō Shōkei, Senka, and Sesson is discussed by Etō, "Sesson no Jigazō," and is further stressed by Tanaka Ichimatsu, "Sesson Jiga Jisanzō."

15. From an account by Ichigen Shōseki (d. 1667) of "Sesson-an," dated 1658, cited by Fuku'i, "Sesson Shinron," pp. 47–49, and Nakamura, *Sesson to Kantō Suibokuga*, pp. 47–48.

16. Works from this period include *Seven Sages of the Bamboo Grove*, a pair of screens in the Hatakeyama Kinenkan Collection, signed with the age of 71 (70 by western count), published in Nakamura, *Sesson to Kantō Suibokuga*, pls. 57, 89; a hanging scroll of calligraphy with a small landscape entitled *Tanteigetsu*

(*Moon over the Water*), signed with the age of 80 (79), in the Yamato Bunkakan in Nara, *ibid.*, pl. 11; a *Li Po Viewing a Waterfall* from the former Fuku'oka Collection with a date corresponding to 1584; and a six-fold screen in the Kuroda Collection of *Eight Views of Hsiao and Hsiang*, signed at age 86 (85), *ibid.*, pl. 56.

17. Fuku'i, "Sesson Shinron."

18. Published in Nakamura, *Sesson to Kantō Suibokuga*, pl. 27.

19. Published in *ibid.*, pl. 56.

20. A comprehensive list of Sesson's works in American collections is published by Nakamura, "Kaigai ni okeru Sesson-ga," with halftone illustrations of all works.

21. See the chronological chart in Nakamura, *Sesson to Kantō Suibokuga*, pp. 109–10.

22. See above, n. 2. More controversial is the chronological position of the *Landscape of the Four Seasons* screens in the Art Institute of Chicago. Fuku'i placed them along with the exhibited *Landscape in Wind* in the first half of Sesson's middle period. In 1958, when the screens were acquired by the Art Institute, Tanaka Ichimatsu discussed them in relation to other landscape paintings and suggested a new chronological sequence. He placed the Nomura *Wind and Waves* before the Chicago screens, on the ground that it more closely emulates compositions of such Hsia Kuei landscapes as the *Sailboat in Rain* in the Museum of Fine Arts, Boston (published in Suzuki, *Ri Tō, Ba'en, Kakei*, pl. 12), and that it does not express the individual stylistic features of Sesson while the Chicago screens do. Tanaka also discussed the similarity between the calligraphic style of Sesson's signature on the Chicago screens and the ex-Kuroda *Hsiao-Hsiang* screen. He did not mention the *Landscape in Wind* exhibited here. See Tanaka Ichimatsu, "Sesson hitsu Shiki Sansui Byōbu ni tsuite."

23. *Setsu-monteishi*, see above, n. 5.

24. One handscroll in the style of Yü-chien was inscribed by the Daitoku-ji monk, Daishitsu Sōseki, who died in 1560 (see above, n. 11). Copies Sesson made of Mu-ch'i and Yü-chien scrolls, dated 1563 and 1564 respectively, are published in Matsudaira Sadanobu, ed., *Shūko Jusshu*, 1:413–40. Others are published in Nakamura, *Sesson to Kantō Suibokuga*, pls. 39–40, 46, 53, 78–80.

25. See above, n. 13.

26. Published in Yonezawa and Nakata, *Shōrai Bijutsu*, pl. 49.

27. Published in Do'i, *Motonobu, Eitoku*, pls. 7–10, 43–48; and *Hihō*, 11: pls. 135–45.

28. Lu-ch'ing is recorded in Hsia Wen-yen, *T'u-hui Pao-chien*, *chüan* 4, p. 70. Lu-ch'ing, who followed Li T'ang, was a painter of the Sung Academy during the reign of Emperor Kuang-tsung (r. 1190–95). Tan'yū's copy of Lu-ch'ing's *Wind and Waves* is published in Etō, "Sesson no Jigazō," p. 93.

Dragon AND *Tiger*

Sesson Shūkei (ca. 1504–ca. 1589)

Pair of six-fold screens, ink on paper, each 171.4 x 365.7 cm. Vessel-shaped relief seals reading Sesson *on upper edge of panels on far right and far left, with double-contoured square relief seals reading* Shūkei *beneath. Signature, "Sesson-ga" (painted by Sesson), written under upper seals. Cleveland Museum of Art, Purchase from J. H. Wade Fund (59.136 and 59.137)*

Sesson's ability to paint virtually every category of subject matter demonstrates his versatility. These monumental screens of *Dragon* and *Tiger* fall into the category of bird-and-flower-and-animal painting, strikingly different from the small expressive *Landscape in Wind*. Sesson's extraordinary creativity is seen here in his forceful manner of coupling the pair of animals, one real and the other imaginary, in contrasting settings. Sesson captures a dragon in movement midway between sea and sky, and contrasts this mythological beast with a self-contained tiger seated impassively on a windy mountain.

In the right-hand screen, a contorted dragon erupts from seething waves. Head jerked back, forelegs rigidly outstretched, claws open, the dragon leaps from the churning waters through spiraling clouds, ready to fly where his impetuous gaze leads. From his fierce face to his tail flipping in the water, the serpent embodies dynamic energy. Moist ink washes swirl to form mysterious atmospheric eddies; stylized lines whirl around surging whitecaps. Every detail generates electric excitement.

A tiger sits inquisitively on a lumpy boulder in the left screen, his curious look directed toward the dragon. With a waterfall cascading in front and bamboo growing sturdily behind, he occupies a relatively narrow space. The tiger is passive. His soft static paws markedly contrast with the violently outstretched claws of the dragon; his self-contained silhouette is the complement of the dragon's extended turbulence. Movement in the left screen pulses through natural motifs surrounding the tiger: the diagonal sway of bamboo, streaks of wind indicated by ink wash in the atmospheric void. Dramatic tonal contrasts create throbbing rhythms in and out of rock crevices.

Two seals are stamped on the outer panel of each screen: a vessel-shaped relief seal reading *Sesson* above with the signature "Sesson-ga" written under it, and a double-contoured relief seal reading *Shūkei* below. This same identifying combination appears on other paintings reliably accepted as being from Sesson's brush.[1] Not only are its seals authentic, but *Dragon* and *Tiger* also have an impressive history. They have been shown in several important exhibitions, both in Japan and in America. Originally in the collection of the Mitsu'i family, they went to the Satomi Collection before the last war. In 1959 they came to the United States and are a prized possession of the Cleveland Museum of Art.[2] Their high artistic quality compares with Sesson's *Birds and Flowers* screens in the Minneapolis Institute of Arts and the pair of *Landscape of the Four Seasons* screens in

the Art Institute of Chicago, and rivals other Sesson screens still in Japan, such as *Hawks* in the Tōkyō National Museum and *Birds and Flowers* in the Yamato Bunkakan.[3]

Compound images of "dragon and clouds" and "tiger and wind" originated in China, inspired by early Taoist beliefs. As early as the Han dynasty *Great Commentary* to the classic *I-ching* (*Book of Changes*), the two are paired: "Things that accord in tone vibrate together. Things that have affinity in their inmost natures seek one another. . . . Clouds follow the dragon, wind follows the tiger." [4]

Japanese painters of the Muromachi period were familiar with a number of Chinese dragon and tiger painters. In the fourteenth century the Engaku-ji monastery in Kamakura owned a pair of *Dragon* and *Tiger* scrolls inscribed by China's artistic emperor Hui-tsung (r. 1101–1125).[5] By the end of the century individual painters who specialized in dragons began to be noted, especially the Southern Sung artist Ch'ên-jung (Ch'ên So-wêng, fl. 1235–1244).[6] By the mid-fifteenth century the Yüan dragon painter Chang T'ai-hsüan was known.[7]

By far the most popular painter associated with the subject of dragons and tigers was the Southern Sung monk-painter Mu-ch'i (d. 1269–1274). Three sets of dragon-and-tiger flanking scrolls by Mu-ch'i are recorded in the fifteenth century inventory of selected Chinese paintings in the Shōgunal collection.[8] Perhaps one of these sets is the famous pair of *Dragon* and *Tiger* in the Daitoku-ji collection, dated to 1279 and bearing the inscriptions, "When the dragon rises, clouds appear," and "When the tiger roars, wind blasts." [9] The basic pose of Sesson's *Tiger* relates to the Daitoku-ji *Tiger* by Mu-ch'i, but Sesson consciously stylizes the animal. He patterns the hide markings, personalizes the head shape and expression, exaggerates the peculiarly observant eyes. Especially he simplifies the contour drawing of rear legs and paws.

While Sesson's *Tiger* can be traced to the manner of Mu-ch'i, his *Dragon* comes from a different tradition. Mu-ch'i's Daitoku-ji *Dragon* pictures only the head of the beast. The writhing vehemence generated through the entire length of Sesson's *Dragon* has its precedent in the frenzy of Ch'ên-jung's mythological animals. One of this Chinese specialist's finest paintings, a vertical silk hanging scroll,[10] was formerly in the collection of the Date family in northern Japan, a family allied with one of

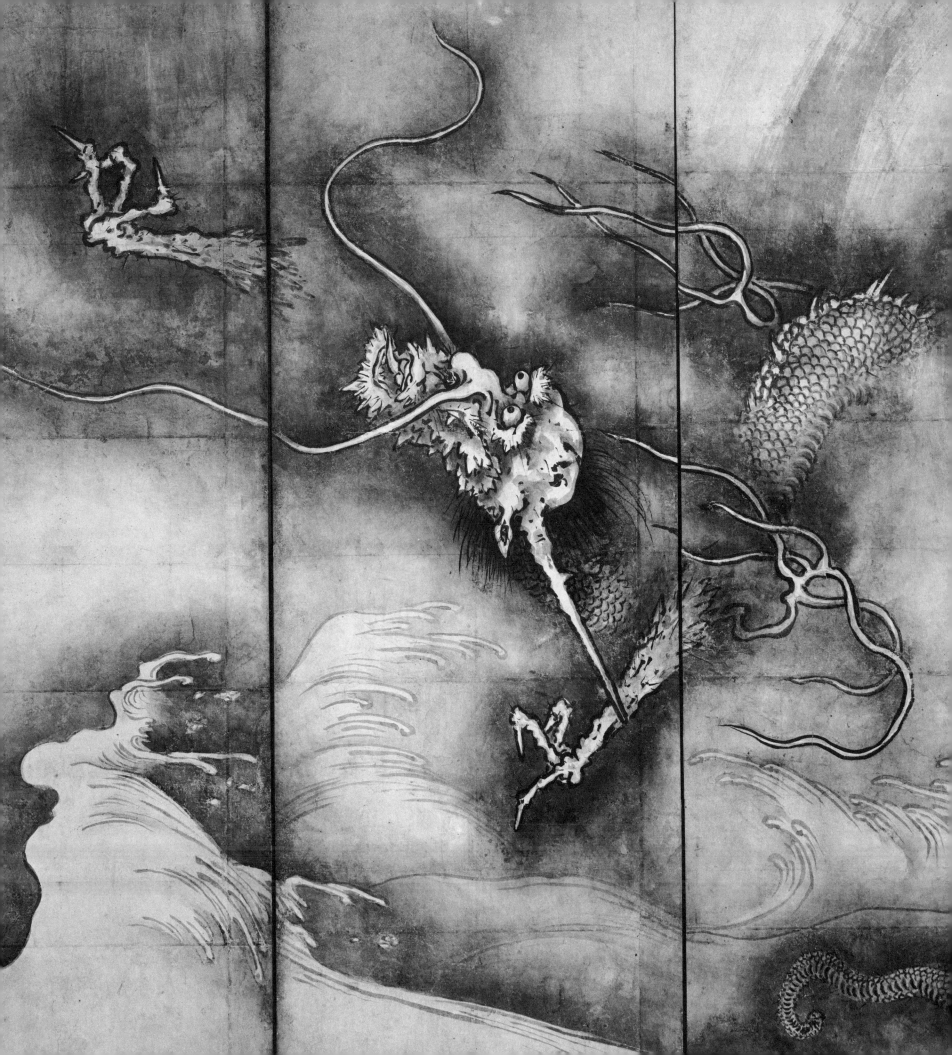

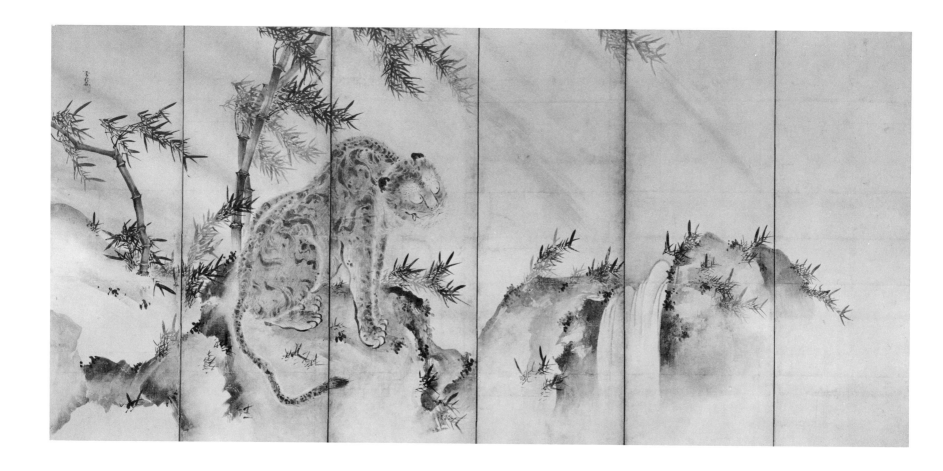

Catalogue number 27,
Dragon and *Tiger*

Sesson's patrons.[11] It shows a dragon in hysterical ascent, just after erupting from the water below. By turning Ch'ên-jung's painting 90° to the left, Sesson attained the composition of this Cleveland screen. An even more faithful Japanese copy of Ch'ên-jung's *Dragon* appears in a pair of hanging scrolls attributed to Kano Shō'ei (1519–1592).[12] In one scroll a dragon descends into the water. In the other, as in the painting formerly in the Date Collection, the dragon ascends from a deep whirlpool. Sesson's version changes the spiraling water into spiraling clouds.

Kano Shō'ei's relevance to Sesson is reinforced by one of the paintings executed with his son Eitoku at the Jukō-in subtemple of Daitoku-ji in 1566. In a rear room west of the altar room, Shō'ei painted tigers in a bamboo grove.[13] A painting by Sesson in the Tōkyō College of Arts, *Bamboo and Tiger,* closely resembles it. Both depict a single tiger with a slightly twisted torso, seated on a rock, looking alertly toward the right. The prototype

for both is Mu-ch'i's Daitoku-ji *Tiger,* yet both have what Mu-ch'i's painting lacks, a sturdy bamboo grove on their left. A similar growth of bamboo shoots up in the Cleveland screen. Apparently Shō'ei and Sesson had access to a common model.

Such a possibility is strengthened by the existence of another set of *Dragon* and *Tiger* screens by Tan'an Chiden (fl. first quarter of the sixteenth century)[14] in the Jihō-in (fig. 65). The tiger paintings of these three sixteenth century artists display similar settings and motifs. All place the tiger in front of a bamboo grove and depict the blast of wind he creates by sharp diagonal streaks of ink wash. All three stylize the twist of the tiger's curved silhouette and darken the tips of his ears. A similar waterfall flows between the rocks in the versions by Chiden and Sesson. The same waterfall motif appears in Sesson's Chicago *Landscape of the Four Seasons* screens and in his pair of *Hawks* screens in the Tōkyō National Museum.[15]

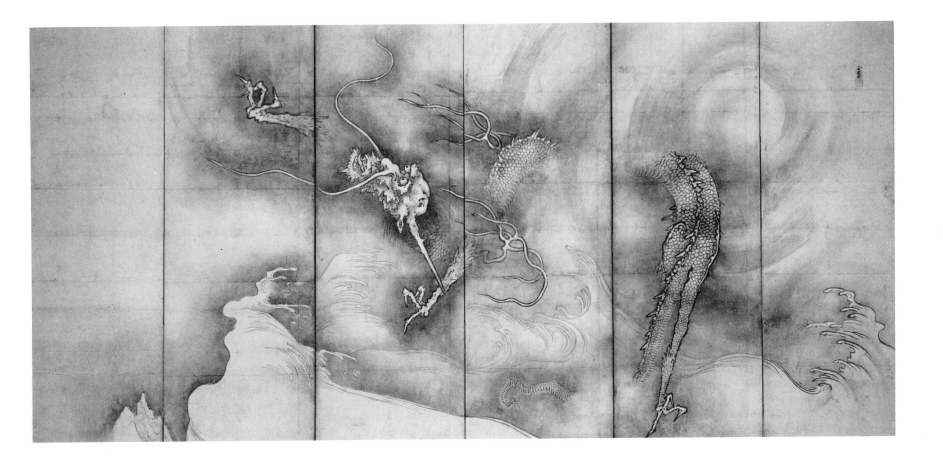

Perhaps the most individual of Sesson's motifs are his wave patterns in the *Dragon* screen. Compelling motion runs through the stylized turbulence of the whitecaps. The same type of wave recurs time and again in his work, notably in his copy of Yü-chien's *Shore and Waves.*[16] The Chinese painting, once in the Ashikaga Shōgunal collection, was destroyed by fire near the end of the sixteenth century. Sesson's copy describes the waves like the claws of an animal.

The compositional schemes of Sesson's *Dragon* and *Tiger* present a pronounced lateral orchestration of rhythmically spaced foreground motifs. Like Kano Shō'ei and Kano Eitoku, who were painting the Jukō-in sliding-door panels in 1566, Sesson suppresses illusionistic space in the middle ground. The *Dragon* and *Tiger* still retain slight penetration into depth with the bamboo grove behind the tiger and the atmospheric swirls around the dragon. But Sesson pursues the tendency seen here to deny spatial depth and to emphasize

lateral development in his famous six-fold screens of *Hawks* in the Tōkyō National Museum, indicating that they come later than the Cleveland screens in his stylistic evolution.

Most of Sesson's works are undated, however, so it is difficult to determine when the *Dragon* and *Tiger* were painted. Tanaka Ichimatsu has been able to determine the late period of Sesson's Chicago *Landscape of the Four Seasons* screens by comparing his signature with the calligraphic style on his *Self-Portrait* and on the Kuroda screens of the *Eight Views of Hsiao and Hsiang.*[17] Perhaps, therefore, a careful stylistic analysis of Sesson's signature on the Cleveland screens would offer a clue to their date. From a purely stylistic point of view, in terms of integration of motifs, the rock formation of the *Tiger* screen recalls the interpretative approach Sesson followed in his handscroll in Yü-chien style of *Eight Views of Hsiao and Hsiang* in the Masaki Museum (fig. 20). Therefore, whatever their precise chronological position, it is

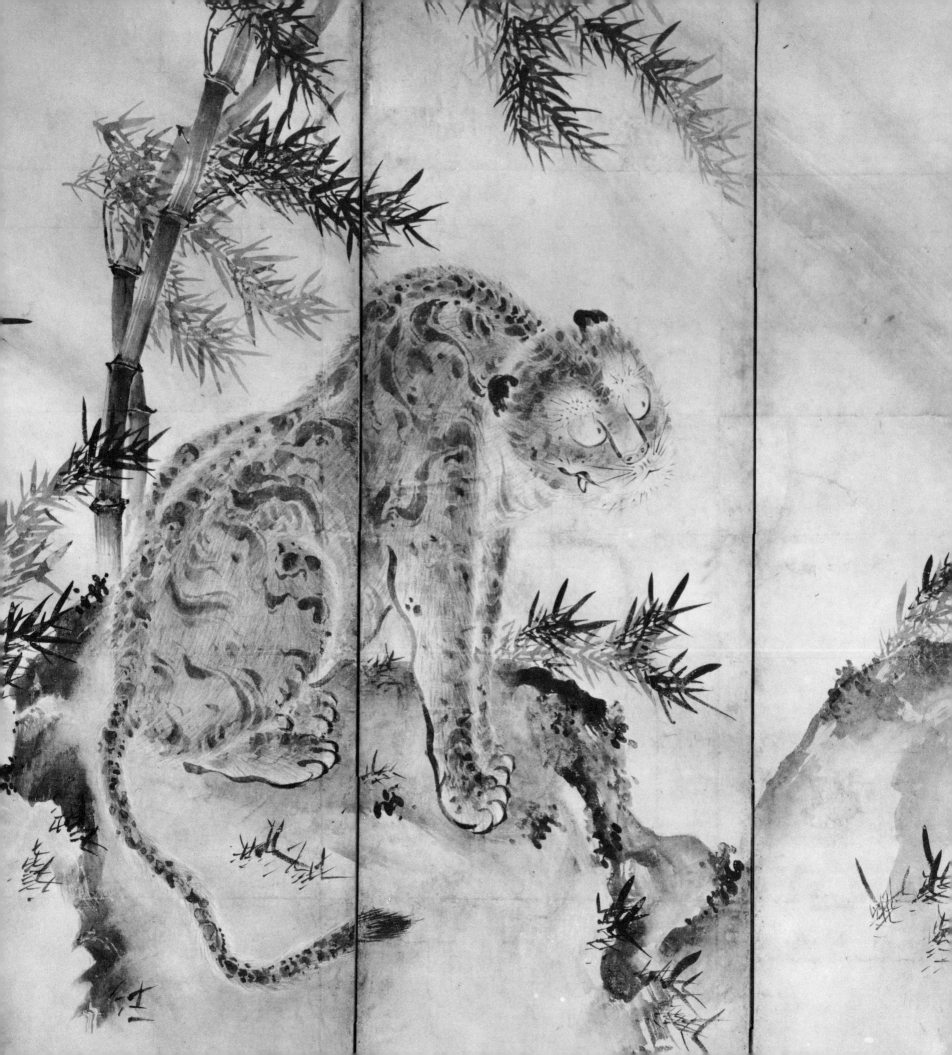

Above: Figure 65. *Tiger,* Tan'an Chiden (fl. first quarter 16th century). One of a pair of *Dragon* and *Tiger* six-fold screens, ink on paper, 170.0 x 372.0 cm. Jihō-in, Kyōto

Left: Detail of catalogue number 27, *Tiger*

evident that the Cleveland *Dragon* and *Tiger,* like the *Landscape in Wind* (cat. no. 26), represents Sesson's mature period. He has absorbed painterly landscape elements from his study of Yü-chien, as well as individual motifs such as the tiger form from Mu-ch'i, into his own artistic vision.

Sesson's extraordinary stylizations found their most direct successor a century later in the bold designs of Ogata Kōrin (1658–1716). In the striking composition and full utilization of two-dimensional space seen in his large works, such as the pair of two-fold *Bamboo and Plum* screens painted in ink on gold-leafed paper,[18] Kōrin reveals his debt to the daring originality of this late Muromachi painter.

YOSHIAKI SHIMIZU

NOTES

1. The same pair of seals is stamped on Sesson's portrait of the Zen master Iten Sōsei, dated 1550, in the Hōshun-in subtemple of Daitoku-ji. See Tanaka Ichimatsu, "Sesson hitsu Shiki Sansui Byōbu ni tsuite," fig. 7.

2. Lee, "The Tiger and Dragon Screens by Sesson," p. 69, n. 2.

3. For the pair of screens *Birds and Flowers* in the Minneapolis Institute of Art, see Etō, "Sesson-ga no Isō," pls. 10–11; for the Art Institute of Chicago *Landscape of the Four Seasons* screens, see Tanaka Ichimatsu, "Sesson hitsu Shiki Sansui Byōbu ni tsuite," frontispiece, pls. 2–3; for the Tōkyō National Museum *Hawks* screens, see *Kokka,* no. 546; for the Yamato Bunkakan *Birds and Flowers* screens, see Etō, "Sesson-ga no Isō," pls. 12–13.

4. Wilhelm, trans., *I-Ching,* pp. 9, 382.

5. *Butsunichi-an Kumotsu Mokuroku* (ca. 1365) in Kumagai, ed., *Bijutsu Kenkyū,* no. 24, p. 26.

6. Mentioned in *Zenrin Shōka* (ca. 1390's), in *Zoku Gunsho Ruijū,* 19:259.

7. Mentioned in *Satsujōshū* (1454), in *Zoku Gunsho Ruijū,* 30:314.

8. *Gyomotsu On'e Mokuroku,* in Tani, p. 137. For Mu-ch'i, see cat. no. 1, n. 5.

9. Published in *Hihō,* 11(Daitoku-ji): pls. 25–26. Mu-ch'i and the genre of dragon-and-tiger painting are discussed by Fontein and Hickman, *Zen Painting and Calligraphy,* pp. 28–32.

10. The painting is now in the Mutō Collection and is published in Mutō, *Chōshō Seikan,* 2: pl. 10. Another fine dragon painting by Ch'ên-jung is the *Nine Dragons* scroll in the Museum of Fine Arts, Boston, published in Tomita, *Portfolio of Chinese Paintings,* pls. 129–35.

11. See cat. no. 26, n. 6.

12. Saitō, *Kano-ha,* Nihonga Taisei, 5: pl. 62.

13. *Hihō,* 11: pl. 143.

14. According to Tōhaku, Tan'an Chiden was a disciple of Sō'ami and died young. See *Tōhaku Gasetsu,* p. 21.

15. The Chicago screens are cited above, n. 3. The *Hawks* are published in *Kokka,* no. 546.

16. Published in *Kokka,* no. 212.

17. Tanaka Ichimatsu, "Sesson hitsu Shiki Sansui Byōbu ni tsuite."

18. *Bamboo and Plum,* by Ogata Kōrin, pair of two-fold screens, ink on gold foil over paper, 66.4 x 183.2 cm; published in Tōkyō National Museum, *Rimpa,* pl. 89.

Figures in Landscape
Attributed to Kano Motonobu (1476–1559)

Hanging scroll, ink and slight color on paper, 165.2 x 86.7 cm. Mary and Jackson Burke Collection

A Chinese scholar plays a *ch'in* (a sitar, or *koto* in Japanese) on a stone table while a friend, accompanied by his standing attendant, listens attentively. The scene is framed by foreground rocks jutting into the lower right of the picture and by a massive faceted outcropping behind and above the seated musician. A pine tree grows from the thin soil on the cliff top, thrusting its angular branches up to the center and then down to the left in the upper half of the picture, defining the middle-ground plane and further enclosing the scene enacted on the level clearing below. A path zigzags into the mountain behind, preventing any illusion of deep space. The viewer's eye focuses on the event occurring on the clearing in the middle ground.

The subject cannot be identified with certainty, for the painting was originally part of a larger composition. Below the listening scholar with his attendant, a crevice suggests greater opening-up of the setting on the left, while tree roots behind the foreground rocks and, above them, the tip ends of a pine branch indicate further development of the scene to the right. Physical features of the painting — size, heavy paper, traces of a door catch now removed, extensive repainting across the bottom — indicate that it formed one panel of a sequence of sliding-door paintings. Removed from its original context, it was remounted as a hanging scroll. It may represent the art of music in a sequence of the Four Accomplishments (called *kinki shoga* in Japanese; *ch'in-ch'i shu-hua* in Chinese) of the cultivated gentleman. Or it may illustrate the legendary P'o-ya, a Chinese scholar of the Spring and Autumn period (eighth to fifth centuries B.C.) noted for his ability to play the *ch'in*, and Chung Tsu-ch'i, famous for appreciating his friend's music. Both themes have a long history in Chinese and Japanese art.

The Four Accomplishments of the cultivated gentleman are music (or more specifically, *ch'in* playing), the game of *go* (a complicated game somewhat similar to chess), calligraphy, and painting. These activities have been associated with the Chinese gentleman-scholar since very early times and undoubtedly were painted frequently by early Chinese artists. It is uncertain when Japanese painters began to depict the theme, but it had become a pictorial subject when Kōzei Ryūha (1374–1446) inscribed a poem about music, *go*, painting, and calligraphy on a painted fan.[1] In 1490, Sōkei painted the Four Accomplishments on a series of sliding-door panels at the Yōtoku-in of the Daitoku-ji (fig. 38),[2] and at least seven versions of the subject are connected with

the sixteenth century shop of Motonobu.[3] By the seventeenth century, the theme was securely established.[4] The Burke painting might be a segment of one of the early-sixteenth century representations of this subject.

All documents connected with the scroll, however, identify it as an illustration of P'o-ya playing his *ch'in* for Chung Tsu-ch'i.[5] According to the story related in the book of *Lieh-tzu,* even more remarkable than P'o-ya's extraordinary musical skill was the ability of Chung Tsu-ch'i completely to fathom the mysteries of his friend's music.[6] When Chung Tsu-ch'i died P'o-ya destroyed his *ch'in* and never played again, saying no one remained who could understand his music.[7]

Chinese artists often illustrated the story of P'o-ya and Chung Tsu-ch'i,[8] and it became known to Japanese artists as a respected theme from the Chinese classics to be expressed in the academic mode of Ma Yüan and Hsia Kuei. For example, a scroll in the collection of the Kyōto temple, Hompō-ji, depicting P'o-ya and Chung Tsu-ch'i is painted in a formal style and signed by the fourteenth century Chinese artist, Sheng Mou (fig. 66). This painting has reportedly been in Japan since very early times.[9] Its compositional similarity to the Burke painting of the *ch'in* player suggests a possible prototype for the depiction of the theme by Japanese artists. Both versions show the musician seated frontally at the base of a massive protective cliff, playing to an attentive listener opposite him. Angular rock forms and pine branches frame the scene. Both paintings can be said to illustrate a specific incident cited in the *Lieh-tzu:* P'o-ya taking refuge under an overhanging rock and recreating in music the drama of a mountain storm.

Since the Burke painting originally formed part of a scheme of architectural decoration, it has neither signature nor seal to identify the artist. It has long been attributed to Kano Motonobu (1476–1559) and stylistically is quite similar to the paintings of Zen patriarchs from the Daisen-in Abbot's Quarters, which are widely accepted as authentic works of about 1513 from the hand of Motonobu[10] (fig. 67). Physically, the painting corresponds closely to the four narrower panels depicting Zen masters. Like the Daisen-in works, it is painted in ink and slight color (basically the warm-cool contrast of red ocher and blue-green with accents of strong vermilion and mineral green) on ten joined sheets of heavy paper approximating the standard size for a sliding-door panel (175 cm high by 90 cm wide). This is not to suggest that the Burke painting came from the Daisen-in; it only corroborates the hypothesis that it was painted as a

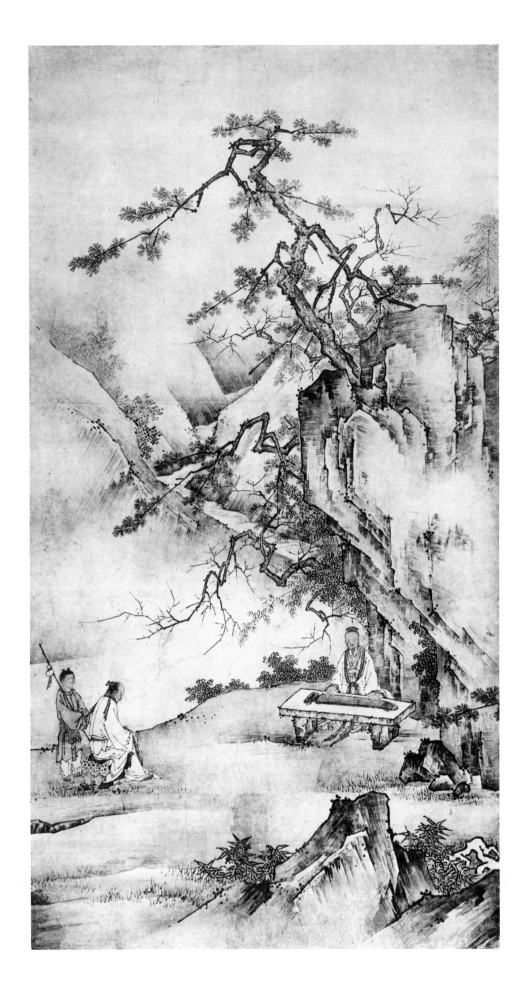

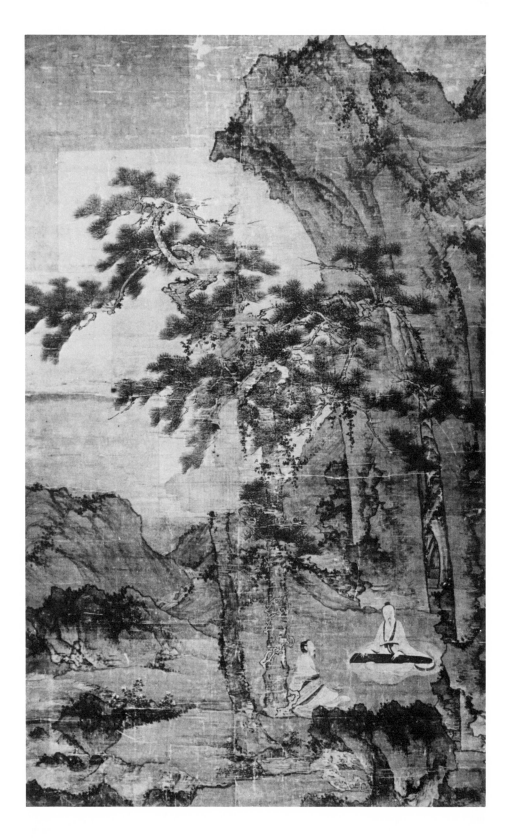

Figure 66. *P'o-ya and Chung Tsu-ch'i*, Sheng Mou (fl. 14th century). Hanging scroll, ink and color on silk. Hompō-ji, Kyōto

sliding-door decoration about the same time and that it may have originated from the same shop.

The Burke painting displays the same clear architectonic structure featured in the representations of Zen patriarchs. Counterbalanced diagonal thrusts settle firmly on each side of a strongly implied central axis, making for maximum stability of forms. Human activity is given greater focus by being enclosed in a large lateral triangle, its open base on the left edge of the panel, its sides defined by mountain path above and foreground rocks below, and its apex spotlighting the frontal figure of the *ch'in* player beneath the cliff. The central axis separates the opening-up of the composition to the left from the compact density of the rock masses on the right, and is articulated upward from the small clump of bamboo at the bottom through the sequence of three sharp angles of tree branches above. The larger composition of adjoining panels probably would have opened into a vista of space on the left (as the Daisen-in sequence opens on the right in fig. 67), while closing more compactly on the side of the rock mass.

The vocabulary of pictorial motifs found in the Zen patriarch paintings are combined in the Burke scroll with the same sense of discrete logic and cubic solidity. Rocks are clearly outlined, their surfaces faceted with the axe-cut texture strokes of the Chinese academic painters Ma Yüan and Hsia Kuei. Perhaps more than any other element, the placement and mass and visual direction of these rocks define the stage for human activity. Foreground boulders thrust up from the bottom edge to separate picture space from viewer's space; rocks in the middle ground block out distractions of far distance.

Moss dots cluster here and there on the rock surfaces, while small clumps of bamboo grow up ornamentally behind the rock masses. Gnarled tree trunks and branches provide visual direction on the picture surface. In the Burke painting the angular movement of the uppermost pine creates a cap for the composition, like a pediment, keeping the viewer's attention focused on the musical activity in the clearing below. All these features, and especially the pine motif, closely follow models from the Chinese academic tradition. Also characteristic of Motonobu's "formal" painting style, exhibited both in the Daisen-in Zen patriarch panels and in the Burke painting, is the sturdy rational brushwork of the Chinese academy. Motonobu's energetic brush outlines robust tree forms and patterns their rough bark

Figure 67. *Zen Patriarchs*, Kano Motonobu (1476–1559). Sliding-door panel paintings, now mounted as hanging scrolls, ink and light color on paper, left panel 175.5 x 137.5 cm, each of right two panels 174.1 x 90.7 cm. Tōkyō National Museum, formerly in the Daisen-in, Daitoku-ji, Kyōto

with pitted cavities and knotholes, while the long streaks of Motonobu's firm translation of Chinese axe-cuts facet the angular rocks. In contrast, softer ground surfaces accented with the sharp fillips of grass blades recall the brushwork of Sō'ami (see cat. nos. 22 and 23), whose *Eight Views of Hsiao and Hsiang* in the Daisen-in (fig. 55) influenced the development of Motonobu's style.

The importance given to the figures relative to their setting in the Burke painting parallels the treatment of the Zen patriarchs in the Daisen-in. And the thoughtful delineation of the faces of the *ch'in* player and his listener compares favorably with the descriptive physiognomy of the Zen masters. The figures themselves are drawn with stiff nailhead strokes, which seem slightly more conventionalized than the more varied outlines and indications of shading on the Daisen-in figures. On the other hand, the technique used for the drapery of the Burke figures follows prototypes from the Chinese academic tradition as it was understood in fifteenth century Japan. The *ch'in* player is remarkably similar, in his unusual frontal pose, the fashion of his costume, and the delineation of his scholar's robe, to the figure of Lin Ho-ching in a painting by Yi Su-mun based on a Hsia Kuei model.[11] Yi Su-mun was a Korean painter who visited Japan during the first half of the fifteenth century. His models were the same Chinese academic paintings that affected the stylistic development of contemporary Japanese artists. Many of his paintings remained in Japan to influence the further evolution of Japanese painting style.

Building on the training given him by his father,

Kano Masanobu (1434–1530), Motonobu synthesized the range of Chinese painting traditions that had flowed into Japan since the fourteenth century into a highly individual and uniquely Japanese style. He thus established the stylistic basis for the Kano school — the important stylistic lineage which was equated with official painting in Japan from the Muromachi period to the end of the nineteenth century. Large-scale paintings executed for the estates of feudal leaders flowed one after the other from the brushes of Kano masters, beginning with Masanobu and Motonobu. Important painters in the family lineage included Motonobu's son Shō'ei (1518–1592), his grandson Eitoku (1543–1590), and, in the seventeenth century, Sanraku (1559–1635) in Kyōto and the influential Tan'yū (1602–1674) in Edo.

A series of sliding-door decorations painted for the Rei'un-in of Myōshin-ji ca. 1543 shows Motonobu's mature versatility. In this subtemple, Motonobu handled at least four Chinese painting traditions, blending each with his Japanese heritage and his own creative genius. His "semi-formal" style is seen in paintings of *Birds and Flowers* in the manner of Mu-ch'i and in a *Snow Landscape* following Sō'ami's transformation of Mu-ch'i (see cat. no. 22). *Eight Views of Hsiao and Hsiang* expresses Motonobu's understanding of the "informal" style of Yü-chien (see cat. nos. 14 and 19, and fig. 51). His "formal" style, destined to become the central focus of subsequent generations of Kano painters, is represented by landscapes in the manner of Ma Yüan and the sequence of the *Four Accomplishments* in Hsia Kuei's academic mode.[12]

Building on such models as these, Motonobu's descen-

dants continued to evolve a style based on lucid compositions executed in sharply defined brushwork. Decorating the sliding doors of the Jukō-in in 1566, Kano Eitoku freely employed themes and motifs from the Rei'un-in paintings. In particular, the scene of *ch'in* playing from the *Four Accomplishments* [13] reveals Eitoku's debt to his grandfather, while at the same time indicates his development toward a bold new style.

In the seventeenth century Eitoku's grandson, Kano Tan'yū, revitalized the formal style of Motonobu which had dominated official artistic production for over a century. Taking Yü-chien's spacious compositions based on ink washes as his model, Tan'yū changed the stylistic orientation of the Kano school and set the standards for professional artists who served the Tokugawa Shōgunate in Edo. For two more centuries the Kano line continued to produce an orthodox academic style patronized by feudal government leaders, a style marked by technical competence but creative stagnation.

Since Motonobu's style was popular and his commissions numerous, many paintings are connected with his name: a recent study by the Japanese scholar, Tsuji Nobu'o, dealt with well over a hundred works. Yet a great deal more research must be undertaken to separate the paintings of assistants and followers from those of the master, and to define intelligibly the components of Motonobu's personal style. The Burke painting of a *ch'in* player in a landscape cannot be unquestionably assigned to the hand of Motonobu, although its high quality suggests the possibility. Its stylistic features indicate that it was produced from Motonobu's atelier slightly later than the paintings of the Daisen-in Zen patriarchs, perhaps about 1520. It is significant as one of the finest paintings known in America associated with the production of Kano Motonobu.

CAROLYN WHEELWRIGHT

NOTES

1. Kōzei Ryūha was the well-known Gozan monk familiar to art historians as one of the inscribers of the famous painting of the Shūbun school *Chikusai Dokusho* (fig. 9). His poem on the *Kinki Shoga* fan refers to whiling away the day playing the *ch'in* and *go*, and comments on the silence of calligraphy and painting. It is included in his collected writings, *Zokusui Shishū*, p. 318.

2. A six-fold screen in the Ryūko-in of Daitoku-ji in Kyōto also illustrates the Four Accomplishments. It too follows the academic style of Ma Yüan, and appears to have been painted in the last years of the 15th century. See Kyōto National Museum, *Muromachi Jidai Bijutsu Zuroku*, pl. 16.

3. None of these was painted by Motonobu himself and most of them seem to have been done during the second half of the 16th century. They include a set of sliding-door panels from the Rei'un-in now in the Tōkyō National Museum (*Kokka*, nos. 137, 150); a single six-fold screen in the Sugiura Collection (*Bijutsu Kenkyū*, no. 271, pl. 43); pairs of six-fold screens in the Gerry Collection (*Kokka*, no. 642), the Yabumoto Collection (*Kokka*, no. 565), a private collection in Ōsaka (*Bijutsu Kenkyū*, no. 271, pl. 50), and the former Tokugawa Collection (*Bijutsu Kenkyū*, no. 271, pl. 53); two hanging scrolls in the Sanada Collection (*Bijutsu Kenkyū*, no. 271, pl. 58); and one of the 240 fans pasted on a pair of six-fold screens at Nanzen-ji (*Kokka*, no. 872, fan no. 69). Except for the brilliantly colored fan with its gold-cloud background, the other versions of the theme are painted in either ink alone or ink and slight color on paper; all are in the formal style developed by Motonobu and based on the Chinese academic painters Ma Yüan and Hsia Kuei.

4. In his *Kōsoshū* compiled in 1623, Kano Ikkei (author of *Tansei Jakubokushū*, see cat. no. 26, n. 4) repeatedly mentions *Kinki Shoga* as a standard subject for professional Kano painters. The *Kōsoshū* is a reference book on Chinese painting to help Japanese painters when dealing with Chinese themes. The major portion is an extensive listing of Chinese painting subjects, ranging from religious subjects such as Confucian sages, Taoist immortals, and Buddhist deities, to secular topics such as famous scenic spots or aspects of beautiful women. A brief comment explains each theme. The rest of the book gives excerpts from Chinese discussions on painting taken from a Ming Chinese book, *Hua-hsüeh Chuan-she* attributed to T'ang Ying, and a list of Chinese painters taken from the *Kundaikan Sayū Chōki* (see cat. no. 29, n. 13).

5. Documents accompanying the painting consistently identify it as *P'o-ya Playing the Ch'in* (*Hakuga Dankin*, in Japanese), and attribute it to Kano Motonobu. These documents include a report on condition given in 1893 to its owner, Lord Date Munemoto; the Date family auction catalogues of 1916 and 1918; and the 1936 authorization of the painting as an "Important Art Object" (*Jūyō Bijutsuhin*), addressed to Mr. Hara

Tomitarō who apparently owned the painting at that time. See Take'uchi, "Hakuga Dankin-zu," p. 87; and Tsuji Nobu'o, "Kano Motonobu," *Bijutsu Kenkyū*, no. 270, p. 59.

6. "P'o-ya played the *ch'in* well, Chung Tsu-ch'i was an appreciative listener. When P'o-ya strummed the *ch'in* and his mind soared to the mountain heights, Chung Tsu-ch'i would say, 'Good! Lofty like Mount T'ai!' When P'o-ya's mind was on flowing waters, Tsu-ch'i would say, 'Good! Vast like the Yellow River and the Yangtze!' Chung Tsu-ch'i never failed to grasp what was in P'o-ya's mind.

"P'o-ya was wandering on the north side of Mount T'ai. He was caught in a sudden rain storm and took shelter under a massive rock. Feeling sad, he picked up his *ch'in* and played. First he composed music about the persistent rain, then he created the sounds of the crashing mountains. Whatever melody he played, Chung Tsu-ch'i immediately grasped his intent. P'o-ya put down his *ch'in* and sighed, 'Good! Good! When you listen, Tsu-ch'i, how well you understand what I imagine. And even more, you know what I feel. Nowhere can my notes escape!' " (*Sung-pen Lieh-tzu*, "T'ang-wen," *chüan* 5, p. 7a).

7. *Lü-shih Ch'un-ch'iu*, "Pen Wei," p. 547.

8. The theme of P'o-ya and Chung Tsu-ch'i began to appear on Chinese ceremonial bronze mirrors of the first centuries of our era, reaching the height of its popularity during the T'ang dynasty (618–907). For discussion of this development, see Ozaki, "Iwayuru Hakuga Dankin-kyō ni tsuite," Yajima, "Hakuga Dankin-kyō," and Ozaki, "Futatabi iwayuru Hakuga Dankin-kyō ni tsuite." Perhaps the most famous example of the subject on Chinese mirrors is the 7th century bronze mirror kept at Hōryū-ji and reproduced in Gotō, *Kokyō Shū'ei*, 2: pl. 13.

9. The Hompō-ji painting was first published with a brief comment in the catalogue of a postwar exhibition of Kyōto art treasures organized for the Kyōto National Museum by Professor Shimada in 1947. See Shimada, *Kyōto Ji'in*, no. 51. It has since been published in Saitō Michitarō, ed., *Chūgoku Chūsei 1. Sōgen*, pl. 76; and in Suzuki and Koyama, eds., *Chūgoku 5. Sōgen*, fig. 40 on p. 158.

10. The earliest document attributing the Zen patriarch paintings to Motonobu is the *Ryūhōzanshi* of 1708, followed by the *Hōsanshi-shō* of 1720 and the *Miyako Rinsen Meisho Zu'e* of 1790. No serious disagreement concering the attribution has emerged since that time. Tsuji Nobu'o, "Kano Motonobu," *Bijutsu Kenkyū*, no. 270, pp. 49–50.

11. The painting attributed to Yi Su-mun is in ink and slight color on paper, 80 x 33.5 cm, and is in the Kusaba Collection, Tōkyō. It is published in Matsushita, *Muromachi Suibokuga*, pl. 21. The model for this painting of Lin Ho-ching is attributed to Hsia Kuei and published in *Bijutsu Shū'ei*, no. 9, pl. 1. The painting of Lin Ho-ching may not be by Yi Su-mun at all, and it has stylistic features which indicate a late 15th century date. The complicated problem of Yi Su-mun (provenance, dates, artistic style) and the possible confusion of the works of two or even three painters from Korea and China using the same characters in their names have not been resolved by art historians. See Watanabe, "Shūbun," in *Higashiyama Suibokuga no Kenkyū*, pp. 200–36, and Kumagai Nobu'o, "Shūbun hitsu Chiku-ga Setsu."

12. A convenient source for these frequently reproduced paintings from the Rei'un-in is Do'i, *Motonobu, Eitoku*.

13. "Music" from *The Four Accomplishments* by Kano Eitoku, sliding-door panel, ink and slight color on paper, 175.5 x 94.5 cm, Jukō-in, Kyōto; *ibid.,* pl. 10.

Reeds and Geese
Artist unknown (early 14th century)

*Hanging scroll, ink on paper,
49.85 x 28.9 cm.
Mary and Jackson Burke
Collection*

In this small hanging scroll, the earliest painting in the exhibition, three geese pause on a river bank. One in a crouching position pulls his head into his plumage, apparently asleep. The other two, nearly identical, stretch their necks upward and cry at the empty sky.

The birds are reached from a foreground specified by four rocks and a few pebbles scattered irregularly from the lower left corner of the composition. A pale film of ink wash has been swept across the terrain with a broad brush, to define the spatial progression from foreground to middle ground. Dynamic strokes of a dry brush with pale ink have rendered a cluster of withering reeds to the left of the geese. Taller blades shoot upward and bend toward the center of the composition to frame the birds The artist subtly varied his ink tones, applying the darkest values to the foreground rocks and to the legs and feather patterns of the geese. No continuous line contours the geese; their forms are described by the so-called boneless manner of ink wash.

On the upper right of the scroll appears a partially effaced wax-print design of lotus flowers with their stems tied together. This kind of ornamental motif suggests that the paper might have come from China, even though similar types of decorated papers had been produced in Japan as early as the Heian period (794–1185). Now the paper has turned brownish gray and many creases have developed. A considerable amount of ink has come off during the centuries.

Considering the scale of the painted images in relation to the void area above, it seems likely that the original composition was several inches taller, with more space in the upper section. The missing portion may have had an inscription — perhaps a poem about a desolate river scene and lonely geese in late autumn, since a group of geese on a river bank with reeds as an accompanying motif announces the coming of winter.

The combined subject of reeds-and-geese is of Chinese origin. Its formation as a unitary subject dates from the late tenth century, although no authentic paintings with this theme survive from that time. By the eleventh century reeds-and-geese painting in China had attained great popularity, and was closely associated with the north Chinese painter Ts'ui-po, the Buddhist painter-monk Hui-ch'ung, and a grandson of the emperor T'ai-tsung (r. 976–997), Chao Tsung-han.[1] No authentic paintings by these artists have survived, but from later copies of their work it is evident that as early as the eleventh century there were two basic types of reeds-and-geese compositions. One type showed close-up

views of geese in various activities; the other depicted groups of geese, in landscape meetings with wintry fields of reeds near a river.[2] Whether these were painted in ink or in color cannot be ascertained. Ts'ui-po, judging from existing later copies, was known for his geese of the first type, painted in ink and color. And the late Yüan poet-scholar, Wang Fêng, reported having seen a handscroll of *One Hundred Geese* by Ts'ui-po.[3] A pure ink painting of this subject might have been similar to the handscroll in the Honolulu Academy of Arts, attributed to Ma Fên and entitled *One Hundred Geese.*[4]

Among the earliest reliably dated depictions of reeds-and-geese are those painted on the walls of a twelfth century tomb excavated in Hopei province in 1960.[5] According to the Chinese excavation report, the subject appears both on the eastern wall and on the western section of the north wall of tomb no. 4 at the site of Pei-ku-t'ai. Whether the two pictures are continuous is not mentioned in the report. A brief comment about execution notes that most of the painting is done in ink, with trees and reeds in green. The paintings are now much effaced, and the two small photographs published are too blurred to permit conclusions about style. They do show, however, at least two geese on the east wall, flying north over a river scene with reeds and willows. The painting on the north wall appears more sparse; reeds are clearly visible, and the trees seem to be leafless.

One of the most frequent appearances of reeds-and-geese as a subject is as one of the *Eight Views of Hsiao and Hsiang* originated by Sung Ti.[6] But ink paintings of reeds-and-geese, along with bamboo, plum, and orchid in ink, also became a favored theme for Chinese gentlemen of the Northern Sung period, such as Su Tung-p'o and Mi Fei. A handful of their poems referring to paintings of this subject have survived, with images of geese among fields of reeds in the river landscapes of South China.[7] Su Tung-p'o, on viewing a painting of reeds-and-geese by Hui-ch'ung, wrote:

> *Hui-ch'ung's reeds-and-geese in mist and rain*
> *Lure me out to sit by the Hsiao and Hsiang Rivers*
> *and Tung-t'ing Lake,*
> *And make me want to hire a skiff to go home.*
> *Such is what a painting must do, as the ancients*
> *rightly said.*[8]

Northern Sung poems often describe the birds in snowy winter settings. Thirty-four of the fifty-four geese paintings listed in the Sung Imperial Painting Catalogue *Hsüan-ho Hua-p'u* (1120), are of geese in winter.[9]

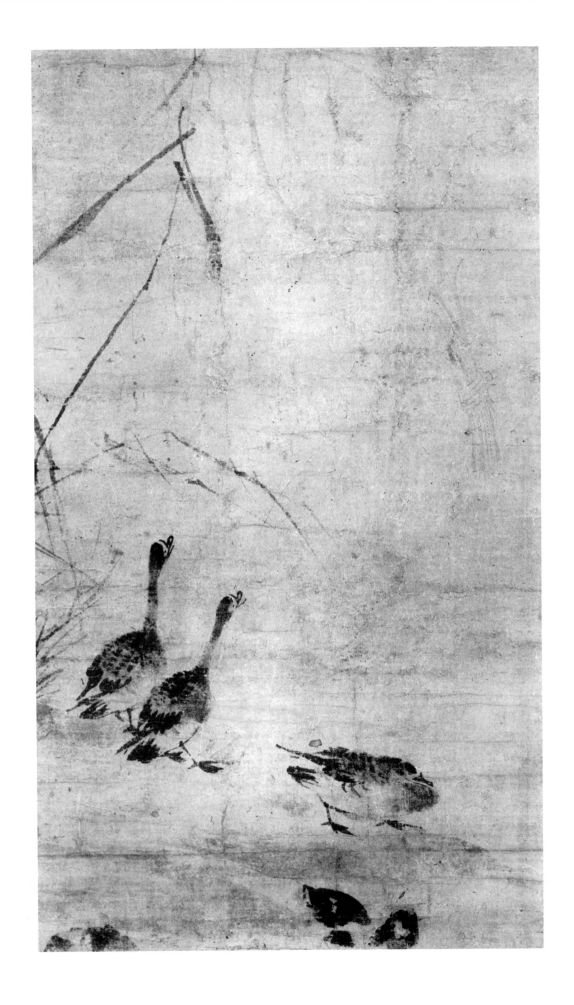

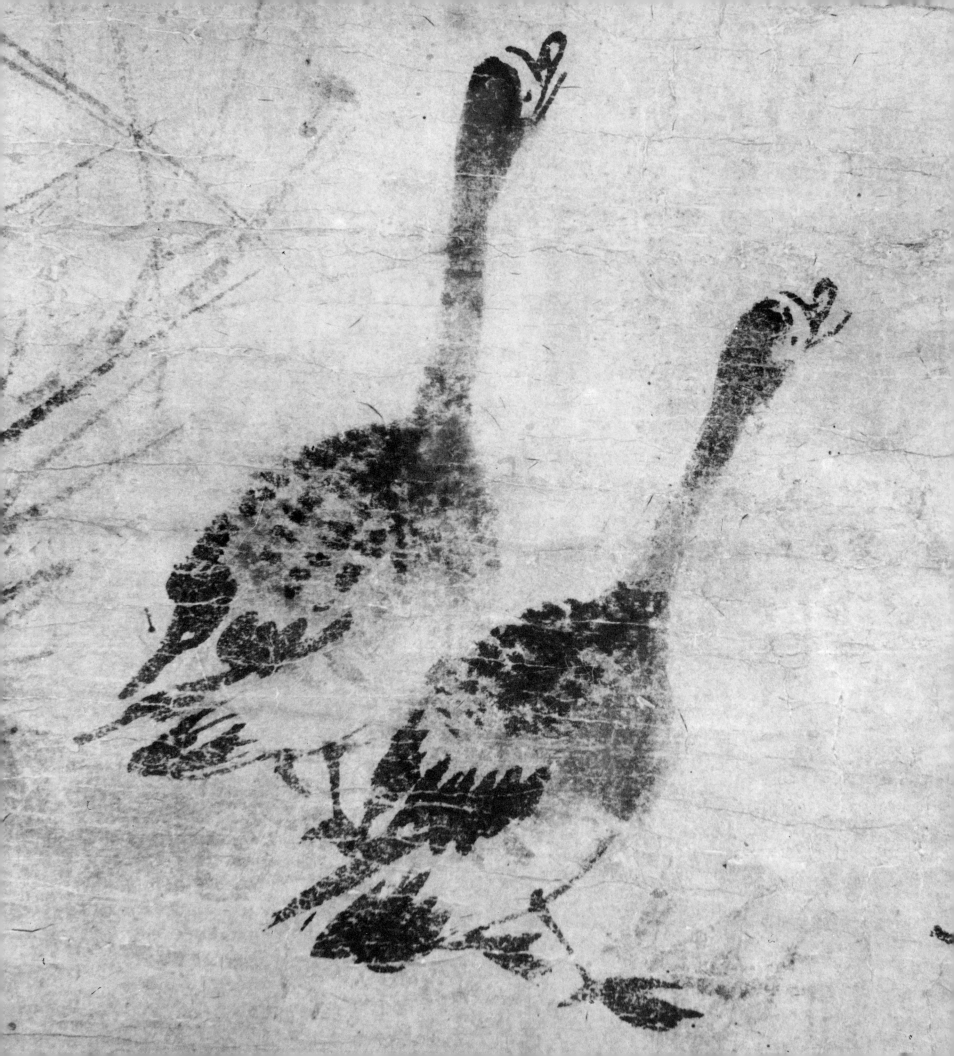

Figure 68. *Reeds and Geese,*
artist unknown, inscription by
I-shan I-ning (1247–1317).
Hanging scroll, ink on paper,
80.9 x 32.2 cm. Nakamura
Collection, Zushi, Kanagawa
prefecture

Detail of catalogue number 29,
Reeds and Geese

In Japan, geese as a pictorial theme began to appear in conservative Buddhist painting toward the end of the thirteenth century.[10] Many were based on Chinese examples brought from the mainland by Japanese pilgrim-monks. In the fourteenth century reeds-and-geese were pictured in Japanese narrative handscrolls in Yamato-e style, some rendered predominantly in ink, although Chinese models seen by Japanese artists were probably both in ink and in color.[11] By the early fourteenth century, however, the Japanese themselves were painting the subject in pure ink, as in *Descending Geese on Sandbanks* by Shikan, datable to no later than 1317 (fig. 2).

In addition to painting geese in Hsiao-Hsiang landscape scenes, Japanese painters adopted the convention established in China a few centuries earlier of depicting four aspects of geese in nature: flying (*hi*), crying (*myō*), sleeping (*shuku*), and feeding (*shoku*). The four aspects of geese could be combined in a single composition or painted separately in sets of four. It is uncertain whether they were initially intended to be allegorical, but they came to be associated with the Four Correct Demeanors (*shi-igi*) of Zen Buddhist monastic discipline: walking (*gyō*), dwelling (*jū*), sitting (*za*), and reclining (*ga*).[12]

While the four aspects of geese and the four demeanors of Zen monks are not identical, their association may have been more than numerological. Part two of the fifteenth century manual written by the connoisseurs of Chinese art objects in the collection of the Ashikaga Shōguns, the *Kundaikan Sayū Chōki,* illustrates prescribed rules about how art objects are to be displayed in the formal reception room (*zashiki*) of the Shōgun's household.[13] It includes a drawing of a set of four reeds-and-geese paintings on the *tokonoma* wall, arranged from right to left in the order of flying, crying, sleeping, and feeding, following the four seasons: spring, summer, autumn, and winter. The Burke painting shows geese in two of these aspects: crying and sleeping. Probably this painting was accompanied by another depicting the aspects of flying and feeding. The two paintings may have formed a pair, or may have been flanking pieces of a triptych with a figural painting in the center. Both combinations occurred often during the Muromachi period.

The Burke *Reeds and Geese* is undated, but its early-fourteenth century origin is unmistakable on stylistic grounds, especially in comparison with a strikingly similar painting, datable to no later than 1317 (fig. 68)[14] and inscribed by the eminent Chinese priest active in

Figure 69. *Reeds and Geese*, artist unknown, inscription by Ching-t'ang Ssu-ku (fl. early 14th century). Hanging scroll, ink on paper, 70.7 x 27.5 cm. Inoue Collection, Takasaki, Gumma prefecture

Japan, I-shan I-ning (1247–1317). In addition, the spatial articulation in the Burke scroll, from the foreground to the middle ground, is similar to that of a handful of datable fourteenth century Japanese ink paintings, including the Maeda *Four Sleepers* by Moku'an Rei'en (fl. 1323–1345; fig. 4), Ka'ō paintings such as the *Kensu (Hsien-tzŭ)* in the Tōkyō National Museum (fig. 32), and *Priest Sewing* in the Cleveland Museum (cat. no. 1).

The Japanese distinguished, though not quite distinctly, two major styles of Chinese reeds-and-geese in a landscape setting: that of the Northern Sung painter Hui-ch'ung, and that of the Southern Sung artist Mu-ch'i. The Hui-ch'ung type gives a high vantage point on a receding terrain. Diluted ink with slight color emphasizes atmospheric effects, softening the forms of the geese as they move around a misty embankment.[15] In the Mu-ch'i type the geese are brought closer to the foreground and are more sharply delineated in clear air. Birds on the ground are balanced by others flying in the sky, and landscape setting is restricted to a few reeds. While paintings of the the Hui-ch'ung type were well known in the Muromachi period, the Mu-ch'i style was more frequently used as a model by Japanese painters. A set of four geese paintings carrying Mu-ch'i's name had appeared in a metropolitan Zen monastery, by 1351.[16] As his reputation became ever greater, from the fourteenth through the sixteenth century, Mu-ch'i's reeds-and-geese paintings were more and more often reported in literary sources. Naturally this tendency, persisting into the Edo period, led later connoisseurs to give the more famous name of Mu-ch'i to some paintings of the Hui-ch'ung type.

One such case is an early-fourteenth century Chinese painting, stylistically similar to the Burke *Reeds and Geese,* which was once attributed to Mu-ch'i (fig. 69). This rendering of *Reeds and Geese* in the Ino'ue collection is inscribed by the Yüan monk Ching-t'ang Ssu-ku of the T'ien-ning-ssu monastery.[17] There are noticeable stylistic affinities in conception and rendering between it and the Burke painting. In the latter, however, there are clear traces of Japanese brushwork, especially in the handling of the plumage patterns, which are more schematic and flattened, and in the leg forms, which are more conceptual and repetitive. This painting and Tesshū's *Reeds and Geese* (cat. no. 32) are rare surviving examples of a subject once popularly depicted by early Japanese ink painters.

YOSHIAKI SHIMIZU

NOTES

1. Evidence for the activity of these painters is found in Kuo Jo-hsü, *T'u-hua Chien-wen Chih*, *chüan* 4; *Hsüan-ho Hua-p'u*, *chüan* 16; and Mi Fei, *Hua Shih*. These are the standard Northern Sung biographical sources for Chinese painters. The *T'u-hua Chien-wen Chih* was written in the late 1070's by a minor court official in the Northern Sung capital of K'ai-feng, Kuo Jo-hsü, and gives biographical information for nearly 300 artists from the late T'ang period to his own day. The book has been translated with thorough and scholarly annotation by Alexander Soper as *Kuo Jo-hsü's Experiences in Painting*. The *Hsüan-ho Hua-p'u*, preface dated 1120, is the catalogue of the Imperial painting collection of the Northern Sung emperor Hui-tsung (r. 1101–26) and covers paintings by 231 painters from the Three Kingdoms period to the Sung era. The *Hua Shih* is a history of painting probably written ca. 1100 by Mi Fei, a famous painter-calligrapher-critic (1051–1107). A complete translation into French has been made by Nicole Vandier-Nicolas, *Le Houa-che de Mi Fou*. For more information about these and other primary sources on Chinese painters and painting, see Lovell, *An Annotated Bibliography of Chinese Painting Catalogues and Related Texts*.

2. See paintings attributed to Ts'ui-po in the Palace Museum, Taiwan, in the photographic archives available through the University of Michigan, nos. 5349, 143–45, 5350–51; and *Geese in Snow* in *Tōsō Genmin Meiga Taikan* (1929), pl. 49. The painting considered closest to the possible Hui-ch'ung style is *Reeds and Geese* in the Yabumoto Collection, painted in ink and thin color on silk, 33.2 x 33.3 cm; published in Yonezawa and Nakata, *Shōrai Bijutsu*, pl. 69.

3. Wang Fêng, *Wu Ch'i Chi*, *chüan* 5.

4. Sirén, *Chinese Painting*, 3:220.

5. "Hopei Ching-hsing hsien Shih-chuang Sung Mu Fa-chüeh Pao-kao," pl. 22, nos. 3, 6.

6. *Meng Chi Pi T'an*, *chüan* 17. See also Shimada, "Sō Teki to Shōshō Hakkei."

7. See *Su Tung-p'o Hsü Chi*, *chüan* 2–3; and Mi Fei's *Hua Shih* under "Tsung-han."

8. *Su Tung-p'o Hsü Chi*, *chüan* 3.

9. *Hsüan-ho Hua-p'u*, *chüan* 16, 18–19.

10. Examples include the painting of geese in one of the *Ten Kings of Hell* at Nison-in. For illustration of this and other early paintings containing pictures of geese, see Kyōto National Museum, *Chūsei Shōbyōga*, figs. 12, 20, 87, 113, 125, 129, in the section on sliding doors and folding-screen paintings in pictures.

11. The 14th century inventory of Chinese paintings in the collection of the Butsunichi-an subtemple of the Engaku-ji monastery in Kamakura lists eleven reeds-and-geese paintings. Two of these were painted in color and attributed to Ts'ui-po. For published editions of this inventory, see Kumagai Nobu'o, "Butsunichi-an Kumotsu Mokuroku;" Kamakura-shi Shi Hensan I'inkai, "Engaku-ji Monjo," in *Kamakura-shi Shi, Shiryō* (History of the City of Kamakura, Source Materials), Kamakura, 1956, vol. 2:200–12; and Fujita, *Butsunichi-an Kumotsu Mokuroku*.

12. For *shi-igi* (Chinese: *ssu-wei-i*) see the collected sayings of the Chinese Ch'an monk Yüeh-chien, *Yüeh-chien Ch'an Shih Yü Lu* (1297), in *Dainihon Zoku Zōkyō*, 2B:23–25; and Muchaku Dōchō, *Zenrin Shōkisen*, p. 402 on *gu-igi*.

13. *Kundaikan Sayū Chōki*, p. 654. The *Kundaikan Sayū Chōki*, traditionally attributed to either Nō'ami or Sō'ami, is a handbook of Chinese works of art compiled late in the 15th century, and divided into two parts. The first part classifies a list of Chinese painters into three qualitative grades. The second part gives instructions on the proper way to display art objects in a *toko* (a decorative alcove) or a *tana* (the adjoining ornamental shelves), and comments on various types of Chinese lacquer works, ceramics, and bronzes. Whether the two parts were originally written by the same author or at the same time is still in question. Numerous versions of the book exist today, the earliest being the 1559 manuscript in the Tōhoku Daigaku Library. The versions differ in their ranking and in the painters mentioned; the number of painters ranges from ca. 140 to 180. Although comments on individual painters are very brief, the list provides a convenient indication of the Chinese painters known to Muromachi Japanese and a guide to the general trend of Japanese appreciation of Chinese painting in the Muromachi period. The book was circulated among connoisseurs and art lovers in manuscript form until it was published in the *Gunsho Ruijū* and in another private edition in the early 19th century. Several versions have been conveniently collected by Fujita in mimeographed form (soon to be published). Page references in this catalogue refer to the *Gunsho Ruijū* version.

14. There is a Kano copy of this painting from the Edo period now in the Tōkyō National Museum, registered as Kano copy no. 5468.

15. See Yonezawa's discussion of Hui-ch'ung in *Kokka* nos. 929 and 943, and of the Yabumoto painting cited above, n. 2.

16. Tani, "Mokkei Hōjō," (Mu-ch'i Fa-ch'ang), in *Muromachi Jidai Bijutsu-shi Ron*.

17. For information about the inscriber Ching-t'ang, see Nan-shih Wen-hsiu, *Tseng Chi Hsü Ch'uan Teng Lu* (1417), *chüan* 6, in *Dainihon Zoku Zōkyō*, 2B:15–5. The date of his death is uncertain. He was the fifth generation in the transmission line of Wu-chun Shih-fan (mid-13th century).

Orchids and Bamboo

Tesshū Tokusai (fl. 1342, d. 1366)
Inscription by Gidō Shūshin (1325–1388)

*Hanging scroll, ink on paper,
51.3 x 32.6 cm.
Square intaglio seal reading
Tesshū.
Square intaglio seal reading
Gidō; oblong relief seal reading
Kūge Dōjin.
Inscription inside lid of inner box
containing painting; three
documents with painting in
inner box.*[1]
*Collection of Mrs. T. Randag,
on loan to The Art Museum,
Princeton University (L55.68)*

Fourteenth century Zen priests painted a wide range of subject matter in many different styles. In addition to the painter-monks who treated figure subjects directly related to the Zen narrative tradition, many humanist monks (*bunjin-sō*) painted non-Buddhist motifs such as the plum, bamboo, and orchids favored by the Chinese amateur scholar-painters (*wen-jên*). Orchid-and-rock paintings by Tesshū Tokusai, Chō'un Reihō (fl. mid-fourteenth century; see cat. no. 33), and Gyoku'en Bompō (early-fifteenth century; see cat. no. 34) illustrate the development of this aspect of Japanese ink painting.

Tesshū Tokusai's life is marked by the strength of his religious discipline and the vigor of his intellectual and artistic pursuits.[2] A disciple of the eminent Japanese Zen priest Musō Soseki (1276–1351), Tesshū followed the precedent of other Gozan monks and went to China, probably when he was twenty or twenty-five years old.[3] His movements are not clear, but information gleaned from contemporary records indicate that his status was high in China, for he visited many important monasteries and associated with several noted monks. One traditional account reports that he was given the Buddhist title of *Entsū Daishi* (*Yüan-t'ang Ta-shin* in Chinese; Great Master of Perfect Penetration) by the Yüan emperor Shun-tsung (r. 1322–1341).[4]

In 1342 Tesshū served as primate of the Ch'eng T'ieh-ssu monastery in Suchou. In that same year, the learned Chinese abbot of the monastery, Nan-ch'u Shih-shuo, presented Tesshū with a *gatha* — a verse form intended to inspire the priest in his calling.[5] Tesshū returned to Japan the following year to become primate at the monastery of Tenryū-ji in Kyōto. In 1347 he became abbot of Hoda-ji in Awa province (modern Tokushima prefecture), and of Zuihō-ji in Harima (modern Hyōgo prefecture) soon afterward. In 1362 Tesshū attained the abbacy of one of the most important Gozan monasteries, Manju-ji in Kyōto. When his term ended, he retired to the Ryūko-in subtemple in the precincts of Tenryū-ji, and died there in 1366.

Tesshū Tokusai was accomplished in painting, calligraphy, and poetry. He was especially noted for his grass-style calligraphy.[6] His poetry was much respected and a portion of his literary work has survived in an anthology known as the *Embushū*.[7] Tesshū's intellectual and artistic attributes closely parallel those of Chinese scholar-painters. This painting of *Orchids and Bamboo*, in fact, is a document representative of Tesshū's position as a *bunjin-sō*. Its inscription is a laudatory poem by a

preeminent contemporary priest, its subject symbolizes the virtuous literary man, and its style derives from the orchid and bamboo painted by Chinese scholar-painters.

The eight-line regulated poem occupying the top half of this painting was composed in Chinese and inscribed by Gidō Shūshin (1325–1388), Tesshū's close friend and a fellow disciple of Musō Soseki. At the end of the poem, his signature is followed by a square intaglio seal reading *Gidō*. An oblong relief seal bearing Gidō's literary name, *Kūge Dōjin*, is stamped to the upper right of the poem's first line. Gidō's poem, written after Tesshū's death, eulogizes the priest's excellence in painting and calligraphy.

> *When the old Zen priest played with painting,
> his brush was divine;
> Both painting and calligraphy were unique and
> outstanding.
> This sage of grass-style calligraphy follows
> the chariot of Huai-su,
> His orchid flowers capture the likeness of
> Ch'ü P'ing.
> At daybreak rain dampens lakes and mountains
> under its clouds,
> In spring mist conceals the colors of bamboo
> at Ch'u rivers.
> Carrying one slipper, my friend Tesshū has left
> for the realm of the West;
> From time to time I open the scroll and tears
> wet my scarf.*[8]

Gidō's reference to Ch'ü P'ing in line four evokes a millennium of Chinese orchid symbolism. Ch'ü P'ing (or Ch'ü Yüan, 332–268 B.C.) was a high minister in the state of Ch'u (modern Hunan province) during China's Warring States period who was slandered and banished to the northern marshlands. His uncompromising moral character and steadfast loyalty to the king of Ch'u came to be symbolic of the purity and incorruptibility of the poet. During his years of wandering in the wilderness, Ch'ü P'ing is credited with composing China's first long narrative poem, *Encountering Sorrow* (*Li Sao*), which forms part of the famous *Songs of the South* (*Ch'u Tz'u*). Orchids figure prominently as part of the lush vegetation described in the poem, beginning a long history of association of the flower with virtue and righteousness in the face of disorder and suffering.[9]

Orchid symbolism became more precise in later ages. The Northern Sung calligrapher and poet Huang Shan-ku (T'ing-chien, 1045–1105) differentiated between *lan*

老禪遊戲筆如神
書畫雖又奇稱瑰倫
艸聖追回懷素鶩
蘭花邈得屈平真
雲根雨溫湖山曉
竹色烟藏楚水春
隻腹已歸西土去
披圖三歎凌沽巾
鐵舟所作弟侯題

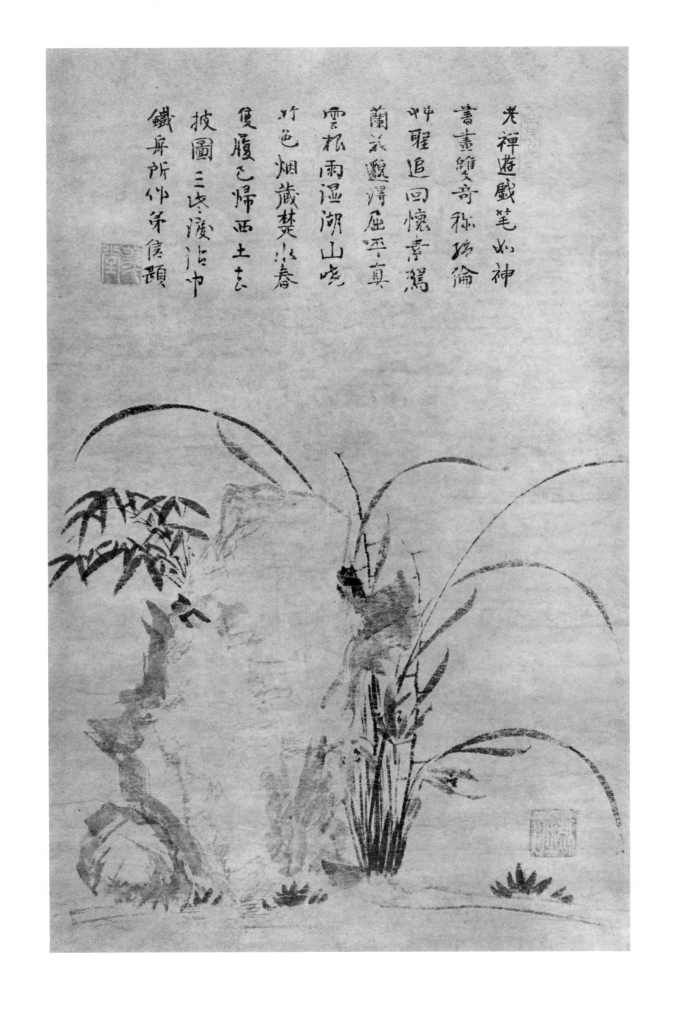

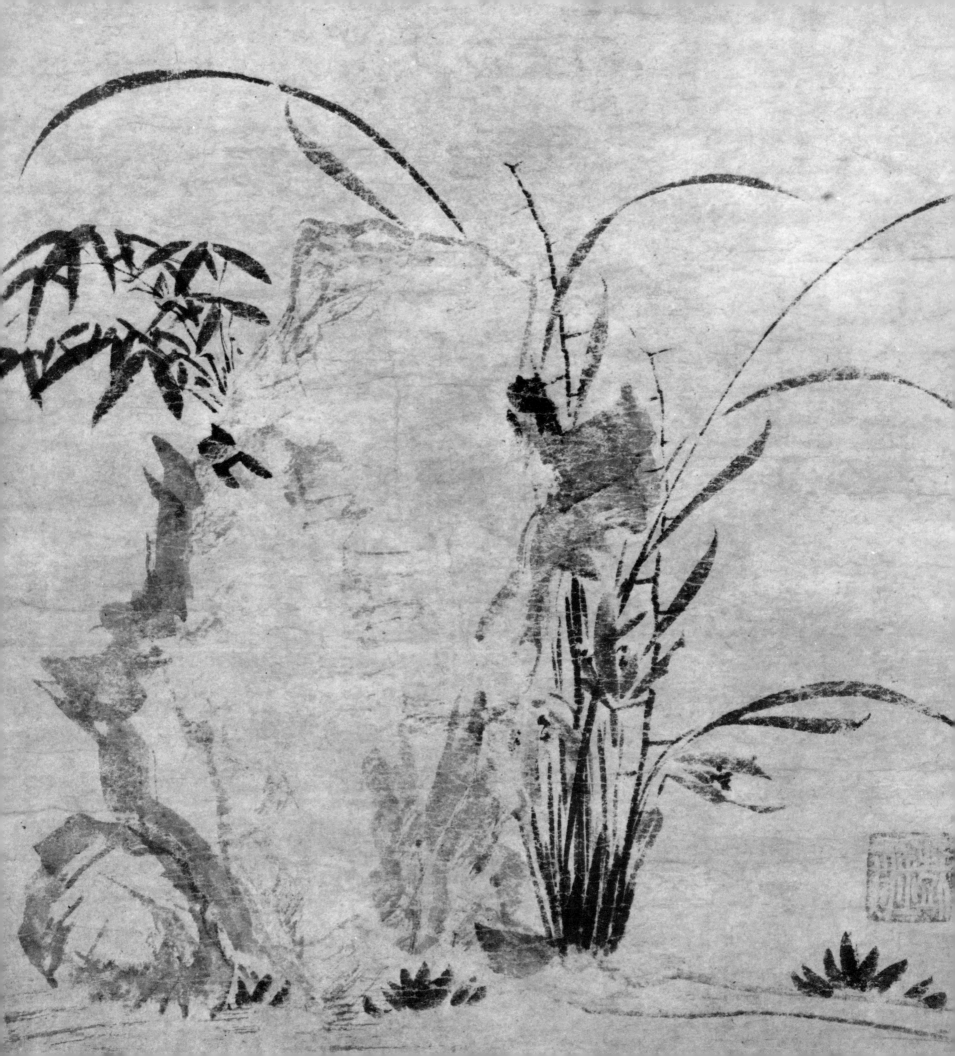

Detail of catalogue number 30,
Orchids and Bamboo

(epidendrum), which is emblematic of the true gentleman (*chün-tzu*), and *hui* (orchid with less fragrance), which he associated with officials (*shih-ta-fu*). Huang used this distinction to dramatize the scarcity of the true gentleman, since *lan* were rarer than *hui* by a ratio of one to ten.[10]

Orchids as a pictorial subject, either alone or combined with rocks, bamboo, and brambles, probably developed during the Southern Sung period (1127–1279) and became even more important in the Yüan dynasty. During this period of social and political instability, climaxed by the total subjugation of China by the Mongols, the subject was passionately adopted by gentlemen who identified themselves with the exemplary moral heroes of China's past. Chao Mêng-chien (1199–1295) made a remarkable contribution to the painting of orchids in ink, and Chêng Ssu-hsiao (1241–1318) seems to have been responsible for strengthening the idea of loyalty associated with the plant. Chao Mêng-fu (1254–1322), the Chinese literatus par excellence, and his son Chao Chung-mu (1289–ca. 1360) are particularly noted as painters of orchids.[11]

Orchid painting was by no means a monopoly of literati gentlemen painters, however. As early as the first half of the thirteenth century Chinese Ch'an monks were writing appreciatively of orchid paintings. For example, Hsi-sou Shao-t'an (fl. 1249–1275) recorded, in his *Collected Sayings* (*Yü Lu*), poems which he inscribed on three sets of orchid paintings, each set depicting the plant in four kinds of weather: wind, sun, rain, and snow.[12] Undoubtedly other Ch'an monks were painting orchids as well as adding their inscriptions to pictures they viewed. By the end of the Southern Sung period, therefore, orchid painting was an established theme for both literati and Ch'an artists.

The earliest-known Chinese ink orchid painting, traditionally attributed to Yü-chien, is inscribed by the monk Yen-ch'i Kuang-wen (1189–1263) and thus can be dated no later than 1263.[13] A similar style is seen in the *Ink Orchid* by Chêng Ssu-hsiao dated 1306, formerly in the Abe Collection.[14] Both show the plant against a neutral background, but other styles and other compositions were being painted at the same time. Orchids in a setting of rocks, bamboo, and brambles painted in an expressionistic calligraphic style are associated with Chao Mêng-fu and his son Chao Chung-mu.[15] Tesshū's *Orchids and Bamboo* appears to be a Japanese development of this kind of composition.

A wide brush dipped lightly in pale ink swiftly outlines and textures the large jagged rock. The brush is pressed and released several times, splitting and centering the tip, creating irregular saturation of ink and changing width of contour line. This is the brush manner used in Chinese calligraphy called flying white (*fei-pai* in Chinese, *hi-haku* in Japanese). It is one of the calligraphic techniques for which Chao Mêng-fu is famous in his orchid, bamboo, and rock paintings. To the lower left of the large boulder Tesshū painted a smaller and nearly spherical rock, its right shoulder tangent to the bottom of the big rock. Three plants grow behind the rocks. Bamboo leaves peek over the left shoulder. Orchids extend their blades gently to right and left. The orchid flowers are in bloom but are scarcely seen, hidden amidst the blades and stems to the right of the rock. Mingled with the orchids, two brambles reveal their sharp thorns. A single horizontal half-dry stroke indicates the ground plane, which is further defined by three clumps of wild grass. Only the grass and the bamboo leaves above the rock are painted in a darker tone of ink, contrasting with the predominantly pale tone of the rest of the picture.

According to the *Kūge Shū*, Gidō's anthology of literary works which records the poem inscribed on *Orchids and Bamboo*, this painting originally formed a pair with another orchid painting, now lost. Gidō says he wrote inscriptions for the pair, then in the possession of a certain monk named Raigoku, who was probably a friend or disciple of Tesshū. Judging from Gidō's poem, the lost painting depicted a shivering image of orchids, bamboo, and grass after a frost. The surviving painting, with its gently spread blades of orchid and the wet leaves of young bamboo, presents a scene after the soft drizzle of spring. The seasonal character of the plants in their natural setting recalls the sets depicting four different aspects of orchid plants mentioned by the thirteenth century monk, Hsi-sou Shao-t'an.

It also brings to mind the well-known set of four orchid paintings, dated 1343, by Hsüeh-ch'uang P'u-ming (fl. mid-fourteenth century; figs. 71 and 75).[16] The work of this late Yüan painter-monk is especially significant when considering Japanese orchid painting of the fourteenth century. He was the direct teacher of the Japanese artist Chō'un Reihō (see cat. no. 33), and Tesshū surely must have seen his paintings when he was in China. Hsüeh-ch'uang was in Suchou by 1335, and in 1344 — only a year after Tesshū returned to Japan — he became abbot of Ch'eng T'ien-ssu, the monastery where Tesshū had served as primate in 1342.

Stylistic comparison of the Randag *Orchids and Bamboo* with representative examples of Hsüeh-ch'uang's plants, however, raises doubts that in this case the Yüan monk's painting provided the model for Tesshū. Hsüeh-ch'uang's orchid blades busily rotate in space, revolving around each other in pairs with a third blade always in swift pursuit. In contrast, the blades of the Randag orchid fan out elegantly in slow arcs; they create dignified rhythms alien to Hsüeh-ch'uang's tangled gyrations. Tesshū's paired blades in the Randag orchid construct a spatial dimension totally different from the coiling pairs of Hsüeh-ch'uang: the longer blade gently turns above the echoing inward curve of the shorter one, defining a three-dimensional pocket of space more subtly felt than in the Chinese orchids. The sophisticated rendering of volumetric intervals seen in the Randag orchid differs also from other extant orchid paintings by Tesshū (see cat. no. 31) and can be explained by two factors: a difference in prototype and a difference in the stylistic maturity of the artist.

While the other orchid painted by Tesshū exhibited here can be equated with Hsüeh-ch'uang's style, it is tempting to speculate that this one follows the manner of the reputed teacher of Hsüeh-ch'uang, Chao Mêng-fu. No authentic example of orchid painting by this renowned Chinese scholar survives today, but many of his works must have been circulating for Tesshū to study when he was in China in 1342, only two decades after Chao's death. The solid construction of Tesshū's rock in flying-white may be stylistically closer to what Chao Mêng-fu painted than is any other extant work in China or Japan. The bamboo, painted in integrated groups of three supremely controlled brush strokes, are quite unlike the trailing strokes of Hsüeh-ch'uang. They reflect a brush manner associated with classic calligraphic methods, recalling the superlative control of Chao Mêng-fu's exquisite writing.[17]

The Randag *Orchids and Bamboo* is unique among Tesshū's surviving work in its stylistic reference. It is also exceptional in its stylistic maturity, displaying the Japanese priest's highest accomplishment in orchid painting. Its artistic quality was recognized by Gidō Shūshin who, after Tesshū's death, chose this painting as representative of his friend's best work and thus worthy of bearing his eulogistic inscription.

Yoshiaki Shimizu

NOTES

1. The inscription was written on the 4th day of the 12th month of 1692 by Sosen, a monk at the Jishi-in subtemple of the Nanzen-ji monastery in Kyōto. It identifies the artist as Tesshū and the inscriber as Gidō, the founding priest of the Jishi-in. The painting was given to the Jishi-in by the 283rd abbot of Nanzen-ji, Zaiten Shosa (d. 1716), as a gift celebrating the refurbishing of the subtemple. Sosen pleads that the painting remain eternally as the treasure of the subtemple and never leave its premises. The three documents in the inner box are a modern transcription of Gidō's poem and two certificates of authenticity issued by the Edo connoisseur Kohitsu Ryōchū (1656–1736; see cat. no. 11, n. 17). One of these certificates gives a cyclical date and season corresponding to summer of 1700.

2. Tesshū Tokusai's biography is in Tayama, *Zenrin Bokuseki*, text vol., p. 110; Nakamura, "Tesshū Tokusai no Gaji"; and Shimada, *Zaigai Hihō*, 1: pt. 1, 96. In English, see Shimizu, "Problems of Moku'an Rei'en," intro. and nn. 22–24; and Li, "The Oberlin *Orchid*," *Archives*, pp. 65–69. Other paintings by Tesshū are published in Kanazawa, *Shoki Suibokuga*, figs. 120–22.

3. For accounts of Japanese pilgrims in China, see Shimizu, "Problems of Moku'an Rei'en," intro. and chap. 1.

4. Shiban, *Empō Dentōroku*, chap. 24, p. 14.

5. The *gatha* is written on paper, now mounted as a hanging scroll in the Hatakeyama Collection and published in Tayama, *Zenrin Bokuseki*, 1: pl. 86.

6. Tesshū's grass-style calligraphy is published in *ibid.*, 2: pl. 79; and Kondō, *Nihon Kōsō Iboku*, 2:pl. 78.

7. The *Embushū* is published in U'emura, *Gozan Bungaku Zenshū*, 2:381–450.

8. The calligraphy of Gidō can be judged authentic by stylistic comparison with another work dated to a year before Gidō's death, 1387, *Kegontō Kan'en Ge* (a poem composed to encourage subscription to the fund-raising campaign for rebuilding the Kegon Pavilion at Engaku-ji), published in Kondō, *Nihon Kōsō Iboku*, 2:pl. 92. The poem on Tesshū's painting is recorded in full in *Kūge Shū*, Gidō's anthology of literary works, and in *Koga Bikō*, p. 306. "Huai-su" in line 3 refers to the 8th century grass-style calligrapher. "Carrying one slipper . . . realm of the West" in line 7 refers to Tesshū's death (1366). Gidō compares Tesshū's departure from this world to that of Bodhidharma. According to one account, three years after Bodhidharma's death a certain Sung Yün saw him at the Onion Range in Turkestan, carrying one slipper, on his way back to India.

9. For example, Ch'ü P'ing writes, "I had tended many an acre of orchids and planted a hundred rods of melilotus . . . / When I had finished twining my girdle of orchids, I plucked some angelicas to add to its beauty. It is this that my heart takes most delight in. / The age is disordered. . . . Orchids and iris have lost all their fragrance" (Hawkes, trans., *Ch'u Tz'u*).

10. A colophon by Huang T'ing-chien quoted in Ch'ing Sheng-tsu, *Kuang-ch'ün Fang-p'u.*

11. See Li, "The Oberlin *Orchid*," *Archives*, p. 12. Also, for Chao Mêng-chien see T'ang-hou, *Hua Chien;* and for Chêng Ssu-hsiao see Hsia Wen-yen, *T'u-hui Pao-chien, chüan* 5, and Mote, "Confucian Eremitism in the Yüan Period." Chao Mêng-fu and Chao Chung-mu are also discussed by T'ang-hou and Hsia Wen-yen.

12. *Hsi-sou Shao-t'an Ch'an Shih Kuang-lu, chüan* 6, in *Dainihon Zoku Zōkyō*, 2A:17-2.

13. On stylistic grounds the calligraphy of Yen-ch'i Kuang-wen can be judged authentic. The painting is published in *Gei'en Shinshō*, vol. 9.

14. Abe, *Sōraikan Kinshō*, pl. 9.

15. The orchid painting most frequently cited as representing Chao Mêng-fu's late-13th century style is *Bamboo, Rocks, and Lonely Orchids* in the Cleveland Museum of Art, published in Lee and Ho, *Chinese Art under the Mongols*, no. 235. The painting by his son, Chao Chung-mu, is represented by *Orchid and Rocks* in color on silk in the Shanghai Museum, published in *Shang-hai Po Wu Kuan*, pl. 16.

16. These four paintings, now in the Imperial Household Collection in Japan, are published in *Kokka*, nos. 483–484. For a thorough biographical account of Hsüeh-ch'uang P'u-ming, see Shimada, "Sessō ni tsuite." For a study in English based on Shimada's article, see Li, "The Oberlin *Orchid*." Tesshū's well-controlled use of ink and his well-differentiated calligraphic strokes for rocks and plants share the period style of Tzŭ-t'ing Tsu-po (1284–1353), another Chinese painter-monk and a contemporary of Hsüeh-ch'uang P'u-ming. The brushwork of Tesshū's rocks in particular is very similar to that in Tzŭ-t'ing's *Irises* in the Umezawa collection. See Shimada, "Shitei Sohaku hitsu Sekishobu-zu."

17. For Chao Mêng-fu's calligraphy, see *Shodō Zenshū*, 17: pls. 1–25.

Orchid and Rock

Tesshū Tokusai (fl. 1342, d. 1366)

Hanging scroll, ink on paper,
21.2 x 38.1 cm.
Square intaglio seal reading
Tesshū.
Documents in box containing the
painting. [1]
Private collection

When juxtaposed with the Randag painting (cat. no. 30), this scroll of *Orchid and Rock* gives some indication of Tesshū's stylistic range. Here Tesshū less representationally abbreviates motifs derived from naturalistic Chinese painting by the Chinese painter-monk Hsüeh-ch'uang P'u-ming (fl. mid-fourteenth century; figs. 71 and 75). Tesshū's personalized handling of similar motifs can be seen in other paintings: *Orchid and Bamboo* in the Gotō Art Museum (fig. 70), and a pair of hanging scrolls now lost, known through a copy by Kano Tsunenobu (1636–1713) in the Tōkyō National Museum.[2]

In the painting exhibited here a cluster of orchids grows with three spiky brambles and a stalk of bamboo beside a rock. Strokes of flying-white texture the lumpy rock surface, but any solidity that might have resulted is denied by a heavy brush stroke that slashes diagonally down the upper left edge of the rock, and by an equally nondescriptive dark ink line geometrically encompassing a smaller rock on the right. By contrast, the Randag rock appears volumetric and massive. A medium gray flying-white stroke delineates the undulating slope to the left of the rock. All plants spring from this line, but are not at all securely rooted in the soil beneath it. Basically, three ink values differentiate between medium-pale orchid blossoms, darker orchid blades, and black silhouetted brambles and bamboo leaves. The flower centers are given focus by accents of dark ink.

The painting cannot be judged by naturalistic criteria. Tesshū is not describing plants in nature. Rather, he is "playing with ink," presenting conventionalized orchid motifs in a mode akin to his famous grass-script calligraphy mentioned by Gidō in the Randag *Orchids and Bamboo* inscription (see cat. no. 30). Like the Gotō painting and Tsunenobu's copies, bamboo, orchid, and rocks are assembled in a centralized self-contained composition with orchid blades sweeping to right and left above the cluster. Yet this painting is further from the logic of organic form than are any of Tesshū's other orchids.

The Gotō scroll (fig. 70), although expressionistic and abstract, shows clear distinction between the character of each motif. Bold wash outlines specify the sharp facets of rock, even though the boulder itself is neither solid nor massive as it would be in nature. Perky bamboo leaves splay from a consistently implied central vertical stalk beside the rock. By contrast, in the painting exhibited here the lumpiness of the rock expressed by dry brush strokes is negated by the broad strokes of saturated ink that link the boulder visually with the jumble of bamboo leaves — blunt leaves which give no indication of growing from a stalk. In the Gotō painting,

brush strokes which blur from pale to dark suggest the delicate translucency of orchid leaves nestled at the base of the plant, shielded by swaying blades. The orchid blossoms in the painting here audaciously assert their presence in uniformly gray strokes, vying for prominence with the longer orchid leaves. In the Gotō painting, by placing the rock lower on the page than the orchid plant, by sweeping horizontal strokes of pale ink over the foreground, and by varying ink tonalities in different motifs, Tesshū creates a narrow stage to contain his orchid. No such accommodation is made in the exhibition painting. Rock, bamboo, orchid blossoms, orchid blades, brambles — all the motifs lie flat on the picture surface in a two-dimensional design that signifies nature only in its convention, not in its form.

These orchids reflect a Chinese prototype different from the one Tesshū used for the Randag *Orchids and Bamboo:* their conventions can be traced to the style of Hsüeh-ch'uang P'u-ming. Both the orchid exhibited here and the Gotō painting follow the compositional arrangement of the lower half of one of the quartet of orchid paintings by Hsüeh-ch'uang in the Imperial Household Collection (fig. 71). An orchid plant grows beside a rock, spreading its long slender leaves above it to fill the width of the painting. Hsüeh-ch'uang's work is unquestionably more detailed and more realistic: graded ink wash describes the solidity of his rock and unambiguous placement of motifs defines spatial recession. But even a cursory glance at the orchid blades shows Tesshū's unmistakable debt to the Chinese master. A good comparison is the pair of blades which curve from the center of the cluster to the left in all three paintings illustrated, with the longer leaf crossing in front of the shorter before it twists at its top curve. A much shorter third blade follows the same coiling movement. This configuration conforms to Hsüeh-ch'uang's principle of painting orchid blades as it was recorded by Kung-ch'i, one of his followers: "The initial stroke should be heavy, the middle one light, the last one heavy, and the closing one somewhat light. This will show the leaves in their back, side, oblique, and frontal views just as in nature. There are three-turn strokes and four-turn ones. Leaves are shown in the manner of big fishing poles and small fishing poles."[3] Hsüeh-ch'uang also thought of his paired leaves in Buddhist terms: the longer one was the Mahāyāna blade (the larger vehicle), the shorter one the Hīnayāna blade (the smaller vehicle). Thus, the coiling of orchid leaves resulted from a painting method explicitly stated by Hsüeh-ch'uang P'u-ming and clearly followed by Tesshū. The tight in-

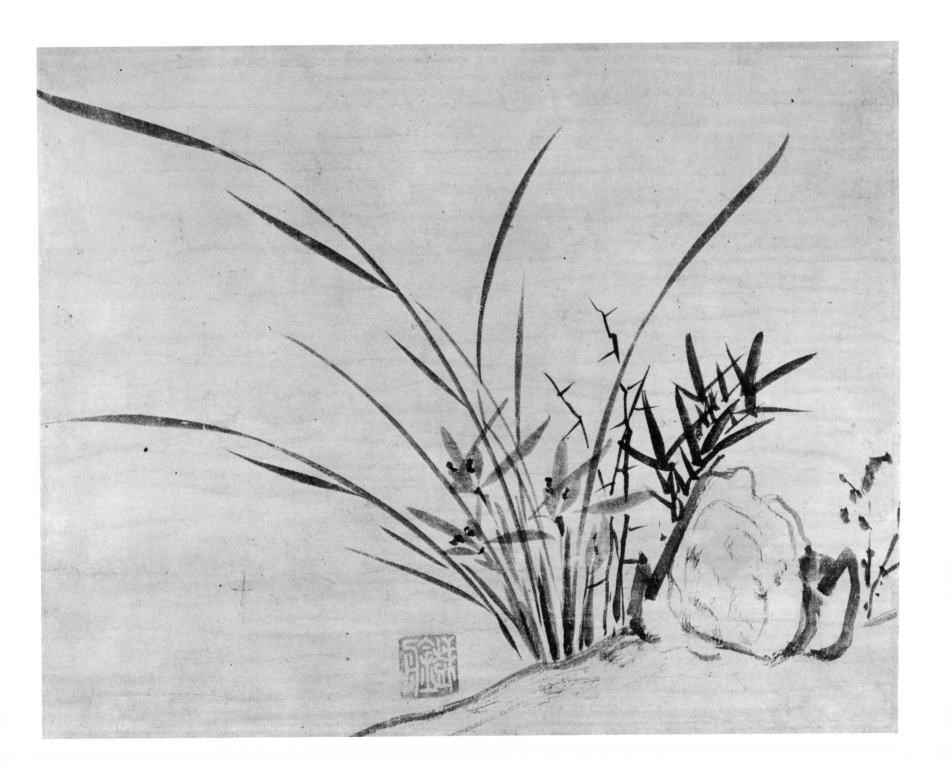

Figure 70. *Orchid and Bamboo,* Tesshū Tokusai (fl. 1342, d. 1366). Hanging scroll, ink on paper, 40.0 x 32.6 cm. Gotō Art Museum, Tōkyō

Figure 71. *Lingering Fragrance from the Nine Fields,* 1343, Hsüeh-ch'uang P'u-ming (fl. mid-14th century). Hanging scroll, ink on silk, 105.9 x 45.7 cm. Imperial Household Collection, Tōkyō

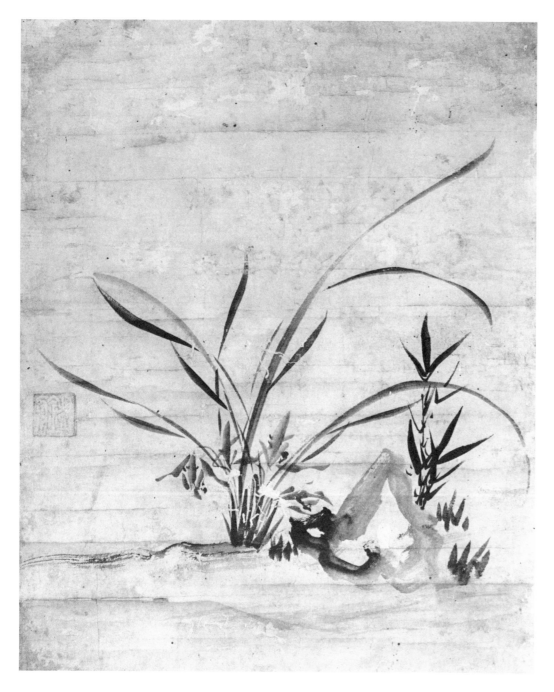

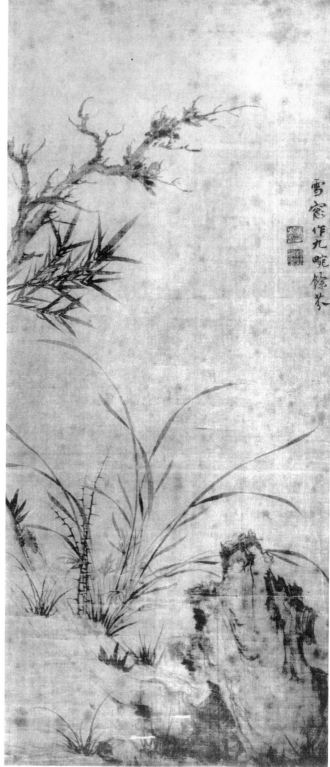

terweaving of blades in the Gotō orchid reveals greater reliance on the model and less individual freedom than does the more powerful sweep of the strokes in the orchid on exhibition, suggesting that the Gotō painting was an earlier attempt.

Tesshū's bamboo leaves also follow the brush conventions of P'u-ming in these two paintings. In contrast to the unified triple bamboo leaves in the Randag *Orchids and Bamboo,* here Tesshū combines a two-stroke unit with an additional third stroke; in contrast to the contained brush power in each bamboo leaf in the Randag painting, here Tesshū releases the brush energy with a trailing tip similar to that used by Hsüeh-ch'uang for bamboo. And in contrast to the organic unity of bamboo stalk and leaves in the Randag orchid, in both the Gotō painting and the orchid shown here the bamboo stalk is only implied; it is not delineated.

Tesshū's stylistic range can be noted in the rocks of his three orchid paintings. The Randag rock is solid, its flying-white brush strokes asserting rough textures and corporeality; the Gotō rock is conceptual, its form suggested by bold wash outlines. The rock in the exhibition painting is ambiguous, its bulging form suggested by swirling strokes of flying-white and then denied by heavy geometric outlines. But both rocks follow the tripartite model of Hsüeh-ch'uang's painting. Such stylistic range could readily be effected by a Japanese ink painter, and a clear parallel for the phenomenon seen here is the variety of styles identified in Bompō's work (see cat. no. 34): from the conceptual rock of his Roku'ō-in orchid (fig. 76) to the lumpy naturalism of the rock in the Metropolitan painting (fig. 78).

Although Tesshū seems to have taken Hsüeh-ch'uang P'u-ming as his model, just as Chō'un Reihō did (see cat. no. 33), Tesshū tended toward greater emancipation from his prototype. While Reihō's orchids were often so close to Hsüeh-ch'uang's paintings that they were attributed to the Chinese master, Tesshū moved away from Chinese naturalism toward greater spontaneity. His paintings, in the true literati tradition, were more abbreviated, more personal — and much more Japanese. His movement toward expressionistic independence from his Chinese model heralded the wave of the future. Japanese painting during the second half of the fourteenth century reveals a diversity and an individuality possible only when apprenticeship to a foreign style ends and fully nationalized mastery develops.

CAROLYN WHEELWRIGHT

NOTES

1. *Document 1:* the lid of the outer paulownia box containing the painting is inscribed by Tayama Hōnan (author of *Zenrin Bokuseki*); on the outside of the lid, he identifies the painting, "*Orchid* by Tesshū Tokusai," and on the inside he identifies himself, "Inscribed by Tayama Hōnan, early winter, Showa 46 [1971]." *Document 2:* a torn sheet of paper glued inside the lid of the inner box containing the painting, bearing the following unsigned inscription: "An *Orchid* by the brush of Tesshū. The seal is read *Tesshū*. He was contemporary with Gyoku'en, his *azana* [pseudonym] is Tokusai, he was a disciple of Musō at the Ryūkō-in of Saga [in Kyōto]." *Document 3:* a piece of worm-eaten paper, 19.35 x 15.24 cm (7⅝ x 6 in.), which identifies the painting as "*Orchid* by Tesshū," and gives a brief biography of Tesshū: "The founder of the Ryūkō-in [a subtemple of Tenryū-ji] of Saga [in Kyōto], his name is Tokusai, his *go* [art style-name] is Tesshū, he was a disciple of Musō Kokushi. In search of the [Buddhist] law, he went to China, and was given the title *Entsū Daishi* [Great Master of Perfect Penetration] by its emperor. After returning to Japan, he became the abbot of Manju-ji, one of the Gozan monasteries. When he was free from his ecclesiastical duties, he enjoyed painting ink landscapes and pictures of patriarchs. The mode of his painting is similar to Mu-ch'i and Yên Hui. He was a man of the Jōwa era (1345–50). Spring of [a cyclical date apparently corresponding to] the year 1852. Property of Ryū'an."

2. *Orchids and Rocks,* a pair of hanging scrolls on silk bearing poems inscribed by the artist and the square intaglio seal *Tesshū*, copied by Kano Tsunenobu (1636–1713), is one of the handscrolls on paper in the Tōkyō National Museum known as *Tsunenobu Shuku-zu (Miniature Copies by Kano Tsunenobu).* Published by Nakamura, "Tesshū Tokusai hitsu Rogan-zu," fig. 2 on p. 30, and Nakamura, "Tesshū Tokusai hitsu Ranchiku Seki-zu." The poetic inscriptions, one of which Asa'oka reproduces in *Koga Bikō*, p. 306, evoke the standard orchid imagery discussed in cat. no. 30: the fragrant orchids ("nation's fragrance") of the Ch'u region, the waters of the Yüan and Hsiang rivers that flow into Tung-t'ing Lake, the righteous suffering of the poet Ch'ü Yüan.

3. Kung-ch'i, *Chih-cheng Chih-chi,* quoted by Shimada, "Sessō ni tsuite," p. 59, and trans. by Li, "The Oberlin *Orchid,*" *Archives,* p. 55.

Reeds and Geese

Tesshū Tokusai (fl. 1342, d. 1366)

Hanging scroll, ink on silk,
109.22 x 45.72 cm.
Square intaglio seal reading
Tesshū.
Private collection

This painting forms a pair with a picture of *Reeds and Geese* by Tesshū now in the Metropolitan Museum of Art (fig. 72). When the pair was in Japan, they flanked an image of Lu Tung-pin, a Chinese Taoist Immortal. The triptych was dispersed in recent years, and the paintings went to three separate collections in the United States.[1] The Metropolitan painting bears the same *Tesshū* seal that is stamped on this scroll, but also carries an incomplete inscription with an imprecisely defined Chinese cyclical date.[2] Both scrolls represent the conservative strain in Tesshū's work. Painted on silk rather than paper, and rendered in graded tones of rich ink wash rather than the abbreviated calligraphic lines Tesshū used for his orchid paintings, these scrolls recall a handful of reeds-and-geese paintings appearing in carefully representational works by late-thirteenth and early-fourteenth century Chinese professional painters, such as the painting of reeds-and-geese in the *Ten Kings of Hell* in the Nison-in.[3]

Viewed from a distance, three groups of geese move in a river landscape much more descriptively portrayed than the other painting of *Reeds and Geese* in this exhibition (cat. no. 29). A broad sweep of ink wash zigzags from foreground into middle ground, terminating at a cluster of tall wind-blown reeds. In the vapory atmosphere, several geese stretch their necks to cry at the sky. One goose in the middle ground flutters his wings, about to join the airborne formation in the cloudy sky above. Ink wash silhouettes the birds' heads, necks, and wings, while short strokes of dark ink detail the eyes, beaks, legs, and feathers. The unpainted lower flanks of the geese are the grayish-white tone of the silk ground.

The four aspects of geese — flying, crying, sleeping, feeding (see cat. no. 29) — are combined in one composition. The sheer number of geese, twenty-five in all, makes the painting lively and even somewhat noisy. But the grouping is schematic. Geese involved in the same activity are simply repeated with little concern for individual variations. The flying geese are nearly identical; even the space between them varies little. Consequently the airborne group is locked in an unyielding formation without freedom of movement. A similar uniformity can be observed in the landscape setting. Both foreground and middle-ground shores are depicted by the formula of a narrow spit of land below the major projection of the river bank, and two smaller knobs of ground in the watery inlet between. The only motif rendered with the spontaneity characteristic of Tesshū's orchid painting is that of the reeds. Thread-thin stalks fan out atop the middle-ground terrain, their leaves brushed in with an agile flip of the artist's wrist. These quickly rendered plants contrast with the more deliberately detailed geese.

Tesshū painted these geese in their most socializing moment. The careful manner he used for painting the gregarious geese and the quiet mood of deep autumn conveyed by the dry reeds should be seen in relation to his personal feeling for the subject. Among his poems is one called *Mourning the Death of a Goose*, which contains allusions to traditional Chinese goose imagery and to the Buddhist notion of salvation for all sentient beings.

> *Long ago I dug a pond and planted reeds for you,*
> *Always anxious that you might be bitten by a fox*
> * and die.*
> *How I regret that you spent your life evading*
> * hunter's arrows*
> *Only to leave me now, but not as a messenger*
> * carrying my letter.*[4]
> *I could make friends with ground birds, but I*
> * have little time for them;*
> *I could talk with parrots, but I have no*
> * interest in their chatter.*
> *I pray that you will revive as a bird on the*
> * Pond in the West*
> *And await me there, preening the feathers*
> * of your green coat.*[5]

Tesshū Tokusai was an amateur painter best known for his orchids. But his artistic scope actually covered a wide range. His *Embushū* provides literary evidence that he painted landscapes (Mount Fuji is mentioned) and animals (specifically water buffalo and monkeys) as well as the literary man's orchids and the Zen monk's allegorical geese. He also painted geese in a second style, close-up views of the birds in sketchy spontaneous brushwork on paper, rather than the distant view seen here painted in meticulous ink wash on silk.[6] Unhampered by the burden of adhering to a single mode of expression, Tesshū's stylistic range indicates that, as a painter-monk, he was a true amateur in the best sense of the word.

YOSHIAKI SHIMIZU

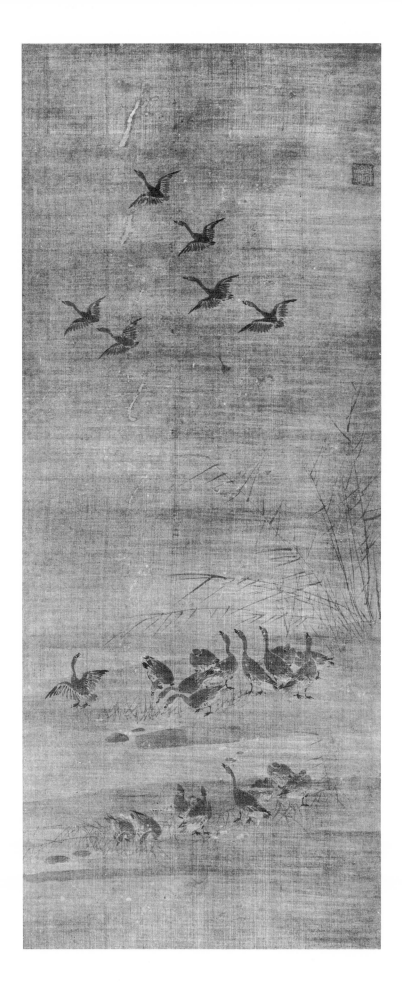

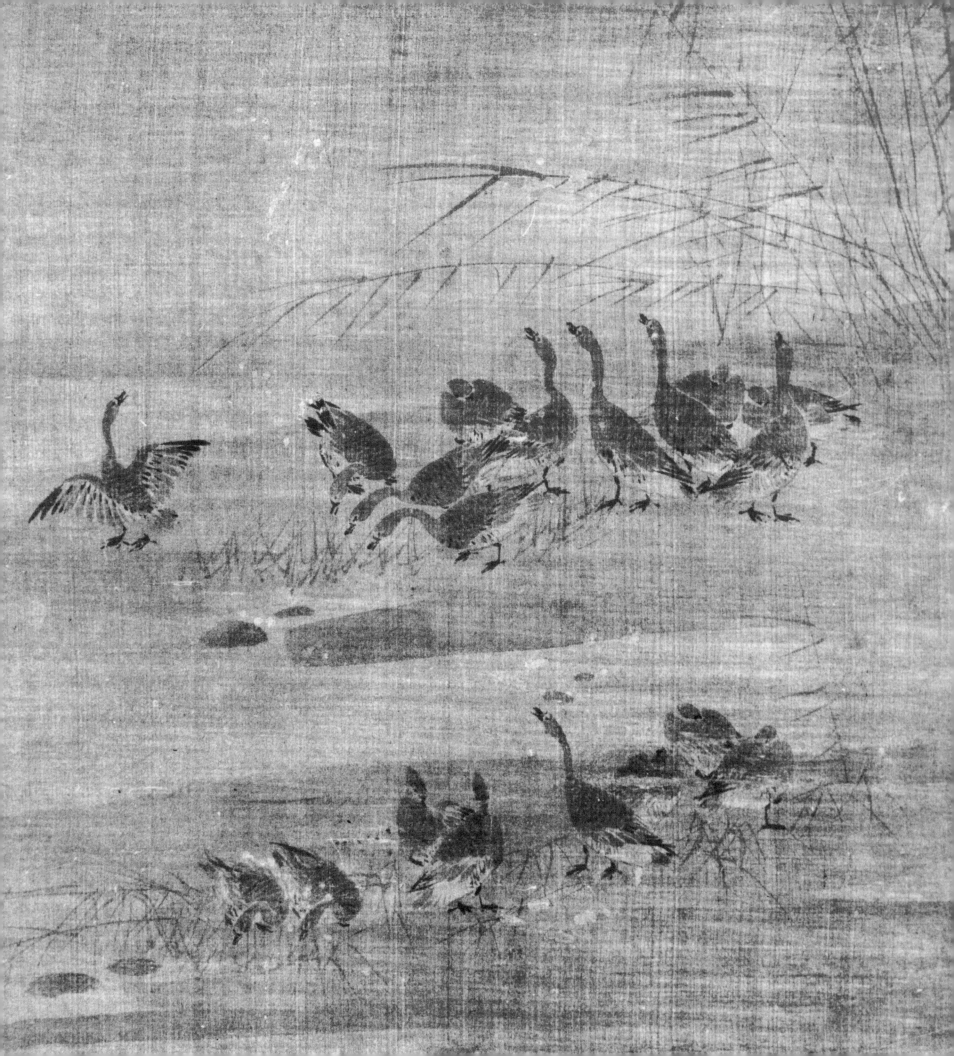

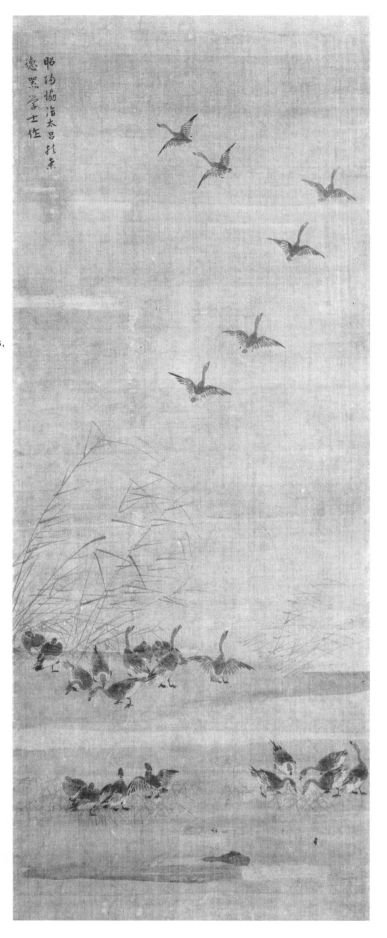

Left: Detail of
catalogue number 32,
Reeds and Geese

Figure 72. *Reeds and Geese,*
Tesshū Tokusai (fl. 1342, d.
1366), incomplete inscription
by the artist. Hanging scroll,
ink on silk, 111.4 x 44.5 cm.
Metropolitan Museum of Art,
Harry G. C. Packard
Collection of Asian Art,
Gift of Harry G. C. Packard
and Purchase, Fletcher, Rogers,
Harris Brisbane Dick and
Louis V. Bell Funds,
Joseph Pulitzer Bequest
and the Annenberg Fund,
Inc. Gift, 1975

NOTES

1. These paintings were combined into a triptych at some
time during the Muromachi period and remained in that form
into the 20th century, when they were in the Fuji'i Collection.
At that time they carried an unaccountable attribution to Mu-
ch'i. The central image of Lu Tung-pin was sold to the Nelson
Gallery in Kansas City in the 1950's, and Tesshū's pair of
geese became part of the Yabumoto Collection in Japan. Still
later, the *Reeds and Geese* were sold separately to private collec-
tors in the United States.

2. The inscription on the Metropolitan picture reads, "The
10th month, the year of *Kuei* [or *Ki* in Japanese], (—) of Fuso
(—) painted (—) scholar Te-chi [Tokki in Japanese]." It is in-
complete in two places. First, the cyclical date is insufficiently
indicated with only a *Kuei* (one of the ten stems), and lacking
the other element (one of the twelve branches) necessary to
define a cyclical date accurately. Second, a few characters are
missing: one or two for the name of the painter, and a charac-
ter meaning "for," or "for the sake of." There is a conspicuous
trace of deletion after the characters "Fuso." Some scholars
assume that "Te-chi" or "Tokki" may be the former name of
Tokusai (there are indeed some instances indicating that Japa-
nese Zen pilgrims were renamed while in China or changed
their names after returning to Japan), and therefore they iden-
tify the date as corresponding to 1343 since Tesshū returned
to Japan late in that year. Such an assumption, however, is
questionable, because there is no evidence that Tesshū had a
former name other than Tokusai, and because there are no
reliable examples of Chinese or Japanese Zen monks of the
14th century styling themsleves as *Hsieh-shi,* or "scholar," as is
indicated in this inscription. One thing clear in the inscription
is that the painter suggested in it is a Japanese, and that he
gave his Chinese friend this painting which he painted in ei-
ther China or Japan. In any case, the seal of Tesshū appears
not to be directly involved in the inscription. It requires fur-
ther careful examination.

3. See cat. no. 29, n. 10.

4. Tesshū refers to the special historical association of geese
as carriers of news from north to south. The Han dynasty
patriot Su-wu (fl. 100–70 B.C.) endured many hardships dur-
ing his long captivity by the Huns in the north. An early Chi-
nese historical chronicle records that the worried Han em-
peror learned of his loyal subject's suffering by shooting down a
goose carrying information about Su-wu written on a silk cloth
tied to its leg. (*T'ai P'ing Yü Lan, chüan* 917, Feathers 4, quotes
the account of Su-wu from the *Shih Chi.*) Tesshū poignantly
remarks that the death of his goose was totally without pur-
pose.

5. Tesshū Tokusai, *Embushū,* p. 440.

6. Published in Tanaka Ichimatsu, *Ka'ō, Moku'an, Minchō,*
pls. 74–75.

Orchid

Late 15th century copy after Chō'un Reihō (fl. mid-14th century)

Hanging scroll, ink on paper,
32.4 x 46.4 cm.
Inscription dated 1348 and
signed "Reihō."
Oblong relief seal reading
Shaku Reihō Chō'un Sho
(Seal of the monk Reihō
Chō'un), followed by square
relief seal reading Jū Kangiji
Sha Museishi *(Dwelling in the*
land of joy, painting a voiceless
poem).[1]
Allen Memorial Art Museum,
Oberlin College (57.12)

So close were the contacts between Chinese and Japanese Zen monks in China during the first half of the fourteenth century that some Japanese painter-monks, whose paintings found their way back to Japan, were later mistakenly thought to be Chinese by their countrymen. Moku'an Rei'en provides one example of this confusion. A similar case is that of Chō'un Reihō. In the fifteenth century Reihō was classified in the *Kundaikan Sayū Chōki* as a Chinese painter of orchids of the Yüan dynasty.[2] In fact, he was one of the Japanese followers of the Chinese orchid painter Hsüeh-ch'uang P'u-ming. Such errors in the identity of Japanese monks suggest that a considerable shift in perspective occurred during the early Muromachi period. In the fourteenth century these men were known to their contemporaries as Zen monks first and as painters second. In the fifteenth century, particularly in the artistic circles of the Muromachi Shōgunal household, their vocational identity was obscured by interest in the paintings ascribed to them. A major factor in the misidentification of Japanese painters as Chinese was the overall Sinophile attitude of the fifteenth century. But the paintings themselves must have contributed to the confusion, suggesting a close resemblance between the styles of Japanese monk-painters working in China and those of their Chinese contemporaries.

In the Oberlin painting, which was first identified as a Chinese painting by Hsüeh-ch'uang,[3] orchids, brambles, and bamboo leaves are depicted on paper in a small format. From the lower right, the orchids gently extend their blades toward the center of the composition. The slowly bending blades maintain a relatively even width and a uniform gray ink tone. The twistings and turnings of the brush are somewhat self-conscious and heavy, making the blades appear rather droopy. Rendered in dark ink, which contrasts with the gray tone of the orchid leaves, three brambles are sharply silhouetted at different heights slightly left of the orchid cluster. Clumps of bamboo leaves spread along the lower edge below the turning orchid blades. The bamboo leaves are as wide as the orchids', but are varied by a difference in tone between those in front and those in rear. Small rocks and pebbles, rendered in flying-white strokes of pale ink, define the foreground plane which links the bamboo clusters to the orchid plant. A single horizontal stroke of flying-white suggests a ground line to the left of the bamboo leaves. All plant motifs remain on the picture surface without receding into space. The blossoming orchid flowers are curiously aligned with the right edge of the painting: a deliberate cutting down of the orchid plants along this row of flowers has resulted in a somewhat cluttered appearance.

An inscription written in running-style calligraphy (Japanese: *gyōsho;* Chinese: *hsing-shu*) occupies the lower left of the composition. A four-line poem is accompanied by notes which explain the circumstances of the making of the painting.

> *Clear waves billow in the waters of the Yüan,*
> *Fragrant orchids flourish in the grasses of the Li.*
> *I recite poetry and sing now and then.*
> *Why don't I go home? As I linger time moves on.*

> *Spring of the year,* wu-tzu *of the Chih-cheng era* [1348]. *I attach this to Hsüeh-ch'uang's ink masterpiece to be sent far away to my old master and senior colleague in the Buddhist law, Chung-pao, for his pure enjoyment. Staying at Pei-shan in Middle Wu, your humble friend, Reihō.*[4]

In content as well as literary style,[5] the poem alludes to *Encountering Sorrow (Li Sao)*, the long narrative poem of the tragic hero Ch'ü Yüan (see cat. no. 30). The Yüan and Li rivers flow into Tung-t'ing Lake in Hunan, the area where Ch'ü Yüan wandered during his banishment and where he composed the poem associated for a millennium with fragrant orchids (literally, "the nation's fragrance"). The note following Reihō's poem explains that the writer is in Middle Wu, a region on the eastern coast of China, and that this painting was made to accompany an ink painting by Hsüeh-ch'uang as a gift to the monk Chung-pao. The inscription suggests that Reihō, like Tesshū Tokusai, was a *bunjin-sō,* a monk whose artistic personality was that of a literary man. The style of his calligraphy reinforces this impression, for it follows the most widely practiced running style of the eminent Chinese scholar Chao Mêng-fu (1245–1322).[6]

Reihō's comment that Hsüeh-ch'uang's ink masterpiece was intended for the pure enjoyment of his friend Chung-pao suggests a kindred spirit between the two men, related more to their appreciation of orchid painting than to their position as Zen Buddhist monks. In this sense Chung-pao was to Reihō what Gidō was to Tesshū (see cat. no. 30) and their relationship gives some insight into the artistic-intellectual milieu of Japanese monks in the fourteenth century. Unfortunately, the monk Chung-pao cannot be identified. He might have been a Japanese monk (in which case his name would be pronounced Choho) or, as assumed here, he

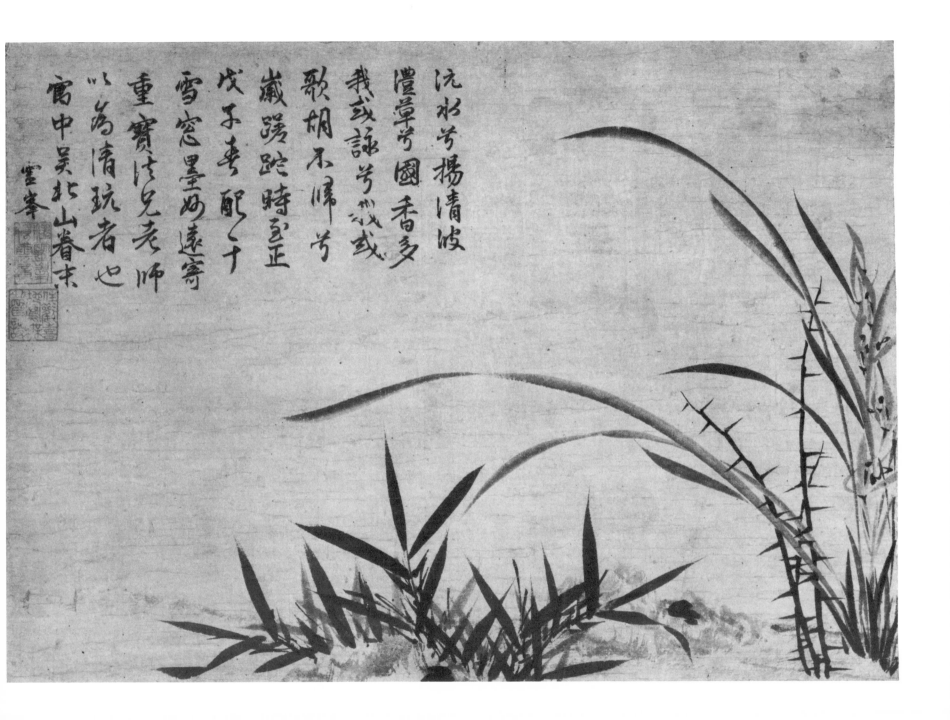

沉水兮揚清波
澧草兮國香多
我或詠兮或歌
歌胡不歸兮
巌蹊跣跣時豈正
戊子暮春眠乙子
雪窗墨妙遠寄
重寶付兄老師
以為清玩者也
富中吳於山卷末

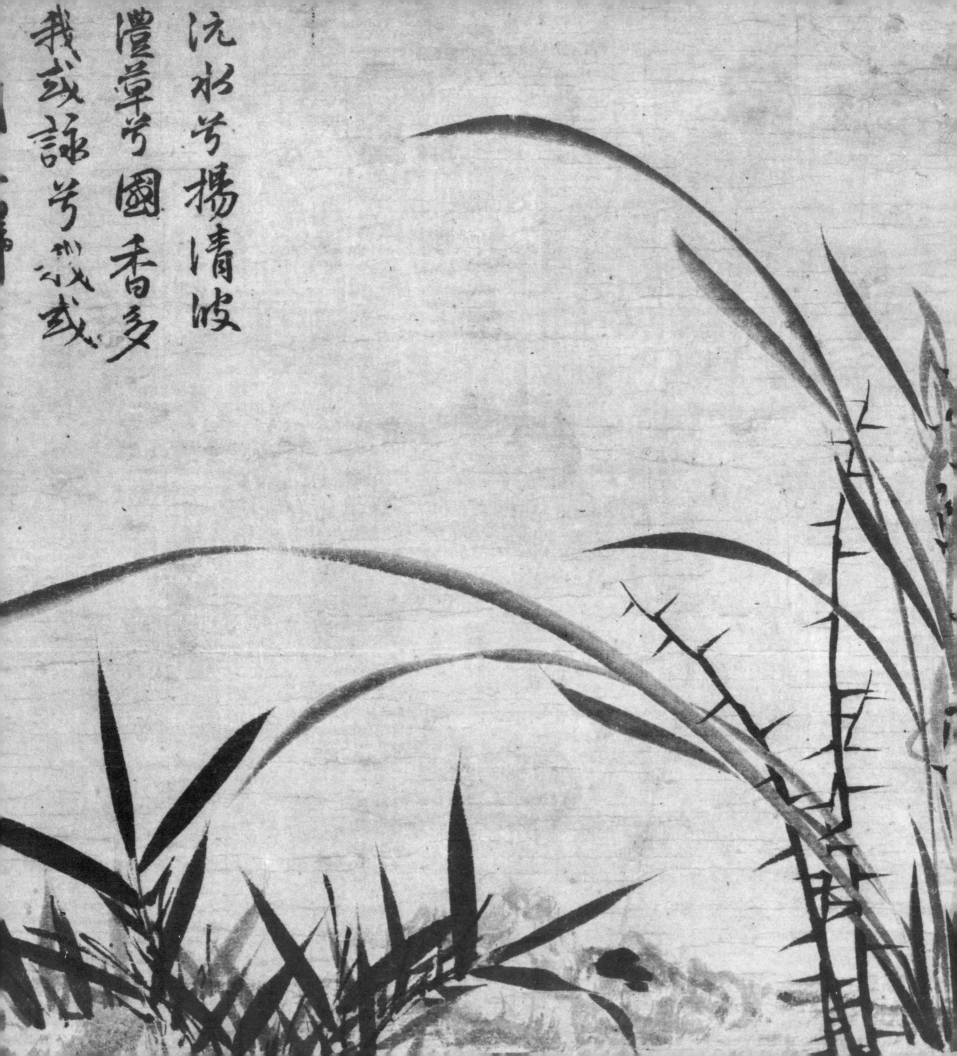

沉水兮揚清波
澧草兮國香多
我或詠兮州公或

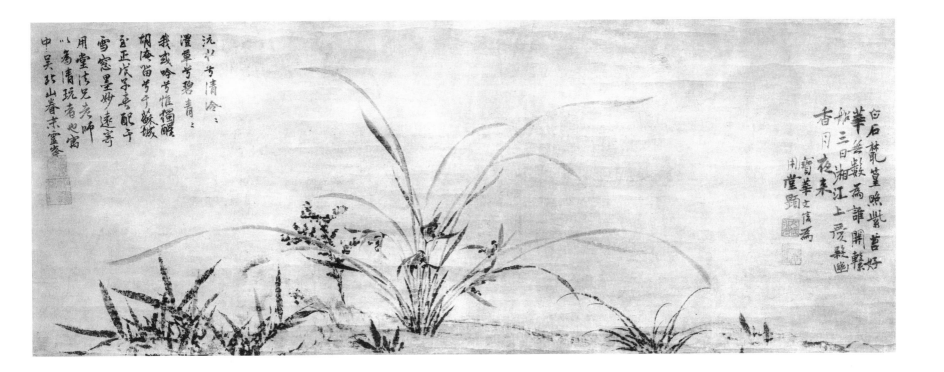

汜

Above: Figure 73. *Orchids,* Chō'un Reihō (fl. mid-14th century). Short handscroll, ink on paper. Collection unknown, formerly Gejō Collection, Tōkyō

Left: Detail of catalogue number 33, *Orchid*

might have been one of the Chinese monks with whom Reihō became intimately associated during his long sojourn in China.

Even though Chō'un Reihō was mistakenly identified during the Muromachi period as a Chinese orchid painter, his true identity was clearly known by his contemporaries. Gidō Shūshin recorded in his diary (*Kūge Nikkō Shū*) the words of a former pilgrim in China, who referred to Chō'un as one of two Japanese disciples of the orchid painter Hsüeh-ch'uang.[7] The Chinese also knew Reihō as Japanese: the Chinese scholar and poet Yang Wei-chen (1296–1370) composed a farewell poem for him when the Japanese monk was preparing to return home.[8] Such first-hand information on Chō'un suggests that he was well known by both Japanese and Chinese contemporaries as a monk of considerable artistic and literary ability.

Today three other paintings by Chō'un are known. One is an orchid painting formerly in the Gejō Collection (fig. 73), and the two others are known through carefully executed Kano copies. One of them depicts orchids and bamboo growing around a cliff (fig. 74)[9] and is strikingly similar to one of the four paintings by Hsüeh-ch'uang in the Imperial Household Collection (fig. 75). The existence of this copy indicates just how close Reihō's paintings could be to those of his Chinese master.

Painted in handscroll format on paper, the Gejō orchid reveals an effortless well-controlled turning of the brush for the orchid blades, rich well-saturated ink for the juicy bamboo leaves, and competent flying-white strokes for the pebbles and ground. When the Gejō painting was first published, it was hastily attributed to

Hsüeh-ch'uang P'u-ming, indicating its proximity to the style of the Chinese artist.[10] Chō'un's extraordinary technical mastery comes much closer than does that of Tesshū to Hsüeh-ch'uang's manner. The high level of artistic quality of the Gejō painting explains how his works could be confused with those of his master, Hsüeh-ch'uang; therefore this work becomes an important document for a consideration of the artist and the authenticity of the Oberlin *Orchid.*

The Gejō painting carries an inscription at the upper left: a four-line poem and notes to the poem, nearly identical to the inscription on the Oberlin painting.

> *Pure coolness of the waters of the Yüan,*
> *Fresh greenness of the grasses of the Li,*
> *Reciting poems now and then, I alone am sober.*
> *Why do I linger in the city of Suchou?*
>
> *Spring of the year* wu-tzu *of the Chih-ching era* [1348]. *I attach this to Hsüeh-ch'uang's ink masterpiece to be sent far away to my old master and senior colleague in the Buddhist law, Yung-t'ang, for his pure enjoyment. Staying at Pei-shan in Middle Wu, your humble friend, Reihō.*[11]

So this painting, too, was painted for a monk and close friend as a companion piece to a work by Hsüeh-ch'uang. The date is identical. The Gejō painting, however, is accompanied by a second inscription, a poem written by Wen-hsin, a priest of the Pao-hua-ssu monastery north of Hangchou.

The similarity of the inscriptions extends to the style of calligraphy: the Gejō inscription is also written in the running style of Chao Mêng-fu. There are also close

241

Figure 74. *Two Purities on the Cliff,* Kano copy of a mid-14th century painting by Chō'un Reihō. Tōkyō National Museum, Kano copy no. 6272. Photographic Archives, Department of Art and Archaeology, Princeton University, courtesy Tōkyō National Museum

Figure 75. *Lonely Fragrance on the Hanging Cliff,* dated 1343, Hsüeh-ch'uang P'u-ming (fl. mid-14th century). Hanging scroll, ink on silk, 109.5 x 45.7 cm. Imperial Household Collection, Tōkyō

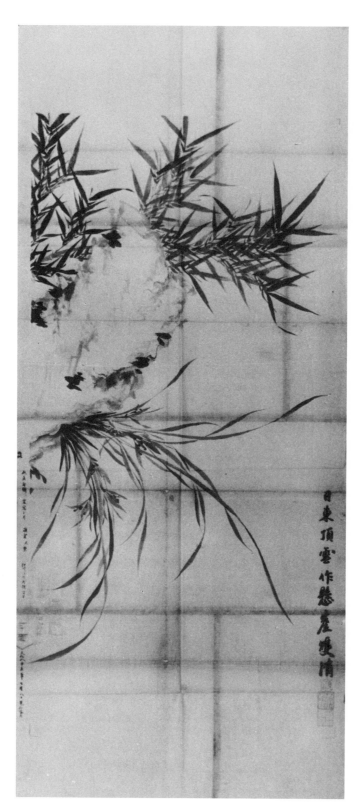

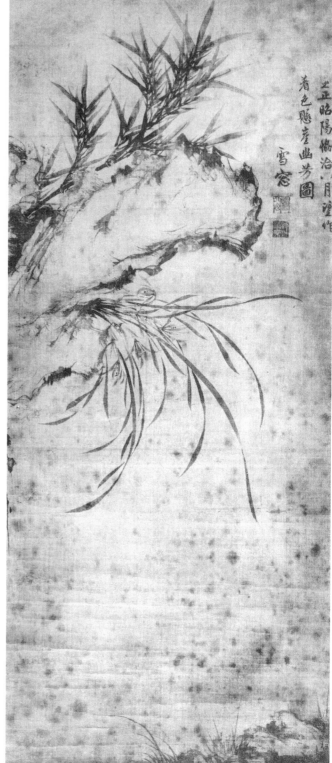

pictorial relationships: the bamboo motif and the orchid blades show stroke-by-stroke correspondence. The brambles in the Oberlin version are not present in the Gejō painting. In their place is a purple fungus, which is referred to in the second inscription on the right of the Gejō *Orchids*. In fact, the composition of the Oberlin painting corresponds to the left half of the Gejō version when divided along the center of the orchid plants. The disturbing truncation already noted in the Oberlin painting can be explained by considering the painting as only half of the original composition.

But the closeness of composition and motifs is offset by important stylistic differences between the two paintings, differences which indicate that these works were painted by different artists at different times. The carefully drawn orchid blades, the somewhat heavy appearance of their silhouettes, and the lifeless shadow-like bamboo leaves in the Oberlin painting strike notes of discord when compared with the Gejō painting and the Kano copy of *Two Purities on the Cliff*. Neither are they stylistically consistent with other fourteenth century orchid paintings such as those of Tesshū Tokusai (see cat. nos. 30 and 31).

A significant stylistic discrepancy also exists in the calligraphy in the Oberlin painting. The rhythm of the Gejō inscription is characteristic of the running style. A sense of ease and freedom results from the seemingly careless alignment of individual characters, the uneven spacing of the rows of characters, and the natural slanting of the columns. The Oberlin inscription lacks this easy rhythm. Regular spacing between columns and between individual characters is self-consciously observed. Even the running of the last stroke of one character into the first stroke of the next shows signs of deliberation — note especially the last two characters of the sixth line and the third and fourth characters of the eighth line from the right.

These observations lead to the conclusion that the Oberlin *Orchid* is a later copy of a composition which, in its complete form, must have looked very much like the Gejō painting. Precise dating is not possible, although it is inconceivable that it was painted before Bompō's early work (see cat. no. 34). A tentative date might be the late fifteenth century.[12]

YOSHIAKI SHIMIZU

NOTES

1. *Kangiji* is a Japanese reading of the Chinese Buddhist term *huang-hsi-ti*, which in turn is a translation of the Sanskrit term *pramudita*, meaning the bodhisattva's stage of joy at benefiting the self and others, which is the first of the ten stages (Japanese: *jūji;* Chinese: *shih-ti;* Sanskrit: *daśa bhūmayah*) in the development of a bodhisattva's path toward Buddhahood. "The voiceless poem" is a proverbial Chinese expression used to refer to painting, in contrast to "painting with voice," which designates poetry. Here Chō'un's seal clearly combines his calling and his avocation: Buddhist monk and painter.

2. *Kundaikan Sayū Chōki*, p. 651. For discussion of this book, see cat. no. 29, n. 13.

3. *Orchid* was first published as a Chinese painting by the Yüan dynasty painter-monk Hsüeh-ch'uang in "Selected Illustrations," Allen Memorial Art Museum *Bulletin* 16 (1959): pl. 243. It was reattributed to Chō'un Reihō by Chu-tsing Li, "The Oberlin *Orchid*."

4. The inscription has been translated in Li, "The Oberlin *Orchid*." The special binome *ken-matsu* (or *chüan-mo* in Chinese) preceding the signature is polite language meaning "one who is distantly related and receiving a favor."

5. The poem is written in *ts'ao* form, characterized by rhymed lines of irregular length and the patterned recurrence of a certain particle used for its sound.

6. The best example of Chao Mêng-fu's running-style calligraphy (*hsing-shu*) is a set of six letters addressed to Chung-feng Ming-pen in the Iwasaki Collection; published in *Shodō Zenshū*, 17: pl. 10. The letter is datable to 1304.

7. The entry is datable to sometime between 1374 and 1376 and reads, "The disciples of the recent orchid painter [P'u-]ming Hsüeh-ch'uang are Kō Reikō and [Rei] hō Chō'un, who are Japanese." Tsuji Zennosuke, ed., *Kūge Nichiyō Kufū Ryakushū*, p. 118. For a careful study of Gidō's diary, see Tamamura, "Kūge Nikkō Shū Kō."

8. Ku Ying, *Ts'ao t'ang ya chi* (preface 1349), *chüan* 3-B, Yang Wei-chen's poems, p. 43r, microfilm by Central Library, Taiwan, 1972. There are no records to indicate whether or not Reihō actually returned to Japan.

9. Both copies are among the Kano copies of ink paintings in the Tōkyō National Museum, registration numbers 6272–73. The orchid painting in fig. 74 has an inscription which reads "Nittō Chō'un Saku Kengai Sosei" ("*Two Purities on the Cliff* by Chō'un, the Japanese"). The second painting is *Bamboo*.

10. For a discussion of the style of Hsüeh-ch'uang, see Tanaka Ichimatsu, "Sessō no Rankei-zu ni tsuite."

11. The poem is also translated by Professor Li, "The Oberlin *Orchid*," p. 67.

12. Li came to a similar conclusion by a different method.

Orchids, Bamboo, and Thorns
Gyoku'en Bompō (1348–after 1420)

Pair of hanging scrolls, ink on paper, each 63.50 x 31.12 cm. Signature in grass-style calligraphy reading "Gyoku'en Ransha hitsu" (Painted by Gyoku'en, the Lazy One) on the left-hand scroll, with square intaglio seal reading Shōrin *beneath second character of signature. A similar, but not identical, seal is stamped on the right-hand painting.*
Four documents inside the wooden box with the paintings. [1]
Brooklyn Museum, Gift of Roebling Society and Oriental Art Acquisitions Fund (73.123.1–.2)

Japanese Zen communities that had been heavily influenced by Chinese practices in the early fourteenth century began to assume a more intrinsically Japanese character as the century drew to a close. The Chinese restoration of native rule by the Ming dynasty in 1368 brought restrictions on Chinese travel as well as strong nationalistic sentiments. Chinese monks no longer emigrated in large numbers to Japan. The Chinese masters who had dominated major Japanese monasteries during the first half of the century were gradually replaced by Japanese priests. Likewise, fewer Japanese monks traveled to China, and those who made the pilgrimage stayed on the mainland for relatively short visits.

During this period of Japanese acclimatization of Zen Buddhism the major priests, including Tesshū Tokusai (d. 1366; see cat. nos. 30–32) and his close friend Gidō Shūshin (1325–1388), were followers of Musō Soseki (1275–1351). Gidō never traveled to China, yet his excellent poetry written in Chinese gives testimony to the high literary achievement attained by Japanese monks in Japan. Although the cultural pull of China was still strong, a growing self-confidence characterized Japanese monks of this period. From the monastic communities led by this new generation of Japanese masters emerged the young priests who were to create a new cultural climate in the early fifteenth century. Under their leadership Japanese Zen culture became nationalized.

Gyoku'en Bompō was a prominent monk of the first quarter of the fifteenth century. Bompō, whose name means "the fragrance of India," was known as much for his artistic and literary talents as for his ecclesiastical career. Strongly individualistic, he left no disciples. The standard biographical sources are silent on his birth and death dates, but the fifteenth century scholar-monk Zuikei Shūhō recorded in his diary that Bompō was seventy-three (seventy-two by western count) in 1420.[2] Thus the year of his birth can be fixed to 1348. Little is known of his early life, except that in his late teens he came into contact with the eminent priest of the Eigen-ji monastery in Ōmi province (modern Shiga prefecture), Jakushitsu Genkō (1290–1367), who had studied in China under the illustrious priest Chung-feng Ming-pen (1263–1323).[3]

For over ten years Bompō was an acolyte or personal attendant (*jisha*) to Shun'oku Myōha (1311–1388), a nephew and disciple of Musō Soseki. He served first at Tōshō-ji in Kamakura, and in 1373 Gidō Shūshin reports that the young Bompō had changed his priest-name (*hōmyō*) from Gyokkei to Gyoku'en.[4] When Myōha became abbot of Nanzen-ji in late 1379,[5] Bompō probably accompanied him, for Gidō also moved to Kyōto in the following year to become abbot at Kennin-ji,[6] and he continued to mention Bompō in his diary. Bompō advanced in rank during the 1380's, becoming sūtra prefect (*zōsu*) and then scribe (*shoki* or *geki*), the two posts usually attained by young monks of literary talent.[7]

Both Myōha and Gidō died in 1388, leaving Bompō's biography hazy for the next twenty years. He became the twentieth abbot of Eikō-ji in Suwō province (modern Yamaguchi prefecture) and later served as abbot of Manju-ji in Bungo province (modern Ōita prefecture) in Kyūshū. At some time between 1405 and 1409 he became the seventy-eighth abbot of the important Kennin-ji monastery in Kyōto.[8] It is likely that he wrote his earliest extant calligraphic work, the preface to *New Moon over the Brushwood Gate* (*Saimon Shingetsu*, dated 1405),[9] while at Kennin-ji.

The cultural climate of Kyōto Zen temples could not have been more favorable for a monk of Bompō's caliber. The fourth Shōgun, Ashikaga Yoshimochi (1386–1428, see cat. no. 3), enthusiastically supported Zen monasteries and eagerly sought the company of leading scholarly monks, giving renewed vigor to the literary movement known as Gozan Bungaku.[10] Apparently Bompō associated closely with the Shōgun. Not only did he write the long preface for the poetry composed to dedicate Yoshimochi's newly built residence, the Yuzen-tei, in 1410,[11] but when Bompō became abbot of Nanzen-ji in 1413, the Shōgun Yoshimochi himself attended the inaugural ceremony.[12] Bompō's inscriptions appear frequently on paintings of this period, including *Banana Trees in Rain* (*Bashō Ya'u*, dated 1410),[13] Josetsu's *Catching a Catfish with a Gourd* (*Hyōnen*, ca. 1413, fig. 7), and *Cottage by a Mountain Stream* (*Kei'in Shōchiku*, dated 1413, fig. 8).

Although Bompō served less than a year as abbot of Nanzen-ji,[14] his affiliation with the monastery was of long standing. As early as 1380, when he was still with Myōha, Bompō lived in a subtemple of Nanzen-ji. The names of two subtemples, the Shōrin-in and the Chi-soku-ken, occur on Bompō's most frequently used seals.[15] Later he retired in the Tōrō-an, a subtemple he built for himself within the Nanzen-ji precincts, and there received a friendly visit from the Shōgun Yoshimochi in 1419.[16]

One morning in the fourth month of 1420, the sev-

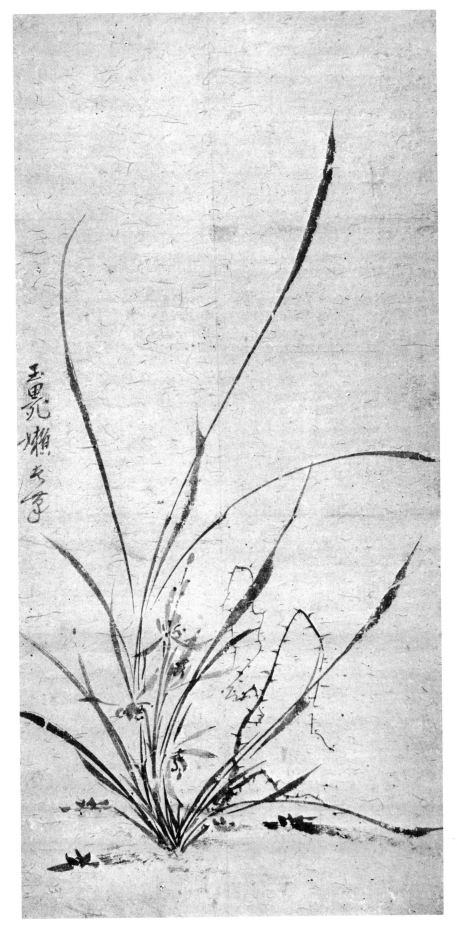

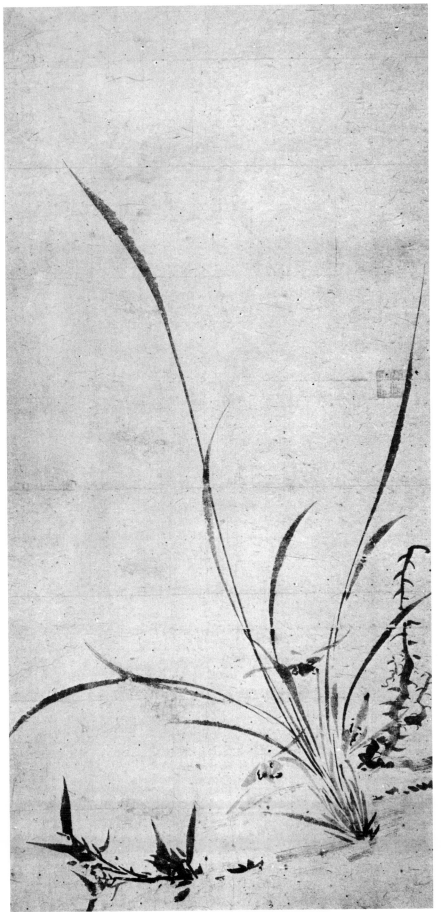

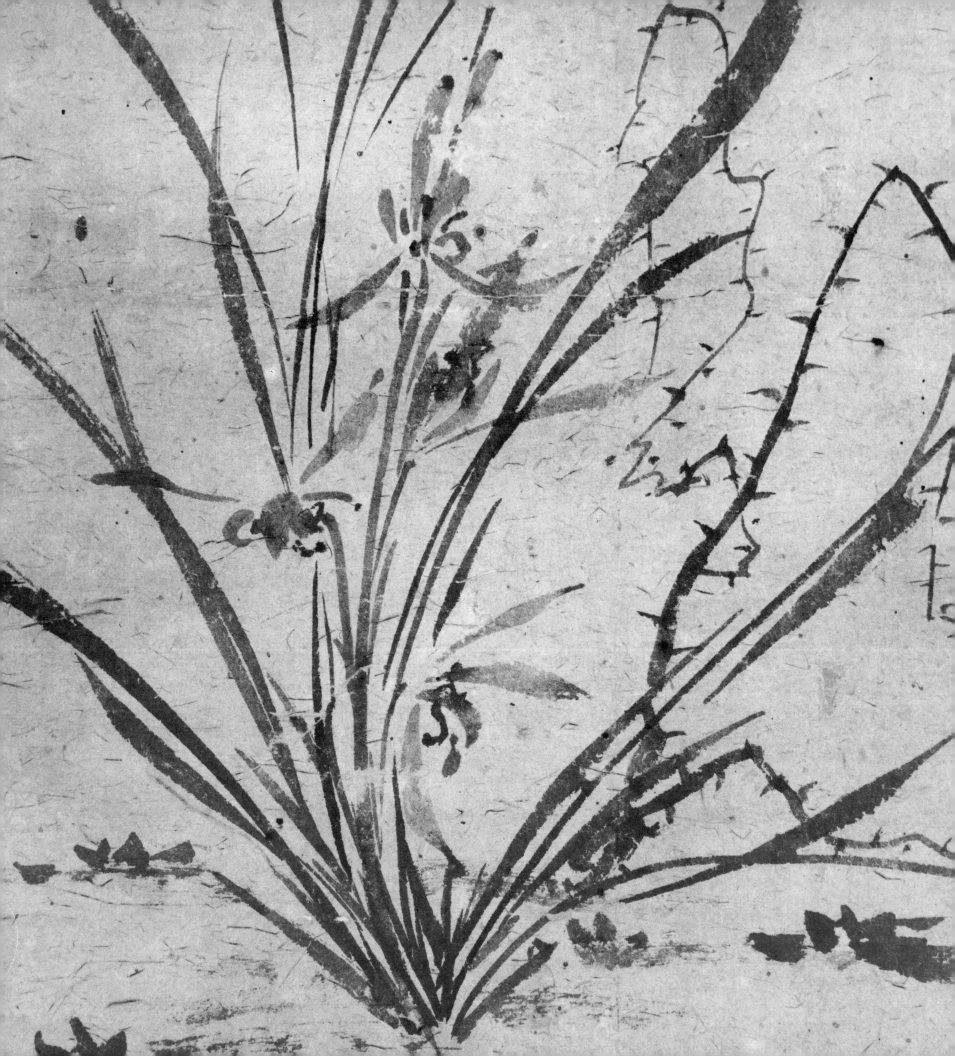

enty-two-year-old Bompō abruptly left the monastery. He spent the night in a temple outside Kyōto. The next morning he chanted the *Diamond Sūtra* and wrote an oath vowing never again to appear at a major metropolitan monastery, probably referring to Nanzen-ji. His oath concludes with a short poem expressing a desire for peace and comfort in the mountains. Then Bompō vanished.[17] A month later, the Imperial Prince Sadashige recorded in his diary a rumor that Bompō was exiled from the capital because of drinking,[18] but the cause for his departure is uncertain. It is generally believed, however, that Bompō and Yoshimochi strongly disagreed on political issues concerning Zen ecclesiastics and secular leaders. Perhaps Bompō left the capital under pressure exerted by the Shōgun.

Despite this possible slur on his political activities, Bompō sustained an excellent reputation throughout the Muromachi period as an outstanding humanist monk (*bunjin-sō*), accomplished in poetry, calligraphy, and painting. Gidō had commented quite early on the youthful Bompō's Chinese-style poetry, calling it "difficult to understand, using strange characters and often impossible to make out,"[19] but in time, Bompō's literary talent blossomed in the cultural milieu of Kyōto. As a calligrapher he was versatile, but he particularly excelled in the running style and the grass style modeled after the writing of Musō Soseki.[20] Orchid painting, however, was the area in which Bompō was most celebrated. One prominent fifteenth century monk later remarked that Bompō "trailed behind Hsüeh-ch'uang, his ink orchids unequalled under heaven."[21] In his early thirties Bompō had already been recognized by his master Myōha as a painter of orchids,[22] and Gidō records Bompō's orchid paintings many times in his *Kūge Shū*.

In spite of a career spanning over forty years, only about thirty orchid paintings by Bompō are recorded. Today about fifteen works attributed to him are known in Japan, but only half have been published. In the United States at least eight orchid paintings have been assigned to him. The Brooklyn *Orchids, Bamboo, and Thorns* are among the most recent additions to the corpus of Bompō's paintings in this country.

This pair of paintings shows two growths of orchids. In the painting on the right, orchids grow on slanting ground indicated by swift flying-white strokes zigzagging from foreground into middle ground. On the lower left, lush leaves of bamboo hug the earth. Behind the orchids two brambles cast their sinuous silhou-

ettes. The orchid blades spring from common roots, the shorter ones opening widely to right and left, rendered with subtle changes in ink tone. From the center of the cluster three longer blades flare out, two of them touching the edges of the painting. The tallest blade rises swiftly along the diagonal axis of the composition and gives a decisive tilt to the orchid group. Only three orchid blossoms appear.

In the painting on the left, orchids and brambles are grouped closely on flat terrain. Flying-white brush strokes indicate a modest space in the foreground, which is sparsely dotted with grasses. More flowers bloom in this group of orchids. The blades are painted with a variation in ink tone — the outer ones rendered in darker ink, the inner ones in slightly paler values. Tall blades sweep up and out. The longest one, as in the painting on the right, follows the diagonal axis of the composition. The orchids are more cohesively grouped than are those in the right-hand painting. The blades fan out, then curve inward; the space between them is narrower than in the right-hand scroll. Additional flowers and two curiously twisting brambles complicate the space between the orchid blades in the left-hand painting.

There are two manners of painting orchid blades in these works. One renders, in different tones of ink, blades of short and medium length that parallel or cross each other. These blades are grouped in a manner recalling the styles of Hsüeh-ch'uang, Chō'un, and Tesshū (see cat. nos. 30, 31, 33). The other renders the impossibly tall blades that spring up like insects' antennae. These blades find no precedent in early-fourteenth century works. The brushwork used for them is likewise unparalleled. A thin, sharp, center-tipped brush draws lines that spring out with no variation in thickening and thinning, no twisting and turning, until the very end, where heavy pressure is applied with the side of the brush. Hsüeh-ch'uang, and his Japanese followers Chō'un and Tesshū, paired orchid blades and changed ink tones for graceful undulations of long leaves. Bompō instead makes swift, almost impatient brush strokes that cut across the picture surface. Tall blades reach toward the uppermost area of the composition.

None of Bompō's surviving orchid paintings are dated, but they are known to have been executed during the last ten to fifteen years of his life since they display the seals that are stamped on some of his dated or datable inscriptions on landscape paintings.[23] The Brooklyn *Orchids, Bamboo, and Thorns* show some unusual stylis-

Figure 76. *Orchids,*
Gyoku'en Bompō (1348–after
1420). Hanging scroll, ink on
paper, 90.0 x 32.2 cm. Roku'ō-
in, Kyōto

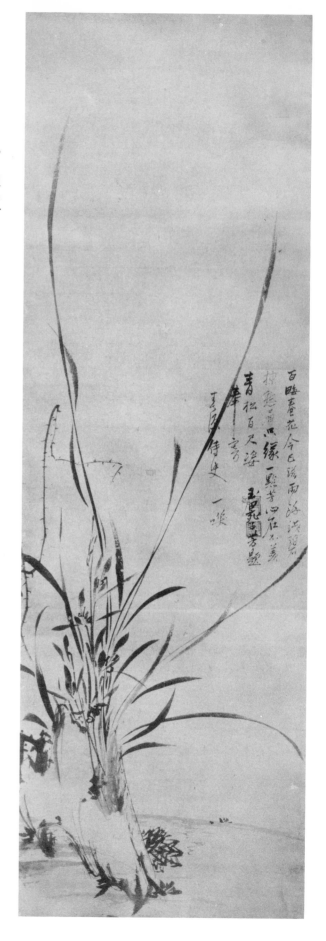

tic features not seen in most paintings attributed to Bompō, especially in other collections in this country.

Extant works assigned to Bompō may be classified into three stylistic groups. The first group consists of the *Orchids* in the former Gyokuryū-in Collection, a pair of *Orchids* in the Burke Collection, *Orchids* in the Freer Gallery of Art, and the Roku'ō-in *Orchids* (fig. 76).[24] The use of flying-white strokes in these paintings is limited to the contour of the rock and groundline. No substantial texturing of the rock motif occurs. The rocks can be related to Tesshū's *Orchid and Bamboo* in the Gotō Museum and to the painting shown in cat. no. 31. Blades of short and medium length seem to spring in many directions, crisscrossing, juxtaposing, superimposing. Yet the blades remain in pairs projected from common roots. They still have features close to the orchid paintings of Hsüeh-ch'uang and Tesshū. One or two tall blades spring from the center of the orchid cluster, their long sweeping strokes contrasting with the slow heavy bends of the short blades. Like Tesshū's Randag *Orchids and Bamboo,* the orchid flowers contained within the blades are not immediately noticeable. Also like Tesshū's painting, in each of Bompō's orchids in this first stylistic group, an accompanying motif, such as brambles, balances the energetic projection of the blades. The swift, spontaneous brush movement of the long blades, however, departs from styles of the early fourteenth century.

Paintings in the second group include *Orchid, Bamboo, and Rock* formerly in the Fuji'oka Collection in Japan, the *Rock, Bamboo, and Orchids* in the Cleveland Museum of Art, and *Orchids* in the Japanese Fuji'i Collection (fig. 77).[25] The foreground rock asserts corporeality, its surface activated by texture strokes of flying-white paralleling the contour of the rock. Something like hemp-fiber texture strokes and dark dots give tactile quality to the rock. Such rock features cannot be found in Tesshū or Hsüeh-ch'uang: a different prototype must be assumed. Orchid blades impatiently spring in multiple directions, although parallel projections of blades of similar length are noticeable. A blade bending in one direction is countered by another in the opposite direction. The Fuji'i painting shows full expression of the flaring-out of blades that occurs in the Roku'ō-in version (fig. 76), and the blades begin to weave a net over the picture plane. Bending movements are more pronounced in paintings of this second group: curve and counter-curve in the orchid blades echo brushwork motions of the rock. The busily intertwining leaves do not grow representationally from their roots. Some merely float, like

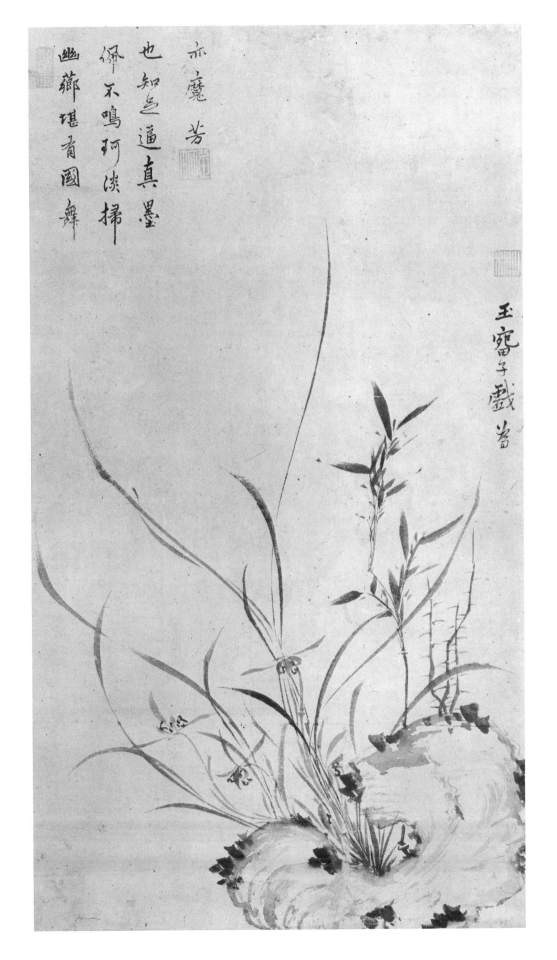

Figure 77. *Orchids*, Gyoku'en
Bompō (1348–after 1420).
Hanging scroll, ink on paper.
Fuji'i Collection, Nishinomiya,
Hyōgo prefecture

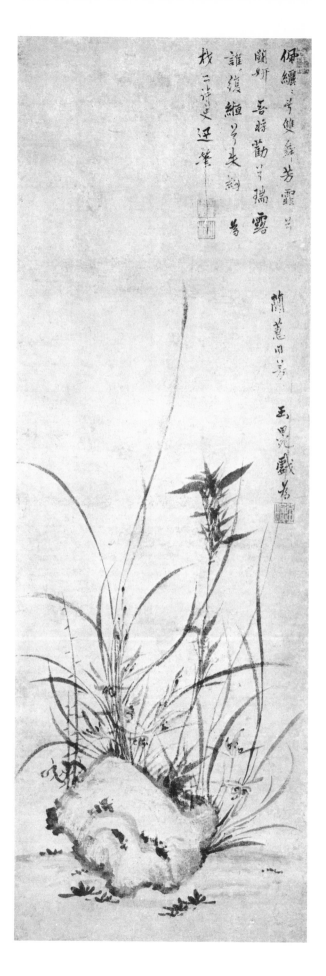

Figure 78. *Orchids,* Gyoku'en
Bompō (1348–after 1420).
Hanging scroll, ink on paper,
106.5 x 34.5 cm. Metropolitan
Museum of Art, Harry G. C.
Packard Collection of Asian
Art, Gift of Harry G. C. Packard
and Purchase, Fletcher,
Rogers, Harris Brisbane Dick
and Louis V. Bell Funds,
Joseph Pulitzer Bequest and
the Annenberg Fund, Inc.
Gift, 1975

arcs spinning out of circles. Always two or three tall
blades whip through the gyrating blades of short and
medium length, a distinct mark of all of Bompō's or-
chids.

Three paintings belong to the third stylistic group:
those in the Asano Collection in Tōkyō, the Masaki Art
Museum, and the Metropolitan Museum (fig. 78).[26] Un-
like the paintings of the first two groups, here the rock
and orchids are more independent. The solidity of the
rock motif is enhanced by the contour line as well as by
texturing and dotting. Foreground space leading to the
rock creates a more representational picture; grass in
front as well as on either side of the rock establishes
clear spatial relationships for the ground plane. Plants
appear to grow in profusion, and massed orchids seem
to embrace the rock from either side. A confusing clus-
ter of arcs at their bases, the blades gradually open mid-
way up and finally fan out close to their tips. The luxu-
riance of blades is made more complex by a wider dis-
tribution of orchid blossoms. The overall centering of
the major motif as well as the spatial recession indicated
in these paintings suggest a third prototype.[27]

Of these three orchid styles, the Brooklyn scrolls be-
long within the conservative group related to Hsüeh-
ch'uang's orchid painting. They are especially close to
the Roku'ō-in painting (fig. 76), sharing a similar
scheme that pushes the motifs into the corner. Both the
Brooklyn and Roku'ō-in works retain Hsüeh-ch'uang's
formula for depicting blades. The role of flying-white
strokes is similar, and the brushwork of the orchid
blades is comparable. Finally, the curious twisting of
brambles, a rather playful element in the Roku'ō-in
painting, appears in the left-hand painting of the Brook-
lyn pair.

This stylistic division of Bompō's orchids does not
imply a chronological progression; a thorough analysis
of his dated inscriptions would be necessary to establish
a stylistic sequence for the three different groups. It can
reasonably be concluded, however, that the Brooklyn
Orchids, Bamboo, and Thorns is contemporary with the
Roku'ō-in scroll. The similarity of the orchid style is
reinforced by the similarity of calligraphic style. Done in
expert grass-style writing, the two characters "gyoku"
and "en" are remarkably close.

YOSHIAKI SHIMIZU

NOTES

1. Documents inside the box include: 1) a certificate of authenticity by the Edo connoisseur Kohitsu Ryōchu (1656–1736; see cat. no. 11, n. 17), giving a cyclical date corresponding to 1705; 2) a certificate of appreciation and authenticity by the Edo connoisseur Kohitsu Ryōhan (1790–1853), giving a cyclical date corresponding to either 1836 or 1848, 9th month; 3) an undated anonymous note on the biography of Bompō, quoting from the *Mampō Zensho*, a book of information for connoisseurs published in 1852, with sketches of Bompō's signature and seals — a marginal note mentions briefly that the pair was inherited by two generations of a certain Watanabe family; 4) an undated, modern transcription of Bompō's biography given in the *Kantei Benran* (1853).

2. Zuikei Shūhō, *Ga'un Nikkenroku*, entry for 1st year of Hōtoku (1449), intercalary 10th month, 4th day, pp. 44–45. Most of the major biographical references on Bompō are collected in *Dainihon Shiryō*, section 7, 18: 20–28. The earliest scholarly article on the biography of Bompō is Kumagai, "Gyoku'en Bompō Den."

3. *Kōshū Eigen-ji Kaizan En'ō Zenji Gyōji* in *Zoku Gunsho Ruijū*, 9B:587–91. See also *Dainihon Shiryō*, section 7, 18:23.

4. Gidō Shushin, *Kūge Nikkō Shū*, p. 81, entry of O'an 6th year, 11th month, 17th day. *Kūge Nikkō Shū* is the commonly used abbreviation for the full title of Gidō's diary, *Kūge Nichiyō Kufū Ryakushū*. It should not be confused with the anthology of his literary works, the *Kūge Shū*.

5. *Chikaku Fumyō Kokushi Goroku*, kan 6, in *Taishō Shinshū Daizōkyō*, 80-4:696.

6. *Ibid*. See also Gidō, *Kūge Nikkō Shū*, in Tsuji, p. 124.

7. Gidō Shūshin, *Kūge Shū*, p. 578; and Zekkai Chūshin, *Shōkenkō*, p. 1050. See also *Dainihon Shiryō*, section 7, 18:47–48.

8. *Dainihon Shiryō*, section 7, 18:24.

9. This frequently published work can be found in *Higashiyama Suibokugashū*, vol. 1; *Kokka*, no. 446; and *Bijutsu Kenkyū*, no. 4.

10. Tamamura, *Gozan Bungaku*, pp. 196–98, 213–34.

11. Tamamura, "*Shōkoku-ji Zenjūseki* Fusai no Gōzan Shiryō." See also *Dainihon Shiryō*, section 7, 18:28–29.

12. Manzei, *Manzei Jugō Nikki, Zoku Gunsho Ruijū*, supp. 1, entry for O'ei 20th year, 3rd month, 18th day. See also *Dainihon Shiryō*, section 7, 18:20.

13. Published in *Kokka*, no. 396, and *Bijutsu Kenkyū*, no. 8.

14. The entry of Ō'ei 20th year, 10th month, 18th day in *Manzei Jugō Nikki* records an inaugural ceremony at Nanzen-ji. Since Bompō's ceremony has already been mentioned in the 3rd month, this occasion must have been for another abbot succeeding him.

15. The Shōrin-in subtemple was built for the Chinese priest Ming-chi Ch'u-shin with the help of Musō Soseki. The Chisoku-ken, an annex of one of the subtemples of Nanzen-ji,
is no longer in existence. The distribution of seals used by Bompō is discussed in Usu'i, "Gyoku'en no In."

16. The entry of Ō'ei 26th year, 6th month, 19th day in the *Manzei Jugō Nikki* records that Yoshimochi came to Bompō to get "immortal pills," perhaps some kind of Chinese medicine.

17. Zuikei Shūhō, *Ga'un Nikkenroku*, entry for Hōtoku 1st year (1449), intercalary 10th month, 2nd day, pp. 44–45.

18. Fushimi Sadashige, *Kammon Gyoki, Zoku Gunsho Ruijū*, supp. 3, entry for Ō'ei 27th year, 5th month, 4th day. See also *Dainihon Shiryō*, section 7, 18:26.

19. Gidō Shūshin, *Kūge Nikkō Shū*, entry for O'an 3rd year, 8th month, 13th day.

20. Compare with Musō Soseki's calligraphy in *Nihon Kōsō Iboku*, 2: pls. 52–53.

21. This is a line from a poem called "Orchid Painting by Bompō" written by Ten'in Ryūtaku (1404–82), recorded in Ishin Sūden, *et al.*, *Kanrin Gohōshū*, kan 41, p. 853.

22. *Chikaku Fumyō Kokushi Goroku*, kan 6, in *Taishō Shinshū Daizōkyō*, 80-4:696.

23. See Usu'i, "Gyoku'en no In."

24. Gyokuryū-in is a subtemple of Myōshin-ji. The painting has not been published, but a photograph is in the possession of Professor Shimada. The pair of orchids in the Burke Collection is published in Nakamura, "Gyoku'en Bompō hitsu Ran-zu," in Shimada, ed., *Zaigai Hihō*, text vol. 1, p. 102, and *Masterpieces of Asian Art in American Collections, II*, pl. 51. The Freer *Orchids* are published in *Kokka*, no. 768, and in Stern and Lawton, *The Freer Gallery*, 2: pl. 24.

25. The former Fuji'oka Collection *Orchid, Bamboo, and Rock* is now in the collection of Sylvan Barnett of Cambridge, Mass., and is published in Fontein and Hickman, *Zen Painting and Calligraphy*, no. 41. The Cleveland painting, is published in the Cleveland Museum of Art *Bulletin* 59 (1972): figs. 13–13a.

26. The Asano *Orchids* are published in Tanaka Ichimatsu, *Moku'an, Ka'ō, Minchō*, pl. 15. The Masaki *Orchids* are illustrated in a small exhibition catalogue, *Masaki Bijutsukan Shuppin Mokuroku*.

27. A possible prototype for this third style might be a painting such as the Nezu Museum orchid attributed to T'an Chih-jui reproduced in *Kokka*, no. 664, and Fontein and Hickman, *Zen Painting and Calligraphy*, no. 27. A painting of *Bamboo and Rocks* in T'an Chih-jui's style attributed to Bompō is published in *Kokka*, no. 634.

Lotus
Artist unknown (15th century)

Pair of hanging scrolls, ink on paper, each 82.55 x 55.56 cm. Private collection

Sheltering a quiet pond, two clusters of lotus lean toward each other. Full-blooming flowers among succulent leaves sway above gently eddying water. Plump fish swim among the rocks and a crab pulls himself onto a leaf. The tranquil opulence of this natural spot is enhanced by the simplicity of the artist's technique. Within a limited range of ink tonalities, drawn as contours and applied in washes, he manages to capture the luxuriance of the water plants.

The six blossoms in the two scrolls display subtle variety in degree of flowering, but all are fresh, none is worm-eaten or dying. A flowing line contours the closed bud in the left scroll, and textures the veins of its furled petals with alternating wavy and smooth lines. The flower at the upper left has opened, exposing the translucent white of its inner petals in contrast to its veined underside. A pink lotus above echoes the efflorescence of the white one, with the faint ink wash of its petals lightening toward the center in imitation of its delicate coloring. The two lotus in the right scroll are at the height of their flowering. Silhouetted against a dark leaf, the lower blossom's intermediate tone results from the fact that most of its petals are seen turned up to exhibit their textured undersides. The topmost lotus has just passed its peak: its petals loosen, showing the fertile center of filaments and spores. Between the leaves on the right edge of the painting, only the bottom rear of a sixth flower is visible.

Generous leaves set off the blossoms. Seen from the side, the top, the back, these leaves display a variety of growth that gives life to the plants. The underside of the leaf remains the mellow gray of the paper, while a pale ink line thickens and thins as it contours the form and draws in the branching veins. The dark upper side of the leaf contrasts in tone and technique. A medium-gray wash suggests the deep green of the plant in nature, with reserved lines of lighter gray describing the primary veins. Soft dots of darker ink on either side of the veins denote juicy tissues. For variety, and to provide a darker ground for the silhouetted blossom, the artist draws the veins for the upper leaf in the right scroll in darker ink.

Unfortunately the paintings have suffered considerable damage, clumsy retouching, and reduction in size. Two large circles of damage are obvious in the upper center of the right scroll; less apparent are the many small patches which have been redrawn and retoned. A great deal of repainting using ink of a different shade, one with an opaque blue cast, widens the range of ink tonalities and inadvertently creates effects of volumetric shading. Most of the darker ink wash on the upper side of the lotus leaves was added later: retouching is responsible for the impression of deep cupping of the two leaves on the left scroll, for the great contrast that makes the silhouette of the blossom in the right scroll so vivid, and for the illogically patterned spread of light veins over the dark leaf at lower right. The awkward hand and misunderstanding of a later painter is also responsible for ambiguities such as the odd curl of the lotus leaf near the middle of the right edge, the globular white lump seen beneath the lower leaf in the right scroll, and the formlessness of the leaf floating on the pond at the bottom of the left scroll. The lotus stems and certain of the reeds are restored, but for the most part the blossoms are in their original condition. The crab and the fish (except the upper part of the fish farthest left) escaped damage, but their closeness to the bottom edge, and the fact that the upper left reed sweeps against the top edge, indicate that the scrolls were once at least four or five inches taller, and probably a few inches wider as well.

The mass of leaves and blossoms project into each painting from one side. Seen as a pair, the two outer edges cut off the lotus cluster, implying lateral extension of the lush vegetation, while the two inner edges are open neutral space. The clumps of lotus curve toward each other like parentheses enclosing the quiet pond. Stems bending up from the water at the bottom and reeds sweeping over the flowers at the top emphasize this reciprocal gesture. This quiet convergence of nearly symmetrical compositions is the unique feature of these scrolls when viewed in the context of other lotus painting.

The concern for realistic depiction of flowers in nature developed in Japan under the influence of Chinese academic painting: the carefully descriptive style associated with the painting academy overseen by the emperor-artist Hui-tsung (r. 1101–1125). Its forte was realism and its most representative subjects were flowers and birds. Chinese scholar-painters of the late Sung and Yüan (twelfth through fourteenth centuries) scorned academic flower-and-bird painting as stereotyped, bound to rules, and plagued by the superficiality which results from expressing only objective "form likeness" without due regard for the essential expression of the artist's own subjective "spirit resonance" (Chinese: *ch'i-yün;* Japanese: *ki-in*).[1] Thus in China, from the mid-twelfth century on, realistic flower-and-bird painting largely became the province of professional painters,

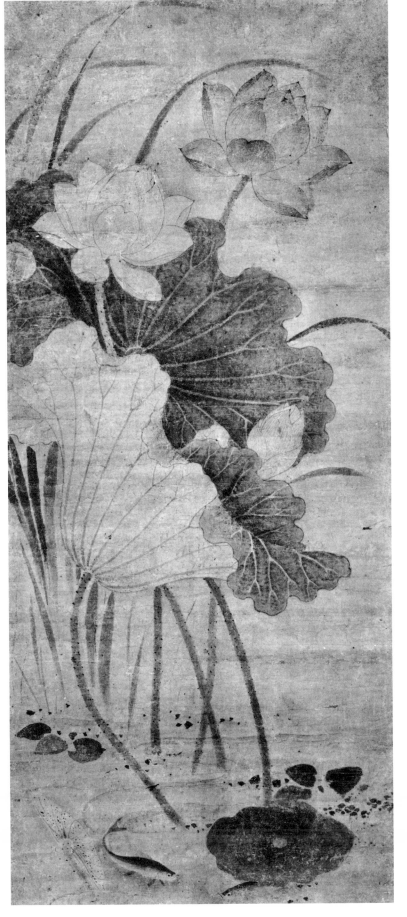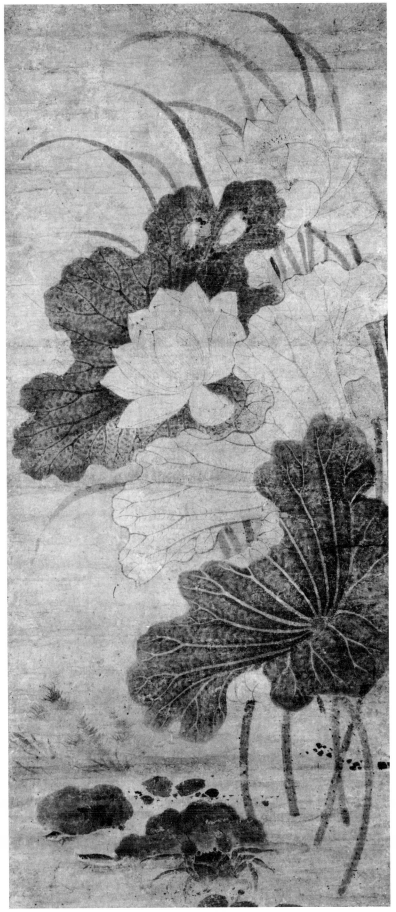

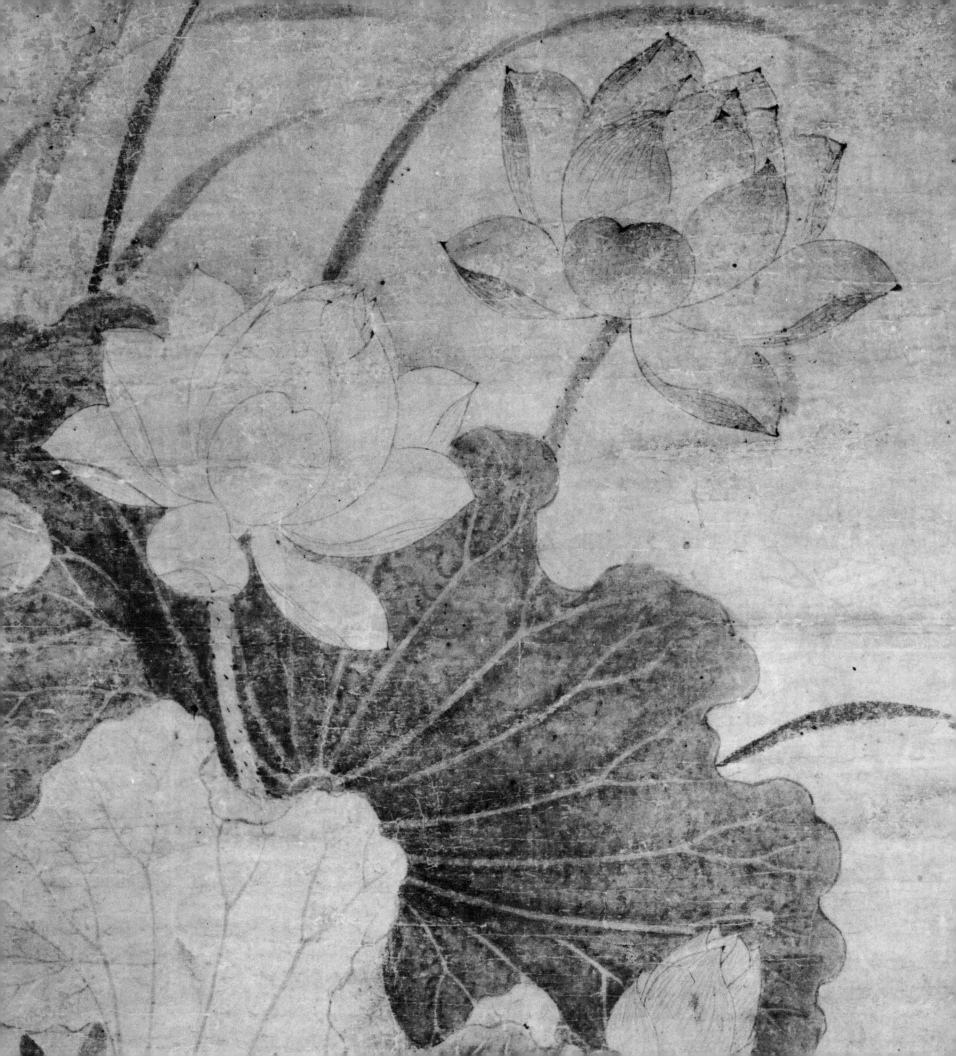

both in and out of the academy, working in traditional styles. But such a social distinction affecting subject matter and style had no relevance for Japanese artists, who took models from all Chinese paintings available to them. Monk-painters such as Tesshū, and Bompō adopted Chinese scholar-subjects (bamboo and orchid), and rendered them in the abbreviated expressionistic techniques associated with Chinese amateur painters (see cat. nos. 30 and 34). Other artists, like the unknown creator of this pair of *Lotus* scrolls, sought inspiration from the carefully descriptive flower-and-bird paintings of unacclaimed late Sung and Yüan professional painters.

Two traditions of flower painting existed in China: the older lineage of painting in full color and the more recent one in ink alone. Flower painting is first mentioned as a subject for artists in early T'ang period texts.[2] In the tenth century it had developed sufficient scope to sustain the two most celebrated artists in the genre: Hsü Hsi, noted for "boneless painting" (Chinese: *mo-ku-hua;* Japanese: *mokkotsuga*) which used washes of color without strong outlines, and Huang Ch'üan, acclaimed for the opposite technique of "outline painting" (Chinese: *kou-lê hua;* Japanese: *kōrokuga*) in which definite boundary lines are filled in with color. How their paintings looked is a matter of conjecture since none survive, but the two methods associated with these legendary artists remain as part of the critical terminology used to discuss Chinese flower painting. A third near-mythic figure in the genre is Ts'ui Po, who was active in the court of Emperor Shên-tsung (r. 1068–1085) and was especially noted for his lotus, as well as for the reeds-and-geese discussed in cat. no. 29. His careful style, using detailed brushwork and fresh coloring, resulted from close observation of nature and set the standard for the academy under Hui-tsung, replacing the Huang family style.

Four pairs of Chinese lotus paintings in color exist in Japanese collections to illustrate the stylistic evolution from early Southern Sung (early-twelfth century) through late Yüan (fourteenth century). The earliest is a large two-fold screen owned by the Hōryū-ji monastery, showing a lotus lake with herons in a continuous composition.[3] The other three pairs are complementary hanging scrolls, each set following the Chinese penchant for representing plants in temporal sequence or in contrasting natural situations such as wind and calm, or early budding and late flowering. Probably the earliest of the three is the pair of scrolls owned by the Chi'on-in in Kyōto,[4] followed by the set in the Tōkyō National Museum.[5] The latest is the pair in Kyōto's Hompō-ji monastery.[6] All four examples are painted primarily in strong outlines filled with color (*kōrokuga*), varied in places by the "boneless" wash technique. Stylistic change can be noted in terms of the compositional arrangement of the plants in space and in the rendering of the lotus blossom motif.

Viewed from above, the Hōryū-ji lotus bloom in massed groups. The major cluster in the right screen grows near the bottom of the composition, while the one in the left screen occupies the upper half of the picture surface. In between, a smaller cluster which continues from one painting into the other takes an intermediate position. Stems emerge logically from the water, leaving no ambiguity about which is in front and which is behind, and lead in a lucid manner to their respective leaves and blossoms. A convincing sense of spatial recession is thus conveyed.

Space in the Chi'on-in pair is no less logical, but a change in point of view limits the expansion of space into depth. These lotus are seen from the side, and instead of growing in massed clusters, the flowers and leaves separate. The plants are more evenly arranged over the whole composition, in a close-up view with less void area than in the Hōryū-ji pair. Space expands laterally rather than receding into depth. The strongly silhouetted wind-blown lotus in the right scroll bend in strong arcs to the left, where vertical plants are accompanied by some seed-topped water weeds and a few fallen petals indicate the wind has passed.

The same compositional scheme is followed in the pair of scrolls in the Tōkyō National Museum. Multiplication and elaboration of motifs, however, indicate a later evolutionary stage. Articulation of space is rational, and the silhouetting noted in the Chi'on-in painting still occurs, but rather than being solid against void, the contrast is light against dark or dark against light, and void space has noticeably decreased. The right scroll shows full blooming lotus bending in a light breeze. The plants in the quiet left scroll have just passed their peak, lacy insect-eaten leaves join the fallen petals and water weeds to create an intricately complicated composition.

Seams in the silk of the Hompō-ji scrolls indicate that they are smaller remnants of a much larger composition. But even in this state the underlying compositional principle can be detected. The most striking feature is

the meticulous concern of the artist for placing distinctly separated stems in a stepped sequence moving upward from the bottom of the pictures. Leaves and blossoms are logically arranged, and each plant is visually separate. A somewhat higher point of view than that of the Chi'on-in and Tōkyō National Museum scrolls allows the flowers to be placed on receding planes rather than remaining in the foreground, yet stronger than recession into depth is the sense of vertical progression.

Change also occurs in the lotus blossoms of these four works. The petals of the Hōryū-ji flowers all open outward, while those of the Chi'on-in are round and full. The soft cupping of the Chi'on-in forms is totally different from the sunburst spray of the Hōryū-ji flowers. In this respect, the petals of the Tōkyō National Museum lotus mark an evolutionary stage between the Hōryū-ji and Chi'on-in paintings, indicating that the artist was following an earlier convention for his flowers. The Hompō-ji lotus petals show the extent of this development. This artist was so preoccupied with the plumpness of each softly curving petal that the unity of the blossom as a whole is lost. Each petal has volume, but the flower does not.[7]

Japanese flower painting developed in response to Chinese influence, first from the decorative T'ang style and later from the realistic Sung manner. Probably the earliest depiction of lotus occurred in Amida Paradise scenes,[8] and these stylizations remained part of the lotus repertoire. The lotus lakes painted on the *Heike Nōkyō* scrolls dedicated to the Itsukushima Shrine in 1164 emerge from this tradition, but they also document early influence from Sung flower painting.[9] The high point of view on the massed clusters of lotus repeats the compositional principle noted in the Hōryū-ji lotus screen. And, although patternized with decorative gold outlines, the configuration of lotus petals echoes the open spread of the Hōryū-ji blossoms. Within the realm of ornamental lotus in Buddhist painting as well, a kind of naturalistic flower emerges. For example, together with the fully patternized lotus blossoms on the gold and lacquer Taimadera shrine, dated 1242, there appear realistic lotus flowers of a type not found in conventional lotus painting.[10]

Later Japanese lotus painting of the Muromachi period shows direct reliance on Sung models. Few of the numerous scrolls which exist have been published, but two examples from the Hosomi Collection in Ōsaka can be cited. Both composition and motifs of the anonymous fourteenth century *Lotus and Waterfowl*[11] follow a prototype similar to that of the Chi'on-in painting, while a model close to the Hompō-ji lotus was used for a pair of scrolls bearing the signature and seals of Genchū, a little-known follower of Kano Motonobu active in the second half of the sixteenth century (fig. 79).[12] Genchū's painting appears to be a faithful copy of a Yüan painting. The right scroll shows the arched stems of lotus blown by the wind while the left one emphasizes the vertical orientation of the plants in a quiet atmosphere. Genchū carefully copied the Chinese artist's precise placement of stems which emerge from the water in rational steps that move up the scroll. He lavished attention on the delicate coloring and soft forms of the succulent petals, with the resultant loss of unity in the blossom. But even in this faithful copy he reveals his sixteenth century Japanese provenance in heavier outlines, greater contrasts, and simplification of tonal range, all of which lead to patternization of the Chinese prototype. The accuracy of his forms is offset by the accompanying strong silhouettes and explicit textures.

The pair of monochrome *Lotus* in this exhibition reflects a concern for realistic detail within the conventions long established for lotus painting. But the conception is freer and the motifs are less locked into a brocaded tracery than those of the Genchū paintings. The lotus lake seems to breathe in a vibrant atmosphere, in contrast to the airless stillness of Genchū's composition. There are several explanations for the more relaxed naturalism of the ink paintings exhibited here: they were painted by a Japanese artist of the fifteenth rather than the sixteenth century; they imitate a Chinese prototype of the early-thirteenth rather than the fourteenth century; they follow a different mode of lotus painting in ink outline called white-drawing (Chinese: *pai miao*; Japanese: *hakubyō*), which is painting done basically in ink outline with some ink washes used to represent color.

The last of these three factors will be discussed first. Flower painting in ink alone was a later development in China, perhaps emerging under the influence of late Northern Sung scholar-paintings of ink-bamboo and ink-plum. Two types evolved during the Southern Sung period: ink wash and ink outline. Ink wash lotus in China is exemplified by *Egrets and Lotus* in the Kōtō-in attributed to Lo-ch'uang, a follower of Mu-ch'i in the thirteenth century.[13] In Japan, a pair of lotus were painted in ink wash by Sesson Tōyō (fl. ca. 1440–1488; see cat. no. 14, n. 25), and now flank his painting of *Three Sages* to form a triptych in the Museum of Fine

Figure 79. *Lotus*, Genchū (fl.
16th century), signed "Kōhoku
Genchū hitsu" with a round
relief seal *Minamoto* and a jug-
shaped seal *Genchū*. Pair of
hanging scrolls, color on silk,
each 113.6 x 57.6 cm. Hosomi
Collection, Ōsaka

Arts, Boston.[14] These two examples, incidentally, represent two iconographic traditions as well. The painting attributed to Lo-ch'uang depicts lotus as a wild grass, deemphasizing the flower and attempting to express the loneliness of primitive nature. The Sessō Tōyō lotus, like the pair in this exhibition, concentrates on the beauty and opulence of the blossoming flower.

The meaning of *hakubyō* (white-drawing) has been incorrectly limited to pure ink line used to depict figure subjects painted by Chinese scholar-painters. But the concept is much broader. Some *hakubyō* are pure ink outlines, but others add ink wash to represent color. For example, the Southern Sung painting of Vimalakirti in the Hauge Collection uses ink wash coloristically on the robes of both Vimalakirti and his female attendant and on Vimalakirti's headdress and shoes.[15] And the likelihood that it was painted by a professional Buddhist artist belies the theory that *hakubyō* were created only by amateur scholar-painters. Concrete evidence that the technique was not associated with a social class and that it was not limited to figures exists in the *T'u-hui Pao-chien* (preface dated 1365) by the Chinese collector Hsia Wen-yen. In the section on Southern Sung and Chin dynasty artists, Hsia says, "The monk Hsi-pai painted lotus in *pai miao*." [16]

Two works which can be dated to the Yüan dynasty indicate that lotus painting in *hakubyō* was flourishing in China by the fourteenth century. The earlier work is the section of a handscroll by Ch'ien Hsüan (ca. 1235–1290) recently excavated from the tomb of Chu T'an (d. 1389), son of the first Ming emperor.[17] It uses the conventions seen in the painting here. The shape of the pale middle leaf in the right-hand scroll is very similar to one of Ch'ien Hsüan's leaves, and both use the method of outline for contours and branching veins, and wash to indicate the darker green inner surface of the leaf. The luxuriant white lotus in the left scroll shown here resembles that of the central blossom of Ch'ien Hsüan's painting, although the latter flower represents a later evolutionary stage, for the outer individual petals begin to take precedence over the cohesion of the blossom as a whole. Both paintings use scattered black dots to indicate texture on the lotus stems.

The second datable example of lotus in *hakubyō* is a pair of scrolls inscribed by the Chinese expatriate priest I-shan I-ning (1247–1317) now lost but known through a Kano copy.[18] It shows lotus blossoms and leaves clustered on the outer edges of the two paintings and slightly inclining toward each other. Motifs are drawn with a fine ink line, and the varying greens of the leaves are suggested by tones of ink wash. The existence of these copies with the datable inscription provides evidence that *hakubyō* lotus were being painted in China by 1317, and that examples had found their way to Japan.

An unsigned, undated *hakubyō* lotus and waterfowl, collection unknown (fig. 80), can be dated to the same period on the basis of stylistic comparison with the pair of colored lotus from Hompō-ji. The consecutive emergence of stems from the water, in sequence up the center of the composition, gives the same vertical emphasis that is seen in the Hompō-ji example. Each motif is self-contained and separate, existing in its own space. The artist concentrates on the generous concavities of the soft petals rather than on the fullness of the entire blossom. Certain other motifs are quite close to those in the Hompō-ji paintings, such as the pattern of light veins on the upper right and middle leaves. But, compared with the lotus in the academic tradition using color, the *hakubyō* scroll has a livelier quality: the ink outline bounds its forms less tightly, the ink wash seems less calculated than do the colors on the Hompō-ji scrolls.

The prototype for the artist of the *Lotus* exhibited here was an earlier painting than the Hompō-ji scrolls or the Yüan *hakubyō* painting. The petals enclose a blossom which, in its unified fullness, falls somewhere between the integrated but stiffly outspread Hōryū-ji lotus and the more softly cupped blossoms of the Tōkyō National Museum paintings. This motif indicates a Southern Sung model, perhaps dating from the first half of the thirteenth century. The placement of stems supports that conclusion, for they seem to reflect a slightly more clustered group than the clearly silhouetted lateral alignment of the Chi'on-in stems.

The compositional scheme, the modification of motifs, and the handling of space in this white-drawing *Lotus* indicate it was painted by a fifteenth century Japanese artist, perhaps by a monk-painter. As noted earlier, the unique feature of these scrolls is their quiet unity. Unlike Chinese pairs which show plants under contrasting conditions, only a very subtle distinction is made here in degree of flowering, with a bud included in the left painting and a wider-open blossom in the right. And no difference is indicated in weather conditions: the lotus clusters curve gently toward each other, unaffected by wind or rain. The tranquility of the lotus lake

Figure 80. *Lotus and Waterfowl*, artist unknown, Chinese, ca. 1400. Hanging scroll, ink on silk. Collection unknown

is enhanced by the nearly symmetrical composition. A similar tendency can be seen in the pair of fifteenth century ink-wash lotus by Sessō Tōyō, although these paintings seem to have been cut down from larger scrolls. On the other hand, the sixteenth century artist Genchū followed the compositional plan of his model faithfully, showing lotus in the wind in one scroll, and lotus in calm in the other (fig. 79).

So the Japanese artist of these *hakubyō* paintings simplified his model by excluding differences in season and weather. He may well have reduced the number and variety of motifs as well. Full blossoms, leaves, reeds, pebbles, and fish in the left scroll are reflected in the right with only the addition of a crab, a few fluffy water plants, and two worm-holes in a lotus leaf. The scrolls seem to be an abridged version of a more complicated Chinese pair. To heighten the effect of quiet opulence, the painter reduced and simplified his detailed and realistic model.

The Japanese artist's preoccupation with emotional effect rather than rational description is reflected in his disregard for spatial logic. In the Yüan scroll (fig. 80) it is possible to follow the water surface step by step, slightly zigzagging up the scroll from one stem to the next, until the grasses on the upper-right edge indicate the shore and the limit of penetration into depth. Blossoms and leaves grow logically on these stems, swaying to left and to right and producing a sense of undulating movement. By contrast, the spatial relationships of stems in the Japanese *Lotus* is ambiguous: the point where each stem emerges from the water is imprecise, and three or four stems stand on the same lateral plane despite the fact that the blossoms and leaves above are in different positions in space. It is difficult to follow the stem to the flower or leaf it supports. The connection between the stem and its flower or leaf is also ambiguous, as in the organically impossible relationship between the lower leaf and its stem on the right scroll, or the white blossom and its stem on the left one. The background reeds are also painted in spatially irreconcilable clusters. The flatly spreading reeds at the top of the scrolls once more find their parallel in Sessō Tōyō's ink lotus of the second half of the fifteenth century rather than in any Chinese work.

The impression of vitality comes from the arrangement of blossoms and leaves, for the Japanese artist concentrated on translating the major motifs from his Chinese model in order to convey the richness of the flower:

reeds and stems play supporting roles, so their relative positioning is intuitive rather than rational. This too accords with fifteenth century attitudes toward copying Chinese models. Genchū's copy is different: the sixteenth century artist concentrates on literal translation of the shape and placement of motifs, even though his simplifications deny the natural description of his prototype and result in ornamental inlaid planes of similar colors, tones, and textures.

In their present condition, these lotus scrolls present an impression of vitality and abundance. If the later retouching could be removed and if the artist's *hakubyō* technique were visible in its candid economy, these *Lotus* would probably reveal the real strength of the "emotional" Japanese artist intuitively transforming a Chinese painting from a highly conventionalized tradition into a subjective expression of the luxuriance of an intimate spot in nature.

CAROLYN WHEELWRIGHT

NOTES

1. A convenient introduction to the Chinese scholar's point of view is Bush, *The Chinese Literati on Painting*, or Cahill, "Confucian Elements in the Theory of Painting."

2. See Ledderose, "Subject Matter in Early Chinese Painting Criticism," p. 2.

3. Professor Shimada has reason to believe that the paintings were executed in the first half of the 12th century, predating the Japanese lotus appearing on the *Heike Nōkyō* dated 1164. Painted in color on Chinese silk, the Hōryū-ji *Lotus and Waterfowl* are now mounted as a two-fold screen, each leaf measuring 172.2 x 121.0 cm. Originally the paintings were pasted on the wooden wall behind the bays of the Shariden, a building completed in the early 13th century. Since they face a painting of Shōtoku Taishi lecturing on the *Shōmangyō* (Sanskrit: *Śrīmālā-devī-simhanāda Sūtra*), painted by Sonchi Hōgen in 1221, some scholars believe that the *Lotus* was done at the same time by this famous Japanese monk-painter. Others note that the Shariden was donated by Keisei, a rich monk who visited China ca. 1300 and returned to contribute many Chinese objects to Kyōto and Nara temples. The lotus paintings are said to be one of his gifts (see Ryōkun, *Kokon Ichiyō-shū*, p. 95). The general opinion is that the Hōryū-ji *Lotus and Waterfowl* are Chinese paintings, but with an enormous amount of Japanese retouching in the more than seven centuries they have been owned by the Hōryū-ji. See I'enaga, "Jōdai Kara-e Kō," Tanaka Ichimatsu, "Sō-ga Yōshiki no Renke-zu ni tsuite," and *Nara Rokudaiji Taikan*, 5:pls. 182–83, 193, and text to the plates, pp. 79–91.

4. The Chi'on-in *Lotus and Waterfowl* are painted in color on silk, each scroll measuring 122.0 x 75.0 cm. Professor Shimada deciphered the two seals on the Chi'on-in painting as *P'i-ling Yü-shih* (Mr. Yü from P'i-ling) and *Tzŭ-ming*. The watery region of P'i-ling in southern China near Ch'ang-chou in Kiangsu fostered a tradition of flower painting from the Sung period to the Ch'ing dynasty (Yün Shou-p'ing, the 17th century "Orthodox" painter known for his flower painting, came from P'i-ling). The Yü family was particularly noted for lotus painting during the Southern Sung and Yüan periods, and three names are recorded in later biographies of painters from the region: Yü Ch'ing-nien (fl. first quarter 13th century), Yü Tzŭ-ming, and Yü Wu-yên (fl. early Yüan). Professor Shimada hypothesizes that the Chi'on-in *Lotus and Waterfowl* were painted by Yü Tzŭ-ming, perhaps in the second half of the 13th century. The strong line and strong color of the Chi'on-in painting corresponds to what is known of the P'i-ling style, in contrast to the greater delicacy of the academic style of the capital. See the brief note by Shimada to pl. 66 in Saitō Michitarō, ed., *Chūgoku Chūsei*, 1, and Sirén's discussion of the painting based on Professor Shimada's research, *Chinese Painting*, 2:163–64. The paintings are frequently published.

Good color reproductions may be found in *Tōyō Bijutsu*, 1: pls. 52–53.

5. Formerly in the Mitsu'i Collection, the pair of *Lotus and Waterfowl* in the Tōkyō National Museum are painted in color on silk, 151.1 x 90.8 cm, and published in *Kokka*, no. 297.

6. The Hompō-ji *Lotus*, bearing a traditional attribution to Ch'ien Hsüan (ca. 1235–90), color on silk, published in *Sōgen Meigashū*, 2: pls. 44–45.

7. A pair of scrolls which illustrates the same features as the Hompō-ji *Lotus* is *Flowers and Insects* in the Hosomi Collection, painted by Chiang Chi-ch'uan, one of the many Yüan artists of the P'i-ling region working in this genre in the Sung and Yüan periods. The right scroll shows summer peonies in wind with butterflies, the left shows autumn chrysanthemums in calm with a bat. On the basis of their vertical spatial emphasis and their discretely volumetric flower petals, these paintings are contemporary with the Hompō-ji *Lotus*. They are published in *Kokka*, no. 717.

8. See, for example, the lotus in the Amida Paradise painted on the wall of the Hōryū-ji Kondō in the early 8th century, in Tanaka Ichimatsu, *Wall Paintings of the Hōryū-ji Monastery*, color pl. of wall 6.

9. Good examples are the paintings done in ink, color, and gold on paper inside the covers of *Shinge-bon* no. 4, *Ninki-bon* no. 9, *Funbetsu-kudoku-bon* no. 17, *Zuiki-kudoku-bon* no. 8, and the covers of *Muryō-gi-kyō*, *Fugen-bosatsu-kanpatsu-bon* no. 28, and *Kan-fugen-kyō*. Kyōto National Museum, *Heike Nōkyō*, color pls. 12, 24, 51, 54, and pls. 3, 80, 82.

10. *Taimadera Ōkagami*, pls. 44–45.

11. *Lotus and Waterfowl*, hanging scroll, color on silk, 126.2 x 53.5 cm, Hosomi Collection, Ōsaka, published in *Kokka*, no. 674.

12. Discussed by Tanaka Ichimatsu, "Sō-ga Yōshiki no Renge-zu ni tsuite." The only information about the biography of Genchū is a single line in Kano Einō's *Honchō Gashi* which says, "Kōhoku Genchū studied Kano Motonobu's brush methods. His painting seal is 'Minamoto' " (quoted in *Koga Bikō*, p. 1743).

13. A hanging scroll in ink on silk in the Kōtō-in of the Daitoku-ji, Kyōto. Published in Toda, *Mokkei, Gyokkan*, pl. 28. There are also several Kano copies of ink lotus by Mu-ch'i, including *Lotus and Swallow* (Tōkyō National Museum no. 5403), a pair of *Lotus and Heron* and *Bulrush and Heron* (TNM no. 6744-29), a pair of *Willow and Snowy Heron* and *Lotus and Snowy Heron* (TNM no. 6744-29), *Egret and Lotus* (TNM no. 5406), *Lotus and Wagtail* (TNM no. 5408), and *Lotus and Small Bird* (TNM no. 5426).

14. *Three Sages and Lotus* by Sesshō Tōyō, three hanging scrolls, ink on paper, each 33.1 x 47.5 cm, Museum of Fine Arts, Boston. Published in Matsushita, *Muromachi Suibokuga*, pl. 40. See also "Sesshō hitsu Kokei Sanshō oyobi Renge-zu."

15. *Sōgen no Kaiga*, pl. 9.

16. Hsia Wen-yen, *T'u-hui Pao-chien, chüan* 4, p. 75.

17. The painting, in ink on paper, is inscribed by two Chinese men of letters, Feng Tzu-chen (1257–1327) and Chao Yen (fl. early-15th century). Published in Fontein and Wu, *Unearthing China's Past*, fig. 133.

18. Kanazawa, *Shoki Suibokuga*, fig. 101. The Tōkyō National Museum number of this copy is not listed; perhaps the copy is part of a handscroll of copies. Kanazawa gives no information concerning either the original or the copy. From the style seen in the photograph, the original painting was probably drawn by a Chinese artist in ink outline with ink wash used coloristically (*hakubyō*).

Radish

Jonan Etetsu (1444–1507)

Hanging scroll, ink on paper,
33.8 x 45.4 cm.
Intaglio seal reading Jonan *and*
relief seal reading Etetsu.
Private collection (formerly
Fuji'i Noriyoshi Collection)

This unsigned painting of a radish bears the seals of Jonan Etetsu, an eminent Zen monk who served as the 183rd abbot of the Tōfuku-ji. There is no inscription, and the relatively small format of the painting is nearly filled by the depiction of a single radish placed at the very center of the composition and executed entirely in ink washes and lively contour lines.

The *Radish* is one of several extant paintings of single radishes or turnips by Japanese Zen monks of the late fifteenth century. All of these paintings share certain compositional and technical similarities, indicating their relationship to a common prototype. Two entries in the *Onryōken Nichiroku,* dated in correspondence to 1466, describe a pair of paintings by Mu-ch'i, one of a radish and the other of a vegetable, each of which bears a four-character inscription.[1] Since the inscriptions cited exactly correspond to those on a pair of hanging scrolls now in the Imperial Household Collection, the *Radish* (fig. 81) and the *Vegetable* traditionally ascribed to Mu-ch'i,[2] these must be the very paintings mentioned in the records of 1466. The passage further relates that the two paintings were promised as a gift to the writer of the *Onryōken Nichiroku* (Kikei Shinzui, 1435–1466) by Taga Takatada, Governor of Bungo province. Thus the record clearly documents how and when the *Radish* and *Vegetable* attributed to Mu-ch'i came into the collection of a major Zen temple in Kyōto, and accounts for the availability of these paintings as models for study by Zen monk-painters of the late fifteenth century.

Although the traditional attribution to Mu-ch'i of the *Radish* and *Vegetable* in the Imperial Household Collection is no longer recognized, it is clear from the passage in the *Onryōken Nichiroku* that these paintings were accepted at that time as genuine works of Mu-ch'i, and were consequently highly regarded in contemporary Zen circles.

Mu-ch'i is best known as a painter of Buddhist figures and landscapes, but there is considerable indirect evidence that vegetables were among his subjects. The most celebrated examples of this genre attributed to Mu-ch'i are the *Persimmons* and *Chestnut* belonging to the Ryūkō-in of the Daitoku-ji.[3] Moreover, several copies by members of the Kano school of paintings no longer extant provide further evidence of the prevalent Japanese image of Mu-ch'i as a painter of vegetables. The Kano copies, including *Apples, Eggplant, Lotus Root, Pears,* and *Melon,*[4] are small in format, and each has a central vegetable motif rendered mainly in ink wash, freely applied. Although none of the surviving Mu-ch'i vegetable paintings in Japanese collections can be deci-

sively identified as a genuine work by his hand, the paintings and the Kano copies together constitute strong evidence that such informal studies of vegetables were included in Mu-ch'i's repertoire. The general stylistic similarities among the paintings and the Kano copies also suggest that his paintings in this genre would very likely have been stylistically consistent with the features common to these works.

There is, moreover, a long handscroll of birds, flowers, and vegetables attributed to Mu-ch'i in the collection of the National Palace Museum in Taiwan.[5] The depictions of vegetables and fruits in this handscroll are similar in style to the individual paintings of these subjects attributed to Mu-ch'i in Japan. It seems unlikely that the Palace Museum handscroll is a genuine work by Mu-ch'i, but it may well be a close copy of such a handscroll. The existence of this handscroll and its stylistic consistency with the similarly attributed works in Japanese collections further support the indirect evidence that Mu-ch'i painted miscellaneous vegetables, possibly in the handscroll format. The isolation of vegetable motifs as individual hanging scroll paintings is likely to have been an innovation of Japanese connoisseurs and painters, since it reflects the preference for hanging scrolls among Muromachi period collectors.[6]

A comparison of the Imperial Household Collection's *Radish,* datable by documentation prior to 1466, with the surviving late-fifteenth century paintings of the same subject leaves no doubt that this painting served as the prototype for the others. Each of the copies, however, differs somewhat from the model, giving some indication of the individual style of each artist.

A painting of a turnip bearing a colophon by Shumpo Sōki (1409–1469)[7] offers a very interesting comparison. The painting may be assumed to date from the late fifteenth century because of the known dates of the inscriber, and is therefore nearly contemporary with Jonan's *Radish.* The unidentified artist of *Turnip* uses very wet ink wash in the leaves, leaving rough, broken edges. The veins and stems of the leaves are also painted in very wet ink which produces a blurred effect. The artist in this case was attempting to imitate the loose, free brushwork of the ink washes in the model painting.

Another work apparently based on the Mu-ch'i *Radish* is the *Radish* by Sesson (ca. 1504–ca. 1589) (fig. 82). This painting, too, relies heavily on ink wash, but it deviates from the model in the use of wetter ink wash and in the heavier compositional massing of leaves near their bases.[8]

Jonan Etetsu's use of ink wash is far clearer and more

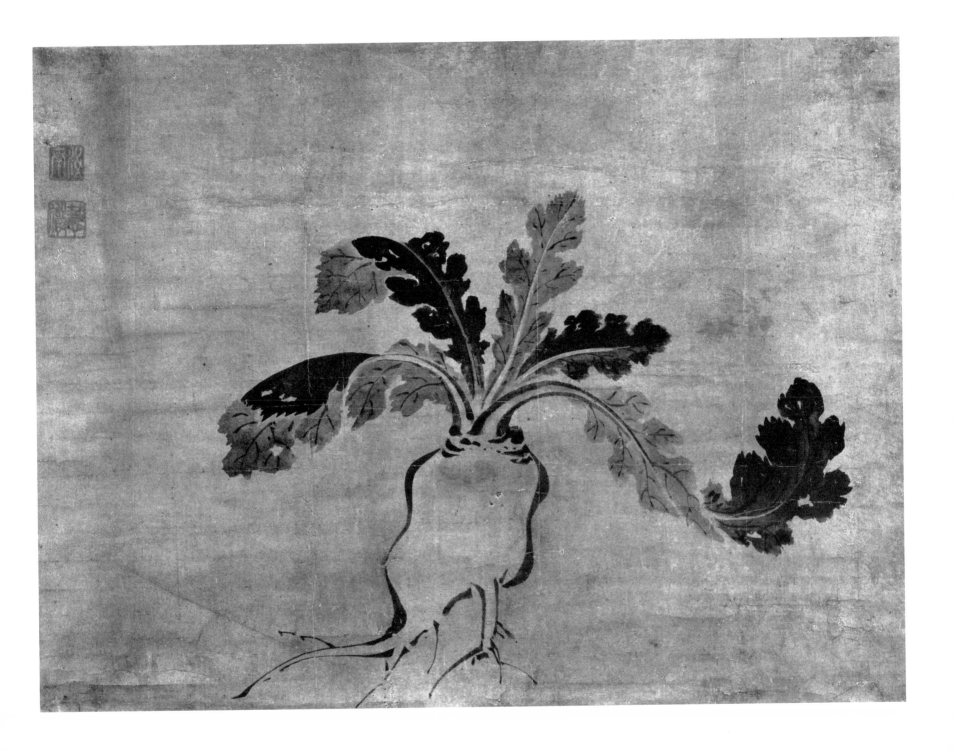

Figure 81. *Radish*, attributed to Mu-ch'i (d. 1269–74). Hanging scroll, ink on paper, 27.4 x 64.9 cm. Imperial Household Collection, Tōkyō

Figure 82. *Radish*, Sesson (ca. 1504–ca. 1589), inscribed by Shi'in Dōjin. Hanging scroll, ink on paper, 29.2 x 44.0 cm. Institute for Zen Studies, Hanazono College, Kyōto

deliberately organized than that in either of these nearly contemporary paintings. The contrast of light and dark ink tones is emphasized to indicate the bending and turning of the spreading leaves in space. The contrast, however, is so strong that it produces a decorative effect of alternating light and dark tones at the expense of the organic unity maintained in the other paintings. Sharply defined, serrated leaf-edges in Jonan's *Radish* further enhance the patterned effect of contrasting ink washes, and give a slightly unnatural but nevertheless attractive silhouette effect.

The contour lines in Jonan's *Radish* are no less distinctive. They are emphatic and firmly accented at each end, rather than tapering as in the other versions. But the most striking innovation is in the composition, which emphasizes the corporeality of the vegetable form. The leaves spread laterally overhead, but they twist and turn, giving a sense of movement into depth. The radish itself is so firmly defined by the contour line that it seems almost to stand upon the threads at its tip, and displays a lively, animated quality. Emphasis on contour, decorative contrast, firm definition of form, and articulation of three-dimensional space distinguishes Jonan's painting from the laterally composed versions of his contemporaries, which used more ink wash. This contrast parallels the diversifying trends in late-fifteenth century landscape painting — in particular, the contrast between the continuation of a style of painting relying heavily on ink wash and atmosphere, and the emphatic use of contour for the articulation of solid forms penetrating into depth by the innovative painter, Sesshū.

Little is known of Jonan Etetsu's life, but the records of the Tōfuku-ji register his death in 1507.[9] The date is verified by a passage in a memorial inscription dedicated to Jonan by his close friend, Ryō'an Keigo, an eminent Zen monk-poet.[10] In the preface to the memorial poem Ryō'an describes his last visit with Jonan in 1505; Jonan had come to bid him farewell, as Ryō'an was preparing to depart on a diplomatic mission to China. Upon his return to the Unkoku-an in Yamaguchi after his trip to China, Ryō'an learned that Jonan had died in his native place.[11]

Jonan's own poetic inscriptions survive on two paintings by other artists. One is a *haboku* style landscape attributed to Sesshū.[12] His inscription on this painting indicates that Jonan must have been close to Sesshū's circle. Indeed, the firm and emphatic use of contour and the clear, logical articulation of form in Jonan's *Radish* suggest that he may have been familiar with certain elements of Sesshū's style. Another inscription by Jonan is on an anonymous painting of *Hotei*.[13] Since he signed the inscription, "Zen Tōfuku Jonan Seki Etetsu," it must have been written after his brief tenure as abbot of the Tōfuku-ji, and must consequently date from late in his life, as the unsteady hand also suggests. The *Radish* probably dates from an earlier period, for the vitality of line in the painting has much in common with Jonan's distinctively sharp and accented calligraphy on the Sesshū landscape.

Since none of the records of Jonan Etetsu's life clearly describes him as a painter, and since he is not mentioned in Muromachi texts on painting, the identification of the priest Jonan Etetsu as the painter of the *Radish* remains somewhat unconfirmed. A similar problem is encountered with another little-known painter of the Yamaguchi circle associated with Sesshū, Bokushō Shūsei (see cat. no. 19). Since both Bokushō and Jonan attained high rank in the Zen hierarchy, it is likely that their obscurity as painters may arise in part from their practice of painting as an avocation, which has left little evidence of their work.[14] This *Radish* bearing the seals of Jonan Etetsu is the only known example of his painting, but it provides a glimpse of his distinctive identity among Zen monk-painters of the late fifteenth century.

ANN YONEMURA

NOTES

1. See Tamamura and Katsuno, ed., *Onryōken Nichiroku*, 2: 631–32. For a discussion of Mu-ch'i and his influence on Muromachi painting, see cat. no. 1, n. 5.

2. *Radish* and *Vegetable* are published in *Kokka*, nos. 486 and 489, where they are entitled *Radish* and *Turnip*, but the traditional titles recorded in the *Onryōken Nichiroku* and other sources are *Radish* and *Vegetable*.

3. Published in *Kokka*, no. 493.

4. The Tōkyō National Museum registration numbers for these Kano copies are 5396, 5440, 5443, 6742, and 6742 respectively.

5. *Plants, Flowers, and Birds*, handscroll, ink on paper, 44.5 x 180 cm, National Palace Museum, Taiwan; published in *Kuo-li Ku-kung Po-wu-yüan*, 3: pls. 120–23.

6. The Japanese practice of cutting handscrolls into sections and remounting the sections as hanging scrolls is described by the painter Hasegawa Tōhaku (d. 1610) in the *Tōhaku Gasetsu* (see cat. no. 20, n. 5). Tōhaku relates how Yü-chien's handscroll depicting the *Eight Views of Hsiao and Hsiang* (see cat. no. 14) was cut into sections and remounted as a set of eight hanging scrolls by the order of Ashikaga Yoshimasa (r. 1443–90). Yoshimasa was active in fostering the cult of the tea ceremony, and it was probably because the ceremony required that paintings be hung in the tearoom for the appreciation of guests that Yoshimasa had many of the best paintings in his collection remounted in that format. See *Tōhaku Gasetsu*, p. 7.

7. The painting bears a seal of the artist, who has not yet been indentified, as well as the colophon and seals of Shumpo Sōki of the Nanzen-ji [*sic*] in Kyōto. The painting, called *Turnip*, is in the collection of the Jōfuku-ji in Kyōto. See Fontein and Hickman, *Zen Painting and Calligraphy*, no. 60. Shumpo Sōki was actually a priest of the Daitoku-ji, rather than the Nanzen-ji.

8. The differences between Sesson's *Radish* and the Mu-ch'i prototype may in part result from Sesson's distance from the capital and the actual model painting. He may have been working from a sketch or intermediary free copy rather than from the Mu-ch'i model. Furthermore, from other examples of Sesson's work, it is evident that Sesson interpreted his models freely, allowing much range for his individual style. See cat. nos. 26–27.

9. Eishō 4th year, 5th month, 27th day. *Tōfuku-ji-shi*, p. 690.

10. Ryō'an Keigo (1425–1514) was an eminent poet in Gozan literary circles. At the age of 83, owing to his prominent position among Zen monks of his time, he was awarded a commission to travel with a diplomatic mission to China. Ryō'an Keigo's poetic inscriptions, which survive on many paintings of the late 15th century, testify to his close contact with Zen painting circles of that period. A brief biography of Ryō'an Keigo is included in Shiban, *Empō Dentōroku*, pp. 454–55 (1931 ed.).

11. The poem, written in Ryō'an's own hand and dated in spring of the 11th year of the Eishō era (1514) is in the Dōju-in of the Tōfuku-ji. A photograph and transcription are published in Ōsaka Yomi'uri Shimbunsha, *Sesshū Ten*, pl. 19. Since Ryō'an's preface does not specify when he reached Yamaguchi except to say that it was in winter, Jonan's death may have occurred either late in 1506 or very early in 1507. The Unkoku-an in Yamaguchi City was a temple affiliated with the Tōfuku-ji in Kyōto. Since it is geographically remote from the Tōfuku-ji monastic complex, it cannot properly be called a subtemple, but the relationship with the main temple was nevertheless close.

12. Published in Matsushita, *Muromachi Suibokuga*, pl. 37.

13. *Ibid.*, pl. 38.

14. Zen monk-painters fall into two distinct categories: those who attained high status as monks and painted strictly avocationally, and those who were in actuality semi-professional painters receiving stipends for their work, but not achieving great distinction as monks. Gyoku'en Bompō (see cat. no. 34), who served as abbot of the Shōkoku-ji and the Nanzen-ji, is an example of the former type of monk-painter, while Shūbun is an example of the latter.

Waterfowl
Shikibu (Ryūkyō; fl. mid-16th century)

Within the narrow confines of a fan painting, the drama of seething waves crashing against a rocky cliff is brilliantly enacted. The energy of great waves breaking and recoiling in swirling eddies around the base of the cliff is counterbalanced by broad, slanted axe-strokes in the down-pointing triangular facets of the rock face. The waterfowl, probably a duck, flies off in the other direction, as if startled, providing a countermovement to the roaring force of the waves. A dark wash applied over most of the painting suggests haze and spume; the tops of the breakers and the eddy curling around the cliff are left white, heightening the drama of their role in the painting. In the left corner are impressed the rectangular relief seal *Terutada* and the square intaglio seal *Shikibu.*

The extant works of Shikibu include a number of fan paintings. There are two fans showing landscapes in the abbreviated style derived from the *Eight Views of Hsiao and Hsiang* attributed to Mu-ch'i (fig. 56), one in the Tōkyō National Museum [1] and the other in the Burke Collection, and a *Landscape with Fisherman* in the academic Ma-Hsia style.[2] There is a painting of ducks among reeds in a private collection in Japan, a painting of *Yellow Mallow* in the Tōkyō College of Arts, and a painting in the Tōkyō National Museum depicting *Emperor Shun and His Five Vassals.* Most of these bear the same seals as this painting. The *Koga Bikō* records a gold screen in the Matsudaira Collection in which some thirty fan paintings of figures, flowers-and-birds, and fish were mounted, all bearing the seal of *Ryūkyō* (i.e., Shikibu).[3] Although the *Koga Bikō* makes no mention of the *Terutada* seal, there is a distinct possibility that some of the fan paintings mentioned above, including the one exhibited here, may have originally formed part of the Matsudaira screen. In any event there is evidence that Shikibu executed numerous fan paintings.

Ink paintings on fans were produced extensively in the fifteenth century. One of the earliest examples is *Wang Hsi-chih Writing on Fans,* painted by Shūbun's teacher Josetsu.[4] Such paintings were often commissioned by feudal patrons. Ōsen Keisan (1429–1493) records that a member of the great Hosokawa family commissioned eight fan paintings depicting *Eight Views of Hsiao and Hsiang,* above which Ōsen was asked to write poems.[5] On such formal occasions the painter would generally use model paintings as an aid. *Tōhaku Gasetsu* records how Tōshun (cat. no. 20) was asked by the Shōgun Yoshiharu to paint three fan paintings. Tōshun replied that he was not able to do so since he had not brought model paintings with him. Sō'ami produced fifty paintings from the Shōgun's collection, from which Tōshun selected a work by Hsia Kuei as a model for the three fan paintings.[6]

In the fifteenth century *senmen-byōbu* (folding screens on which fan paintings are mounted) seem to have been largely confined to fan paintings in the colorful Yamato-e style.[7] In the sixteenth century, however, there is clear evidence that ink fan-paintings were occasionally mounted on gold screens. A gold screen on which fan paintings by Kano Motonobu (cat. no. 28) were mounted is recorded as having been used at a ceremony in 1550.[8] A pair of such screens dating from the late sixteenth century survives in the Iri'e collection in Kyōto. On each of the two six-fold screens are mounted thirty fan paintings depicting various topics, all bearing the seal *Genkyū.*[9] Thus it is possible that the gold *senmen-byōbu* mentioned in *Koga Bikō* as bearing thirty paintings by the single artist Ryūkyō may have been an original Muromachi mounting, resembling in format the Genkyū screens.

Seething waves around rocky shores appear early in the history of Chinese painting, and are usually associated with dragons.[10] By the late Northern Sung some painters are noted solely for their rendering of billowing waves.[11] Paintings such as the *Nine Dragons Appearing through Waves and Water* in the Museum of Fine Arts, Boston,[12] demonstrate the linear manner of representing waves. In Japanese ink painting, seething waves depicted in a linear fashion appear first in religious painting of the fourteenth century (see Ryōzen's *White-Robed Kannon,* fig. 5) and later in the paintings of the fifteenth century inheritors of this tradition (see cat. nos. 2 and 6). However, the type on which this Shikibu fan is based is probably a painting of waves and shore similar to that reflected in a painting by one of Sesshū's followers, possibly a free copy of an original Sesshū (fig. 83). The basic idea of the composition in which waves crash against an overhanging cliff-face is very similar in both paintings. Moreover, the curious triangular shape of the overhanging elements in the painting of the Sesshū school suggests that Shikibu was possibly familiar with the model referred to by Sesshū's follower. The rather exaggerated forms of Shikibu's waves, with their long curling hooks outlined in dark ink, may be compared to those found frequently in Sesson's work (cat. nos. 26 and 27). In Sesson, these forms take on a plastic, almost surrealistic shape. Both painters reflect the baroque trends of the sixteenth century.

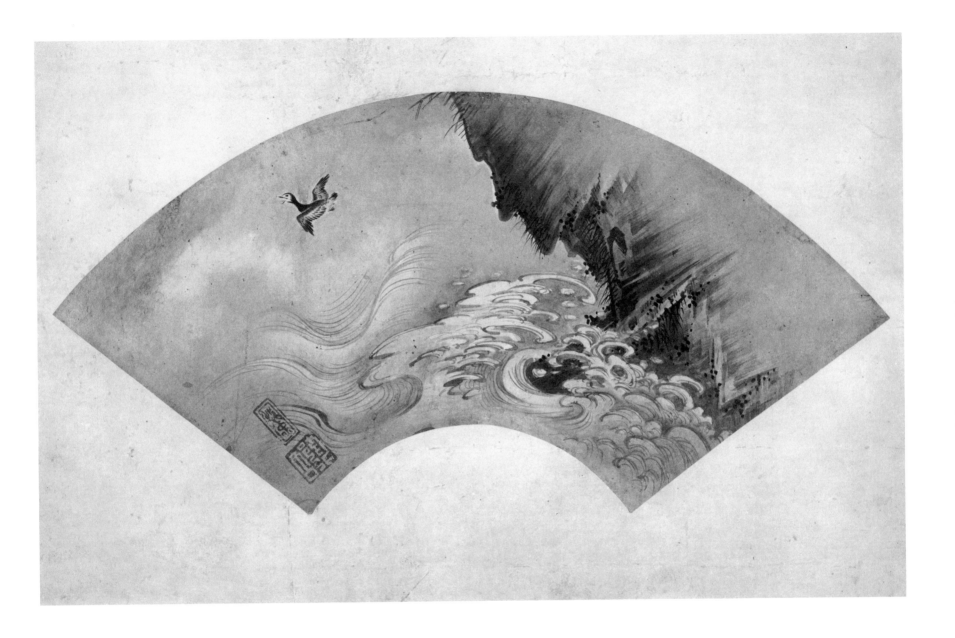

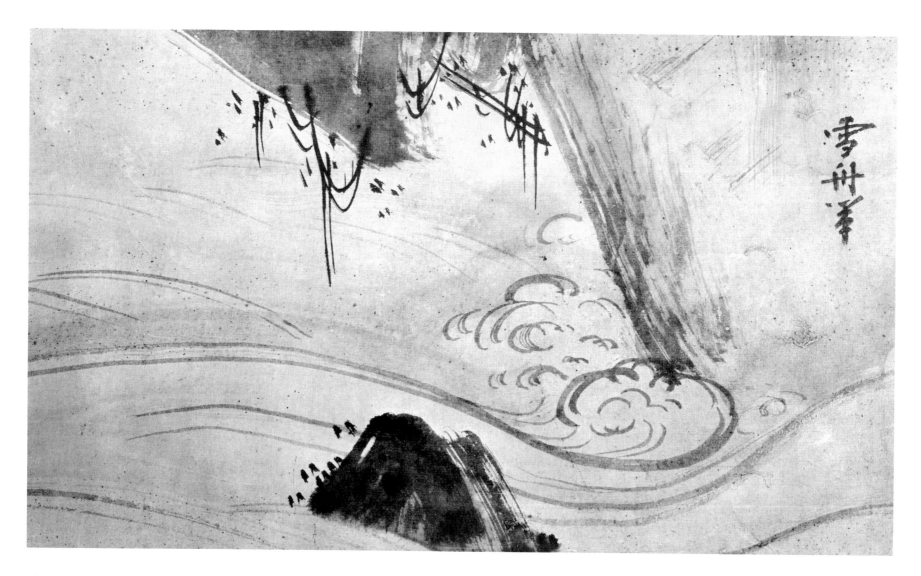

Figure 83. *Waves and Shore*,
follower of Sesshū. Hanging
scroll, ink on paper, 19.8 x 33.4
cm. Nezu Art Museum, Tōkyō

Shikibu's addition of the waterfowl, which gives out a cry as it flies, lends an intimate quality to the scene. Shikibu's bird resembles those (identified as ducks) found in several flower-and-bird folding screens of the Sesshū school, such as the one attributed to Shūgetsu in the Mutō Collection, or the screens of *Monkeys and Hawks* attributed to Sesshū in the Museum of Fine Arts, Boston.[13] In these screens the ducks are usually portrayed quacking in flight, as in Shikibu's work. The bird motifs in such screens are culled in a random manner from Ming academic flower-and-bird paintings, such as those by Lü Chi.[14] Shikibu was clearly familiar with Ming flower-and-bird painting, as is shown in other works,[15] and it is likely that he borrowed this motif of the quacking duck from a Ming model which was also known by the painters of the Sesshū school.

Shikibu's rendering of the duck in *Waterfowl* has a lively charm characteristic of much of his bird painting. Three swimming ducks on his fan painting in a Japanese private collection are portrayed in a lively manner, and the group of ducks based on the same model seen in his screens of *Monkeys* in the Kyōto National Museum[16] enjoy a spirited conference of quacking. His rendering of the cliff-face here is achieved with many broad axe-strokes, little highlighting, and relatively few dots, in contrast to the busy profusion of details seen in his screen paintings (cat. no. 25). His penchant for triangular shapes is again apparent, but the brushwork is firmer and less facile than in the rocks of his screen paintings. The surging waves are outlined with forceful lines, nicely offset by a judicious use of light wash to produce the effect of dramatic turbulence around the base of the cliff. Although a small painting, it is a remarkably successful work.

RICHARD STANLEY-BAKER

NOTES

1. Published in Matsushita, *Muromachi Suibokuga*, pl. 96.

2. Published in *Kokka*, no. 43.

3. See cat. no. 25 for mention of the problems concerning the reading of these seals, and *Koga Bikō*, p. 799.

4. Illustrated in Tanaka and Yonezawa, *Suibokuga*, pl. 34.

5. Ōsen Keisan, *Ho'an Keikashū*, p. 593 (1485).

6. *Tōhaku Gasetsu*, item 59, p. 17. In a similar instance, the *Onryōken Nichiroku* (entry for the 14th day of the 6th month of Entoku 3, or 1491) records that Sōkei was provided with Sun Chün-tse models for his paintings in the Shōsenken.

7. See Tanaka Kisaku, "Senmen-byōbu ni tsuite."

8. *Zoku Ōnin Ki*, scroll 5, Temmon 19 (1550), quoted by Tsuji Nobu'o, "Kano Motonobu," *Bijutsu Kenkyū*, no. 246, p. 26.

9. Tanaka Kisaku, "Senmen-byōbu ni tsuite."

10. Su Tung-p'o's essay on the development of water painting, dated 1080, claims that the late T'ang master Sun Wei, famous for his paintings of dragons in water, was the first to achieve some degree of realism in rendering waves. Trans. in Giles, *An Introduction to the History of Chinese Pictorial Art*, pp. 76–77. Text in *P'ei-wen-chai shu-hua-p'u* (preface 1708), *chüan* 13, pp. 9r, 9v.

11. Li Tsung-cheng, Tsao Jen-hsi, and P'u Yung-sheng are noted by Kuo Jo-hsü in his late-11th century *T'u-hua Chien-wen Chih*.

12. Published in Sirén, *Chinese Painting*, 3: pls. 356–60.

13. Nakajima, "Sesshū-kei Kachō-zu Byōbu Kenkyū," fig. 11, panel 1, left screen, and fig. 19, panel 6, right screen.

14. Illustrated in *Minshin no Kaiga*, pls. 16–17.

15. Published in *Kokka*, no. 801.

16. Published in Matsushita and Tamamura, *Josetsu, Shūbun, San-Ami*, pls. 161–62.

ARTISTS' SIGNATURES AND SEALS

CATALOGUE NUMBER 1

CATALOGUE NUMBER 4

Priest Sewing under Morning Sun (Chōyō Hotetsu)
Square relief seals reading *Ka'ō* and *Ninga,* with traces of an erased signature, "Seikai-jin." Cleveland Museum of Art, Purchase, John L. Severance Fund (62.163).

Priest Reading in the Moon-light (Taigetsu Ryōkyō)
Square relief seals reading *Ka'ō* and *Ninga.* Museum of Fine Arts, Boston, Keith McLeod Fund (63.786).

Kensu (Hsien-tzŭ)
Square relief seals reading *Ka'ō* and *Ninga.*
Tōkyō National Museum.

Ox and Herdsman
Oblong intaglio seal reading *Sekkyakushi.* Mary and Jackson Burke Collection.

CATALOGUE NUMBER 5

CATALOGUE NUMBER 7

Kanzan and Jittoku
Trace of effaced seal in upper right-hand corner. Mary and Jackson Burke Collection.

Three Vinegar Tasters
Square intaglio seal reading *Kyaku To Jitsu Chi,* with signature, "Reisai hitsu." Umezawa Collection, Tōkyō.

The Three Laughers of Tiger Valley
Square relief seal reading *Bunsei.* Collection of Kimiko and John Powers.

West Lake
Square relief seal reading *Bunsei.* Masaki Art Museum, Ōsaka.

CATALOGUE NUMBER 8

CATALOGUE NUMBER 9

CATALOGUE NUMBER 10

Kensu (Hsien-tzŭ)
Square intaglio seal reading
Yōgetsu. Private collection.

Hotei (Pu-tai)
Oblong relief seal with double
border reading *Yamada-shi
Dō'an.* Collection of
Mrs. Milton S. Fox.

Landscape in Shūbun Style
Square relief seal reading
Shūbun. Seattle Art Museum,
Eugene Fuller Memorial
Collection (49.90).

CATALOGUE NUMBER 11

CATALOGUE NUMBER 14

*Landscape with Distant
Mountains*
Square relief seal reading
Shōkei. Collection of Kimiko
and John Powers.

*Kozan Shōkei (Small Scene of
Lake and Mountains)*
Square relief seal reading
Ten'yū. Fuji'i Collection, Nishi-
nomiya, Hyōgo prefecture.

Hotei (Pu-tai)
Square relief seals reading
Ten'yū and *Shōkei.* Kōsetsu
Collection.

Mountain Landscape
Square intaglio seal reading
Saiyo. Seattle Art Museum,
Eugene Fuller Memorial
Collection (55.55).

CATALOGUE NUMBER 15

Autumn Moon over Tung-t'ing Lake/Evening Bell from a Distant Temple
Square intaglio seal reading *Kantei.* Mary and Jackson Burke Collection.

Autumn Moon over Tung-t'ing Lake/Evening Bell from a Distant Temple
Back of scroll showing number 4 behind the seal. Mary and Jackson Burke Collection.

Descending Geese on Sandbanks/Evening Snow on the Hills
Square intaglio seal reading *Kantei.* Mary and Jackson Burke Collection.

Descending Geese on Sandbanks/Evening Snow on the Hills
Back of scroll showing number 6 behind the seal. Mary and Jackson Burke Collection.

CATALOGUE NUMBER 16

Sunset Glow over a Fishing Village
Square intaglio seal reading *Kantei.* Private collection.

CATALOGUE NUMBER 17

Spring Landscape
Square intaglio seal reading *Kantei,* with mirror image of "Spring 1" written on the back, clearly visible on the front. Private collection.

CATALOGUE NUMBER 18

Winter
Square relief seal reading *Tōyō,* with signature, "Sesshū hitsu," above it. University of Michigan Museum of Art, Margaret Watson Parker Collection (1970/2.151).

CATALOGUE NUMBER 19

Haboku Landscape
Square double-contoured intaglio seal reading *Bokushō.* Mary and Jackson Burke Collection.

CATALOGUE NUMBER 20

Viewing a Waterfall
Square intaglio seal reading
Tōshun. Collection of Kimiko
and John Powers.

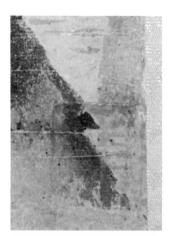

CATALOGUE NUMBER 21

Landscape
Square intaglio seal reading
Shūtoku. Mary and Jackson
Burke Collection.

CATALOGUE NUMBER 23

Landscape of the Four Seasons
Right-hand screen: square in-
taglio seal with double border
reading *Shinsō* and signature,
"Kangaku Shinsō hitsu," writ-
ten above it. Metropolitan
Museum of Art, New York,
Gift of John D. Rockefeller,
Jr., 1941 (41.59.1).

Right:
Viewing a Waterfall
Square intaglio seal reading
Kangaku and signature,
"Shinsō," written above it.
Fuji'i Collection, Nishi-
nomiya, Hyōgo prefecture.

CATALOGUE NUMBER 24

*Landscape with Figures Going
Up a Hill*
Upper oblong relief seal with
double border reading
Kenkō, lower square intaglio
seal with double border read-
ing *Shōkei.* Museum of Fine
Arts, Boston, Fenollosa-Weld
Collection (11.4127).

CATALOGUE NUMBER 25

Landscape of the Four Seasons
Left-hand screen: upper rec-
tangular relief seal reading
Terutada, lower square in-
taglio seal reading *Shikibu.*
Asian Art Museum of San
Francisco, Avery Brundage
Collection (B60 D49+).

Landscape of the Four Seasons
Right-hand screen: upper rec-
tangular relief seal reading
Terutada, lower square in-
taglio seal reading *Shikibu.*
Asian Art Museum of San
Francisco, Avery Brundage
Collection (B60 D48+).

CATALOGUE NUMBER 37

Waterfowl
Upper rectangular relief seal
reading *Terutada,* lower
square intaglio seal reading
Shikibu. Private collection.

CATALOGUE NUMBER 26

CATALOGUE NUMBER 27

Landscape in Wind
Upper tripod relief seal reading *Sesson,* lower intaglio gourd-shaped seal reading *Shūkei.* Private collection.

Tiger
Upper vessel-type relief seal reading *Sesson,* lower double-contoured square relief seal reading *Shūkei,* and signature, "Sesson-ga," written under upper seal. Cleveland Museum of Art, Purchase from J. H. Wade Fund (59.137).

Dragon
Upper vessel-type relief seal reading *Sesson,* lower double-contoured square relief seal reading *Shūkei,* and signature, "Sesson-ga," written under upper seal. Cleveland Museum of Art, Purchase from J. H. Wade Fund (59.136).

CATALOGUE NUMBER 30

CATALOGUE NUMBER 31

CATALOGUE NUMBER 32

Orchids and Bamboo
Square intaglio seal reading *Tesshū.* Collection of Mrs. T. Randag, on loan to The Art Museum, Princeton University (L55.68).

Orchid and Rock
Square intaglio seal reading *Tesshū.* Private collection.

Reeds and Geese
Square intaglio seal reading *Tesshū.* Private collection.

Reeds and Geese
Square intaglio seal reading *Tesshū,* incomplete inscription. Metropolitan Museum of Art (1975.268).

CATALOGUE NUMBER 33

Orchid
Upper oblong relief seal reading *Shaku Reihō Chō'un Sho*, lower square relief seal reading *Jū Kangiji Sha Museishi*, and detail of inscription with signature, "Reihō." Allen Memorial Art Museum, Oberlin College (57.12).

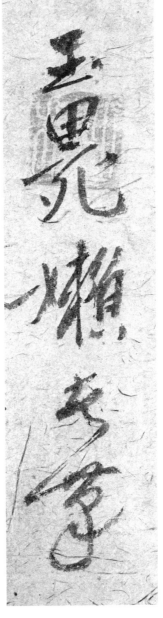

Orchids, Bamboo, and Thorns
Right-hand scroll: square intaglio seal reading *Shōrin*. Brooklyn Museum, Gift of Roebling Society and Oriental Art Acquisitions Fund (73.123.1).

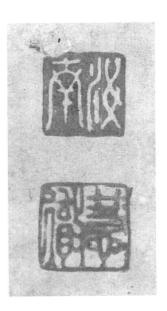

CATALOGUE NUMBER 34

Orchids, Bamboo, and Thorns
Left-hand scroll: square intaglio seal reading *Shōrin*, and signature in grass-style calligraphy, "Gyoku'en Ransha hitsu." Brooklyn Museum, Gift of Roebling Society and Oriental Art Acquisitions Fund (73.123.2).

CATALOGUE NUMBER 36

Radish
Upper square intaglio seal reading *Jonan*, lower square relief seal reading *Etetsu*. Private collection.

Orchids
Upper oblong relief seal reading *Shaku Reihō Chō'un Sho*, lower square relief seal reading *Jū Kangiji Sha Museishi*, and detail of inscription with signature, "Reihō." Collection unknown, formerly Gejō Collection, Tōkyō.

CHRONOLOGICAL CHARTS

CHINESE HISTORICAL PERIODS		JAPANESE HISTORICAL PERIODS	
Prehistoric	to 1523 B.C.	Jōmon	2000 B.C.–300 B.C.
Shang	1523 B.C.–1028 B.C.		
Chou	1027 B.C.–221 B.C.		
"SPRING AND AUTUMN ANNALS"	722–481		
WARRING STATES	481–221	Yayoi	300 B.C.–A.D. 200
Ch'in	221 B.C.–207 B.C.		
Han	207 B.C.–A.D. 220		
Three Kingdoms	220–265	Kofun (Tumulus)	200–552
Six Dynasties	265–589		
Sui	589–618	Asuka (Suiko)	552–645
T'ang	618–907	Hakuhō (Early Nara)	645–710
		Tempyō (Late Nara)	710–794
		Kōnin (Early Heian)	794–897
Five Dynasties	907–960	Fujiwara (Middle Heian)	897–1086
Northern Sung	960–1127	Insei (Late Heian)	1086–1185
Southern Sung	1127–1279	Kamakura	1185–1333
Yüan	1280–1368		
Ming	1368–1644	Muromachi (*See chart at right*)	1333–1573
		Momoyama	1573–1615
Ch'ing	1644–1912	Edo	1615–1868
		Meiji	1868–1912
Modern	1912–	Taishō	1912–1926
		Shōwa	1926–

THE MUROMACHI PERIOD
1333–1573

			Ashikaga Shōguns		Reigned
Nambokuchō	1333–1392	1	TAKA'UJI	(1305–1358)	1338–1358
		2	YOSHI'AKIRA	(1330–1368)	1358–1367
		3	YOSHIMITSU	(1358–1408)	1367–1394
Kitayama	1394–1428	4	YOSHIMOCHI	(1386–1428)	1394–1423 1425–1428
		5	YOSHIKAZU	(1407–1425)	1423–1425
		6	YOSHINORI	(1394–1441)	1428–1441
		7	YOSHIKATSU	(1433–1443)	1441–1443
		8	YOSHIMASA	(1435–1490)	1443–1474
Ōnin Civil War	1467–1477				
Higashiyama	1474–1490	9	YOSHIHISA	(1465–1489)	1474–1489
Sengoku Jidai	1490–1573	10	YOSHITANE	(1465–1522)	1490–1493 1508–1521
		11	YOSHIZUMI	(1478–1511)	1493–1508
		12	YOSHIHARU	(1511–1550)	1521–1546
		13	YOSHITERU	(1535–1565)	1546–1565
		14	YOSHIHIDE	(1564–1568)	1565–1568
		15	YOSHI'AKI	(1537–1597)	1568–1573

BIBLIOGRAPHY

SOURCES IN JAPANESE AND CHINESE

All names are given Japanese style, with surnames first.

Abe Fusajirō. *Sōraikan Kinshō* (A Collection of Chinese Paintings). 6 pts. in 2 vols. Ōsaka: Hakubundō, 1930–39.

Aimi Kō'u. "Den Soga Dasoku Sansui-zu" ("A Landscape Attributed to Soga Dasoku"), *Nihon Bijutsu Kyōkai Hōkoku,* no. 30.

———. "Soga Hyōbu Keishu," *Nihon Bijutsu Kyōkai Hōkoku,* no. 35.

———. *Unshū Yosai* (Art Heritage in Izumo Province). 2 vols. Tōkyō: Aimi Kō'u, 1922.

Akazawa Eiji. "Shijiku to Shigajiku" ("Poetry Scrolls and Poetry-Painting Scrolls"), *Bijutsushi* 10:4 (1961): 105–18.

———. "Richō Jitsuroku no Bijutsu Shiryō Shōroku" ("Extracts of Art Historical Sources from the Chronicles of the Yi Dynasty in Korea"), *Kokka,* nos. 882, 884 (1965); 892 (1966).

Arai Hakuseki (attrib.; 1656–1725). *Gakō Benran* (Handbook of Painters, ca. 1680). In Sakazaki Tan, ed., *Nihon Garon Taikan,* 2:1055–1116. Tōkyō: Ars, 1926–28.

Akiyama Terukazu. *Heian Jidai Sezokuga no Kenkyū* (Secular Painting in Heian Period Japan). Tōkyō: Yoshikawa Kōbunkan, 1964.

Akiyama Teru'o. *Momoyama Jidai Shōhekiga Zushū* (A Collection of Momoyama Period Paintings on Sliding Doors). Tōkyō: Jurakusha, 1929.

Asano Kōshakuke Hōkaifu (Illustrated Catalogue of the Paintings in the Marquis Asano Collection). Tōkyō: Geikaisha, 1917.

Asa'oka Okisada (1800–56). *Koga Bikō* (Handbook of Classical Painting). 3 vols. plus index vol. Revised and enlarged by Ōta Kin as *Zotei Koga Bikō* in 1904. Tōkyō: Shibunkaku, 1970.

Bengyokushū. See *Gakō Inshō Bengyokushū.*

Bijutsu Kenkyūjo, Tōkyō (The Institute of Art Research, Tōkyō). *Ryōkai* (Liang K'ai). Kyōto: Benridō, 1957.

Bijutsu Shū'ei (Collected Gems of Art). 20 vols. Tōkyō: Shimbi Shoin, 1912.

Chang Yen-yüan. *Li-tai Ming-hua Chi* (Famous Paintings Through the Ages, A.D. 847). 10 *chüan.* In Yang Chia-lo, ed., *I-shu Ts'ung-pien,* vol. 8, no. 58. Taipei: preface 1962. See also Acker, *Some T'ang and Pre-T'ang Texts.*

Ch'ing Sheng-tsu. *Kuang Ch'ün-fang-p'u* (Enlarged Encyclopedia of Flowers). Vol. 2. *Kuo-hsüeh Chi-pen Ts'ung-shu.* Published by Shang wu yin shu kuan (Commercial Press; n. p., n.d.).

Daijō-in Jisha Zōjiki. See Jinson.

Dainihon Bukkyō Zensho (The Collected Works of Japanese Buddhism). 100 vols. Tōkyō: Suzuki Gakujutsu Zaidan, 1972.

Dainihon Kokiroku (Collection of Japanese Historical Records). 32 vols. Compiled by Tōkyō Daigaku Shiryō Hensanjo. Tōkyō: Iwanami Shoten, 1952–.

Dainihon Kōtei Daizōkyō (The Tripitaka in Chinese). 419 vols. in 41 cases. Tōkyō: Bukkyō Shoin, 1880–85.

Dainihon Zoku Zōkyō (A Continuation of Dainihon Kōtei Daizōkyō). 750 vols. Kyōto: Zōkyō Shoin, 1905–12. Also called *Manji Zoku Zōkyō.*

Dainihon Shiryō (Japanese Historical Documents). Compiled by Tōkyō Teikoku Daigaku, Shiryō Hensanjo. Tōkyō: Tōkyō Daigaku, 1902–.

Do'i Tsuguyoshi. *Motonobu, Eitoku.* Suiboku Bijutsu Taikei, vol. 8. Tōkyō: Kōdansha, 1974.

Dokushi Biyō (Handbook of History). Tōkyō: Tōkyō Teikoku Daigaku, Shiryō Hensanjo, repr. 1966.

Etō Shun. "Sesson no Jigazō" ("*Self-Portrait* by Sesson"), *Yamato Bunka,* no. 30 (1959): 87–94.

———. "Yū'e Gukei hitsu Byaku'e Kannon-zu" ("*White-Robed Kannon* by Gukei Yū'e"), *Yamato Bunka,* no. 34 (1961): 57–60.

———. "Byaku'e Kannon-zu, Gyoshō-zu" ("Paintings of *White-Robed Kannon* and *Fisherman and Woodcutter*"), *Yamato Bunka,* no. 46 (1967): 53–57.

———. "Sesson-ga no Isō" ("Study of Sesson"), *Yamato Bunka,* no. 46 (1967): 41–48.

———. "Ashikaga Yoshimochi Jigasan Daruma-zu" ("*Bodhidharma* Painted and Inscribed by Ashikaga Yoshimochi"), *Kobijutsu,* no. 35 (1971): 104–6.

———. "Sesson no Kachōga" ("Bird-and-Flower Paintings by Sesson"), *Museum,* no. 281 (1974): 4–13.

Fujikake Shizuya. "Sesson hitsu Ryūko-zu" ("*Tiger and Dragon* by Sesson"), *Kokka,* no. 737 (1953): 224.

Fujita Bijutsukan Meihin Zuroku (Illustrated Catalogue of the Collection of the Fujita Art Museum). Tōkyō: Nihon Keizai Shinbunsha, 1972.

Fujita Tsuneyo. *Muromachi Jidai Gasanshū* (Muromachi Period Inscriptions on Paintings). In "Kōkan Bijutsu Shiryō," no. 46. Mimeographed, printed edition forthcoming. Tōkyō: Bijutsu Kenkyūjo, 1954.

———. *Sesshū Nempu* (Chronology of Sesshū). In "Kōkan Bijutsu Shiryō," no. 71. Mimeographed, printed edition forthcoming. Kanazawa: 1956.

————. *Butsunichi-an Kumotsu Mokuroku* (Inventory of Public Properties in the Butsunichi-an of the Engaku-ji). In "Kōkan Bijutsu Shiryō," no. 113. Mimeographed, printed edition forthcoming. Tōkyō: 1962.

————. *Kundaikan Sayū Chōki Shū* (Collected Versions of the *Kundaikan Sayū Chōki*). In "Kōkan Bijutsu Shiryō," no. 114. Mimeographed, printed edition forthcoming. Tōkyō: 1963.

————. *Kōkan Bijutsu Shiryō: Ji'in Hen* (Historical Source Materials on Japanese Art: Temples). Tōkyō: Chū'ō Kōron Bijutsu Shuppan, 1972.

————. ed. *Nihon Bijutsu Zenshi* (A Comprehensive History of Japanese Art). 2 vols. Tōkyō: Bijutsu Shuppansha, 1959.

Fuku'i Rikichirō. "Nihon Suibokuga no Genryū" ("The Origin and Development of Japanese Ink Painting"), *Kyōto Hakubutsukan Kō'enshū* (Collected Lectures at the Kyōto National Museum), vol. 2. Kyōto: 1930.

————. "Sesson Shinron" ("A New Discussion of Sesson"), *Iwanami Kōza: Nihon Bungaku*, pp. 41–81. Tōkyō: Iwanami Shoten, 1933.

————. "Mokkei Itteki" ("A Few Words on Mu-ch'i"), *Bijutsu Kenkyū*, nos. 135–136 (1944).

Fuku'oka Kōtei. "Impu Benmō" ("Revisory Notes on Painters' Seals"), *Kokka*, nos. 79, 80, 84 (1896); 102 (1898).

Fushimi Sadashige. *Kammon Gyoki* (Diary of Go-Sukō'in, 1416–48). *Zoku Gunsho Ruijū*, supp. vols. 3 and 4. Tōkyō: Zoku Gunsho Ruijū Kanseikai, 1942.

Gakō Inshō Bengyokushū (Discrimination of Jade from Stone in Painters' Seals; 1672). In Sakazaki Tan, ed., *Nihon Garon Taikan*, 2:1117–85. Tōkyō: Ars, 1926–28.

Gei'en Shinshō (Selected Masterpieces of Painting, Sculpture, and Industrial Art of the Orient). 12 vols. Tōkyō: Shimbi Shoin, 1915–18.

Gidō Shūshin (1325–88). *Kūge Shū* (Anthology of Literary Works of Gidō Shūshin). In U'emura Kankō, ed., *Gozan Bungaku Zenshū*, 2:451–1021. Tōkyō: Gozan Bungaku Zenshū Kankōkai, 1936.

————. *Jūkan Jōwa Ruiju So'en Renhōshū* (A Collection of Sung and Yüan Ch'an Priests' Poems; 1388). In *Dainihon Bukkyō Zensho*, 88:90–210. Tōkyō: Suzuki Gakujitsu Zaidan, 1972.

————. *Kūge Nikkō Shū*. See Tsuji Zennosuke.

Go-Sukō'in. See Fushimi Sadashige.

Gotō Bijutsukan (The Gotō Art Museum). 2 vols. Edited by Tanaka Ichimatsu. Tōkyō: Mainichi Shimbun Sha, 1971.

Gotō Shu'ichi. *Kokyō Shū'ei* (A Pictorial Catalogue of Ancient Bronze Mirrors). Vol. 2. Tōkyō: Ōtsuka Kōgeisha, 1935.

Gumpō Seigan (Appreciation of Gems of Painting). 10 vols. Edited by Wada Miki'o. Tōkyō: Seigei Shuppan Sha, 1920.

Gunsho Ruijū (Collection of Historical Books and Documents). 29 vols. with sequel in 82 vols. Edited by Hanawa Hoki'ichi. (Includes the *Zokuhen* and the *Zoku Gunsho Ruijū*.) Tōkyō: Zoku Gunsho Ruijū Kanseikai, 1922–33.

Gyomotsu On'e Mokuroku. See Tani Shin'ichi.

Haga Kōshirō. *Higashiyama Bunka no Kenkyū* (Research on the Culture of the Higashiyama Period). Tōkyō: Kawade Shobō, 1945.

————. *Chūsei Zenrin no Gakumon oyobi Bungaku ni Kansuru Kenkyū* (A Study of the Learning and Literature in Medieval Zen Circles). Tōkyō: Nihon Gakujutsu Shinkōkai, 1956.

Hasumi Shigeyasu. "Nara Hōgen Kantei," *Nihon Bijutsu Kyōkai Hōkoku*, no. 38.

————. *Sesshū Tōyō Ron* (A Study of Sesshū Tōyō). Tōkyō: Chikuma Shobō, 1961.

————. "Nissō Bunka Kōryu to Shunjō — Suibokuga no Torai no Hajime o Motomete" ("Shunjō as a Promoter of the Cultural Exchange between Japan and Sung China"), *Bukkyō Geijutsu*, no. 36 (1958).

Higashiyama Suibokugashū (Ink Painting of the Higashiyama Period). 13 vols. Tōkyō: Jurakusha, 1933–36.

Hihō (Treasures). 12 vols. Tōkyō: Kōdansha, 1967–70.

Hiyama Tansai (1774–1842). *Kōchō Meiga Shū'i* (Record of Famous Japanese Painters; 1819). In Sakazaki Tan, ed., *Nihon Garon Taikan*, 2:1383–1443. Tōkyō: Ars, 1926–28. Also known as *Zoku Honchō Gashi* (History of Japanese Painting, Continued).

"Hopei Ching-hsing hsien Shih-chuang Sung Mu Fachüeh Pao-kao" ("Excavations of the Sung Tombs at Shih-chuang, Ching-hsing County, Hopei), *K'ao-ku Hsüeh-pao*, no. 30 (1962): 31–73.

Hori Naonori (1806–80) and Kurokawa Harumura (1798–1866). *Fusō Meiga Den* (Biographies of Japanese Painters). Revised by Kurokawa Mamichi. Tōkyō: Tetsugaku Shoin, 1899.

Hsia Wen-yen. *T'u-hui Pao-chien* (Reflection of Famous Paintings; preface 1365). In Yang Chia-lo, ed., *I-shu Ts'ung-pien*, vol. 11, no. 83. Taipei, preface 1962.

Hsüan-ho Hua-p'u (Catalogue of Paintings in the Imperial Collection of the Hsüan-ho Era; preface 1120). In

Yang Chia-lo, ed., *I-shu Ts'ung-pien*, vol. 9, no. 65. Taipei, preface 1962.

I'enaga Saburō. *Chūsei Bukkyō Shisōshi Kenkyū* (A Study of the History of Thought in Medieval Buddhism). Rev. ed. Kyōto: Hōzōkan, 1955.

———. "Jōdai Kara-e Kō, 1" ("Study of *Kara-e* Painting of the Nara and Heian Periods, part 1"), *Bijutsu Kenkyū*, no. 111 (1941): 67–81.

I'izuka Bei'u. *Nihonga Taisei* (Comprehensive Collection of Japanese Painting), vol. 3. Tōkyō: Tōho Shoin, 1931–34.

Ima'eda Aishin. *Zenshū no Rekishi* (A History of Zen Buddhism). Tōkyō: Shibundō, 1952.

———. *Shintei Zusetsu Bokuseki Soshiden* (Biographies of Zen Monk Calligraphers, Revised and Illustrated). Tōkyō: Hakurinsha, 1970.

Ima'izumi Yūsaku. *Shoga Kottō Sōsho* (A Connoisseur's Guide to Calligraphy, Painting, and Antiquities). Tōkyō: 1920.

Iriya Yoshitaka. *Kanzan* (Han Shan). Chūgoku Shijin Senshū, vol. 3. Tōkyō: Iwanami Shoten, 1958.

Ishin Sūden, *et al.*, ed. *Kanrin Gohōshū* (Anthology of Chinese-style Poems by Zen Monks of the Muromachi Period). In *Dainihon Bukkyō Zensho*. Tōkyō: Yūseidō, 1932.

Iwanami Shoten, ed. *Sesshū*. Tōkyō: Iwanami Shoten Bunko, 1956.

Iwano Masa'o, ed. *Bussho Kaisetsu Daijiten* (Comprehensive Bibliography of Buddhist Writings). 11 vols. Tōkyō: Daitō Shuppansha, 1965.

Jinson (1430–1508; abbot of the Daijō-in of the Kōfuku-ji in Nara). *Daijō-in Jisha Zōjiki* (Diary of Jinson and Various Records of Functionaries of the Kōfuku-ji; 1450–1527). Tōkyō: Sankyō Shoin, 1931–37. See also Tsuji Zennosuke.

Kamakura-shi Shi (History of Kamakura City). Vol. 2. Tōkyō: Kamakura-shi, 1959.

Kameda Tsutomu. "Tōdai-ji Kegon Gojūgokasho'e Shōkō" ("Preliminary Study of *Kegon Gojūgokasho'e* in the Tōdai-ji Collection"), *Seikan*, no. 18 (1943): 13–19.

Kamimura Kankō. See U'emura Kankō.

Kammon Gyoki. See Fushimi Sadashige.

Kanazawa Hiroshi. "Kyū-Yōtoku-in Fusuma-e ni tsuite" ("Concerning the Sliding-door Paintings Formerly in the Yōtoku-in"), *Bijutsushi*, no. 55 (1964).

———. *Shoki Suibokuga* (The Early Stages of Ink Painting). Nihon no Bijutsu, no. 69. Tōkyō: Shibundō, 1972.

Kano Einō (1634–1700). *Honchō Gashi* (History of Japanese Painting; 1678). In Sakazaki Tan, ed., *Nihon Garon Taikan*, 2: 951–1017. Tōkyō: Ars, 1926–28.

———. *Honchō Ga'in* (Seals of Japanese Painters; 1693). In Sakazaki Tan, ed., *Nihon Garon Taikan*, 2: 1018–54. Tōkyō: Ars, 1926–28.

Kano Ikkei (1599–1662). *Kōsoshū* (Themes in Chinese Painting; 1623). In Sakazaki Tan, ed., *Nihon Gadan Taikan*, pp. 536–90. Tōkyō: Mejiro Shoin, 1917.

———. *Tansei Jakubokushū* (Biographies of Japanese Painters). In Sakazaki Tan, ed., *Nihon Garon Taikan*, 2: 923–50. Tōkyō: Ars, 1926–28.

Karan, ed. *Mei'an Saikō Zenji Tōmei* (A Commemorative Biography of the Zen Priest Eisai). *Zoku Gunsho Ruijū*, vol. 9. Tōkyō: Zoku Gunsho Ruijū Kanseikai, 1923–28.

Kawasaki Yoshitarō. *Chōshunkaku Kanshō* (Appreciation of Art Works in the Chōshunkaku Gallery of Baron Kawasaki, Kōbe). 6 vols. Tōkyō: Kokka Sha, 1914.

Keijo Shūrin (1440–1518). *Kanrin Koroshū* (Literary Anthology of Keijo Shūrin). In U'emura Kankō, ed., *Gozan Bungaku Zenshū*, vol. 4. Tōkyō: Gozan Bungaku Zenshū Kankōkai, 1936.

Kikō Daishuku. *Shaken Nichiroku* (diary of Kikō Daishuku, a Monk at the Tōfuku-ji, Kyōto; 1484–86). In *Dainihon Kokiroku*. Tōkyō: Iwanami Shoten, 1953.

Kisei Reigen (1404–88). *Son'an-kō* (Anthology of the Literary Works of Kisei Reigen). In Tamamura Takeji, ed., *Gozan Bungaku Shinshū*, 2:163–494. Tōkyō: Tōkyō Daigaku Shuppankai, 1967–72.

Koga Bikō. See Asa'oka Okisada.

Kokuhō (National Treasures). Tōkyō: Mainichi Shimbun Sha, 1963–.

Kondō Yoshihiro, *et al.*, ed. *Nihon Kōsō Iboku* (Works of Calligraphy by Famous Japanese Priests). 3 vols. Tōkyō: Mainichi Shimbunsha, 1971.

Kōzei Ryūha. *Zokusui Shishū* (Anthology of the Literary Works of Kōzei Ryūha, ca. 1420). *Zoku Gunsho Ruijū*, vol. 12A. Tōkyō: Zoku Gunsho Ruijū Kanseikai, 1926.

Kumagai Nobu'o. "Ō'ei Nenkan no Shigajiku" ("Paintings with Poetical Inscriptions during the Ō'ei Years, 1394–1427"), *Bijutsu Kenkyū*, no. 4 (1932):122–28.

———. "Gyoku'en Bompō Den" ("A Biographical Study of Gyoku'en Bompō"), *Bijutsu Kenkyū*, no. 15 (1933): 95–113.

———. "Senka hitsu Setsureisai-zu" ("*Snowy Mountain Study* by Senka"), *Bijutsu Kenkyū*, no. 19 (1933):24–26.

————. "Butsunichi-an Kumotsu Mokuroku" ("Inventory of Public Properties in the Butsunichi-an of the Engaku-ji"), *Bijutsu Kenkyū*, no. 24 (1933):24–30.

————. Sesshū. Tōkyō: Heibonsha, 1936.

————. "Sesshū-ga Nendai Kō" ("On the Chronology of Sesshū's Paintings"), *Bijutsu Kenkyū*, no. 155 (1949): 31–45.

————. *Sesshū Tōyō*. Nihon Bijutsushi Sōsho, vol. 4. Tōkyō: Tōkyō Daigaku Shuppankai, 1958.

————. "Shūbun hitsu Chiku-ga Setsu" ("Discussion of Bamboo Paintings by Su-mun"), *Kokka*, no. 910 (1968): 20–32.

Kundaikan Sayū Chōki (A Fifteenth Century Connoisseur's Manual of Chinese Art). In *Gunsho Ruijū*, 19: 648–70. Tōkyō: Zoku Gunsho Ruijū Kanseikai, 1933.

Kuo Jo-hsü. *T'u-hua Chien-wen Chih* (Experiences in Painting; ca. 1078). 6 *chüan*. In Yang Chia-lo, ed., *I-shu Ts'ung-pien*, vol. 10, no. 66. Taipei, preface 1962. See also Soper, *Kuo Jo-hsü's Experiences in Painting*.

Kuo-li Ku-kung Po-wu-yüan (Three Hundred Masterpieces of Chinese Painting in the Palace Museum). 6 vols. Taiwan: National Palace Museum and National Central Museum, 1959.

Kurokawa Harumura (1798–1866). *Kōko Gafu* (Catalogue of Ancient Paintings in Japan). In *Kurokawa Mayori Zenshū*, vols. 1–2. Tōkyō: Hayakawa Junsaburō, 1910.

Kyōto Kokuritsu Hakubutsukan. See Kyōto National Museum.

Kyōto National Museum. *Sesshū* (Catalogue of the Sesshū Exhibition). Kyōto: Kyōto National Museum, 1956.

————. *Bokuseki Suibokuga Kokuhō Ten Zuroku* (Exhibition Catalogue of Ink Paintings that are National Treasures). Kyōto: Kyōto National Museum, 1958.

————. *Muromachi Jidai Shoga* (Calligraphies and Paintings of the Muromachi Period). Kyōto: Kyōto National Museum, 1961.

————. *Muromachi Jidai Bijutsu Ten Zuroku* (Fine Arts of the Muromachi Period: Illustrated Catalogue of the Special Exhibition). Kyōto: Kyōto National Museum, 1967.

————. *Chūsei Shōbyōga* (Sliding-Door and Folding-Screen Paintings of the Japanese Middle Ages). Kyōto: Kyōto National Museum, 1970.

————. *Heike Nōkyō*. Kyōto: Kōrinsha, 1974.

Lü-shih Ch'un-ch'iu (Lü Version of the Spring and Autumn Annals). Vol. 1. Peking: Wen hsüeh ku chi k'an hsing she, 1955.

Mainichi Shimbunsha, ed. *Suibokuga* (Ink Painting). 3 vols. Tōkyō: Mainichi Shimbunsha, 1971–73.

Manji Zoku Zōkyō. See *Dainihon Zoku Zōkyō*.

Makita Tairyō. *Sakugen Nyūminki no Kenkyū* (Study of Sakugen's Mission to Ming China). 2 vols. Kyōto: Hōzōkan, 1955–59.

Manzei (abbot of Daigo-ji; 1378–1435). *Manzei Jugō Nikki* (Diary of Manzei; 1411–35). In *Zoku Gunsho Ruijū*, supp. 1–2. Tōkyō: Zoku Gunsho Ruijū Kanseikai, 1928.

Masaki Bijutsukan Shuppin Mokuroku (Masaki Art Museum Exhibition Catalogue). No. 1, 1968.

Matsudaira Sadanobu (1758–1829), ed. *Shūko Jusshu* (Ten Albums of Antiquities). 4 vols. Tōkyō: Ichijima Kenkichi, 1908.

Matsumoto Ei'ichi. "Suigetsu Kannon-zu Kō" ("Discussion of Water-Moon Kannon Paintings"), *Kokka*, no. 429 (1926): 205–13.

————. *Tonkōga no Kenkyū* (Study of Tun-huang Paintings). 2 vols. Tōkyō: Tōhō Bunka Gakuin, 1937.

Matsushita Taka'aki. "Chūsei ni okeru Chūgoku Kaiga Sesshu no Ichi-yōso" ("One Phase of Chinese Painting Introduced to Japan in her Middle Ages"), *Ars Buddhica* (*Bukkyō Geijutsu*), no. 5 (1949).

————. *Muromachi Suibokuga* (Muromachi Ink Painting). Vol. 1. Tōkyō: Ōtsuka Kōgeisha, 1960.

————. *Suibokuga* (Ink Painting). Nihon no Bijutsu, no. 13. Tōkyō: Shibundō, 1967.

————. "Shūsei no Sūten no Sakuhin" ("On Several Paintings by Shūsei"), *Ars Buddhica* (*Bukkyō Geijutsu*), no. 69(1968):135–43.

———— and Tamamura Takeji. *Josetsu, Shūbun, San-Ami*. Suiboku Bijutsu Taikei, vol. 6. Tōkyō: Kōdansha, 1974.

Mi Fei (1051–1107). *Hua Shih* (History of Painting; ca. 1100). 1 *chüan*. In Yang Chia-lo, ed., *I-shu Ts'ung-pien*, vol. 10, no. 68. Taipei, preface 1962. See also Vandier-Nicolas.

Minamoto Hōshū (Toyomune). *Nihon Bijutsu-shi Zuroku* (An Illustrated History of Japanese Fine Arts). Kyōto: Hoshino Shoten, 1931.

————. "Shūbun Yōshiki no Seiritsu" ("Formation of Shūbun Style"), *Yamato Bunka*, no. 46 (1967):25–36.

————. "Soga-ha to Asakura Bunka" ("The Soga School and the Culture of the Asakura Clan"), *Kobijutsu*, no. 38 (1972):29–39.

————, ed. *Momoyama Byōbu Taikan* (Folding Screens of the Momoyama Period). Kyōto: Nakashima Taiseikaku, 1934.

————, ed. *Tōhaku Gasetsu* (Tōhaku's Discussion of Painting; recorded by Nittsū, ca. 1591). Kyōto: Wakō Shuppansha, 1963.

Minshin no Kaiga. See Tōkyō National Museum.

Mizu'o Hiroshi. "Chū'an Shinkō hitsu Kannon-zu" ("*Kannon* by Chū'an Shinkō"). *Kokka*, no. 797 (1958).

Mochimaru Kazu'o. "Ishiyama-dera Engi to Boki E-kotoba ni arawareta Shōheiga" ("Sliding-Door and Screen Paintings Appearing in the *Ishiyama-dera Engi* and the *Boki E-kotoba*"), *Bijutsu Kenkyū*, no. 169 (1952):190–200.

————. "Hōnen Eden ni arawareta Shōheiga" ("Sliding-Door and Screen Paintings Appearing in the *Hōnen Eden*"), *Bijutsu Kenkyū*, no. 171 (1953):85–102.

Mochizuki Shinkyō. *Bukkyō Daijiten* (Dictionary of Buddhism). 8 vols. Kyōto: Sekai Seiten Kankō Kyōkai, 1954–58.

————. *Bukkyō Dai Nempyō* (Chronological Table for Buddhism). Kyōto: Sekai Seiten Kankō Kyōkai, 1956.

Muchaku Dōchū (1653–1744). *Zenrin Shōkisen* (Dictionary of Zen Terminology; 1741). Edited by Shida Otomatsu. Tōkyō: Seishin Shobō, 1963.

Mutō Sanji, ed. *Chōshō Seikan* (Chinese Paintings Preserved in the Mutō Collection in Japan). 3 vols. Ōsaka: 1928.

Naga'i Makoto, ed. *Honchō Kōsō Den* (Biographies of Japanese Priests; preface 1702 by Shiban 1626–1710). Tōkyō: Dainihon Bukkyō Zensho, 1935.

Nakajima Junji. "Kakejuku kara Byōbu-e" ("The Influence of Hanging Pictures on the Formation of Screen Painting"), *Bijutsushi*, 16:1 (1966):1–17.

————. "Shiki Sansui no Henyō" ("The Development of Paintings of Landscapes of the Four Seasons"), *Museum*, no. 191 (1967):2–21.

————. "Sesshū-kei Kachō-zu Byōbu Kenkyū" ("Study of Sesshū-style Flower-and-Bird Screen Paintings"), *Museum*, no. 199 (1967):9–30.

————. "Keishiki Yōkyū to Gikotensei" ("Reversion of 'Form' and Pseudo-Classicism — The Unique Standing of Sliding-Door Paintings of Landscape in the Hōki-in"), *Museum*, no. 226 (1970):4–25.

————. "Shinju-an Fusuma-e no Yōshikiteki Kenkyū," ("Stylistic Study of the Sliding-Door Paintings at the Shinju-an"), *Daitoku-ji.* Shōhekiga Zenshū, vol. 8. Edited by Tanaka Ichimatsu, Do'i Tsuguyoshi, and Yamane Yūzo. Tōkyō: Bijutsu Shuppansha, 1971.

Nakamura Tani'o (Hide'o). "Den-Shūbun hitsu Sansui-zu Byōbu" ("The Landscape Screens Attributed to Shūbun"), *Museum*, no. 14 (1952):18–21.

————. "Suibokuga no Fuji: Chū'an Shinkō hitsu Fuji-zu o Chūshin ni" ("Ink Painting of Mount Fuji: Focusing on *Fuji* by Chū'an Shinkō"), *Museum*, no. 52 (1955):18–20.

————. "Gukei hitsu Chikujaku-zu to sono Nendai" ("Gukei's *Bamboo and Sparrow* and Its Date"), *Kokka*, no. 762 (1955):261–69.

————. "Bokushō Shūsei ni Kansuru Shiryō" ("Material for the Study of Bokushō Shūsei"), *Kokka*, no. 767 (1956):40–45.

————. "Sansui-zu to Hotei-zu" ("*Landscape* and *Hotei* [by Gukei]"), *Museum*, no. 73 (1957):14–16.

————. "Tesshū Tokusai no Gaji" ("Paintings by Tesshū Tokusai"), *Museum*, no. 98 (1959):20–22.

————. "Kano Gyokuraku ni tsuite" ("Concerning Kano Gyokuraku"), *Museum*, no. 101 (1959):17–19.

————. "Bokusai hitsu Sansui-zu ni tsuite" ("*Landscape* by Bokusai"), *Museum*, no. 134 (1962):15–20.

————. "Gyoku'en Bompō hitsu Ran-zu" ("Pair of *Orchids* by Gyoku'en Bompō"), *Kobijutsu*, no. 14 (1966):107–8.

————. "Sōyū to Gyokuraku," *Yamato Bunka*, no. 48 (1968):38–46.

————. "Bunsei hitsu Kokei Sanshō-zu ni tsuite" ("Concerning the *Kokei Sanshō* by Bunsei"), *Museum*, no. 222 (1969):24–27.

————. *Shōkei.* Tōyō Bijutsu Sensho, no. 9. Tōkyō: Sansaisha, 1970.

————. *Sesson to Kantō Suibokuga* (Sesson and Ink Painting of Artists of the Kantō Region). Nihon no Bijutsu, no. 63. Tōkyō: Shibundō, 1971.

————. "Tesshū Tokusai hitsu Rogan-zu" ("*Reeds and Geese* by Tesshū Tokusai"), *Kobijutsu*, no. 38 (1972):79–81.

————. "Jonan Etetsu hitsu Daikon-zu" ("*Turnip* by Jonan Etetsu"), *Kobijutsu*, no. 40 (1973):112–14.

————. "Tesshū Tokusai hitsu Ranchiku Seki-zu" ("*Orchid, Bamboo, and Rock* by Tesshū Tokusai"), *Kobijutsu*, no. 40 (1973):69–71.

————. "Kaigai ni okeru Sesson-ga" ("Sesson's Paintings in Foreign Collections"), *Museum*, no. 281 (1974):14–26.

————. "Shiryō kara mita Sesson no Omokage" ("Reference Materials about Sesson"), *Museum*, no. 281 (1974):27–34.

Nara Rokudaiji Taikan (Overview of the Major Temples in Nara). 14 vols. Edited by Nara Rokudaiji Taikan Kankōkai. Tōkyō: Iwanami Shoten, 1971.

Nezu Kaichirō. *Seizansō Seishō* (Illustrated Catalogue of the Nezu Collection). 10 vols. Tōkyō: Nezu Art Museum, 1943.

Nihon Chōkokushi Kiso Shiryō Shūsei (A Collection of Basic Materials for the History of Japanese Sculpture). 8 vols. Tōkyō: Chū'ō Kōron Bijutsu Shuppan, 1966–70.

Nihon Emakimono Zenshū (Compilation of Japanese Narrative Handscrolls). 25 vols. Tōkyō: Kadokawa Shuppansha, 1958–68.

Nihon Kokuhō Zenshū (Illustrated Catalogue of the National Treasures of Japan). Nos. 1–84. Edited by the Mombushō. Tōkyō: Kokuhō Zenshū Kankōkai, 1924–39.

Nihon Kōsō Iboku (Works of Calligraphy by Famous Japanese Priests). 2 vols. Tōkyō: Mainichi Shimbunsha, 1970–71.

Nittsū (d. 1608). *Tōhaku Gasetsu.* See Minamoto.

Noma Seiroku. *Nihon Bijutsu Jiten* (Dictionary of Japanese Art). Tōkyō: Tōkyōdō, 1966.

Okudaira Hide'o. *Nihon Bijutsu Benran* (Handbook of Japanese Art). Tōkyō: Bijutsu Shuppansha, 1957.

Onryōken Nichiroku. See Tamamura and Katsuno.

Ōsen Keisan (1429–93). *Ho'an Keikashū* (Literary Anthology of Ōsen Keisan: 1485). In Tamamura Takeji, ed., *Gozan Bungaku Shinshū*, vol. 1. Tōkyō: Tōkyō Daigaku Shuppankai, 1957.

Ōsaka Yomi'uri Shimbunsha. *Sesshū Ten* (Sesshū Exhibition Catalogue). Ōsaka: Ōtsuka Kōgeisha, 1971.

Ōta Takahito. "Daisen-in Fusuma-e no Shōshō Hakkei ni tsuite" ("On the Sliding-Door Paintings of *Shōshō Hakkei* in the Daisen-in"), *Bijutsushi*, no. 86 (1972): 48–60.

Ozaki Nobumori. "Iwayuru Hakuga Dankin-kyō ni tsuite" ("A Consideration of the So-called *P'o-ya Playing the Ch'in* Mirrors"), *Museum*, no. 95 (1959):26–29.

———. "Futatabi iwayuru Hakuga Dankin-kyō ni tsuite" ("A Second Consideration of the So-called *P'o-ya Playing the Ch'in* Mirrors"), *Museum*, no. 120 (1961): 20–21.

Roku'on Nichiroku. See Tsuji Zennosuke.

Ryōkun, ed. *Kokon Ichiyō-shū)* (Handbook on Icons and Art Treasures at Hōryū-ji). Nara: Ikarugasha, 1948.

Saitō Ken. *Kano-ha Taikan* (General View of Works by the Kano School). 3 vols. Tōkyō: Kano-ha Taikan Hakkōjo, 1912–14.

———. *Kano-ha* (Kano School). Nihonga Taisei, vols. 5–6. Tōkyō: Tōhō Shoin, 1931.

Saitō Michitarō, ed. *Chūgoku Chūsei*, 1. *Sōgen* (Chinese Middle Ages, 1. Sung and Yüan). In Sekai Bijutsu Zenshū, vol. 14. Tōkyō: Heibonsha, 1951.

Sakamoto Yuki'o and Iwamoto Yutaka, trans. and collators. *Hokke-kyō* (The Lotus Sūtra). 3 vols. Tōkyō: Iwanami Bunko, 1965–70.

Sakazaki Tan, ed. *Nihon Gadan Taikan* (Collection of Japanese Painting Texts). Tōkyō: Mejiro Shoin, 1917.

———, ed. *Nihon Garon Taikan* (Collection of Japanese Painting Texts). 2 vols. Tōkyō: Ars, 1926–28.

Sanetaka-kō Ki. See Sanjōnishi Sanetaka.

Sanjōnishi Sanetaka (1455–1537). *Sanetaka-kō Ki* (Diary of Sanjōnishi Sanetaka, a Kyōto Courtier; 1474–1536). 13 vols. Tōkyō: Zoku Gunsho Ruijū Kanseikai, 1931–63.

Segai-an Kanshō (Album of Paintings in the Possession of Segai-an, or Marquis Inou'e). Tōkyō: Kokka Sha, 1912.

Seikadō Kanshō. See Taki Sei'ichi.

Sekiguchi Shindai. *Daruma no Kenkyū* (Study of Bodhidharma). Tōkyō: Iwanami Shoten, 1967.

"Sessō hitsu Kokei Sanshō oyobi Renge-zu" ("*Three Sages* and *Lotus* by Sessō Tōyō"), *Kokka*, no. 207 (1907).

Shaken Nichiroku. See Kikō Daishiku.

Shang-hai Po-wu-kuan (Paintings in the Collection of the Shanghai Museum). Peking: People's Art Publishing House, 1959.

Shiban (1626–1710). *Empō Dentōroku* (Biographies of Japanese Zen Monks Compiled in the Empō Era, 1673–81). In *Dainihon Bukkyō Zensho*, vol. 70. Tōkyō: Suzuki Gakujutsu Zaidan, 1972. Also in *Dainihon Bukkyō Zensho*, vol. 2. Tōkyō: Yūseido, 1931.

———. *Honchō Kōsō Den.* See Naga'i.

Shimada Shūjirō. "Sessō ni tsuite" ("On Hsüeh-ch'uang"), *Hō'un*, no. 15(1935):49–64.

———. "Mōryō-ga" ("Apparition Paintings"), *Bijutsu Kenkyū*, nos. 84 (1938); 86 (1939).

———. "Sō Teki to Shōshō Hakkei" ("Sung Ti and the *Eight Views of Hsiao and Hsiang*"), *Nanga Kanshō* 10 (1941):6–13.

———. "Shigajiku no Shosaizu ni tsuite" ("Concerning Paintings of the Study as a Type of Poetry-Painting Scroll"), *Nihon Shogaku Kenkyū Hōkoku*, no. 21. Tōkyō: Mombushō Kyōgakukyoku, 1943.

———. *Kyōto Ji'in Jūhō Shin-shiryō Ten Mokuroku* (Exhibition Catalogue of New Materials, Priceless Treasures, in Kyōto Temples). Kyōto: Kyōto National Museum, 1947.

———. "Ume-zu" ("Plum"), *Kokka*, no. 694 (1950):19–21.

————. "Yū'e Gukei no Sakuhin Nishu" ("Some Works by Gukei Yū'e"), *Kokka*, no. 707 (1951):83–90.

————. "Kōtō-in Shozō no Sansui-ga ni tsuite" ("On the Landscape Paintings in the Kōtō-in Subtemple, Kyōto"), *Bijutsu Kenkyū*, no. 165 (1951):12–26.

————. "Shitei Sohaku hitsu Sekishobu-zu" ("*Iris and Rock* by Tzŭ-t'ing Tsu-po"), *Bijutsu Kenkyū*, no. 180 (1955):245–50.

————. "Shōsai Baifu Teiyō" ("Résumé of the *Sung-chai Mei-p'u*"), *Bunka* 20:2 (1956):96–118.

————. "Shishoga Sanzetsu" ("Three Excellences: Poetry, Calligraphy, and Painting"), *Shodō Zenshū* 17:28–36. Tōkyō: Heibonsha, 1956.

————. "Gukei Yū'e hitsu Budō-zu" ("*Grapes* by Gukei Yū'e"), *Kokka*, no. 824 (1960):430–35.

————, ed. *Zaigai Hihō* (Japanese Painting in Western Collections). 3 vols. Tōkyō: Gakushu Kenkyūsha, 1968.

Shimbi Taikan. See Tajima.

Shintei Zōho Kokushi Taikei (Compilation of Historical Documents and Reference Sources). 66 vols. Edited by Kuroita Katsumi. Tōkyō: Yoshikawa Kōbunkan, 1939–62.

Shiraishi Hōryū. *Tōfuku-ji-shi* (History of Tōfuku-ji). Kyōto: Daihonzan Tōfukuzenji, 1930.

Shodō Zenshū (Collected Works of Calligraphy). 20 vols. Edited by Shimonaka Kunihiko. Tōkyō: Heibonsha, 1956–60.

Shōhekiga Zenshū (Collected Works of Paintings on Sliding Doors and Folding Screens). 10 vols. Edited by Tanaka Ichimatsu, Do'i Tsuguyoshi, and Yamane Yūzo. Tōkyō: Bijutsu Shuppansha, 1966–72.

Sōgen Meigashū (Collection of Famous Sung and Yüan Paintings). 2 vols. Edited by Akiyama Terukazu, Tanaka Ichimatsu, and Aimi Shige'ichi. Tōkyō: Isseidō, 1930.

Sōgen Minshin Meiga Taikan. See Tōkyō Imperial Academy of Art.

Sōgen no Kaiga. See Tōkyō National Museum.

Sompi Bunmyaku (Genealogies of Noble Families). 3 vols. and 2 supp. vols. (index). Edited by Tō'in Kinsada, Mitsusu'e, Sanehira, *et al.* In *Shintei Zōho Kokushi Taikei*, vols. 58–60. Tōkyō: Yoshikawa Kōbunkan, 1956–61.

Sōraikan Kinshō. See Abe.

Suibokuga (Catalogue of an Exhibition of Ink Paintings). Ōsaka: Ōsaka Municipal Art Museum, 1958.

Sumi no Bi (Beauty in Ink). Kamakura: Tokiwayama Bunko, 1972.

Sung-pen Lieh-tzu (Sung Edition of *Lieh-tzu*). Taipei: Kuang wen shu chü, 1960.

Suzuki Kei. "Gyokkan Jakufun Shiron" ("A Study of Yü-chien Jo-fên"), *Bijutsu Kenkyū*, no. 236 (1954):79–92.

————. *Ri Tō, Ba'en, Kakei* (Li T'ang, Ma Yüan, Hsia Kuei). Suiboku Bijutsu Taikei, vol. 2. Tōkyō: Kōdansha, 1974.

———— and Koyama Fuji'o, eds. *Chūgoku 5, Sōgen* (China 5, Sung and Yüan). Sekai Bijutsu Zenshū, vol. 16. Tōkyō: Kadokawa Shoten, 1956.

Taimadera Ōkagami (The Catalogue of Art Treasures of Taimadera). Tōkyō: Ōtsuka Kōgeisha, 1935.

Taishō Shinshū Daizōkyō (The Tripitaka in Chinese). 85 vols. Edited by Takakusu Junjirō and Watanabe Kaigyoku. Tōkyō: Daizō Shuppan Kabushiki Kaisha, 1924–32.

Taishō Shinshū Daizōkyō: Zuzō (The Tripitaka in Chinese: Iconographic Drawings). 12 vols. Edited by Takakusu Junjirō and Ono Genmyō. Tōkyō: Daizō Shuppan Kabushiki Kaisha, 1933–34.

Tajima Shi'ichi. *Shimbi Taikan* (Selected Relics of Japanese Art). Kyōto: Nippon Bukkyō Shimbi Kyōkai, 1899.

————. *Motonobu Gashū* (Collection of Paintings by Motonobu). 3 vols. Tōkyō: Shimbi Shoin, 1903–7.

————. *Tōyō Bijutsu Taikan* (Masterpieces of Oriental Art). 15 vols. Tōkyō: Shimbi Shoin, 1908–18.

Takagi Bun (Fumi). *Gyokkan Mokkei Shōshō Hakkei-e to sono Denrai no Kenkyū* (A Study on the Transmission of the Most Noted Masterpieces of "Kara-e" Attributed to either Yü-chien or Mu-hsi). Takagi Bun Zuihitsu, no. 4. Tōkyō: Shūhōkaku, 1926.

Takahashi Masataka. *Sangoku Soshi Ei no Kenkyū* (Study of Portraits of Eminent Patriarchs of the Three Countries). Kyōto: Benridō, 1969.

Take'uchi Shōji. "Hakuga Dankin-zu to Daisen-in Hōjō Ehatsukaku Shōhekiga" ("*P'o-ya Playing the Ch'in* and the Wall Paintings of the Ehatsu Room in the Daisen-in Abbot's Quarters"), *Kobijutsu*, no. 39 (1972):87–88.

Taki Sei'ichi, ed. *Seikadō Kanshō* (Appreciation of the Seikadō Art Collection). 3 vols. Tōkyō: Kokka Sha, 1922.

Tamamura Takeji. "Shōkoku-ji Zenjūseki Fusai no Gozan Shiryō" ("Historical Sources about Gozan Inscriptions attached to the Shōkoku-ji Records of Abbacy"), *Gasetsu*, no. 59 (1941): 867–77.

————. *Gozan Bungaku*. Tōkyō: Shibundō, 1958.

————. "Kūge Nikkō Shū Kō: Bessho-bon oyobi Rya-

kushū Ihon ni tsuite" ("Discussion of the Journal of Gidō Shūshin: On the Different Editions and the Expurgated Sections"), *Rekishi Chiri* 75:5–6 (1963).

———, ed. *Gozan Bungaku Shinshū* (New Compilation of Literature by Gozan Monks). 6 vols. Tōkyō: Tōkyō Daigaku Shuppan Kaisha, 1967–72.

——— and Katsuno Ryushin, ed. *Onryōken Nichiroku* (The Official Diary of the Directors of the Onryōken of Shōkoku-ji; 1435–66 and 1484–93). 5 vols. Kyōto: Shiseki Kankōkai, 1953–54.

Tanaka Ichimatsu. "Sessō no Rankei-zu ni tsuite" ("Concerning *Orchids* by Hsüeh-ch'uang"), *Nanga Kanshō* 13 (1944):2–6.

———. "Sō-ga Yōshiki no Renge-zu ni tsuite" ("Concerning Lotus Paintings of Sung Style"), *Kokka*, no. 679 (1948):267–74.

———. "Shōkei hitsu Sansui-zu" ("*Landscape by Shōkei*"), *Kokka*, no. 695 (1950): 45–46.

———. "Sesson hitsu Shiki Sansui Byōbu ni tsuite" ("The Folding-Screen *Landscape of Four Seasons* by Sesson"), *Bijutsu Kenkyū*, no. 198 (1958):1–10.

———. "Sesson Jiga Jisan Zō no Ichi Kōsatsu" ("A Study of a Self-Inscribed Self-Portrait by Sesson"), *Kokka*, no. 859 (1963):28–37.

———. "Tōshun-ga Setsu" ("Discussion of Tōshun's Painting"), *Kokka*, nos. 888, 890 (1966). Also in *Nihon Kaigashi Ronshū*, pp. 383–449.

———. *Nihon Kaigashi Ronshū* (Collected Essays on Japanese Art History). Tōkyō: Chūō Kōron Bijutsu Shuppan, 1966.

———. "Soga Dasoku to Sōjō o Meguru Sho-mondai" ("Several Problems Concerning Soga Dasoku and Sōjō"), *Ars Buddhica* (*Bukkyō Geijutsu*) 79 (1971): 15–35.

———. *Ka'ō, Moku'an, Minchō*. Suiboku Bijutsu Taikei, vol. 5. Tōkyō: Kōdansha, 1974.

——— and Yonezawa Yoshiho. *Suibokuga* (Ink Painting). Genshoku Nihon no Bijutsu, vol. 11. Tōkyō: Shōgakukan, 1970.

——— and Nakamura Tani'o. *Sesshū, Sesson*. Suiboku Bijutsu Taikei, vol. 7. Tōkyō: Kōdansha, 1973.

Tanaka Kisaku. "Senmen-byōbu ni tsuite" ("Concerning Folding Screens on which Fan Paintings Are Mounted"), *Bijutsu Kenkyū*, no. 51 (1936):89–95.

———. "Gashi Shūtoku" ("Shūtoku, a Priest-Painter of the Ashikaga Period"), *Bijutsu Kenkyū*, no. 54 (1936): 16–22.

———. *Momoyama Jidai Kimpeki Shōhekiga* (Decorative Wall Paintings of the Momoyama Period). Tōkyō: Ōtsuka Kōgeisha, 1947.

Tanaka Toyozō. "Mokkei Kanwa" ("On Mu-ch'i"), *Bijutsu Kenkyū*, no. 130 (1943):117–26.

———. *Chūgoku Bijutsu Kenkyū* (Studies of Chinese Art). Tōkyō: Nigensha, 1964.

T'ang Hou. *Hua Chien* (Survey of Painting; ca. 1320's). In Yang Chia-lo, ed., *I-shu Ts'ung-pien*, vol. 11, no. 82. Taipei, preface 1962.

Tani Bunchō (1763–1840). *Bunchō Gadan* (Bunchō's Discussion of Painting; ca. 1811). In Sakazaki Tan, ed., *Nihon Gadan Taikan*, pp. 757–817. Tōkyō: Mejiro Shoin, 1917.

Tani Shin'ichi. "Mokkei Gashi — Chūsei ni okeru Shina-ga no Kanshō no Issetsu" ("Old Japanese Documents Concerning Mu-ch'i's Paintings: On the Appreciation of Chinese Paintings in the Kamakura and Ashikaga Periods"), *Bijutsu Kenkyū*, no. 43 (1935):197–307.

———. "Hakusai Shina-ga no Seishitsu to Kakaku" ("Critical Studies on Chinese Pictures Imported into Japan in the Kamakura and Ashikaga Periods"), *Bijutsu Kenkyū*, no. 46 (1935):455–61.

———. "Gyomotsu On'e Mokuroku" ("Discussion and Transcription of the *Gyomotsu On'e Mokuroku*, A Selection of Chinese Paintings in the Ashikaga Shōgunal Collection"), *Bijutsu Kenkyū*, no. 58(1936):439–47. Also in *Muromachi Jidai Bijutsu-shi Ron*, pp. 116–42.

———. *Muromachi Jidai Bijutsu-shi Ron* (Studies in Art History of the Muromachi Period). Tōkyō: Tōkyōdō, 1942.

———, ed. *Nihon 7, Muromachi* (Muromachi Art). Sekai Bijutsu Zenshū, vol. 7. Tōkyō: Kadokawa Shoten, 1964.

Tao-yüan. *Ching-te Ch'uan-teng-lu* (Record of the Transmission of the Lamp; 1004). Taipei: P'u Hui Ta Ts'ang Ching K'an Hsing Hui, 1967.

Tayama Hōnan, ed. *Zenrin Bokuseki* (Calligraphy by Zen Priests in China and Japan). 2 vols. plus text vol. Tōkyō: Ichikawa, 1955.

———, ed. *Zoku Zenrin Bokuseki* (Additional Calligraphy by Zen Priests in China and Japan). 3 vols. Tōkyō: Zenrin Bokuseki Kankōkai, 1965.

Tesshū Tokusai (d. 1366). *Embushū* (Literary Anthology of Tesshū Tokusai). In U'emura Kankō, ed., *Gozan Bungaku Zenshū*, 2:381–450. Tōkyō: Gozan Bungaku Zenshū Kankōkai, 1936.

Toda Teisuke. *Mokkei, Gyokkan* (Mu-ch'i, Yü-chien). Suiboku Bijutsu Taikei, vol. 3. Tōkyō: Kōdansha, 1973.

Tōfuku-ji-shi. See Shiraishi.

Tōhaku Gasetsu. See Minamoto.

Tokunaga Kōdō (Hiromichi). "Nansō Shoki no Zenshū Soshizō ni tsuite" ("On the Pictorial Images of the 'Founders of the Zen Sect' that Date from the Earliest Southern Sung Period"), *Kokka*, no. 929 (1970); 930 (1971).

Tōkyō Bijutsu Gakkō Zōhin Mokuroku (Inventory of Art Works in the Possession of Tōkyō Academy of Fine Arts). Tōkyō: Shimbi Shoin, 1914.

Tōkyō Imperial Academy of Art. *Tōsō Genmin Meiga Taikan* (Compilation of Famous Chinese Paintings from T'ang to Ming). Tōkyō: Ōtsuka Kōgeisha, 1929.

————. *Tōsō Genmin Meiga Taikan* (Compilation of Famous Chinese Paintings from T'ang to Ming). 4 vols. Tōkyō: Ōtsuka Kōgeisha, 1930.

Tōkyō Kokuritsu Hakubutsukan. See Tōkyō National Museum.

Tōkyō National Museum. *Jūyō Bijutsuhin* (Catalogue of Works Designated as Important Art Objects). Tōkyō: Kōgakusha, 1948.

————. *Tōkyō Kokuritsu Hakubutsukan Shūzōhin Mokuroku* (Catalogue of Masterpieces in the Collection of the Tōkyō National Museum). Tōkyō: Tōkyō National Museum, 1952.

————. *Sesshū*. Tōkyō: Benridō, 1956.

————. *Sōgen no Kaiga* (Chinese Paintings of the Sung and Yüan Dynasties). Tōkyō: Benridō, 1962.

————. *Minshin no Kaiga* (Chinese Paintings of the Ming and Ch'ing Dynasties). Tōkyō: Benridō, 1964.

————. *Sesson: Tokubetsu Tenran* (Sesson: Special Exhibition). Tōkyō: Tōkyō National Museum, 1972.

————. *Rimpa* (The Kōrin School of Art). Kyōto: Benridō, 1973.

Tōsō Genmin Meiga Taikan. See Tōkyō Imperial Academy of Art.

Tōyō Bijutsu (Asiatic Art in Japanese Collections). 6 vols. Edited by Tanaka Ichimatsu, Yonezawa Yoshiho, and Kawakami Kei. Tōkyō: Asahi Shimbunsha, 1967–69.

Tōyō Bijutsu Taikan. See Tajima.

Tsuji Nobu'o. "Kano Motonobu," *Bijutsu Kenkyū*, nos. 246, 249 (1966); 270, 271, 272 (1970).

Tsuji Zennosuke, ed. *Roku'on Nichiroku* (Diaries of Priests of the Roku'on-in of Shōkoku-ji; 1487–1651). 6 vols. Tōkyō: Zoku Gunsho Ruijū, 1934–37.

————, ed. *Kūge Nichiyō Kufū Ryakushū* (The Journal of Gidō Shūshin). Tōkyō: Taiyōsha, 1938.

————, ed. *Daijō-in Jisha Zōjiki* (Diary of Jinson and Various Records of Functionaries of the Kōfuku-ji; 1450–1527). Tōkyō: Kadokawa Shoten, 1964.

Tsuruta Takehiko. "Nihon Garon Nempyō" ("A Chronology of Japanese Literature on Painting"), *Bunka* 33 (1970):539–76.

U'emura Kankō, ed. *Gozan Bungaku Zenshū* (Compilation of Literature of Gozan Monks). 5 vols. Tōkyō: Gozan Bungaku Zenshū Kankōkai, 1936.

Usu'i Nobuyoshi. "Gyoku'en no In" ("Seals of Gyoku'en Bompō"), *Nihon Rekishi*, no. 171 (1962):36–39.

Wakimoto Sokurō. "Kō Nenki ni tsuite" ("On Kao Janhui"), *Bijutsu Kenkyū*, no. 13 (1933):8–16.

————. "Sengoku no Bujin Gaka, Yamada Dō'an" ("Yamada Dō'an, Warrior-Artist of the Sengoku Period"), *Gasetsu*, nos. 10–12 (1937).

————. "Gei'ami no Kambaku So-zu" ("Gei'ami's *Viewing a Waterfall*"), *Gasetsu*, no. 31 (1965):579–82.

Wang Feng (14th century). *Wu Ch'i Chi* (Wang Feng's Literary Anthology). In Wang Yün-wu, ed., *Ssu-k'u Ch'üan-shu Chen Pen Tu Chi*, no. 347. Taipei, 1971.

Washi'o Junkei. *Nihon Zenshū-shi no Kenkyū* (Study of the History of the Zen Sect in Japan). Tōkyō: Kyōten Shuppan Kabushiki Kaisha, 1947.

Watanabe Hajime. "Nihonsō Kichō Sōbetsu-zu" ("Departure of a Japanese Monk — An Anonymous Chinese Painting of the Southern Sung Period"), *Bijutsu Kenkyū*, no. 4 (1932).

————. "Shūbun," *Bijutsu Kenkyū*, no. 80 (1938):333–90.

————. "Reisai," *Bijutsu Kenkyū*, no. 87 (1939):105–15.

————. *Higashiyama Suibokuga no Kenkyū* (Studies in Ink Painting of the Higashiyama Period). Tōkyō: Zayūhō Kankōkai, 1948.

Wu T'ai-su. *Sung-chai Mei-p'u* (Handbook of Painting and Poetry of Plum; preface dated 1350 or 1351). Unpublished. See Shimada, "Shōsai Baifu Teiyō."

Yajima Kyōsuke. "Hakuga Dankin-kyō" ("Mirrors of P'o-ya Playing the Ch'in"), *Museum*, no. 96 (1959):23–25.

Yamaguchi Prefectorial Museum. *Sesshū* (Catalogue of a Special Sesshū Exhibition). Tōkyō: Ōtsuka Kōgeisha, 1973.

Yamato Bunkakan. *Sesson Meisaku Tokubetsu Shutchin Mokuroku* (Catalogue of the Exhibition of Special Works by Sesson). Nara: Yamato Bunkakan, 1961.

————. *Kannon no Kaiga* (Exhibition of Kannon Paintings). Nara: Yamato Bunkakan, 1974.

Yasuda Aya'o. *Nihon no Geijutsu Ron* (Discussion of Japanese Art). Tōkyō: Tōkyō Sōgensha, 1957.

Yonezawa Yoshiho. "Sekkyakushi hitsu Bokudō-zu" ("*Ox and Herdsman* by Sekkyakushi"), *Kokka*, no. 802 (1959):17–18.

———. "Rogan ni tsuite" ("On Pictures of Reeds-and-Geese"), *Kokka*, no. 929 (1970):31–40.

———. "E-sō to Denshō Sakuhin" ("Hui-ch'üang and Pictures Ascribed to Him"), *Kokka*, no. 943 (1972):7–12.

———. and Nakata Yūjirō. *Shōrai Bijutsu* (Chinese Painting and Calligraphy in Japan). Genshoku Nihon no Bijutsu, vol. 29. Tōkyō: Shogakukan, 1971.

Yung-lo Kung (Illustrated Album of the Architecture and Art Objects of the Yung-lo Temple). Peking: Jen-meng-mei-hsu Chu-pan, 1964.

Zekkai Chūshin (1336–1405). *Shōkenkō* (Literary Anthology of Zekkai Chūshin). In U'emura Kankō, ed., *Gozan Bungaku Zenshū*, 2:1023–78. Tōkyō: Gozan Bungaku Zenshū Kankōkai, 1936.

Zenseki Mokuroku (Index to Zen Literature). Tōkyō: Komazawa Daigaku Toshokan, 1962.

Zoku Gunsho Ruijū. See *Gunsho Ruijū*.

Zoku Honchō Gashi. See Hiyama Tansai.

Zuikei Shūhō (1391–1473). *Ga'un Nikkenroku Batsuyū* (Diary of Zuikei Shūhō, Scholar-monk of Shōkoku-ji. Excerpt edited by Yikō Myō'an in 1562). In *Dainihon Kokiroku*, part 13. Tōkyō: Iwanami Shoten, 1961.

SOURCES IN WESTERN LANGUAGES

Acker, William. *Some T'ang and Pre-T'ang Texts on Chinese Painting*. Leiden: Brill, 1954.

Akiyama, Terukazu. *Japanese Painting*. Lausanne: Skira, 1961.

Asiatic Art in the Seattle Art Museum. A Selection and Catalogue by Henry Trubner, William J. Rathbun, and Catherine A. Kapula. Tōkyō: Kōdansha, 1973.

Auboyer, Jeannine. *Rarities of the Musée Guimet*. New York: Asia Society, 1975.

Awakawa, Yasuichi. *Zen Painting*. Translated by John Bester. Tōkyō: Kōdansha International Ltd., 1970.

Barnhart, Richard. "Li T'ang (c. 1050–c. 1130) and the Kōtō-in Landscapes," *Burlington Magazine* 114:830 (1972):305–14.

Brinker, Helmut. "Shussan Shaka in Sung and Yüan Painting," *Ars Orientalis* 9 (1973): 21–40.

Boston. Museum of Fine Arts. *Art Treasures from Japan*. Boston: Museum of Fine Arts, 1936.

Bunkazai Hogo I'inkai. *Art Treasures from Japan*. Tōkyō: Kōdansha, 1966.

Bush, Susan. *The Chinese Literati on Painting*. Cambridge: Harvard University Press, 1971.

Cahill, James. "Confucian Elements in the Theory of Painting," in Arthur F. Wright, ed., *The Confucian Persuasion*, pp. 115–40. Stanford: Stanford University Press, 1960.

Chang, Lily P., and Sinclair, Marjorie. *The Poems of T'ao Ch'ien*. Honolulu: University of Hawaii Press, 1945.

Chapin, Helen B. "Three Early Portraits of Bodhidharma," *Archives of the Chinese Art Society of America* 1 (1945–46):66–95.

Cleveland Museum of Art. *Selected Works*. Cleveland: The Cleveland Museum of Art, 1967.

Collcutt, Martin. "The Zen Monastic Institution in Medieval Japan." Unpublished Ph.D. dissertation, Harvard University, 1975.

Dumoulin, Heinrich. *A History of Zen Buddhism*. Translated from the German by Paul Peachey. Boston: Beacon Press, 1963.

Fontein, Jan. *The Pilgrimage of Sudhana*. The Hague: Mouton, 1967.

——— and Hickman, Money L. *Zen Painting and Calligraphy*. Boston: Museum of Fine Arts, 1970.

——— and Tung Wu. *Unearthing China's Past*. Boston: Museum of Fine Arts, 1973.

Giles, Herbert A. *An Introduction to the History of Chinese Pictorial Art*. Shanghai: Kelly and Walsh Ltd., 1918.

Hawkes, David. *Ch'u Tz'u: Song of the South.* Oxford: Clarendon Press, 1959.

Hightower, James Robert. *T'ao Ch'ien,* Oxford: Clarendon Press, 1970.

Hisamatsu, Shin'ichi. *Zen and the Fine Arts.* Translated by Gishin Tokiwa. Tōkyō: Kōdansha, 1971.

Ho, Wai-kam. "Ka'ō: Myth and Speculations," Cleveland Museum of Art Bulletin 50 (1963): 71–79.

Japanese-English Buddhist Dictionary. Tōkyō: Daitō Shuppansha, 1965.

I-Ching. See Wilhelm.

Kern, H. *Saddharma-Pundarīka, or The Lotus of the True Law.* New York: Dover Publications, 1963.

Lee, Sherman E. "Japanese Art at Seattle," *Oriental Art* 2 (1949–50): 89–98.

———. "Japanese Monochrome Painting at Seattle," *Artibus Asiae* 14 (1951):43–61.

———. "Winter and Spring by Shūbun," Cleveland Museum of Art *Bulletin* 46 (1959):173–80.

———. "The Tiger and Dragon Screens by Sesson," Cleveland Museum of Art *Bulletin* 47 (1960):65–69.

———. *Tea Taste in Japanese Art.* New York: Asia House Exhibition Catalogue, no. 40 (1963).

———. *Japanese Decorative Style.* New York: Harper and Row, 1972.

———. "Zen in Art: Art in Zen," Cleveland Museum of Art *Bulletin* 59 (1972):238–59.

——— and Ho, Wai-kam. *Chinese Art Under the Mongols: The Yüan Dynasty (1279–1368).* Cleveland: Cleveland Museum of Art, 1968.

Li, Chu-tsing. "The Oberlin Orchid: A Problem in Attribution," Allen Memorial Art Museum *Bulletin* 20 (1961):4–25.

———. "The Oberlin *Orchid* and the Problem of P'u-ming," *Archives of the Chinese Art Society of America* 16 (1962):49–76.

Lotus Sūtra. See Kern.

Lovell, Hin-cheung. *An Annotated Bibliography of Chinese Painting Catalogues and Related Texts.* Michigan Papers in Chinese Studies, no. 16. Ann Arbor: Center for Chinese Studies, University of Michigan, 1973.

McCune, Evelyn. *The Arts of Korea.* Rutland and Tōkyō: Tuttle, 1962.

Martinson, Fred. "Early Muromachi Screen Painting." Unpublished Ph.D. dissertation, University of Chicago, 1968.

Masterpieces of Asian Art in American Collections, II. New York: Asia House, 1970.

Matsushita, Taka'aki. *Ink Painting.* Translated and adapted by Martin Collcutt. Arts of Japan, no. 7. New York: Weatherhill/Shibundō, 1974.

Mayuyama, Junkichi, ed. *Japanese Art in the West.* Tōkyō: Mayuyama and Co., Ltd., 1960.

Momoyama: Japanese Art in the Age of Grandeur (An Exhibition at the Metropolitan Museum of Art). New York: The Metropolitan Museum of Art, 1975.

Mote, Frederick W. "Confucian Eremitism in the Yüan Period," in Arthur F. Wright, ed., *Confucianism and Chinese Civilization,* pp. 202–40. Stanford: Stanford University Press, 1960.

Murase, Miyeko. "Farewell Paintings of China: Chinese Gifts to Japanese Visitors," *Artibus Asiae* 32 (1970):211–36.

———. *Byōbu: Japanese Screens from New York Collections.* New York: Asia Society, 1971.

Noma, Seiroku. *The Arts of Japan: Ancient and Medieval.* Translated and adapted by John Rosenfield. Tōkyō: Kōdansha International Ltd., 1966.

Obata, Shigeyoshi. *The Works of Li Po.* New York: Dutton, 1928.

Paine, Robert Treat, and Soper, Alexander C. *The Art and Architecture of Japan.* Rev. ed. Baltimore: Penguin Books, 1975.

Papinot, E. *Historical and Geographical Dictionary of Japan.* Yokohama: Kelly and Walsh, 1910.

Rosenfield, John M., and Shimada, Shūjirō. *Traditions in Japanese Art: Selections from the Kimiko and John Powers Collection.* Cambridge: The Fogg Art Museum, 1970.

San Francisco Museum of Art. *Art in Asia and the West.* San Francisco: San Francisco Museum of Art, 1957.

Sansom, George B. *A History of Japan: 1334–1615.* Stanford: Stanford University Press, 1961.

———. *Japan: A Short Cultural History.* Rev. ed. New York: Meredith Corporation, 1962.

Seattle Art Museum. *Handbook: Selected Works from the Permanent Collection.* Seattle: Seattle Art Museum, 1951.

———. *Japanese Art in the Seattle Art Museum.* Seattle: Seattle Art Museum, 1960.

"Selected Illustrations from the Miller Fund Acquisitions," Allen Memorial Art Museum *Bulletin* 16 (1959).

Shimizu, Yoshiaki. "Problems of Moku'an Rei'en (?–1323–1345)." Unpublished Ph.D. dissertation, Princeton University, 1974.

Sirén, Osvald. *Chinese Painting.* 7 vols. New York: The Ronald Press Company, 1956.

Soper, Alexander C. *Kuo Jo-hsü's Experiences in Painting.*

Washington: American Council of Learned Societies, 1951.

Stanley-Baker, Richard. "Gaku'ō's Eight Views of Hsiao and Hsiang," *Oriental Art* 20 (1974):283–303.

Stern, Harold P., and Lawton, Thomas. *The Freer Gallery*, vol. 2. *Japan.* Tōkyō: Kōdansha, 1972.

Suzuki, Daisetsu T. *Zen and Japanese Culture.* Rev. ed. Bollingen Series 64. Princeton: Princeton University Press, 1970.

Suzuki, Kei. "Hsia Kuei and the Pictorial Style of the Southern Sung Academy," *Proceedings of the International Symposium on Chinese Painting,* pp. 417–43. Taipei: National Palace Museum, 1972.

Tanaka, Ichimatsu. *Wall Paintings of the Hōryū-ji Monastery.* Tōkyō: Benridō, 1951.

————. *Japanese Ink Painting: Shūbun to Sesshū.* Translated by Bruce Darling. New York: Weatherhill/ Heibonsha, 1972.

Tomita, Kōjirō. *Portfolio of Chinese Paintings in The Museum of Fine Arts, Boston (Han to Sung Periods).* Cambridge: Harvard University Press, 1933.

Tsunoda, Ryūsaku; deBary, William Theodore; Keene, Donald. *Sources of Japanese Tradition.* 2 vols. New York: Columbia University Press, 1958.

Vandier-Nicolas, Nicole. *Le Houa-che de Mi Fou.* Paris: Université Institut des Hautes Etudes Chinoises, 1964.

Watson, Burton, trans. *Cold Mountain.* New York: Grove Press, 1962.

Wilhelm, Richard, trans. *The I-Ching or Book of Changes.* English translation from the German by Cary F. Baynes. Bollingen Series 19. Princeton: Princeton University Press, 1967.

Yampolsky, Philip B. *The Platform Sutra of the Sixth Patriarch.* New York: Columbia University Press, 1967.

INDEX

*Page numbers for illustrations
are in italics.*